THE GREAT BRITISH DREAM FACTORY

'Witty . . . enthusiastic . . . a passionate and admirable defence of coach-party musical theatre, large-print historical fiction, wedding reception rock, Orc sagas, *To the Manor Born*, Arnold Bennett, Billy Bunter and Billy Elliot . . . made of the most thrillingly unlikely material' Matthew Sweet, *Guardian*

'Splendid . . . a book about the very things that, over the past century, we have most enjoyed, from Hercule Poirot to *Sgt Pepper*' David Aaronovitch, *The Times*

'A vivid, endlessly fascinating account of the numerous achievements of this country's national imagination. This book is my personal dream factory' Jessie Thompson, *Huffington Post*

'Sparkling . . . fascinating . . . always enlightening . . . as usual with Sandbrook, there are some lovely vignettes and incongruous details . . . Academic writers could certainly learn something from his lightness of touch and ability to build an argument' Joe Moran, *Literary Review*

'Sandbrook's hugely enjoyable analysis of why we continue to punch above our weight in this area covers everything from boarding school tales (*Tom Brown* to *Harry Potter*) to country house tales (*Brideshead* and *Downton*), the works of Tolkien to the 2012 Olympics' *Mail on Sunday*, Books of the Year

'Brilliant' A. N. Wilson, *The Tablet*

'A marvellous read . . . juicy, irresistible . . . He delights in the sheer, tumbling crowdedness of British popular culture over the past half century or so . . . catches with infectious excitement the cracking pace and headlong productivity of this teeming crowd' Fred Inglis, *Times Higher Education Supplement*

'Masterly . . . lively and stimulating . . . He loves to debunk received opinion' Robert Low, *Standpoint*

'Delightfully good . . . an exuberant and learned celebration of British culture . . . full of love for and fascination with everything from the origins of heavy metal in the metal-bashing industries of the West Midlands to John Lennon's and Damien Hirst's lust for money' Nick Cohen, *Observer*

'Relentlessly entertaining . . . unashamed in its concentration on popular culture . . . unearthing all kinds of forgotten cultural heroes' Daisy Goodwin, *Sunday Times*

'Defiantly populist ... Dominic Sandbrook zestfully charts the route that has taken Britain from 'workshop of the world' to 'cultural superpower'. This whimsical nation of boy wizards, glam-rock bands, eccentric detectives and time-travelling saviours touches the hearts (and wallets) of the planet as no ship-builder or kiln-master ever did ... as Sandbrook rightly insists, "we still live in the shadow of the Victorians"' Boyd Tonkin, *Independent*

'An engaging and very accessible history book about our modern artistic achievements that, provocatively, also debunks some of the very icons it praises' Simon Copeland, *The Sun*

ABOUT THE AUTHOR

Dominic Sandbrook is one of Britan's best-known historians. Educated at Oxford, St Andrews and Cambridge, he taught history at the University of Sheffield before publishing a series of best-selling books on post-war Britain. On television he has written and presented BBC documentaries on subjects as diverse as the joys of the Volkswagen and the history of science fiction. Currently Visiting Professor at King's College London, he writes regularly for the *Daily Mail* and *Sunday Times*, and lives in Oxfordshire.

DOMINIC SANDBROOK

The Great British Dream Factory

The Strange History of Our National Imagination

PENGUIN BOOKS

PENGUIN BOOKS

UK | USA | Canada | Ireland | Australia
India | New Zealand | South Africa

Penguin Books is part of the Penguin Random House group of companies
whose addresses can be found at global.penguinrandomhouse.com.

First published by Allen Lane 2015
Published in Penguin Books 2016
003

Copyright © Dominic Sandbrook, 2015

The moral right of the author has been asserted

Set in 9.08/12.39 pt Sabon LT Std
Typeset by Jouve (UK), Milton Keynes
Printed in Great Britain by Clays Ltd, St Ives plc

A CIP catalogue record for this book is available from the British Library

ISBN: 978-0-141-97930-4

www.greenpenguin.co.uk

MIX
Paper from
responsible sources
FSC® C018179

Penguin Random House is committed to a
sustainable future for our business, our readers
and our planet. This book is made from Forest
Stewardship Council® certified paper.

For Arthur

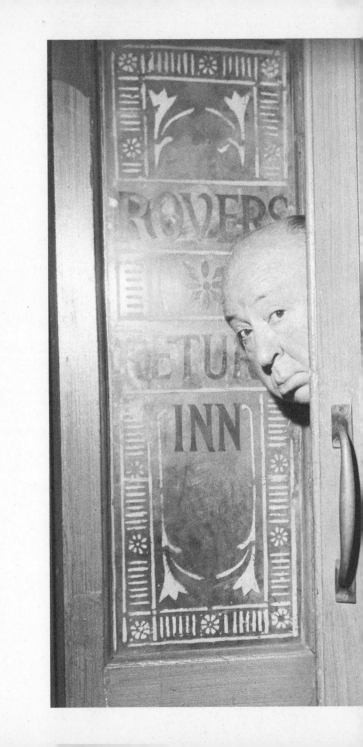

Previous pages: Alfred Hitchcock pops into the Rovers Return, 1964.

Lying in bed, I abandoned the facts again and was back in Ambrosia.

Keith Waterhouse, *Billy Liar* (1959)

As if by magic, the shopkeeper appeared.

David McKee, *Mr Benn* (1971-2)

Contents

PART ONE

Made in Britain

From Workshop of the World to Cultural Superpower

PART TWO

Play up! Play up! and Play the Game!

The Victory of the Old Order

PART THREE

We Are the Martians

British Culture in the Shadow of the Past

List of Illustrations

Preface: The British Are Coming!

Somebody asked me yesterday what face of Britain I wanted to put forward, is it Blur or the Beefeaters, and frankly it's both.
David Cameron, speaking before the
London Olympics, 27 July 2012

In the summer of 2012, the Olympics came to London. For seven years their arrival had been keenly anticipated, and yet in the weeks leading up to the opening ceremony the public mood was far from optimistic. Almost from the moment London had been awarded the Games, there had been a sense of foreboding: only hours after the announcement, the news had been driven off the front pages by the Islamist bomb attacks on the London transport system. In the following years, much had changed. Shaken by the worldwide banking crisis, the British economy had struggled through one of the deepest recessions in its history. In its aftermath, the Labour government that had secured the right to host the Games had fallen from office, replaced by a Conservative-led coalition committed to deep spending cuts. Yet even though the budget for the Games had originally been set at some £2.4 billion, by the time the athletes arrived it had ballooned to almost £9 billion. And with the newspapers competing to find the most sensational examples of corruption, extravagance, paranoia and incompetence, it was little wonder that, as the opening ceremony approached, many people steeled themselves for the worst.

'With all the rampant commercialism, the grotesque fawning over foreign "dignitaries", the obscene cost, the dubious legacy and the fear we've made ourselves a major terror target,' wrote one columnist in the *Daily Mirror*, people were 'begging their partners to manacle them to the bed and blindfold them so they're nowhere near a TV set when the

inevitable disasters unfold'. Even abroad, expectations seemed depressingly low. The *New York Post* warned its readers to prepare for 'the feel-bad extravaganza of the century', while *Der Spiegel* predicted 'an Olympic-sized fiasco' that would be remembered only for interminable queues, driving rain and an atmosphere of stifling paranoia. Embarrassingly, even the American presidential candidate Mitt Romney, visiting London the day before the opening ceremony, doubted the city's capacity to put on a suitably enjoyable show. The early signs were 'disconcerting', he told American broadcasters, sending Downing Street into a paroxysm of fury. 'It's hard to know just how well it will turn out.'[1]

As almost everybody recognized, the tone would be set by the opening ceremony. In 1948, the last time that London had hosted the Olympics, the athletes had simply marched around Wembley Stadium before King George VI, with army bands entertaining the crowds. But, by the twenty-first century, such a modest kick-off was simply inconceivable. Opening ceremonies had now become vastly expensive showcases, proudly proclaiming the unique virtues of the host nation, with Beijing's extravagant blowout in 2008 having set an almost impossibly high standard. But the Prime Minister, David Cameron, was clearly not afraid of the challenge. This, he declared, was a chance to send 'a powerful message to the world: if you're looking for a great place to do business, to invest, to work, to study, to visit – then look no further than Great Britain'. As Cameron pointed out, London had a proud record of putting on spectacular shows. The organizers, he insisted, should take inspiration from 'the Great Exhibition of 1851, when the personal drive of one man, Prince Albert, created South Kensington – a new quarter of our capital that became a home to art, to science and to technology', while his own commitment to a lasting economic legacy had been inspired by 'the Festival of Britain [in] 1951, which was a showcase of national enterprise and innovation'. Now as then, he insisted, 'we need to sell Britain to the world on the back of British success'.[2]

The obvious problem, as commentators anxiously pointed out, was that Britain's international standing in 2012 was very different from what it had been in 1851 or even in 1951. Although the Festival of Britain had taken place in an exhausted, indebted, bomb-damaged capital, it had nevertheless been a tribute to the collective unity that had taken Britain and its Empire to victory in the Second World War. As for the Great Exhibition, the inspiration for all subsequent spectacles of this

kind, it had been conceived from the outset as a celebration of Victorian Britain's position as the world's outstanding imperial, economic and commercial power. Indeed, the day before the Crystal Palace opened to the public, *The Times* had printed a triumphant ode by William Makepeace Thackeray, singling out its gleaming steam engines as the instruments of Britain's global supremacy:

> Look yonder where the engines toil;
> These England's arms of conquest are,
> The trophies of her bloodless war:
>> Brave weapons these.

> Victorious over wave and soil,
> With these she sails, she weaves, she tills,
> Pierces the everlasting hills,
>> And spans the seas.

Nobody could have written a similar poem in 2012. Britain's economic ascendancy had gone the way of its Empire, and the nation's worldwide reputation had clearly declined since its Victorian heyday. In its gleefully morbid Olympic preview, the *New York Post* described the United Kingdom as 'an economically depressed country', a 'cowering, cringing place ... not only spiritually but literally soggy, gray and damp'. Even many domestic commentators apparently endorsed this gloomy verdict. The Great Exhibition and the Festival of Britain, declared one Eeyorish historian in the *Daily Mail*,* had been 'celebrations of the best in education, art and design, temples to technology and industry'. But 'recapturing the spirit of 1951, let alone 1851, seems well beyond us now. The truth is that we have long since lost the national self-confidence and moral seriousness that were once intrinsic elements of British identity.'[3]

The general atmosphere before the opening ceremony, therefore, was one of doom-laden trepidation. Many columnists shuddered to recall the utter fiasco of the previous attempt to recreate the spirit of the Great Exhibition. 'Believe me,' Tony Blair had said of the Millennium Dome, 'it will be the envy of the world.' Instead, the Dome had become a byword for disaster: a cavernous structure that had nothing worthwhile to say about Britain's past, present or future. As the *Guardian*'s Hugo

* Me.

Young had remarked, it was a 'humiliating embarrassment ... which leaves Britain looking like a nation led astray by profligate, self-regarding philistines'. The prospect of another debacle, only twelve years later, was almost too gruesome to contemplate. 'Nobody could describe its director, Danny Boyle, or some of its performers as second-rate,' wrote the *Spectator*'s Andrew Gilligan, previewing the opening ceremony. 'But we must still cross our fingers that we're not aesthetically shamed before the world.' The stakes could scarcely have been higher: if things went wrong, warned the *Independent*, 'Britain's embarrassment will be witnessed by a global audience estimated in excess of one billion people'.[4]

But the opening ceremony was not, of course, an embarrassment: quite the reverse. With a handful of exceptions, millions of British viewers were entranced by the rousing tributes to their rural and industrial heritage, the stirring evocations of Milton, Blake and Shakespeare, the comic nods to James Bond and Mr Bean, and the loving homages to J. M. Barrie and J. K. Rowling. The soundtrack alone was a hymn to British cultural talent, taking in everything from Edward Elgar to Tinie Tempah, from the Beatles, the Rolling Stones and the Sex Pistols to the Prodigy, Amy Winehouse and Dizzee Rascal. And although foreign viewers were impressed by Danny Boyle's spectacular restaging of the Industrial Revolution, it was his emphasis on music, comedy and children's stories that really captured their attention.

The 'hilariously quirky' ceremony, wrote the *New York Times*'s London correspondent Sarah Lyall, suggested 'that the thing that is most British about the British is their anarchic spirit and their ability to laugh at themselves'. It was impossible, agreed her colleague Alessandra Stanley, 'to imagine any other nation willing to make so much fun of itself on a global stage'. Even the Chinese, whose opening ceremony four years earlier had struck a very different note, were impressed. The state-run Xinhua news agency told readers that it had celebrated 'British humour and fantasy literature', the product of 'Britain's well-developed cultural and creative industries', while the dissident artist Ai Weiwei applauded Boyle's celebration of 'stories and literature and music'. But perhaps the most telling tribute came in the *Washington Post*, the house newsletter of the capital that, decades earlier, had displaced London as the centre of world affairs:

> Amid green and pleasant pastures, they read from the storybook that is Britain, not just Shakespeare but Peter Pan and Harry Potter. And if the

Opening Ceremonies of the London Games sometimes seemed like the world's biggest inside joke, the message from Britain resonated loud and clear: We may not always be your cup of tea, but you know – and so often love – our culture nonetheless.

The themes showcased Britain, past, present and future, capturing the mind-set of a nation seeking to redefine itself through these Games after nearly a century of managed decline. A great empire, gone. Military might, ebbing. Sense of humor, very much intact . . .

For an audience across the Atlantic, it seemed like the rock-and-roll Olympics, an event celebrating the shared culture of the English-speaking world – so much of it thanks to these relatively tiny isles.

As it happened, Britain was the third most populous island in the world, with its sixth largest economy and fourth biggest military budget, so it was not really so tiny. Still, the *Post* meant well.[5]

The 'biggest single inspiration for the Olympics opening ceremony', Danny Boyle said later, was Humphrey Jennings's book *Pandaemonium* (1985), which explores the coming of the machine age through a vast compilation of contemporary accounts from 1660 to 1886. The book had been a present from Boyle's chief collaborator, the screenwriter Frank Cottrell Boyce, who insisted afterwards that 'the whole nation collectively had forgotten that they did the Industrial Revolution. That we invented the modern world!' No doubt plenty of history teachers would consider that a bit of an exaggeration. All the same, Boyle loved the idea. Having grown up in Radcliffe, Lancashire, a former mill and mining town, he was instinctively drawn to the thought of celebrating Britain's industrial heritage. But 'it's not just because I come from the north of England; it's just a no-brainer', he said later:

> The stadium was built on land which they sealed and recovered from the Industrial Revolution poison. It's the area Dickens wrote about. Britain's Industrial Revolution was exported all over the world and is still happening in certain countries, as they go through the painful process of mechanisation. We invented that. Wow! All this talk of British kings and queens is irrelevant by comparison.[6]

In his enthusiasm for the Industrial Revolution, Boyle was not a million miles away from embracing the spirit of the Great Exhibition, which had, after all, been a gigantic tribute to the triumphs of the machine age.

The difference was that, although Boyle's vision found room for Sir Tim Berners-Lee, the inventor of the World Wide Web, his Industrial Revolution was set firmly in the past.

As late as 1951, when London had hosted the Festival of Britain, the nation's manufacturers had produced a third of its national output, employed four out of ten workers and commanded a quarter of the world export trade. But by the time Boyle's performers took the stage, Britain's manufacturers produced barely a tenth of its GDP, employed just 8 per cent of its workforce and accounted for a mere 2 per cent of world exports. 'We aren't economic leaders any more. Our industrial importance has diminished,' Boyle admitted. By contrast, 'we are very good at all things cultural'. Pop music, for example, was 'clearly one of the most outstanding things we've given to the outside world'. Hence the ceremony's emphasis on popular culture, the one thing that, as foreign commentators immediately agreed, Britain still did better than almost anybody else. The point, Boyle added, was to celebrate those stories that had taken root in the national imagination. 'Whether you've seen a film like *Kes* or not, it's part of your culture,' he explained. 'Your heritage. It's running in your veins. It's an invisible fingerprint that everybody carries, whether you ever sit down and watch it, or not. I love that idea.'[7]

The idea of Britain as, above all, a land of storytellers, musicians and entertainers would have seemed very odd to the men and women who poured into the Crystal Palace in the summer of 1851. Foreign visitors might have found plenty of things to admire about the workshop of the world – its unwritten constitution, its newspapers, its manufacturers, its navy – but they rarely paid tribute to its popular culture. Had a visiting businessman from Leipzig or Lyons been asked what he admired most about Britain, it is highly unlikely that he would have singled out its hilarious tradition of music-hall comedy. Instead, he would probably have mentioned Britain's maritime and manufacturing might, its record as the world's first industrial power or its traditions of democracy and free speech. The sinews of British life, wrote Samuel Smiles, whose book *Self-Help* (1859) became the bible of Victorian individualism, were 'its tools, its machinery, its steam-engine, its steam-ships, and its locomotive'. When Smiles published a tribute to the 'principal men by whom this nation has been made so great', his title, *Lives of the Engineers* (1874), said it all. These, he wrote, were the men who, 'by their industry, skill, and genius, have made England the busiest of workshops'. It simply would not have

occurred to him to argue that Britain's influence might be based on its novels, its magazines, its theatres or its music halls. This is not to deny, of course, that Victorian Britain had a vibrant and exciting popular culture, or that writers like Charles Dickens were much admired abroad. But these things seemed incidental to a much bigger story: the glory of British commerce and industry. The idea that the British were born entertainers, bubbling with natural flair, good humour and musical exuberance, would have struck people on both sides of the Channel as patently ridiculous.[8]

At one level, therefore, the story of Danny Boyle's opening ceremony was that of a nation that, having lost its genuine manufactories, had embraced a new identity as the world's great dream factory. A cynic might suggest that this role was invented to disguise the fact that, as George Orwell had once warned, the loss of Empire had reduced Britain to 'a cold and unimportant little island where we should all have to work very hard and live mainly on herrings and potatoes'. Politicians have certainly been pushing it with great enthusiasm ever since the departure of Margaret Thatcher, perhaps the last Prime Minister who felt no need to hide her total indifference to contemporary popular culture. It was her successor, John Major, who in 1992 appointed the first Culture Secretary – then known as the National Heritage Secretary – in David Mellor, who was immediately and rather inappropriately dubbed the 'Minister for Fun'. But it was under Tony Blair that the notion of Britain as a fundamentally fun-loving place, something Mrs Thatcher would surely never have tolerated, really took hold.

As the Demos pamphlet *Britain*™ argued in 1997, the country's image desperately needed an overhaul. 'One hundred or even fifty years ago, Britishness meant industry,' explained its author, an earnest wonk in his early twenties called Mark Leonard. 'At the Great Exhibition of 1851, the organisers were happy to put on display the world's finest products because they could be confident that the British ones would stand out.' But times had changed, and Britain needed a new global brand, emphasizing its record of 'success in creative industries like music, design and architecture'. Like all good brands, it needed a slogan, and Leonard considered such possibilities as 'Hub UK – Britain as the world's crossroads', 'United colours of Britain' and 'Open for business'. But the slogan that seemed to enthuse him most was 'Creative Island' – an appropriate label, he thought, for a country 'blossoming in film, design, architecture, music, computer games and fashion'.[9]

In many ways *Britain*™ reads like an abandoned idea for an episode of *The Thick of It*. Among some of Leonard's wackier notions, for instance, were a plan to send the Queen around the world 'from Ireland to Iran' to 'heal difficult memories and to signal that Britain has moved beyond its imperial heritage', and a suggestion that people arriving at Britain's airports should be greeted 'with a mouthful of British food – from Scottish to Chinese, Balti to roast beef', which would have made for interesting scenes in the immigration queues at Heathrow. But although it is easy to scoff, Leonard's basic idea – that Britain should rebrand itself as 'Creative Island' – has now become a political commonplace. 'The creative industries', declared Labour's new Culture Secretary, Chris Smith, in 1998, 'have moved from the fringes to the heart of the UK economy; a key economic driver, providing the jobs of the future and maintaining our position in the world.'

This, of course, was the heyday of that much-mocked phenomenon, Cool Britannia. But although the expression rapidly became a joke, the underlying message did not. When David Cameron invited a selection of entertainers to Downing Street for a party dubbed 'Cool Britannia II' in 2014, he insisted that the United Kingdom had always 'punched well above our weight in culture and the arts. We don't have the natural resources to rival other nations but we've got the cultural resources ... So tonight let's resolve to keep on leading the world with our culture.' Determined not to be outdone, his opposite number, Ed Miliband, unveiled a 'task force ... to draw up a policy blueprint for Britain's creative industries', including executives from Sony Music UK and Faber and Faber. Whether Britain's musicians, writers and artists had much to learn from either man, however, was debatable at best. After the Labour leader's appearance on *Desert Island Discs*, the verdict of the normally supportive *Guardian* was less than encouraging. 'Ed Miliband's pop choices', the piece began, 'reveal a man of no musical taste.'[10]

As the Olympic opening ceremony showed, though, there is more to Britain's cultural success than political bluster. It is as difficult to imagine Western pop music without the Beatles, the Rolling Stones, David Bowie and the Sex Pistols as it is to imagine Western crime fiction without Sir Arthur Conan Doyle and Agatha Christie, fantasy fiction without J. R. R. Tolkien and C. S. Lewis, cinema without Alfred Hitchcock and James Bond, or video games without *Elite*, *Tomb Raider* and *Grand Theft Auto*. Why? One obvious explanation, which takes us back to

Pandaemonium, is that Britain's history as the first industrial nation gave it not just a relatively large, affluent and, crucially, literate public, but also the means for talented people to reach them, from railways to newspapers. It was this industrial and economic success that underpinned the cultural institutions giving creative people a chance to flourish, from universities and art colleges to public libraries and the BBC. So by the time the entertainment market rapidly expanded in the 1950s and 1960s – the result not merely of economic prosperity, but of increased education, the launch of television and the emergence of a distinctive teenage culture – Britain was unusually well placed to benefit. There was an imperial dimension, too. Britain's connections with the outside world, from Ireland to India, meant that its great ports and cities were always cultural crossroads. But the Empire's cultural legacies go well beyond *King Solomon's Mines*, *Kim* and *A Passage to India*, or even reggae, ska and dubstep. Tolkien was born in South Africa; Christie spent long periods in the Middle East; Ian Fleming wrote the James Bond books in Jamaica; even Cliff Richard, slightly implausibly, was born in Lucknow. And then, of course, there is the question of language. For more than a hundred years, the United States has been the world's most lucrative market for music, films, books and television. And nominally, at least, Americans speak English.

The more you think about it, though, the more remarkable Britain's cultural success begins to look. Britain was not unique in benefiting from empire, industry, literacy and communications: all those things were true for France, too. But apart from Asterix and *Le Petit Prince*, France's recent contributions to the global imagination have been strikingly tangential. Of course Albert Camus, François Truffaut and Jean-Luc Godard all have their devotees, but only Camus really has any mass appeal. There are no French Beatles; there is no French James Bond, no French J. R. R. Tolkien, no French David Bowie. The truth is that, over the last century or so, just two countries have dominated the worldwide cultural mainstream: Britain and the United States. That may sound like a typically parochial, Anglo-Saxon thing to say: what about Picasso, Tintin, *La Dolce Vita* and the Buena Vista Social Club? Fair enough: there are plenty of exceptions.

Nevertheless, the fact remains that, compared with Britain and the United States, even large, prosperous, technologically advanced countries have contributed surprisingly little to the worldwide cultural

mainstream. Many have produced one or two big names – a world-famous novelist, an enormously influential painter, an acclaimed film director, a briefly all-conquering pop group – but the well soon runs dry. Germany? Kraftwerk, obviously, but then you are really struggling. For all his qualities, Günter Grass never came close to matching the global popularity of Christie or Tolkien. Italy has given the world some great directors, from Vittorio De Sica and Federico Fellini to Luchino Visconti and Bernardo Bertolucci, and a couple of wonderful novels, Lampedusa's *The Leopard* and Umberto Eco's *The Name of the Rose*, but nothing else. Belgium? Magritte and Tintin. Sweden? Abba and Ingmar Bergman. Spain? Pedro Almodóvar, but even that is a bit of a stretch. The Netherlands? A black hole. In fact, the thought of *any* of these countries choosing to open the Olympic Games with a celebration of their twentieth-century culture is so implausible as to be downright laughable. Perhaps, if Paris had beaten London for the right to host the Games in 2012, the world might have been treated to a retrospective of the works of Johnny Hallyday and Serge Gainsbourg, while volunteers dressed as Jean-Paul Sartre floated down on clouds of hot air. But it does seem a bit unlikely.

Whether British culture is the world's best is an unanswerable and ultimately pointless question. But it has a very good claim, pound for pound, to be its most successful. There is a strong case, of course, for American culture, but the facts and figures make interesting reading. Only Shakespeare and the King James Bible have sold more books than Agatha Christie.*Almost half a century after they broke up, the Beatles are still comfortably the most successful musical group of all time. *The Lord of the Rings* is the second bestselling novel ever written, behind only *A Tale of Two Cities*. No children's hero has ever sold more books than Harry Potter, not even Noddy or Thomas the Tank Engine. The James Bond films are the world's longest-running film series; *Doctor Who* is its longest-running science-fiction series; *Coronation Street* its longest-running television soap opera. Indeed, British television can claim to be one of the nation's outstanding export industries. Between 2011 and 2014, Britain sold more than 600 shows abroad, six times as many as Germany, a country with a bigger economy and a bigger

* Although, when you think about it, both the Koran and Mao's Little Red Book must be up there too. And then there are all those copies of various countries' highway codes . . .

population. *Sherlock* is watched in some 200 countries, and when the second series began in China, the video download site Youku Tudou reported almost 50 million hits. *Downton Abbey*, meanwhile, is watched in more than 250 countries, and has received more Emmy nominations than any other international series in history. Even *Top Gear* is sold to some 214 countries, more than any other factual programme on the planet. It even boasts a loyal audience in Iran, which protested fiercely when the BBC's Persian channel dropped an episode for an exclusive interview with Hillary Clinton. The world could hardly say it had not been warned. 'The British are coming!' yelled Colin Welland, accepting his Oscar for *Chariots of Fire* in 1982. But few people could have guessed that Jeremy Clarkson would be leading the charge.[11]

This book explores the rich history and often surprising implications of the popular culture that has so entranced the world. Indeed, in many ways, books, music, films and television are a much better guide to the modern British experience than political history. That might sound like an annoyingly modish thing to say. But, as early as 1926, the philosopher Alfred North Whitehead, then in his sixties, argued that 'to discover the inward thoughts of a generation ... it is to literature that we must look'. A little later, in his famous essay 'Boys' Weeklies' (1940), George Orwell argued that 'most people are influenced far more than they would care to admit by novels, serial stories, films and so forth', and that to understand their imaginative world, 'the worst books are often the most important, because they are usually the ones that are read earliest in life'. And even some notable parliamentarians have thought popular culture more important than politics, among them the controversial proto-Thatcherite prophet Enoch Powell. 'The life of nations no less than that of men', the MP for Wolverhampton South West once remarked, 'is lived largely in the imagination.' In the late 1960s, at the height of his fame, he appeared on a television chat show alongside the columnist Alan Watkins. Afterwards, Watkins was surprised to see Powell making a beeline for the ageing American bandleader Bill Haley, of *Rock around the Clock* fame, and shaking him warmly by the hand. Why, Watkins asked Powell afterwards, had he done it? 'Why did I want to shake Bill Haley's hand?' Powell replied. 'Surely the answer must be obvious. He is the most influential character of our age.'[12]

I should perhaps say what this book is not. It is absolutely not a

contribution to academic cultural studies. Enthusiasts for that particular discipline will search in vain for the opaque theoretical discussions, invented abstract nouns and interminable references to obscure Continental theorists that they love so much. At no stage have I tried to define what I mean by popular culture: as the United States Supreme Court justice Potter Stewart remarked of pornography, you know it when you see it. (The Beatles? Obviously. David Bowie? Yes. Benjamin Britten? Perhaps just about. Harrison Birtwistle? Definitely not.) The two things that are most obviously missing are sport and fashion, partly because there are perfectly good books on them already, but largely because I knew it would be impossible to cover everything. I am also very conscious that I have talked almost entirely about the kind of culture produced by professional artists, musicians, writers and filmmakers, rather than the culture that ordinary people produce themselves in, say, writing groups, painting classes, pottery clubs and amateur dramatic societies. That would make a great subject for a book; but it would be another book entirely.

The Great British Dream Factory is not a definitive narrative history, and still less a pop-cultural encyclopaedia. Only a madman would try to cover the entire sprawling spectrum of British cultural life in the last few decades, and I have made no effort to mention everything. Some very obvious things – *Monty Python*, David Hockney, Factory Records, *Trainspotting* – fell by the wayside, while others never even made it into the original outline. Perhaps a basic rule of thumb is that if you think something really *has* to be here, then it almost certainly isn't. Some of my choices reflect my own tastes. Others are here because of their sheer, unignorable popularity, such as the novels of Catherine Cookson or J. K. Rowling, or because they tell us interesting things about their historical moment, such as the novelists of the mid-1950s or the Young British Artists of the 1990s. By and large, I have stuck to the middle ground – the 'middlebrow', some might say – and have deliberately not picked things that appeal only to self-styled intellectuals. Perhaps one day somebody will write a brilliant book bringing together the songs of Nick Drake, the films of Peter Greenaway and the novels of Angela Carter, but this is not it. There are more men than women, far more white people than black or Asian ones, and far more public-school-educated characters than I thought there would be. But perhaps that tells its own story, for one of the arguments of the book is that our popular culture,

which we often imagine to be tremendously subversive, is actually much more conservative than we think.

My original plan was to write about British culture since the Second World War, but it soon became clear that I would need to go back rather further. Most accounts of modern Britain kick off in 1945, or, if they are talking primarily about popular culture, with the advent of rock and pop at the beginning of the 1960s. But when you think about it, was the war really such a great break? Were the Sixties really such a watershed? The most important British cultural institution of modern times, the BBC, was founded in 1922, while many of the art colleges that trained our painters, film directors, rock stars and advertising men were Victorian foundations. The two most influential newspapers of the century, the *Daily Mail* and the *Daily Mirror*, were founded in 1896 and 1903 respectively. The most successful British film star of all time, Charlie Chaplin, was at his peak in the 1910s and 1920s, while the greatest of all British directors, Alfred Hitchcock, made his first film in 1925. And although rock and pop have been dominated by people born during and after the Second World War, many of the writers who inhabit our collective imagination were much older. Sir Arthur Conan Doyle was born in 1859, Beatrix Potter in 1866, Agatha Christie in 1890, J. R. R. Tolkien in 1892, Enid Blyton in 1897, Ian Fleming in 1908 and Roald Dahl in 1916. As a result, much of our imaginative life is still rooted in the late nineteenth and early twentieth centuries: indeed, the only living writer who seriously matches their popularity, J. K. Rowling, made her name writing remodelled Victorian and Edwardian school stories. In fact, as the American writer Christopher Caldwell has pointed out, much of the culture that we call 'modern' is closer to our grandparents' heyday than it is to our own. The last album the Beatles recorded, *Abbey Road*, was released in 1969. Almost unbelievably, that means it is closer in time to 1924, when Thomas Hardy, Joseph Conrad and H. Rider Haggard were still alive, than 2015, when I am writing this. And to borrow one of Caldwell's examples, the year of the Sex Pistols' first concert, 1975, is closer in time to Rachmaninoff's Third Symphony (1936), than it is to the present day – and Rachmaninoff wrote most of his music during the Victorian era.[13]

Perhaps this book's main contention, therefore, is that in terms of our popular culture, we still live in the shadow of the Victorians. That may seem blindingly obvious, but it also undermines the common cliché

that, since we live in an age of unprecedented change, our imaginative lives are completely different from those of the people who came before us. That strikes me as self-regarding nonsense. To future generations, we will probably seem so close to the Victorians as to be almost entirely indistinguishable. Their world, like ours, was one of industry, cities, mass media and mass communications, a landscape transformed by innovation, entrepreneurship and globalization. Like us, they felt that time had somehow speeded up. 'We have been living, as it were, the life of three hundred years in thirty,' wrote Rugby's legendary headmaster Dr Thomas Arnold, who did so much to establish the moral climate of the age.

Indeed, just consider the life of the historian Goldwin Smith, who was born in 1823 and died in 1910. On the first page of his autobiography, he painted a loving picture of his boyhood in Reading: 'The mail-coaches travelling on the Bath road at the marvellous rate of twelve miles an hour ... The watchman calls the hour of the night. From the tower of old St Lawrence's Church the curfew is tolled. My nurse lights the fire with the tinder-box. Over at Caversham a man is sitting in the stocks.' But the world of his youth, he wrote, had 'disappeared almost over the horizon of memory'. Now he found himself living in 'an age of express-trains, ocean greyhounds, electricity, bicycles, globe-trotting, Evolution, the Higher Criticism, and general excitement and restlessness ... Between that state of things and the present there is only a single lifetime; yet I feel as if I were writing of antiquity.' This is exactly how many older people feel in 2015. Few of them, though, have lived through greater changes than Goldwin Smith.[14]

Precisely because of the importance of change, it would be silly to argue that Victorian culture was exactly the same as our own. But it was not as different as we often think. They, like us, were a nation of readers, devouring newspapers, sensation-sheets, novels and periodicals. Charles Dickens's magazine *All the Year Round* sold an estimated 120,000 copies a week, far more than the combined sales of the *Spectator* and the *New Statesman* today. They, like us, were anxious about the morals of the young and alarmed by the gulf between rich and poor. We often think of them as technologically backward, yet they, like us, were simultaneously fascinated and frightened by gadgets and innovations: the railway, the telegraph, the bicycle, the typewriter, the motor car, the light bulb. We think of them as staid and stuffy, but like us they craved entertainment and excitement, speed and sensation. They were, writes

Matthew Sweet in his book *Inventing the Victorians*, 'engaged in a continuous search for bigger and better thrills'. The Victorians might have been bewildered by the emphasis of Danny Boyle's opening ceremony, but they would have loved the spectacle. Indeed, it was the Victorians who devised many of the pleasures that still dominate our social and cultural lives, for, as Sweet adds, 'they invented the theme park, the shopping mall, the movies, the amusement arcade, the roller-coaster, the crime novel and the sensational newspaper story'. We walk their streets, we live in their buildings and we read their books. All in all, we still live in the world they made.[15]

Unlike my previous books on Britain since the 1950s, *The Great British Dream Factory* is not a single continuous narrative, but is divided into four vaguely thematic parts. The key word here is 'vaguely': popular culture is such a richly diverse and fissiparous phenomenon that it would seem both odd and misleading to force it into the straitjacket of an excessively tight and hectoring argument. In some ways, in fact, this book is a bit of a jigsaw puzzle, which could easily be reassembled to give a very different picture. Even now it strikes me that some sections might easily be swapped around to emphasize very different points. So, if nothing else, I hope this book encourages readers to think of parallels and connections that might never have occurred to me in a million years.

Part One, 'Made in Britain', begins in Birmingham, a city that became emblematic of the industrial and urban self-confidence of late Victorian Britain. Through the stories of Black Sabbath, J. Arthur Rank, Laurence Olivier's *Henry V* and the rise of the Beatles, it explores how Britain stopped seeing itself as a country that led the world in making *things* – steel, ships, machinery, even flour – and began to see itself as one that led the world in telling *stories*. All this happened against a background of ebbing diplomatic and economic power, and it went hand in hand with a growing fear of so-called Americanization – the belief that Britain's children were turning into 'little Americans'. Later chapters explore the roots of the Swinging London craze, and the success of the carefully packaged vision of Englishness, at once reassuringly nostalgic and thrillingly ultra-modern, presented by *The Avengers*. They show how Chris Blackwell, the founder of Island Records, turned Britain's history of colonialism and immigration into a potent formula for musical success,

and how a new generation of talented young men, such as David Puttnam, Alan Parker, Hugh Hudson and Ridley Scott, won fame and fortune by selling carefully crafted visions of Britain's past and present. Finally, Part One discusses two of the most surprising cultural success stories of the last thirty years: Britain's new prominence in the world art market, embodied by Damien Hirst and the Young British Artists; and the stellar success of its video-games industry. Both of these phenomena, it argues, were inspired, if only indirectly, by the legacy of the Victorians.

Part Two, 'Play up! Play up! and Play the Game!', opens in the West Sussex countryside, the setting for the notorious Redlands raid in February 1967, when Keith Richards and Mick Jagger were briefly imprisoned for drugs offences. It argues that the really interesting thing about the story was not the drugs but the house, a typical example of the new rock aristocracy's fondness for turning themselves into country gentlemen. As Part Two shows, this is a very good illustration of the way in which, far from challenging or subverting the established order, Britain's popular culture has actually ended up reinforcing it. Indeed, country houses occupy an extraordinarily prominent role in our contemporary imagination, not just in, say, *Brideshead Revisited* and *Downton Abbey*, but in the novels of Kazuo Ishiguro, Ian McEwan, Alan Hollinghurst and Sarah Waters. The next chapter looks at the most popular country-house drama of all – the Windsors – and the way in which the monarchy has used our popular culture, especially pop music, to bolster its own image. It shows how the very principle of monarchy is embedded in the modern imagination, from T. H. White's *The Sword in the Stone* to J. R. R. Tolkien's *The Lord of the Rings*. It also shows how the Harry Potter books, the most successful fictional phenomenon of recent years, draw not just on the legend of King Arthur, but on *Tom Brown's School Days* and the Billy Bunter stories. Indeed, this section argues that the legacy of Victorian public-school fiction is far greater than we often realize. Not only is James Bond a quintessential public-school hero, presenting an only slightly modernized vision of Victorian gentlemanly values, but his antithesis, George MacDonald Fraser's adventurer Harry Flashman, is drawn straight from the pages of *Tom Brown's School Days*. In this, as in so much else, we are much closer to the world of the 1850s than we often think.

Part Three, 'We Are the Martians', examines the long shadow of two

of the most popular of all Victorian and Edwardian writers, Charles Dickens and H. G. Wells. Both keep popping up in unlikely places, not least in *Doctor Who*. Dickens has been claimed, not entirely convincingly, as the founding father of the soap opera, the inspiration for *Coronation Street* and even as the nineteenth-century equivalent of Catherine Cookson. He was not just Mervyn Peake's favourite author, he was Agatha Christie's favourite, too. Peake produced a series of drawings based on *Bleak House*, which were not published until after he died, while MGM paid Christie to write a screenplay of the novel, which was never filmed. Christie's universe might seem very different from Dickens's, and their books could hardly be more different. But both were fascinated by crime, both greatly admired the police, and both held what would now be considered fiercely conservative moral views. As for Wells, whose contemporaries saw him as Dickens's natural heir, his claim to be the father of modern science fiction is surely unassailable. Without Wells, there would have been no *Doctor Who*, no John Wyndham, no *The Day of the Triffids*, and no *28 Days Later*. But Wells's influence was not confined to science fiction. The themes that obsessed him after the First World War – the destructive potential of technology, the likelihood of ecological disaster, the inevitability of another total war – were not so different from those that preoccupied the young J. R. R. Tolkien, who had fought on the Somme. And Wells's shadow also hangs over the early novels of William Golding, whose book *Lord of the Flies* is surely one of Britain's greatest contributions to world literature since the Second World War. Golding's high-minded father had been a great Wells fan, and Golding probably got a rebellious thrill from kicking his father's hero. In that respect, he was not so different from the teenagers who were about to reject their parents' cultural tastes for the new excitements of rock and roll.

Finally, Part Four, 'Going to the Top', explores the single most striking theme of Britain's popular culture in the last century: the cult of the individual. The man who epitomizes this better than anybody else is John Lennon, the ambitious, self-willed product of a Liverpool art college. Whatever you think of Lennon's talent, his sheer narcissism is hard to overstate. Paul McCartney, he once remarked, wrote songs about 'boring people doing boring things ... I'm not interested in writing third-party songs. I like to write about me; 'cause I *know* me.' This, as Part Four shows, has been a very common refrain in Britain's modern

popular culture. It is sometimes described as a uniquely Thatcherite ethos, yet it draws on the legacy of Victorian writers such as Samuel Smiles, who preached the gospel of self-help at the very Mechanics' Institute from which Lennon's art college evolved. This is the spirit that drives the heroes of novels such as *Room at the Top* and *Billy Liar*, who believe that only by throwing off the shackles of class and community can they find true happiness. But the ethos of individual self-fulfilment has also found expression in everything from the television series *The Prisoner* to the musical careers of David Bowie and Kate Bush. For some writers, individualism is nothing but materialistic self-interest, as in Martin Amis's *Money*. For others, it represents personal liberation, as in Hanif Kureishi's novel *The Buddha of Suburbia* or Monica Ali's *Brick Lane*. In many ways the cult of the individual reached its apotheosis in the career of Andrew Lloyd Webber, whose spectacular musicals celebrate the values of competition, ambition, success and self-fulfilment. And all these things are wrapped up in the story of one of Britain's most successful living entertainers. An ordinary suburban boy whose talent, self-belief and sheer hard work turned him into one of the richest cultural entrepreneurs in the land, he became a knight of the realm, the confidant of a princess and a philanthropist like no other. Infamous for his tantrums and his profligacy, he often cut a faintly ridiculous figure, yet he took tea with President Reagan, partied with Mikhail Gorbachev and danced with Queen Elizabeth. Critics loved to sneer; audiences, however, simply loved him. All in all, nobody better embodies the power and potential of British pop culture than Elton John. Readers can decide for themselves what to make of that.[16]

Author's Note

Before we get stuck in, a couple of observations about facts and figures:

Book sales. There are no reliable or universally accepted figures for all-time book sales. In August 2012 the *Guardian* compiled what it claimed was the definitive list of Britain's 'top bestselling books of all time', based on the Nielsen Bookscan sales data. But the list incurred well-deserved ridicule, since it included virtually nothing published before the late 1980s. In fact, the best surveys of all-time book sales are probably the Wikipedia entries 'List of best-selling books' and 'List of best-selling fiction authors', the latter compiled from minimum and maximum estimated sales figures. The key word here, obviously, is 'estimated'. Some figures are heavily dependent on publishers' claims for their own authors: for example, HarperCollins's claim that Agatha Christie has sold 2 billion books. Others look more like guesswork: how does anybody really know that J. R. R. Tolkien's *The Lord of the Rings* has sold 150 million copies but H. Rider Haggard's *She* only 100 million? Still, in the absence of anything more solid, these figures are all we have to go on.

Record charts. It may surprise some readers to learn that for a very long time the singles and album charts were basically estimates. The first chart, compiled by Percy Dickins for the *New Musical Express*, dates from 14 November 1952, but as it was based on a telephone survey of no more than two dozen record shops, it was hardly definitive. For most of the 1950s and 1960s there were in fact three rival charts, compiled by the *NME*, *Melody Maker* and *Record Mirror* (later *Record Retailer*), each based on surveys of selected record shops. In 1969 the British Market Research Bureau began compiling the so-called official chart, but even that was based on postal returns from just 250 shops. By the late 1980s the sample had been widened to 500 shops, and the charts have obviously continued to evolve to reflect the new technology

of the twenty-first century. Alas, people care less about the charts now, when they are probably more reliable than ever, than they did in the days when they were based on telephone surveys and postal returns. In any case, I have not been very consistent about my chart figures. Generally I used two websites, the Official Chart Archive at www.officialcharts. com/archive/ and the unofficial Top 40 database at http://everyhit.com/. The latter is very good for annual and monthly rankings as well as the weekly charts. As for all-time bestselling singles, albums or artists, the relevant Wikipedia lists, which seem to be reasonably well researched, are probably as good a place as anywhere to start.

Measuring worth. In the 1890s Pears spent £30,000 on their 'Bubbles' soap campaign. In the early 1940s the budget for *Henry V* came in at about £475,000. In 1963 the BBC spent £2,000 on each episode of *Doctor Who*, in 1969 John Lennon spent £145,000 on a country house and in 1972 Chris Blackwell gave Bob Marley £4,000 to make *Catch a Fire*. But what do any of these figures really mean? The truth is that converting old money into today's equivalent is trickier than it looks. The best way to do it is to use the calculators at the website www.measuringworth.com, which is run by a group of American and British academics. But even that is harder than it looks, because there are five different possible indicators: the retail price index (RPI), the GDP deflator, average earnings, GDP per capita and plain GDP. Some are better for prices, others for incomes; some for consumer goods, others for large-scale projects. To borrow the site's own example of how these produce different results, the first real mass-market newspaper, the *Daily Mail*, cost ½d when it was launched in 1896. That was the equivalent, at the time of writing, of 20p, 23p, 80p, £1.27 or £2, depending which indicator you use. You pays your money and takes your choice, basically. I have always tried to use the indicator that seemed most appropriate, but as with pretty much everything else in this book, I don't claim to have been very consistent.

Finally, there is no denying that this book inevitably covers some of the same ground explored in my histories of Britain since the 1950s. It would have been absurdly self-denying, I think, to leave out *Lucky Jim*, the Beatles, James Bond or *The Avengers* just because I have written about them before. The focus is quite different, though, and I have tried (and probably failed) to keep repetition to a minimum. In some cases I have even changed my mind – a reckless thing for a historian to do, I know, but there you go.

PART ONE

Made in Britain

*From Workshop of the World
to Cultural Superpower*

Previous pages: The heyday of the dream palace: filmgoers outside a London cinema, some time in the 1930s.

I

The Land without Music

THE SOUND OF HAMMERS

We came from Aston. There wasn't a whole lot of flowers being handed out.
'Geezer' Butler, bassist and songwriter of Black Sabbath,
interviewed on *Heavy Metal Britannia*, 5 March 2010

One Friday afternoon in 1965, Tony Iommi chopped off his fingers. It was his last day at the sheet-metal factory, and he was just back from his lunch break. Normally he worked as a welder, but the woman who operated the giant steel press next to him was away, so that morning the foreman had put him on the machine instead. Even years later, Tony could still remember the wobbly foot pedal that he had to press to bring the great guillotine slamming down on the sheet of steel. He had never used it before, but the morning went well enough. At lunchtime he went home – he was, after all, only 17 – and told his mother that, since it was his last day, he might as well not bother going back for the afternoon. She was not impressed. 'You want to go back and finish the day off, finish it proper!' she said.

So back went Tony, dreaming, like so many teenagers in 1965, about being on stage, guitar in hand, thrilling the crowds beneath the lights. He was still daydreaming when he sat back down at the machine, pushed on the pedal and brought the full weight of the steel press down on his right hand. Instinctively he pulled his hand away, and to his horror he caught a glimpse of the ends of his two middle fingers, just sitting there on the machine. Later, when he was in hospital, someone from the factory thoughtfully brought the severed fingertips over in a matchbox, but by this time they had turned black.[1]

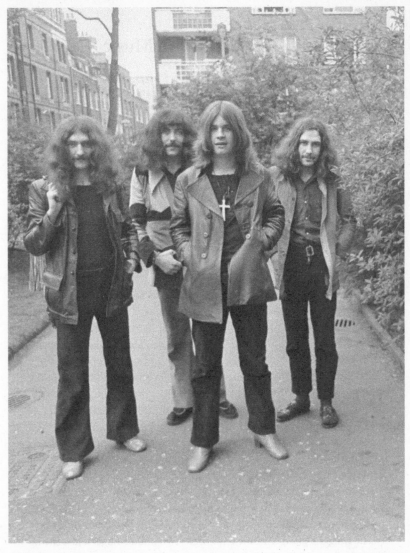

The original members of Black Sabbath – 'Geezer' Butler, Tony Iommi, Ozzy Osbourne and Bill Ward – photographed in 1970. What magnificent hair!

Up until the point he cut his fingers off, Tony Iommi had enjoyed a typical working-class upbringing in inner-city Birmingham. Born into an Italian family in 1948, he grew up in a world that was poor by twenty-first-century standards, but was far more comfortable – affluent, even – than what had gone before. For the first few years, he lived above his grandfather's ice-cream shop. Later, after his parents had bought a little grocery shop of their own, they moved to Aston, which he remembered as 'an awful, gang-infested, rough part of Birmingham'. The house was cold and clammy, and he hated bringing friends back because their sitting room, which they used as a stockroom, was full of tins of beans. But life was not all damp and drudgery. He had a set of lead soldiers, and every time his father went away for work – he doubled as a carpenter, and worked on Cheltenham Racecourse – he brought back another soldier for little Tony's collection.

Tony's real joy, though, was music. Like so many of the pop and rock stars of the 1960s and 1970s, he came from a musical family, and his father and his uncles loved to play the accordion. For Tony, however, the supreme pleasure lay in retreating to his bedroom and tuning in to Radio Luxembourg on his little radio. His favourites were Cliff Richard and the Shadows; as a keen amateur guitarist, he liked them much more than Elvis or the Beatles. When he was 16 he joined a local band called the Rockin' Chevrolets, who wore red lamé suits and knew all the Shadows' songs by heart. By now he had left school: never a very keen pupil, he worked first as a plumber's assistant, then in a factory, then in a music shop, and finally at the sheet-metal works. In fact, he quite liked the sheet-metal works. 'I enjoyed working in the foundry,' he recalled, many years later. 'It was hard work but it was rewarding. I became quite good as a welder. It was as noisy as hell with all the crashing of the metal, the hiss of the steam and the sizzle of the welding. Real heavy metal.' But then he was offered the chance to join a much more professional local band, the Birds & the Bees, who had been booked on a tour of Europe. For a teenager who dreamed of copying the Shadows, it was too good a chance to turn down. And then, on his last day at the factory, he cut the ends of his fingers off.[2]

At that point, his musical career might have been over. But it was the factory manager, whom Tony remembered as 'an older, balding man with a thin moustache called Brian', who saved him. Visiting him in hospital one day, the manager handed over a Django Reinhardt record

and told him to put it on. 'This guy plays guitar,' the manager remarked, 'and he only plays with two fingers.' Tony did as he was told. 'Bloody hell,' he thought, 'it was brilliant!' And if Django could do it, then so could he. Against his doctor's orders, he tried playing with bandaged fingers, but it was impossible. So he fell back on the skills he had learned during his short spell at the steel factory:

> I got a Fairy Liquid bottle, melted it down, shaped it into a ball and waited until it cooled down. I then made a hole in it with a soldering iron until it sort of fitted over the finger. I shaped it a bit more with a knife and then I got some sandpaper and sat there for hours sandpapering it down to make it into a kind of thimble ... Then I found this old jacket of mine and cut a piece of leather off it ... I cut it into a shape so that it would fit over the thimble and glued it on, left it to dry and then I tried it and I thought, bloody hell, I can actually touch the string with this now!

Even decades later, after he had become one of the best-known rock guitarists on the planet, Tony Iommi still used the same technique, only using prosthetic thimbles made especially for him. He even used pieces from the same old leather jacket that he had first ripped up in 1965. 'There isn't much of it left now,' he wrote more than four decades later, 'but it should last another few years.'

There was, however, one more crucial change before Iommi could play comfortably again. Guitars in the mid-1960s invariably had tight, heavy strings that gradually shredded the leather from his thimbles; what was worse, his mutilated fingers were simply too weak to bend the strings for any length of time. Again and again, with the meticulous patience of a master craftsman, he would take his Fender Stratocaster apart, searching for a way to relieve the pressure on his fingers. Eventually he gave up and asked his local shop to give him banjo strings, which were much lighter than the usual guitar strings. And as he slackened the strings, turning up his amplifier to compensate, so he began to develop an entirely new sound, all his own. Some guitar groups of the mid-Sixties had already experimented with a grittier, more aggressive sound: the Kinks' breakthrough hit, 'You Really Got Me', which had come out in August 1964, is a famous example. But by using lighter, deliberately down-tuned strings, Iommi was now producing a lower, louder, heavier sound than anything in the charts at the time. To put it very crudely, the

combination of his missing fingertips and his mechanical tinkering had invented heavy metal.[3]

It is tempting to wonder what might have happened if Iommi had been concentrating that afternoon at the steel press. No doubt he would have gone on tour with the Birds & the Bees, but since they never broke through to stardom he might never have achieved his dream. Perhaps he would have ended up back at the factory. As it was, though, his story became a kind of 1960s version of the triumph-over-adversity tales that used to be served up to Victorian children. In the first months after his accident, Iommi worked as a typewriter repairman. Then, in the late summer of 1968, he formed a blues band, Earth, with three other Birmingham lads: Bill Ward, 'Geezer' Butler and 'Ozzy' Osbourne. Despite their subsequent wayward reputation, they were actually a very good example of the importance of parental support in rock and roll success: not only did Iommi's mother help them to buy their van, but Osbourne's father signed a pay bond for their new Triumph amp. A year later, they renamed themselves Black Sabbath; the story goes that Butler had seen the Boris Karloff horror film of the same name at a local cinema, but Iommi later insisted that they had never seen it, and the name 'just sounded like a good one to use'.

Black Sabbath's early lyrics were, to put it kindly, a bit unsophisticated. In his autobiography, Iommi admits that Osbourne often sang whatever came into his head, and that at least half the band did not know what 'Paranoid', the title of perhaps their most famous single, actually meant. But it hardly mattered. When their first album, *Black Sabbath*, came out in February 1970, its heavy, distorted sound and vaguely occult associations propelled it to number eight in the charts. Their next album, *Paranoid*, released only eight months later, went to number one and stayed in the American charts for seventy-two weeks. By now Iommi, who was still living with his parents in a working-class area of Birmingham, had more money than anybody in his family had ever dreamed of. He promptly bought himself a Lamborghini. Then he bought his father a Rolls-Royce, which the dealers delivered to the house. 'Can you imagine me going to work in that?' his father exclaimed. 'What would all the people say, and the neighbours, what are they going to think?' To his son's consternation, he refused even to get in it. In the end, it had to go back.[4]

Heavy metal is not, of course, to everybody's taste; in fact, it is not even to mine. From the beginning, its audience was overwhelmingly

male and working-class, which made it stand out in a record market dominated by teenage girls. What was more, its belligerent sound and often primitive lyrics made for a stark contrast with the arty, self-consciously 'progressive' rock beloved of most music critics in the early 1970s, who snobbishly wrote it off as mere noise, made by cavemen for cavemen. Indeed, as a genre, it has never really escaped from beneath the shadow of Rob Reiner's film *This Is Spinal Tap* (1984), an affectionate parody which cemented the stereotype of heavy metal musicians as knuckle-headed dimwits called Derek. Yet heavy metal is an outstanding example of the worldwide impact of British popular culture in the last half-century. Black Sabbath's record sales alone come to an estimated 75 million, while other British bands such as Judas Priest and Iron Maiden have sold similar totals. In the 2011 census, some 6,242 people listed heavy metal as their religion, and when Black Sabbath released their album *13* two years later, it reached number one not just in Britain, but in Canada, Denmark, Germany, New Zealand, Norway, Sweden, Switzerland and – most lucratively, and therefore most importantly – the United States. Perhaps it is little wonder, then, that when Birmingham inaugurated a Hollywood-style 'Walk of Stars' in the city centre, just a few yards from the gleaming golden statues of the fathers of the steam engine, Matthew Boulton, James Watt and William Murdoch, they turned to Black Sabbath. The first star, in July 2007, was awarded to Ozzy Osbourne. Tony Iommi got his just over a year later. And in recent years Birmingham's media have been keen to emphasize the connections between the city's most famous musical export and its long industrial heritage. 'It seems only fitting', declared the *Birmingham Post* some forty-eight years after Iommi's accident, 'that a city at the heart of the Industrial Revolution should also be the birthplace of heavy metal music.'[5]

Even in the early 1970s, music critics often pointed out the connections between Black Sabbath's music and their West Midlands background. 'Birmingham is a natch for rock 'n' roll,' wrote the *New Musical Express*'s Rob Partridge in 1974. 'It is dour and grubby, the biggest industrial city in Britain. Birmingham is flanked by coal fields, steel mills and car and engineering plants. Something a little like Detroit, in fact.' At the time, though, the band themselves were far from starry-eyed about living in Birmingham; when they thought about their native city, they thought about getting out. 'I hated it, living there,' Iommi said later. 'I think that influenced our music, as far as where we come from and the

area we were from. It made it sort of more mean.' Yet they were simulta-
neously conscious of their status as provincial outsiders, fighting against
the cultural trends that emanated from supposedly swinging London. To
youngsters like Iommi and Osbourne – and probably most of their West
Midlands contemporaries – the hippyish, free-love, flower-power ethos
of the late 1960s seemed like something from another planet. 'We lived
in a dreary, polluted, dismal town and we were angry about it,' Osbourne
told *Q* magazine decades later. 'For us the whole hippy thing was bull-
shit. The only flower you saw in Aston was on a gravestone. So we
thought, let's scare the whole fucking planet with music.'[6]

This does not quite explain, though, why heavy metal came from
Birmingham, rather than Hereford or Hull. The answer is that Birming-
ham, more than any other city, had become synonymous with the sound
and the spectacle of industry. Indeed, the story of heavy metal offers a
perfect example of the debt that modern British popular culture owes to
the achievements of the Victorians.

Thanks to Birmingham's canal network, steam engines, closeness to
the Shropshire and Staffordshire coal belt, and its entrepreneurial, work-
shop economy, no city in Britain became a more potent symbol of the
Industrial Revolution. As early as 1791, the agricultural and travel writer
Arthur Young declared that Birmingham was 'the first manufacturing
town in the world', while eighty years later *Willey's History and Guide
to Birmingham* enthused that the city's manufactures were 'almost infin-
ite in their variety . . . from a pin to a steam engine, from pens to swords
and guns, from "cheap and nasty" wares sold at country fairs by "cheap
Johns" to the exquisitely beautiful and elaborate gold and silver services
which adorn mansions of the rich'. To many observers, of course, Bir-
mingham seemed a monstrous place: for Charles Dickens, it was one of
the principal inspirations for Coketown, the industrial Hades in his
novel *Hard Times* (1854): 'a town of unnatural red and black like the
painted face of a savage . . . a town of machinery and tall chimneys, out
of which interminable serpents of smoke trailed themselves for ever and
ever, and never got uncoiled'. It even made an impression on the
13-year-old future Queen Victoria, who passed through Birmingham in
August 1832. Afterwards she wrote a memorable entry in her diary:

> We have just changed horses at Birmingham where I was two years ago
> and we visited the manufactories which are very curious. It rains very

hard. We just passed through a town where all coal mines are and you see the fire glimmer at a distance in the engines in many places. The men, women, children, country and houses are all black. But I can not by any description give an idea of its strange and extraordinary appearance. The country is very desolate everywhere; there are coals about, and the grass is quite blasted and black. I just now see an extraordinary building flaming with fire. The country continues black, engines flaming, coals in abundance, every where, smoking and burning coal heaps, intermingled with wretched huts and carts and little ragged children.[7]

Just as twenty-first-century travel writers are drawn to Chinese cities such as Shanghai and Guangzhou, seeing them as irresistible, if hellish, symbols of dynamism and progress, so their Victorian equivalents followed the road to the West Midlands, their eyes almost popping with wonder at the blazing spectacle of industrial modernity. Approaching the city through the Black Country in 1860, for example, the Royal Society's librarian, Walter White, could barely contain his excitement at the 'roaring-furnaces ... pouring forth their fierce throbbing flames like volcanoes', or 'the hundred chimneys of iron-works' with their 'fiery tongues'. Yet what really struck White was not so much the spectacle, infernal as it was, as the *sound*. Here is his description of the Birmingham Battery Works:

I could scarcely refrain from stopping my ears when led to the Battery, where three large hammers, moved by machinery, are smiting at the rate of five hundred strokes a minute, and with tremendous din. The hammer-head is wedge-formed, like a V, the thin end being the striking part. By each hammer sits a man, at the level of the floor, fashioning brass bowls, kettles, and pans under the noisy blows ... Poor battery-men! compelled to sit with their heads close to the hammers. Only by plugs of cotton in their ears do they preserve themselves from speedy deafness.

Other nineteenth-century visitors also found their ears ringing from the din. After visiting Birmingham in 1835, the French historian and travel writer Alexis de Tocqueville, best known today for his book *Democracy in America*, thought the city was 'an immense workshop, a huge forge, a vast shop', where 'one hears nothing but the sound of hammers and the whistle of steam escaping from boilers'. And has there ever been a more evocative description of the terrible noise of industry than in *The Old*

Curiosity Shop (1841), when Dickens's Little Nell, wandering desperately through the Midlands, finds herself in Birmingham?

> On every side, and far as the eye could see into the heavy distance, tall
> chimneys, crowding on each other, and presenting that endless repetition
> of the same dull, ugly form, which is the horror of oppressive dreams,
> poured out their plague of smoke, obscured the light, and made foul the
> melancholy air. On mounds of ashes by the wayside, sheltered only by a
> few rough boards, or rotten pent-house roofs, strange engines spun and
> writhed like tortured creatures; clanking their iron chains, shrieking in
> their rapid whirl from time to time as though in torment unendurable,
> and making the ground tremble with their agonies ...

A few lines later, Dickens describes the machines as 'wrathful monsters ... screeching and turning round and round again'; further down, he tells us that the sound was at its worst at night, 'when the noise of every strange machine was aggravated by the darkness'.[8]

The Birmingham of Tony Iommi's youth was, of course, a very different place from its nineteenth-century predecessor. It was both cleaner and quieter, for a start. But it is surely not too fanciful to see a link between the sound of the Victorian industrial giant and the noise produced by the city's heavy metal stars more than a century later. Black Sabbath's drummer, Bill Ward, told an interviewer that he used to lie awake at night listening to the rhythmical pounding of the machines in a nearby factory and drumming with his fingers on the headboard. Similarly, Sabbath's great local rivals, Judas Priest, who played their first gig in Walsall in 1970, often identified the area's industrial soundtrack as the defining influence on their music. Their singer, Rob Halford, whose father worked for a Walsall metalworking firm, recalled that at school:

> We'd be doing English, and we'd be next to a metal foundry, and the
> steam hammers would be banging up and down, and the whole desk
> would be shaking ... Walking home, the air was full of all these bits of
> metal grit, and you could taste it, and you could breathe it in ... You literally breathed in metal.

His bandmate Glen Tipton, who worked as an apprentice at British Steel, agreed. 'We really did grow up in a labyrinth of heavy metal. Huge foundries, big steam hammers,' he remembered. 'You could always hear

the steam hammers. There was always a steel mill within audible distance.' Perhaps it was little wonder, then, that Judas Priest's lyrics were saturated with references to the West Midlands' industrial past, especially in their album *British Steel* (1980). The title, in fairness, is a bit of a giveaway. 'Pounding the world like a battering ram / Forging the furnace for the final grand slam,' runs 'Rapid Fire'. 'Hammering anvils straining muscle and might / Shattering blows crashing browbeating fright.'[9]

For both Judas Priest and Black Sabbath, 1980 marked something of a high point. In the United States alone, Judas Priest sold a million copies of *British Steel*, a feat matched by Black Sabbath's album *Heaven and Hell*. By this point, Sabbath had sacked Ozzy Osbourne for drunkenness, but it barely seemed to dent their popularity: when they played at the Los Angeles Coliseum that July, they attracted a sell-out crowd of 75,000 people. The irony, though, is that at precisely that moment, on the other side of the Atlantic, the industrial world in which they had grown up was falling apart. The rot had set in years, even decades earlier, but when the economy tipped into recession within months of Margaret Thatcher's arrival as Prime Minister, it was the manufacturing industries of the Midlands that paid the heaviest price. On 4 July, three weeks before Black Sabbath's triumph at the Los Angeles Coliseum, *The Times* reported that in some parts of the West Midlands more than one in four people were out of work. A table in that day's paper told the dreadful tale, charting, month by month, the factory closures – Wolverhampton, Wednesbury, Bilston, Tipton, Halesowen, Oldbury, Walsall, West Bromwich – a few hundred out of work here, a few thousand there. In Birmingham alone, 20,000 people had lost their jobs in just a few months. Every week another workshop closed its doors, another chimney came down, another factory fell silent.

And worse was to follow. By the time of Mrs Thatcher's re-election in June 1983 – a victory won in part because of her electoral popularity in the West Midlands – the area had lost some 330,000 jobs in four years. 'The names of firms which have slashed jobs or shut plants', said the *Sunday Times* in May 1983, read 'like a roll-call of the biggest names in British industry: British Leyland, BSA, Swan, Alfred Herbert, GKN, Lucas, Typhoo, Bird's, Dunlop'. It was a blow from which the West Midlands never really recovered. As late as 1976, Birmingham had been the most productive city in England outside the south-east; just five years later, it

was the least productive. Almost overnight, the world that Dickens and de Tocqueville had described with such horrified fascination, the world symbolized by the sweat and grit and din of industry, the world that had given birth to heavy metal, had almost entirely disappeared. Where there had once been the sound of hammers, there was only silence.[10]

If Tony Iommi had not cut off his fingertips, therefore, his life might have worked out very differently. There is an argument that talent will out; perhaps he was so good a guitarist that he would have made it eventually. But the history of rock music is so full of accidents and coincidences that if Iommi had gone on that European tour with the Birds & the Bees, and had never stayed behind to nurse his fingers and detune his guitar, there is every chance that his career might have taken a much less spectacular course. Far from playing the Los Angeles Coliseum in 1980, he might have been just another number, another greying figure shuffling, through no fault of his own, into the ranks of the unemployed. As it was, though, the former welder became a symbol not of Britain's industrial failure, but of something that the men and women who lived in Birmingham during its Victorian heyday could never have anticipated. For even as the forges and foundries of the West Midlands were falling silent, the British were inventing a new role for themselves, as entertainers to the world.

THE ONLY COUNTRY THAT COUNTS

The fact is, the Americans realised almost instantaneously that the cinema was a heaven-sent method for advertising themselves, their country, their methods, their wares, their ideas, and even their language, and they have seized upon it as a method of persuading the whole world, civilised and uncivilised, into the belief that America is really the only country which counts.

Lord Newton, speaking in the
House of Lords, 14 May 1925

When Danny Boyle was planning the opening ceremony of the 2012 Olympics, it seemed only natural to emphasize Britain's musical achievements. By this point, few people remembered that for much of its history Britain had been derided abroad as a musical wasteland. 'These people have no ear, either for rhythm or music, and their

Talking American: *The Jazz Singer* (1927) came to symbolize Hollywood's assault on the British imagination.

unnatural passion for piano playing and singing is thus all the more repulsive,' wrote the German poet Heinrich Heine after touring Britain in 1840. 'Nothing on Earth is more terrible than English music, save English painting.' At least he had the courtesy not to mention English cooking. The most memorably damning verdict, however, came in 1904 from another German critic, Oscar Schmitz, whose celebrated title rather said it all: *Das Land ohne Musik* ('The Land without Music'). But by the end of the twentieth century, that view, which had never been very fair anyway, was completely untenable.* As Boyle explained after the Olympics, he had chosen to emphasize British pop and rock because, as 'any economist could tell you ... it's made us a ton of money. After America, we are the biggest exporter of music in the world.' And indeed the facts bore him out. In the year London welcomed the Olympics, British artists accounted for more than 13 per cent of album sales worldwide, the country's highest figure of the century. For the second year in a row, Adele's album *21* was the world's bestselling album, the fifth time a British artist had taken the top spot in six years, while One Direction took both the third and fourth slots. Not surprisingly, the BPI – the official trade association of the British music industry – was in boastful form. 'Music is fundamental to Britain's identity as a nation,' declared its chief executive, Geoff Taylor, 'and the world is singing with us.'[11]

Today the idea of Britain as one of the world's leading exporters of music seems part of the natural order of things. A century ago, however, Britain's image was rather different. To put it crudely, when people abroad thought about Britain they thought about dreadnoughts, not dances, and ball bearings, not ballads. Indeed, there is probably no better way of summing up Britain's reputation before the Second World War than Napoleon's apocryphal line about it being 'a nation of shopkeepers':† hard-headed, pragmatic, calculating, mercenary, stoical, courageous and just a little bit dull. Even the British tended to think of

* Schmitz had, of course, been talking about music in the classical tradition. So perhaps, if he had lived to an unnaturally Biblical age, he might be arguing today that pop and rock don't count. Even so, given the riches of British classical music in the last century – Elgar, Vaughan Williams, Britten, Tavener – he would surely find it hard to defend the idea that Britain is a land without music.

† Actually, it was probably Adam Smith who coined the phrase, in Book IV of *The Wealth of Nations* (1776).

themselves in similar terms: as the *Annual Register* put it in 1867, the nation owed 'her great influence ... to her commanding position in the arena of industry and commerce'. And yet, even at Britain's imperial and industrial height, there was a creeping dread that it might all be slipping away. Once the American Civil War and Franco-Prussian War were out of the way, the reunified United States and newly united German Empire steadily eroded Britain's economic lead. To mark Queen Victoria's Diamond Jubilee in 1897, Rudyard Kipling composed a remarkably gloomy poem, 'Recessional', warning that all the nation's pomp might soon be 'one with Nineveh and Tyre', and just two years later Britain found itself bogged down in the Boer War, which struck many observers as a dreadful harbinger of imperial decline. It was at precisely this point that some critics began to warn of a new and insidious cultural threat, which – borrowing a word popularized by the French poet Charles Baudelaire – they called 'Americanization'.[12]

In 1902, the year Britain finally defeated the Boers, the sensationalizing newspaper editor W. T. Stead published a book entitled *The Americanisation of the World*, which opened in resounding style:

> The advent of the United States of America as the greatest of world-Powers is the greatest political, social, and commercial phenomenon of our times. For some years past we have all been more or less dimly conscious of its significance. It is only when we look at the manifold manifestations of the exuberant energy of the United States, and the worldwide influence which they are exerting upon the world in general and the British Empire in particular, that we realise how comparatively insignificant are all the other events of our time.

Stead himself was surprisingly cheerful about the prospect of American cultural and commercial dominance. Most critics, however, were less sanguine. Talk of Americanization usually reflected a deep sense of insecurity: what people really dreaded was that the buoyant, booming United States, with all its economic power and cultural confidence, would do to Britain what Britain had done to so many others. When the philosopher Goldsworthy Lowes Dickinson visited the United States on a lecture tour in 1901, for example, he warned his friend C. R. Ashbee, the founding father of the Arts and Crafts movement, that he had learned two things: '(1) that the future of the world lies with America. (2) that radically and essentially America is a barbarous country ...

without leisure, manners, morals, beauty or religion . . . a country which holds competition and strife to be the only life worth living.' Indeed, it is a sign of how deeply this fear was beginning to permeate that in November 1914 the young T. S. Eliot, who had been born and bred in St Louis, Missouri, spoke in a debate at Merton College, Oxford, about 'the threatened Americanisation of Oxford'. 'I pointed out to them frankly', he wrote to his cousin in an exaggerated American drawl, 'how much they owed to Amurrican culcher in the drayma (including the movies) in music, in the cocktail, and in the dance.' Eliot even had the gall to tell his British audience that 'the few Americans here' were cultural missionaries, 'bending our energies toward your uplift'. Evidently his listeners took it in good part: Eliot's side won the debate by two votes.[13]

But it was in the decade after the First World War that the threat of Americanization really loomed large. After four years of bloodshed, Britain was a country in shell-shock: grey, weary, disillusioned and divided. The United States, on the other hand, seemed a society brimming with self-confidence: the land of ragtime and jazz, fizzing with energy and excitement. 'I am counting the days till I can get away and have decided from now on to live in America,' wrote P. G. Wodehouse in 1923. There was, he said, something 'dead and depressing about London . . . all I want to do is to get back and hear the American language again'. Today we often see Wodehouse as the most quintessentially English of twentieth-century writers; in fact, he had first visited the United States before the war, carefully tailored his style for the profitable American market and spent many of his best years writing for Broadway and Hollywood. When Wodehouse went to California in 1930, MGM paid him a staggering $2,500 a week, far more than he could ever have earned in Britain, and the equivalent of at least £20,000 a week today.

But he was only one of many British writers who made the voyage west between the wars, drawn not just by the enormous financial rewards, but by the sheer glamour and excitement of the movies. The dramatist R. C. Sherriff, best known today for his moving First World War play *Journey's End* (1928), went to Hollywood in 1932 to work for Universal, while J. B. Priestley, of all people, tried his luck on the West Coast three years later. In 1937 Aldous Huxley, too, moved to Hollywood, where his efforts to turn *Alice in Wonderland* into a film went down very badly with Walt Disney, who said 'he could only understand every third word'. By now there were enough British expatriates

in Los Angeles to form the Hollywood Cricket Club. Among those to pull on the whites, incidentally, were David Niven, Errol Flynn, Cary Grant and, terrifyingly, Boris Karloff.[14]

While British talent went west, American products were coming in the opposite direction. As Britain struggled to rebuild from the trauma of the First World War, Hollywood had seen its opportunity. With a far bigger domestic market, and therefore far greater revenues – an American film typically made ten times more money than its British equivalent – the Californian studios could afford much larger production and marketing budgets. Their power was now simply irresistible: as early as 1925, some 95 per cent of all cinema tickets sold in Britain were for American films. And with the recovering British economy now importing more American products than ever, from Heinz baked beans to Kellogg's cornflakes, films were widely seen as the supreme symbol of the shifting balance of power. Hollywood's products, boasted Will Hays, the president of the Motion Picture Producers and Distributors of America, were 'silent salesmen of American goods'. By contrast, many British observers saw Hollywood's growing influence as a terrible harbinger of imperial eclipse. Here, for instance, is the *Morning Post* in 1923:

> If the United States abolished its diplomatic and consular services, kept its ships in harbour and its tourists at home, and retired from the world's markets, its citizens, its problems, its towns and countryside, its roads, motor cars, counting houses and saloons would still be familiar in the uttermost corners of the world ... The film is to America what the flag was once to Britain. By its means Uncle Sam may hope some day, if he be not checked in time, to Americanise the world.[15]

For many historians, the moment that really brought these anxieties to a head came in 1927 with the release of Al Jolson's picture *The Jazz Singer*, which marked the end of the silent film era and the advent of the talkies.* For years British critics had worried that audiences were picking up American slang from the on-screen titles, but now that people were not just seeing but *hearing* American English, the debate took on a new urgency. Even before *The Jazz Singer* had reached British shores,

* It was not, though, the first film with sound. There had been short films with sound since 1921. Interestingly, even *The Jazz Singer* had surprisingly little sound: apart from the songs, the dialogue comes to barely two minutes.

Stanley Baldwin's government had legislated for a controversial quota system, under which 7½ per cent (later increased to 20 per cent) of distributors' films had to be made in Britain. Among the bill's keenest supporters was the Conservative MP for Enfield, Lieutenant-Colonel Reginald Applin, DSO, OBE. Now almost 60, Lieutenant-Colonel Applin had seen action in the Boer War and had commanded the Anzac machine gunners at Passchendaele. A man of spectacularly right-wing opinions who ended up moving to South Africa, he held a very low opinion of American films. 'The scenes in the cabarets and the women and that sort of thing', he told his fellow MPs, 'are not the kind of thing we British people want to see.' Readers who enjoy stereotypes will be pleased to hear that he then read out a recent column from the *Daily Express*:

> The plain truth about the film situation is that the bulk of our picture-goers are Americanised to an extent that makes them regard a British film as a foreign film, and an interesting but more frequently an irritating interlude in their favourite entertainment. They go to see American stars; they have been brought up on American publicity. They talk America, think America, and dream America. We have several million people, mostly women, who, to all intent and purpose, are temporary American citizens.[16]

In recent years some writers have done their best to stick up for the quota and even to talk up the cheap 'quota quickies' that poured out of British studios to fill the gap. But given that the quota was meant to erode British audiences' appetite for Hollywood's products, the fact remains that it was a failure. When Mass-Observation conducted a survey of filmgoers in Bolton in 1937, they found considerable hostility to home-grown products. As so often, there was a wide gulf between the anxieties of the elite and the tastes of the masses. American films, one Bolton youngster said, were '100% better than British ones'. They were 'far superior to British ones on every point', agreed another: 'acting, direction, humour, yes, everything!' 'English films', lamented a third, 'have no tension about them, no life, when anyone sees an English film it's nearly always got a mist in it same as a foggy day. Why don't they spend a bit of money and get some proper scenery.' The general consensus, reported Mass-Observation, was that British films were 'dull and lifeless'; by contrast, American films were 'slick, polished, fast-moving, often spectacular'. It was no accident, then, that at Portsmouth's luxurious American-style Regent Cinema, the management showed

311 Hollywood films as first features, but only 142 British. Indeed, many cinema managers were greatly put out at having to give up screen time to British films under the quota system. 'I see no reason', said the chairman of Bolton's Cinematograph Exhibitors Association, 'why I should bolster up incompetence by being forced to give 15 per cent of my screen time for British films on which I know I shall lose money. The British public, in the main, does not like them, and shows its dislike at the box office as my records prove.'[17]

For Hollywood's critics, what made this so alarming was that the cinema was now by far the most popular form of entertainment in the country, leaving plays, books and records far behind. In the late 1930s, some 20 million people, the majority of them women, went to the cinema every week, a figure almost unimaginable today. Indeed, the demand was such that there were 110 cinemas in Birmingham alone, as well as 70 in Leeds and 96 in Liverpool. It was no wonder that in 1936 a parliamentary report described the cinema as the crucial factor 'in the education of all classes of the community [and] in the spread of national culture', concluding that 'the propaganda value of the film cannot be overemphasized'. Many young filmgoers naturally imitated what they had seen on screen, from girls copying the clothes and hairstyle of Greta Garbo to boys copying the slang and swagger of James Cagney. Some British films tried to use this as a selling point: the posters for one of the first British talkies, Alfred Hitchcock's thriller *Blackmail* (1929), proclaimed: 'See & Hear It – Our Mother Tongue As It Should Be Spoken!' But to many commentators, the continuing spread of American English ('Yeah', 'Sez you', 'OK', 'Attaboy') seemed a terrifying sign of Britain's cultural subordination.[18]

In the same year that Hitchcock moved into sound, a writer in the *Radio Times* complained that 'the American invasion of the entertainment world' had been responsible for 'changes of taste, for the blunting of dialect . . . for new manners of thinking, for higher pressure of living, for discontent among normally contented people, for big ideas, and for "Oh yeah!"' A year later, the Tory MP Major-General Sir Alfred Knox told his colleagues that, since the quota system had palpably failed, they should further limit 'the import of American talking films' in order to 'protect the English language as spoken by the people of this country'. At the other end of the political spectrum, George Orwell similarly bemoaned the 'false values of the American film'. Indeed, for Orwell,

nothing symbolized this better than the transition from E. W. Hornung's Edwardian 'Raffles' stories to James Hadley Chase's hard-boiled novel *No Orchids for Miss Blandish* (1939). 'The whole book, *récit* as well as dialogue, is written in the American language; the author, an Englishman who has (I believe) never been in the United States, seems to have made a complete mental transference to the American underworld,' wrote Orwell in his famous essay 'Raffles and Miss Blandish' (1944).

> The career of Mr Chase shows how deep the American influence has already gone. Not only is he himself living a continuous fantasy-life in the Chicago underworld, but he can count on hundreds of thousands of readers who know what is meant by a 'clipshop' or the 'hotsquat', do not have to do mental arithmetic when confronted by 'fifty grand', and understand at sight a sentence like 'Johnny was a rummy and only two jumps ahead of the nut-factory'. Evidently there are great numbers of English people who are partly americanized in language and, one ought to add, in moral outlook.

For Orwell, as for Major-General Knox, all this was thoroughly regrettable. Even the 'schoolboy atmosphere' of the Raffles stories, he thought, was preferable to the 'cruelty and corruption' of the Americanized thriller.[19]

What gave all this added piquancy was the fact that the United States had once been a British colony. But now it was Hollywood's filmmakers who appeared as ruthless imperial occupiers, with their British audiences cast as helpless colonial subjects. As the writer Wyndham Lewis put it, 'the tables have effectively been turned'. The irony, of course, was that world maps were still splashed with British imperial pink. But with the Irish Free State having broken away, India moving towards greater self-government and the nation's finances exhausted by depression and war, Britain's imperial position was weaker than it looked. Indeed, some commentators blamed American films for undermining Britain's patriotic and imperial spirit. As early as 1925, the Conservative peer Lord Newton warned that since Hollywood products tended to be of an 'anti-British character ... we are suffering materially and morally, not only here but throughout the Empire'. And ten years later, having returned to Britain after fourteen years abroad, the arch-conservative Major Rawdon Hoare issued a state-of-the-nation tirade identifying the cinema as one of the chief agents of national decline. 'Small boys', he complained, 'no longer read with gaping mouths about the adventures of great men who helped to build our Empire', but instead sat 'amid

gilded luxury' watching the latest Hollywood stars. Even petrol pump attendants, Major Hoare noted, spoke with affected American accents. 'What good can all this do to England? Will it create patriotism? Will it create a desire to keep our great Empire together? I doubt it.'[20]

THE PASSION OF J. ARTHUR RANK

If I could relate to you some of my various adventures and experiences in the larger film world ... it would, I think, be as plain to you as it is to me that I was being led by God.

J. Arthur Rank, *Methodist Recorder*, 26 March 1942

The man who took it upon himself to rebuild the domestic film industry, repel the tide of American imports and turn popular culture into a gigantic advertisement for British virtues could hardly have been a more unlikely figure. Indeed, everything about him seemed wrong. To actors, directors, producers and journalists, he was a baffling figure, a Victorian relic unaccountably thrust into the modern world. A man of deeply conservative opinions, he lived like a country squire and was regarded as one of the finest shots in the country. He always travelled with three briefcases, which held his most important business papers, and kept a box of chocolates in his desk drawer. A man of burning religious passion, he believed he was being guided by God, was obsessed with the Holy Spirit and once insisted that the capital's finest monument was Cleopatra's Needle, 'because it is the only monument in London upon which the eyes of our Lord Jesus Christ have gazed'. Even at the height of his fame he still taught his weekly Sunday school class, and in Hollywood he sometimes cut short meetings with studio executives so that he could write postcards to his pupils; yet he was such a boring speaker that he once sent the church pianist to sleep. He knew virtually nothing about films and rarely went to the cinema; his greatest dream was not that one of his films might win an Academy Award, but that one of his dogs might win a prize at Cruft's.* And yet, by the end of the Second World War, J. Arthur Rank was simply the most powerful man the British film industry had ever seen.[21]

* Alas, they never did.

The country squire as film mogul: J. Arthur Rank, 1945.

The story of J. Arthur Rank is the perfect example of the closely entwined relationship between the industrial successes of the Victorians and the cultural triumphs of their twentieth-century successors. But while Tony Iommi and his friends turned the sound of the steelworks into a global musical export, Rank built his film empire on the principles of manufacturing, from the laws of supply and demand to the importance of presentation and packaging. The key thing about him, in fact, is that he was not really a film-maker at all. He was a miller. His family had been flour millers in Hull since 1825, and his father, Joseph Rank, had built up the largest milling business in the country. Rank senior was a man of almost implausibly Victorian credentials; as one of his son's biographers later put it, he 'would not have been out of place in Charles Dickens's Coketown'. After falling out with his family, he started his own independent mill, grinding the wheat, collecting the flour and delivering the sacks entirely by himself. Crucially, he was an innovator, gradually introducing gas engines, roller millers and triple expansion engines that made his mills the most modern and efficient in the country.

And as the supreme Victorian exponent of self-help, Samuel Smiles, might have predicted, Joe Rank's hard work and self-discipline brought their inevitable reward. Within just thirty years, he went from being the smallest miller in the country to the biggest miller in the world. Little wonder, then, that he believed so strongly in the gospel of work. Dour and driven, a man of all-consuming Methodist faith, he remarked that the 'guiding principles' of his life were 'firstly, attention to business, and secondly, living within one's income'. Like all good Victorian capitalists, he had a strong sense of social obligation. The company had a pioneering pension scheme for its workers, while Joe Rank himself donated hundreds of thousands of pounds to various charities and some £300,000 to the city of Hull alone. He found 'more real joy in handing out', he once said, than he 'ever found in raking in'. Yet all this was based on a typically Darwinian view of human nature. 'We cannot get away from the law of the survival of the fittest, whether we like it or not,' Rank senior told *Milling* magazine in 1922. 'It is a natural law, and human nature without competition would soon become effete.'[22]

By the time J. Arthur Rank was born in 1888, his father was already one of the richest men in the country. The youngest of seven children, Arthur was not conspicuously bright; his father used to call him a 'dunce', a jibe that seems to have cut deep, since he often brought it up in later life. After

boarding school, there was no question of university; instead, Arthur started in the mills, sweeping the floors and carrying sacks of flour. Soon he was in charge of his own mill, a brand-new establishment in Hull, equipped with the very latest technology. At this stage nobody could possibly have predicted his impact on popular culture. Indeed, as late as 1930, when Rank turned 42, he seemed a deeply uninteresting figure, living quietly in Surrey, the soul of comfortable, middle-class respectability. A solid, taciturn and conservative man, who held a senior position in his father's firm and liked shooting, playing bridge and a round of golf, he would have made an excellent murder victim – or perhaps an implausible suspect – in an early novel by Agatha Christie.

But there was, perhaps, one notable thing about him. Like his father, J. Arthur Rank was devoutly religious. On Sundays the Rank children not only sang hymns and read the Bible at home, but spent four hours in church, attending two Sunday school classes and two services. (Intriguingly, given Rank's later involvement in the film industry, he was not allowed to go to the theatre or to public dances, which were seen as sinful.) Although Arthur temporarily abandoned going to church as a young man, he soon returned to his father's faith; indeed, his Sunday school classes ran every week for almost half a century. In 1952 his first biographer, Alan Wood, described him as 'a miller, a millionaire, a Methodist and a Yorkshireman'. It is hard to be sure which of those labels Rank valued most, but my money would be on the third.[23]

It was Rank's faith that brought him into the film business. Ever since the mid-1920s the *Methodist Times* – in which Rank owned a considerable stake – had attacked Hollywood for its 'cynical pandering to depraved imaginations'. Talking pictures, argued the paper's film critic, G. A. Atkinson, had 'stripped woman not only of clothing, but of morals, decency, truth, fidelity and every civilized quality or virtue'. In 1932 two more Methodist writers, R. G. Burnett and E. D. Martell, published *The Devil's Camera: Menace of a Film-Ridden World*, in which they declared that most Hollywood stars 'seem ready to go to any length in nakedness and decadence' in order to please 'the little group of mainly Jewish promoters' who controlled the film industry. (Tellingly, their book was dedicated 'to the ultimate sanity [i.e. health] of the white races'.) Yet some evangelical Christians believed that they could turn film to their advantage: in Lambeth, one Methodist preacher, the Reverend Thomas Tiplady, had been using films to attract younger audiences since 1928.

'The cinema', Tiplady argued, 'is the greatest invention since the printing press and the Church must put aside all moral, intellectual and artistic snobbery and, either directly or indirectly, bring this invention into the service of Christ.' This was J. Arthur Rank's kind of talk. For all his piety, he was a man of the world: the Rank mill empire, after all, had been built on technological innovation. He had already asked his secretary to find Christian films that he could show to his Sunday school class, and had been disappointed to hear that there were virtually none. In 1933, therefore, Rank helped to set up a new voluntary body, the Religious Film Society, to work in churches and Sunday schools. He even came up with the idea for their first twenty-minute film, *The Mastership of Christ* (1934), which starred the East End preacher William Henry Lax. It was, Rank himself admitted later, 'lousy – there is no other word for it'. But now he had got the bug: his later films would be rather better.[24]

The secret of Rank's success was that he saw films as a commodity like any other. Like so many evangelical preachers before and since, he believed that spreading the Word of God was like selling a product. Films, too, could be produced, marketed and sold like bags of flour. And very quickly the business of making films roused Rank's competitive instincts. Within barely two years, not content with funding straightforwardly religious films, he had decided that it would be better to make mainstream ones for a wider audience, gently introducing them to 'moral' and 'wholesome' values without subjecting them to a sermon. Through films, he said, he would 'help men and women make this world a better place to live in'. So it was that, in 1935, in alliance with the Tory peer Viscount Portal, he set up the General Cinema Finance Corporation. And then, with dizzying speed, the rest of the business fell into his lap. Dominated by 'quota quickies' and the cheap comedies of George Formby and Gracie Fields, the industry was ripe for conquest. Most British film companies were badly run and horribly under-funded, which made them easy pickings for somebody with Rank's deep pockets and hard head. And so, year after year, he built up his empire: the Pinewood studios here; a distribution company there; a share of Universal; the suburban Odeon cinema chain; the Gaumont-British cinema chain; the Denham studios; the Lime Grove studios; and so on. Nobody – at least, not in Britain – had ever built a film empire so quickly or with such ruthless acumen. It was as though, quite suddenly, he had discovered

his father's famous entrepreneurial spirit – only with cinemas, studios and production companies standing in for old Joe Rank's flour mills.[25]

To many people in the film industry, Rank came not as a saviour but as a capitalist carpetbagger. Fancying themselves as civilized, creative types, far above the tawdry demands of commerce, they hated the fact that they owed their living to a Victorian industrialist. His shy manner did him no favours: in a business dominated by cigar-chewing, wisecrack-dispensing showmen, the Methodist flour miller cut a bizarrely reticent figure. After seeing Sir Laurence Olivier's *Hamlet* (1948), one of the most prestigious films the Rank Organisation ever made, as well as the first British film to win the Academy Award for Best Picture, Rank said simply to the star: 'Thank you very much, Sir Laurence.' This was not good enough for Olivier, who had been expecting a torrent of praise and never forgave him for such an outrageous slight. (There is, perhaps, a parallel here with Charles Saatchi's reluctance to talk about his enthusiasm for the Young British Artists, of which more later.)

On the left in particular, Rank's name was mud. The socialist paper *Tribune* regularly damned his 'bad taste', while the Association of Cinematograph Technicians regarded him as the modern equivalent of a 'monopolistic factory-owner in Victorian times'. Even many of Rank's own employees resented his power: the director Roy Ward Baker later recalled that 'if, say, some arc lamps went wrong or there was a half-hour hold-up, [the crew] would all shrug their shoulders and say, "Oh well, it's only another few bags of flour"'. Most famously, the actor James Mason, who had made his name in a series of Rank Organisation films during the Second World War, made a blistering attack on his patron after decamping to Hollywood at the end of 1946. Rank, he said, had 'no apparent talent for cinemas or showmanship' and surrounded himself with people 'who know nothing about the creative side of film-making'. As a result, Mason declared, 'Arthur Rank is the worst thing that has happened to the British film industry'.[26]

This was, of course, horribly unfair. If, as many critics believe, the 1940s were the golden age of British cinema, then much of that is down to Rank. It was Rank who put up the money for David Lean's *Brief Encounter* (1945), *Great Expectations* (1946) and *Oliver Twist* (1948); for Michael Powell and Emeric Pressburger's *The Life and Death of Colonel Blimp* (1943), *A Canterbury Tale* (1944), *A Matter of Life and Death* (1946) and *The Red Shoes* (1948); and for Olivier's *Henry V* (1945) and *Hamlet*

(1948). It was even Rank who paid for the Ealing comedies that have become synonymous with Britain in the age of post-war austerity: had it not been for his bags of flour, there would have been no *Passport to Pimlico* (1949), no *Kind Hearts and Coronets* (1949), no *The Lavender Hill Mob* (1951), no *The Man in the White Suit* (1951) and no *The Ladykillers* (1955). By any standards this was a pretty extraordinary list, and although most of Rank's productions never reached such exalted heights, the plain fact is that without his money British cinema would have been infinitely poorer. Of course Rank himself had nothing to do with writing or making these films. His great virtue, though, was that he gave more talented people the freedom to do it themselves. As Lean put it in 1947, 'we can make any subject we wish, with as much money as we think that subject should have spent on it. We can cast whichever actors we choose, and we have no interference with the way the film is made.' In the same year, *Time* magazine claimed that 'not since the time of the Renaissance Popes have a group of artists found a patron so quick with his wallet, so slow with unsolicited directions and advice'. And even Rank's great rival, Alexander Korda, believed that had it not been for the Yorkshire miller the British film industry would probably have been dead before the end of the Second World War. 'Any who deny what Arthur has done,' Korda said, 'they know nothing.'[27]

Rank's empire reached its zenith in April 1946, when the Rank Organisation held its first 'World Film Convention' at the Dorchester Hotel in London. This was Rank's equivalent of the Delhi Durbar. By now he employed 31,000 people, turned over £45 million a year and controlled five studios, five newsreel firms, a host of production companies and almost 650 cinemas across Britain. What was more, his goal of rolling back the advance of Hollywood had been at least a partial success, for in 1946, for the first and only time in history, British films did better at the domestic box office than their American counterparts.* Yet for Rank that was only half the battle. The real challenge, as he saw it, was to break the American market itself.[28]

The Rank family had a long history of resisting American imports. In 1902 Joe Rank had visited the great mills of the American Midwest to

* This was also the year in which cinema attendance peaked in Britain, with 1.6 billion admissions. For comparison, the equivalent figure in 2013 was 166 million admissions, almost exactly ten times smaller.

learn from their innovations, and the Ranks had always supported protection for British farmers from cheap American bread. Now J. Arthur Rank was prepared to take the fight to the enemy: Hollywood, or, as he called it, 'Fairyland'. Interviewed by the *Cine-Technician* in 1943, he explained:

> It is all very well to talk of being able to make good pictures here without bothering about American or world markets, but in all honesty the continued existence of British film production depends on overseas trade. And to get that trade you must have power ... the whole future of British films is bound up in the question of overseas trade. Without it we must be resigned to a position as bad as – or worse than – the position before the War ... Without that foreign trade, all other things are idle dreams.

There was, perhaps, more to it than commercial calculation. Rank's collaborator John Davis once said that his boss's greatest motivation was patriotism – 'a love of England and projecting the British way of life'. There was probably a religious dimension, too: as Rank would have been the first to admit, his Christian principles did not stop at the coast. 'What I am trying to do', he told one reporter, 'is change the American cinema-goer. It takes a lot of time and it needs a lot of films ... But it can be done. It must be done.' And so it was that, at the beginning of 1944, Rank set up Eagle-Lion Distributors, with instructions to sell 'prestige' films to every continent on earth. 'Our films', declared its boss, Teddy Carr – like Rank, a native of Hull – 'must show the British way of life, what we represent, where we stand and why, and what we mean by what we say.'[29]

The problem, however, was that British films had a terrible reputation across the Atlantic. One American exhibitor told a Rank emissary, who was on a fact-finding tour, 'that the day he has a British film in his kinema [*sic*], he will get out of the business'. The scorn was reciprocated. 'In America, they like to make pictures about things that might happen once in twenty centuries,' Rank remarked. 'We like to make them about reality.' But American audiences did not want British reality, which had been tried at the American box office and had utterly failed. There was, though, an obvious solution. As long ago as 1928, one correspondent in the American film journal *Close Up* had suggested that British studios ought to concentrate on emphasizing those qualities for which their national character was famous abroad: 'Restraint, for instance, reason, taste possibly, and tradition.' Of these four qualities, by far the most promising was the last: tradition. There had been a sign of things to come in 1933, when

Alexander Korda's film *The Private Life of Henry VIII* had broken the run of box-office duds, winning an Oscar for its star, Charles Laughton, and earning a first British nomination for Best Picture. It was also enormously profitable, earning five times its budget on its first world tour. American audiences might not like British reality, then, but they did like British history, as long as it was presented with lip-smacking Tudor jollity. To filmgoers in Hicksville, Ohio,* historical accuracy was beside the point. What they wanted was the kind of atmosphere – extravagant hats, serving wenches, the Tower of London, a fat man eating a haunch of venison – that they associated with old England. This was a fairy story, of course. But as Rank knew very well, it was fairy stories that had built Hollywood in the first place.[30]

BAND OF BROTHERS

Henry V, *I must put in a class of its own, never has such a film been made and I do not think it will ever be made by an American studio.*

17-year-old girl, interviewed in J. P. Mayer, *British Cinemas and Their Audiences: Sociological Studies* (1948)

The film which came to symbolize Rank's assault on Hollywood could hardly have had a more distinguished pedigree. Boasting the talents of Britain's most celebrated actor and its greatest playwright, *Henry V* was the ultimate 'prestige' project, and has a good claim to be one of the most influential British pictures ever made. As so often, however, Rank had very little to do with it, besides providing the money and institutional backing. There are various accounts of how the film came to be made: one even claims that Winston Churchill personally asked Olivier to make it as a propaganda boost for British troops fighting the Nazis. In his autobiography, however, Olivier recalled being summoned to the Ministry of Information and being told by the minister's sidekick, Jack Beddington, that he would be released from the Fleet Air Arm to make *Henry V* as 'popular propaganda'.

The play was indeed perfect propaganda, not just because of the

* A real place, by the way.

Made when Britain was fighting for survival against a Continental foe, Laurence Olivier's *Henry V* (1945) is perhaps the ultimate expression of cultural Euroscepticism.

martial subject matter – a plucky band of English and Welshmen over-coming a horde of effeminate foreigners – but because it had become a well-established focus for patriotic sentiment, having been performed at the Old Vic every year during the First World War. As for Olivier, he was a natural choice to star and direct, since he had not only played Shake-speare's national hero at the Old Vic in 1937, but had recited various stirring passages on the radio since the outbreak of war in 1939. A treatment was already in circulation, written by Olivier's former BBC radio producer, Dallas Bower. The film's producer, meanwhile, was Filippo Del Giudice, a former Vatican lawyer with a taste for expensive cigars. Having fled Mussolini's Italy, Del Giudice had founded a produc-tion company, Two Cities, which wound up making big-budget pictures such as *In Which We Serve* (1942). Like Rank, Del Giudice thought the best way to crack the American market was to concentrate on films with 'the Rolls-Royce stamp'. Like Rank, too, he knew remarkably little about actually making films: one of his former colleagues recalled that Del Giudice never looked at the script, never came to the studio and never even watched the rushes. But he knew how to part audiences from their money – a sadly underrated skill in the British film industry.[31]

Today it is almost impossible to mistake *Henry V*'s origins as a war-time propaganda film. Not only does it open with a dedication to 'the Commandos and Airborne Troops of Great Britain', but the film pre-sents Henry's invasion of France as a moral crusade, staunchly supported by his English subjects and buttressed by his rousing speeches at the siege of Harfleur ('Once more unto the breach, dear friends / . . . Cry "God for Harry, England and Saint George!"') and before the Battle of Agincourt ('We few, we happy few, we band of brothers'). Olivier's Henry is the ideal English hero: brave, cheerful and effortlessly graceful. One American critic wrote that he incarnated 'the public school virtues that were supposed to have built the British Empire'. Meanwhile, any-thing that undermined the sense of collective British patriotism was cut: not only did Olivier and his colleagues take out a subplot about a con-spiracy to assassinate Henry, but they also excised a reference to the Scots as the enemy, as well as a passage in which the king orders his troops to kill their prisoners. On top of that, the filmmakers explicitly drove home the parallel between Agincourt, with the English army alone against overwhelming odds, and the recent achievements of the Royal Air Force. 'Surely this is comparable with Britain's hour in the

autumn and winter of 1940, when a "pitiful few" during the Battle of Britain went up into the skies, hour after hour, week after week, and kept a powerful invader at bay,' noted the screenwriter Alan Dent, who helped Olivier with the script. 'These modern warriors of the skies ... had that same courage and won the day as King Henry and his soldiers won theirs centuries ago. This parallel is very significant and of immense exploitation value from the viewpoint of the ordinary public.'[32]

But *Henry V* was far more than a wartime morale booster. Its style and structure could hardly be more sophisticated: it opens with a fabulous overhead shot of Elizabethan London – which would, of course, have been all the more stirring to audiences who had just endured the Blitz – before we find ourselves at the bustling Globe Theatre during a performance of the play. As the film continues, the setting subtly shifts from painted theatrical backdrops to increasingly realistic exteriors; and then, after Agincourt, the theatrical gradually takes over again, so that we end back at the Globe and another sweeping model shot of London. The Agincourt scenes are as exciting as anything in the history of cinema to that point, the atmosphere heightened by William Walton's tremendously exciting music. As many critics pointed out, Olivier's scenes recall the famous battle on the ice in Sergei Eisenstein's *Alexander Nevsky* (1938), in which the Teutonic Knights charge across the frozen surface of Lake Peipus to a pounding Prokofiev soundtrack. As always, though, stylistic excellence came at a cost. Although the budget had been set at £325,700, the final cost was just under £475,000, the equivalent of perhaps £73 million today.* To get it finished, Del Giudice had to borrow more money from Rank. In return, Rank demanded three-quarters of *Henry V*'s profits and effectively annexed Del Giudice's company. Their relationship, not surprisingly, was never easy, and after three years of fighting about budgets, Del Giudice walked away from the film business. According to his friend Peter Ustinov, the final breach came while they were talking in the gents one day, when Del Giudice managed to urinate on Rank's feet.[33]

The story of the release and reception of *Henry V* speaks volumes about the enduring pressures on the British film industry, caught between the demands of making upmarket pictures and the need to

* To put that into a twenty-first-century context, *Henry V* cost about as much to make as the last *Harry Potter* film.

make a profit. Although Rank himself claimed that the film brought 'special credit and added prestige to the British Film Industry', he was worried about its commercial prospects and asked Olivier to cut it down from 140 to around 100 minutes. Olivier, needless to say, refused. Even the distribution firm, Eagle-Lion, which Rank had set up specifically to deal with 'prestige' pictures, treated it very gingerly, initially showing the film only in a few West End cinemas before a nationwide release in the summer of 1945. Yet *Henry V* attracted tremendous reviews. *The Times* called it 'a great film', the *Manchester Guardian* hailed its 'boldness, colour and sweep', and the *Sunday Graphic* even congratulated Olivier on giving Shakespeare back 'to the people to whom he wanted to belong', picturing 'audiences in little market towns, wartime ports and garrisons and destroyers'. Indeed, there is no doubt that many ordinary people loved it. When the sociologist J. P. Mayer interviewed audience members about their favourite films in the summer of 1945, many of them – especially if they were bright and self-improving – mentioned Olivier's film. The film was 'the beginning, I hope of a series of Shakespeare plays brought to the screen', said a 24-year-old Admiralty typist: 'what a pleasure to hear our English language spoken correctly and in such beautiful tones.' 'I adored Olivier's *Henry V*,' agreed another woman, a 28-year-old clerk. 'Why can't British films be always up to this standard. I have seen it four times already and shall see it again, more than once.'[34]

All the same, Rank's anxieties were very well grounded. It would be easy to mock him as a tight-fisted philistine who knew nothing of the value of Art, but he probably had a better idea than Olivier of what the great majority of the public wanted. As the historian James Chapman points out, cinemas outside the West End reported poor audiences. The manager of the Birmingham Odeon told Del Giudice's staff that he was 'nervous' about showing it; in Muswell Hill, the audience was 'bored and restive'; and the future film encyclopaedist Leslie Halliwell watched it in his native Bolton in 'the most scattered and paltry house I remembered seeing'. In another northern cinema the film was even 'booed off the screen', forcing Rank to issue a statement backing 'the intelligence of the British people'. Olivier's attitude, however, was spectacularly dismissive. His intention, he said, had always been to make an 'artistically successful' film, not a 'financially successful one' (which must have been news to Rank). 'Our primary object', Olivier added, 'must be to give the minority pleasure, and the majority the possibility of grasping that pleasure.' Today

that sounds horribly snobbish; at the time, though, it tallied pretty closely with the views of cultural grandees such as John Maynard Keynes and Lord Reith. But evidently Rank was not persuaded. 'I have explained to Rank before', Olivier sighed, 'that this film is for the good of his name, not his pocket.' If Rank and his staff could not see that *Henry V* was more important than crowd-pleasing melodramas such as *The Wicked Lady*, 'then he and his organisation will have done no more for British films than Bungalows have done for architecture'. As Rank would surely have pointed out, however, a lot of people liked bungalows.[35]

What turned *Henry V* into a money-spinner was the reaction in the United States. Many American executives believed the film would never work: one told Del Giudice that American audiences would never understand it, while another observed that Henry's marriage proposal to Princess Katharine, which takes some 2,000 words, would be too long for Pittsburgh steel workers who 'were accustomed to make their proposals in two words or none at all'. But Rank's men marketed it brilliantly. The film was shown in college towns for one night only, as if it were a touring British stage production, and in small venues, ensuring that they would be packed. As word of mouth spread, the distributors then booked bigger halls. Reviews, meanwhile, were ecstatic. 'I am not a Tory, a monarchist, a Catholic, a medievalist, an Englishman, or, despite all the good it engenders, a lover of war,' wrote *The Nation*'s James Agee, one of the most influential American critics; 'but the beauty and power of this traditional exercise was such that, watching it, I wished I was, thought I was, and was proud of it.' After just twelve months, the film had already made a profit of some £275,000. And its appeal was not limited to the English-speaking world. The director Franco Zeffirelli, who later made celebrated versions of *The Taming of the Shrew* and *Romeo and Juliet*, saw it in Florence just after the war. Olivier, he said later, 'was the flag bearer of so many things we did not have. I'd been educated and brought up in a fascist country. He was the emblematic personality of a great free democracy. The whole world was opening up for us and this *Henry V* was the beginning of a new era for us.'[36]

Although *Henry V* was nominated for Oscars for Best Picture and Best Actor, Olivier won only an honorary award for his 'outstanding achievement as actor, producer and director'. With characteristic immodesty, Olivier believed that this had been fixed to prevent an Englishman from taking home all the awards: it was, he said, 'an absolute

fob off'. But he did not have long to wait: in 1948 his version of *Hamlet*, made by much the same team, won him Oscars for Best Picture and Best Actor. Today British triumphs at the Oscars are relatively common: at the time, however, Olivier's victory seemed a stunning achievement.

Indeed, from the perspective of the twenty-first century, *Henry V* looks like an early and enormously accomplished example of an enduring blueprint for British success. The values that American critics associated with Olivier's Shakespeare films – history, tradition and high culture – are precisely the same values projected by most successful British (or part-British) pictures of the last thirty years, from *Chariots of Fire*, *Gandhi* and *A Room with a View* in the 1980s to *The Remains of the Day*, *The English Patient* and *Shakespeare in Love* in the 1990s, or *Atonement*, *The Queen* and *The King's Speech* in the 2000s. It hardly needs pointing out how often the same themes recur – the monarchy, the Second World War, Shakespeare, country houses – rather as if the film industry were an offshoot of the national tourist board. No doubt this is a bit unfair: many of these, after all, are excellent films, subtly questioning the very things they appear to celebrate. Of course it would be easy to put together an alternative list of British films by directors such as Terence Davies, Ken Loach and Mike Leigh, who have ploughed very different furrows. Even so, there is no denying that Rank, Del Giudice and Olivier had hit on an approach that has come to define British cinema, and perhaps Britain itself, in the eyes of the world. To put it very simply, Rank had found the formula. And in this respect he was arguably one of the most important and influential British cultural figures of the century.[37]

For Rank, however, the appeal of the film industry was beginning to wane. Creating 'prestige' films was inherently risky because they were so expensive; to make matters worse, his producers had a bad habit of going wildly over budget. Unlike cheap melodramas, films like *Henry V* alienated many British cinemagoers. 'For some time now,' one film fan wrote to the *Picturegoer* in May 1947, 'it has seemed to me that here in England we are making films for a small group of long-hairs rather than for the public.' Even the sight of Rank's famous gong, agreed another reader, inevitably brought a 'muffled yawn' and the remark: 'Oh dear, now we are going to be educated.' When Rank's producers got it wrong, the consequences were devastating. Gabriel Pascal's adaptation of George Bernard Shaw's *Caesar and Cleopatra*, released in 1945, cost a staggering £1.25 million (roughly £200 million in today's money, even

more than *Avatar* or *The Dark Knight Rises*). Although it did extremely well in the United States, the British reviews were terrible, and its vast publicity costs meant it never made a profit. Then, at precisely the moment Rank was looking to tighten his belt, the Attlee government introduced a new film quota and an 'ad valorem' tax on American pictures, which threw the industry into chaos. By the end of 1949 the Rank Organisation was actually making a loss, which would have been unimaginable a few years earlier. For the time being, at least, the age of the 'prestige' pictures was dead, and by the mid-1950s the Rank Organisation was churning out cheaper films starring the likes of Norman Wisdom, Kenneth More and Dirk Bogarde, which would never work in the United States but were guaranteed a decent domestic audience. And as television ate into cinema attendances, the Rank empire began to do the unthinkable. Now, instead of opening cinemas, they were shutting them. By 1962, when Rank retired as chairman, one in four of his cinemas had closed its doors.[38]

Whether Rank really minded about any of all this, though, remains a mystery. His priority, after all, had never been films; it had always been flour. By the Second World War, Rank mills provided about a third of Britain's flour, and when his older brother Jimmy died in 1952, Rank effectively abandoned day-to-day control of his film empire to return to the milling business. As his grandson, Fred Packard, later recalled, films simply 'did not interest him that much – he was far more interested in flour'. Milling's gain, however, was the movies' loss. Not only had Rank saved the British film industry from extinction in the 1930s, he had come closer than anybody before or since to establishing a permanent foothold in the American market. He was not, of course, a vain man. But perhaps, from time to time, he wondered how the world would remember him.

Fred Packard later told a story about being on holiday with his grandfather in Scotland. One day the 12-year-old Fred idly carved his initials and the date into the wall of the toilet in the grand house where they were staying. His crime was discovered, and he was promptly summoned to see his grandfather. The terrified Fred walked slowly down a long, narrow corridor, where, at the end, he could see Rank waiting in a lurid dressing gown. When Fred arrived, Rank looked down at his grandson. There was a pause, and then Rank said: 'Don't carve your name in dark and gloomy places. Carve your name with pride for all the world to see.' When Fred told that story at his twenty-first birthday party, his grandfather had tears in his eyes.[39]

2

I'm Henry the Eighth, I Am

DEATH TO HOLLYWOOD

It is not only American comics that should be banned, but also
so many of the other false practices that have been imported into
this country. The sooner that we return to a sane British way of
life (built on traditional lines) the better for this great nation.

Letter in *Picture Post*, 17 May 1952

The fate of the Rank Organisation during the 1950s, retreating from its old ambitions towards a lowest common denominator of middlebrow melodramas and Norman Wisdom comedies, says a great deal about British cultural tastes in the years after the Second World War. The Fifties get an unfairly bad press, but there was indeed something narrow and tired about the culture of the day. Having sacrificed so much to defeat Hitler's Germany, the nation was morally and financially exhausted. Britain had run up enormous debts to the United States, its colonies were slipping away, its cities were scarred by bomb damage and its everyday life was still hidebound by rationing and regulations. Perhaps the best way of putting it is that there seemed a pervasive sense of drizzle, dreariness and damp, no matter how many coins you jammed into the meter. Even the Ealing comedies, which are regarded today as among the high points of 1950s culture, became gradually quainter, more unambitious and more nostalgic as the decade progressed. Culturally speaking, Britain seemed to have sunk into a long torpor. 'Five years after the war,' lamented a commentator in the *New Statesman*, 'there is still no sign of any kind of literary revival; no movements are discernible, no trends.' Two years later, the *Times Literary Supplement* predicted 'a

'A peculiarly thin and pallid form of dissipation': Teddy Boys gather around a jukebox, 1955.

difficult and confusing decade', dominated by the gloom of 'A Generation in Search of Itself'. Across the board, in fact, critics mourned a stultifying conformity, reflecting the supposed complacency of British politics in an age of relative consensus. Where, wondered the veteran playwright J. B. Priestley, were the cultural titans of tomorrow?

> Who and where are the massive talents, the towering personalities, the men of genius? Who represents us abroad as we ought to be represented – by the English mind blazing with art and throwing a light on the world we all share – and not by the assistant secretary to the Department of Drains, the vice-chairman of the Busybodies Association, the Secretary of the Society of Stuffed Shirts?[1]

There is, of course, a good case for the defence. In the world of literature alone, the mid-1950s threw up such new talents as Kingsley Amis, Philip Larkin, William Golding, Iris Murdoch and Anthony Burgess, which is a pretty strong list by anybody's standards. And yet there is no denying a pervasive sense of narrowness and conservatism. Take perhaps the emblematic book of the decade, Kingsley Amis's debut, *Lucky Jim* (1954). It happens to be one of my favourite books, but it is hard to imagine a novel less likely to appeal to enthusiastic readers on, say, New York's Upper West Side. The hero, Jim Dixon, is a history lecturer at a redbrick university, somewhere in the Midlands. His aims in life are to do as little work as possible, to avoid his head of department, to go to the pub, to find a better girlfriend and, ultimately, to give up his job and move to London. Far from being idealistic or admirable, Dixon is completely, unrepentantly *ordinary*, and often behaves in a selfish, petty and cowardly way – not least in the splendidly funny scene when, discovering that he has accidentally burned a hole in his professor's bedclothes with a cigarette, he tries to hide the evidence by cutting a great hole in the sheets with his razor. To many older critics the book seemed shockingly cynical, even philistine, in its aggressive contempt for the values of the *bien-pensant* cultural elite. Dixon, we discover, only took up medieval history because it was a 'soft option'. He hates people in the Middle Ages ('nasty'), classical music ('filthy'), Italian food ('filthy') and French plays ('Why couldn't they have chosen an English play?'), as well as, naturally, people with berets or beards. Above all, he hates everything dear to the hearts of Britain's university-educated intellectuals, 'the

home-made pottery crowd, the organic husbandry crowd, the recorder-playing crowd': *Guardian* readers, basically.[2]

Despite Amis's protestations to the contrary, all this very obviously reflected his own background and temperament, which was resolutely lower-middle-class, anti-metropolitan, anti-eccentric and anti-idealistic. The fact that it struck such a chord, though, says a great deal about the insularity of British culture in the 1950s. Amis's generation, explained the *Spectator*'s literary editor, J. D. Scott, were 'sceptical, robust, ironic, prepared to be as comfortable as possible in a wicked, commercial, threatened world which doesn't look, anyway, as if it's going to be changed much by a couple of handfuls of young English writers'. This was not exactly very inspiring. But then not being very inspiring was a value dear to the hearts of Amis and his contemporaries. Even the working-class New Wave which swept over the stage, the novel and the cinema at the end of the 1950s never really broke with the prevailing narrowness. Perhaps *Private Eye* was being a bit unfair when it unveiled the film adaptation of 'Stan Blister's little-known novel *A Waste of Living*', the story of 'the latently homosexual professional lacrosse player Arthur Sidmouth and Doreen, the girl who watches sympathetically from a bar stool in the film's opening shots as Arthur vomits up his half-pint of ginger shandy'. Even so, it is hard to imagine films such as *A Kind of Loving*, *A Taste of Honey* or *The Loneliness of the Long-Distance Runner*, for all their virtues, persuading foreign cinema-goers that, for innovation and excitement, Britain was the place to be – especially when compared with the films produced on the Continent and in Hollywood during the same period, such as *Last Year at Marienbad*, *La Notte*, *The Silence*, *West Side Story*, *Jules et Jim* or *The Man Who Shot Liberty Valance*.[3]

It was little wonder, then, that highbrow periodicals were full of hand-wringing laments about the introspection and complacency of the nation's cultural and political life. Britain, wrote Anthony Sampson in his bestselling *Anatomy of Britain* (1962), was 'a country that doesn't believe in anything and is confused about its direction'. Its people were 'riveted on the past', with their 'gaze turned backward and inward', agreed Arthur Koestler a year later. Perhaps the most withering denunciation, though, came from the journalist Malcolm Muggeridge, then not completely mad. 'Each time I return to England from abroad,'

Muggeridge wrote, 'the country seems a little more run down than when I went away; its streets a little shabbier; its railway carriages and restaurants a little dingier; the editorial pretensions of its newspapers a little emptier; and the vainglorious rhetoric of its politicians a little more fatuous.' And, to be fair, perhaps he was not entirely wrong.[4]

At this point, it is highly unlikely that anybody would have predicted that British popular culture would soon become the height of fashion. Broadcasting to the nation in 1945 to mark the foundation of the new Arts Council, the economist John Maynard Keynes had called for a British cultural rebirth, ending with the words: 'Death to Hollywood.' But in the two decades that followed the release of *Henry V*, Hollywood was very much alive. Indeed, it was American culture that set the tone for the rest of the world – and even that is to understate its crackling energy, its technical innovations, its glamour and excitement and sheer modernity. While Britain wrapped itself up in the cultural equivalent of a cardigan, the United States was giving the world *The Catcher in the Rye*, *The Crucible*, *Invisible Man*, *Lolita*, Jackson Pollock, Willem de Kooning, Charlie Parker, Dizzy Gillespie, Ella Fitzgerald, Elvis Presley, *Vertigo*, *The Searchers*, *Some Like It Hot* ... and that is merely off the top of my head. By contrast, Britain's major musical export was Acker Bilk, a trad jazz Somerset bandleader in a striped waistcoat and bowler hat. As the journalist and jazz singer George Melly remarked, it was simply bizarre that, at a moment of such extraordinary cultural change, the British public turned to a 'cider-drinking, belching, West Country contemporary dressed as an Edwardian music-hall "Lion Comique", and playing the music of an oppressed racial minority as it had evolved in an American city some fifty years before'. Yet Bilk made an unexpectedly successful assault on the American market, with his wonderfully mournful instrumental 'Stranger on the Shore' spending twenty-two weeks in the *Billboard* chart and reaching number one in May 1962. Perhaps the Americans were feeling charitable.[5]

To many observers, there now seemed little prospect that Britain would ever be able to resist the march of Americanization. 'I must say,' muses Jimmy Porter in John Osborne's play *Look Back in Anger* (1956), 'it's pretty dreary living in the American Age – unless you're an American of course. Perhaps all our children will be Americans.'

Similar sentiments came a year later from a very different source, the magazine *Everybody's Weekly*: 'Are We Turning Our Children into Little Americans?' And when Harry Hopkins looked back at Fifties Britain from the vantage point of 1963, he wrote that

> from hula-hoops to Zen Buddhism, from do-it-yourself to launderettes or the latest sociological catch-phrase or typographical trick, from Rock 'n' Roll to Action Painting, barbecued chickens rotating on their spits in the shop windows to parking meters, clearways, bowling alleys, glass-skyscrapers, flying saucers, pay-roll raids, armoured trucks and beatniks, American habits and vogues now crossed the Atlantic with a speed and certainty that suggested that Britain was now merely one more offshore island.[6]

As in the interwar years, the flood of American imports aroused strong feelings. In the early 1950s there had been a brief outbreak of tabloid hysteria about the pernicious effect of American 'horror comics', but the import that really stoked the anxieties of British parents was American music. When the jukebox crossed the Atlantic, many older observers shook their heads with disapproval. In May 1954 the *Daily Mirror*, then a very good barometer of working-class opinion, ran a lovely caption under a picture of a couple quietly enjoying a cup of tea. 'What the British Think of the Yanks,' it read. 'We dislike the fun you make about our domestic habits, the way you despise us for being dull. A cup of tea is more enjoyable to us than the garish delights of the juke box.' The most memorable indictment, however, came from Richard Hoggart, whose book *The Uses of Literacy* (1957), an affectionate portrait of working-class culture in the North of England, made him an intellectual star almost overnight. Almost every northern town, Hoggart wrote, now had a milk bar with nasty 'modernistic knick-knacks' in which local youths congregated every evening. There, horror of horrors, they would gather around the jukebox:

> Girls go to some, but most of the customers are boys aged between fifteen and twenty, with drape-suits, picture ties and an American slouch. Most of them cannot afford a succession of milkshakes, and make cups of tea serve for an hour or two whilst – and this is their main reason for coming – they put copper after copper into the mechanical record-player . . .

The young men waggle one shoulder or stare, as desperately as Humphrey Bogart, across the tubular chairs.

Compared even with the pub around the corner, this is all a peculiarly thin and pallid form of dissipation, a sort of spiritual dry-rot amid the odour of boiled milk.

The key word in that passage, by the way, is 'American'. As Hoggart saw it, the teenagers' clothes, hairstyles and even their 'facial expressions' all indicated that they were living in 'a myth-world compounded of a few simple elements which they take to be those of American life'. Yet this was not, of course, a new argument: in essence, it was exactly the same thing that the *Methodist Times*, or indeed Lieutenant-Colonel Reginald Applin, had been saying as far back as the 1920s. The only thing that had changed was the technology.[7]

It was the arrival of rock and roll, however, that provoked the most ferocious reactions, not least because it was associated with two things many British columnists automatically disliked: sex and black people. The bandleader Ted Heath – no relation – insisted that it would never catch on because it was 'primarily music for coloured folks, played by coloured bands. It includes a great deal of jumping up and down and crazy antics which I do not feel would be acceptable here.' Even the jazz-crazed *Melody Maker* condemned rock and roll as 'one of the most terrifying things to have happened to popular music' and the absolute antithesis of 'good taste and musical integrity'. The *Daily Mail*, meanwhile, was on memorably robust form. Rock and roll, it declared on 4 September 1956, was 'sexy music. It can make the blood race. It has something of the African tom-tom and voodoo dance.' The following morning it ran an apocalyptic front-page editorial entitled 'ROCK AND ROLL BABIES'. 'It is deplorable,' the *Mail* warned its readers. 'It is tribal. And it is from America. It follows ragtime, blues, dixie, jazz, hot cha-cha and the boogie-woogie, which surely originated in the jungle. We sometimes wonder whether this is the Negro's revenge.' Yet despite the *Mail*'s warnings, rock and roll was in Britain to stay. At the end of 1956, the *Sunday Times* summed it up as the year of 'Rock 'n Roll. Pizza. Cigarillos – cigarette-size cheroots. Tortoiseshell-tinted hair. *The Outsider*. Records of *My Fair Lady*. "Angry young men" ... Skiffle Groups.' And soon even the BBC, then in one of its dullest and stuffiest phases, was forced to acknowledge rock and roll's place at

the centre of youth culture. 'Welcome aboard the *Six-Five Special*,' began the disc jockey* Pete Murray's hilariously excruciating introduction to the BBC's first dedicated show for teenagers, which went out on 16 February 1957. 'We've got almost a hundred cats jumping here, some real cool characters to give us the gas, so just get on with it and have a ball.'[8]

Rock and roll threw Britain's cultural inferiority into sharp focus, for where the Americans led, their former colonial masters dutifully followed. To enjoy lasting success in the British charts – let alone the American ones – aspiring stars had no choice but to adopt American accents. Thus the first British act to make the *Billboard* Top Twenty, the skiffle star Lonnie Donegan, sang with a nasal American accent, despite the fact that he had been born in Glasgow and brought up in the East End. And younger stars, too, invariably sang with faux-American accents. Cliff Richard, for example, sang his first hit, 'Move It', in a strong mid-Atlantic accent and however continued to speak in a peculiar semi-American drawl for the rest of his life. Adam Faith, however, never quite managed to banish the sound of his native Acton, which meant that 'baby' came out as 'by-a-bee'. And after seeing a concert by Tommy Steele, the novelist Colin MacInnes was baffled and depressed by the contrast between Steele's speaking voice – 'the flat, wise, dryly comical tones of purest Bermondsey' – and his singing voice – a 'shrill international American-style drone'. Britain's pop stars, MacInnes thought, had won their 'battle for a place among the top twenty . . . at the cost of splitting their personalities and becoming bi-lingual: speaking American at the recording session, and English in the pub round the corner afterwards'. And with Americanization now so advanced, MacInnes even wondered whether the English would, in the future, be considered 'a people in any real sense at all'.[9]

* The term 'disc jockey' itself, of course, was a recent American import, having first appeared in *The Times* in 1955. (I take no credit for spotting this, since it was my copy-editor who pointed it out.)

SIR ALEC'S SECRET WEAPON

Are we going to have a situation in which other centuries will
look back and say that the eighteenth century was the century of
Bach and Beethoven, the nineteenth century was the century of
Brahms, and the twentieth century was the century of Beatles
and Bingo?

Lord Willis (Ted Willis), speaking in the
House of Lords, 13 May 1964

And then came the Beatles. They are so well known that it is half-tempting to ignore them altogether, or at least to find some iconoclastic way of undervaluing them. In the first months after the Beatles' breakthrough to worldwide fame, some older observers insisted that they were merely a short-lived fad. In May 1964, during a House of Lords debate on the 'problem of leisure', the playwright and Labour peer Ted Willis dismissed them as 'a cheap, plastic, candyfloss substitute for culture'. More famously, and more fiercely, the *New Statesman*'s Paul Johnson claimed that the Beatles appealed only to 'the dull, the idle, the failures' of their generation. 'The boys and girls who will be the real leaders and creators of the society of tomorrow', Johnson prophesied, would 'never go near a pop concert'.[10]

This was, by any standards, a singularly unfortunate prediction. Whether you like the Beatles or not, there is no way of dismissing them. They are simply part of our cultural canon. The Cambridge historian Tim Blanning even finds room for them in his book *The Triumph of Music*, which is largely devoted to classical music, noting that Paul McCartney's song 'Yesterday' has been covered more than 3,000 times by other artists, making it the most recorded song in history. In fact, even to list their feats – the 177 million records sold in the United States, the estimated 1 billion records sold worldwide, the twenty American number ones, the 22 million singles sold in Britain – merely scratches the surface of their achievement. In the twentieth century, perhaps only Winston Churchill and Elizabeth II rivalled them as symbols of Britishness. Perhaps not since Dickens had any cultural figures become so synonymous with their native land.[11]

For decades, biographers have poured out oceans of ink trying to

'At least we've *one* Union Jack we don't have to haul down.' In the *Daily Express* (21 September 1964), Cummings conflates the Beatles' conquest of America with the news of Maltese independence, a disastrous British performance in the America's Cup and reports that BOAC aircraft would no longer display the Union Jack. It has to be said that Sir Alec Douglas-Home makes a lovely Britannia.

understand how and why the Beatles did it. Timing, temperament, hard work, ambition and pure native talent all played their part; but if there were a simple formula, somebody would have patented it long ago. Perhaps the only thing that is often underrated is the Beatles' supremely clear sense of themselves, at least initially, as businessmen with a product to sell. No doubt some readers will find such a notion offensive: contemplating rock music, or indeed any kind of music, we typically prefer the idea of the creator as a romantic genius holed up in his garret, a martyr to high-mindedness and self-expression, which Blanning traces back to the 'romantic revolution' of the eighteenth century. But one of the keys to the Beatles' success is that, until the late 1960s, they were among the worldliest of rock bands. It is telling, for example, that in his great book *Revolution in the Head*, the critic Ian MacDonald twice describes John Lennon and Paul McCartney as 'business partners', and constantly emphasizes the 'professional formality' of their song-writing relationship.[12]

In fact, right from the beginning the Beatles were motivated not just by artistic self-expression, but by uncomplicated financial ambition. When, soon after they had been taken up by Brian Epstein, his secretary asked them to fill in 'Life Lines' questionnaires, one of the questions was 'Ambition?' McCartney's answer was: 'Money, etc.' Lennon's answer: 'Money and everything.' George Harrison's answer: 'To retire with a lot of money, thank you.' When Epstein secured them their first contract with EMI, which paid them a penny per record on 85 per cent of their sales, their reactions said it all. 'When are we going to be millionaires?' read Lennon's congratulatory telegram, while McCartney's message quipped: 'Wire ten thousand pound advance royalties.' There was nothing ironic about the Beatles' cover version of the Motown song 'Money (That's What I Want)'; nor was there anything ironic about George Harrison's 'Taxman', written to express his outrage at Harold Wilson's 95 per cent 'supertax' rate. Later, Harrison earned the reputation of being the 'Business Beatle', partly thanks to his mother, who told their first biographer that he was 'always very serious about his music, and the money. He always wanted to know how much they were getting.' But who can blame him? He had grown up in a council house, the son of a bus conductor and a shop assistant. For years he had played, night after night, for virtually nothing. It would have been bizarre if he had *not* shared the material ambitions of other working-class youngsters

who had grown up in the 1950s. As he knew perfectly well, money might not buy you love, but it had its compensations.[13]

None of this is meant to downplay the vivacity, imagination and sophistication of the Beatles' songs, without which they would never have been so successful for so long. But given the stigma attached today to 'manufactured' bands, it is worth emphasizing that the Beatles, too, were a *manufactured* band. After all, they would probably never have tasted success had it not been for their manager, Brian Epstein. Epstein was not a musician; he ran a shop, which meant he knew exactly how to sell records. It was Epstein who packaged the Beatles for the mass market, encouraging them to ditch their leather jackets and putting them in smart dark suits. Far from resisting his rebranding, the Beatles embraced it: Lennon even remarked that he would 'wear a fucking balloon if someone's going to pay me'. Similarly, they acceded to Epstein's request that they perform a synchronized bow at the end of their concerts; likewise Lennon, McCartney and Harrison gave in when their EMI producer, George Martin, told them to sack their drummer, Pete Best, who had been with them for two years. Indeed, the truth is that in those crucial early years the Beatles were just as carefully packaged as any modern boy-band, even down to their stark black-and-white publicity photos, which, tapping the vogue for northern working-class settings, showed them standing moodily against a bleak warehouse backdrop. For their first American tour in 1964, too, nothing was left to chance. Before their plane touched down on 7 February, Capitol Records had spent an unprecedented $50,000 – ten times as much as they had ever spent on any other artist – on posters, badges and car stickers proclaiming 'The Beatles Are Coming'. Even the teenagers waiting for them at the airport had been bribed with free T-shirts.[14]

The Beatles' arrival in New York was not merely the single most important moment in their careers, it was one of the most important moments in Britain's modern cultural history. As J. Arthur Rank had known, it was one thing to enjoy success at home, but quite another to conquer the American market. Thanks to Capitol Records' efforts, however, some 4,000 screaming fans were waiting for them at the airport. No British group had ever arrived to such a reception. But then very few British groups had ever toured in the United States at all: even Cliff Richard, for all his domestic success, had made only one American sortie, appearing halfway down the bill to total indifference. Most

American executives believed that British music would never take off: even as the Beatles' early singles had stormed the British charts in the summer of 1963, Capitol had refused to release them across the Atlantic. 'We don't think the Beatles will do anything in this market,' Capitol's boss, Jay Livingstone, told George Martin. Gradually, however, news of the Beatles' extraordinary success filtered across the ocean. 'The rise of the Beatles also marks the end of American domination of popular music in Britain,' the *New York Times* predicted in December 1963. 'Naturally, songs from the US will continue to pour in, but the recordings which reach the hit parade have to be made by British groups.'[15]

Even so, nobody could possibly have predicted the hysteria that greeted the Beatles' arrival, from their appearance before 73 million viewers on the *Ed Sullivan Show* to their sell-out concerts at the Washington Coliseum and Carnegie Hall. As for their chart success, it was simply phenomenal. That spring, almost two out of three records bought in the United States carried the Beatles' name, and at one point in April they occupied the top five places in the *Billboard* chart. If that were not enough, on the other side of the border they held *nine* of the top ten positions in the Canadian Top Ten. Almost overnight the Americans had been miraculously transformed from overbearing cultural imperialists to supine colonial subjects. 'YEAH! YEAH! USA!' screamed Britain's bestselling paper, the *Daily Mirror*, after the band's arrival at Kennedy Airport. Two days later, after the *Ed Sullivan Show*, the *Mirror* ran another banner headline. 'BEATLES ON TV WOW AMERICA: They've Never Seen Anything Like It.'[16]

Yet the *Mirror*'s excitement disguised a deeper story: this was triumphalism born of insecurity. For the Beatles' international success came at precisely the moment when Britain's conventional exporters were running into trouble. The signs had been there since the 1950s: indeed, in 1956, the year rock and roll arrived in Britain, West Germany had overtaken Britain as a car exporter, while Japan became the world's leading shipbuilder. At the time, some observers blamed the snobbery and complacency of British management, while others blamed disputatious and obstructive trade unions. Today many historians blame a long-term culture of under-investment and poor strategic decisions: in particular, the misguided emphasis on the soft markets of the Commonwealth rather than the more competitive but also more dynamic markets of Britain's European neighbours. In any case, the results were

disastrous for British manufacturing. Between 1951 and 1964, West Germany's exports increased by 247 per cent, Italy's by 256 per cent, Japan's by 378 per cent – and Britain's by just 29 per cent. In the same period, Britain's share of the world trade in manufactured goods fell from 25 per cent to 15 per cent. For the time being, affluence acted as a comfort blanket. Slowly but surely, though, Britain's industrial heritage – the sweat and din of manufacturing that Tony Iommi and Ozzy Osbourne took for granted in post-war Birmingham – was beginning to disappear.[17]

Almost from the very beginning, many commentators saw the Beatles not merely as musicians but as *exporters*. Exports were much in the news in the early 1960s, as successive governments, alarmed by Britain's balance of payments deficit and the inevitable decline of foreign confidence in the pound, urged manufacturers to concentrate on overseas markets. It was no good, though: in the summer of 1964, after the Beatles had flown back from New York in triumph, Britain's balance of payments was a whopping £600 million in the red, widening to £800 million by the autumn. Perhaps it was not surprising, therefore, that almost immediately Britain's politicians welcomed the Beatles as potential harbingers of a national cultural and economic renaissance. 'They herald a cultural movement among the young which may become part of the history of our time,' the government's Minister of Information, William Deedes, told the Young Conservatives, while the President of the Board of Trade, Edward Heath, hailed them as 'the saviours of the corduroy industry' – an odd remark, given that at that stage the Beatles almost exclusively wore non-corduroy suits. Perhaps the most remarkable attempt to claim them, however, came on 15 February 1964, only three days after they had played to a packed Carnegie Hall. The speaker was the Prime Minister, Sir Alec Douglas-Home, the last person anybody would have credited with a passionate interest in pop music, and his audience was the annual conference of the Young Conservatives. 'The Beatles', he announced, 'are now my secret weapon. If any country is in deficit with us I only have to say the Beatles are coming ... Let me tell you why they have had a success in the United States – it is because they are a band of very natural, very funny, young men.'[18]

At the time, the Labour leader, Harold Wilson, was quick to condemn such an embarrassingly insincere gimmick, mocking 'these apostles of a

bygone age trying to pretend they are with it by claiming the Beatles as a Tory secret weapon'. The Conservative government, Wilson said, 'would not hesitate, if there were votes in it, to appoint Paul and George, Ringo and John, collectively to Washington to run the embassy'. This was not, in fact, such an implausible prediction. In September 1964 the British Embassy in Washington invited the group to visit the British pavilion at a Houston trade fair, where, according to *The Times*, they would appear alongside 'the guided missile ship *London*, a demonstration of a Hovercraft and other events calculated to attract attention to Britain and her products'. In the end, the Beatles never made it. Yet even at this early stage, popular culture – and pop music in particular – was seen as an important element of Britain's self-presentation to the world. And having initially mocked his predecessor's attempt to climb aboard the Beatles' bandwagon, Harold Wilson, who became Prime Minister in October 1964, was quick to follow suit. On 12 June 1965 Buckingham Palace announced that the Beatles had been awarded MBEs in the Queen's Birthday Honours list. 'BEATLES, MBE!' shrieked the *Mirror*. 'Now They've Got into the Topmost Chart of All.'[19]

Today we take it for granted that, every year, honours are handed out to pop stars, footballers and entertainers of all kinds. But in June 1965 the Beatles' awards seemed genuinely shocking. The nation's priorities had been turned on their head. To many, perhaps most people, the honours system was meant to reward political leadership, industrial achievement and military gallantry, and John Lennon's initial reaction spoke volumes: 'I did not think you could get it for this sort of thing. I thought you had to drive tanks and win wars and stuff.' Harrison, too, told reporters that he 'didn't think you got that sort of thing just for playing Rock and Roll music'. Popular wisdom holds that they had been rewarded 'for services to exports', and indeed *The Times* reported that the list had been designed to give 'increasing recognition to people who have helped in the export drive'. In fact, the citation merely read 'member of the Beatles'; contrary to popular belief, there was no mention of exports. Interviewed at home in Weybridge, Lennon joked that if the award had been for rock and roll, 'we'd have got OBEs [a higher award] . . . and the Rolling Stones would have got the MBEs. I reckon we got them for exports, and the citation ought to have said that.' The next day, a news crew explicitly asked the band: 'Do you think your export sales have something to do with this?' 'Well, you know,

somebody said it could have been that,' said Paul McCartney coyly. 'But you never know.'[20]

Even to Wilson loyalists such as Tony Benn and Barbara Castle, the idea of awarding MBEs to pop stars came as a shock. But it was outside the Commons that tempers flared most spectacularly. Two days after the announcement, Paul Pearson, a former RAF squadron leader who had subsequently been decorated for commanding rescue operations in the Channel, posted his medal back to the Queen. 'I feel that when people like the Beatles are given the M.B.E.', he explained, 'the whole thing becomes debased and cheapened.' On the same day, a former Canadian MP returned his MBE because he thought medals should be given to 'statesmen, heroes and industrialists', not 'sorry fellows' like the Beatles. There then followed a deluge of such stories, usually with a wartime twist. A Cardiff sea captain, 'torpedoed twice' during the Second World War, sent back his OBE; an official in the New Guinea government returned his Military Medal, claiming that 'the Beatles' M.B.E. reeks of mawkish, bizarre effrontery to our wartime endeavours'; and a former lieutenant-commander in the Royal Canadian Navy disavowed his MBE, adding: 'For the next war do not count on me – use the Beatles or the Beatniks.'

Even the Mayor of Poole waded into the debate, asking his Conservative MP to raise the matter in the Commons. Both his brothers, he observed, had been given MBEs. 'One of them won it for combatting three enemy planes at a height of 20,000 feet,' he said sternly. 'Giving it to the Beatles is an insult to all of us.' The most prominent critic, however, was one Colonel Frederick Wagg, a serial complainer from Dover who had served in both world wars. Not content with returning one medal, Colonel Wagg returned all twelve of his military awards, resigned as a member of the Labour Party and even instructed his solicitor to cancel a £12,000 bequest to the party in his will. 'Decorating the Beatles', he declared, 'makes a mockery of everything this country stands for. I've heard them sing and play and I think they're terrible.' Colonel Wagg was promptly besieged with letters, including an angry communication from some Beatles fans from Forest Hill, London. To the colonel's fury, a scribbled note on the envelope read: 'Waggy will pay the postage.'[21]

Not everybody disagreed with the Beatles' awards, although letters to Harold Wilson were reported to be running two to one against it. Revealingly, though, almost all the letters and editorials backing the

Beatles emphasized their importance as 'dollar earners' and international ambassadors rather than their purely musical achievements. When Liverpool MPs tabled a Commons motion praising the awards, for example, they explicitly mentioned the Beatles' role as 'the first entertainment group that has captured the American market and brought in its wake great commercial advantage in dollar earnings to this country'. 'What *would* be the point of serving a country that tried to ignore the talent, vivacity and even the dollar-earning capacity of its young?' agreed R. I. L. Guthrie of London SE5 in a letter to *The Times*. Another correspondent, Charles de Hoghton of London W9, listed the reasons why the Beatles' awards were 'quite appropriate'. The order is, I think, interesting:

1. They are significant earners of foreign exchange.

2. They have, to quote Mr Heath when he was President of the Board of Trade, 'saved the British corduroy industry'.

3. They have helped to correct the foreign vision of Britain as a country entirely populated by middle-aged conservatives of all sorts – e.g., stockbrokers, wildcat strikers, Beefeaters and Pembrokeshire coracle fishermen.

4. They are representative of a movement which has raised 'pop' music to a degree of sophistication and sheer musical interest never before attained.

5. They have started a fashion of music-making among the young in the street and have made it smarter to tote a guitar than a cosh.

6. They have given much pleasure to all age groups in all sections of the population.

Perhaps the most telling defence of the awards, however, came in the *New Musical Express*. The editor, Andy Gray, agreed that it was 'incongruous to lump war heroes together with entertainers'. The Beatles, though, were not merely 'entertainers': their music might well 'be regarded as culture by generations to come'. Above all, he argued, they were a rare British success story in an age of political and economic decline:

I think it's wrong to imply that they have earned their medals as dollar-earners. Let's face it, they haven't been earning dollars for Britain so much as for themselves. No, where The Beatles honestly and justifiably deserve their awards is in the field of prestige. Their efforts abroad to

keep the Union Jack fluttering proudly have been far more successful than a regiment of diplomats and statesmen.

We may be regarded as a second-class power in politics, but at any rate we now lead the world in pop music!*[22]

He was not exaggerating. Britain *did* now lead the world in pop music. Indeed, given what had come before, the transformation was simply extraordinary. Before the Beatles' first American tour, the musical traffic across the Atlantic had been almost all one way. While British teenagers thrilled to the sound of Bill Haley, Elvis Presley and Buddy Holly, their American counterparts had been less eager to snap up the latest singles by Cliff Richard, Billy Fury and Adam Faith. But now the picture was very different. Almost overnight – and single-handedly – the Beatles had completely transformed the image and desirability of British music. In the last week of July 1964, not only did the Beatles have four albums in the *Billboard* chart, but they were joined by four other British acts: the Dave Clark Five, the Searchers, the Rolling Stones, and Peter and Gordon. The singles charts offered even more striking evidence of the British Invasion. Before the Beatles arrived in New York, only two British singles – Acker Bilk's 'Stranger on the Shore' and the Tornados' 'Telstar' – had topped the *Billboard* Hot 100 chart, both of them in 1962. But between February 1964 and the end of 1966 no fewer than *thirty* British singles reached the American number one spot. Not all of them were Beatles songs: the Animals, Manfred Mann, Herman's Hermits and Petula Clark, for example, all got in on the act too. Indeed, in 1964 and 1965 British acts hogged the top spot for no fewer than fifty-two weeks. 'All any English band with a working-class accent had to do', wrote one American observer afterwards, 'was show up at the airport.'[23]

Even at this early stage, there was an obvious formula for success. If a group were *too* British – British to the point of obscurity – then they would find it hard to break into the American market. The Kinks, for example, never acquired a major American following, partly because, after a brawl with American union officials in Los Angeles, they were effectively banned from touring, but also because Ray Davies's songs

* It is worth noting that Gray himself was hardly the voice of youth, since his journalistic career had begun before the Second World War. Although he edited the *NME* from 1957 to 1972, his real passion was playing golf.

were so introspectively English. Instead of singing about love, sex and drugs, he laconically regaled the listener with comic monologues, music-hall routines and quirky stories about the forgotten rhythms of English life, from cracked ceilings and leaking sinks to Southend guest-houses and steam-powered trains. But American teenagers did not, by and large, want to hear about Southend. They preferred what the pop historian Alan Clayson calls the 'Hollywood movie idea of Britain, the mythical land of Good Queen Bess, Robin Hood, fish 'n' chips, Oxford-and-Cambridge, Beefeaters, monocled cads, kilted Scotsmen and hello-hello-hello policemen'. Like their parents, they wanted *The Private Life of Henry VIII*, only on vinyl. Hence the success of Herman's Hermits, a Manchester quintet whose single 'I'm into Something Good' had topped the British chart in August 1964. A few months later they reinvented themselves as a walking parody of nostalgic Britishness before launching an astonishingly successful invasion of the American charts. Their new singles were either cover versions of half-forgotten music-hall classics, such as 'Leaning on a Lamp-post' and 'Mrs Brown You've Got a Lovely Daughter', or glorified tourist-board advertise-ments, such as 'Je Suis Anglais' and, naturally, 'I'm Henry the Eighth, I Am'. In Britain many of these songs sank without a trace. But with more than 10 million American sales in 1965 and 1966, Herman's Hermits were singing all the way to the bank.[24]

Even bands such as the Beatles and the Rolling Stones, who openly admitted their debts to American forerunners such as Little Richard, Chuck Berry and the blues singers of the Mississippi Delta, heavily emphasized their own Britishness. Without the legacy of the music hall, the Goons, the art schools and the satire boom, the Beatles would never have evolved as they did. It was no accident that their most celebrated album, *Sgt Pepper's Lonely Hearts Club Band* (1967), drew heavily on the sound of the Victorian music hall, while Paul McCartney's lilting 'When I'm Sixty-Four', one of the album's best-remembered songs, could almost have been a hit for George Formby. Even the album's cover, designed by Peter Blake, teemed with Victorian and Edwardian charac-ters, from Oscar Wilde, Dr Livingstone and Sir Robert Peel to Lewis Carroll, George Bernard Shaw and H. G. Wells. In fact, the Beatles' music appealed to exactly the same kind of people who had patronized the music halls in their Victorian heyday: working-class and lower-middle-class youngsters in towns and cities who had a spare bob or two for a

cheap evening's entertainment. In the Beatles' case, there was also a direct link. McCartney's father had once worked as a spotlight operator at the Liverpool Hippodrome and used to entertain his son with stories of life at the theatre. He would play the old tunes on the piano when teaching young Paul how to sing.[25]

As in the music halls, which had been famously and aggressively patriotic, the Union Jack played a central role in the iconography of the British Invasion. Contrary to what is sometimes claimed, there was nothing 'ironic' about it. After the Who returned from a tour of the United States, Pete Townshend told an interviewer that 'what made us first want to go to America and conquer it was being English. We didn't care a monkey's about the American dream or the American drug situation or about the dollars . . . It was 'cos we were English and we wanted to go to America and be English.' Touring abroad, agreed Manfred Mann, made him 'just that little bit more Union Jack conscious'. Since the British Empire had now almost completely disintegrated, the flag no longer carried imperial connotations, at least not in the United States. Instead, thanks to groups like the Who, it seemed a symbol of modernity, liberation and even – something previously unimaginable – *fun*. Cashing in on the success of Britain's pop groups, enterprising manufacturers churned out tens of thousands of Union Jack mugs and T-shirts, and eventually there were even Union Jack bikinis and knickers. Just a few decades earlier, the notion that such things might have appealed to an overseas market would have been frankly laughable. In an earlier, proudly imperial age, when the Union Jack flew above every continent on earth, the idea of turning it into a symbol of youth and excitement would have seemed about as plausible as, say, naming a boutique after Lord Kitchener's valet.[26]

There is, I think, a good case for arguing that the reinvention of Britain as a pop-cultural superpower could never have happened had it not been for the eclipse of the strengths that once had symbolized the Empire around the world, namely its manufacturing might and naval ascendancy. When Rank made *Henry V*, Britain still had pretensions to global supremacy. We know now that these were merely illusions, soon to be blown away by Suez and decolonization. But to the men and women who went to see Olivier's film, it was far from obvious, since much of the map was still coloured pink. Within two decades, however, the picture had changed completely. By the time the Beatles landed in

New York in February 1964, India, Pakistan, Burma, Sri Lanka, Egypt, Sudan, Ghana, Malaya, Nigeria, Sierra Leone, Tanzania, Jamaica, Trinidad, Uganda and Kenya had all won their independence, leaving British power a very pale shadow of its former self. Of course old resentments lingered, especially in countries where the retreat from Empire had been violently contested. In the United States, some older people still saw Britain as the embodiment of imperial arrogance and inherited privilege. Indeed, even during the Second World War, Franklin D. Roosevelt, one of the architects of the so-called special relationship, had warned Churchill that he had no intention of helping the British 'hang on to the archaic, medieval Empire ideas'. But by the early 1960s those ideas had largely disappeared. Now that the Union Jack was coming down across the world, it was harder for Britain's critics to see it as an arrogant, domineering bully, the land of screw merchants, missionaries, gunboats and dreadnoughts. At home, many older people, precisely the kind who disliked rock and roll and were horrified by the Beatles' MBEs, were shocked and saddened by the end of Empire. But the decline of British power had its compensations. Market resistance to British culture had never been weaker. And now that people abroad no longer feared and resented John Bull, he was free to turn himself into a joke.[27]

AVENGERLAND

The most astonishing change of all to me is the muscular virility of England's writers and dramatists and actors and artists – this from an island we'd most thought of in terms of Noël Coward and drawing-room comedy.

John Crosby, 'London, the Most Exciting City in the World',
Weekend Telegraph, 16 April 1965

The success of the Beatles and their competitors was only one element of Britain's cultural self-reinvention. In fashion, for example, the key figure was Mary Quant, who had opened her famous boutique, Bazaar, in 1955. 'I just happened to start when that "something in the air" was coming to the boil,' she wrote. 'The clothes I made happened to fit in exactly with the teenage trend, with pop records and expresso bars and

'One hundred per cent British': Diana Rigg flirts with a suit of armour in *The Avengers* (1966).

jazz clubs.' What set Quant apart, though, was her entrepreneurial instinct. Like Joseph Rank, she embraced manufacturing and marketing innovations; like his son J. Arthur, meanwhile, she set her sights on reaching a mass market and breaking into the United States. By 1961 she had moved into mass production, and two years later she struck a deal with J. C. Penney, one of the largest American department stores, to market the Quant label in its 1,700 branches. The obvious parallel is with Rank's efforts to build alliances with the Hollywood studios; the difference is that Quant was much more successful. By 1966 her companies were raking in an annual income of more than £4 million, the *Sunday Times* had given her an award for 'jolting England out of its conventional attitude towards clothes' and, like the Beatles, she had been rewarded with a medal, in her case the OBE. This time nobody complained.[28]

Like the Beatles, Quant benefited from the disappearance of the Empire, which meant that Britain's image in the United States could be safely reinvented, free from any unpleasant imperial associations. In a curious way she also benefited from the stereotype of Britain as stuffy and old-fashioned. As the reaction to the Beatles' press conferences shows, Americans were often hugely amused by the contrast between their image of an old-fashioned, tweedy, aristocratic Britain and the youthful, talented and entrepreneurial reality. It was as though, having steeled themselves for a date with Margaret Rutherford, they found themselves sitting across the table from Jean Shrimpton instead. When Quant first visited the United States in late 1960, *Life* thought that her 'kooky styles' seemed 'wackier than they are because they come from England, stronghold of the court gown, the sturdy tweed and the furled umbrella'.* And once the Beatles had made their appearance, Britishness became the height of fashion. By 1966 American teenagers could order a Beatle cap from the Carnaby Street Boutique catalogue, a pair of Liverpool Flame bell-bottoms from the Brolly Male collection, some Margo of Mayfair Beatles Talc and, perhaps, a Royal Navy pea-coat with shoulder epaulettes. Even Yardley made a special 'Britannic scent' for the American market, a 'frisky-frilly fragrance full of tender flowers', called, unforgivably, Oh! de London.[29]

At the cinema, too, all things British enjoyed unprecedented popularity.

* Bizarrely, though, the magazine insisted on calling her 'Mrs Alexander Plunket Greene'.

By 1966 *Goldfinger* and *Thunderball*, perfecting the James Bond formula of sex, snobbery and designer gadgets, had broken almost every box-office record on the planet. In the United States alone *Thunderball* sold almost 60 million tickets, which meant that, statistically, one in every four Americans had been to see it. Meanwhile, the prominence of Britain's actors and actresses at the Oscars was simply astounding. In 1964 Britain could boast four Best Actor nominations (Richard Burton, Peter O'Toole, Peter Sellers and Rex Harrison, the winner), three Best Supporting Actor nominations, the Best Actress winner (Julie Andrews) and one Best Supporting Actress nomination. In 1965 Julie Christie beat Julie Andrews and Samantha Eggar to win Best Actress, while there were two more British Best Actor nominations (Burton and Olivier), three Best Supporting Actor nominations and two nominations for Best Supporting Actress. A year later, Burton, who merely needed to turn up on set to be shortlisted for an award, picked up a third consecutive Best Actor nomination. This time he was up against Michael Caine and Paul Scofield (the winner), while Britain also picked up a further six acting nominations. Little wonder, then, that even American observers got carried away. 'Talent is getting to be Britain's greatest export commodity,' gushed the journalist John Crosby in the *Telegraph* in April 1965. There was, he noted, a popular explanation: 'England, shorn of its world-wide responsibilities for keeping the peace, has turned its energies, previously dissipated in running the colonies, inwards towards personal self-expression.'[30]

Crosby's article was one of two pieces credited with inventing the idea of Swinging London, the other being Piri Halasz's *Time* magazine cover story of 15 April 1966, 'You Can Walk Across It on the Grass'. Both were written by Americans who spent most of their time in Chelsea and the West End, and both were pretty preposterous. For most people, especially those who were not young, rich and university-educated, the reality of life in the capital was far from glamorous. To ordinary Londoners, Crosby's version of life in the capital – 'young', 'talented', 'elegant', 'brilliant', 'throbbing' and 'glowingly alive', typified by the 'twist and shake' parties held by dynamic young swingers such as Prince Charles and Princess Anne – must have seemed the stuff of some mad fantasy. Indeed, the mind boggles at what female *Telegraph* readers made of Crosby's claim that 'even the sex orgies among the sex-and-pot set in Chelsea and Kensington have youth and eagerness and, in a

strange way, a quality of innocence about them ... Young English girls take to sex as if it's candy and it's delicious.' But, if anything, Halasz's piece was even odder, with her scenes from ordinary London life including such everyday activities as a Chelsea lunch party with David Bailey, Jean Shrimpton, Terence Stamp and Michael Caine, and a Kensington dinner party for, bizarrely, Marlon Brando, Warren Beatty and Barbra Streisand, none of whom lived in London. One sentence in particular cast doubt on her credibility: 'The guards now change at Buckingham Palace to a Lennon and McCartney tune, and Prince Charles is firmly in the long-hair set.' Had she even been to London? Either way, she had never seen a picture of Prince Charles.[31]

It is perhaps telling that the most acute analysis of the Swinging London phenomenon was published in the *New York Times*, the most respected paper in the country that had supplanted Britain as the Western world's greatest economic and military power. According to Henry Fairlie, the hard-drinking British journalist who had popularized the term 'the Establishment' before moving to Washington, the British had hitherto been an 'outward-looking people'. But now, he told his American readers, 'there is nowhere to which they can paddle for glory, for empire or for booty'. So they had 'turned in on themselves', sunk in narcissism, absorbed in what Fairlie called the arts of decoration and amusement. Looking through the list of celebrities who populated Halasz's famous *Time* article, Fairlie was shocked by their sheer frivolity:

> Not one of them – in this or any list – is connected in any way with the skills and industries on which Britain's prosperity must rest. They do not spurn trade – in fact, one of the unlovely facts about them is the intensity of their ambition for quick material success – but they deliberately choose an area of trade which, because it is allegedly artistic, has snobbish connotations. To learn slowly the skills of a great industry, such as electronics, would be much too workaday for them.
>
> Yet so intent are they on making money by exploiting their customers, by shocking, by exaggerating fashion and fad, by pop and by op, that they can claim no superiority to the values of business and large industry. They are ruthless in using the media of communication to create desires which are artificial, to encourage precisely the 'ingenuity of indulgence' and 'varieties of vanity' of which Ruskin spoke ...

The fact of the matter is that the British have not come to terms with their decline. Even the humiliation of Suez was smothered – brilliantly – by Mr Macmillan ... The result is that decline in Britain – which is inevitable – is passing into decadence – which is not.

Fairlie's essay is worth quoting at such length, not just because he was relatively unusual in linking Britain's pop-cultural efflorescence with its industrial decline, but because he so accurately anticipated many of the criticisms that would surface in decades to come. He died in 1990, too early to see the rise of the Young British Artists, the cult of Damien Hirst or the extraordinary success of British-made video games such as *Grand Theft Auto*. But, on this evidence, he would not have been at all surprised.[32]

For all its silliness, the Swinging London phenomenon contained a tiny grain of truth. London in the mid-1960s *did* have an energy and enthusiasm that had simply not been there ten or twenty years earlier, fuelled by the new affluence of, in particular, young working women and teenage girls. And even if the Swinging London craze was largely invented by the newspapers, it had a dramatic impact on the capital's worldwide image. A decade or two earlier, only a lunatic would have concurred with Crosby's verdict that London was 'the gayest, most uninhibited, and – in a wholly new, very modern sense – most wholly elegant city in the world'. When Graham Greene had published *The End of the Affair* (1951), set during and just after the Second World War, his dilapidated pubs and tired teashops, endless drizzle and shadowed horizons had captured the mood of a city battered by the Luftwaffe and worn down by austerity. Dingy and damp, wreathed in smog, London in the early Fifties had been a symbol not of optimism and glamour, but exhaustion and decline. As the literary journalist Cyril Connolly put it, the capital was 'the largest, saddest and dirtiest of great cities ... its crowds mooning round the stained green wicker of the cafeteria in their shabby raincoats, under a sky permanently dull and lowering like a metal dish-cover'.[33]

Swinging London dealt a death blow to the Greene–Connolly image of the British capital. In Hollywood, it became the dominant impression not merely of London but of contemporary Britain, thanks to films such as *Alfie*, *Darling*, *Blow-Up* and *The Knack*, all of which came out during 1965 and 1966. But perhaps the most influential interpretation of

Swinging London appeared on television. *The Avengers* had begun life in 1961 as a relatively gritty black-and-white thriller series, made by the independent Associated British Corporation. By its third series, however, it had evolved into a much wittier, more playful show, regularly appearing among the twenty most popular programmes on television. The tone was set by the two leads: Patrick Macnee's John Steed, an urbane man about town, complete with smart suit, bowler hat and umbrella; and Honor Blackman's Cathy Gale, a feisty widow with a doctorate in anthropology and a black belt in judo.

Blackman's black leather costumes inspired particular excitement among male viewers, and the two leads even released a conspicuously unsuccessful single, 'Kinky Boots'. But by the end of 1963 the show's future seemed uncertain. The stars, who were relatively modestly paid and barred from appearing in advertisements, were restless, and Blackman announced her departure to star as Pussy Galore in *Goldfinger*. When the third series ended in March 1964, Associated British simply shut down production. For seven months nothing happened. Finally, by the end of the year, the producers found a proper replacement for Blackman in the willowy figure of Diana Rigg, and began shooting a fourth season, again in black and white. But what really transformed the show into a cultural phenomenon was not the casting of Rigg, brilliant as she was. It was Associated British's success at selling the series to the Americans.[34]

Until the mid-1960s, the direction of trade in television programmes across the Atlantic, as in film and music, had been predominantly from west to east. Since big-budget American shows such as *I Love Lucy*, *Dragnet* and *Gunsmoke* were much slicker than their British counterparts, they were hugely popular with audiences, despite the scorn of highbrow critics such as Richard Hoggart. But the trade was not entirely one way. As early as 1955 the ITC production company, run by the cigar-chomping Lew Grade, sold *The Adventures of Robin Hood* to CBS, where it attracted at least 30 million viewers a week. The series' parentage was at least half-American, since it had been devised by an expatriate New Yorker, Hannah Weinstein, who had moved to London to escape the Red Scares and liked to use blacklisted left-wing American writers. Even so, *The Adventures of Robin Hood* conformed to the formula laid down by Korda and Rank, presenting audiences with an exaggerated version of medieval England, complete with plenty of feasting, jousting and derring-do. By the end of 1955 this black-and-white

vision of Merrie England had earned Grade's firm a cool $1.25 million (at least $10 million today), and by 1958 Robin Hood merchandise had been licensed to thirty-three different manufacturers. 'In thousands of homes from Manchester to Maine and Manitoba today's youngsters have a new TV idol,' exulted Britain's *News Chronicle*.* 'Davy Crockett and Superman have been ousted to the limbo of television while the kids clamour for English longbows and jerkins of Lincoln green.'[35]

The Adventures of Robin Hood set the tone for future exports. In the next five years, ITC sold the Americans a host of further historical series, from *The Adventures of the Scarlet Pimpernel* and *The Adventures of Sir Lancelot* to *The Buccaneers*, *Ivanhoe* and *Sir Francis Drake*. As one of Lew Grade's regular writers, Dennis Spooner, put it, 'ITC was basically an exporting company. We were earning foreign currency ... It's no good trying to sell a locomotive in America if you insist on building it for the gauge of track that's relevant in Britain.' For the time being, however, the American networks were reluctant to buy anything more contemporary. What changed their minds was the success of the Bond films, and in the autumn of 1965 the Associated British Corporation sold *The Avengers* to the American network ABC (no relation). The impact on the show's style could hardly have been more dramatic. Since the Americans demanded colour film, not black-and-white videotape, the results looked infinitely more polished, but that came at a cost, with the budget for each episode rocketing from £6,000 to almost £40,000, the equivalent of at least £600,000 today. Still, the expense was worth it. *The Avengers* was the first British export guaranteed a regular prime-time slot on an American network, rather than being used as a mere schedule-filler. And by the late 1960s, as the historian James Chapman records, the show was watched by some 30 million people in seventy different countries, with its foreign revenues coming to at least £5 million. It was not, of course, the only British show watched abroad, since Grade sold his rival adventure series *Danger Man*, *The Baron* and *The Saint* to the American networks, too. But it was *The Avengers* that made the biggest impression – perhaps because, of all these series, it was by far the most ostentatiously British.[36]

* The timing of that piece, incidentally, was no coincidence: it came out on 5 September 1956, at precisely the moment parents were wringing their hands at the arrival of the film *Rock around the Clock*.

The Avengers' Britishness was absolutely central to its success. Things might have been different if Associated British had accepted ABC's offer of more money to add an American element to the show; fortunately, however, they refused. 'The really significant factor in the success of *The Avengers*', explained Associated British's managing director, 'is that the series is one hundred per cent British in conception, content, casting and style.' Yet what appeared in *The Avengers* from 1965 onwards was a very particular, if deliciously enjoyable, vision of contemporary Britain, a fantasy on a par with the medieval history in *Henry V* or *The Adventures of Robin Hood*. Filmed almost exclusively in the Home Counties, close to the studios at Pinewood and Borehamwood, *The Avengers* depicted a Britain of luxury hotels, golf courses and bachelor pads, where every village, dancing school or butlers' training college holds a dark secret. Immigration, poverty and industrial decline are completely absent, the roads are suspiciously empty of traffic, all retired military men sport vast moustaches, and every self-respecting millionaire has his own underground base. 'It was a never-never world,' the show's most prolific writer, Brian Clemens, explained. 'It's the England of "Is there honey still for tea?" that people imagine existed even if it didn't.'[37]

In Britain, too, the show's publicity proudly trumpeted its tourist-board aesthetic:

> The new AVENGERS formula is set against a tongue-in-cheek panorama of the picture-postcard Britain illustrated in tourist brochures. Every aspect of British life as it is promoted overseas, from atom-stations, bio-chemical plants and modern industry on the one hand to fox-hunting, stately homes and the Olde Englishe Inne on the other, is used as a good-humoured counterpoint to the tough and fast-moving adventures of two dedicated Secret Agents, who hide their iron fists beneath the velvet gloves of high living and luxurious sophistication.

As James Chapman points out, this is a classic case of the having-your-cake-and-eating-it approach that played such an important part in British cultural exports to the United States. And perhaps it is only a slight stretch to add that it was also a very familiar juxtaposition in twentieth-century British high culture. In its combination of the pastoral and the ultra-modern, the world of *The Avengers* is not really so different from the aesthetic described in the critic Alexandra Harris's book *Romantic Moderns*, which explores the work of artists and

writers such as John Betjeman, John Piper and Paul Nash during the 1920s and 1930s. This, she writes, was 'a machine age with old-fashioned doorbells', all 'concrete and curlicues', at once reassuringly nostalgic and thrillingly modern. It was an artistic ethos with a distinctly tourist-board flavour, the product of an age in which cars were opening up the countryside to day-trippers from the cities, while artists such as Eric Ravilious and Vanessa Bell were making posters for Shell, and Betjeman was editing his celebrated Shell County Guides. Not so different, then, from 'fox-hunting' and 'atom-stations'. Alas, there is no *Shell Guide to Avengerland*.[38]

Nothing captured *The Avengers'* canny blend of old and new better than its two leads. When the series returned in 1965, the marketing campaign emphasized its new female star, Emma Peel, played by the young Shakespearean actress Diana Rigg, 'a willowy, auburn-haired beauty with a sparkling wit who leads the streamlined life of an emancipated, jet-age woman'. The press release took the trouble to point out that Rigg had grown up 'at Jodhpur in Rajputana, where her father was in the Indian Government Service' – i.e. she was from good imperial stock – but also claimed that, as 'an intriguing mixture of the grave and the gay', she represented 'all that is best in the forward-looking Woman of Tomorrow'. Then there was her co-star, Patrick Macnee, 'Eton-educated and Hollywood-trained, cousin of David Niven and descendant of Robin Hood'. His character could hardly have been better scripted to appeal to American viewers:

> If Emma represents the future of Britain, Steed stands for the best of the past. In his tastes and character he embodies tradition and the qualities that people overseas have come to associate with the British way of life – gracious living, a London house full of family heirlooms and handsome antiques, a cultivated appreciation of food, wine, horseflesh and pretty women, proficiency at ancient and gentlemanly sports such as fencing, archery and polo, exquisite tailoring, a high-handed way with underlings and an endearing eccentricity which manifests itself in such preferences as driving a vintage Bentley convertible and fighting with swordstick, rolled umbrella or any handy implement rather than the more obvious weapons such as guns.

In the wrong hands, all this could have made for a terrible show. But it is a tribute to the skill of the actors, writers and producers that

The Avengers has lasted better than almost any other programme of the mid-Sixties. There was, perhaps, a slight dip in the final series, when Diana Rigg was replaced by the young Canadian actress Linda Thorson, although some of Thorson's episodes are the most flamboyant and imaginative of all. At its peak, though, *The Avengers* had a wit, a polish and a sheer *joie de vivre* that elevated it above any other series of the day. By comparison, even the Connery Bond films feel positively leaden, although it is, of course, heresy to say so.[39]

Not everybody liked *The Avengers*. The *Daily Express*'s critic thought it had become 'a commercial product aimed at the U.S. market' and urged the producers to tone it down and 'tell the Americans that they can like it or leave it'. Unfortunately, the Americans decided to leave it. With ratings falling, ABC pulled out in early 1969, and that was the end of that. Yet *The Avengers*' vision of Britain – stylish, nostalgic and hedonistic, a land of debonair men about town and sophisticated, liberated women – proved a remarkably enduring blueprint for international success.

Indeed, this was the image that Richard Curtis revived in *Four Weddings and a Funeral* (1994), which was then the most lucrative British film ever made. It was only a short step from 'Avengerland', which critics meant affectionately, to what they derisively called 'Curtisland'. After all, the vision of London in *Notting Hill* (1999) or *Love Actually* (2003) – sanitized, romanticized, poverty-free; a city where the pavements gleam in summer, the snow falls thickly in winter, most people went to Oxford and nobody does any work – is not really so different from the world of John Steed's mews house or Emma Peel's studio flat, except for the sex and the swearing. When the *Observer*'s Tim Adams wrote a profile of Curtis to mark the release of the disastrous Sixties comedy *The Boat That Rocked* (2009), his waspish take on the writer's formula – 'shiny, happy ... messianic about fun and celebrity ... obsessed with the educated middle class, perfectly relaxed about the filthy rich, much more in love with sentiment than ideas, and insatiable in its optimism' – read like something from a Sixties film journal. As Adams put it, Curtis had 'mastered the knack of making the parochial international' by telling 'audiences across the Atlantic almost exactly what they wanted to hear about the old country'. But this was hardly a new trick. J. Arthur Rank, John Steed and Herman's Hermits had been doing it for years.[40]

THE KING OF JAMAICA

*I led a double life – going to Harrow and having a social-class
life in the evening, while in the daytime I was living a life of driv-
ing around the ghetto areas of South London or North London,
where all the Jamaicans were, bringing records to their stores.*
Chris Blackwell, interviewed in *Billboard*, 29 September 2001

For all the virtues of *The Avengers*, the series would surely never have
cracked the American market if it had not been for the extraordinary suc-
cess of the James Bond films. By the mid-1960s the familiar formula was
already established, from the gun-barrel opening and the eroticized cred-
its to the gorgeous girls, the ludicrous gadgets and the excruciating
wisecracks. Perhaps even more than the music of the Beatles, the Bond
films benefited from the collapse of British colonial supremacy. Inter-
national audiences might have recoiled from the adventures of a British
imperial bruiser when the Empire was a going concern, but now that it
was largely defunct, Sean Connery's adventures could be marketed as
harmless escapism. But although the Bond films are often seen as the
ultimate British cultural export, there is an obvious difference from the
death-defying escapades of Emma Peel or the romantic misadventures of
Hugh Grant. Both Avengerland and Curtisland are firmly rooted in an
idealized, romanticized version of contemporary Britain. James Bond, on
the other hand, spends very little time in Britain, only popping in to toss
his hat into the corner, flirt with Miss Moneypenny and annoy his superi-
ors. In Ian Fleming's books, Britain largely features only as a place to
escape from: grey, rain-swept, depressing; a place where, as Major Dexter
Smythe reflects in the short story 'Octopussy' (1966), 'people munched
their spam, fiddled in the black market, cursed the government and suf-
fered the worst winter weather for thirty years'. Major Smythe himself
has left the damp and the drizzle far behind. Now he lives in Jamaica, a
place with 'wonderful servants, unlimited food and cheap drink, and all
in the wonderful setting of the tropics'. 'Yes,' he thinks, 'it was paradise all
right.'[41]

For Fleming, too, Jamaica was paradise. Having first set eyes on the
island during the Second World War, he had settled there in 1946, build-
ing a simple three-bedroomed house, Goldeneye, on the cliffs above the

In an oddly excruciating photo-call, the disc jockey Alan 'Fluff' Freeman welcomes Millie
Small back to the 'Swinging UK', 1964.

Caribbean. It was there that he wrote the Bond books. And as the historian Matthew Parker points out, not only does Jamaica feature in three of the novels, but the island's unique atmosphere – 'its exotic beauty, its unpredictable danger, its melancholy, its love of exaggeration and gothic melodrama' – seeps into all the stories. That probably helps to explain the novels' extraordinary success: to readers in Fifties Britain, desperate for glamour, escapism and sunlight, the imagined world of Fleming's Jamaica seemed like a promised land. It is tempting to wonder how many of them knew that, like Birmingham and Manchester, the Caribbean island had been one of the great engines of Britain's Industrial Revolution, which was largely funded by the profits from Jamaica's vast slave plantations. Few of them probably thought much about the island's appallingly bloody past under the Spanish and British empires, or about the hundreds of thousands of slaves, toiling in punishing heat in the sugar fields, or even about the thousands of Jamaicans who had made the long voyage east to Britain, and were now struggling to build new lives in London, Birmingham, Bristol and Liverpool. No doubt few were even aware of the island's contemporary ills: the political neglect and the economic stagnation, the racial inequality and the terrible squalor, the disease, the poverty and the casual violence. Instead, like Fleming, they preferred to think of Jamaica as a hedonistic playground, where, after you had finished sunbathing and snorkelling, a servant obligingly handed you a vodka martini, and then you dressed for dinner.[42]

The spring of 1956 found Fleming, as usual, at Goldeneye, where he was working on his fifth Bond book, *From Russia, with Love*. He had almost finished when, at a neighbour's dinner party, he met the greatest love of his life. In her mid-forties, Blanche Blackwell had an impeccable colonial pedigree. Her family, the Lindos, were originally Sephardic Jewish refugees from Spain, and had come to Jamaica in the eighteenth century. There they made a fortune in sugar and slaves before moving into bananas, coffee and rum. With their bustling warehouses and enormous plantations, the Lindos became one of Jamaica's elite families, so rich that part of Kingston was even nicknamed 'Lindo's Town'. Blanche had grown up as a typical plantation child, taught by tutors, sent off to finishing school, and utterly isolated from most black Jamaicans. She married an Irish Guards officer, Joseph Blackwell, descended from the chutney family, who owned the best racehorses on the island.

Eventually her marriage broke up, but she remained a fixture of Jamaican high society. For Fleming, unhappily married to the former Ann Rothermere, Blanche made the perfect partner: funny, relaxed and undemanding. He got on well with the rest of her family, too. He played golf with her ex-husband's cousin, John, who told him about a modernist architect called Ernő Goldfinger. And when, a few years later, Eon Productions were preparing to shoot the first Bond film, *Dr No*, in Jamaica, Fleming suggested that they use Blanche's son as a local fixer. None of them could have known then that the shaggy-haired young man would turn out to be one of the most successful cultural entrepreneurs of the second half of the century.[43]

Born in 1937, Chris Blackwell had an upbringing that most other British children would have glimpsed only in old-fashioned imperial stories for boys. In effect, his world was that of the colonial aristocracy, a world of sweltering heat and cooling drinks, racehorses and parties, deference and privilege, amid the crumbling ruins of the plantation economy. He had an English nanny, and an English tutor who was so useless that Blackwell was still struggling to read and write at the age of 7. A shy, asthmatic boy, he spent most of his time on his own, like Little Lord Fauntleroy, or with his mother's Jamaican servants, whom he used to line up for photographs. No doubt his happy memories of the groom, the gardener and the cook explain why, unlike so many of his contemporaries, he never showed the slightest hint of prejudice. 'I cared for them,' he said later, 'and I think they cared for me a bit, although there was still a huge natural divide.' The only other people he saw were the Blackwells' celebrity neighbours: people like Fleming, Noël Coward and Errol Flynn, for whom his parents would throw loud, boozy dinner parties. Decades later, Blackwell still kept a picture of Errol Flynn in his office, signed 'To my pal Chris'.[44]

By the time Blackwell was 8, his parents' marriage was heading for the rocks. With the war in Europe coming to an end, his mother moved back to England and joined the Berkshire hunting set. Meanwhile, little Chris was sent to a Catholic school and then to Harrow, which was something of an ordeal. A natural rebel – which was hardly surprising, given his solitary life in Jamaica – he was constantly in trouble. Later, he remembered being 'caned by everybody you could be caned by – the head of the school, the housemaster, everybody'. It was at Harrow, however, that he first showed signs of the business acumen that would make

him such a vital figure in the international music industry, buying ciga-rettes and spirits from shops in the town and selling them on at a profit. Disaster struck, however, when the masters found the stock hidden in his room. The headmaster promptly telephoned Blanche. 'He told her, to use his precise terms, that "he thought I might be happier elsewhere",' Blackwell recalled. So that was the end of that; back he went to Jamaica. There he drifted from job to job, trading, like so many rich boys before and since, on his looks, charm and family connections. He worked at his cousins' hotel in Montego Bay; he taught water-skiing; he rented scoot-ers; he sold air conditioners; he even worked briefly as an assistant to the British governor, Sir Hugh Foot, the older brother of the future Labour leader Michael. But it was at the Half Moon Hotel that Black-well met a blind jazz pianist from Bermuda called Lance Hayward, who was part of the resident band every winter. Entranced, Blackwell per-suaded him to come to Kingston, hired a studio and recorded an album, *Lance Hayward at the Half Moon*, which became the first release of his new company, Island Records. It was July 1959, and Blackwell was 21 years old.[45]

On the surface, the story of Island's birth sounds like a wonderful blend of youthful enthusiasm and sheer serendipity. But of course there was more to it than that. The vast majority of young men in 1959 would never have been able to hire a recording studio, still less set up their own company, because they did not have the money. Later, Blackwell explained that his mother gave him an allowance of £2,000 a year, which was enough to 'get by'. But this was an understatement of heroic proportions. In terms of economic status and buying power, his mother's allowance was the equivalent of more than £100,000 a year in today's money. Indeed, by Jamaican standards it was simply enormous. In 1960 income per head on the island was just £117 a year. In other words, Blackwell's allowance was *seventeen times* bigger than most people's annual earnings. On top of that, his mother had also given him £18,000 when he turned 18. Even in today's Britain that would have been the equivalent of £1 million. In poor, violent, run-down colonial Jamaica, it must have seemed a fortune beyond imagination. And all this reinforces the point that Blackwell was not just *anybody*. He was the scion of one of the island's richest and most powerful families and the heir to centuries of colonial moneymaking. Decades later, interview-ers were often struck by the apparent incongruity of a Harrow-educated

Englishman in shorts and flip-flops immersed in the semi-criminal sub-culture of the Jamaican record business. One American journalist even wrote that Blackwell 'should be narrating a book on tape by P. G. Wode-house. He is the Dude by way of *Downton Abbey*, Sir Laurence Olivier wasting away in Margaritaville.' But this was to miss the point: in the context of colonial Jamaica, there was nothing incongruous about him at all.[46]

In the next couple of years, Blackwell built up a flourishing import business, flying to New York to buy rhythm and blues records, and then selling them at a profit to Jamaican disc jockeys and jukebox owners. At the time, the island's music scene was dominated by 'sound systems' – open-air dance parties sponsored by the beer and spirits companies, with gigantic speakers blasting out American music to crowds of revel-lers. Every firm demanded exclusives, and since they were often linked to organized crime, Blackwell had to be very careful. 'I'd buy them for 43 cents each in New York, cross off the labels so they didn't know what they were and sell it for 200 pounds to the sound system guys,' he recalled. 'But I just sold one – if I'd sold two I wouldn't be alive today.' Meanwhile, he was releasing his own records on the Island label, includ-ing chart-topping hits by local artists such as Laurel Aitken, Jackie Edwards and Owen Gray. The problem, however, was that the market was dominated by the sound systems' own labels, which were now pio-neering a Caribbean–American hybrid, ska. So in the early summer of 1962, only weeks before Jamaica became an independent country, Blackwell decided on a bold new venture. Instead of selling Jamaican records in Jamaica, he would sell them in Britain.[47]

Blackwell's timing was perfect. Even fifteen years earlier the market for Jamaican music would have been virtually non-existent. But with the arrival of the SS *Empire Windrush* in 1948, mass immigration had come to Britain. In 1953, when Blackwell was still at Harrow, some 3,000 people arrived from the West Indies. In 1956 the annual figure was 30,000; by 1961 it was 66,000. By the end of the 1960s there were more than a quarter of a million Caribbean immigrants in Britain. Across the capital they formed little networks of West Indian civiliza-tion: Jamaicans in Clapham and Brixton, Trinidadians in Notting Hill, Dominicans and St Lucians near Paddington, and so on. At first their cultural impact was relatively marginal: there were virtually no black faces in, say, *Coronation Street* or *Doctor Who* for years. But they were

there. As early as 1955 the sociologist Sheila Patterson recorded the 'strangeness, even shock' at seeing so many black faces in Brixton. 'There were coloured men and women wherever I looked,' she wrote: 'shopping, strolling, or gossiping on the sunny street-corners with an animation that most Londoners lost long ago.' Some Londoners simply ignored them; others saw them as a threat. To Blackwell, though, they were a market, waiting to be tapped. By the summer of 1962 he was driving around the dilapidated streets of areas like Notting Hill and North Kensington, records packed into the boot of his Mini Cooper. At first he thought only of selling them to Jamaicans. But then he played them to some white friends, and was struck by their enthusiasm. 'Wow,' he thought. 'We can really spread this.'[48]

To break into the British market, Blackwell unveiled his secret weapon, a pretty Jamaican teenager called Millie Small, who had already had a number one hit in her native land. Precisely how old she was is still unclear; the daughter of an overseer on a sugar plantation, she was probably about 15 or 16 when Blackwell wrote to her parents, asking if he could bring her to London. They agreed, with Blackwell becoming her legal guardian as well as her manager. Instead of giving her a Jamaican ska song, however, he chose to start with an adapted version of an old rhythm and blues song, 'My Boy Lollipop'. Not only did it show off her strikingly high voice, but there was an obvious irony in combining such suggestive lyrics with her childlike appearance. And since she was so young, Blackwell got to make the record exactly as he wanted. 'I had in my head the type of sound, rhythm and feel that I wanted to get,' he said later. 'It worked well for radio, it was a minute and 51 seconds. Also, Millie's voice was irresistible. I knew it was a hit.' Cannily, he licensed it to a bigger player – Fontana, a subsidiary of Philips – instead of releasing it on the Island label. Watching the American market, he had noticed that smaller, independent companies 'couldn't collect the money from the stores fast enough to pay the pressing plant to make more records in order to meet the demand'. So Fontana got the song. And Blackwell had his hit.[49]

Given that 'My Boy Lollipop' went on sale in the spring of 1964, at the height of Beatlemania, it might have been expected to sink without trace. But as Blackwell had predicted, Millie Small's sheer exoticism meant that she stood out from the identikit beat bands with smart grey suits, nasal accents and pudding-bowl hairstyles. After three weeks her

single had reached number two in both the British and the American charts, a stunning achievement for an unknown teenager from Jamaica. At home she was a national hero: as the *Jamaica Gleaner* later remarked, 'any Jamaican old enough to remember anything about 1964 will remember the sheer energy of Millie's voice, the frenetically pulsating ska beat and the instant party-pandemonium that would seize the crowd the moment a DJ dropped needle to vinyl on a crazily spinning turntable'. For Blackwell, meanwhile, a first British hit only fuelled his appetite for success. Over the next few years he built up a little rock empire, often signing artists he had heard while touring with Millie Small. After accompanying his teenage star to Birmingham, for example, he discovered the Spencer Davis Group, for whom he produced the chart-topping singles 'Keep on Running' and 'Somebody Help Me'. The rock bands Traffic and Free became Island staples; so were the folk group Fairport Convention, the singers Cat Stevens and Nick Drake, and the prog rockers Jethro Tull, King Crimson and Emerson, Lake and Palmer. But although Blackwell had very rapidly diversified from Jamaican music, he was still choosy, rejecting Elton John because he feared Pinner's finest was too shy for stardom. He always thought of Island Records, he said, as a 'very classy delicatessen', not a supermarket.[50]

By the early 1970s Blackwell was firmly established as one of the most imaginative producers in the business. What he had singularly failed to do, however, was to convert British audiences to Jamaican music. For a long time he had hoped that the reggae star Jimmy Cliff might do the trick, but after the lukewarm reception of his reggae film *The Harder They Come* (1972), Cliff left for a rival label. A week later, a group of young Jamaicans walked into Blackwell's office in Notting Hill. The Wailers had been trying to break into the British market since the late 1960s, but had enjoyed conspicuously little success. Indeed, they were so short of money that, after a miserable Scandinavian tour organized by CBS, they had effectively been dumped in London, unable to scrape together the cash to get home. Blackwell was immediately smitten. Although the Wailers had a reputation for being 'impossible to deal with', he thought they 'carried themselves like superstars', especially their founder and lead singer, Bob Marley. 'I felt so much power and charisma when Bob came in my office,' Blackwell said later. He asked what it would take for them to sign with Island. Marley replied that they wanted £4,000 – the equivalent of somebody asking for about

£100,000 today. Blackwell reached into his desk drawer and wrote out a cheque. 'Everybody said I was mad and I'd never see the money again,' he recalled. 'But it was the best £4,000 he ever spent.[51]

Even today, long after Bob Marley's untimely death from cancer in 1981, some of his more impassioned fans cannot forgive Blackwell for making him a household name. For what Blackwell realized was that there was a good reason why the Wailers had failed to crack the British market. To put it bluntly, their music was too different, too unsettling, too Jamaican. Just as he had packaged Millie Small for a white teenage audience, so Blackwell now wanted to package the Wailers for older, more affluent (but no less white) listeners, who might otherwise be buying Genesis or Led Zeppelin records. Reggae, as he well knew, was regarded as 'novelty music', but he wanted to reach a mass audience. 'I never viewed Bob as a reggae artist,' he said later. 'From the moment I met him, I felt he could be a new Jimi Hendrix.' And so when Marley flew back from Kingston with the material for the Wailers' new album, *Catch a Fire*, Blackwell persuaded him that they should tone down the 'rough and raw' sound for something smoother and more palatable. 'I moved things around, I added rock guitar, synthesisers, and expanded into solos,' Blackwell explained. 'I needed to polish it to bring in the rock audience and to get them accepted as a black rock group.' Some artists might have bridled, insisting on the integrity of their original style. But Marley was tired of toiling in ill-paid obscurity: as Blackwell put it, 'he was as keen as I was'.[52]

Contrary to popular belief, *Catch a Fire* was far from being an overnight success: indeed, on its release in April 1973 it sold only 14,000 copies, well below the threshold for a serious chart contender. Even so, reggae was seeping into the British musical mainstream. To adventurous, open-minded or slightly bohemian listeners, it felt satisfyingly rebellious, while its Caribbean and Rastafarian connections gave it a pleasingly dangerous atmosphere. Indeed, Marley's success in Britain by the late 1970s reflected not just the record-buying power of the country's Caribbean immigrant community, but an appetite for the exotic that went back at least to the Victorian era. As the *Guardian* pointed out at the time, the audiences that were now dancing to reggae would, only six or seven years earlier, have been swooning before Ravi Shankar, another brilliantly talented musician who had grown up under the British Empire. Like the nineteenth-century Orientalists who had

immersed themselves in the Kama Sutra or the sacred books of the East, many reggae listeners were clearly attracted by its heady associations with freedom, authenticity and sensuality as much as its aesthetic qualities. And when, in December 1976, Marley narrowly survived an assassination attempt in his native Jamaica, it only added to his reputation as the 'wild man of reggae music', as the *Daily Express* called him. By now he had become a poster star for disaffected youngsters from Derby to Detroit. When Island released *Exodus* six months later, the album stayed in the British charts for fifty-six weeks, peaking at number eight. But by now cracks were emerging. The other Wailers resented Marley's star billing, while some black Britons saw Blackwell as a latter-day imperialist. In a blistering essay published in 1975, the young dub reggae poet Linton Kwesi Johnson, who had been born in Jamaica and moved to Brixton when he was 10, deplored the 'eroticism and romanticism' of Marley's new image. The man responsible, he wrote savagely, was 'Chris Blackwell, descendant of slave masters and owner of Island Records, continuing the tradition of his white ancestors'.[53]

It is to Blackwell's credit that, far from harbouring a grudge, he later signed Johnson to Island Records. (He would not have been human, though, if he had not enjoyed Johnson's recantation, which praised him for 'making Jamaica a brand name'.) But although Blackwell insisted that he paid Jamaican artists just as much as British ones, the criticism never entirely went away. Indeed, some Jamaicans thought he was exploiting their natural resources for his own benefit, just like the plantation owners of the past. In an interview with the *NME* in 1984, the legendary Jamaican producer Lee 'Scratch' Perry lamented that Blackwell 'came like a big hawk and grab Bob Marley up'. Blackwell, he said, was a 'thief', a 'parasite', even a 'vampire'. A year later, Perry recorded the song 'Judgement in a Babylon', which opens with the memorably shocking image of Blackwell drinking a chicken's blood at his new studio in the Bahamas.* Again and again the lyrics repeat the phrase 'Chris Blackwell is a vampire'. As the song continues, it claims not only that Blackwell wants to 'control Jamaican music' but that he killed Bob

* Blackwell never denied that he had done it. It was a Jamaican custom, he told *Billboard* on 29 September 2001, to drink rum and chicken's blood, and then to spit the mixture in all four corners of a new building, for luck.

Marley in order to steal his royalties. Not surprisingly, Blackwell was furious. Again, though, it was to his credit that he refused to sue.[54]

Given Jamaica's unhappy history, it is perfectly understandable why Blackwell bridled at descriptions of himself as an empire-builder, ruthlessly packaging the music of the newly independent Caribbean for a largely white, affluent, British and American market. But he *was* an empire-builder. By the mid-1980s he had expanded well beyond his original Jamaican base, producing records by artists as diverse as U2, Grace Jones and the B-52s.* Like all great businessmen – and like the genuine empire-builders of centuries past – Blackwell seemed driven, unsatisfied, never ready to settle down and enjoy his money. As he once told *Rolling Stone* magazine, he just liked 'building things, making things, causing things to happen and chasing ideas I'm excited about'. That might sound touchingly idealistic, but as the American journalist Mark Binelli pointed out, there was always a hard business edge. Blackwell's friend Ahmet Ertegün, founder of Atlantic Records, called him a 'baby-faced killer', while another friend, Bono, described him as 'the right tough guy to have in your corner, and ... the wrong one to have against you'. Blackwell was 'a classic empire-builder', wrote an interviewer in the *Telegraph*: 'charming, restless, flighty, certainly capricious and clever'. Not for nothing was his industry nickname 'the Croc'.[55]

In 1989 Blackwell sold Island Records to the American giant Polygram for a reported $300 million. Far from retiring, however, he ploughed the money into a string of new ventures, including a series of high-class resort hotels on the Jamaican coast. He had long since bought Ian Fleming's old house, Goldeneye, turning that into a hotel, too, with its own dedicated butler, housekeeper and cook. (Before Bond fans get too excited, they should note that even in the off-peak summer season the rate for one room starts at $2,500 a night.) But, as Mark Binelli remarked, the 'dynamics of class and race' were simply impossible to ignore when visiting Blackwell's Jamaica. The guests at his luxury hotels were almost all rich white Americans and Europeans, while the staff were poor black Jamaicans. Visiting the hotels with their owner, Binelli noticed that the 'employees, who seem to appear out of nowhere

* Blackwell has a good claim to have 'discovered' U2. Although they had released two songs in their native Ireland, they had no British or American presence at all until Island signed them in 1980.

bearing what food or drink he desires, no matter where on the property he ends up, feel like his personal servants'. He was struck, too, by the waiters' evident nervousness as their Old Harrovian boss lectured them about the right way to grind pepper or mix cocktails. And even the *Daily Telegraph*, hardly the voice of bleeding-hearted anti-colonialism, described Blackwell as an updated equivalent of the plantation aristocrats and colonial bigwigs of the past. 'To join Blackwell in Jamaica', wrote the *Telegraph*'s interviewer, Edward Helmore, 'is to enter an informal cult of personality. He surrounds himself with managers and publicists, drivers and accountants, who keep each other informed of the king's whereabouts by mobile phone. The king is in his chamber. The king is 10 minutes away. The king will be here on Wednesday. He never stops moving.'[56]

None of this is meant to undermine Blackwell's enormous impact on the international music industry. Celebrating its fiftieth anniversary in 2009, the trade journal *Music Week* named Blackwell as the most influential figure in British music in the previous half-century. There are other contenders, of course; even so, a music scene without ska and reggae would have sounded incalculably different. Yet there could hardly be a better illustration of the lasting economic and cultural legacy of the British Empire. It is not just that Blackwell himself was effectively a colonial aristocrat; it is that his entire enterprise was built on imperial foundations. Not only did his initial capital come from the profits of Jamaica's plantations, but his first customers in London's burgeoning West Indian community would never have been there had it not been for the Empire. Indeed, despite the T-shirts and flip-flops, it makes sense to think of him as a modernized version of the old colonial exporters, capitalizing on the long-established trading relationship between London, the imperial metropolis, and Kingston, the colonial port, only with ska and reggae replacing sugar and rum. No American producer could have pulled it off; perhaps only an Anglo-Jamaican would have had the necessary contacts. To compare him to the great sugar barons of old, the Draxes, the Beckfords and the Codringtons, whose vast fortunes were built on the blood and sweat of thousands of slaves, would be grossly unfair. He was, after all, only making music. But given his family's role in Jamaica's history, you can understand why some people can never quite forget it, no matter how much they like Bob Marley.[57]

Previous pages: The apotheosis of Cool Britannia: Tony Blair and Noel Gallagher shake hands at a Downing Street party, 1997.

3

Sensation

THE ADMAN COMETH

Never forget: a brand is an agglomeration of stories linked together by a vision.

John Hegarty, *Hegarty on Advertising* (2011)

One day in 1968 a delegation from Island Records arrived at an office in central London, on the corner of Goodge Street and Tottenham Court Road. By now Blackwell's label had far outgrown its origins in the back of his Mini, and the men from Island had decided that it was time to advertise. But since they thought of themselves as outsiders, cocking a snook at the mainstream music business, they were reluctant to approach one of London's traditional advertising agencies. Instead, they had arranged a meeting with a small consultancy, set up just a year earlier on the third floor of a converted department store. At first, however, the meeting did not go well. The men from Island seemed uncomfortable, and kept coming back to the same point. 'They didn't believe in hype,' one of the advertising men recalled. 'Hype was against everything they practised.' The admen looked at each other. 'We certainly don't believe in hype at Cramer Saatchi,' one of them said. 'Absolutely not,' said a second. 'Hype, no way, not here,' said a third. That seemed to reassure the team from Island Records: the ice was broken and the deal was done. As soon as the door closed behind them, the advertising men burst out laughing. 'What do they mean, they don't believe in hype?' said Charles Saatchi.[1]

It was no accident that Island Records, which prided itself on its insurgent, iconoclastic image, hesitated to enter the world of advertising. To

From advertising to Hollywood: Alan Parker on the set of *Fame* (1980).

many people, advertising was the work of the Devil. Fifteen years earlier, having been invited to address the annual conference of Britain's Advertising Association, the Labour politician Aneurin Bevan had told them that advertising was 'one of the most evil consequences of a society which is itself evil'. They were, he said to a stunned silence, 'harnessed to an evil machine which is doing great harm to society', leaving the consumer 'passive, besieged, assaulted, battered and robbed'. This was fairly run-of-the-mill stuff, although it took considerable nerve for Bevan to say it to the admen's faces. Almost across the board, cultural critics recoiled from advertising as the sign of a society enslaved by American-style consumerism. This, wrote J. B. Priestley, was the age of 'admass', an era defined by 'high-pressure advertising and salesmanship', which inevitably created 'the mass mind, the mass man'. Meanwhile, the Marxist critic Raymond Williams even claimed that, whenever he visited London, its 'smart, busy commercial culture', typified by the advertisements on the Tube, gave him a headache.[2]

The importance of advertising, not just in selling British culture abroad but in transforming the image of Britain itself, can hardly be exaggerated. And yet, in the 1950s and 1960s, it often seemed that among British intellectuals an ostentatious loathing of advertising, especially on television, came as standard. The arrival of ITV in 1955 had provoked a storm of protest from clergymen, university vice-chancellors and other self-appointed guardians of public morality; and when the new channel proved a huge popular hit, the critics were furious. The 'commercialized media', wrote the Labour MP Richard Crossman, had been 'systematically used to dope the critical faculties', while his fellow MP Tom Driberg claimed that ITV viewers were 'completely passive', wandering around vacantly and mumbling 'infantile ditties in honour of *cornflakes in the morning* or *brightness women want*'. Time did not mellow attitudes: when the trade journal *Campaign* asked twenty-one public figures for their thoughts on advertising in 1970, only one – the right-wing iconoclast Peregrine Worsthorne – was at all keen, while most dismissed it as a materialistic swindle. Part of the problem, needless to say, was that advertising was seen as American. In 1968, the same year that Island Records got into bed with Cramer Saatchi, two *Daily Express* journalists published a book entitled *The American Take-Over of Britain*, in which they claimed that packaged meat, cake mixes and even new kinds of bras had appeared in British shops only as a result of

American marketing. American advertising agencies, they warned, had long employed 'practitioners in the esoteric realms of motivational research and deep analysis. They are now at work in the UK. In advertising, more than any other business, it is true to say "What America does today, England will do tomorrow".'[3]

But the intellectuals' horror at the culture of advertising was not merely a reflection of their anti-American insecurity. It is also an excellent illustration of the historian Martin Wiener's controversial argument that in the twentieth century the British elite turned their backs on – or more accurately, turned their noses up at – the commercial, entrepreneurial values that had served them so well during the Victorian period. In fact, it is bizarre that in the decades after the Second World War so many intelligent people thought that advertising was inherently American. After all, the Victorians had been besotted by advertising; indeed, they invented many of the techniques that their successors later blamed on sharp-suited Don Draper figures from Madison Avenue. As Matthew Sweet points out in his jolly book *Inventing the Victorians*, nineteenth-century advertisers hung gigantic transparencies on the Strand, sent out millions of handbills, stickers and postcards, and even pioneered celebrity endorsements, with Rudyard Kipling and Robert Baden-Powell lending their names to Bovril and Oscar Wilde promoting Madame Fontaine's Bosom Beautifier. By the 1890s Cadbury's, Fry's, Rowntree's and Colman's all regularly used advertising agencies. Beecham's advertising budget alone was £120,000 a year, the equivalent of perhaps £130 million today. Pears, meanwhile, spent £30,000 on their 'Bubbles' soap campaign, having bought the rights to use Millais's sentimental painting of his grandson Willie. During the Boer War, Bovril not only took out full-page adverts in the *Daily Mail*, boasting that it had shipped 85,000 pounds of beef extract to the army in South Africa, it even sponsored a special news service, with regular customers receiving telegram updates from the battlefield. Indeed, given the ubiquity of posters, handbills and sandwich boards, it is just as well Raymond Williams was not born until 1921. If twentieth-century London gave him a headache, it is terrifying to think how he would have got on a few decades earlier.[4]

Advertising naturally played a central part in the explosion of consumerism, borrowing and material ambition that transformed the everyday lives and cultural horizons of so many British families in the

decades after the Second World War. The interesting thing, however, is how Britain went from being pretty bad at television advertising to being exceptionally – perhaps even uniquely – good at it.* When ITV was launched in 1955, it seemed a gift to advertisers. Yet most early adverts were badly acted, badly lit and thuddingly literal-minded, with relentless jingles ('Murray mints, Murray mints, the too-good-to-hurry mints') that drove viewers to distraction. At the Cannes advertising awards in 1957, British advertisers were responsible for 142 out of 655 cinema and television entries – and did not win a single prize. Most agencies were introverted, conservative, stuffy places, dominated by the old officer class. Bright, ambitious recruits, such as the future Provence resident Peter Mayle, tended to go to New York; there seemed little for them in London. When a young man called John Hegarty joined Benton & Bowles in June 1965, he found it intolerably old-fashioned. Apart from a few Americans, Hegarty wrote, 'the staff consisted of public-school-educated account men who were trained only to say "yes", whatever the question'. All they were good for, he thought, was knowing 'how to pour the perfect gin and tonic' and deciding 'which piece of cutlery should be used for which course at dinner'.[5]

Within two decades, though, the picture had changed completely. The reason that so many older people fondly recall the Hovis boy pushing his bike, the Smash Martian robots, the Cockburn's-drinking shipwreck survivors or the Sugar Puffs Honey Monster is not merely down to nostalgia. As the former chairman of the Advertising Association, Winston Fletcher, writes in his history of the industry, these were the 'campaigns that built the creative supremacy of British advertising throughout the world'. Many adverts connected with audiences more deeply than the programmes they were funding: probably nobody who grew up in the 1970s and 1980s can hear Bach's 'Air on a G String' without thinking of Hamlet, the mild cigar, while it is almost impossible to walk up Shaftesbury's Gold Hill without hearing a few ghostly bars of Dvořák's Ninth Symphony. As Fletcher points out, they appeared to have little in common: on the surface there seems little to connect the

* A sceptic might well ask how one country could possibly be better at advertising than another. How can you measure it? But given Britain's record at, say, the Cannes Golden Lions awards, as well as the enormous success of British advertising agencies at breaking into foreign markets, and their influence on international film and design more generally, the evidence is, I think, pretty overwhelming.

puckish humour of Smash's Martians to the surreal spectacle of Hugh Hudson's 'Swimming Pool' commercial for Benson & Hedges, which is often considered the best of the lot. What they shared, though, was a subtlety, a deftness of touch, a craftsmanship and an intelligence that seemed worlds away from the clunking, lecturing adverts of ITV's early years. And the world was watching. For five straight years, from 1974 to 1978, the British industry dominated the Cannes advertising awards, often winning almost half the Gold Lions, as well as the top Palme d'Or and Grand Prix awards. Of course the vast majority of British viewers neither knew nor cared who had picked up gold at Cannes. But by now the superior quality of British advertising had become a national cliché. As the joke had it, people only watched ITV for the adverts.[6]

How did Britain do it? One crucial element was the influx of a new generation, born in the last years of the Second World War and educated at grammar schools and art colleges. As outsiders they were naturally hungry for fame and fortune, but their ambitions were artistic as well as financial. John Hegarty was an obvious example: the son of an Irish labourer, he went to Hornsey College of Art and the London College of Printing, dreamed of becoming a painter, but fell into advertising. In the 1980s Hegarty got Nick Kamen to strip down to his boxer shorts and introduced the phrase 'Vorsprung durch Technik' to the British public, and eventually he was rewarded with a knighthood. But he was far from unusual. When he joined Cramer Saatchi in 1967, he found himself working two floors up from another brilliant young outsider, David Puttnam, a former Southgate grammar-school boy who had been an account man at Collett Dickenson Pearce (CDP) before setting up as a photographer's agent. Also at CDP was Alan Parker, a house-painter's son from Islington, who worked his way up from copywriting to directing. And then there was Charles Saatchi: the son of an Iraqi Jewish immigrant, mercurial, obsessive, burning with ambition. All were typical products of the grammar schools and art colleges of the 1950s, clever and aspirational, but also self-consciously egalitarian.* Hegarty wrote that he chose advertising over painting because it 'gave me a platform to talk to the masses'. Puttnam said that they dreamed of tearing down 'the world of privilege and position and place and

* Puttnam was the oldest, having been born in 1941. Saatchi was born in 1943, and Hegarty and Parker in 1944.

deference'. Parker recalled being asked what his father did for a living. 'He's a painter,' he said, to great enthusiasm from his listeners. 'No,' Parker said drily, 'he paints railings for the electricity board.'[7]

What copywriters like Parker brought to advertising was an entirely new approach, at once more subtle and more informal. At CDP, Parker became the protégé of Colin Millward, the firm's irascible creative director. Millward had been born in 1924, but as an old boy of Hull Grammar School and Leeds College of Art (and a fine amateur painter), he too was an outsider. A fearsome taskmaster with a nice line in dry put-downs, he pushed his recruits to adopt a wittier, snappier, more colloquial style, the kind of writing people might find in articles in the *Sunday Times*'s new *Colour Section*, which CDP saw as their 'shop window'. The trick, Millward thought, was to use the kind of humour that viewers already knew and loved, often poking fun at the class conventions that Americans simply could not understand. And when Alan Parker moved from writing to directing, he honed the style to perfection. His advert for Cockburn's port (1973) shows a group of cruise passengers adrift in a lifeboat, dressed for a Jazz Age cocktail party and sharing their last bottle of port. The humour depends on viewers appreciating the social chasm between the patrician crew, resplendent in their white uniforms, and the salt-of-the-earth passengers, one of whom gets the name wrong ('*Cock*burn's, is it?' '*Cock*burn's? Oh, you mean Co'burn's!'). In other hands the ad might have seemed patronizing; but since the joke is really on the ship's crew, with their preposterously strangled upper-class accents, it feels gently satirical. It was the kind of advert that perhaps only a house-painter's son could have made.[8]

But there was another reason why London's agencies overtook their American rivals. While the American networks, desperate to maximize their revenue, had as many ad breaks as possible, ITV were restricted to just six minutes per hour. By the late 1960s, therefore, British adverts were literally half the length of their American counterparts, coming in at just thirty seconds each. What was more, British agencies had to fight much harder to keep the audience's attention, because if viewers felt they were being lectured they would simply switch over to the BBC, which had no ads at all. As a result, directors had to make their films as tight and snappy as possible, filling every last frame with incident and imagination. Every word, every shot mattered. With so many products competing for viewers' attention, it was imperative to establish a strong

brand identity: hence the Hofmeister bear, the PG Tips chimpanzees, the Milk Tray Man, and so on. And because there was so little time, British adverts relied unusually heavily on their visuals – not least Hugh Hudson's famous Benson & Hedges advert, which had no words at all, not even the name of the product. Indeed, instead of starting with the words, copywriters often started with the pictures, especially after colour television arrived in 1967. By contrast, even twenty years later, Americans started with the words – perhaps reflecting their longer history of radio advertising – which explains why their ads were so terrifyingly boring. What Britain's advertising men had grasped, therefore, was that television was both a challenge and an opportunity, requiring an entirely different approach from the staid techniques of the past. It was no accident that, as Charles Saatchi's biographer noted, he was a 'compulsive TV watcher', fascinated by soaps and serials, forever poring over the listings in search of something to watch that night. For, to make adverts, the one thing you really needed to understand was television.[9]

Some readers may still be wondering what advertising is doing in a book about popular culture. But many adverts, especially those from the days before video recorders and digital television made it possible to avoid them, have lodged much more deeply in our collective imagination than all the Booker Prize winners put together. Even the catchphrases – 'I bet he drinks Carling Black Label', 'Monsieur, with these Rochers you are really spoiling us!', 'Papa?' 'Nicole!' – have entered the national idiom.* More importantly, the renaissance of British advertising had a profound influence on our broader popular culture. The adventure series of the 1960s, for example, were positively drenched in consumerism. In 1969 the *Sunday Telegraph* complained that *The Saint* was 'glossy British rubbish with Roger Moore, who looks like an ad for after-shave', while just five weeks later the *Daily Mail* remarked that the heroes in *The Champions* had 'the look of brimming health and lightness of step of the characters in the commercials when they've got hold of the right laxative or hair shampoo'. As for *The Avengers*, its publicity boasted that Diana Rigg's clothes, which had been designed by

* 'Researching' this section – i.e. watching old clips on YouTube – I was shocked to discover that the line is *not*, in fact, 'Ambassador, you are really spoiling us', although the occasion is, of course, the ambassador's reception. I was also struck by the relative youth of the ambassador, and disturbed to see that among his guests is the Nazi commander from *Raiders of the Lost Ark*, who appears to be passing himself off as an Italian.

the ultra-fashionable John Bates, were 'available in stores throughout Britain and overseas', as well as her fur coats (made by Selincourt), her berets (Kangol), her handbags (Freedex), her stockings (Echo) and even her lingerie (Charnos). Indeed, six years after the series had finished, Patrick Macnee and Linda Thorson were still advertising Laurent-Perrier champagne, in character, on French television.[10]

It was on the British film industry, however, that advertising made the most striking impact. Influence flowed both ways, and Alan Parker readily acknowledged that his funny, often touching little vignettes of everyday working-class life were inspired by 'people like Ken Loach'. (Loach himself, incidentally, was not above working in advertising. When his film work dried up, he directed adverts for the *Guardian*, Tetley's bitter and – almost incredibly – McDonald's. 'I should never have done that one, really,' he admitted, 'because McDonald's represents everything I've been campaigning against.' Still, no doubt the money was good.) But as making adverts became a rite of passage for young directors, so the techniques of advertising – the pace, the flair, the rapid cutting – seeped into mainstream cinema. Thus the two Beatles films, with their restless, hand-held, slapstick style, were undoubtedly influenced by the fact that their director, Richard Lester, had cut his teeth in advertising. *A Hard Day's Night* (1964), wrote the critic Alexander Walker, was 'firmly anchored in the world of the television commercial'. And as early as 1966, the drama critic of the *Observer*, Ronald Bryden, suggested that advertising might represent the future of cinema:

> The majority of young British and American directors nowadays cut their teeth on advertising films for cinemas and television. What advertisers want is the shortest possible transition from the image of need to the image of their product, the image of satisfaction to that of their brand name. The technique of the commercial, you might say, is the jump-cut from wish to fulfilment. It has become the technique of the new international pop cinema.

Bryden would not have made a very good advertising man, since strikingly few of the next decade's great adverts made the 'shortest possible transition' to the brand name. But in his vision of a 'pop cinema' colonized by commercial techniques, he was spot on.[11]

The most celebrated example of a director who crossed from advertising into the cinema is, of course, Ridley Scott. Born into an army

family in South Shields in 1937, Scott was himself a walking advertisement for the post-war state education system. After leaving his Stockton-on-Tees grammar school, he studied at West Hartlepool College of Art and the Royal College of Art, where he helped to set up a new film department. By the early 1960s he had become a set designer at the BBC; the story goes that he was originally assigned to design the Daleks, before a scheduling clash meant that he was replaced by Raymond Cusick, the man who dreamed up their pepper-pot appearance. Soon Scott moved into directing, working on shows such as *Z Cars* and *Adam Adamant Lives!* Even at this early stage, though, he realized that advertising would give him more money and more freedom. In the evenings he would drive to Chelsea, where he designed the sets for the Benson & Hedges and Fairy Liquid adverts. Soon he was directing his own adverts – and making four times more money than he did at the BBC. As he later recalled, he 'could see that the way society was going, with consumerism and so on, advertising was going to become a driving force'. Not only was he a ferocious worker, he was a brilliantly gifted magpie, whether borrowing *Citizen Kane*'s lighting techniques to shoot an advert for Radion washing powder or modelling a toothpaste ad on *Doctor Zhivago*. By the late 1970s he had graduated to the big screen, first with *The Duellists* (1977), which was produced by David Puttnam, and then with *Alien* (1979) and *Blade Runner* (1982). But he still used the same methods that had served him so well in, for example, the Hovis adverts: a painterly visual style; moody, atmospheric lighting; lots of smoke and steam; and sudden changes of pace to keep the audience interested. 'My training in commercials', he said, 'was really my film school.'[12]

Where Scott led, younger directors naturally followed. When the American music channel MTV was launched in 1981, it seemed only natural that bands would turn to British advertising directors to make their first videos. As Wham!'s manager, Simon Napier-Bell, explained four years later, Britain had 'a large number of brilliant film directors who specialized in making 30-second TV commercials', whereas American directors were simply not capable of hammering the message home with comparable speed and flair:

> The British directors had an exceptional understanding of how to sell
> something in the briefest space of time. And when these advertising

directors got together with Britain's highly image-conscious pop stars, the results were dramatic. For the first two years MTV was totally dominated by the imagery of British groups and directors. For young Americans the videos were positively exotic. They were glossy brochures for fantasy lifestyles and, for the price of a record, American kids could feel part of it. Outrageous and trendy.

For Napier-Bell, it was this emphasis on image-making that explained the so-called Second British Invasion, typified by the success of groups such as the Police, Duran Duran, Culture Club and his own group, Wham! The most successful British bands, agreed the disc jockey Paul Gambaccini, 'had the images with the most impact', which allowed them to win 'the hearts, minds and wallets of American youth'. And Hollywood was not slow to take note. In 1983 the producers Don Simpson and Jerry Bruckheimer, masters of the expensive 'high concept' blockbuster, hired the young British advertising director Adrian Lyne to direct *Flashdance*. Three years later, they repeated the trick with even greater success, employing Ridley Scott's brother Tony, another advertising prodigy, to make *Top Gun*. At the time, American audiences welcomed its glossy, ultra-stylized look as a breath of fresh air. But as Scott pointed out, he had effectively been making *Top Gun* for years, only in thirty-second instalments.[13]

The film that really marked the triumph of the adman's aesthetic, though, felt very different from Tony Scott's paean to aviator sunglasses. In 1977 David Puttnam had moved to Hollywood, renting a house in Malibu in a bid to succeed where J. Arthur Rank had failed. One day, suffering with flu, he pulled a book off the shelves. It was a history of the Olympic Games, and when he reached the 1924 Games in Paris, Puttnam knew he had found the subject of his next film. At first he planned to tell the stories of four British athletes, but this was soon narrowed down to two: the Scottish runner Eric Liddell, who was an evangelical Christian, and the Cambridge-educated Harold Abrahams, who was Jewish. To write the script, Puttnam turned to the TV dramatist Colin Welland. Getting the finance, however, was tricky. By now the British film industry was practically non-existent, except as a province of Hollywood, and some American executives rejected the story as 'too English'. On the other hand, as Korda and Rank had proved, 'English' films could do well at the American box office if they had the right

blend of prestige, drama and moral uplift – and, of course, if they were set in the past. In the end, most of the £4 million budget came from Twentieth Century Fox and, bizarrely, Dodi Fayed, later one of the world's most famous car passengers, who fancied himself as a film producer. As it happens, Fayed had to be banned from the set after Puttnam accused him of offering cocaine to the actors. He was, Puttnam said, 'one of the laziest human beings I've ever come across'.[14]

Puttnam's great coup, though, was to choose Hugh Hudson, another advertising specialist, as his director. Hudson was then in his early forties, and having watched the meteoric ascent of his friends Ridley Scott and Alan Parker, he thought he had missed the boat. Unlike his colleagues, he was very much *not* an outsider, having been educated at Eton. But, like his contemporaries, he treated adverts as though they were high art. Directing a Courage bitter ad set in a 1920s pub, for example, he decided to shoot it in black and white and persuaded Carol Reed's cameraman, who had worked on *The Third Man*, to come out of retirement. Advertising, he said, 'gave me discipline, taught me to create atmosphere and tell a story crisply'. Indeed, if anybody doubts that advertising can be the perfect preparation for cinematic storytelling, then they ought to watch the climactic scenes in *Chariots of Fire*, as first Abrahams and then Liddell win gold. Of course these scenes are now so well known that it is hard to see them with fresh eyes, and with its clear moral message and unembarrassed patriotism, *Chariots of Fire* is usually the target of sniggering rather than admiration. Even so, had it not been for the technical mastery of those short sequences – the rapid cutting of the images, the gathering momentum of the music, the use of slow motion, the shots of the crowd, the close-up of Abrahams's good-luck charm, the way that Liddell's evangelical sermon builds into Vangelis's electronic score – the film's unashamedly stirring climax would never have commanded so much power.

The odd thing about *Chariots of Fire* is that it is so often seen, quite wrongly in my view, as an uncomplicated advertisement for the flag-waving populism that erupted during the Falklands War and carried Mrs Thatcher to re-election a year later in 1983. In fact, the film had been written some years previously, during the premiership of Labour's Jim Callaghan, and would have been made earlier if only Puttnam had been able to raise the money. More to the point, the film's authors never thought of it as a tribute to conservative values; quite the

reverse, in fact. Both Puttnam and Welland were enthusiastic Labour supporters. Among Welland's previous works was the television play *Leeds – United!* (1974), the story of a female textile-workers' strike, which made no secret of its left-wing politics. Even Hudson, whom Puttnam described as being afflicted with 'upper-class guilt', went on to make Labour's glossy, American-style 1987 election broadcast 'Kinnock: The Movie'. All three thought of *Chariots of Fire* as an outsiders' film: as Hudson told Alexander Walker, it was 'not about winning, but striving'. At its heart, after all, is not athletics, but the personal struggles of two men who, for ethnic and religious reasons, never quite fit in with the Establishment. It is true that when Eric Liddell runs for gold, we see the future Edward VIII cheering in the stands. But the Prince of Wales's most significant appearance comes earlier, when Liddell turns down his entreaties to run on a Sunday. Similarly, one of Harold Abrahams's most memorable scenes comes when he defies his Cambridge dons, who are appalled that he has employed a professional coach. Theirs, he exclaims, are 'the archaic values of the prep school playground . . . I believe in the pursuit of excellence and I carry the future with me.' Some critics, both at the time and later, have seen those words as proof of *Chariots of Fire*'s credentials as a Thatcherite film, committed to radical, ruthless competition. But those words were written well before Mrs Thatcher came to office. What they really reflected were the restless ambitions of the grammar-school generation, who hated hierarchy, deference and the cult of the amateur, and had transformed advertising in their own image.[15]

In March 1982 *Chariots of Fire* became only the fourth British film to win the Oscar for Best Picture, following *Hamlet*, *Tom Jones* (1963) and *Oliver!* (1968).* 'The British are coming!' exclaimed Colin Welland, who picked up the award for Best Screenplay. Given that the Academy had ranked him alongside Shakespeare, Henry Fielding and Dickens, he can be forgiven for getting carried away. By now Rank's dream of an independent British film industry, taking on the Americans in their own heartland, was dead and buried. But *Chariots of Fire* was a reminder

* It is perhaps worth noting that of the British films to have won the Oscar for Best Picture, all but one have had historical settings. The exception, interestingly, is *Slumdog Millionaire* (2008), which is set in contemporary India. I take no credit for noticing this: it was the copy-editor again.

that Britain's reserves of talent and craftsmanship were as good as, if not better than, anybody else's. Indeed, its success was front-page news, with the coverage easily dwarfing the column inches devoted to Britain's previous Oscar winners.

Once again, though, this was triumphalism born of insecurity. For in early 1982 Britain's morale was at a very low ebb indeed. The winter had been one of the coldest and wettest in living memory, the economy was only just struggling out of the most devastating recession since the war, and Mrs Thatcher's government was the most unpopular since polling began. When Puttnam and Welland flew back with their Oscars, the Falklands War, recovery and re-election were still in the future. To many observers, Britain seemed doomed to decline: only a few weeks earlier, a long leader in *The Times* had warned that 'with three million out of work, output at below the level of 1974, large chunks of our industry disappearing, our cities crumbling [and] services deteriorating', the country desperately needed a new direction. No wonder, then, that so many people sought solace in *Chariots of Fire*. After all, news of a successful British export was all too rare in the spring of 1982. And even if it did mark the triumph of advertising – well, that was better than nothing.[16]

FISH WITHOUT CHIPS

GORDON BURN: What is art?

DAMIEN HIRST: It's a fucking poor excuse for life, innit, eh?! ... I have proved it to myself that art is about life and the art world's about money. And I'm the only one who fucking knows that ...

GORDON BURN: What is great art?

DAMIEN HIRST: Great art is when you just walk round a corner and go, 'Fucking hell! What's that!'

Damien Hirst and Gordon Burn, *On the Way to Work* (2002)

One day in 1991 Vic Hislop saw an advertisement on a wharf in his native Queensland, Australia. An artist in England wanted a tiger shark, preferably a big, scary-looking one, in perfect condition. For Hislop, this was all in a day's work. He had been catching sharks for twenty

'It's amazing what you can do with an E grade in A-level art, a twisted imagination and a chainsaw': Damien Hirst, 1993.

years, and he prided himself on knowing more about them than any other hunter in the world. So out he went into Hervey Bay with his bait and his hooks, and, as requested, he came back with a fourteen-foot monster, for which the artist paid him some £4,000. Time went by, and Hislop forgot about the shark. And then, a year later, the shark reappeared – but in a way he could hardly have anticipated. Pickled in formaldehyde inside a gigantic glass box, and given the title *The Physical Impossibility of Death in the Mind of Someone Living*, it was the star of an exhibition entitled 'Young British Artists', organized at the Saatchi Gallery in St John's Wood, north London. It had been commissioned by the gallery's owner, Charles Saatchi, from a young man called Damien Hirst. Later, people said to Hirst: 'I could have done that.' And he had the perfect answer: 'But you didn't, did you?'[17]

Right from the start, the shark was a sensation. 'There's no getting round the shark, a ton or so of pure killer instinct,' began Andrew Graham-Dixon's review of the show for the *Independent*. The *Sun* had had some fun with the price tag, its headline memorably claiming that Saatchi had paid '£50,000 for Fish without Chips'. But Graham-Dixon thought it was worth it: the shark, he wrote, was both an unforgettable 'image of man's power over nature' and a meditation upon death, and would be remembered as 'one of the most remarkable British works' of the age. He was not far wrong. Not just in Britain, but around the world, the shark became the symbol of contemporary art itself, its successes and excesses. Even some of Hirst's detractors conceded that, for sheer spectacle, there was nothing to touch it. His admirers, meanwhile, could hardly contain themselves. 'The work offers drama without catharsis, confrontation without resolution, and provocation without redress. Responsibility is returned to the viewer,' enthused *Time Out*'s art critic Sarah Kent, rather opaquely, in a gushing tribute to Saatchi's collection. But Hirst's view was rather less elevated. 'It's amazing', he once remarked, 'what you can do with an E grade in A-level art, a twisted imagination and a chainsaw.'[18]

Damien Hirst's shark is not just one of the most widely recognized British artworks of the modern age, it has become a symbol of Britain's new self-image as a young, dynamic, irreverent and, above all, creative country – or, as Henry Fairlie surely would have put it, a country obsessed with narcissism, sensationalism and shameless materialism.

Even at the time, many visitors commented that the shark felt like an advertisement. 'Like all the best advertising,' wrote the *Observer*'s Lynn Barber, 'it is bold, simple, ambitious and, above all, big.' That was no accident: it had been commissioned by Britain's most celebrated advertising man.[19]

Since leaving CDP in the late 1960s, Charles Saatchi had established his own firm with his brother Maurice, organized the advertising campaign that helped Margaret Thatcher to victory in 1979, and saw his agency become the biggest in the world. An obsessive collector, who as a boy built up vast hoards of *Superman* comics and American jukeboxes, Saatchi had been introduced to contemporary art by his first wife, the American-born Doris Lockhart, during the 1970s. Soon art became one of the great passions in his life, perhaps even the greatest. By the following decade he was one of the most prolific art collectors on either side of the Atlantic. One gallery owner in New York was impressed that Saatchi knew what he wanted even before he came in. 'Being a collector like that', he said admiringly, 'is a full-time business.' But to a man of Saatchi's burning intensity, *everything* was a full-time business. By the late 1980s his private gallery, housed in a converted repair shop in St John's Wood, was one of the most expensive anywhere on the planet. 'Many say he is the most powerful collector in contemporary art – in the words of one dealer, a twentieth-century Medici,' wrote an American journalist in 1987. 'Where Saatchi leads, it is said a host of others follow. Fittingly, the adman himself has become the ultimate advertisement for the latest artist or trend.'[20]

At this point, Saatchi's main interest lay in American art, not British. But in July 1988 he visited a show called 'Freeze', organized in an empty Docklands building by a second-year fine art student at Goldsmiths' College called Damien Hirst. According to legend, Hirst and his friends had modelled the space on the vast white expanse of the Saatchi Gallery, hoping to catch the great man's attention. It worked: within a few years Saatchi was pouring money into British art on an unprecedented scale. For young British artists such as Sarah Lucas, Tracey Emin and Rachel Whiteread, Saatchi's support could mean the difference between exhibiting in an obscure warehouse and living it up on Millionaire's Row. And since so many dealers and collectors followed his lead, young artists deliberately set out to make things they knew he liked: big, visceral, often shocking, the kind of art you would expect an adman to

appreciate. 'A lot of artists', complained the painter Chris Ofili, himself a controversial Saatchi protégé, 'are making Saatchi art ... You know it's Saatchi art because it's one-off shockers.' But just as Saatchi could make young artists, buying them in bulk so that their price went through the roof, so he could break them, *selling* them in bulk so that their price fell through the floor. 'There's Charles Saatchi,' said the sculptor Richard Wentworth – 'and there's no one else.'[21]

Saatchi's admirers loved to see him as an artistic patron to rank with the great figures of Britain's imperial heyday. As early as 1985 the art critic Waldemar Januszczak compared him with the 'Victorian plutocrats with their passion for leaving behind museums in their names'. Twelve years later, in an essay specially commissioned for Saatchi's artistic apotheosis, the 'Sensation' exhibition held at the Royal Academy in the autumn of 1997, the historian Lisa Jardine waxed lyrical about the importance of 'vigorously entrepreneurial collectors' such as the textile magnate Samuel Courtauld and the Scottish shipping merchant Sir William Burrell, both of whom had established great collections bearing their names. 'The amassing of a vast art collection was his great passion,' Burrell's biographer wrote of the man who founded one of Glasgow's most celebrated museums. 'He derived as much enjoyment from the pursuit of a work of art as he did from concluding a successful commercial transaction.' When Jardine quoted those words, few readers would have missed the implied parallel with the man whose private collection now decorated the walls of the Royal Academy.[22]

But Saatchi's critics often reached for rather different Victorian analogies. One unflattering parallel, for example, was Gilbert Osmond, the Machiavellian villain in Henry James's novel *The Portrait of a Lady* (1881), a 'sterile dilettante' who collects both porcelain and people. Meanwhile, speaking anonymously, one art writer told the journalist Nick Clarke that Saatchi reminded him of Augustus Melmotte, the central character in Anthony Trollope's state-of-the-nation novel *The Way We Live Now* (1875). Many people might think this a deeply offensive comparison, since Melmotte is not merely a self-made man of mysterious foreign origins, he is 'the most gigantic swindler that had ever lived', a grasping, toad-like figure who tries to buy his way to the top of the British Establishment. Still, there *is* something very Victorian about Saatchi's story. After all, the Victorians adored tales of self-made men,

clambering up the ladder of status and success, and then tumbling melo-dramatically back to earth, from the real-life con-man Jabez Spencer Balfour to Mr Merdle in Dickens's *Little Dorrit* (1857), 'a Midas without the ears, who turned all he touched to gold'. They would surely have loved the story of a ferociously ambitious immigrant's son, who makes millions from selling dreams, builds up perhaps the most famous private art collection in the world – and then, consumed by his demons, suffers terrible public disgrace.[23]

Even the 'Sensation' show felt like something of a throwback to the Victorian age, perhaps the last time contemporary art genuinely shocked and thrilled a mass audience. This was the high point of Saatchi's career as a collector, exhibiting some 110 works by the men and women whom journalists were now calling the Young British Artists (YBAs), and it drew more than 285,000 visitors, an extraordinary figure for a contemporary art event. Many people were undoubtedly attracted by the whiff of controversy, especially the furore surrounding Marcus Harvey's portrait of the child-killer Myra Hindley, made up of children's handprints.* Indeed, the press coverage of works like the Hindley portrait, Damien Hirst's bisected animals, Marc Quinn's self-portrait sculpted in frozen blood or the Chapman brothers' grotesquely obscene dummies, made for excellent publicity. In the *Daily Mail*, Paul Johnson, whom we last encountered in 1964 condemning people who went to Beatles concerts, was on top form. 'Sensation', he wrote, was a symbol of 'nightmare Britain . . . perverted, brutal, horribly modish and clever-cunning, degenerate, exhibitionist, high-voiced and limp-wristed, seeking to shock and degrade'. This, he thought, was the Britain of a 'corrupt and depraved cultural elite . . . whose overwhelming passion is to spit on everything the rest of us value'. Well, if you will let Beatles fans run the country . . .'[24]

Saatchi's defenders reacted as defenders of contemporary art always do: they reached for comparisons with the past. The likes of Hirst and Harvey, wrote the Royal Academy's Norman Rosenthal, were no different from other 'enterprising artists imposing themselves on an unwilling

* The mothers of Hindley's victims pleaded with the Royal Academy not to show it. One mother even stood outside and begged people not to go in. Almost incredibly, however, the Royal Academy responded by inviting the mothers to *come and see the painting*, as though determined to confirm people's worst suspicions about the crass irresponsibility and amoral sensationalism of the contemporary art world.

audience', such as 'Courbet, Manet and the Impressionists'. This is, of course, a bit of a cliché, but the nineteenth-century parallel was not entirely unmerited. It was in the Victorian era, after all, that the very word 'sensation' acquired its current meaning, especially after the publication of novels such as Wilkie Collins's *The Woman in White* (1860) and Mary Elizabeth Braddon's *Lady Audley's Secret* (1862). Not for nothing is the first chapter of Matthew Sweet's book on the Victorians entitled 'The Sensation Seekers': they were, he explains, in love with spectacle, with shock, with the 'hysterical urgency' aroused by a thrilling novel, a melodramatic play or a lurid painting. Some of them might rather have enjoyed being shocked by what the 'Sensation' exhibition catalogue called the 'Post-Colonial Neo-Victorianism' of the Royal Academy show. They might also have recognized some familiar themes. Damien Hirst's works, from the arresting photograph of himself posing *With Dead Head* (1991) to his collection of animals in formaldehyde, were really all about one thing: death. And if there was one thing that fascinated the Victorians, it was death. As Simon Heffer notes in his history of the age, they elevated death 'into a cult of its own', complete with increasingly elaborate funeral rituals, lavishly ornate tombstones, black-edged letter paper and an 'unsavoury obsession' with ghosts and mediums. No doubt many of them would have been appalled by Hirst's diamond-encrusted skull, *For the Love of God* (2007), which cost at least £14 million to make and was reportedly sold for up to £50 million. Still, it is hard to resist the thought that Augustus Melmotte would have liked it.[25]

Even by the standards of the artistic punch-ups that the Victorians relished so much, Saatchi and his protégés provoked extraordinary opprobrium. Saatchi, wrote the *Evening Standard*'s colourful art critic Brian Sewell, was 'utterly frivolous, brash, superficial, ostentatious, the author of incalculable damage'. Posterity, Sewell thought, would 'marvel, not at his so-called works of art, but that we were so credulous and gullible'. This view – that Saatchi was either the victim or the author of a gigantic con trick – was, and is, very common. As the critic John Carey points out, it is revealing that when builders accidentally defrosted Marc Quinn's self-portrait in blood, or when the warehouse storing part of Saatchi's collection burned down in 2004, destroying Tracey Emin's tent (formally entitled *Everyone I Have Ever Slept With 1963– 1995*), newspaper columns and letter pages reacted with unbridled

glee.* Even the head of the Institute of Contemporary Art, Ivan Massow, published a *New Statesman* essay arguing that so-called Britart was 'the product of over-indulged, middle-class (barely concealed behind mockney accents), bloated egos who patronize real people with fake understanding ... pretentious, self-indulgent, craftless tat that I wouldn't accept even as a gift'. It was a sign of how firmly Britart was entrenched, though, that Massow was sacked just two weeks later.[26]

Perhaps the YBAs' most memorable critic was the *Private Eye* satirist Craig Brown, who had evidently pinned a picture of Damien Hirst on his mental dartboard. Reading Hirst's self-description as 'a Bonnard, a Turner, a Matisse', Brown suggested that 'in fact his spot paintings, pleasant enough as wallpaper, put him more on a par with a Llewellyn-Bowen or a Carol Smillie'. Hirst was, he thought, 'closer to an entrepreneur than to an artist: little separates him from, say, Sir Bernard Matthews of Turkey Roasts ... a man who has also, incidentally, glimpsed the profit to be found in corpses'. And when a Tate bigwig told him, 'Say what you like about Damien, he's brought a lot of publicity to the art world,' Brown had the perfect response. This was, he remarked, 'a bit like saying, "Say what you like about Osama, he's brought a lot of publicity to tall buildings."'[27]

What shocked people about the YBAs was not, I think, just the content but the price tag. As early as 1990, Andrew Graham-Dixon had written that Goldsmiths graduates had a 'reputation for pushiness' and were 'unembarrassed about promoting themselves and their work'. Indeed, more than any other British artists in living memory, Hirst and his contemporaries saw themselves as entrepreneurs, producing enormously expensive treats for the private market. As one of their most outspoken critics, the art historian Julian Stallabrass, pointed out, they could hardly have been more different from the romantic stereotype of the struggling painter. Even the 'Freeze' show had an 'impressive list of corporate sponsors', whose largesse paid for an expensive colour catalogue, while Hirst made sure that all the major dealers and collectors were invited to the private view. And once the YBAs became successful,

* Not unpredictably, the *Guardian* deplored 'the level of sheer hatred shown towards British art from every section of society'. But judging by its letters pages, its readers thought rather differently. 'I can't think of better fuel for a fire – fully insured and unsellable,' wrote one man. 'You can't beat a good bonfire to get rid of your rubbish,' agreed another. (See the *Guardian*, 26 May, 28 May and 5 June 2004.)

they began to cater much more openly to the luxury market, which expanded tremendously during the 1990s. To put it simply, contemporary art was becoming a playground for the super-rich. Little wonder, then, that so many British artists saw pound signs dancing before their eyes. And for customers who could not quite afford the latest luxury products, there were always the cheaper spin-offs: the £75 catalogues, the £200 prints, the clothes, the furniture. That 'one idea of yours ceases to be an idea and turns into a product, a waiting list, a schedule, a production line', wrote the *Guardian*'s critic Adrian Searle. 'You're eating better now and sending your clothes to the laundry. Your address book's fatter and so are you . . .'[28]

What really defined the art of the 1990s, though, was its affinity with advertising. To their critics, the YBAs, with their emphasis on sex, sensationalism and shock tactics, were doing little more than copying the tactics of the ad agencies. Even Hirst himself admitted his debt to the advertisements that Saatchi and his fellow admen had been making during the 1970s and 1980s. In an interview with *Dazed and Confused*, he explained:

> I spent a hell of a lot of time talking about commercials when I was at art school, conversations like, 'My God, did you see the Coalite advert where the dog kisses the cat and then the cat kisses the mouse? Fantastic!' That's the one that Tony Kaye did a few years back where the theme tune plays [*singing*] 'Will you still love me tomorrow?', just a brilliant advert. I didn't realise at the time, but that was where the real art was coming from – the rest of it was in the art library going: 'Shit, I wish I could understand all this stuff.' In retrospect, my work was always a fusion of the two.

Advertising images, of course, are not designed to be contemplated; their effect has to be immediate, because there will be another advert along in a few moments. Perhaps this explains why although Hirst's works are certainly arresting and even memorable, they almost never encourage profound or lasting reflection. The initial impact is everything; once that fades, the images lose their power to provoke. On the other hand, as Hirst knew very well, advertising could be enormously lucrative. An interviewer once asked him if, like his patron, he would ever make adverts for the Conservatives. 'It depends on how much money,' he said. 'You're not a socialist at heart?' the interviewer asked,

apparently in disbelief. 'I'm not anything at heart,' Hirst said. 'I'm too greedy.'[29]

Greedy is not, perhaps, quite the right word. Born in 1965, Hirst had grown up in Leeds. His father, who worked as a motor mechanic, left when he was a boy; his mother worked in the Citizens Advice Bureau. At his local state school he got two A-levels, including that E in art, and before art college he worked briefly on a building site. Like George Harrison, he knew what it was to be poor. 'Money is massive,' he once told the *Observer*. 'I don't think it should ever be the goal, but I had no money as a kid and so I was maybe a bit more motivated than the rest.' It is a common phenomenon: the self-made man from a humble background, never quite convinced that his money is real, never able to shake the nagging fear that it might all be taken away, never ready to say: 'Enough'.

And so it was that, more than any other cultural figure of his generation, Hirst became the embodiment of shameless materialism, as if he had walked out of the pages of a novel by Martin Amis. As early as 1997, he had started repeating himself – 'There are only so many ways to slice a dead cow,' wrote Andrew Graham-Dixon – but still the products kept coming: more vitrines, more spot paintings, more spin paintings. Decades earlier, the American artist Andy Warhol, who employed a host of assistants to turn out assembly-line products in his aptly named Factory, had claimed that 'Business Art is the step that comes after Art'. Now, like Warhol, Hirst turned himself into a brand. More than a one-man factory, employing a host of assistants to make his lucrative spot and spin paintings, he was a personality: a celebrity who went drinking with Blur's bassist, Alex James, opened a restaurant with Marco Pierre White, and founded his own publishing firm and fashion line. Far from denying his material ambitions, he revelled in them. He was the 'champion', said one profile, 'of converting public attention into financial reward'.[30]

That was putting it mildly. By September 2008, Hirst's fame was such that he dispensed with his usual dealers and put 223 new works up for auction at Sotheby's, bringing in a record £111 million. Three years later, at the World Economic Forum in Davos, Switzerland, Hirst put on spin-painting classes for bankers who fancied making a masterpiece of their own. His critics accused him of pandering to the super-rich. But he *was* one of the super-rich. More than any other British cultural figure of his generation, he had learned how to squeeze every last penny out of his

talent, relentlessly turning artistic inspiration into hard cash. And like any good self-made industrialist, he ploughed his winnings into property, buying a 300-year-old farmhouse in Devon, a beach estate in Mexico and a holiday home in Thailand. In 2005 Hirst bought Toddington Manor in Gloucestershire, a sprawling neo-Gothic pile originally designed in 1819 by Charles Hanbury-Tracy, Baron Sudeley. Despite his aristocratic-sounding name, Sudeley actually came from a long line of Pontypool ironmasters, whose wealth was based on their patented process for rolling tin. But not even Toddington, with its 300 rooms, was enough for his twenty-first-century successor. In August 2014 Hirst spent a reported £34 million on another Grade I listed mansion, this time overlooking Regent's Park in London. If anything, he had gone up in the world: his new house had been designed in 1811 by John Nash for the future George IV. Not bad going for a comprehensive-school boy who had once said that his ambition was 'to make really bad art and get away with it'.[31]

Although it is hard to imagine Hirst's high-minded Victorian predecessors coming out with something so cynical, his worldly ambitions would have seemed immediately familiar. After all, nineteenth-century artists had been no strangers to the nexus between fine art and mass consumerism. As early as 1871, the realist painter Frederick Walker had been commissioned to produce a poster for the West End adaptation of Wilkie Collins's *The Woman in White*, while Sir John Everett Millais's painting *Bubbles* (1886) achieved lasting notoriety as an advertisement for Pears's soap. In her novel *The Sorrows of Satan* (1895), Marie Corelli even had one character declare that 'the fame of Millais as an artist was marred when he degraded himself to the level of painting the little green boy blowing bubbles of Pears's Soap. That was an advertisement.' Millais promptly sent her a letter pointing out that he had had no control over the advertisement, because Pears had bought the rights from the owner of the painting. Even so, the fact is that Millais, like Hirst, made enormous amounts of money from selling his pictures as luxury products. To commission a three-quarter-length portrait, patrons had to pay him £1,000, the equivalent of at least £500,000 today. In 1885 Millais was heard boasting to two friends, a famous lawyer and an eminent doctor, that for the previous ten years he had earned more than £30,000 a year, as much as the two of them put together. The only thing stopping him from making £40,000, he added, was the fact that

he spent four months a year on holiday. And when he moved into a palatial new house at 2 Palace Gate, Kensington, his friend the author Thomas Carlyle exclaimed: 'Millais, did painting do all that? Well, there must be more *fools* in this world than I had thought!'[32]

But the YBAs were also very obviously the products of a distinctive moment in Britain's post-war history. While Hirst and his contemporaries were studying at Goldsmiths, Margaret Thatcher was celebrating her third successive election victory. And to many commentators, Charles Saatchi's prominence in the art world marked the apotheosis of what they saw as Thatcherite values. 'Symbolically he represents Commerce, not [Oliver] Goldsmith's disinterested variety that takes place between equals, but the Monetarist variety which is very interested indeed in what takes place at the top of the tree but has no interest at all in the roots,' wrote Waldemar Januszczak after visiting the Saatchi Gallery in 1985. 'A giant wave of business has broken over art.'

What is certainly true is that the economic earthquake of the 1980s literally opened up space for contemporary art: it was no accident that so many exhibitions were held in what had once been bustling warehouses. It is also true that the YBAs' unashamed commercialism reflected the imperatives of the time: ever since coming to office, the Thatcher government had encouraged artists to rely on private patronage rather than public subsidies. Little wonder, then, that many critics saw them as Thatcherite crusaders, carrying her market-oriented gospel into the galleries of the Tate. In the *London Review of Books*, the critic Peter Wollen even suggested that 'Freeze' had been 'a kind of art-world Big Bang, necessary for giving Britain a significant role in the new global economy'. And far from rejecting the comparison, Saatchi, for one, embraced it. Artists like Hirst, he told an interviewer, were 'part of the Thatcherist [*sic*] legacy. They have an entrepreneurial spirit that is very new for British artists, and indeed unique around the world.'[33]

Given the Iron Lady's rather chequered reputation in artistic circles, it is easy to see why the YBAs' critics are so keen to identify them as Mrs Thatcher's children. The fact is, though, that they did not come to prominence until several years after she had left office. While she was in power, the idea that they might have been hailed as Britain's semi-official artistic representatives would have been inconceivable: the mind boggles at the thought of, say, Willie Whitelaw hanging a Hirst on his office wall, or Norman Tebbit telling an audience of foreign businessmen that

Tracey Emin was the future of British exports. But by the mid-1990s the political mood was subtly different. After thirty years modernization was back in vogue; once again politicians were keen to proclaim the virtues of youth. And, as in the 1960s, the driving force was a Labour leader keen to rebrand his party as vigorous, modern and forward-looking.[34]

Addressing his second party conference as leader in 1995, in a speech that read like a pastiche of early-period Harold Wilson, Tony Blair used the words 'young country' no fewer than seventeen times. 'I want us to be a young country again,' he insisted. Like Wilson, Blair saw popular culture as the ideal way of proving his democratic, populist, modernizing credentials. At one point, it seemed that no music awards ceremony could go ahead without the Labour leader popping up to offer some inspiring words. There he was, for example, at the Brit Awards in 1996, hailing a 'great year for British music ... back once again in its right place, at the top of the world'. And there he was at the *Q* magazine awards, waxing lyrical about music's importance to the British economy:

> I just want to say two things to you here. First of all, rock 'n' roll is not just an important part of our culture, it's an important part of our way of life. It's an important industry; it's an important employer of people; it's immensely important to the future of this country ...
>
> The great bands I used to listen to – the Stones and the Beatles and the Kinks – their records are going to live forever, and the records of today's bands, the records of U2 or the Smiths and Morrissey, will also live on because they are part of our vibrant culture. I think we should be proud in Britain of our record industry and proud that people still think that it is the place to make it.

This was precisely the kind of thing his audience wanted to hear. 'If you've all got anything about you, you'll go up there and you'll shake Tony Blair's hand,' Noel Gallagher declared at the Brit Awards in 1996. 'He's the man! Power to the people.' Alas, his enthusiasm did not last long. 'We were off our heads that night,' Gallagher said later. 'We were talking some right bullshit.'[35]

Championing the latest chart-topping rock bands was one thing, but endorsing Britain's most controversial artists, who often doubled as punch-bags for the nation's tabloid columnists, was a rather more

dangerous proposition. But it is striking how thoroughly Westminster had fallen for self-consciously 'modern' culture that the first politician to use the phrase 'Cool Britannia' – five times, no less, during 1996 and 1997 – was John Major's National Heritage Secretary, Virginia Bottomley. She was the first government minister to endorse the work of the YBAs, telling audiences that British art was 'the most exciting and innovatory in the world'. Today this is merely par for the course; at the time, though, it seemed extraordinary. 'To my knowledge,' wrote the former Tory minister George Walden, 'no Cabinet minister – still less a Conservative – had ever before given official approval to what is conventionally regarded as avant-garde art.' In this respect, therefore, Mrs Bottomley was a more elegant version of William Deedes, the Tory minister who had tried to claim the Beatles for Sir Alec Douglas-Home.[36]

It was after the New Labour landslide, though, that Westminster's enthusiasm for popular culture approached its peak. In April 1998 the Department of Trade and Industry organized an exhibition, entitled Powerhouse::uk,* to 'rebrand Britain as a dynamic and diverse economy'. 'We've been a creative nation in the past throughout the whole of the Industrial Revolution and well into the 20th century. But sometimes we do not shout about it enough,' explained one junior minister. But if visitors were expecting a rerun of the Great Exhibition, they were in for a shock. This time, contemporary art played a central role: a gigantic video screen showed the turning pages of a Damien Hirst flip-book, while art books were incorporated into displays of the London skyline. A few weeks later, Bottomley's successor, Chris Smith, published a slim volume entitled *Creative Britain*, its cover adorned with one of Hirst's spin paintings. But whereas his Labour predecessors might have hesitated to equate the values of business with those of culture, Smith had no such qualms. 'The qualities demanded for business – such as communications skills, flexibility of approach, improvisational and creative thinking, working as a team so that the parts add up to a whole – are precisely those that can be inculcated through exposure to the arts,' he explained.[37]

* This is not, unfortunately, a misprint: there really were two colons. According to the website of the architect Nigel Coates, the exhibition was 'courageously sited on the central axis of Horse Guards Parade'. This was, at the very least, a bracingly unconventional interpretation of courage.

The irony is that although Smith is often portrayed as the great advocate of Cool Britannia, he hated the phrase and was not actually a fan of the YBAs. When the press saw the paintings in his office at the new Department of Culture, Media and Sport, they were surprised to find no YBA pictures at all. But that did not, of course, prevent them from giving him a kicking anyway. 'I don't think Chris Smith knows the first thing about art if he has a Howard Hodgkin on his wall,' wrote Matthew Collings. Worse was to come when Collings discovered that Smith had put up a Lake District landscape by the painter Norman Ackroyd. 'We can't forgive him for this,' Collings wrote. 'This is kitsch and shows he has no feeling for art or knowledge. You would be a crass philistine to have a Norman Ackroyd on your wall.' To make matters *even* worse, if that were possible, in 1999 Smith laid into the shortlist for the Turner Prize, the holy grail of British contemporary art. To the horror of the avant-garde, he declared that there was not enough 'traditional' art and that a small clique of conceptual artists were giving Britain a bad name. In this respect, at least if the press coverage and anecdotal evidence is any guide, he was speaking for the great majority of the British public. But it was no good: by now the British Council were proudly showing the YBAs' works all over the world.[38]

At the time, many critics thought that Smith's chief target was Tracey Emin's stained bed, the favourite for the prize. In fact, the award went to the video artist Steve McQueen, who in 2014 became the first black Briton – indeed, the first black man of any nationality – to win the Academy Award for Best Picture. But it hardly mattered. In the popular imagination only Hirst's shark outstripped Emin's bed as an example of the YBAs' ability to win headlines and provoke controversy. The *Guardian* called her bed a 'modern icon'; the *Telegraph*'s critic, however, called it 'unprocessed sewage', while in *Private Eye*, Craig Brown wrote a parody entitled 'My Turd'. Still, whatever you might think of *My Bed*, the fact is that in financial terms it was an unmitigated triumph. In 1999 it was bought for £150,000 by Charles Saatchi – who else? – who reportedly displayed it in his dining room, surrounded by his nineteenth-century silver collection. In 2014, however, Saatchi sold it to the German investor and industrialist Count Christian Duerckheim. Despite paying a whopping £2.5 million, the count immediately loaned it to the Tate Gallery, whose director, Sir Nicholas Serota, fairly bubbled with pleasure at the prospect of exhibiting such an 'iconic' work. No doubt readers will

have their own views about the lasting artistic qualities of Emin's bed. But as a British export its success is beyond question. In just fifteen years, after all, its value had increased almost twentyfold. By the standards of most British products, that really was a sensation.[39]

SPACEMEN INVADE BRITAIN

The UK High Commissioner in India has tried to convince Indians to study in Britain amid fears they are being deterred by red tape and exchange rates ... He extolled the cultural attractions of Britain, including James Bond, pop music and the British-designed Grand Theft Auto V, 'the world's best-selling game ... which I have been known to play myself when I need some violent therapy'.

Times Higher Education Supplement,
11 January 2014

On the afternoon of 20 May 1997, nineteen days after Tony Blair's landslide election victory, one of the new Labour ministers, Lord Williams of Mostyn, answered his first question in the House of Lords. As a member of the new team at the Home Office, he might have expected to be talking about prisons, drugs or gangs. Instead, he found himself talking about video games.

Would the government, asked the Conservative Lord Campbell of Croy, be taking action about the forthcoming release of a game entitled *Grand Theft Auto*?

LORD WILLIAMS OF MOSTYN: My Lords, the Government are very concerned about violent computer games as is the public and the noble Lord who asked the Question. All computer games which encourage or assist in crime or which depict human sexual activity or acts of gross violence must be passed by the British Board of Film Classification, which can refuse classification. If there is a refusal that automatically makes their supply illegal. Grand Theft Auto has not yet been submitted to the BBFC for classification. I understand that it shortly will be.

LORD CAMPBELL OF CROY: My Lords, I am grateful to the Minister for his reply. As this is the first occasion upon which he is speaking from the

Made in Scotland, the *Grand Theft Auto* series has become one of the most lucrative entertainment products of all time. Here a young devotee plays *GTA IV* on its day of release, 2008.

Government Front Bench, I congratulate him on his appointment and wish him well.

Is it true, as reported, that that game includes thefts of cars, joyriding, hit-and-run accidents, and being chased by the police, and that there will be nothing to stop children from buying it? To use current terminology, is that not 'off-message' for young people?

To this, Lord Williams repeated that *Grand Theft Auto* had not yet been submitted for classification. But to laughter from the Lords benches, he solemnly acknowledged that his fellow peer was right to be worried:

> One has to bear in mind the vice of these computer games. They deal not just with the type of activity to which the noble Lord has referred but also with acts of gross violence. I heard a rumour that some transactions between Miss Widdecombe and Mr Howard were going to be translated into a video game, possibly entitled 'A Touch of Darkness'.[*40]

Given that *Grand Theft Auto* was not due for release until October, it was not immediately obvious how Lord Campbell knew about it. In fact, he was playing an unwitting part in a clever marketing campaign, orchestrated by the publicist Max Clifford. A few months earlier the game's publisher, BMG Interactive, had engaged Clifford to drum up interest. This was far outside his usual kiss-and-tell turf, but as soon as Clifford heard that the game involved carjacking and drug dealing, he knew what was required. There would, he said, be some 'members of the establishment that would take and find something like this absolutely repulsive', and the publisher should exploit that for all it was worth. The trick was to get the right people 'to speak out on how outrageous this is', which would 'encourage the young people to buy'.[41]

As marketing campaigns went, it could hardly have been more cynical – or more effective. Everything went exactly as Clifford had predicted. 'It is deplorable to open young minds to car crime in this way,' a spokesman for the Scottish Motor Trade Association told the *Daily Mail*, which ran the story under the headline: 'Criminal Computer Game that Glorifies Hit and Run Thugs'. The game was 'sick', agreed a spokesman for Family and Youth Concern, who warned that it would

* The day before, the Conservative MP Ann Widdecombe had effectively torpedoed her former boss Michael Howard's bid for the vacant leadership of the party, telling the press that there was 'something of the night about him'.

'make children think it is OK to rob cars and kill'. The *News of the World* called for a ban, while Lord Campbell of Croy simply could not leave the issue alone. The game presented car theft as 'normal', he told the Lords in January 1998. 'The owners of vehicles in Britain may not yet recognize what a damaging disservice this game is inflicting upon them, although I understand that the motoring organisations do.' Alas, not all his colleagues took the matter as seriously as he did. Lord Avebury, for instance, reported that his 12-year-old son had been avidly playing a demonstration copy of the game; but he 'assures me that he is not motivated to go out and steal cars'. In any case, Clifford's strategy had done its work. At Christmas 1997, despite its simple graphics, *Grand Theft Auto* sold half a million copies.[42]

To a great extent, the history of popular culture is the history of technology. Nothing bears that out more fully than the evolution of video games, surely one of the most compelling cultural stories of the last four decades. In 1975 the market was practically non-existent; by 2015, however, the worldwide games industry was generating far bigger revenues than the film industry, while Britain's video-games market was twice as big as its music market. By this point, Britain's games industry was comfortably the biggest in Europe, while its most celebrated title – *Grand Theft Auto V* – was the fastest selling entertainment product of all time. In 2006 the *GTA* franchise was voted among the top ten British designs since 1900, taking its place alongside Concorde, the Mini and the London Underground map. Four years later, speaking at the Global Investment Conference in London, the Prime Minister specifically singled out the video-games industry as one of Britain's greatest economic success stories. 'We are leading the way in creative industries,' said Gordon Brown proudly, adding that Britain was now 'by far the biggest producer of computer games in Europe'. Even during his election campaign a few months later, Brown made a point of praising 'our world-leading film and video games industry'.[43]

And yet, in the industry's early years, the prospect of Britain becoming a significant player had seemed very unlikely indeed. The first coin-operated arcade machines, such as *Space Invaders* (1978) and *Pac-Man* (1980), were almost all made in Japan or California, and when they first arrived in Britain, they were often described as foreign invaders, rather like American films in the 1920s, or the music of the 'Negro's revenge' thirty years later. 'Spacemen Invade Britain – at a Price' read

the headline on a piece in the *Guardian* in December 1980, which claimed that Britain was being 'swamped' by 'literally dozens of new video games'. Indeed, to some older observers, *Space Invaders* seemed a sign of cultural degeneration. It was a game, wrote Nicholas Wapshott in *The Times*, that 'reduces grown men to lines of zombies'. Children in the West Midlands seem to have been unusually weak-willed: one 13-year-old boy reportedly stole £321 'to satisfy his obsession' with the machine at Dudley Zoo, while in Perry Bar, Birmingham, another teenager took more than £2,000 from his father's bank account. Psychologists at Birmingham University even claimed that the games posed a health risk, with serious players suffering 'exactly the same symptoms of stress as a managing director facing a difficult board meeting'.[44]

As if channelling the spirit of Lieutenant-Colonel Reginald Applin, the Labour backbench MP George Foulkes saw the *Space Invaders* craze as an opportunity to mount his soapbox. In May 1981 Foulkes proposed a bill for the 'Control of Space Invaders and Other Electronic Games'. They were, he said, a 'force for evil', dependent on 'blood money' extracted from children:

> I have seen reports from all over the country of young people becoming so addicted to these machines that they resort to theft, blackmail and vice to obtain money to satisfy their addiction . . .
>
> That is what is happening to our young people. They play truant, miss meals, and give up other normal activity to play 'space invaders'. They become crazed, with eyes glazed, oblivious to everything around them, as they play the machines. It is difficult to appreciate unless one has seen it for oneself. I suggest that right hon. and hon. Members who have not seen it should go incognito to an arcade or café in their own areas and see the effect that it is having on young people.

As in the debate about *Grand Theft Auto*, not everybody took the matter so seriously. The motion was 'outrageous and ridiculous', said the Tory MP Michael Brown, dismissing it as a typical example of Labour's 'petty-minded, Socialist' obsession with other people's pleasures:

> If I have glazed eyes, it is perhaps because I am the one hon. Member who is an avid player of 'space invaders'. I make no apology for the fact that before I came to the House early this afternoon I had an innocent half pint of beer in a pub with a couple of friends, put 10p in a machine, and

played a game of 'space invaders'. Many young people derive innocent and harmless pleasure from 'space invaders' . . . Many people derive an income from manufacturing and providing the machines . . .

What Brown did not point out, though, was that almost all the manufacturers were, in fact, Japanese. At this stage, the idea that Britain might became one of the world's leading games makers would have seemed very implausible indeed.[45]

Yet it was at exactly this moment that the foundations of Britain's computer-games industry were being laid. Part of the credit belongs to the indefatigable Clive Sinclair, whose pioneering pocket calculator had been a hit in the early 1970s. Even as George Foulkes was wringing his hands with anxiety at the advent of *Space Invaders*, Sinclair's cut-price ZX80 and ZX81 machines were effectively creating a new market for home computers. But the credit also belongs, perhaps surprisingly, to the government of the day. Barely a month after the Conservatives' 1979 election victory, the new Industry Secretary, Sir Keith Joseph, sent Margaret Thatcher a memo entitled 'Micro-Electronics'. Computer technology, he explained, would be 'of crucial importance to our future industrial and economic performance and our competitive position in world markets'. In fact, it was 'likely to be of the same sort of importance as was the steam engine with the difference that (a) it will be even more pervasive and (b) we are not in the forefront of its development'.

A month later, the Chief Secretary to the Treasury, John Biffen, added his voice to Joseph's, warning that without government support British electronics manufacturers would lose out to foreign competition. Their combined pressure did the trick, for Mrs Thatcher's government, belying its skinflint reputation, was extremely supportive of the computer industry. Indeed, no country in the Western world supplied more computers to schools or made more efforts to promote computer science than Mrs Thatcher's Britain, while the Prime Minister proudly trumpeted Sinclair's achievements. 'We must be way up front in the new industries, the new products, the new services,' she told a Conservative rally in March 1983. 'Think of Clive Sinclair and his microcomputers.' A year later, presenting computers to schools in Portugal, she boasted that 'these marvellous machines now seem second nature to our children. Our aim is that every schoolchild in Britain should have access to a computer. Per head of population, Britain has

the highest use of home computers in Europe. They are not only useful, they are fun to use!'[46]

Mrs Thatcher's idea of fun was not, perhaps, the same as most people's. Indeed, one of the ironies of the home-computer revolution was the great gap between the high-minded rhetoric of the manufacturers, all spreadsheets and science, and the reality of most children's daily experience, which was rather more *Chuckie Egg* and *Jet Set Willy*. To put it bluntly, most children were less interested in spending their weekends typing out programs on Sinclair's rubber ZX Spectrum keyboard than they were in exterminating an invading Martian battle-fleet. Indeed, although Sinclair's first adverts emphasized his machines' potential for education and business, games were part of the picture from the very beginning. As early as February 1980, one reporter wandered in amazement around the 'Microsystems 80' exhibition at Wembley, where the titles of the 'coloured tape cassettes' – *Mastermind, Super Startrek, Super Alien Attack, Wartrek, Deathstar* – seemed like weird messages from some lurid science-fiction future. And within a year or two, retailers had realized that what shifted home computers were not business packages for adults, but glossy games for children. As *The Times* told its readers in September 1982, 'the microcomputer has ceased to be a plaything of the enthusiast and is established as a family purchase with a market that peaks at Christmas . . . a sophisticated toy with educational trappings'. 'We've produced some more serious software, but it doesn't seem to sell,' explained Tony Baden, a young Oxford graduate who had bought a ZX80 at university and now ran his own software business, Bug-Byte. 'The future of home computing is more and more games oriented.'[47]

Even the BBC Micro, which became the default computer in schools and middle-class homes – a kind of electronic Volvo – after being developed to accompany the national broadcaster's Computer Literacy Project, was probably used most for games. But who would write the games? Not the Japanese or the Americans: they had different kinds of home computers, so their games were incompatible with either the ZX Spectrum or the BBC Micro. So Britain, almost accidentally, had the chance to develop its own industry. And the people driving it were the consumers themselves, a new generation of self-taught 'bedroom programmers' who stretched their machines further than even the manufacturers had believed possible. Tony Baden, for instance, wrote his

first programs at Oxford, set up his own business with a university friend after graduating and was soon turning over £1 million – and this during the deepest recession since the 1930s. Another good example was a Northern Irish teenager called David Perry, who was just 14 when his school got its first computer. A year later he started sending games to a computer magazine. They sent him a cheque for £450; he didn't even have a bank account. By the time he was 17 he had moved to London and was working full time as a games designer on a salary of £3,500 a year. Within a decade he had moved to the United States, and in 2013 he sold his cloud gaming service, Gaikai, to Sony for a reported $380 million. He was, he said delightedly, 'quids in'. That was more like Mrs Thatcher's idea of fun.[48]

In a sense, programmers like Tony Baden and David Perry were the skiffle stars of their generation. Like the aspiring teenage musicians of the 1950s, they were self-taught and self-motivated, driven by a youthful sense of enthusiasm, discovery and intellectual adventure. Previously they had been addicted to arcade machines like *Space Invaders*, but this was their chance to create their own worlds. Like generations of would-be rock and pop stars, they spent hours in their bedrooms, tinkering tirelessly away. If they thought their efforts were good, they shared them with friends at school or the local computer club, or sent cassettes to computer magazines and fledgling software firms. This was a young man's game: the designer of *Repton*, the lizard-maze game that I played obsessively on our school computers during the mid-1980s, was only 15.[49]

The most celebrated members of this electronic skiffle generation, however, met at university in the autumn of 1982. They were first-year students at Jesus College, Cambridge, and the result of their partnership was one of the most influential cultural phenomena of the decade. Yet David Braben and Ian Bell were about as far from the *Brideshead Revisited* stereotype of glamorous, floppy-haired Oxbridge students as it is possible to imagine. They had both grown up in quiet suburban corners of the Home Counties: Braben in Chigwell, Essex, and Bell in Hatfield, Hertfordshire. Both were doing science subjects – natural sciences and maths, respectively – and both loved science fiction, role-playing games and home computers. At a time when students were popularly imagined to be either champagne-swilling socialites or Thatcher-baiting socialists, they spent their evenings fiddling with their beloved machines, working

on a role-playing game set in space. At one point they showed a demo to Thorn EMI, but the executives were not impressed. The boys' game – a blend of aerial combat, commodity trading and flight simulation, influenced by films such as *Star Wars* (1977) and *2001: A Space Odyssey* (1968) – seemed crazily over-ambitious, and it was nowhere near being finished. So, like Decca rejecting the Beatles, Thorn said no. Undeterred, Braben and Bell took it to Acornsoft, the software arm of the firm that made the BBC Micro. Based in a little office above Cambridge's marketplace, Acornsoft had a youthful, even amateurish feel. 'You got there', notes the writer Francis Spufford, 'by sidling around the dustbins next to the Eastern Electricity showroom.' For his part, Braben thought it felt 'very back bedroom'. But perhaps because Acornsoft's staff were so young – the managing director was 27, the senior editor 24 – they were more likely to take risks. They decided to give it a try. And for the next eighteen months, in a rented student house on Jesus Lane, Braben and Bell worked on the game that became *Elite*.[50]

To describe *Elite*, which came out in September 1984, as a landmark in the popular culture of the decade might seem a bit over the top, since at the time computer games were routinely dismissed as trivial entertainments for children and hobbyists. Yet, in the long run, it was far more important than any of the decade's rock albums. Indeed, by the standards of the day, the game was simply breathtaking. As anyone who had a BBC Micro will remember, most early games were painfully primitive. Paying over your hard-earned pocket money for a new game by Acornsoft or Micro Power, you prayed that the graphics would live up to the lurid cover. More often than not, however, you found yourself staring at a hastily programmed, error-strewn rip-off of *Space Invaders* or *Donkey Kong*. But *Elite* was different. Instead of having, say, twenty levels, it had eight galaxies, each with 256 planets, all with distinctive political systems and economic priorities. In the game, the player travels between them at will, fighting, trading or merely exploring the vast blackness of space. There is no narrative: each player makes his own story, gradually accumulating enough kills to move up the rankings from Harmless to Elite. 'You could', said Bell, 'be hero or villain, good citizen or hair-triggered psychopath.' To a 10-year-old boy, the possibilities seemed almost overwhelming. When, one cold morning in January 1985, my father drove me through the snow to Telford to pick up my

copy, I was almost beside myself with excitement. The fact that I then completely failed to make it past Harmless is surely beside the point.*

Elite was an overnight hit. Although it is a myth that Acornsoft sold as many copies of the game as there were BBC Micros in existence, the sales figures – 107,898 copies sold for the BBC and 35,294 for its little brother, the Acorn Electron – were far beyond the publisher's dreams. And for Bell and Braben, the game's success proved life-changing. To sell the rights to other publishers, who would prepare versions for the rival ZX Spectrum and Commodore 64 platforms, they even hired a literary agent, who negotiated a lucrative six-figure deal with Firebird, the software division of the newly privatized British Telecom. Almost by accident, the two science students had become self-made success stories, invited on to the upstart *Channel 4 News* and lauded as the pioneers of a new kind of entertainment. Here were industrial craftsmen for the Thatcher age, brilliant tinkerers whose technological gifts had paid handsome dividends. The very ethos of their game seemed to reflect the political mood: in Spufford's words, they had created a 'cosmos of pure competition', where success was measured in terms of rivals killed and money earned. And even the timing felt supremely appropriate. In the summer of 1984, while they were putting the finishing touches to *Elite*, striking coal miners and policemen had clashed at Orgreave in York-shire. By the following spring, when *Elite* came out on the Spectrum and Commodore 64, the strike was over and the miners had lost. There could hardly have been a better symbol of the tectonic shifts reshaping Britain's political and economic life.[51]

Although, by today's standards, *Elite*'s gameplay feels slow and stately, its reputation is well deserved. As the most comprehensive history of the British games industry points out, Bell and Braben had pioneered many of the devices that today's players take for granted – 'open-world gameplay, freeform objectives, optional missions, wanted levels, player rankings' – in just 32 kilobytes of computer mem-ory. (To put that into context, the PlayStation 4's memory is fully 262,144 times bigger.) They had, in other words, created the first game

* My basic problem was that I found it impossible to dock, which made the game more or less unplayable. To my relief, however, I see that I was not alone. 'The frustration this can cause has made many people throw away their copies of the game,' admitted *Micro User*'s special guide to *Elite* in December 1986.

that felt like a world in itself, rather than merely a colourful diversion. And although Britain's software firms never commanded the financial muscle to crack the American market, the teenage programmers of the 1980s left an enduring legacy.

Indeed, in a sense they were small-scale equivalents of the industrial pioneers who, in the eighteenth and nineteenth centuries, had transformed Birmingham and Manchester. To take an obvious example, in 1987 a young enthusiast called Peter Molyneux co-founded a software firm in the loft above Guildford's solitary computer shop. At the time, nobody could have predicted that his *Fable* games would sell some 12 million copies between 2004 and 2014, or that he would be awarded an OBE and made a *Chevalier de l'Ordre des Arts et des Lettres*. But together with his partner, the computer shop's owner, Les Edgar, Molyneux turned Guildford into the heartland of Britain's video-games industry, attracting firms such as Electronic Arts, Media Molecule and Criterion Games, as well as a considerable amount of American investment. It is tempting to wonder how many of the millions worldwide who play the *Burnout*, *Need for Speed* and *Little Big Planet* games realize that they were, in fact, made in Surrey. Indeed, if there was ever any doubt about Britain's importance to the worldwide games industry, then it was surely dispelled at the Electronic Entertainment Expo (E3) convention in Los Angeles in the summer of 2014. For when the organizers announced the award for the Best Original Game, it went to a game called *No Man's Sky*, inspired by *Elite*, and made by a ten-man team in ... Guildford.[52]

The most unexpected games-industry story, though, unfolded further north. At the turn of the twentieth century, the city of Dundee had been a great Scottish success story, with an economy based on shipbuilding and what local wags called the 'three Js': jute, which provided enough jobs for tens of thousands of people; jam, or rather marmalade, produced at the pioneering Keiller's factory; and journalism, thanks to the enormous success of the publisher D. C. Thomson, home of the *Beano*, the *Dandy*, *Jackie* and *Commando*. But as the jobs in jute, jam and shipbuilding slowly dried up, the city cast around for alternative employers. In 1946 it attracted the American watch manufacturer Timex, which began with just eleven workers in a converted farm building, but grew to employ some 7,000 people. By 1983, when a young school leaver called Dave Jones joined the firm on an apprentice scheme, Timex had won a contract to make computers for Clive Sinclair. As a result, its staff

were able to buy subsidized Spectrums, and the company even paid for them to take computer courses at Kingsway Technical College. In fact, Jones was already something of a computer buff. Growing up in working-class Dundee, he had been an obsessive *Space Invaders* fan, while his secondary school, Linlathen High, had been involved in a pilot scheme testing the government's new O-level in computer studies. When he went to Kingsway for the computer course, he found not just plenty of other Timex employees but a little network of young programmers. 'While the rest of the club spent their time copying games,' one of them recalled, 'we'd talk about making them.'[53]

In 1986, with Sinclair's sales having peaked and Timex cutting back, Jones accepted a small redundancy package, which he spent on a software degree at Dundee College of Technology. And slowly but surely his hobby began to pay dividends. A year later, he sold his first game to the Liverpool-based publisher Psygnosis, and by the end of the decade he and his college friends had set up their own business, DMA Design, above a takeaway on Dundee's Perth Road. The atmosphere still had an Adrian Mole quality: they joked that whenever Jones's fiancée visited the office, she would roll up her sleeves and start cleaning. But in 1991 they made their breakthrough with their fourth game for Psygnosis, *Lemmings*. On paper it sounded childishly simple: you have to guide a group of lemmings through one level after another, against the clock. In fact, the game was devilishly addictive. ('We are not responsible', read a label on the box, 'for: loss of sanity, loss of hair, loss of sleep.') According to one of its programmers, it sold 55,000 copies in twenty-four hours, and a total of 15 million copies by 2006. 'To say that *Lemmings* took the computer gaming world by storm', the *Scotsman* declared, 'would be like saying that Henry Ford made a slight impact on the car market.'[54]

Twenty years earlier, Tony Iommi had splashed his first big cheque on a Lamborghini. Now Dave Jones bought himself a Ferrari. Within the growing computer-games industry, he was a celebrity, attracting admiring profiles in the *Scotsman* and the *Herald*. But repeating his initial success proved trickier than expected, and *Lemmings*'s two sequels never quite matched its impact. It was at this point that the Dundee team began working on a simple game they called *Race 'n' Chase*. Even by the standards of the day, its top-down graphics were far from spectacular, but the game had two crucial selling points. First, it was set in a

world teeming with life: a city full of cars, pedestrians, ambulances and police vehicles, all doing their own thing. And second, although there were missions to complete, the player could, if he preferred, spend his time simply exploring the vast, open environment. The point, said the game's chief programmer, Keith Hamilton, was 'to make you think that if you turn it off the city's still there'. And as he cheerfully admitted, he had borrowed this idea directly from one of his favourite games: *Elite*. 'You could argue', he later recalled, 'that *Elite* was the first open world. You could fly anywhere you wanted in *Elite* and you could pick up missions', just as you could drive wherever you wanted, and do whatever you liked, in *Race 'n' Chase*. As DMA's creative director put it, their new game – which they later renamed *Grand Theft Auto* – would be '*Elite* in a city'.[55]

To journalists in the mid-1990s, games like *Lemmings* and *Grand Theft Auto* offered the perfect blueprint for Britain's post-industrial revival. Here was a small band of innovative cultural entrepreneurs building a thriving business from the ruins of Scottish industry. Yet the story was a little bit more complicated. *Grand Theft Auto*'s controversial publicity campaign had been funded, after all, by Dave Jones's corporate partners, BMG Interactive, the computer-games arm of the multinational giant Bertelsmann. Indeed, by this stage the do-it-yourself spirit of *Elite* and *Lemmings* had largely disappeared. As early as September 1999, Jones sold his firm, including rights to the *GTA* franchise, to BMG Interactive, which had been renamed Rockstar Games. He went off with his old friends and some £7 million in cash, and in the meantime all future *GTA* products carried Rockstar's label and were distributed by the American software giant Take-Two. Indeed, although *GTA* products are still made in Scotland – though in Edinburgh, not in Dundee – a sceptic might ask just how Scottish they are. It is telling that, in the journalist David Kushner's gossipy history of the franchise, any real sense of Scottishness – or even Britishness – disappears as soon as Dave Jones leaves the story. The settings are exclusively American, while the lead writer's chief inspirations are, in his own words, 'Brian de Palma's *Scarface*, *Reservoir Dogs* and *Boyz N The Hood*'. Even the big decisions are taken in New York, since the company's head office is located in downtown Manhattan. Perhaps it is not surprising, then, that in 2010 just three in a hundred British youngsters knew *Grand Theft Auto* was made in Britain.[56]

There is, however, a good case for seeing *Grand Theft Auto* as a fundamentally British product. It was born in Scotland and has always been made there, apart from some minor sequels that were made in Leeds. The series' executive producer and chief creative force, Sam Houser, as well its chief writer, his brother Dan, are both English public schoolboys, brought up in London and educated at St Paul's. (Their mother, incidentally, was the actress Geraldine Moffat, best known for playing Glenda, Michael Caine's ill-fated lover, in *Get Carter*.) Growing up, the Houser boys were obsessed by American popular culture, from skateboards to gangster films. But in that respect they were no different to millions of other British youngsters from the 1920s to the present. Indeed, although the *GTA* series has been described as 'a love letter from England to America in all of its fantastic excess: the sex and the violence, the money and the crime, the fashion and the drugs', the Housers might be compared with bands like the Animals, the Rolling Stones and Fleetwood Mac, or even with the painter David Hockney or the novelist Martin Amis, all of whom sold exaggerated versions of American life to an Anglo-American market.*

And just as *Elite* was born at the University of Cambridge, so *Grand Theft Auto* has an Oxford connection. Dan Houser, who once remarked that 'the single longest process is always creating the world', read geography at Christ Church, a pretty good training for somebody who spent four years creating a fictional metropolis based on Los Angeles. Even *GTA*'s animation engine, Euphoria, evolved from a program designed at Oxford's zoology department to simulate the human nervous system. As a shareholder in NaturalMotion, Euphoria's parent company, the University of Oxford profited from every *GTA* disk sold. When NaturalMotion was sold in early 2014, Houser's alma mater banked more than £30 million.[57]

By any standards, *Grand Theft Auto* is a staggering success story. Its fifth instalment alone sold 34 million copies in its first twelve months, earning almost £1.2 billion. Only two films, *Avatar* and *Titanic*, have ever made more money. It is, in fact, a perfect example of what Britain has done very well in the past half-century, harnessing native imagination, craftsmanship and an almost childlike love of tinkering, and

* Stretching the point a little, *Time* magazine claimed that the Housers were 'creating tapestries of modern times as detailed as those of Balzac or Dickens' (*Time*, 30 April 2009).

producing something very clearly aimed at the largest English-speaking market in the world. And although the product would have seemed unrecognizable to the men whose ideas drove the Industrial Revolution, the skills, the vision and the entrepreneurial spirit might have looked distinctly familiar. Little wonder, then, that the video-games industry has joined films, pop music and contemporary art as an officially recognized great British asset, with David Cameron hailing it as 'incredibly inventive and creative and a massive provider of growth and jobs'.[58]

But there is, alas, another side to the picture. Our sceptic might point out that, despite its growing importance in our collective imagination, the video-games industry still employs only a very small number of people. In Scotland, for example, the industry's own figures showed that in 2012 it employed just 668 permanent staff in fifty companies. In fact, a report for the Scottish government found that games contributed less to Scotland's economy than any other creative industry, and that the industry's gross value added measure was, in fact, nil. And though this figure is surely an underestimate, the fact remains that Britain's cultural industries will never employ as many people as the heavy industries that the Victorians took for granted. Indeed, our sceptic might well suggest that Britain's enthusiastic self-portrayal as a cultural superpower is merely a symptom of its industrial and imperial decline – and that people were better off when Dundee did still turn out jute and jam, instead of American-themed video games.[59]

Trying to untangle twenty-first-century Britain's self-image, a historian from the future could have great fun with a story from 2006, when *Grand Theft Auto* was nominated as one of the top ten British designs since 1900. The list was as follows:

1. Concorde
2. The London Underground Map
3. The Spitfire
4. The Mini
5. The World Wide Web
6. The Routemaster Bus
7. Cat's eyes
8. The cover of *Tomb Raider*
9. *Grand Theft Auto*
10. The K2 red telephone box

As with all such stories, there was a heavy element of present-mindedness. Absurdly, only one entry dates from before 1931: the red telephone box. Yet the list could hardly have been a better illustration of Britain's cultural and economic preoccupations. Two of the top ten, the Tube map and cat's eyes, were lasting British achievements. The World Wide Web was certainly developed by a Briton, Sir Tim Berners-Lee, but since he was based in Geneva and worked alongside the Belgian scientist Robert Cailliau, it is a bit of a stretch to claim it as uniquely British. The Spitfire was presumably included as the obligatory homage to the Second World War, while the telephone box and the Routemaster bus were effectively defunct. Red phone boxes have not been built since the 1990s, while the last Routemaster was delivered as long ago as 1968. As for the Mini, it was last made in its original form in 2000 before being bought and redesigned by the German firm BMW, while the last Concorde was built in 1979 and was retired in 2003. That left only *Tomb Raider* and *Grand Theft Auto*. A historian from the future, therefore, might well conclude that twenty-first-century Britons' greatest pleasures were contemplating their past and playing video games. It feels harsh to say it, but perhaps he might not be far wrong.[60]

PART TWO

Play up! Play up! and Play the Game!

The Victory of the Old Order

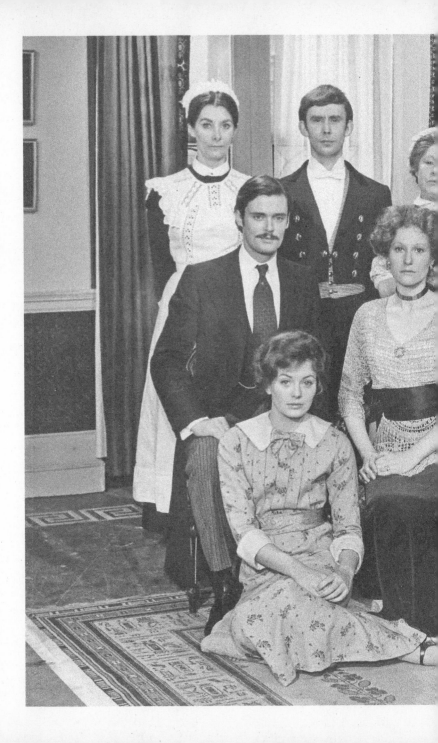

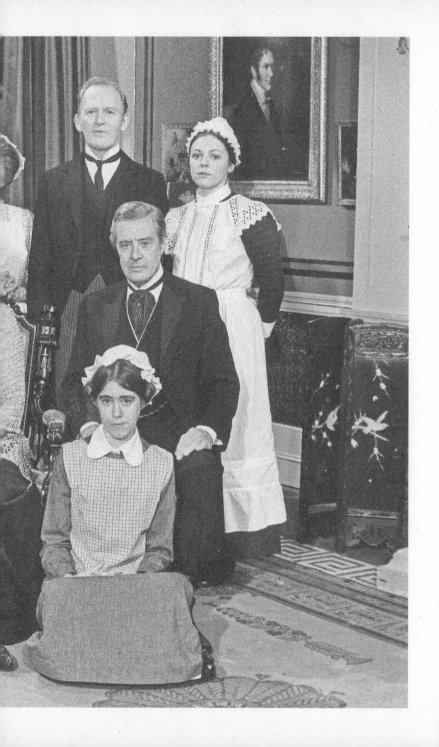

Previous pages: A vision of Britain as a social hierarchy: the cast of *Upstairs, Downstairs*, 1974.

4

Enchanted Gardens

LORDS OF THE MANOR

I always wanted to live in a castle.

Bill Wyman, interviewed in *Forbes* magazine,
10 September 2011

Shortly before eight o'clock on the evening of Sunday 12 February 1967, Keith Richards and Mick Jagger were watching television with friends when they heard a knock at the front door. Richards looked up, and saw what he thought was 'a little old lady' peering through his living-room window. Then, a bit groggy from a weekend of drink and drugs, he opened the door, and was slightly surprised to see 'a whole lot of dwarves ... very small people wearing dark blue with shiny bits and helmets'. 'Am I expecting you?' Richards asked confusedly. The dwarves' leader handed over a piece of paper. 'Come on in,' their host said. The dwarves trooped inside. But by now it was becoming clear, even to Richards, that far from being extras from an amateur production of *The Hobbit*, his visitors were in fact the West Sussex constabulary: eighteen of them, to be precise, armed with a warrant issued under the Dangerous Drugs Act 1965. Their leader, Chief Inspector Gordon Dineley, asked Richards if he was the owner of the house. Richards nodded. He had only one request, he said. Could Chief Inspector Dineley's men please be careful not to tread on his North African cushions?[1]

So began the most controversial drugs raid in modern British history. The details have become part of the folklore of the late 1960s, from the constables' shock at the sight of Mick Jagger's naked girlfriend, Marianne Faithfull, wrapped in a large fur rug, to the paranoid allegations

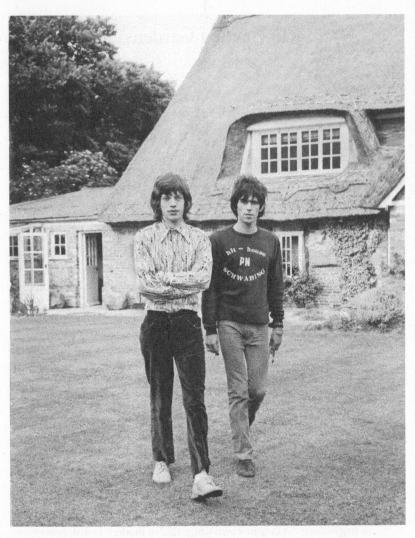

Street fighting men? Mick Jagger and Keith Richards stroll on the Redlands lawn, 1967.

that the bust had been planned in Whitehall's corridors of power. When the case came to court in Chichester, Richards and Jagger, as well as their friend Robert Fraser, were found guilty of various drugs offences and handed short prison sentences. At the time, the Rolling Stones and their admirers saw the three men as victims of a government conspiracy. But the notion that the political elite conspired to throw the Stones behind bars is nonsense. After all, it was the Establishment's most celebrated mouthpiece, *The Times*, which led the campaign for the sentences to be overturned on appeal. Indeed, the Redlands case, as it became known, is an excellent example of how the Sixties are routinely misunderstood. Many accounts paint Jagger, Richards and Fraser as popular heroes, oppressed by a conservative upper-class elite. But it was the upper-class elite, notably *The Times*'s editor, William Rees-Mogg, and the Lord Chief Justice, Lord Parker, who got them out of prison. By contrast, Gallup's pollsters found at the time that three out of four people thought that those who took drugs, even soft drugs, should be punished. A few hours after the Appeal Court's verdict had come through, Mick Jagger appeared alongside Rees-Mogg, the Bishop of Woolwich, a Jesuit priest and the former Home Secretary Frank Soskice on the current-affairs show *World in Action*. The programme opened with the striking statistic that no fewer than 85 per cent of Britain's youngsters thought Jagger should still be behind bars.[2]

But the Redlands affair was not just about the drugs. The clue is in the name: it was also about the house. In their statements to the court, the police often drew attention to what they considered the decadence of Richards's West Wittering retreat. They were shocked that he and his friends were simultaneously watching an old film and listening to Bob Dylan records, which struck them as absurd. They were taken aback by the scent of burning joss sticks: 'a strong, sweet, unusual smell', one sergeant told the court. They were fascinated by the clothes strewn casually in the bedrooms: 'pink ostrich feathers ... a pair of black velvet trousers, a white bra, a white lace Edwardian blouse, a black cloth half coat, a black sombrero-type hat and a pair of mauve-coloured ladies boots,' according to one woman police constable, who also noticed 'a number of books on witchcraft'. It was no wonder that all this – the stereo, the television, the swirling Moroccan drapes, the incense and the cushions – made such a vivid impression on the men and women who tramped through the house that evening, most of whom came from ordinary

working-class backgrounds and had never seen anything like it. 'Redlands gave us a bit of a shock,' remembered Constable Don Rambridge. 'From the outside it's a really beautiful house – Olde Worlde, half-beamed. Then you go inside and it's decorated in mauve and blacks, all the beams painted like that. It turned out to be a real raver's place. It really hurt looking at the inside.'[3]

From the very outset, Richards's Tudor farmhouse played a central part in the story of the case. When Britain's bestselling national daily, the *Daily Mirror*, first reported the raid, it ran a large picture of Redlands, described as an 'old thatched farmhouse ... surrounded by a moat and five-acre lawn'. Four months later, when Richards and Jagger were sent to prison, the *Mirror* ran another big spread, this time showing Jagger and Richards lurking vaguely outside the porch. And on 5 July, when the Court of Appeal agreed to hear their case, Redlands finally made it to the *Mirror*'s front page, the two men again framed against the house's chocolate-box exterior – Richards shaggy and surly in his sweatshirt, Jagger sheepishly half-smiling in a natty jacket.

Indeed, in one sense the house *was* the story: not just as the place where the crime had taken place, but as the definitive symbol of the Stones' rise to extraordinary wealth and fame. A few weeks later, after the success of their appeal, the judge at their trial, Leslie Block, made a telling gaffe at a dinner of the Horsham Ploughing and Agricultural Society. 'We did our best, your fellow countrymen, I, and my fellow magistrates, to cut these Stones down to size,' he said, 'but, alas, it was not to be, because the Court of Criminal Appeal let them run free.' Block was in his late sixties, a former naval commander who had won a Distinguished Service Cross for bravery in the Second World War. A successful local farmer, he too lived in a large Tudor farmhouse. What he thought of Richards's presence at Redlands can easily be imagined.[4]

Richards had moved into Redlands in April 1966, the day after the Stones released their hugely successful fourth album, *Aftermath*. Like many of the era's rock stars, he had quickly tired of life in London, where there were always reporters around the corner. Later, in his autobiography, he recalled the moment he first set eyes on his Sussex retreat:

> We just spoke to each other the minute we saw each other. A thatched house, quite small, surrounded by a moat ... I had a brochure with a couple of houses marked and I'm poncing around in my Bentley, 'Oh, I'm

going to buy a house.' I took a wrong turn and turned into Redlands. This guy walked out, very nice guy . . . and he said, are you looking for a house to buy? He was very pukka, an ex-commodore of the Royal Navy. And I said yes. And he said, well, there's no sign up, but this house is for sale. And I looked at him and said, how much? Because I fell in love with Redlands the minute I saw it. Nobody's going to let this thing go, it's too picturesque, ideal.

By his own account, Richards drove straight back to London, got to the bank just before it closed and took out 'twenty grand in a brown paper bag' (actually, the exact figure was £17,750).* 'By evening', he wrote, 'I was back down at Redlands, in front of the fireplace, and we signed the deal.' The story sounds almost too good to be true. Even if Richards was exaggerating, though, it is revealing that he relished telling such a highly romanticized story. He had bought Redlands, he said proudly, 'cash on the barrelhead, done in really an old-fashioned way'. But then Richards, for all his excesses, was really an old-fashioned person.[5]

A few weeks after Richards had moved in, the journalist Sue Mautner drove down to West Sussex to interview him for the monthly fan-club magazine *The Rolling Stones Book*. What she found was a scene of almost pastoral tranquillity, with the 22-year-old Richards already playing the part of a country squire. As she approached the house, marvelling at the thatched roof, 'very talkative ducks' and 'beautifully mowed lawn', an elderly gardener told her that the new owner had gone out. The door was open, and she wandered into the living room – the principal setting, of course, for the police raid nine months later – which she described as 'a massive oak-panelled room with parquet flooring, wooden beams, two enormous stone pillars and a huge stone fireplace'. On the floor was a white fur rug. The room also boasted an electric piano, a harpsichord and a guitar, while stacked in bookcases was Richards's library – *The Great War*, *Great Sea Battles*, *Drawings of Rembrandt* and numerous 'books on England' – and a record collection that included Chopin, Rossini and Segovia as well as the Beatles, Bob Dylan and Elvis Presley.

* House-price inflation makes it very hard to provide contemporary equivalents for the sums that Richards and co. paid for their country houses. Strictly speaking, Redlands's purchase price was the equivalent of about £700,000 today. But if Richards put his house on the market tomorrow, the asking price would surely be at least three times higher.

While Mautner was poking around the rest of the house, Richards turned up in his chauffeur-driven Bentley Continental. He was, it seems, bursting with pride at his new acquisition:

> What do you think of the place? Of course it's not finished yet, I want to do it bit by bit. I'm going to mix the furniture and have modern and Tudor. As you can see, I've bought some pieces off the people who lived here before. I'm going to have mauve paint in the dining room and prob-ably the lounge and spotlights on the walls. I've got this interior decorator who did the *Queen Mary* as it is today.

If that makes him sound like a guest on a home-makeover show, worse was to follow. 'There's so much to be done,' he went on. 'I'm knocking down walls and blocking out doors. Downstairs I'm making a small cloakroom for people to hang their coats in, and wait till you see the kitchen finished, I've got this cooker which disappears into the wall.' Perhaps he had been spending too much time with the local estate agents. 'You know, it's marvellously situated here,' he added. 'There's a little shopping village where you just ring up and they send your order round, and also I'm only a mile from the sea.' Outside, he pointed at a run-down cottage just outside the garden. 'As it's so cheap,' he said, 'I'm going to buy it and have a couple of staff living there. A husband and wife preferably, so she can cook and clean the house, and he can do all the odd jobs.'[6]

Although much of the fascination surrounding Richards's life at Red-lands inevitably derives from the infamous drugs case, some of it can surely be attributed to sheer incongruity. The previous owner – a former naval commodore, not unlike Judge Leslie Block – was the sort of person you might expect to find in a thatched Tudor farmhouse in the West Sussex countryside. But Richards's background could hardly have been more different. His father was a foreman in a light-bulb factory, and he grew up on a new council estate in Dartford, Kent, which he later described as a 'wasteland'. Disaffected and undisciplined, he was expelled from Dartford Tech when he was just 15, and drifted into Sid-cup Art College, which was seen locally as something of a last resort. By contrast, his friend Mick (originally Mike) Jagger was the son of a middle-class lecturer, passed his eleven-plus and studied briefly at the London School of Economics, while Brian Jones, who went to grammar school in genteel Cheltenham, was the son of an engineer and a teacher.

But the other two Rolling Stones, like Richards, were unarguably working-class. Charlie Watts had grown up in Wembley, the son of a van driver, while the band's oldest member, Bill Wyman, had grown up in Sydenham, in suburban south London, in almost stereotypical poverty, bathing once a week in a zinc tub, sharing a toothbrush with his six siblings, and shivering through the winters when his father, a bricklayer, struggled to find work. When Wyman was a boy, his mother would send him to the local market to buy stale bread and to cadge bruised fruit and vegetables from the stallholders. Later, he helped her to earn a little extra money peeling onions for a pickling firm, which they abandoned after the neighbours complained about the smell. Unlike Richards, Wyman worked hard and won a scholarship to the local grammar school. Even so, he could never have dreamed that his musical talents would one day elevate him to Lord of the Manor of Gedding and Thormwood.[7]

Perhaps the Stones' memories of cramped suburban flats and windswept council estates help to explain why, as soon as they had tasted success, they became such enthusiastic dabblers in the luxury property market. By the middle of 1965, barely a year after their chart breakthrough, Richards was living in a rented flat in St John's Wood, while Jagger moved from Bryanston Mews, Marylebone, into a nearby mansion flat at Harley House. Interviewed for a teenage magazine, Jagger posed nonchalantly before a gilded nineteenth-century mirror, a modern G Plan shelf unit and a collection of outsize Cantonese cups. 'The scene', writes his biographer Philip Norman, 'is worthy of one of those Edwardian young men about town whose only domestic companion would be a discreetly gliding gentleman's gentleman', as if the Rolling Stones' lead singer were auditioning for the title role in *Adam Adamant Lives!*

Like Richards, Jagger had become close friends with two Old Etonians: the art dealer Robert Fraser, who was arrested with them at Redlands; and the antiques dealer Christopher Gibbs. They had 'nerve and fearlessness', Richards wrote later: the kind of nerve and fearlessness that you get with a trust fund and a boarding-school education. But the two men were in the vanguard of an upper-class rush to embrace Britain's so-called 'new aristocracy'. 'There's no harm these days in knowing a Rolling Stone,' announced the *Daily Express*'s William Hickey column, which usually devoted its attentions to duchesses and debutantes. 'Some of their best friends, in fact, are fledglings from the

upper classes.' In his autobiography, Richards looked back fondly on the days when he and Jagger would spend their evenings in mock-Scottish-Baronial Mayfair nightclubs with earls and countesses. 'We were being courted by half the aristocracy, the younger scions, the heirs to some ancient pile, the Ormsby-Gores, the Tennants, the whole lot,' he recalled. 'I've never known if they were slumming or we were snobbing.' The answer is probably a bit of both. Marianne Faithfull later remarked that Mick Jagger would eagerly turn up to 'dinners given by any silly thing with a title and a castle. He was as smitten as any American millionaire in the movies.'[8]

One of the many misconceptions about the so-called Swinging London scene is that it was classless. The actor Terence Stamp, for example, claimed that there was 'an absolute coming together', based on 'music and dancing'. It was only in the new world of the mid-1960s, he thought, that 'some yobbo like me could get into the Saddle Room [one of the capital's most exclusive nightclubs] and dance with the Duchess of Bedford's daughter, and get hold of her, and get taken down to Woburn Abbey to hang out for a long weekend and have dinner in the Canaletto room with the Duke's sons!' But his own anecdote rather gives the game away. Far from being classless, the Swinging London scene was positively drenched in class-consciousness, especially on the part of working-class youngsters like Stamp who made no secret of their social ambitions. Mick Jagger's appetite for social climbing, for instance, can scarcely be exaggerated. In January 1968, even as his admirers in the bohemian counterculture were imploring him to stand with them on the barricades, he joined the Country Gentlemen's Association, a landowners' society founded in 1893. Two months later Jagger bought his own country house, Stargrove in Hampshire, for a knockdown £25,000, and immediately set about restoring it to its former glory.*[9]

Within just four years of their first chart hit, all the Rolling Stones had turned themselves into country gentlemen. Brian Jones initially contemplated buying Aston Somerville Hall, not far from his native Cheltenham, but eventually settled for A. A. Milne's former house,

* Stargrove was previously known as Stargroves: what happened to the 's' is anybody's guess. In any case, as children of the 1970s may recall, the house had an exotic history. In 1911 it had been taken over by robotic mummies under the control of the demented Sutekh the Destroyer. Some years later, it was the location for Dr Fendelman's experiments on an ancient human skull, which unfortunately reawakened the alien Fendahl.

Cotchford Farm in Sussex, where he drowned in the swimming pool. Charlie Watts, meanwhile, bought Peckhams, a sixteenth-century house near Lewes, which came with another swimming pool, staff quarters and some 34 acres. The vendor was, of all people, the former Labour minister and Nuremberg prosecutor Hartley Shawcross. Here, Watts lived quietly with his vast collection of American Civil War memorabilia, model soldiers, jazz records and antique silver. His van-driving father thought it was an excellent choice, but his mother reportedly complained that he should have chosen somewhere 'a bit more modern'.[10]

Perhaps the most striking example of the new rock aristocracy, given the deprivation of his childhood, was Bill Wyman. Like his fellow Stones, Wyman was desperate to get out of London because 'too many unwelcome visitors' were turning up on his doorstep. In 1965 he bought a house in Keston Park, on the rural southern fringe of the capital. In effect, this was an early gated community, dating from the interwar years: it was here that Margaret and Denis Thatcher had lived before she moved to Finchley. However, as Wyman's marriage fell apart and his friends acquired grander country houses, he began to get itchy feet. In the summer of 1968, he and his new girlfriend drove out to Bury St Edmunds to look at Gedding Hall, which had just come on the market:

> On our arrival Gedding Hall, built in 1480, struck us as so stunning that we were sure we'd arrived at the wrong place. Gathering courage, we drove up the long drive to the Hall, which was surrounded by a beautiful moat, with black swans and ducks. The park and grounds were immaculately kept but a gardener stopped us to say the owner was away ...
>
> We went back six days later ... On our arrival the owner, Geoff Allen, showed us the interior of the house ... The place was beautiful: I offered £41,000, even though I had only £1,000 in my bank account; this was accepted. Geoff said that although a member of the Queen's Household had offered more, he preferred to sell it to me, a self-made man like him.*

* Geoff was a self-made man of an unusual kind. A close friend of the Krays, known as 'the Godfather', he then became a successful property developer and was eventually sent to prison for insurance fraud.

The autobiography of a rock star, or the memoir of an estate agent? Reading Wyman's book, it is sometimes hard to tell the difference. Not only does he list his bandmates' house purchases in loving detail, including final costs and completion dates, he even tells us about houses they *failed* to buy, such as Jones's Aston Somerville Hall. After telling us the date he moved into Gedding – 30 October 1968, in case readers were wondering – Wyman feels the need to explain that his furniture had been installed a week earlier 'by Dennis Halfacre, who agreed to become my resident gardener (essential for fourteen acres)'. The house, he says proudly, was 'comfortable and spacious', as it ought to have been, given the 'six bedrooms, three bathrooms and an eight-car garage'. Indeed, for all the press fascination with Wyman's tangled and frankly rather off-putting love life, there is a good case that his greatest romance was not with a woman, or even with a metal detector, but with his house.[11]

It is naturally tempting to mock the Rolling Stones for their eagerness to re-enact *Brideshead Revisited*. But what were they supposed to do with their money? Where were they supposed to live? Their friends the Beatles, after all, had hardly made a conspicuous success of their early arrangements. After their first American tour, the Beatles' accountant had concocted a scheme for them to live in a kind of 'mock-Tudor compound' in Weybridge, Surrey, which was classic stockbroker territory. John Lennon and Ringo Starr promptly bought Weybridge mansions, while George Harrison bought a house on another estate in Esher. Lennon's house, in particular, was a model of what older people – accountants, architects, interior designers – assumed the new pop stars would probably like; quite wrongly, as it turned out. A twenty-seven-room Tudorbethan mansion, it boasted black deep-pile carpets, a gigantic television in the fireplace, mauve velvet wall hangings and a modern kitchen so complicated that somebody had to be sent from London to show Lennon's wife, Cynthia, how to work it. When visitors came, they found Lennon holed up rather like Napoleon on St Helena, and miserably watching his giant television or flicking idly through the *Daily Express*. It was no wonder he was so dejected: it was a house for a twenty-first-century Russian oligarch, not a bohemian art-school drop-out from Liverpool.[12]

Lennon would probably have been better off staying in London, like Paul McCartney, who was living at 57 Wimpole Street with his girlfriend, the actress Jane Asher. The peculiar thing about this arrangement

was that, since Jane Asher was still living at home, McCartney had effectively moved in with her parents: Richard Asher, the eminent endocrinologist who first identified Munchausen syndrome, and his wife Margaret, a music teacher. In such company, McCartney was very obviously a social outsider, a bit like Nick Guest, the main character in Alan Hollinghurst's novel *The Line of Beauty* (2004), who stays with the upper-class Fedden family in their luxurious London townhouse. But it did McCartney a lot of good: not only did his adopted family keep his feet on the ground during the Beatles' heyday, but they introduced him to plays, books and music he might not otherwise have encountered. It was only after Jane Asher played him Vivaldi, for example, that he came up with the string arrangement for 'Eleanor Rigby', while it was through her Oxford-educated brother, Peter, that he came across the music of John Cage and Karlheinz Stockhausen. Had he moved out to Weybridge with Lennon, it is very unlikely that he would have embarked on such a course of cultural self-improvement, and the Beatles would have evolved in a very different, and probably much less interesting, direction.

But McCartney's association with the Ashers reinforces the point that, far from being classless, the popular culture of the mid-Sixties was strongly driven by social ambition. The Ashers were, by most standards, upper-class: Richard had been educated at Lancing, Peter went to Westminster, and Jane went to Queen's College on Harley Street, which had also educated Gertrude Bell, Katherine Mansfield and Churchill's youngest daughter, Mary, among others. It was precisely because the Ashers were rich, well educated and well connected, with a townhouse in the heart of London, that they were able to open so many doors for McCartney. It is surely no coincidence that, at precisely this point, he began to dress in a way inconceivable for most working-class or even middle-class young men, having his suits hand-made and buying his shirts and ties from Turnbull & Asser. And when he moved out of Wimpole Street, he did his best to recreate its patrician atmosphere, buying a three-storey Regency townhouse in St John's Wood for £40,000 – a lot more, incidentally, than Richards and Jagger had paid for their country estates. He spent a further £20,000 doing it up, installing paintings by Peter Blake, a concealed cinema screen and even the gigantic clock that had once stood outside the Army and Navy Club in Pall Mall. Like so many self-made millionaires, however, he had trouble with the staff, a

married couple who did not take kindly to being ordered around by a Beatle. Eventually he sacked them and found new ones.[13]

The basic problem for all successful rock stars was that if they lived in London it was almost impossible to keep the fans and the press at bay. On a practical level, therefore, country houses made a lot of sense, not least since they usually had space for a recording studio and an army of hangers-on. Within a decade of moving into St John's Wood, then, not only had McCartney bought a 160-acre farm in Sussex, not far from Charlie Watts and Keith Richards, but he and his wife Linda had also bought their celebrated farm on the remote Mull of Kintyre. Meanwhile, Lennon and his second wife, Yoko Ono, had bought Tittenhurst Park, a sprawling Georgian house in Ascot in Berkshire, which they subsequently sold to Ringo Starr. If anything, George Harrison went one better, buying Friar Park in Henley, a gargantuan neo-Gothic mansion with Elizabethan, Japanese and Alpine gardens and, bizarrely, a scale model of the Matterhorn.

And where the Beatles and Stones led, others inevitably followed. Led Zeppelin's Jimmy Page, for example, bought Plumpton Place in East Sussex, an Elizabeth manor house that had been restored in the 1920s by Lutyens for Edward Hudson, the founder of *Country Life*. According to Page's estate agent, 'Jimmy's taste was always Gothic revival and the Arts and Crafts period', which was fairly typical of Sixties rock stars who had drunk deeply of the decade's romantic neo-Victorianism. Even Black Sabbath's Tony Iommi was not immune to the craze for country houses, briefly moving into another late Victorian pile, Kilworth House in Leicestershire. Alas, the practicalities of country living were too much for him. 'I tried to rebuild and redecorate it,' he wrote in his autobiography. 'I phoned up this one company and I saw this painter and decorator's van come up the long drive. He came to the house, looked at it, turned around and drove straight off.'[14]

In his autobiography, Iommi had great fun with the incongruity of 'a long-haired guy from Aston' living at Kilworth, 'this massive, 200-year-old house'. And yet, far from Iommi being the last person you might have expected to find in such a splendid country house, the fact is that he was *precisely* the kind of person you might expect. For Kilworth was not, in fact, two centuries old. When Iommi lived there, it was not even a century old. It had been built for John Entwisle: not the Who's bassist, but a successful Victorian businessman, whose family had made

their money in the Lancashire mills. Entwistle commissioned Kilworth in 1888 when he was only 32. Having just become High Sheriff of Leicestershire, he evidently felt he needed an Italianate status symbol. What this ambitious young man would have made of Tony Iommi can scarcely be imagined. Just possibly, however, he might have seen in him another talented young man who had made his money in one of contemporary Britain's most celebrated export industries.[15]

In 1967, at the height of the press infatuation with Swinging London, David Frost and Antony Jay published a mildly ridiculous book claiming that the 'ancient partitions' of class were being swept away. 'Carnaby Street usurps Savile Row; Liverpudlian pop stars weekend at ducal castles; dukes go out to work,' they gushed. 'The bad old system is smashed . . . The three great classes melt and mingle. And a new Britain is born.' But this was nonsense. In reality, a small group of talented, self-made men had suddenly banked a great pile of money from the rapid expansion of the entertainment market. Almost overnight, therefore, they found themselves propelled up the social hierarchy. And by sinking their winnings into country houses, they were doing exactly what self-made men had been doing for generations.

In his much-debated book on culture and industry in the nineteenth and twentieth centuries, Martin Wiener lists plenty of examples of bankers, manufacturers and industrialists who, ignoring the sneers of their detractors, bought or built country houses, sent their children to public schools and gradually worked their way into the old elite. The London banker Baron von Schroeder, for example, bought an estate in Cheshire in 1868, rode to hounds with the local hunt, became a local magistrate and finally became the county's high sheriff in 1889. And just as bohemian radicals of a later vintage were disappointed by Mick Jagger's social climbing, so Victorian radicals were frustrated that the new entrepreneurs were so easily assimilated into the old elite. 'Manufacturers and merchants as a rule seem only to desire riches', lamented Richard Cobden in 1863, 'that they may be enabled to prostrate themselves at the feet of feudalism.' Indeed, by the end of the nineteenth century the House of Lords was positively crowded with 'new men', from bankers and brewers to industrialists and newspaper barons. When the banker Nathan Mayer Rothschild took his seat on the red benches in 1885, it seemed altogether more shocking to many of his contemporaries than the thought of Sir Mick Jagger did to most people more than a century later.[16]

The fantasy of popular culture as a kind of classless enclave, untouched by the social distinctions that mark the rest of our national life, has proved remarkably enduring. But being mobile (or being aspirational) and being classless are not the same thing at all. Take one of the most celebrated examples of social mobility in British cultural life: Bryan Ferry, the former lead singer of Roxy Music. Ferry was born in the coal-mining town of Washington, between Sunderland and Gateshead, in 1945. His father, Fred, was a farm labourer whose working life seemed like something from the nineteenth century. He was 'very quiet, smoked a pipe, courted my mother for ten years, walked the five miles through the fields to see her and go back again because he had to be up to milk the cows', his son recalled many years later.

Young Bryan, however, was both clever and ambitious. Like the heroes of so many novels of the 1950s, he was determined to throw off the fetters of class and community. 'I didn't want to be kept down,' he explained. 'I didn't want to work in the mine or the local steel factory, which were the two main sources of work in the area that I lived in.' So he worked hard, went to grammar school, studied fine art at the University of Newcastle, became a ceramics teacher and eventually co-founded Roxy Music. Having made his money, he naturally bought himself a country house in Sussex. Like the previous generation of rock stars, however, he vigorously denied that he had moved up the social hierarchy. What class did he belong to now, asked a *Telegraph* interviewer in 2013. 'I'd say classless, definitely, I like to think,' Ferry said firmly. 'The class rigidity that some people still beat themselves up with in this country seems a bit old-fashioned to me now.'[17]

But of course the reality was more complicated. Describing his lifestyle in another interview, Ferry could hardly have sounded less classless:

> I normally go out on Friday night, so on Saturday I wake up quite late in my studio house in Chelsea . . . Then I head for Mount Street – one of the great streets of London – where I visit Rubinacci, a splendid tailor from Naples who always has wonderful fabrics, and also Anderson & Sheppard, a stalwart of Savile Row. My shirtmaker, Sean O'Flynn, is close by, as is the great bespoke shoemaker, Berluti.
>
> Saturday afternoon is a good opportunity to visit galleries, such as my friend Simon Lee's and Gagosian. I don't buy much contemporary art

myself, but I like to see what's showing. My collection is mainly
early-20th-century British art – Augustus John, Walter Sickert, Paul Nash
and Wyndham Lewis . . .

 If it is warm enough, I play tennis before lunch . . . I like entertaining
friends for lunch, too – it's a good excuse to go to the cellar and get out
some decent wine . . .

Shirtmakers? Bespoke shoes? A wine cellar? What would Fred Ferry
have made of all this? He would surely have considered it upper-class,
not least because it appeared in the luxury *Financial Times* magazine
How to Spend It. Fred might also have been struck by the fact that
Bryan sent his own four sons, Otis, Isaac, Tara and Merlin, to Eton and
Marlborough – and by the fact that Otis, who invaded the House of
Commons to protest against the Blair government's anti-hunting laws,
later became joint master of the South Shropshire Hunt. At the time of
writing, Fred Ferry's grandson is even ranked at number ninety-four on
the *Tatler* List of 'the people who really matter', probably the best advert
for revolutionary Marxism ever created.[18]

 Of course it is easy to mock Bryan Ferry's social ambitions. It is cer-
tainly a lot easier than it would be to emulate his extraordinary rise from
working-class Wearside to the fringes of the upper classes. It is easy, too,
to sneer at the rock stars in their country piles, cut off like political pris-
oners behind their dank green moats. But millionaire musicians such as
Keith Richards and Bill Wyman were really not so different from the
cultural superstars of Victorian Britain who, like them, had ploughed
their winnings into bricks and mortar. The comfort and status of the
country house were precisely what Charles Dickens had bought in 1856,
when he paid £1,700 for Gad's Hill Place,* the solid eighteenth-century
house that he had first glimpsed as a boy in the fields outside Rochester.
Dickens was very far from being a social climber: if anything, he became
more radical as he got older. But he was not alone in being unable to
resist the allure of a house in the country.[19]

 Almost half a century later, Rudyard Kipling – whose biographer
calls him 'the least socially pretentious of men' – paid £9,300, then an
almost unimaginable sum, for Bateman's, a glorious Jacobean house
near Burwash in Sussex. Like the rock stars of the 1960s, Kipling was

* And another £90 for the shrubbery across the road.

keen to get away from his fans, who would take day trips to his previous residence, just outside Brighton, and peer over the garden wall in the hope of seeing him at work. Like Keith Richards, he made self-deprecating jokes about his new house, insisting that it was not a country manor but merely the home of a successful seventeenth-century ironmaster – which was true, as it happened. And like his latter-day successors, Kipling took a mixed view of his responsibilities as a country squire. He enjoyed walking the fields in plus fours and discussing crops with his foreman, but he drew the line at attending the local fete. In this respect, at least, he was in tune with Keith Richards.[20]

THE MIDDLE-CLASS
CORONATION STREET

'As well as everything else,' Nick said, with determined brightness, 'I can't wait to see the house.'

Alan Hollinghurst, *The Line of Beauty* (2004)

When Keith Richards and Bill Wyman collected the keys to their country houses, they were not merely buying somewhere to live. They were buying into one of the most enduring of all British myths, embedded in everything from reassuring Sunday evening television series to the novels of Jane Austen and Walter Scott. The very idea of the country house has itself become a symbol of Britishness, or, more accurately, Englishness: an idealized, supposedly timeless paradise, set in a pastoral rural landscape, untouched by modernity. 'Of all the great things that the English have invented and made part of the credit of the national character,' wrote Henry James, 'the most perfect, the most characteristic, the only one they have mastered completely in all its details, so that it becomes a compendious illustration of their social genius and their manners, is the well-appointed, well-administered, well-filled country house.' Even in 1879, when James wrote those words, the power of the landed elite was on the wane. And yet not even two world wars, crippling death duties and the political eclipse of the aristocracy have shaken the extraordinary mystique of the country house. In 2013–14 almost 20 million people visited one of the National Trust's properties, which were staffed by more than 70,000 volunteers. 'They

'You think A. A. Milne is a motoring organisation, I suppose.' Penelope Keith and Peter Bowles, in character as Audrey fforbes-Hamilton and Richard DeVere in *To the Manor Born* (1981).

are the quintessence of Englishness: they epitomize the English love of domesticity, of the countryside, of hierarchy, continuity and tradition.' So, according to the historian Peter Mandler, runs the myth of the country house – which he promptly debunks, showing how this idea was invented in the twentieth century as a way of coming to terms with decline. But the myth is now too entrenched for even the most accomplished historian to make much of a dent in it. 'We've all been there,' began an article in the *Guardian* in October 2013. 'You're settling down in your chair ready for the new season of *Downton Abbey* in the glow of your vanilla-scented M&S Downton candle after a relaxing bath using your *Downton Abbey* cream bath (fragranced with subtle tones of freesia and mandarin) and you just can't relax. Really, who would place that vase there?'[21]

Like it or loathe it, *Downton Abbey* is one of the great British success stories of the last few years. When it first appeared on ITV in the autumn of 2010, this old-fashioned saga charting the life of a country house in the early years of the twentieth century was generally seen as an extremely expensive gamble. Yet buoyed by the early reviews – 'Is it really on ITV1? It feels just a little bit too, well, classy,' wrote one critic – the series rapidly became a popular phenomenon, attracting more than 10 million viewers a week. Then its appeal spread overseas. By January 2013, when PBS began showing the third series in the United States, it had become probably the best-known British drama series in the world. Here, the *New York Times* told its readers, was 'a bit of Britain where the sun still never sets', watched by an estimated 120 million people in some 200 countries, and rewarded by enough Emmys and Golden Globes to crush even the sturdiest mantelpiece. 'You travel thousands and thousands of miles, and you get off the plane, and someone says, "Is Mr Carson going to marry Mrs Hughes?"' said a gleeful Julian Fellowes, the show's writer. The actor who plays Carson the butler, Jim Carter, told an even better story. A few months earlier, after completing work on the third series, Carter had flown to Cambodia for a cycling holiday along the Mekong River. 'Amid the ancient temples of Angkor Wat,' reported the *New York Times*, 'he found himself wilting in the steamy climate – and suddenly swarmed by a group of Asian tourists screaming, "Mr Carson!"'[22]

By now *Downton Abbey* was so popular that it had earned its

own backlash. 'As a format and a concept', wrote the *Sunday Times*'s waspish critic A. A. Gill, 'it is everything I despise and despair of on British television: National Trust sentimentality, costumed comfort drama that flogs an embarrassing, demeaning and bogus vision of the place I live in.' Meanwhile, in a characteristically hissy piece for *Newsweek*, Simon Schama told American readers that the show served up 'a steaming, silvered tureen of snobbery ... servicing the instincts of cultural necrophilia'. Both agreed that it was basically a glorified soap opera: '*EastEnders* with better tailoring, and Maggie Smith', as Gill put it. Doubtless *Downton*'s fans would think the comparison horribly unfair. Yet, in an interview with *Vanity Fair*, Julian Fellowes himself admitted that one of the major inspirations for his old-fashioned melodramatic narrative was, of all things, *Coronation Street*. 'I have', he explained, 'a penchant for soap that informs my work.'

That would surely come as no surprise to anyone who had watched the show's first two or three series. Even the show's starting point – the wreck of the *Titanic*, which eliminates the two heirs presumptive to the estate, leaves Lady Mary Crawley, eldest daughter of the Earl of Grantham, bereft of a fiancé and opens the way for her middle-class cousin, Matthew – is the stuff of pure melodrama. So is the show's reliance on implausible or troubled romances, from Lady Mary's growing feelings for Matthew Crawley to the affair between her maid, Anna, and the scandal-plagued valet Mr Bates, or the preposterous relationship between her sister, Lady Sybil, and the family's Irish republican chauffeur, Tom Branson. Indeed, even the writers of *Coronation Street* or *EastEnders* might baulk at the storyline that sees Matthew, paralysed from the waist down in the Battle of the Somme, make a miraculous recovery. And what about the laughable episode in which a visiting Ottoman diplomat, Mr Pamuk, blackmails the homosexual under-butler into smuggling him into Lady Mary's room, where he not only seduces her into surrendering her virginity, but – in a truly outrageous contrivance – drops dead at the point of orgasm? This may well be the stuff of soap opera, but it feels more like *Dallas* or *Dynasty* than *Coronation Street* or *Emmerdale*. No wonder the Americans like it.[23]

The really striking thing about *Downton Abbey*, though, is just how extraordinarily conservative it is. In reality, as the historian Lucy Lethbridge has shown, the world of the early twentieth-century country

house was built on deference, fear and backbreaking toil. Most servants worked for long hours in dreadful conditions. Edna Wheway, who worked at a house in Dorset, used to scour fifty copper pans every week with green carbolic soap; in winter her hands were so badly chapped that she would weep with pain. Footmen scrubbed the silver so hard that their hands would become badly blistered. 'But in those days if you complained', one said later, 'you were just told to get on with it . . . The blisters burst and you kept on despite the pain.' Afterwards, while their masters relaxed with port and cigars, the servants retired to their damp, joyless quarters, dreaming of a liberation that might never come. Too much comfort, explained a housewives' manual of the day, was bad for them. Born and bred in poverty, servants were only happy 'if their rooms are allowed in some measure to resemble the home of their youth, and to be merely places where they lie down to sleep as heavily as they can'. And far from becoming fast friends with their servants, many aristocrats barely recognized them as fellow human beings. 'They weren't unkind,' recalled another woman, 'for the simple reason that they took no notice of you anyway. I honestly think they took no notice of you at all.' Not unpredictably, some of the worst employers were bohemian intellectuals of the Virginia Woolf type, who could not contain their contempt for 'skivvies with ideas'. In 1919, for example, the writer Katherine Mansfield described her own cook, who had just handed in her notice, as 'evil'. 'It is dreadful enough to be without servants,' Mansfield wrote bitterly. 'But to be with them – is far more dreadful. I cannot forget the dishonest hateful old creature down in the kitchen. Now she will go & I shall throw her bits to the dustman & fumigate her room & start fair again.'[24]

In 1900 domestic servants were the single biggest occupational group in the country, so it is a pretty safe bet that millions of people who regularly tune in to *Downton Abbey* are themselves descended from the men and women who used to scrub the silver. That makes it all the more striking that almost none of this appears in the series at all. Far from being exploited or downtrodden, Downton's staff are superbly treated, testament to the kind-hearted paternalism of their employer, Hugh Bonneville's saintly Earl of Grantham. Indeed, the servants are depicted as just as conservative, snobbish and status-obsessed as their social superiors. 'We may have to have a maid in the dining room,' the butler announces gloomily in the very first episode. 'Cheer up, Carson,' the

earl says breezily. 'There are worse things happening in the world.' Carson's face is like thunder. 'Not worse than a *maid* serving a *duke*,' he says grimly. Are we meant to laugh? A little, perhaps – although as *Vanity Fair*'s David Kamp points out, Julian Fellowes is the kind of man who, in his novel *Past Imperfect*, dismisses the drawing room of a social upstart because the carpet is too 'smooth and sprung and *new*'.*

Indeed, not only is Fellowes a carpet-obsessive, he is a title-obsessive, changing his name to Kitchener-Fellowes after marrying the great-grandniece of Lord Kitchener, and making a tremendous song and dance about the 'outrageous' rules that prevented her, as a woman, from succeeding to the Kitchener earldom. So perhaps it is hardly surprising that his characters think in exactly the same way. Even the opening titles show a servant carefully checking the distance for the table-settings with a ruler. Everything has to be just so; this is a society that depends upon absolute fidelity to the done thing. Any sign of disorder, from the late arrival of the newspapers to the presence of salt on the cook Mrs Patmore's raspberry meringue pudding, feels like the first stirrings of the Russian Revolution. Indeed, to Maggie Smith's Dowager Countess of Grantham, the guardian of upper-class values, even the slightest technological innovation seems a challenge to the old order. 'First electricity, now telephones,' she sighs. 'I feel as if I'm living in an H. G. Wells novel.'†[25]

Even before the first episode had gone out, Fellowes was eager to trumpet the novelty of setting his series in 1912, at precisely the point when landowners were indeed installing electric lights and telephones in their country houses. As he explained to the *Daily Telegraph*, he had picked this period 'because it was just before all the changes ... By the end of the series the family in this house has a telephone. You can smell those changes – they're already in the air. The modern world is coming in, so their life is much more recognisable to modern viewers.' Even the first page of his script made the same point. 'The sun is rising behind

* In fact, Fellowes mentions the quality of people's carpets no fewer than seven times in this book, on pages 12 ('over-springy'), 13 ('bouncy'), 202 ('thick'), 223 ('ravishing'), 300 ('matching Savonnerie'), 374 ('dirty shagpile') and 415 ('huge'). I have let him off the red carpet on page 283.

† A classic bit of historical signposting. In reality, would the dowager countess have known who H. G. Wells was? It is hard to imagine her poring over *Kipps* or *Tono-Bungay*, let alone *The Island of Doctor Moreau*.

Downton Abbey, a great and splendid house in a great and splendid park,' it begins. 'So secure does it appear that it seems as if the way of life it represents will last for another thousand years. It won't.' As most previews happily agreed, this was a breath of fresh air: a period drama set in an age of change. 'Downton Abbey seems sure to rattle preconceptions when it is broadcast over seven weeks starting later this month. It seizes on a beloved, long-standing television genre, shakes up its elements, and creates something new. Or rather, set as it is in 1912, something relatively modern,' enthused the Telegraph. But this was nonsense. The series on which Downton Abbey was obviously modelled, the enormously successful Upstairs, Downstairs (1971–5), followed a strikingly similar timeline, kicking off in 1903 and ending in 1930. Like Downton, it explored the impact of the suffragette movement, the First World War and the turmoil of the 1920s on an upper-class household, only in London, not in the country. In fact, the conflict between tradition and change has been the central theme in almost every country-house drama ever made, including the sitcom You Rang, M'Lord? (1990–93), which was also set in the 1920s. And, on the page, there is no bigger cliché than an Edwardian country house.[26]

That is not to say, though, that Fellowes did not know what he was doing. As the viewing figures suggest, he certainly did. What he had grasped is that the key to the country-house drama is the atmosphere of romantic melancholy that comes when we realize that the foundations are beginning to crumble. From a maid serving a duke in the dining room to the shock of the First World War, Downton Abbey, like all such dramas, portrays a world in which change is hammering on the gates. The paternalistic, ordered society, in which everybody knows the rules and everybody has his place, is already breaking up. Ahead lies only chaos, the shattered idols and broken images of the twentieth century. As the writer Jenny Diski, no Downton fan, points out in a thoughtful essay, the motif that drives all such books and programmes is the idea that 'nothing will ever be the same again'. In most cases, as she goes on to observe, 'the nothing that will ever be the same is the centuries-old entitlement of a small group of highly privileged people, for whom, for various reasons, we must feel sorry, both before and after the changes'. This is precisely why it is so important for country-house dramas to show us the lives of the servants, the Carsons and Bateses and Bransons.

They too have staked everything on the survival of the country house; if it all goes wrong, they, the little people, will suffer just as much as the great and the good. From the richest landowner to the humblest kitchen maid, they are all dancing on the edge of a precipice. And perhaps that explains the show's extraordinary appeal to audiences in the early 2010s. The ethos of *Downton Abbey* may be intensely conservative, but at a moment of intense economic uncertainty, with the headlines full of bank bailouts and protest marches, the series offers more than mere glamorous escapism. It is not just that, in an age of atomized individualism, it presents us with an idealized alternative Britain, a lost world of deference and hierarchy, an extended family governed by an enlightened patriarch. It is that it so accurately echoes our own anxieties about technological progress, international turmoil and social change, our nagging fear that the best has passed, and will never return.[27]

In this respect, *Downton Abbey* is hardly unusual, since modern country-house dramas have always reflected the anxieties of their age. The first twentieth-century writer to sell the English country house abroad was P. G. Wodehouse, whose influence is often underrated because he is seen as a purely comic writer. But it was Wodehouse, more than anybody else, who marketed the romanticized, pastoral vision of the English country estate to American readers. The timing is interesting: it was, in fact, at precisely the point at which *Downton Abbey* begins, just before the First World War, that the young Wodehouse realized how to break into the American market. 'I started writing about Bertie Wooster and comic earls because I was in America and couldn't write American stories and the only English characters the American public would read about were exaggerated dudes,' he explained later. 'It's as simple as that.'

This is the world evoked in his first Blandings book, *Something Fresh* (1915), which introduces us to the amiable, dreamy Lord Emsworth, sublimely indifferent to the anxieties that trouble his fellow countrymen. It is a world not just of daydreaming aristocrats, but, as one character explains to a visitor, of 'kitchen maids and scullery maids . . . chauffeurs, footmen, under-butler, pantry-boys, hall-boy, odd man and steward's-room footman . . . house-maids and nursery-maids', all united in one extended family. Yet Wodehouse's world is not, as is often thought, sealed off entirely from social change. Even the blissfully comic

Something Fresh acknowledges the existence of 'strikes, wars, suffragettes, diminishing birth-rates, the growing materialism of the age', while Wodehouse's masterpiece, *The Code of the Woosters* (1938), introduces us to the lingerie designer Roderick Spode, now better known as the leader of the fascist Black Shorts. Even in Wodehouse's world, in other words, we still hear the echoes of the twentieth century. But his country-house stories, unlike, say, Evelyn Waugh's novel *Brideshead Revisited* (1945), are not defined by social change. There is no sense of loss, no bittersweet melancholy. 'For Mr Wodehouse', Waugh observed in 1961, 'there has been no fall of Man, no "aboriginal calamity". His characters have never tasted the forbidden fruit. They are still in Eden.'[28]

It is Waugh himself who remains the guiding spirit of the country-house drama. Indeed, Brideshead, the house at the heart of his most famous novel, has become a symbol of the romantic nostalgia for which British popular culture is internationally famous. As Waugh explained in a later preface, *Brideshead Revisited* was intended to be above all a religious book, exploring 'the operation of divine grave on a group of diverse but closely connected characters'. But, as he admitted, the book had become 'infused with a kind of gluttony, for food and wine, for the splendours of the recent past, and for rhetorical and ornamental language', as a reaction against the atmosphere of the early 1940s, 'a bleak period of present privation and threatening disaster – the period of soya beans and basic English'. To Waugh, the standard-bearer of Catholic conservatism, the country house seemed a last redoubt of an embattled old England, a crumbling sanctuary from the secularism and socialism of modern life. And both in 1945 and subsequently, what struck readers about his book was not so much the religious theme – which many non-Catholics find baffling and implausible – but the lush, lovingly painted evocation of a vanished aristocratic Arcadia, the 'enchanted palace' into which Charles Ryder wanders one afternoon before the Second World War. It was this, not Waugh's Catholicism, that prompted the American Book-of-the-Month Club to offer him a deal worth a staggering £20,000: in terms of earnings, the equivalent of some £2 million today. It was this that made *Brideshead Revisited* a hit on both sides of the Atlantic. And it was this that, at the end of the 1970s, prompted Granada Television to adapt it for the small screen.[29]

Granada's adaptation of *Brideshead Revisited* is often described as one of the best television programmes Britain has ever produced. It was placed tenth in a survey by the British Film Institute of television professionals, and second in a similar survey by the *Guardian*. It was not, however, the unexpected success that is sometimes suggested. The previous decade had been awash with lavish historical costume dramas, kicking off in 1967 with BBC2's twenty-six-part adaptation of John Galsworthy's Edwardian sequence *The Forsyte Saga*, which cost an unprecedented £200,000, or as much as £8 million in today's money. Amusingly, the public reaction to *The Forsyte Saga* offered a strikingly accurate taste of what lay ahead for both *Brideshead Revisited* and *Downton Abbey*. Early reviews were ecstatic, and since many people did not yet have sets capable of receiving BBC2, in 1968–9 the entire series was repeated on Sunday evenings on BBC1. This time the applause was even greater, with audiences peaking at around 18 million, almost a third of the entire population. Some churches even altered the times of their evening services so that parishioners could watch it.[30]

Soon, however, the anti-*Forsyte* backlash began. At Oxford the new Professor of Poetry, Roy Fuller, devoted his inaugural lecture to attacking Galsworthy's 'middlebrow' and 'philistine' appeal, while in *The Times* the critic Henry Raynor dismissed the series as a glorified soap opera. The characters, he insisted, never changed or suffered; the show was merely '*Coronation Street* for the middle class'. As is so often the way, this drew a torrent of infuriated letters. 'This', said one man from Dorset, 'is an example of how critics tend to become quite divorced from the opinion of ordinary people, who can place little reliance on their criticism.' And one Mr Boydell of Leeds wrote in defence of the millions who had been so grievously insulted by Raynor's piece:

> Henry Raynor condemns the Forsyte Saga for being a glorified soap opera, and in so doing condemns the 17 million viewers who have enjoyed it.
>
> Why shouldn't we enjoy it?
>
> We are sick to death of living in a world where we are exhorted to be different from what we are by critics and politicians. We are tired of having a guilty conscience if we are luckier than our neighbours and of trying to take the burdens of Vietnam and Biafra on our shoulders.

Above all, we are sick of the sight and sound of scruffy teenagers and students and kitchen sink drama!

No wonder we are happy to escape for 45 minutes each week into a world of elegance and good manners and to enjoy watching the superb acting of Margaret Tyzack and Eric Porter.

I could happily watch it all over again.

If you change the names, it could easily be one of the letters that *Downton* fans send to the newspapers whenever somebody criticizes their favourite series.[31]

When, almost exactly ten years later, Granada began shooting *Brideshead Revisited*, the producers had every reason to expect a similar success. In the intervening decade, one costume drama after another, from *Upstairs, Downstairs* and *The Onedin Line* to *Poldark* and *I, Claudius*, had drawn millions of viewers. But *Brideshead* had an exceptionally troubled birth. After location filming on the island of Gozo, an ITV technicians' strike shut down production for four months. The director had to leave for another job, so he was replaced by the novice Charles Sturridge, who was still in his late twenties. Sturridge and his producer, Derek Granger, promptly decided that the current structure – five one-hour episodes – was too short, and that the series must be radically expanded. So now they were filming and writing at the same time, spending their evenings scribbling dialogue for the next day. By Christmas 1979 the script was finished, and the next few months were relatively plain sailing.

But then another, even bigger disaster struck. Because of the previous hiatus, Granada had had to renegotiate all the actors' contracts, and Jeremy Irons, who was playing Charles Ryder, had asked for a clause that allowed him time off if he was cast in the film of *The French Lieutenant's Woman*. Since he was in almost every scene, that meant production had to be shut down once again, this time until the autumn of 1980. Extraordinarily, the last scenes were not filmed until early 1981, more than a year and a half after the cameras had rolled for the first time. All in all, it had taken four years from the initial decision to go ahead to the final touches in post-production, while estimates of the total cost ranged from almost £5 million (according to Granada) to more than £11 million (according to the newspapers). As *The Times* put it, 'the operation of divine grace has proved breathtakingly expensive . . .

Nothing could sound more like a recipe for disaster on a scale previously only known to Hollywood and Lord Grade.'[32]

In fact, it was a recipe for triumph. Even before broadcast, Anthony Burgess, who had been asked to write a preview for the house magazine of Exxon – the oil giant having invested some $300,000 in the production – had proclaimed *Brideshead Revisited* 'the best piece of fictional television ever made', and 'even better than the book'. When the first episode went out on 12 October 1981, the reviews were euphoric, while some 10 million tuned in to watch, an astonishing figure given that Waugh's book is a much more rarefied pleasure than Galsworthy's saga. As with *Downton Abbey*, many people enjoyed pointing out the production's mistakes. Among the 'shocking errors' identified by one *Times* reader were the stripes on a sergeant major's uniform and Charles Ryder's habit of saluting while not wearing a cap, while another eagle-eyed viewer complained that the members of the Bullingdon Club would never have done up all their waistcoat buttons and that Sebastian Flyte would never have smoked a cigar with the paper band still on. 'We've had letters about the fashions, the morals, the cookery, the furniture, the interior decorations, the gardens, even the place settings at dinner,' said the producer, Derek Granger. 'We really have touched a nerve.'

The *Guardian* claimed that the series had 'divided the nation'. In reality, though, critical voices were very thin on the ground. By mid-December, when the series ended, it had become one of the great cultural accomplishments of the age: 'the drug of the middle classes', according to the *Express*. With bookings down on Tuesday nights, the nation's restaurateurs were reportedly praying for the series to end. But everybody else was cashing in. The paperback version of Waugh's novel sold 200,000 copies and topped the bestseller list for six weeks, while the soundtrack album sold 75,000 copies. In the nation's fashion houses, all the talk was of the 'Brideshead look'. 'It's an indulgent, extravagant look – wider ties, cravats and bow ties,' one menswear magazine advised high-street retailers. 'So opt for bold patterns for accessories – stripes, polka dots, Panama felt hats, braces and armbands for shirts.' What Waugh would have made of all this is anyone's guess.[33]

No sane person would seriously argue that *Downton Abbey*, with its laughable contrivances and fibreboard performances, is even remotely

in the same league as *Brideshead Revisited*. What they have in common, though, is a deeply conservative ethos that celebrates the English country house as the ideal of hierarchy and order, while presenting social change as something to be feared. Yet even as 10 million people were tuning in to *Brideshead*, even greater numbers were enjoying a country-house drama of a very different order. This was Peter Spence's sitcom *To the Manor Born*, which ran from September 1979 to November 1981 and attracted gigantic audiences. Almost 24 million people watched the finale of the first series – the biggest audience for any non-live event of the 1970s – while more than 21 million people watched the last episode, placing it fifth in the chart for the 1980s.

To the Manor Born is the story of an upper-class widow, Audrey fforbes-Hamilton (Penelope Keith), who is forced to sell her ancestral home to a supermarket millionaire (the incomparable Peter Bowles). It might easily have been another lament for a lost world. 'Here we are in the midst of a Recession', wrote *The Times*'s reviewer in December 1979, 'with starvation in Cambodia, boat people in Vietnam and the Mullahs on the warpath in Islam' – presumably Iran; the late 1970s was not the paper's finest hour – 'and there is Penelope Keith as Mrs fforbes-Hamilton, the gentry widow, about to burst her tweed seams because a Jew has moved into the manor and is acting like the squire.'[34]

But the show is not quite as conservative as it seems. We soon discover, for instance, that Audrey really is the most dreadful snob. 'To think that Grantleigh is in the hands of a man who has no interest in farming, doesn't go to church and now, it turns out, hasn't even heard of Winnie the Pooh,' she says witheringly to her successor in the third episode. 'You think A. A. Milne is a motoring organisation, I suppose.' Yet the millionaire in question – ostensibly 'Richard DeVere', but actually Bedrich Polouvica, whose mother brought him to Britain from Nazi-occupied Czechoslovakia in 1939 – turns out to be a thoroughly decent chap. And as time passes, Audrey not only falls in love with a man she originally despised, she also comes to appreciate the virtues of modernization. Far from shrinking from change, *To the Manor Born* ends up embracing it – quite literally, in fact, as the final series ends on the two leads' wedding day.

It is true that this represents the restoration of the old order, since Audrey ends up back at Grantleigh after all. But it is only after she

changes, abandoning some of her old snobbery and recognizing that not everything was better in the past, that she gets her hands on the keys. It might be fun to interpret the series as an extended metaphor for Britain under Thatcherism, with the marriage of Audrey and Richard representing the union of the old landowning classes and the new breed of self-made men, the estate owners and the estate agents. In fact, as the writer Peter Spence explained, it was based on a true story that he had heard from a 'well-known Cockney comedian', who bought a large manor house and invited the previous owner, a widow, to the housewarming party, with disastrous consequences. Interestingly, Spence toyed with the idea of presenting Audrey's antagonist as a pop star, but dropped it because 'up against a character as forceful as Audrey they would present no contest'. So the world was denied the spectacle of Penelope Keith flaying Mick Jagger alive every Sunday night. That certainly would have been worth seeing.[35]

PARADISE LOST

As I drove away and turned back in the car to take what promised to be my last view of the house, I felt that I was leaving part of myself behind . . .

A door had shut, the low door in the wall I had sought and found in Oxford: open it now and I should find no enchanted garden.

Evelyn Waugh, *Brideshead Revisited* (1945)

The success of *To the Manor Born*, *Brideshead Revisited* and *Downton Abbey* is merely one aspect of a far wider story. For much of the twentieth century, the world of the country house had seemed to be in a deep and terminal decline. The world wars had taken a heavy toll on the old rural estates, the supply of domestic servants had virtually dried up and marginal tax rates and death duties were making it impossible for many landowners to keep their houses in a decent condition. Even middle-class Conservative papers shrank at the thought of bailing out the old order: in a blistering attack on 'doles for dukes' in 1953, the *Daily Express*

Anthony Andrews as Sebastian Flyte in *Brideshead Revisited* (1981), the very image of upper-class style.

savaged politicians who wanted to 'bolster up those who exist on the fruits of privilege, inheritance and lack of enterprise'.

Yet even as more houses disappeared beneath the wrecking ball, the mood was changing. As Peter Mandler shows in his history of the stately home, it was not just that aristocratic owners, copying the formula pioneered at Warwick Castle, Beaulieu and Longleat, were turning themselves into entrepreneurs. The real change was the fact that higher wages, paid holidays and car ownership had created a vastly expanded market for day trips. And with the new anti-urban, anti-modern spirit of the late 1960s and 1970s, interest in the lost world of the rural country house reached unprecedented heights. The biggest winner was the National Trust. Founded in 1895, it grew very slowly at first, and by the 1920s its membership stood at barely 1,000 people. Yet by 1960 its membership had reached 100,000; by 1970, 200,000; and by 1980, when *To the Manor Born* was at its peak, it reached 1 million. By the end of the century, surveys found that between a third and a half of the entire population had visited a stately home in the previous year. And ever since, the Trust has carried on growing. Today its membership stands at just under 4 million people – a figure, as its website proudly points out, that is six times bigger than the membership of all Britain's political parties put together.[36]

Given the enormous public appetite for visiting country houses, as well as the proven success of country houses in films and on television, perhaps it is hardly surprising that many of Britain's finest contemporary novelists have turned their hands to emulating Evelyn Waugh. The twenty-first century alone has given us Ian McEwan's *Atonement* (2001), Alan Hollinghurst's *The Line of Beauty* (2004) and *The Stranger's Child* (2011), A. S. Byatt's *The Children's Book* (2009) and Sarah Waters's *The Little Stranger* (2009), and this is merely to scratch the surface. There are, of course, perfectly good aesthetic reasons to write about a country house. For the critic Blake Morrison, what attracts modern writers to the country-house novel is the 'opportunity to play with ideas and motifs that date back centuries'. Similarly, the American writer Lev Grossman observes that there is 'a romantic melancholy about them: each one is a little universe the sustaining god of which has died, never to be revived, leaving this even more elegant husk behind'. And yet you do not, I think, have to be unduly cynical to suggest that there may be a more basic reason, too. Writers need to make money, and country-house novels sell very well. In the mid-1980s, Kazuo Ishiguro

was a tremendously well-respected, prize-winning young novelist with two acclaimed but hardly bestselling books to his name. At this point, as he explained to the *Paris Review*, he decided it was time 'to write for an international audience'. So he cast around for 'a myth of England that was known internationally – in this case, the English butler'. The result was *The Remains of the Day* (1989), the beautifully subtle story of a butler who worked in a great house during the years of appeasement. Not only did it win the Booker Prize, it secured him a Merchant Ivory film deal and sold more than a million copies. The butler had done the trick.[37]

The challenge, and presumably much of the fun, of writing about country houses is that the author simply has to shoulder the weight of all that has come before. As Lev Grossman colourfully puts it, modern writers have to build their houses 'out of words recycled and scavenged from other descriptions of other country houses'. By far the most favoured site for salvaging and scavenging, not surprisingly, is *Brideshead Revisited*. It was Waugh who popularized the simple but enormously effective device of having his central character, an outsider from a lower social caste, act as a kind of tour guide, introducing us to the house in tones of awestruck admiration. This is how Waugh's narrator, Charles Ryder, first sees his personal Arcadia:

> We drove on and in the early afternoon came to our destination: wrought-iron gates and twin, classical lodges on a village green, an avenue, more gates, open parkland, a turn in the drive; and suddenly a new and secret landscape opened before us. We were at the head of a valley and below us, half a mile distant, grey and gold amid a screen of boskage, shone the dome and columns of an old house.
>
> 'Well?' said Sebastian, stopping the car. Beyond the dome lay receding steps of water and round it, guarding it and hiding it, stood the soft hills.
>
> 'Well?'
>
> 'What a place to live in!' I said.

Suggestively, they go in not through the front door, but through the 'fortress-like, stone-flagged, stone-vaulted passages of the servants' quarters': ostensibly to meet Sebastian's old nanny, but of course this also hammers home Charles's position as an outsider. At last, Sebastian

leads him into a darkened hall. And there, for a fleeting but wonderful moment, Charles gets to see Brideshead's interior in all its glory, the afternoon sun flooding in over the great marble fireplaces and frescoed ceiling. He feels a bit like a man peering 'from the top of an omnibus into a lighted ballroom', catching a brief glimpse of a world in which he does not belong. And that, of course, is exactly how millions of people feel when they troop around a National Trust house on a wet Sunday afternoon – or, indeed, when they curl up in front of *Downton Abbey*.[38]

To anyone who has read a country-house novel published in the last few decades, the sensation of being an outsider looking in may seem oddly familiar. Country-house novels are full of Charles Ryder types, glorified day-trippers who find themselves unexpectedly ushered through the rope barriers into a lost paradise. So, in A. S. Byatt's novel *The Children's Book*, we first see the rambling old Kentish house, Todefright, through the eyes of a little boy, Philip, who has run away from the Potteries and been rescued by the bohemian Wellwood family. In Ian McEwan's *Atonement*, our guide to the Tallis family's mock-Gothic house is Robbie, the housekeeper's son, who has hauled himself up and got into Cambridge. And in L. P. Hartley's brilliantly suffocating book *The Go-Between* (1953), we travel to Brandham Hall with another displaced little boy, Leo Colston, whose schoolmate has invited him to stay. In *The Go-Between*, as in *The Children's Book*, there is a lot of stuff about wearing the wrong clothes – there being no better way, as anyone who has ever misread an invitation will know, of making somebody feel utterly inferior. Poor Leo's clothes are much too hot, so he asks his friend Marcus if he should wear his 'cricket togs' instead. 'Only cads wear their school clothes in the holidays,' says Marcus, a truly horrible little boy. 'It isn't done. You oughtn't really to be wearing the school band round your hat, but I didn't say anything. And, Leo, you mustn't come down to breakfast in your slippers. It's the sort of thing that bank clerks do.'[39]

The writer who draws most obviously on *Brideshead Revisited* is Alan Hollinghurst, who has a decent claim to be the best British novelist of the last two or three decades. As Hollinghurst once told the *Guardian*, he rather resented being 'saddled with *Brideshead*'. And yet, he conceded in an interview to promote *The Stranger's Child*, 'I have now

twice used the idea of a young person who falls in love with a richer family, in *The Line of Beauty* and this book. So there must be something to it.' In *The Line of Beauty* – for my money, as elegant and accomplished a book as any produced in the last quarter of a century – our young outsider is the aptly (if a bit unsubtly) named Nick Guest, the gay son of a provincial antiques dealer, who is taken up by the rich Fedden family. The book opens with Nick already in residence at the Feddens' house in Notting Hill, but before too long he joins them on a trip to Hawkeswood, the sprawling mock-chateau that belongs to Mrs Fedden's brother, Lord Kessler.

For Nick, the first glimpse of the house is a moment of almost physical ecstasy: a 'complete climax', indeed. And, like Charles Ryder, Nick feels what Hollinghurst calls 'a hilarious sense of his own social displacement'. Tellingly, when Gerald Fedden encourages him to look around, he reminds Nick that 'the house is never open to the public'. Nick is, in other words, not merely a guest; he is a tourist, a tripper.* Here, too, he is following in the footsteps of Charles Ryder, who finds it 'an aesthetic education to live within these walls, to wander from room to room, from the Soanesque library to the Chinese drawing room'. 'Oh, Charles, don't be such a tourist,' says Sebastian, after his friend shows too much interest in Brideshead's dome. 'What does it matter when it was built, if it's pretty?' Charles insists that it is 'the sort of thing I like to know', just as it is the sort of thing that Nick's antiques-dealing father needs to know. But it is also the sort of thing that identifies him as irredeemably middle-class. 'Oh dear,' says Sebastian, 'I thought I'd cured you of all that.'[40]

For the outsiders admitted to these secret worlds, there is, at least at first, the thrilling sense of having been allowed into a lost Eden. When Charles falls in with Sebastian at Oxford, he feels as though he has been given 'a brief spell of what I had never known, a happy childhood, and though its toys were silk shirts and liqueurs and cigars and its naughtiness high in the catalogue of grave sins, there was something of a nursery

* It is perhaps worth noting that, when Hollinghurst shared a house with his friend Andrew Motion, the two were regular visitors to country houses. In the latter's words, 'we kept the National Trust going all by ourselves'. (See the Hollinghurst profile in the *Observer*, 17 October 2004.)

freshness about us that fell little short of the joy of innocence'. Similarly, in *The Go-Between*, Leo feels temporarily liberated from his old self; roaming around the gardens of Brandham Hall, he imagines that he has been 'given the freedom of the heat'. Like Charles, he idolizes his aristocratic patrons, 'those resplendent beings, golden with sovereigns ... citizens of the world who made the world their playground, who had it in their power (for I did not forget that) to make me miserable with a laugh and happy with a smile'. And in *The Line of Beauty*, too, Nick Guest falls unashamedly in love with the patrician family who have ushered him into their private world. Alone in the Feddens' townhouse, he loves to climb the stairs past the double drawing room, imagining himself 'leading someone up them, showing the house to a new friend ... as if it was really his own, or would be one day: the pictures, the porcelain, the curvy French furniture so different from what he'd been brought up with'.[41]

The idea of the aristocratic house as a secret Garden of Eden, its gates closed to the anxieties of the modern world, is immensely powerful. It is this idea, after all, that is at the heart of shows like *Downton Abbey*: the lost paradise, holding out as long as possible against the intrusions of modernity. It is this idea, too, that surely explains much of the appeal of country houses to tourists and day-trippers: the chance to throw off the cares of the present and to escape into a romantic Arcadia. Hollinghurst himself uses it again in his next novel, *The Stranger's Child*. In a section set in 1967, a young gay couple meet at the gigantic Victorian pile of Corley Court, which has now been taken over by a private school. Peter is a teacher at the school, yet as his car turns into the drive, he feels a Charles Ryder-style thrill at the prospect of entering a secret world, where the noise of the traffic fades into nothingness, a world infused with a 'magical mood, made out of privilege and play-acting'. It is easy to see why, to a gay writer who came of age in an era when homosexuality carried an unmistakeable social stigma, the theme of the secret garden might be very appealing. This is exactly what Charles Ryder is looking for in Oxford in the early pages of *Brideshead Revisited*: the 'low door in the wall, which others, I knew, had found before me, which opened on an enclosed and enchanted garden, which was somewhere, not overlooked by any window, in the heart of that grey city'.[42]

But the underlying story of the modern country-house novel is ultimately the collapse of the dream, the shattering of the illusion, the fall from grace. Far from being the 'resplendent beings' that Leo Colston imagines, the typical house's inhabitants invariably prove all too human. Inevitably there comes a moment when the veneer cracks and the novel's protagonist, cruelly reminded of his own social inferiority, sees them for the arrogant snobs that they really are. So when Charles Ryder tries to stop Sebastian drinking, the latter is quick to put him in his place: 'What the devil's it got to do with you? You're only a guest here – *my* guest.' When Leo, troubled by his conscience, refuses to carry a letter to the upper-class Marian's illicit lover in *The Go-Between*, she says something very similar: 'You come into this house, our guest . . . we take you in, we know nothing about you, we make a great fuss of you . . .' And when, in *The Line of Beauty*, the Feddens are brought down by scandal, they waste no time in casting Nick as the scapegoat. 'Remind me how you came to be here,' says the disgraced Gerald Fedden coldly. Then, like Marian in *The Go-Between*, he twists the knife:

> I mean, we've always been very kind to you, actually, I think, haven't we? Made you a part of our life – in the widest sense. You've made the acquaintance of many remarkable people through being a friend of ours. Going up indeed to the very highest levels . . . I mean, didn't it strike you as odd, a bit queer, attaching yourself to a family like this?

When Nick has the temerity to answer back, Gerald's mask is pulled away completely: 'Do you honestly imagine that your affairs can be talked about in the same terms as mine? I mean – I ask you again, who are you? What the fuck are you doing here?' And even though we, unlike Nick, have seen it coming, there is still something shocking about the sheer force of his social contempt.[43]

As Nick leaves the Feddens' house for the last time, the street is empty, the skies are grey and, in stark contrast to the warm sunlight with which the book opens, there is rain in the air. Indeed, perhaps the real lesson of the modern country-house novel is that if you are ever staying in an upper-class household and notice rainclouds overhead, you ought to start packing immediately. Charles Ryder arrives at Brideshead 'on a cloudless day in June, when the ditches were creamy with meadowsweet

and the air heavy with all the scents of summer',* but as soon as he starts talking about puddles on the terrace, we know that his relationship with Sebastian's sister Julia is doomed. During Leo's stay at Brandham Hall, he delights in recording the sweltering summer temperatures, the mercury climbing higher and higher as the novel's sexual tension nears its unbearable climax. But by lunchtime on his birthday the sky has an 'ominous look, white upon grey, grey upon black' – and then, at the very moment when Mrs Maudsley discovers that he has been carrying secret letters for her daughter, the storm breaks and rain pours down. When, in *Atonement*, Robbie walks to the Tallis house, he feels 'the warm, still air saturated with the scents of dried grasses and baked earth'; yet when he leaves in handcuffs hours later, it is in the grey, smudged mist of early morning. Even *The Children's Book*, which ends with the mud of the First World War, opens with a midsummer party.[44]

So it is that our hero is cast out of Eden into the cold grey dawn of the real world. But when we close the last page, do we care more about the narrator, blighted and betrayed, or about the vanished world of country-house elegance? All these books, from *Brideshead Revisited* onwards, were written at a time when the life of the country house was under tremendous pressure, and all of them, one way or another, show how the realities of the twentieth century took a heavy toll on Britain's upper-class elite. Indeed, the default ending for the contemporary country-house novel is that at least some of its bright young characters are killed off in a world war, while the house itself is reduced to a pathetic shadow of its former glory. In *The Go-Between*, the Maudsley boys are killed in the First World War; in *The Children's Book*, the Wellwood boys and their friends are killed, mutilated and driven mad by the horror of the trenches. In *The Stranger's Child*, the aspiring poet Cecil Valance is killed on the Somme while his house is converted into a school. In *Atonement*, Robbie dies in the retreat from Dunkirk, his lover, Cecilia, is killed in an air raid and the Tallis house is converted into a hotel. And even in *The Remains of the Day*, which avoids most

* There is an obvious allusion here to Edward Thomas's poem 'Adlestrop' (1917), one of the most celebrated modern evocations of pastoral England: not just the time of year ('late June') and the meadowsweet, but the overpowering sense of nostalgia for a lost summer's day.

of the clichés associated with the country-house novel, the Second World War effectively destroys Lord Darlington, who has staked his career on appeasement, while Darlington Hall, reduced to a shell, is sold to an American. The butler, Mr Stevens, draws up a plan to run the house with a staff of just four – compared with a team of twenty-eight at Darlington Hall's peak – with the servants' quarters and the guest corridor being 'dust-sheeted', which is exactly what happened to many real country houses after the Second World War.

The most famous example, though, is Brideshead. When Charles Ryder at last returns to the house, the Second World War is under way and British troops are preparing for the invasion of France. Having been taken over by the army, the house is a ruin, its walls and fireplaces boarded up, its tapestries ripped down, its painted rooms vandalized, its parkland disfigured by roads, its balustrade smashed by a three-ton lorry, its fountain filled with cigarette-ends and the remains of the drivers' sandwiches, recalling the imagery in T. S. Eliot's poem *The Waste Land* (1922).* 'It doesn't seem to make any sense – one family in a place this size,' says the hateful Hooper, who is Waugh's personification of socialist meritocracy. 'What's the use of it?'[45]

Not all country-house novels go in for the openly reactionary nostalgia that became *Brideshead*'s lasting legacy. In Sarah Waters's tremendously clever and greatly underrated *The Little Stranger*, which appears to be an old-fashioned ghost story set in a decaying country house in the late 1940s, the narrator's romantic fantasy of country-house life eventually reveals itself to be a kind of madness. We think we are reading another book about the lost paradise of the country house, narrated by a middle-class outsider, but we come to realize that the romantic nostalgia is all in his strange and tortured mind.

But the fact that this makes *The Little Stranger* feel so unusual is very telling. For although the writers themselves are often quick to deny that the country-house novel is an inherently conservative genre, even the very best of them simply cannot help themselves from falling into misty-eyed nostalgia. Almost despite their best intentions, they give us a lost world of soaring domes, dazzling windows, gleaming silver and cloudless summers. And although they often take care to shatter the

* 'The river bears no empty bottles, sandwich papers, / Silk handkerchiefs, cardboard boxes, cigarette ends / Or other testimony of summer nights.'

illusion at the end of the book, it is nevertheless the illusion, painted with such meticulous care, that we remember. So it is that *Brideshead*'s influence lives on. And so it is that, more than a century after its peak, the world of the country house, with its atmosphere of romantic melancholy, its sexual charge, its lost innocence, its sparkling sunlight and gathering shadows, retains its place at the centre of our national imagination. Indeed, the longest-running country-house drama of all has probably never been more popular. And that, of course, is the story of the Windsors.

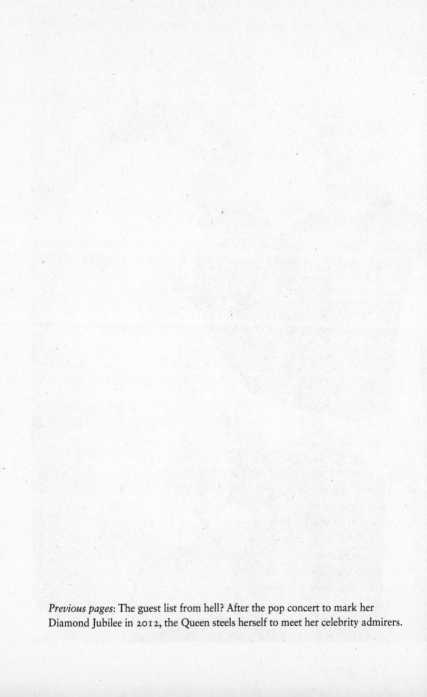

Previous pages: The guest list from hell? After the pop concert to mark her Diamond Jubilee in 2012, the Queen steels herself to meet her celebrity admirers.

5

God Save the Queen

PARTY AT THE PALACE

Your Majesty – Mummy – ladies and gentlemen, in my long
experience of pop concerts, this has been something very special
indeed. I don't think that any of us will ever forget this evening.
It really has been a wonderful celebration of some of the best of
British musical talent . . . And when you're talking about British
talent, my goodness, there's a lot of it about.

> Prince Charles, speaking at 'Party at
> the Palace', 3 June 2002

On 22 June 1897, London celebrated Queen Victoria's Diamond Jubilee. With Britain's imperial prestige at its height, the celebrations naturally had a distinctly martial flavour. To cheers from the vast crowds, estimated at several hundred thousand, colonial troops from India, Canada, Australia, New Zealand and Africa, as well as assorted colonial statesmen and Indian princes, marched through the centre of London. For the elderly Victoria, it seemed a supremely personal tribute: the crowds, she wrote in her diary, were 'quite indescribable and their enthusiasm truly marvellous and deeply touching'. But as *The Times* remarked the next day, the event had been above all a celebration of 'a great kingdom and a huge Empire'. It was with considerable relish that the newspaper listed the various detachments marching through London, a 'long and splendid panorama of Empire', from the Sierra Leone Artillery and Frontier Police to the West Australian Infantry. The onlookers, it noted in passing, had 'showed not a trace of insular intolerance'. Indeed, the people of London seemed delighted by the exotic

The triumph of music, 2002. From the roof of Buckingham Palace, Brian May treats the vast crowd to an unconventional version of the national anthem.

appearance of the marchers, being especially intrigued by the officers of the Imperial Service Troops, led by Sir Partab Singh, whose 'dark-bearded faces [and] strange and rich uniforms . . . excited roars of applause'. The real darling of the crowds, though, was Field Marshal Lord Roberts, the hero of Kandahar, who led the troops through Victoria's capital on a handsome Arab stallion. 'There were no signs yesterday', said a triumphant editorial, 'of those "craven fears of being great" which have sometimes appeared to make our people recoil from the weight of Empire.'[1]

The mind boggles at what *The Times*, or indeed the people lining the streets in June 1897, would have made of Elizabeth II's Diamond Jubilee, held more than a century later. No doubt they would have enjoyed the Thames river pageant, although perhaps not if they had been watching the BBC's *Tiswas*-style coverage. But they would surely have been stunned to discover that for millions of people the highlight of the celebrations in June 2012 was not the national service of thanksgiving, or even the visit of so many Commonwealth prime ministers, but the Diamond Jubilee concert, held outside Buckingham Palace on the evening of 4 June. And perhaps they would also have raised an eyebrow or two at the identity of Lord Roberts's spiritual heir, leading his troops on stage to a roar of acclamation. This was none other than Gary Barlow, of Take That, *X Factor* and charity-campaigning fame. As a 'royal source' explained to the *Sun* (which ran the story under the inspired headline 'Could It Be Maj-Ic?'), the octogenarian monarch had been a keen admirer of Barlow's career for some time. 'Her Majesty has been made well aware of his charity work and the events he has put together,' said the mysterious source. 'Gary's got the power to pull in some big names and ensure it's a party to match the occasion.'[2]

Whatever you might think of Gary Barlow's accountant, there can be no disputing the quality of his address book. Although Cliff Richard inevitably put in an appearance,* the line-up for the Diamond Jubilee concert could hardly have been more impressive, featuring contemporary stars such as Jessie J, will.i.am and Ed Sheeran as well as old favourites such as Robbie Williams, Tom Jones, Annie Lennox, Elton John, Kylie Minogue, Stevie Wonder and Paul McCartney. Some 17 million people watched on television, although the Queen herself did not

* So did Rolf Harris, unfortunately.

make an appearance until late in the proceedings, when Barlow escorted her on stage. The singer could hardly contain his delight, telling the *Manchester Evening News* that it was 'the biggest achievement' of his life.

Interviewed on television, some of the other musicians involved in the concert seemed amused by the incongruity of the occasion: Madness, for example, joked about being 'four scumbags from Camden Town unleashed on the top of Buckingham Palace'. For Gary Barlow, however, even the slightest trace of irony was probably tantamount to treason. 'I think artists', he said seriously, 'are so honoured to be involved in this show.' In fairness, however, he was far from alone. The Queen was 'a remarkable woman, and I'm very proud to be asked to play', said Elton John, no stranger to royal occasions. 'She's brilliant, she's wise, she's funny, and we're all very happy to be here.' Even the suspiciously raven-haired Paul McCartney, who had first played before a royal crowd at the Royal Variety Performance in November 1963, seemed in unnaturally earnest form. 'She's only one woman,' he conceded, 'but what a great woman, what a fantastic job she's done ... she's amazing. She's a really good example for Britain.'[3]

As far as most of the press were concerned, the Jubilee had been a triumph. But for at least one 'convinced and unshakeable monarchist', it had been a deep disgrace. 'It was awful,' wrote the *Mail on Sunday*'s Peter Hitchens:

> The worst moment of all was the Buckingham Palace concert, where the poor Queen pledged allegiance to the vile new culture of talentless celebrity. Any institution that has to suck up to Grace Jones and Paul McCartney to get down with the kids has plainly lost the will to live.
>
> It is a measure of how bad things have got that Her Majesty has to pretend to like the cacophonous, semi-literate, musically trite rubbish that seems to have invaded almost every space in this country. I bet she loathes it, really ...
>
> Its songs are the hymns and anthems of the modern religion of The Self. Self-pity. Self-indulgence. Drugs. Loveless sex. They are the exact opposite of the Queen's pledge, made on her 21st birthday in 1947, that 'My whole life, whether it be long or short, shall be devoted to your service'.

It is easy to see why a very conservative writer might come to such a gloomy conclusion. For many viewers, after all, the highlight of the evening had been Madness's appearance on the roof of Buckingham

Palace, singing 'Our House'. On the face of it, this looked like the moment seven ordinary Londoners reclaimed the supreme symbol of inherited privilege for the masses.

But that would be to mistake appearance for reality. Madness had not taken possession of Buckingham Palace any more than the Queen had abased herself before the gods of celebrity and self-indulgence. A very different commentator, the art critic Jonathan Jones, was closer to the mark in the *Guardian*. Studying a photograph of the Queen and Prince Charles on stage before their assembled troubadours, among them Paul McCartney, Elton John, Cheryl Cole, and Peter Kay in a Beef-eater's outfit, Jones argued that 'the new triumph of the royal family is a cultural achievement accomplished with all the art and finesse on show in this picture . . . This is statehood [*sic*] as showbiz.' And this, if the polls were to be believed, was exactly what the public wanted. By the time of the Diamond Jubilee, the popularity of the Royal Family had reached record levels. As the *Guardian* rather grumpily reported, sup-port for the monarchy now outstripped opposition by 47 per cent, the largest margin since the pollsters ICM had first posed the question. Asked what should happen when the Queen died, just one in ten people thought that Britain should become a republic, while the Queen's per-sonal approval rating was close to 90 per cent, better than almost any other head of state outside North Korea. Not even Victoria had been so popular.[4]

As both Hitchens and Jones recognized, most people find it weirdly incongruous to see the Queen on stage alongside pop stars like will.i.am or Jessie J. In reality, though, it is no odder than the spectacle of Keith Richards in a country house. Musicians, entertainers and national cul-tural heroes are precisely the kinds of people that monarchs have been associating with for centuries. Indeed, the idea that Elizabeth II and Jessie J really ought to be on opposite sides of the barricades is based on a double misunderstanding. First of all, kings and queens have always relied heavily on art and music. Holbein worked for Henry VIII, and Handel for George II. Both Ralph Vaughan Williams and William Wal-ton wrote music for the coronation of George VI in 1937 as well as that of his daughter sixteen years later. It is true that the Royal Family were painfully slow to adjust to changing tastes during the 1960s and 1970s, which is when the image of the Windsors as a family of Vera Lynn-loving sticks-in-the-mud became engrained in our national consciousness. But

in embracing the new culture of rock and pop music, the Queen was hardly tearing down centuries of tradition. What she was doing, in fact, is what sensible monarchs always do, from Roman emperors to Hanoverian kings: exploiting the cultural talents of her people in order to present herself and her family in the best possible light. As the music writer Alexis Petridis remarked, the moment that Madness appeared on Buckingham Palace could hardly have been better publicity for a family determined to show itself as humble, good-humoured and self-deprecating, even amid the pageantry of the Jubilee. 'It looked genuinely spectacular,' he wrote, 'a solitary moment that even the most implacable opponent of the monarchy might have felt themselves softening at least a little to the event.' And that, of course, was the point.[5]

The more persistent misunderstanding, though, is the idea that rock music is, or was, or ought to be, subversive and confrontational, a gesture of defiance towards the rich and powerful. If it were, that would make it very unusual. For most of history, musicians have done as they were told. Ancient musicians tended to be slaves or prostitutes, while the founders of the European classical tradition, such as Bach, Handel, Haydn and Mozart, were heavily dependent on the patronage of the powerful and well-to-do. Since rock music was born in an age of mass consumerism, its performers had no need of rich patrons: they merely needed to please their record companies, which meant pleasing their audiences. Of course it has always suited rock stars to pose as romantic rebels, and the idea of the musician as a man apart, driven only by the cult of his own genius, has a long pedigree. Franz Liszt and John Lennon would have got along famously, as long as there was room for both their egos. It is also true that rock music has often had a political element: during the 1960s it played a part in the American civil rights and anti-war movements, and during the 1970s organizations such as Rock Against Racism played a vital role in making it deeply unfashionable for teenagers to hold (or at least express) racist opinions. But all this is easily overstated. As a glance at the charts for the last forty years, or even at rock music's own musical canon, will immediately confirm, rock was no more intrinsically subversive than classical music, opera, music hall, sea shanties or anything else. The blues might have originated in the slave songs of the American Deep South, but the British teenagers who bought the first Rolling Stones records were not rebelling against the

slave-owning establishment or the capitalist system. They were rebelling against their parents; that is, if they were rebelling at all.[6]

Despite the music industry's self-image, the history of British rock and pop is littered with performers who were patriotic, conservative and great admirers of the Royal Family. Take, for instance, the former Acton messenger boy Adam Faith, who was the only serious rival to Cliff Richard as the leading British rock and roll singer of the late 1950s. In Faith's autobiography, published in 1961, the photo inserts show him riding a horse, playing golf in a Pringle sweater and shaking hands with the Queen Mother. People often ask him, he says, what has been the 'highspot' of his career so far:

> I don't have to think before I answer that question. There's only one high-spot as far as I'm concerned. That's the night that I was included among the stars honoured to appear before the Queen and Prince Philip at the 1960 Royal Variety Performance at the Victoria Palace ...
>
> He [Prince Philip] put on that famous quizzical smile of his and almost winked at me.
>
> 'This isn't your usual garb, is it?' he said humorously. And, suddenly, I felt as proud as Punch, because it meant that at least I was known to him from TV or the papers.
>
> I went home in a daze that night, saying to myself, 'Terry Nelhams, for an ordinary kid from Acton, you haven't done so badly for yourself, mixing with Royalty!'

Perhaps this was merely the ghostwriter talking. Or perhaps this example is much too early, coming before rock acquired its dangerously radical edge. Yet when the Beatles appeared at another Royal Variety Performance in 1963, there was not the slightest hint that they were anything other than pleased to be there. It was on this occasion that John Lennon made his famous suggestion that the people 'in the cheaper seats' clap their hands, and the rest 'rattle your jewellery'. The story goes that, backstage, Lennon had threatened to ask them to 'rattle their *fuckin'* jewellery', which is often taken as evidence of his marvellously scathing wit. It seems odd, though, to give him so much credit for something he did not actually say. Indeed, as the television footage shows, Lennon's tone when he delivered his diluted witticism could hardly have been less confrontational. It might just, I suppose, qualify as cheeky.

Two years later, the Beatles were perfectly happy to accept their MBEs,

just as Mick Jagger, Bob Geldof, Bono, Elton John and Tom Jones were subsequently delighted to accept their knighthoods. And even that great radical, Paul Weller, the 'Modfather', author of 'The Eton Rifles' and champion of Arthur Scargill's miners, turns out to have had a soft spot for the Queen. 'She's the best diplomat we've got,' he told the *NME* in May 1977. 'She works harder than what you or I do or the rest of the country.' In the same interview, he added that he planned to vote Conservative at the next election, though in any case 'it's the unions who run the country'. As the interviewer himself put it: 'So much for "Anarchy in the UK".'[7]

If the Royal Family had been better advised, they would surely have tapped all this much earlier, instead of retreating inside their tweed-lined bunker. As it was, the Silver Jubilee of 1977 had to make do with a truly terrible unofficial song by the former Bonzo Dog Doo-Dah Band member Neil Innes (sample lyrics: 'Sailing in the yacht Britannia / Nowhere in the world would ban ya' / Or your Royal Family'). But of course the song that has really come to define the summer of 1977 is the Sex Pistols' shriek of rage, 'God Save the Queen'. This is the song that commentators always wheel out when they are bemoaning the supine conservatism of today's rock and pop stars, such a contrast with their free-thinking predecessors.

And yet the notoriety surrounding 'God Save the Queen' is a bit misleading. As is well known, it was banned by both the BBC and the Independent Broadcasting Authority, as well as Woolworths, Boots and W. H. Smith. Yet when the single was released at the end of May 1977, it sold an estimated 150,000 copies in five days, peaking at number two, just behind Rod Stewart's 'I Don't Want to Talk About It / The First Cut is the Deepest'. A popular conspiracy theory, now widely accepted as fact, holds that the official charts were rigged to keep the Pistols off the top spot in the week of the Silver Jubilee. Maybe they were, but there is absolutely no evidence for it. To sign up to the theory, you have to believe that the British Market Research Bureau, which managed the charts, was prepared to risk a national scandal by distorting the figures, something it had never shown the slightest interest in doing in the past. In any case, a glance at the charts for the summer of 1977 shows that Rod Stewart's single had been selling much more strongly than 'God Save the Queen' for weeks. And although the latter was comfortably the Sex Pistols' most successful single, it was not remotely one of the most popular songs of the year. For all punk's sound

and fury, what people actually bought tended to be much more mainstream: the top ten singles of 1977 included hits by the likes of Wings, David Soul, Leo Sayer, Abba and the Bee Gees. In terms of the year's total sales, 'God Save the Queen' was not even in the top forty.[8]

The truth is that the song that best captures the relationship between popular music and the monarchy is not 'God Save the Queen' but 'Candle in the Wind'. Love it or hate it – and how many people now would admit to loving it? – there is no escaping the staggering popularity of Elton John's tribute to Princess Diana. Released on Saturday 13 September 1997, a week after his show-stopping performance at Diana's funeral, it rocketed to number one within minutes of the shops opening. Television pictures showed people queuing outside record shops that morning, waiting for the doors to open. Some, almost unbelievably, had camped overnight, and as soon as the staff let them in they rushed to the singles stands, scooping up CDs by the armful. By lunchtime, most stores had already sold out; the next day, Mercury Records sent a thousand employees to the presses to prepare another million copies for Monday's shoppers. By this point, the record had already sold more than 600,000 copies, going platinum in just twenty-four hours. By the end of the year, sales had reached almost 5 million, one copy for every five households in the country.

But its appeal transcended international boundaries. In the United States, 'Candle in the Wind' was by far the biggest seller of the year, shifting what *Billboard* called 'an astonishing 8.1 million units'. Many New York stores sold out within hours; at HMV on Broadway, where the song went on sale at midnight on 24 September, thousands of copies changed hands within hours, while there were long queues at the Virgin store on Times Square. 'I was up at 4 a.m. watching that funeral and I was crying,' explained one New Jersey woman, who had just picked up a copy at her local mall. 'And now we bought this record,' added her friend, 'so we can cry some more.'[9]

In total, 'Candle in the Wind' sold some 33 million copies worldwide, a figure unequalled by any other single since the industry began keeping reliable records. But the really remarkable thing about it was not the astounding sales total, which was entirely driven by the international orgy of mourning for Princess Diana, so much as the fact that Elton John had performed it at all. The singer had been close to Diana for some time; they had a shared interest in fashion and common

commitments to various AIDS charities. But as a gay man from the west London suburbs, John was hardly an obvious candidate to sing at such a solemn royal occasion. Exactly who demanded his inclusion in the funeral ceremony is unclear: some accounts name Diana's brother Charles Spencer, others the Dean of Westminster. What is surely beyond dispute, though, is that when the former Reg Dwight began playing at Westminster Abbey, it was the most remarkable moment at a royal service in living memory.

When the former *NME* journalist Barbara Ellen heard the news, she thought 'a pop song at a royal funeral seemed about as appropriate as receiving holy communion in a nightclub toilet'. Perhaps surprisingly, more conservative papers seemed not to mind terribly: in the *Spectator*, Simon Hoggart wryly remarked that 'there was something deeply moving about the sight of a plump, red-nosed gay in a ginger wig performing at a royal occasion of any kind'. Alas, the readers of the *Guardian* were less deeply moved. 'Who suggested that Elton John sing at the funeral?' demanded Raul Jaylan of London N11. 'I'm sorry, but this man made Freddie Mercury's tribute concert look cheap. Hopefully he will at least take that stupid rug off his head.' And from the London School of Economics, Dr David C. Lane issued a bloodcurdling prediction. 'We have', he warned, 'not touched the bottom of this matter. By public demand this song will be released on CD and rise to the top of the charts, justified by the profits being given to charity. And so this ghastly, inappropriate and incomprehensible business will spin out for another fortnight.' Another *fortnight*? Dr Lane was in for a shock.[10]

It is too easy, though, to sneer at 'Candle in the Wind' and the millions who bought it. The song may have been written originally as a tribute to Marilyn Monroe, and the lyrics may have struck some listeners as excessively sentimental, but as Simon Hoggart pointed out, 'there are times when only lachrymose sentimentality will do, and the funeral was one of them'. And while music critics lined up to pour scorn on Elton John's bestseller, the most passionate defence of the song, and of his place in Westminster Abbey, came from the unlikely pen of the socialist balladeer Billy Bragg. As Bragg remarked, the fact that Elton John had arrived at the Abbey with his boyfriend David Furnish was 'a first at a state occasion, the love of two gay men recognized and accepted in the presence of the monarch and the nation watching at home'. And although Bragg himself was hardly a natural admirer of Elton John's

hit, he thought that it had 'leapt out of the austere solemnity of Westminster Abbey and touched the thousands gathered in the streets'. Amid all the ritual seriousness, he wrote, 'here was something that we knew, that we could hum, that offered a brief solace, the comfort of recognition that comes with hearing a cherished, half forgotten song on the radio. Here was something of the culture that we and Diana grew up in, a sentimental Top 40 culture that nevertheless moves people much more than "Nimrod".' In this respect, in fact, 'Candle in the Wind' was merely the latest in a long line of sentimental favourites to have captured the national imagination at moments of heightened public emotion. After all, what could be more sentimental than 'Keep the Home Fires Burning' or 'We'll Meet Again'?[11]

The importance of 'Candle in the Wind' is not just that it provided a kind of national catharsis at a moment when the monarchy's reputation seemed in greater danger than at any time since the Abdication Crisis in 1936. The single's staggering success was a powerful reminder that no successful monarchy can ignore the power of popular culture, both to advertise its relevance and to proclaim its virtues. At the time, the Queen's advisers were routinely dismissed as sluggish and antediluvian, but they learned their lesson remarkably quickly. Barely had the dust settled after the death of Diana than they were making plans for the Queen's Golden Jubilee in 2002. It could easily have been a pleasant but frankly rather humdrum public holiday, not unlike the Silver Jubilee of 1977, but the Queen's accountant, Sir Michael Peat, Keeper of the Privy Purse, had an idea. Why not, he suggested, hold two concerts in the gardens of Buckingham Palace, one devoted to classical music, the other to pop? As a public relations move, it was a masterstroke. There could hardly have been a better demonstration of the new post-Diana mood, or of the Palace's grim determination to win back public opinion. 'The best way to celebrate and thank people is to invite them round to your place for a party, and that's what the Queen wants to do,' Sir Michael told the BBC. 'She would have liked to ask all the people in the country to come, but they wouldn't fit in.'[12]

The first concert, 'Prom at the Palace', was exactly the kind of thing that people might have expected. But it was the second, 'Party at the Palace', that really captured the national imagination. As the handsomely coiffured figure of Brian May, alone on the roof of Buckingham Palace, opened the proceedings with a memorably unusual interpretation of the

national anthem, a million people were gathered in and around the Mall, while another 15 million – a far larger national audience, incidentally, than had seen Live Aid – were watching on television.* The symbolism could hardly have been more powerful: having effectively closed their ears to popular culture for decades, the Royal Family had now thrown open the palace gates.

Afterwards, the newspapers eagerly told their readers that the Queen's grandchildren had embraced the spirit of the occasion: Prince William, for example, was reported to have gazed longingly at the members of Atomic Kitten, and to have said the single word 'Brilliant' after watching Ozzy Osbourne. Indeed, the *Sunday Express* even claimed that the younger members of the Queen's family had persuaded her to soften her attitude to the Sex Pistols' most famous single, which had been re-released to mark the occasion:

> Princes William and Harry have told friends they think the re-released song is 'hilarious' – and even Prince Charles reckons it's just a bit of fun. One senior courtier told the *Sunday Express*: 'When it was first released back in 1977, the Queen was distinctly un-amused. But William and Harry have always liked it. Staff working for Princess Diana said she had a copy which she would occasionally play for a giggle. It was also believed that Prince Charles has always found it rather amusing – without meaning any disrespect to his mother, of course. The Queen hasn't complained at all this time around, though she was furious before. But remember this is 25 years on from the Sex Pistols' heyday. I still can't see her going out to buy a copy, somehow. Her Majesty has certainly heard it and doesn't mind.'

It is tempting to suggest that this story should be taken with a truckload of salt. But perhaps there is some truth in it. Tony Iommi, who appeared alongside Ozzy Osbourne, reported that afterwards the two of them 'ended up meeting the Queen, Prince Charles, Princess Anne and all the gang, and they were really nice'. The two young princes, he recalled, approached him and asked why he hadn't played 'Black Sabbath'. 'I don't think that would have gone down too well,' Iommi said sheepishly. But he was clearly delighted that they knew who he was.[13]

Although it is now largely overshadowed by the London Olympics and the Diamond Jubilee, 'Party at the Palace' was the perfect stage for

* About 10 million people watched Live Aid, a smaller number than is often remembered.

the monarchy's public relaunch after the death of Diana. Previously the institution had been a kind of monument to the cultural values of the early 1950s, all starched collars and stiff stoicism. Now the Queen's advisers packaged it as one of the pillars of Britain's new identity as the world's great dream factory, an image the BBC, which spent some £3 million on the two concerts, were very happy to endorse. It was perfectly appropriate, David Dimbleby told the television audience, to celebrate the Queen's jubilee with pop music: 'Over her reign she's seen every new movement in pop, in those fifty years, because her reign pretty well coincides with the rock 'n' roll years.' The irony, as everyone knew, was that the Queen herself heartily disliked pop music, which is hardly surprising given that she was born in 1926. While her people were singing along to the concerts of 2002 and 2012, the woman at the heart of the celebrations wore earplugs.

But that hardly mattered. What mattered was that the Queen and her advisers had comprehensively blown away the black clouds of five years earlier. In the newspapers, it was almost as if the Diana debacle had never happened. The *Guardian*'s columnist Hugo Young, the high priest of the high-minded, told his readers that 'public relations' were the Palace's 'overarching skill', a line nobody would have written in 1997. 'The timing of the Queen Mother's death, and now the admission of the music mobs to the private garden, each of these events massively projected by the benign propaganda machine of the BBC: how could the jubilee possibly have failed?' he wrote sadly. In the *Scotsman*, another republican columnist, Peter MacMahon, agreed with him. During the royal scandals of the previous two decades, he thought, republicanism had been gathering strength. But now, 'after the skilful rehabilitation of the monarchy through the Jubilee, the republicanism that was fuelled by the royal crises of the Eighties and Nineties has suffered a severe setback ... What matters is the mood – and the mood has swung back in favour of monarchy.'

Indeed it had. Republicanism sank into the doldrums, and as one royal knees-up followed another, the institution's popularity rose to still greater heights. Now even the former Sex Pistol John Lydon, the man who had once insisted that the Queen 'ain't no human being', changed his tune. 'When I heard William had popped the question to Kate, I had a nice cup of tea for them,' Lydon told the *Sun* after hearing the news of Prince William's engagement in 2010. As a youngster, he admitted, he had taken

exception to the Queen's 'Mother Superior' tone. 'But I don't get that from this lot. They've mellowed that out. Charles is a really good-natured bloke who talks to plants. There's nothing wrong with that.'[14]

THE RETURN OF THE KING

> *Kay was kneeling down too and it was more than the Wart could bear.*
>
> *'Oh, do stop,' he cried ... 'Please get up, Sir Ector, and don't make everything so horrible. Oh, dear, oh, dear, I wish I had never seen that filthy sword at all.'*
>
> *And the Wart also burst into tears.*
>
> T. H. White, *The Sword in the Stone* (1938)

After the last chords of the Diamond Jubilee had died down, the BBC's home editor, Mark Easton, wrote a much-debated column speculating on the reasons for the monarchy's extraordinary success. In the long term, as he pointed out, support for the institution had remained remarkably consistent: since polling began, at least three-quarters of the British public had been in favour. Easton's view was that, in a confusing world, the monarchy represented a reassuring fixed point, 'a bulwark against rapid and scary change'. What was more, he thought that it reflected a basic British antipathy to the cold rationalism of our neighbours: a preference for 'eccentricity and quirkiness', a delight in 'the twists and turns of a rural B-road' rather than 'the pragmatism of a highway'. This is all plausible enough. But another obvious answer is that the very idea of monarchy – kings and queens, crowns and thrones – is deeply embedded in the stories Britain tells about itself. After all, the first British film to crack the American market, Alexander Korda's *The Private Life of Henry VIII*, was a biography of the most colourful king of all, while from Olivier's portrayals of Henry V and Richard III to the eye-catching turns by Cate Blanchett and Helen Mirren in *Elizabeth* (1998) and *The Queen* (2006), the monarchy has proved to be excellent box office. Indeed, *The King's Speech* (2010) – whose biographical subject, George VI, might have been thought one of the least charismatic of all Britain's monarchs – not only won four Oscars but remains the most successful independent British film of all time.[15]

The Victorians could not get enough of Sir Thomas Malory's *Le Morte d'Arthur*. Here, in one of Aubrey Beardsley's illustrations for the 1893 edition, the Lady of the Lake reclaims Excalibur. Sir Bedivere, however, looks like somebody waving goodbye to a distant and little-liked relative at a railway station.

In contemporary literature, too, the monarchy plays a surprisingly central role. The Queen herself has appeared in two novels by Sue Townsend, a play and a novella by Alan Bennett and an enormously successful play by Peter Morgan, while a fictionalized version of her eldest son appears in Mike Bartlett's play *King Charles III* (2014). But in showbiz terms, the modern-day royals cannot possibly compete with their ancestors, especially the Tudors. One example tells a wider story. In the last twenty years, only one Booker Prize winner, Yann Martel's *The Life of Pi* (2002), has sold more copies than Hilary Mantel's novel *Wolf Hall* (2009), which is set at the court of Henry VIII. By the beginning of 2014, when the stage adaptations of Mantel's first two Tudor novels opened at Stratford upon Avon, their combined sales had reached some 1.2 million, with another 650,000 copies sold in the United States – and this was even before the BBC's big-budget adaptation, which opened to an audience of some 4 million people, had reached the television screens. And the principle of monarchy is at the heart of by far the most successful modern British novel of all, with worldwide sales estimated at around 150 million copies. This, of course, is J. R. R. Tolkien's *The Lord of the Rings* (1955), which was so long that it was originally released in three volumes – the third of which, over Tolkien's objections, admittedly, was called *The Return of the King*.[16]

In some ways Tolkien's book, especially in its later sections, might be seen as a kind of treatise on kingship. The two human realms that the hobbits visit, Rohan and Gondor, are both governed by thoroughly unsatisfactory rulers, who have lost sight of their moral and political duty. In Rohan, the aged King Théoden has been reduced to a withered, passive husk by his corrupt adviser, Wormtongue, although he subsequently recovers, rekindles his martial spirit and dies a hero's death in battle. In Gondor, meanwhile, the Steward, Denethor – who stands in for the vanished line of kings who once ruled in Minas Tirith – cuts a very unappealing figure indeed. Bitter, nihilistic, seduced into defeatism by his own logic, Denethor is the very antithesis of a strong, decisive leader. On no fewer than three occasions, as the critic Tom Shippey points out, he says bleakly, 'The West has failed'; and even as the enemy are besieging his capital, he ritually sacrifices himself on his son's funeral pyre. Tolkien fiercely resisted suggestions that his book was an allegory, but it is impossible to read Denethor's scenes today without reflecting on the fact that Tolkien began work on his great epic in 1937, at the

height of appeasement, and completed much of it during the Second World War. One way or another, weak kings – and bad kings, for that matter – were much in the news.[17]

By contrast, Tolkien also presents us with one of the most idealized images of kingship in modern fiction. The hobbits first meet him at the Inn of the Prancing Pony: 'a strange-looking weather-beaten man sitting in the shadows', with mud-caked boots and a stained green cloak, but a telling gleam in his eyes. This is Strider, or, as they later discover, Aragorn, heir to the throne of Gondor, who has spent his life in exile. In good medieval style, Aragorn's return has long been prophesied, not least in a poem by the hobbit Bilbo, which ends with the lines:

> From the ashes a fire shall be woken,
> A light from the shadows shall spring;
> Renewed shall be blade that was broken,
> The crownless again shall be king.

The story of *The Lord of the Rings*, therefore, is not just about the destruction of the Ring; it is also about Aragorn's bid to reclaim his inheritance. By the standards of real medieval kings, he is a paragon: handsome, brave, wise, kind, thoughtful, and so on. His friends must have hated him.* As he gets closer to Gondor, he throws off Strider's rather mundane trappings and becomes ever more the idealized king. When the Fellowship are sailing down the Great River, past the colossal statues of Aragorn's ancestors, Frodo looks around and sees that 'the weatherworn Ranger was no longer there. In the stern sat Aragorn son of Arathorn, proud and erect, guiding the boat with skilful strokes; his hood was cast back, and his dark hair was blowing in the wind, a light was in his eyes: a king returning from exile to his own land.' Later, when Aragorn stands up to the Riders of Rohan, throwing back his cloak and unsheathing his sword, his friends are amazed by the transformation. 'He seemed to have grown in stature while Éomer had shrunk,' writes Tolkien; 'and in his living face they caught a brief vision of the power and majesty of the kings of stone.' But only at his coronation is his majesty fully revealed. 'When Aragorn arose all that beheld him gazed in silence,' says Tolkien, his style now more self-consciously archaic than

* It is tempting, though, to wonder whether he would seem quite so impressive if Tolkien had stuck with his original name for the character: 'Trotter'.

ever, 'for it seemed to them that he was revealed to them now for the first time. Tall as the sea-kings of old, he stood above all that were near; ancient of days he seemed and yet in the flower of manhood; and wisdom sat upon his brow, and strength and healing were in his hands, and a light was about him.'[18]

Although I like *The Lord of the Rings* as much as the next man, it has to be said that Aragorn is hardly the most original character Tolkien created. He is, in fact, a medieval archetype: an idealized Germanic hero-king, descended from a god. In the book, his right to rule is more or less taken for granted; interestingly, however, Peter Jackson's first *Lord of the Rings* film (2001) at least nodded to the fact that some of the audience, especially outside the English-speaking world, might not be great fans of the hereditary principle. When Aragorn's real identity is revealed, Denethor's son Boromir, played by Sean Bean on fine form, says bluntly: 'Gondor has no king. Gondor needs no king.' When we finally meet Denethor, of course, we discover just how wrong this statement is. Indeed, the message of the films, like that of the book, is that Gondor certainly does need a king. Even Boromir eventually bows to the inevitable. Having brought disaster on the Fellowship through his own greed, pride and folly, he redeems himself by slaughtering a vast quantity of orcs before a giant archer takes him down. As he lies dying, Aragorn kneels over him and whispers some consoling words. 'I do not know what strength is in my blood,' he says – there is a lot of stuff in both the book and the films about Aragorn's bloodline, as if he were a particularly well-born racehorse – 'but I swear to you I will not let the White City fall, nor our people fail.' 'Our people, our people,' Boromir gasps. 'I would have followed you, my brother . . . my captain . . . my king.' Then he dies. The dialogue might have been drafted by a Buckingham Palace press officer.[19]

What makes Aragorn's story so familiar is that it so obviously resembles one of the oldest and most beloved British stories of all – the story, in fact, that has come more than any other to stand for Britain's national identity. To put it bluntly, Aragorn is King Arthur. They are both raised in exile, unaware of their real identities. They are both the subject of prophecies that one day they will come into their true inheritance. They both state their claims to kingship by reclaiming their forefathers' swords: in Arthur's case the Sword in the Stone, in Aragorn's the 'Sword that was Broken', which is reforged for him by the Elves. And both of

them owe their success, at least in part, to the tutelage of a wise old wizard: in Arthur's case Merlin, in Aragorn's Gandalf. One academic critic even argues that, against the backdrop of the Second World War, Tolkien had deliberately created 'a rehabilitation of Arthur: not an avatar, but a courageous, loving, formidable, adaptable, and more appealing figure ... a new-and-improved twentieth-century Arthur, the once and present king *in* whom no one believed but *for* whom many, whether publicly or privately, hoped'.[20]

In fact, Tolkien explicitly rejected suggestions that he had been inspired by the legend of King Arthur. In a much-quoted letter to an American publisher, he described 'the Arthurian world' as 'imperfectly naturalized', lamenting that it was 'associated with the soil of Britain but not with [the] English'. What Tolkien wanted was to create something dedicated 'to England; to my country'; unfortunately, Arthur is a Celtic hero who spends much of his time fighting the Anglo-Saxons. So, on the face of it, Arthur was no good to him. But like so many writers' claims about their own work, this is a bit misleading. Not only had Tolkien loved the Arthur stories as a boy, but as a young academic at the University of Leeds he had put together the definitive edition of the great Middle English poem *Sir Gawain and the Green Knight*. What is more, in the first half of the 1930s, not long before he started work on *The Lord of the Rings*, Tolkien wrote an unfinished epic poem, *The Fall of Arthur*, which remained unpublished until 2013. Here Arthur appears as a British king, loyal to the Christian faith and the memory of the Roman Empire, leading his people against the pagan Saxons. As in *The Lord of the Rings*, there is a lot of stuff about the shadow of the East:

> The endless East in anger woke,
> and black thunder born in dungeons
> under mountains of menace moved above them.

And as in much of *The Lord of the Rings*, the poem is shot through with a terrible sense of dread, as Arthur reflects that

> his house was doomed,
> the ancient world to its end falling,
> and the tides of time turned against him.

Again, it is worth remembering the context: the early 1930s, the headlines full of the shadow of war, the weakness of the West, the spectre of

totalitarianism and the decay of civilization. This is not to say that either *The Fall of Arthur* or *The Lord of the Rings* were allegories. But like any writer, Tolkien was a man of his time.[21]

It should hardly be surprising that Tolkien was so heavily indebted to the legend of King Arthur. The 'Matter of Britain' is, after all, the oldest, most successful and most influential story in our islands' history. But the Oxford philologist was also precisely the kind of person most receptive to the Arthurian tradition: a conservative Englishman, born during the last years of Queen Victoria, who had been profoundly influenced by nostalgic romantics such as William Morris. In other words, Tolkien was not merely a man of the 1930s: he was, in spirit at least, a classic late Victorian. The Victorians had been obsessed with Arthur, as they were obsessed with the Middle Ages in general. Taking inspiration from the Romantic poets and the novels of Sir Walter Scott, writers and artists such as Alfred Lord Tennyson, John Ruskin, Thomas Carlyle and Dante Gabriel Rossetti saw medieval England as a lost utopia, a pastoral paradise of beauty, faith and order, in stark contrast to the growling, smouldering industrial cities of their own century. In their imagination, Arthur stood out as the supreme British hero: a spiritual crusader for truth and virtue, whose rise to power, cult of chivalry and tragic end provided them with endless inspiration.

Indeed, the very idea of kingship played a central part in the Victorian imagination. In Scott's novel *Ivanhoe* (1819), which heavily influenced both Ruskin and Carlyle, Richard the Lionheart's return from exile is one of the plot's key turning points. Little wonder, then, that Scott was credited by Cardinal Newman, no less, with having 'turned men's minds in the direction of the middle ages'. And to the profoundly reactionary, anti-materialistic and anti-democratic Carlyle, kingship was 'the last form of Heroism', which he saw as the driving force in history. 'The Commander over Men,' he wrote in *On Heroes, Hero-Worship and the Heroic in History* (1841), 'he to whose will our wills are to be subordinated, and loyally surrender themselves, and find their welfare in doing so, may be reckoned the most important of Great Men.'[22]

Perhaps the most compelling example of the Victorian obsession with Arthur was provided by the painter Sir Edward Burne-Jones. Like Tolkien, Burne-Jones was a Birmingham boy, and it takes little imagination to speculate that it was the din and dirt of the city's industrial landscape

that drove both men back into an idealized past. Born in 1833, just before his great friend William Morris, Burne-Jones grew up in a world drenched in Arthurian legend. In 1855, when Morris was visiting Birmingham, the two young men read Sir Thomas Malory's *Le Morte d'Arthur*, originally written in the mid-fifteenth century. Burne-Jones was smitten. Like his contemporaries, he saw the story of Arthur as the inspiration for a national moral revival. There was, he said later, 'some magic in the air then that made some people destined to go mad about the S. Grail'. But in Burne-Jones's case there was something more: an obsessive, almost erotic fascination with the stories of Sir Lancelot, Sir Percival and Sir Gawain, Merlin and Guinevere, Tristan and Iseult. His biographer, Fiona MacCarthy, thinks that they became a kind of spiritual and psychological 'signpost', recurring again and again from his early drawings to his final tapestries. 'Nothing', he wrote later, 'was ever like Morte d'Arthur – I don't mean any one book or any one poem, something that can never be written I mean, and can never go out of the heart.'

Even in later life, Burne-Jones's Arthur mania never left him; if anything it grew even stronger. When, in 1881, his patron George Howard commissioned a giant painting on a subject of Burne-Jones's choice, he began work on his masterpiece, *The Sleep of Arthur in Avalon*. For the next seventeen years, as Burne-Jones became older, sicker and ever more reclusive, the unfinished painting became his *Morte d'Arthur*, his escape from the realities of industrial Britain. 'I need nothing but my hands and my brain to fashion myself a world to live in that nothing can disturb,' he once claimed. 'In my own land I am king of it.' This was not, perhaps, a very healthy attitude. His wife even recorded that he had become so obsessed by the picture that he took to sleeping in the same posture as his dying Arthur. This would be his supreme homage to Malory: so loving, so meticulous was his work that he once remarked that he did not expect to finish it until 1970.[23]

Malory evidently has a strange effect on people. In the autumn of 1936, just over eighty years after Burne-Jones had first opened *Le Morte d'Arthur*, another intense, idealistic young man picked the book off the shelves in the gamekeeper's cottage at Stowe Ridings, Buckinghamshire. After a brief stint as an English teacher at Stowe School, Terence Hanbury White had moved into the little cottage to pursue his eccentric

dream of living in 'a feral state', with only his hawks, some owls and a hound for company. But life as a rural recluse had its downsides. 'One evening, exhausted of everything to read,' White wrote later, 'I took down the Morte d'Arthur once more in the lamplight and began to read it for recreation as if it were as simple as Edgar Wallace.'

White was no stranger to Malory: a few years earlier, while reading English at Cambridge, he had written a dissertation about him. But now, poring over the book in his cottage, surrounded by his beloved birds, he 'read it with passion, knowing how Launcelot would behave in any circumstances, how Arthur, how Gawaine. They were real people.' By the time he turned the last page two days later, White was convinced that 'the thing was a perfect tragedy, with a beginning, a middle and an end implicit in the beginning', populated by 'real people with recognisable reactions'. Now he had an idea. In Malory's fifteenth-century narrative, there is a gap between Arthur's birth, when Merlin takes him to live with his foster-father, Sir Ector, and the moment of his maturity, when he pulls the sword from the stone and becomes king. What had happened in between? Here was the genesis of White's idea to write 'a preface to Mallory [sic]'. It was, he told his old tutor, L. J. Potts, in January 1938, 'rather warm-hearted – mainly about birds and beasts. It seems impossible to determine whether it is for grown-ups or children ... It is more or less a wish-fulfillment of the kind of things I should have liked to have happened to me as a boy ... It is called *The Sword in the Stone*.'[24]

As the author of *The Sword in the Stone*, the first part of his cycle *The Once and Future King*, T. H. White has a good claim to be the most influential interpreter of the Arthurian legend since Tennyson, and perhaps even since Malory himself. He was, by any standards, a very strange man. Born in Bombay in 1906, the son of a superintendent in the colonial police, he was cursed with an unhappy childhood. His parents broke up while he was boarding at Cheltenham College, where he was bullied by the prefects and savagely beaten by his headmaster, 'a sadistic, homosexual, middle-aged bachelor with a gloomy, suffused face'. According to White, this left such a scar on him that he, in turn, became a 'sadist and flagellant'. He then went to Cambridge, briefly became a prep school teacher and then got a job at Stowe, where he proved an enormously popular and charismatic teacher. But his real passions lay elsewhere. Having thrown up his job to write full time, he became obsessed with hunting, hawking and fishing. Later, in

self-imposed exile on the island of Alderney, he spent his time digging his own swimming pool, making films about puffins and building a temple to the Emperor Hadrian. His occupation, he told the BBC's Robert Robinson, was 'manual labourer'. He never married; his real passion seems to have been his red setter, Brownie. Some seven months after her death, he told Potts's wife Mary that he still had 'fits of tears' several times a week. Later, after becoming besotted with a young boy, he complained that his 'hideous fate' was to have been 'born with an infinite capacity for love and joy with no hope of using them'. But this may have been self-delusion, for he was not what we would now call a people person. Nor was he a man of excessive modesty. 'I happen to know', he once remarked, 'that I am a genius – there is no boastfulness about this at all; it is like knowing that you squint.'[25]

Whether White was a genius is a matter of opinion, but there is no doubt that *The Once and Future King* is one of the outstanding works of twentieth-century children's fiction. The first and best-known volume, *The Sword in the Stone*, tells of young Arthur's boyhood at Sir Ector's castle. The setting is an idealized vision of medieval England, all knights, jousting, hunting and falconry, while the story charts the growing friendship between Arthur, universally known as the Wart, and his eccentric tutor, the wizard Merlyn. Much of the narrative describes the Wart's adventures in the animal kingdom: as part of his education, Merlyn transforms him into a fish, a bird, a snake and a badger, encouraging him to see human affairs from an entirely different perspective. In the final pages, the Wart pulls the sword from the stone, thereby declaring himself as Uther's heir and the true king of all Britain. For the first time, his real name – which we, of course, have known all along – is revealed. 'Will you stay with me for a long time?' he asks Merlyn anxiously. 'Yes, Wart,' the wizard says, before correcting himself. 'Or rather, as I should say (or is it have said?), Yes, King Arthur.'[26]

The striking thing about *The Sword in the Stone*, apart from the wry, knowing tone, is White's taste for anachronism. On the novel's second page, we find Sir Ector and his friend Sir Grummore discussing whether to send the Wart and his foster-brother, Kay, to Eton. Amid all the clutter in Merlyn's house is a 'complete set of cigarette cards depicting wild fowl by [the explorer's son and ornithologist] Peter Scott', and when the wizard is asked for his references he produces 'some typewritten duplicates signed by the Master of Trinity'. At one point we even hear the

reactionary goshawk Cully ranting about 'Damned niggers . . . Damned politicians. Damned bolsheviks.'

All this is amusing enough, but there is, I think, a deeper purpose. White was a committed pacifist who spent the Second World War in Ireland. 'The central theme of Morte d'Arthur', he told his old Cambridge tutor in 1940, 'is to find an antidote to war.' The point of the anachronisms, therefore, is to undermine the violent knightly code that many of his characters take so seriously, to debunk their pretensions and expose their absurdities. White constantly emphasizes not only the costs of war but the folly of a political order based on force. When the Wart spends time among the geese, for example, he is amazed to discover that they do not even understand the word 'war', and later he is struck when a badger tells him that man is 'almost the only animal which wages war'. Perhaps this helps to explain why, when he realizes that he is going to be king, he bursts into tears. But although Arthur understands Merlyn's lessons, his efforts to implement them prove futile. This is the tragedy of the book, which grows ever darker as White himself became more pessimistic. At the end of the fourth volume, *The Candle in the Wind* (1958), which leaves Arthur facing his final battle, he reflects that his whole life has been a vain attempt to 'dam a flood . . . the flood of Force Majeure'. His last thoughts are about the birds who 'lived together peacefully without war – because they claimed no boundaries. He saw the problem before him as plain as a map. The fantastic thing about war was that it was fought about nothing – literally nothing.'[27]

Just as the Victorians had used the Arthurian legend as a mirror to their own society, White's retelling of the 'Matter of Britain' could hardly have been more political. In essence, he used it as a vehicle for his increasingly committed pacifism, even revising *The Sword in the Stone* to hammer home the point. But, like Tolkien, he was a curiously indefinable political animal, a kind of conservative anarchist who might have been more at home in the 1850s than the 1950s. Although White attacks the code of chivalry, he has warm words for medieval society more generally. The countryside of Arthur's boyhood, despite the depredations of the knights, is a happy, settled rural community, and he describes Sir Ector's paternalistic feudalism in glowing terms, insisting that his villeins were happy and healthy, 'free of an air with no factory smoke in it, and, which was most of all to them, their heart's interest was bound up with their skill in labour'. This is pure Arts and Crafts medievalism.

Indeed, when White was interviewed by Robert Robinson in 1959, he proudly identified himself as a 'middle-class Edwardian Englishman', upholding the moral standards he had learned from his grandfather, a judge, the old 'standards of value which King Arthur and Victoria and good people have'. Perhaps it would be unfair to compare him to Henry Williamson, the author of another rural children's classic, *Tarka the Otter* (1927), who made no secret of his admiration for the Nazis; not least because, in the second volume of *The Once and Future King*, Merlyn issues a powerful denunciation of 'an Austrian . . . who plunged the civilised world into misery and chaos'. But in its evocation of a lost medieval England – its landscape, its traditions, its wildlife, its history – White's vision could hardly have been more conservative. Indeed, in an earlier book, *England Have My Bones* (1936), he had stern words for left-wing intellectuals who could not even 'light a fire in an English interior grate . . . How safe would Karl Marx have been, I wonder, walking in a line of guns. Would he have mooned along star-gazing, and left a loaded gun against the wall at lunch, and shot his own foot off climbing over a stile?'[28]

The influence of White's Arthurian saga is hard to exaggerate. The Broadway adaptation, *Camelot*, was one of the great hits of the early 1960s, becoming a musical symbol of the new Kennedy administration as well as a rather dubious film starring Richard Harris, while the child-friendly Technicolor cartoon of *The Sword in the Stone* was one of Disney's most successful films of the decade. And White's basic idea – the anxious boy, tutored by a wise old mentor, who finds greatness thrust upon him – has proved enormously enduring. After all, the process by which the Wart turns into King Arthur goes to the very heart of the strange mystery of monarchy: its combination of the everyday and the extraordinary, the mundane and the magical. Indeed, it is perhaps only stretching the point a little to observe that this is effectively the plot of *The King's Speech*. The future George VI, like the Wart, is a younger brother, constantly reminded of his own inferiority. Like the Wart, he spends much of the narrative under a false name, assuming the identity 'Mr Johnson' when he visits his speech therapist. Like the Wart, he is indebted to an older mentor: in this case, the Australian Lionel Logue, who, like White's Merlyn, is an irreverent, eccentric outsider. In *The King's Speech*, as in the novel, the new king is horrified by his elevation to the throne: while Wart bursts into tears at the sight of Kay and Sir

Ector on their knees, Bertie breaks down at the sight of his state papers. 'I'm not a King. I'm a naval officer. It's the only thing I know about,' he bursts out, before collapsing into what the screenplay calls 'fierce, wracking sobs'. Yet thanks to Logue he not only conquers his fears but emerges as Britain's national standard-bearer in its darkest hour: an Arthur for the 1940s, albeit of a rather humdrum sort. There is even a remarkable parallel between Merlyn's last line in *The Sword in the Stone* – 'Yes, Wart. Or rather, as I should say . . . Yes, King Arthur' – and Logue's proposed last line in an early draft of *The King's Speech*. 'I always called you Bertie,' Logue was to have said. 'Today, I call you King.'[29]

For all its Oscars, not even *The King's Speech* can compete with the most successful British export to have been inspired by T. H. White's Arthurian books. This is the story of a bright, enthusiastic, but rather nondescript boy who, like the Wart, lives with a foster-family in an unremarkable corner of England, unaware of the extraordinary future that has been predicted for him. Like the Wart, he grows up in the shadow of a spoiled older brother, who loves to put him down at every opportunity. Soon after we meet him, he encounters the aged wizard who will change his life, 'tall, thin and very old, judging by the silver of his hair and beard'. The wizard, it turns out, was the man who rescued him as a baby, taking him from his parental home and hiding him with his new family for his own safety. Under his aegis, the boy finds himself in a magical new world – or rather, as in *The Sword in the Stone*, he finds the old world transformed into a beguiling mixture of the magical and the mundane. He assembles a small group of loyal companions, united in their devotion to truth and justice. At one point he pulls an ancestral enchanted sword, not from a stone, but from a hat; later, he tries to retrieve it from a frozen lake. He goes on quests, including the search for a magical goblet. He talks to snakes. All in all, then, the parallels could hardly be more striking. No wonder his creator, by far Britain's most successful living author, as well as one of the richest women in the country, once described the Wart as Harry Potter's 'spiritual ancestor'.[30]

At the heart of the Potter phenomenon – and of *The Sword in the Stone*, for that matter – is what Sigmund Freud called the 'family romance'. 'For a small child,' wrote Freud, 'his parents are at first the

only authority and the source of all belief.' As the child grows up, how-ever, he begins to pull away from his parents. Often 'the child's imagination becomes engaged in the task of getting free from the par-ents of whom he now has such a low opinion and of replacing them by others, occupying, as a rule, a higher social station'. He daydreams, for example, of 'being a step-child or an adopted child', and fantasizes that one day he will be reunited with his real, usually aristocratic, parents and will come into his full estate. To put it another way, he dreams that one day the king will come into his own again.

This is precisely the fantasy of *The Sword in the Stone*. 'He was not a proper son,' the Wart reflects in the first chapter. 'He did not understand this, but it made him feel unhappy, because Kay seemed to regard it as making him inferior in some way.' In different forms, it is also the story of Cinderella, Clark Kent and Luke Skywalker, all of whom grow up in relatively humble, even slightly downtrodden, circumstances, only to discover that they have an extraordinary inheritance and a momentous destiny. And of course this is the story that Rowling develops in her first book, *Harry Potter and the Philosopher's Stone* (1997). Harry's adop-tive family, the Dursleys, treat him far more cruelly than Sir Ector treats the Wart: not only does he have to sleep beneath the stairs, but he is excluded from Dudley Dursley's birthday parties and sent to school in shabby old clothes. Like so many children's heroes, he 'dreamed and dreamed of some unknown relation coming to take him away'. Little does he realize that this is more than an idle fantasy. 'He'll be famous – a legend,' says Professor McGonagall when Harry is first brought to the Dursleys' house. 'I wouldn't be surprised if today was known as Harry Potter Day in future – there will be books written about Harry – every child in our world will know his name!'[31]

Having sold more than 400 million copies worldwide, the Harry Potter books are, without question, the outstanding British literary phe-nomenon of the last twenty years. Not everybody likes them, though. Six months after the third book, *Harry Potter and the Prisoner of Azkaban*, had missed out on the Whitbread Prize in 1999, one of the judges, the biographer Anthony Holden, wrote a blistering piece in the *Observer*, decrying Rowling's 'predictable' storylines, 'cloying' sentimentality and 'pedestrian, ungrammatical prose style'. Perhaps this was a bit harsh, although surely nobody can deny that, when it comes to her prose,

Rowling is not remotely in the same league as, say, T. H. White or J. R. R. Tolkien, let alone Kenneth Grahame or Edith Nesbit. So why are her books so successful? The obvious answer is that, as the critic Wendy Doniger puts it, Rowling 'is a wizard herself at the magic art of *bricolage*: new stories crafted out of recycled pieces of old stories'. Long after she had become a multi-millionaire, Rowling tried to play down her borrowings from earlier authors, insisting that she was 'not a huge fan of fantasy', had never finished *The Lord of the Rings* and had a 'big problem' with C. S. Lewis's Narnia stories, which she had never finished either. Perhaps her memory was playing her false, though, for in earlier interviews she had talked warmly of her affection for *The Lord of the Rings* (her first husband, in fact, claimed that she 'could not put the book down'). In 1998 she even told an interviewer that she 'loved' C. S. Lewis, whom she considered a 'genius', and actively reread his Narnia books. None of this, though, would surprise an attentive reader of her work. Indeed, I suspect much of the attraction of the Harry Potter stories for older readers is the fun of spotting the allusions, as well as the nostalgic reassurance of seeing old devices and even familiar characters in a new context. As Wendy Doniger remarked, 'children who do not read ... will here encounter the charisma of Lewis, Carroll, Barrie, Tolkien, Nesbitt [*sic*] and Travers, not to mention Dickens and Stevenson, all at once'.[32]

But there is, of course, another element which would be familiar to anybody who has ever dipped into the classics of children's fiction. T. H. White told Robert Robinson that Merlyn was essentially a version of himself, a former teacher who believed above all in '*knowing* things'. Asked about his moral and political principles, White said firmly: 'I believe in education.' This shines through in his books: reviewing *The Sword in the Stone* for the Book-of-the-Month Club in 1939, the Yale literature professor Henry Seidel Canby described it as 'a humorous, satiric commentary on education – real education ... the narrative of how the boy, Wart, was made worthy to become the king and leader, Arthur'. That children would be interested in books about education should hardly be surprising, given how much it dominates the first two decades of their lives. And this is surely one of the keys to J. K. Rowling's success. Her stories are set in a place that every child knows very well, the place where friendships are made, enemies resisted, battles fought and prizes won. The Potter stories are merely the latest

incarnation of one of the most successful British literary genres of all: the genre that has arguably done most to impress the virtues of hierarchy, teamwork and patriotism on generations of British school-children, and thereby to ensure support for the status quo. This is the genre that, more than any other, has come to embody Victorian values: the school story.[33]

" You feller Koo-koo——" Koo-koo gave a spring, almost
yawning jaws of the shark-god. Little did he know th

ear of the floor, as a voice came, or seemed to come, from the
t it was the work of Billy Bunter, the fat ventriloquist !

Previous pages: No caption can really do justice to this picture, which comes from Frank Richards's story 'Big Chief Bunter!' (*Magnet*, 10 September 1938). Adrift in the South Seas, Bunter and his chums wash up on a desert island inhabited by a tribe of cannibals.

6

Billy Bunter on Broomsticks

THE EDUCATION OF TOM BROWN

Tom's heart beat quick as he passed the great school field or close, with its noble elms, in which several games at foot-ball were going on, and tried to take in at once the long line of grey buildings, beginning with the chapel, and ending with the School-house, the residence of the head-master, where the great flag was lazily waving from the highest round tower . . .

Thomas Hughes, *Tom Brown's School Days* (1857)

The school story was a Victorian invention, and the man who invented it was Thomas Hughes. Born in 1822, Hughes was sent away to boarding school when he was just 8 years old, and moved to Rugby three years later. There he fell under the influence of the legendary Dr Thomas Arnold, a headmaster of almost superhuman moralism, dedication and sheer earnestness, who is often regarded not merely as the father of the public-school spirit, but as the intellectual godfather of Victorian high-mindedness. On leaving Rugby, Hughes became a lawyer, Christian Socialist and eventually a Liberal MP. But he is best remembered for the book he started writing in 1856 for his son Maurice, who was about to go away to school.

Like his father before him, Maurice was just 8, and Hughes wanted to write something that would help his son understand the perils of boarding-school life, and would rally him to what was Christian, right and true. Halfway through, he showed it to a friend, who said simply: 'Tom, this must be published.' So it was, in April 1857, though Hughes kept his name off the first edition, which was attributed merely to 'an

The Christian hero pays homage to his spiritual master: Tom bows his head to Dr Arnold, buried beneath the altar of Rugby's chapel, in an illustration for the 1869 edition of *Tom Brown's School Days*.

Old Boy'. But *Tom Brown's School Days* was an instant hit. Within five years it had sold 28,000 copies, and four decades later it had gone through no fewer than fifty-three editions. Probably few people read it today, and no doubt even fewer read it with a straight face. But had there been no *Tom Brown's School Days*, there might be no Billy Bunter, no Molesworth, no Jennings and no Harry Potter. All in all, it is hard to think of many other Victorian books – indeed, many other books of *any* era – that have left such a deep imprint on the British imagination.[1]

Today the common objection to *Tom Brown's School Days* is that it is so extraordinarily moralistic. Even at the time, some critics accused Hughes of 'too much preaching', but as he wrote in the preface to the sixth edition: 'Why, my whole object in writing at all was to get the chance of preaching.' His genius, however, was to wrap up his lecture in an eminently readable story of a schoolboy thrust from home into a new environment, at once thrilling and terrifying, full of new friends and beguiling temptations, moral hazards and sporting challenges. The book opens with a wonderfully lyrical evocation of rural England, the Berkshire of Tom's boyhood. He is, we discover, a boisterous, kind-hearted, athletic boy: no intellectual, but a 'robust and combative urchin'. He goes to a local school, and then to a small private school, but when all the boys are sent home because of a fever panic, his father, the Squire, decides to send the 11-year-old Tom to Rugby. There he falls in with a mentor who becomes his great friend, Harry 'Scud' East, and together they defy the school bully, Harry Flashman, who roasts Tom over an open fire. But Flashman is soon kicked out, and Tom settles down to become a popular and successful member of the school.[2]

Unfortunately a new danger now presents itself: complacency. In their high spirits, Tom and East get into one scrape after another. So Dr Arnold asks Tom to look after a homesick new boy, George Arthur, who is very clever, but also thin, frail, immensely pious and supernaturally earnest, and therefore an obvious target for bullying. Looking after Arthur is the making of Tom. Not only does he defend him from the other boys, but Arthur shames Tom into reading the Bible and saying his prayers. In perhaps the most celebrated chapter of all, Arthur catches a fever and nearly dies: on his recovery, suffused with religious passion, the solemn little boy persuades Tom to give up cheating ('cribs') in his Latin translations. At last, as captain in the cricket match that marks the end of his time at Rugby, Tom sends Arthur in to bat instead of a

nominally better boy – and of course the little lad does splendidly, even though Rugby lose eventually. And so Tom goes out into the world, no longer a boy but a gentleman, a Christian and, above all, an Englishman. In the final chapter, set many years later, he sees the news of Dr Arnold's death and is moved to make a pilgrimage to Rugby. In the chapel he prays for his old headmaster, and we leave him on his knees at the altar, 'before which he had first caught a glimpse of the glory of his birthright, and felt the drawing of the bond which links all living souls together in one brotherhood'.[3]

As all this might suggest, *Tom Brown's School Days* is saturated in values that, on the surface at least, seem very different from our own. As Jeffrey Richards writes in his superlative history of school stories, Hughes's underlying aim was to exalt the ethos of 'Christian gentlemanliness' over the older Regency model of manliness, which he and his mid-Victorian contemporaries saw as louche and irreligious. Much of *Tom Brown*'s narrative, therefore, touches on overtly religious themes. One of the key moments in the second half comes when Arthur shames him into kneeling for his prayers, a practice Tom has abandoned for fear of looking weak. He has been exposed, in other words, as a coward, who has 'lied to his mother, to his conscience, to his God', while 'the poor little weak boy, whom he had pitied and almost scorned for his weakness, had done that which he, braggart as he was, dared not do'. The next morning, Tom kneels, ignoring the stares of his schoolfellows, and says inwardly: 'God be merciful to me a sinner!' At first only a few boys follow suit; gradually, however, more join them on their knees. Thanks to little Arthur – and to his awakened conscience – Tom has shown them the way, and before either of them had left school, says the narrator, 'there was no room in which [praying] had not become the regular custom'. It is, I think, very hard to imagine a twenty-first-century teenager, even at the most conservative public school imaginable, reading this passage with great approval.[4]

But if *Tom Brown's School Days* had merely been an exercise in religious education, then it would never have become such a hit. Hughes's genius was to package his sermon inside a story with which generations of children could identify, whether they went to boarding schools or not. Every child knows a Flashman, every child knows an Arthur, and there can be few children who have not, like Tom, been tempted to bend the rules in their homework. Children are often fascinated by tales of

trials and challenges, through which the hero, though initially daunted, develops into a brave and noble character. On top of that, as the critic Kathryn Hughes observes, the sheer level of 'procedural detail' in *Tom Brown's School Days* – 'pocket money and bedtimes . . . who is allowed to fag for whom, what time "calling over" is, and exactly how many lines of Latin prep each class generally prepares' – naturally appeals to children, who are always fascinated by 'the detail of other small people's lives, no matter how different from their own'.

Even Thomas Hughes's sermonizing may well have struck a chord with young readers who worried about their place in the world or dreamed of achieving great things. For although Hughes lectures his readers, he never talks down to them. Instead he addresses them with great solemnity, as potential crusaders against all that is evil. 'Now is the time in all your lives probably when you may have more wide influence for good or evil on the society you live in, than you ever can have again,' the narrator tells his readers at one point:

> Quit yourselves like men then; speak up, and strike out if necessary for whatsoever is true, and manly, and lovely, and of good report; never try to be popular, but only to do your duty and help others to do theirs, and you may leave the tone of feeling in the school higher than you found it, and so be doing good which no living soul can measure to generations of your countrymen yet unborn.

No doubt some people might find this risible, but in the right mood I find it rather splendid.[5]

The impact of *Tom Brown's School Days* was simply extraordinary. Certainly it is hard to think of a book that better captures Victorian values, at least as later generations understood them. The Victorians themselves devoured it with tremendous enthusiasm: not only did tens of thousands of children read it, but Tennyson read it, William Holman Hunt read it, Octavia Hill read it and Walter Bagehot read it. Even Dr David Livingstone read it. It might seem dated in some respects, but it has never been out of print, and as late as 1940 a survey of more than 600 teenage boys found that only three books – *Treasure Island*, *Robinson Crusoe* and *A Christmas Carol* – were more widely read. There have been numerous adaptations, meanwhile, for the cinema and television, including an Emmy-award-winning BBC series in 1971 and a two-part ITV version (which, bizarrely, starred Stephen Fry

as Dr Arnold) as recently as 2005. This might seem a puzzle, given that Hughes's ostentatiously Christian vision has largely fallen from favour. Yet his basic narrative feels oddly familiar, even to those who have never read the book, because *Tom Brown's School Days* established a lasting formula that has never lost its power. In 1941 the historian E. C. Mack summarized it as follows:

> A boy enters school in some fear and trepidation, but usually with ambitions and schemes; suffers mildly or seriously at first from loneliness, the exactions of fag-masters, the discipline of masters and the regimentation of games; then makes a few friends and leads for a year or so a joyful, irresponsible and sometimes rebellious life, eventually learns duty, self-reliance, responsibility and loyalty as a prefect, qualities usually used to put down bullying or over-emphasis on athletic prowess; and finally leaves school with regret for a wider world, stamped with the seal of an institution which he has left and devoted to its welfare.

When Stephen Fry, himself a former public schoolboy, was publicizing ITV's *Tom Brown* series, he described the formula in remarkably similar terms. 'A boy ... arrives in this strange school to board for the first time and makes good, solid friends and also enemies who use bullying and unfair tactics,' he explained. 'He then is ambiguous about whether or not he is going to be good or bad. His pluck and his endeavour, loyalty, good nature and bravery are the things that carry him through.' He was talking, as it happens, about Harry Potter. But that, as he went on to observe, is also the story of *Tom Brown's School Days*.[6]

From the moment *Tom Brown's School Days* was published, boarding-school stories – and with the notable exception of *Grange Hill* (1978–2008), they *are* almost always boarding-school stories – have played a disproportionately large role in the British imagination. 'The school story is a thing peculiar to England,' wrote George Orwell in 1940. 'So far as I know, there are extremely few school stories in foreign languages ... It is quite clear that there are tens and scores of thousands of people to whom every detail of life at a "posh" public school is wildly thrilling and romantic.' Orwell had strong views about the political significance of school stories. But he was quite right about their appeal to

millions of children who had never gone near a boarding school. At its peak, the paper *Boys of England*, which was founded in 1866 and heavily featured *Tom Brown*-style school stories, sold 250,000 copies weekly, while during the 1880s the *Boy's Own Paper*, which probably did more to popularize the formula than any other publication, was read by at least a million children every week. Meanwhile, novels of boarding-school life, such as Talbot Baines Reed's *The Fifth Form at St. Dominic's* (1887) or Rudyard Kipling's *Stalky & Co.* (1899), were hugely successful, even though they often abandoned Hughes's overt moralism. And even after their authors were dead and buried, these stories lived on. As late as 1940, a survey found that school stories accounted for one in eight books read by boys in their early teens, as well as one in four books read by girls.[7]

Did this matter? Of course it did. Nobody, surely, would dispute that public schools still play a central role in the British class system. In 1861 the Clarendon Commission, which had been set up to report on the condition of the top schools, called them the 'chief nurseries of our statesmen', and so they have remained to this day. A century later, grammar schools across the country were still trying to model themselves on schools such as Eton and Rugby, complete with everything from uniforms and a house system to prefects and caning. And even today, the Victorian public school is often taken as a kind of gold standard, against which all other schools are measured. Why? One reason, surely, is that boarding schools are so deeply embedded in the national imagination. The dominant images of public schools tend to be overwhelmingly positive: far more people, after all, have read *Tom Brown's School Days* or the Harry Potter stories than have ever read the memoirs of former boys who hated their schools. Indeed, in his definitive account of school stories, the historian Jeffrey Richards points out that popular culture has, with the odd exception such as Lindsay Anderson's film *If . . .* (1968) or the Jam's song 'The Eton Rifles' (1979), been extraordinarily sympathetic to boarding schools.[8]

Perhaps most strikingly, school stories have always been enormously popular among the very people who might have been expected to dislike them most – working-class boys and girls who never stood a chance of going to private schools. One example tells a wider story. Looking back in 1950, a hatter called Frederick Willis recalled his days growing

up in London before the war. At his local elementary school, which admitted a mixture of working-class and middle-class boys, he was taught to be 'God-fearing, honourable, reliable and patriotic'. But he learned as much from fiction as from fact:

> We were great readers of school stories, from which we learnt that boys of the higher class boarding schools were courageous, honourable, and chivalrous, and steeped in the traditions of the school and loyalty to the country. We tried to mould our lives according to this formula. Needless to say, we fell very short of this desirable end, and I attributed our failure to the fact that we were only board school boys and could not hope to emulate those of finer clay. Nevertheless, the constant effort did us a lot of good . . . The object of our education was to train us to become honest, God-fearing, useful workmen, and I have no complaints about this very sensible arrangement.

With their unassuming, self-deprecating, even deferential tone ('those of finer clay'), Fred Willis's recollections make oddly moving reading. He was far from unusual: at the dawn of the twentieth century, as at the dawn of the twenty-first, boys and girls across the country thrilled to the adventures of their favourite boarding-school characters. But by this stage they had moved on from the solemn pieties of *Tom Brown's School Days*. As the evangelical spirit of the Victorians had waned, so the school story had developed a sense of fun. The heroes of the new century were funnier, less formal and, in one case in particular, an awful lot fatter.[9]

THE TIGHTEST TROUSERS
IN GREYFRIARS

> *'If you please, sir,' gasped Bunter, 'c-c-couldn't you make it the sack?'*
>
> *'Make it the sack?' repeated the Head dazedly . . .*
>
> *'Yes, sir! I mean' – Bunter stuttered – 'I – I mean, I'd rather go home, sir! You – you see, sir, I should have a few weeks at least before I was sent to another school – that would be so much to the good –'*
>
> *'Bless my soul!' said the Head blankly.*

'And then I might get into a better school than this –'
'A-a-a better school than Greyfriars!' gasped the Head.
Frank Richards, 'The Vanished Ventriloquist!',
Magnet, 15 November 1924

In March 1940, in the pages of the literary magazine *Horizon*, George Orwell addressed the subject of boys' weekly magazines:

> The year is 1910 – or 1940, but it is all the same. You are at Greyfriars, a rosy-cheeked boy of fourteen in posh tailor-made clothes, sitting down to tea in your study on the Remove passage after an exciting game of football which was won by an odd goal in the last half-minute. There is a cosy fire in the study, and outside the wind is whistling. The ivy clusters thickly round the old grey stones. The King is on his throne and the pound is worth a pound. Over in Europe the comic foreigners are jabbering and gesticulating, but the grim grey battleships of the British Fleet are steaming up the Channel and at the outposts of Empire the monocled Englishmen are holding the niggers at bay. Lord Mauleverer has just got another fiver and we are all settling down to a tremendous tea of sausages, sardines, crumpets, potted meat, jam and doughnuts. After tea we shall sit round the study fire having a good laugh at Billy Bunter and discussing the team for next week's match against Rookwood. Everything is safe, solid and unquestionable. Everything will be the same for ever and ever.

To anybody who has ever read one of Frank Richards's Billy Bunter stories, and even, I suspect, to many who have not, all this is immediately familiar. As Orwell noted, weekly papers such as the *Magnet* and the *Gem* had been running these kinds of stories, almost unchanged, for three decades. 'All the principal characters in both papers – Bob Cherry, Tom Merry, Harry Wharton, Johnny Bull, Billy Bunter and the rest of them – were at Greyfriars or St Jim's long before the Great War, exactly the same age as at present, having much the same kind of adventures and talking almost exactly the same dialect,' he wrote, almost in admiration. Every week, he noted, the stories were attributed to 'Frank Richards', but it was clearly impossible that one man could have produced some 20,000 words a week for thirty years. Hence the unusually wordy and formulaic prose: 'Groan!', 'Oh my hat!', 'Go and eat coke!', 'Ha, ha, ha!' This, wrote Orwell, was an 'extraordinary, artificial,

With his skull-cap and dressing gown, Charles Hamilton cut a forbiddingly austere figure. Yet under the pen name 'Frank Richards', Billy Bunter's reclusive creator probably gave more innocent pleasure to more British children than any other individual of his generation.

repetitive style, quite different from anything else now existing in English literature' – a style deliberately designed to be imitated.

Orwell's real objection to the Greyfriars stories concerned their politics. The plots had barely moved on since the days of *Tom Brown*, while the heroes were all in the 'clean-living Englishman tradition – they keep in hard training, wash behind their ears, never hit below the belt etc.' Again and again the stories hammered their readers with the 'supposed "glamour" of public-school life', from the paraphernalia of 'lock-up, roll-call, house matches, fagging, prefects [and] cosy teas round the study fire' to the endless references to the 'old school', the 'old grey stones' and the 'team spirit' of the 'Greyfriars men'. By contrast, Orwell argued, the working classes appeared only as 'comics or semi-villains', while the political realities of 'trade unionism, strikes, slumps, unemployment, Fascism and civil war' were never mentioned. As for the outside world, foreigners were always funny, and always conformed to stereotype, from the typical Frenchman – 'Excitable. Wears beard, gesticulates wildly' – to the average Italian – 'Excitable. Grinds barrel-organ or carries stiletto.' But did all this matter? Orwell certainly thought so:

> Here is the stuff that is read somewhere between the ages of twelve and eighteen by a very large proportion, perhaps an actual majority, of English boys, including many who will never read anything else except newspapers; and along with it they are absorbing a set of beliefs which would be regarded as hopelessly out of date in the Central Office of the Conservative Party. All the better because it is done indirectly, there is being pumped into them the conviction that the major problems of our time do not exist, that there is nothing wrong with *laissez-faire* capitalism, that foreigners are un-important comics and that the British Empire is a sort of charity-concern which will last for ever.

All in all, Orwell observed caustically, the world of the boys' weeklies was 'that of a rather exceptionally stupid member of the Navy League in the year 1910'.*[10]

* In his brilliant book *George Orwell: English Rebel* (2013), Robert Colls plausibly argues that, as a former public schoolboy who never broke with his old friends, Orwell 'far more believed in the comic world of Greyfriars than in any progressive line he may have wanted to wish on it', and probably enjoyed the stories as a guilty pleasure (p. 161).

A few weeks after Orwell's article, *Horizon* printed a long reply from a disgruntled reader. This was none other than Frank Richards, the man whose very existence Orwell had doubted. He had been 'agreeably surprised', he said, to find his boys' stories analysed at such length in a 'high-browed paper'. But he was not pleased to find them being traduced as 'a fell scheme for drugging the minds of the younger proletariat into dull acquiescence in a system of which Mr Orwell does not approve'. Yes, they mocked foreigners, but 'foreigners *are* funny. They lack the sense of humour which is the special gift of our own chosen nation.' As for snobbishness, Richards stuck to the unfashionable view that 'in this country at least, noblemen are generally better fellows than commoners'. But he was outraged by Orwell's claim that the working classes were routinely caricatured as comical or villainous. There were, Richards pointed out, 'three working-class boys in the Greyfriars Remove . . . each one is represented as being liked and respected by the other boys; each in turn has been selected as the special hero of a series: and Mr Orwell must have used a very powerful microscope to detect anything comic or semi-villainous in them'.

It was true, Richards conceded, that there was no politics in his stories. 'A boy of fifteen or sixteen is on the threshold of life: and life is a tough proposition; but will he be better prepared for it by telling him how tough it may possibly be?' In a ringing defence of the virtues of escapism, he went on:

> He may, at twenty, be hunting for a job and not finding it – why should his fifteenth year be clouded by worrying about that in advance? He may, at thirty, get the sack – why tell him so at twelve? . . . Every day of happiness, illusory or otherwise – and most happiness is illusory – is so much to the good. It will help to give the boy confidence and hope. Frank Richards tells him that there are some splendid fellows in a world that is, after all, a decent sort of place. He likes to think himself like one of these fellows, and is happy in his day-dreams. Mr Orwell would have him told that he is a shabby little blighter, his father an ill-used serf, his world a dirty, muddled, rotten sort of show. I don't think it would be fair play to take his twopence for telling him that!

Above all, though, the thing that really offended Frank Richards was Orwell's suggestion that the stories could not have been written by one person. 'In the presence of such authority, I speak with diffidence,' he

wrote ironically: 'and can only say that, to the best of my knowledge and belief, I am only one person, and have never been two or three.'[11]

Frank Richards certainly was one person. His real name was Charles Hamilton, and he has a good claim to be the most prolific British writer of all time. Born in 1876, the son of an occasional journalist, he had been educated at a series of small private schools in west London. A shy boy but an avid reader, he had his first story accepted for publication when he was just 17, began writing for the *Gem* in 1907, and produced his first story for the *Magnet* the following year. In later life, Hamilton was, by all accounts, a reserved and reclusive character, who lived quietly in Kent with his cat, his pipe and his typewriter. Decades after his pen name had become one of the most famous in his land, visitors would find him in a seaside bungalow near Broadstairs, wearing a skull-cap and a dressing gown, with bicycle clips on his trousers to keep out the cold.

But if all this makes him sound a bit of an oddball, there is no getting away from his Stakhanovite productivity. Orwell believed that no single individual could possibly have written Frank Richards's stories. But Hamilton did not merely write as Frank Richards; he *also* wrote as Martin Clifford, Owen Conquest, Ralph Redway and Winston Cardew; and even, when he was writing for girls, as Hilda Richards. In all, he used at least two dozen different pen names, from the patrician-sounding Sir Alan Cobham to the attractively raffish Talbot Wynyard. Probably nobody has ever read every word he wrote: he wrote too many. Not content with inventing an estimated thirty schools, he boasted that for more than thirty years he had reached a quota of *one and a half million* words a year, and sometimes more than that. To put that into context, the critic E. S. Turner estimates that Hamilton effectively wrote the equivalent of at least twenty novels a year. In the course of his lifetime, he probably wrote the equivalent of almost a thousand novels. No popular writer in our modern history – not J. R. R. Tolkien, not Agatha Christie, not even Catherine Cookson or Barbara Cartland – is even vaguely in the same league.[12]

Hamilton's most famous character was born by accident. In the very first edition of the *Magnet*, published on 15 February 1908, he wrote a story called 'The Making of Harry Wharton', which introduced his readers to Greyfriars School. In essence, the story is no different from countless other Edwardian examples. Like Harry Potter, Harry Wharton is an orphan. Although 'quick and intelligent', he has become

'obstinate and wilful', so his uncle decides to send him to boarding school. 'The boy has the makings of a man in him, I am sure of that,' thinks the uncle. 'Greyfriars is just the place.' So off Harry goes to Greyfriars, a classic Edwardian public school, somewhere in the south of England. As in the first Harry Potter book, there follows a scene on the train, where Harry meets another boy, Frank Nugent, and provokes a punch-up. 'It was the first time Harry Wharton had been licked,' says the narrator, 'but licked he now was without a doubt about it. It was a new experience and a painful one.'

On the way to the school, however, Harry manages to save Nugent from drowning, greatly impressing his new headmaster. But Harry's pride and obstinacy prevent him from accepting the grateful Nugent's offer of friendship. Having failed to settle, he at last decides to run away. In the dark, a footpad attacks him with a cudgel – but who should be on hand to save him? Why, none other than Frank Nugent, risking his life for his old adversary. With a 'hot rush of tears', young Harry repents of his pride and begs Frank for forgiveness. 'Come back with me, and we'll keep all this dark, and make a fresh start,' says Frank. 'Make up your mind to it, old fellow, and I can promise you that you'll find Greyfriars a ripping place.' They shake hands as friends; and so, according to the last line, 'Harry Wharton faced his difficulties again, to fight his battle out, with a true chum by his side to help him to win.'[13]

All this is pure *Tom Brown*: the new boy, the bullies and bounders, the godlike headmaster, the lesson in self-discipline, the ethos of comradeship. Almost lost amid the familiar ingredients, however, was one of the great comic figures in British fiction. He is initially only an incidental character, introduced as one of Wharton's study-mates, 'a somewhat stout junior, with a broad, pleasant face and an enormous pair of spectacles'. But, as the stories continued, Billy Bunter, the 'Fat Owl of the Remove', began to occupy an increasingly prominent role, forever lining his stomach with stolen tuck, gabbling his implausible excuses and banging on about his long-expected postal order. And as Harry Wharton, the incarnation of the public-school spirit, gradually turned into a bit of a bore, Bunter rolled inexorably on to centre stage, his paws sticky with jam, his eyes blinking furiously behind his glasses. Even before 1908 was out, he had started to push Harry off the front page of the *Magnet*. Jeffrey Richards calls him the 'schoolboy Falstaff', and even Orwell thought him a 'first-rate character', comparable with some of

Dickens's finest creations. 'His tight trousers against which boots and canes are constantly thudding, his astuteness in search of food, his postal order which never turns up,' wrote Orwell, 'have made him famous wherever the Union Jack waves.' Very few people remember the other members of the vast Greyfriars cast, from Wharton's pals Bob Cherry and Johnny Bull to Wingate, the peerless school captain, and Vernon-Smith, the incorrigible Bounder of the Remove. But Bunter's name endures.[14]

Unusually for a much-loved children's character, especially one born in the Edwardian era, Bunter has almost no redeeming features at all. He is the negation of everything Dr Arnold stood for, the antithesis of everything Thomas Hughes believed in. While his schoolmates improve their minds in the classroom or exercise their bodies on the sports field, Bunter, the 'owner of the tightest trousers in Greyfriars', thinks only of jam and biscuits. He is greedy, lazy and deceitful; a fool, a liar, a thief and a coward; a monster of selfishness, vanity and prejudice. As Jeffrey Richards notes, the first full-length Bunter novel, *Billy Bunter of Greyfriars School* (1947), offers an impressively full summation of his vices and their consequences. He falls asleep in a history lesson and is given lines. He makes a mess of his Latin and is beaten. He steals another boy's jam and is caned. He steals another boy's hamper and is caned again.* Ordered to repay the owner of the hamper, Bunter steals the other boys' possessions and tries to sell them. He scrawls abuse of his form master on the blackboard ('Quelch is a beest') and is put in detention. He escapes and is threatened with expulsion. Having been selected to play cricket, he skips the match to eat some more jam. When Quelch makes it clear that the Fat Owl's school career is over, Bunter decides to get revenge by dropping soot on him from a tree. But then, even as Bunter is preparing to 'soot Quelch', the master is attacked by a cudgel-toting vagrant. And so we discover that 'somewhere under Billy Bunter's layers of fat, there was a spot of pluck – genuine old British pluck'. Bunter jumps, or perhaps just falls, out of the tree, squashing the tramp and saving Quelch's life. Not only does Quelch change his mind, he even rewards Bunter with a box of toffees. Cue the inevitable happy

* On both occasions, bizarrely, he hides to eat his stolen tuck in the study of his form master, Mr Quelch. This says a great deal about Bunter's lack of nous as well as Charles Hamilton's fearless willingness to recycle his material.

ending. 'The toffees were good,' reads the book's last line, 'and almost as good as the toffees was the knowledge that Quelch had relented, and that the Remove was not going to lose its brightest ornament: that next term the happy Owl would still be Billy Bunter of Greyfriars School!'[15]

In some ways Orwell's much-quoted analysis of the Bunter stories was grossly unfair. He was completely wrong to complain that the working classes only appear as comics or criminals, for as Hamilton pointed out, the Remove includes three popular, hard-working scholarship boys, the sons of a seaman, a cobbler and a factory worker. When Mark Linley, a mill-boy from an industrial town in Lancashire, arrives at Greyfriars, nervous and alone, his ill-cut clothes betraying his humble origins, Harry Wharton makes a point of shaking his hand in welcome, with 'no hint in his manner that he felt he was talking to one of a lower station in life'. And when Mark, stammering with embarrassment, tells him that he worked in a mill, Harry nods quietly, 'as if factory-hands were not at all uncommon at Greyfriars'. 'Yes, I've heard about it,' he says. 'Awfully plucky of you to go in for the scholarship and get it. I've heard that it's very hard.' Poor Mark feels tears rushing to his eyes, and tries to thank him. 'Oh, bosh!' says Harry. 'Give us your fist!'[16]

Orwell was absolutely wrong, too, to identify the stories as racist. Bunter himself is certainly racist, but his schoolmates regard his attitude as deplorable. Even in the politically rather dodgy *Billy Bunter among the Cannibals* (1950) – in which, somewhat implausibly, the Owl and his schoolmates encounter a tribe of cannibals on a trip to the South Seas – it is only Bunter who uses the word 'nigger', while his friends are much more broad-minded. By the standards of the day, in fact, Greyfriars is surprisingly multicultural. Indeed, in creating Bunter's Indian classmate Hurree Jamset Ram Singh ('Inky'), Hamilton was ahead of his time. Hurree might speak rather peculiar English ('Is the expectfulness terrific, my esteemed fat Bunter?'), but he is a fine bowler, a demon chess player and a much-loved member of Wharton's gang, the Famous Five. Later, Hamilton explained that by creating Hurree as a 'comrade on equal terms with English schoolboys', he had hoped 'to rid the youthful mind of colour prejudice'. This was more than retrospective self-justification. In the penultimate *Magnet* of 1910, a new boy called

Fisher T. Fish arrives from the United States. 'By gum!' he says when he sees Hurree Singh. 'What sort of a critter do you call that?' And straight away, Harry Wharton steps in to put him right:

> Inky isn't a nigger – he's an Indian, which is as unlike a negro as an American is. And if he were a nigger, we should like him just as much, and he would be just as good a sort. And we don't share your ridiculous prejudice against coloured people, and if a nigger ever comes to Greyfriars, and you put on any airs about it, we'll jump on you. Is that quite clear?

Twenty-first-century readers might find the language offensive; but not, I think, the sentiment.[17]

And yet, deep down, like so many school stories, the Billy Bunter stories do project a deeply conservative view of the world. Greyfriars is England: unchanging and hierarchical, ruled by a stern but fair monarch, the headmaster, in tandem with an aristocratic elite of masters and prefects. As Orwell observed, this is a world of jam tarts and postal orders, roaring fires and footer matches, utterly untouched by social or political change. The countryside beyond, however, is plagued with tramps and footpads, walking affronts to the public-school code of hard work and clean living. Hamilton's tramps are never victims of circumstance: they are men like Quelch's assailant Nosey Jenkins in *Billy Bunter of Greyfriars School*, a shabby vagrant with 'little red-rimmed eyes, with an unpleasant threatening glint in them'. Indeed, Nosey conforms absolutely to what Jeffrey Richards calls the 'classic figure of menace in inter-war fiction, the deracinated loafer, loner and criminal'. And while Harry Wharton is essentially an updated version of Shakespeare's Prince Hal – the dissolute boy who transforms himself into a model of leadership – Bunter is a kind of super-charged Falstaff: a 'larger-than-life embodiment of human failings, weaknesses and prejudices'. Crucially, though, he is never allowed to get away with it: much of the first Bunter novel, for example, consists of his inevitable punishment by 'beating, booting, bouncing, detention, suspension and exclusion'. And the fact that Bunter keeps coming back for more is, as Jeffrey Richards notes, a lesson in the 'enduring strength of human frailty and the undying need for vigilance in the maintenance of the [public-school] code as a bulwark against it'.[18]

At its high point during the 1920s, the *Magnet* was selling 200,000 copies a week, which was more than Britain's most respected weekly papers, the *Spectator* and the *New Statesman*, put together. Recalling his days teaching at two small private schools in London, where the boys were the sons of 'shopkeepers, office employees and small business and professional men', Orwell reported that almost all of them read the *Magnet* and the *Gem* and 'were still taking them fairly seriously when they were fifteen or even sixteen'. Even in the poorest areas of Britain's cities, Orwell had seen copies in the local newsagents, and he had also seen them being read 'by boys whom one might expect to be completely immune from public-school "glamour"', including a young coal miner 'who had already worked a year or two underground'.

Jeffrey Richards suggests that the Bunter stories were particularly popular among bright middle-class boys on their way up, noting that both John Osborne and Noël Coward singled out the *Magnet* stories in their memoirs. Osborne even went to the lengths of searching for old *Magnet* issues in Epsom market. Some middle-class parents, especially of the more high-minded variety, banned them: when V. S. Pritchett's father discovered his son's stash of *Magnet* papers, he ritually burned them in the fireplace and told him to read John Ruskin instead. But Pritchett could not help himself. Like millions of Harry Potter fans many decades later, he was an addict. Not only did he and his friend, a compositor's son, affect Greyfriars slang, they even adopted Greyfriars nicknames. 'One page and I was entranced,' he wrote later. 'I gobbled these stories as if I were eating pie or stuffing. To hell with poor self-pitying fellows like Oliver Twist; here were the cheerful rich. I craved for Greyfriars, that absurd Public School, as I craved for pudding.'[19]

The really striking thing, though, is the impression the Greyfriars stories made on working-class readers in the early twentieth century. As the historian Jonathan Rose observes in his marvellous book on *The Intellectual Life of the British Working Classes*, the Greyfriars stories were a central element in a 'common schoolboy culture'. No matter how wide the gulf between the reader and the characters, the stories still found a keen audience. Even the disabled son of two Yorkshire millworkers, who was educated at home and had no experience of school, adored the *Magnet* stories and 'rather wished I could go to one or other of these schools, in spite of the thrashings, kickings and other personal violence I would have to suffer if I did'. It was from these stories, he

wrote later, that he learned 'what might be called the Schoolboy Code'. This was a common refrain among working-class readers. Paul Fletcher, a colliery winder's son who grew up in the 1920s, agreed that the *Magnet* taught him the 'code of schoolboy honour'. 'Although I never realised it at the time,' he wrote many years later, 'it proved to influence me more about right and wrong than any other book. And that includes the Bible.' Another boy, the son of a Camberwell labourer, admitted that his 'mind boggled' at the adventures of Harry Wharton and his friends; yet 'how determined I was to emulate their true blue behaviour by my conduct in the more prosaic atmosphere of St George's [Church School], even if I sometimes wore no shoes and the arse was out of my trousers'. And in the south Wales coalfield, young Nye Bevan, who earned two shillings and sixpence a week as a butcher's boy, would make a weekly pilgrimage to the newsagent's to pick up the latest copies of the *Magnet* and the *Gem*. Like many other parents, Bevan's father, a miner, had banned them from the house. But his son bought them anyway and hid the illicit copies beneath a local bridge.[20]

The interesting thing about these recollections is how rarely they mention the character for which Frank Richards is best remembered. No doubt these young working-class readers found Billy Bunter funny, but for most of them the role model was Harry Wharton, that brave, upstanding incarnation of gentlemanly virtue. A good example is the working-class historian Robert Roberts, who won acclaim for his moving account of growing up in the 1910s in the terraced streets of industrial Salford, *The Classic Slum*. He and his friends, he wrote, were addicted to Richards's stories, and he knew 'boys so avid for current numbers of the *Magnet* and *Gem* that they would trek on a weekday to the city railway station to catch the bulk arrival from London and buy first copies from the bookstall'. But it was not Bunter whom they loved; indeed, Bunter's name does not appear in Roberts's book at all. It was Harry Wharton and his friends, 'young knights, *sans peur et sans reproche*', from whom the Salford boys learned the Greyfriars code of 'guts, integrity, tradition'. And when Roberts looked back on his own boyhood, he thought the importance of the Greyfriars stories could hardly be exaggerated:

> With nothing in our own school that called for love or allegiance, Greyfriars became for some of us our true Alma Mater, to whom we felt bound

by a dreamlike loyalty ... Over the years these simple tales conditioned whole generations of boys. The public school ethos, distorted into myth and told among us weekly in penny numbers, for good or ill, set ideals and standards. This our own tutors, religious and secular, had signally failed to do. In the final estimate it may well be found that Frank Richards during the first quarter of the twentieth century had more influence on the mind and outlook of young working-class England than any other single person.

Orwell, in other words, had been right all along. And although Hamilton understandably rejected the accusation that his stories were mere propaganda, the truth is that, right from the beginning, school stories had always preached a clear moral lesson. Thomas Hughes, after all, had openly admitted that his goal had been 'to get the chance of preaching'. The sermon might be better disguised in the Greyfriars stories; but it was still there, deep down. It was there, too, in another set of school stories, many years later. 'I certainly didn't set out to teach, or to preach, to children,' insisted J. K. Rowling as she picked up an award for her contribution to 'the struggle against injustice, poverty, disease or ignorance'. But then she said something very different: 'I wanted to depict the ambiguities of a society where bigotry, cruelty, hypocrisy and corruption are rife, the better to show how truly heroic it is, whatever your age, to fight a battle that can never be won.' So, like Thomas Hughes, she was preaching after all.[21]

A JOLLY WIZARD JOB

> His name's been down ever since he was born. He's off ter the
> finest school of witchcraft and wizardry in the world. Seven
> years there and he won't know himself. He'll be with youngsters
> of his own sort, fer a change, an' he'll be under the greatest
> Headmaster Hogwarts ever had ...
>
> J. K. Rowling, *Harry Potter and the*
> *Philosopher's Stone* (1997)

By the outbreak of the Second World War the *Magnet* had run out of steam. The final issue appeared on the newsstands in the week of 18 May

The public schoolboy as hero: Daniel Radcliffe in *Harry Potter and the Philosopher's Stone* (2001).

1940. Across the Channel, Britain's army was falling back towards Dunkirk; in London, Churchill had just made his 'blood, sweat and tears' speech. Yet the final issue of the *Magnet* did not explicitly mention the war at all, except to note the 'acute paper shortage' that had severely affected the page count. At the end of the editor's introduction, though, came an oddly moving admonition. 'Come what may,' he exhorted his readers, 'we can always raise a smile, and it is this cheerful spirit that has made Great Britain what she is to-day!'

Brave words, but that was the end of the *Magnet*. In the world of Hitler and the Holocaust, there seemed no place for Billy Bunter. He was last seen scuttling off down the corridor in his 'highest gear', having been threatened with a booting. The last story ends, appropriately enough, with a laughing Harry Wharton and his chums heading up to Study No. 1 for tea. 'All was calm and bright,' the narrator tells us; although, 'had the chums of the Remove only known it, they were at the beginning of what was going to be a rather exciting term.' And that was that: the end – or so it seemed.[22]

But Bunter's place in the national imagination was now too firmly assured for him to go down without a fight. Six years later, a publisher called Charles Skilton was on honeymoon in Oban when he came across the latest *Picture Post*. Inside was an interview with Charles Hamilton under the headline 'Do You Remember Billy Bunter?' The tone was unashamedly nostalgic: on the drive from the station, the interviewer reported, his taxi driver had waxed lyrical about 'the old *Magnet*', and complained that 'there's nobody writing stories like that now'. When he got back, Skilton promptly commissioned Hamilton to write a series of Bunter books. The first, *Billy Bunter of Greyfriars School*, came out in 1947 and sold 25,000 copies within a year; it would surely have sold more were it not for post-war paper restrictions. Within five years Hamilton had produced another ten novels – a positively trifling output by his high standards – and by his death in 1961 he had produced a further twenty-seven.* And now there was a screen Bunter, too, thanks to the BBC's immensely popular television series, which ran for seven seasons from 1952 to 1961. As is often the way, the BBC made a great fuss

* Or twenty-eight, depending on what source you follow. Nothing better reflects Hamilton's extraordinary productivity than the fact that even the most authoritative sources disagree about exactly how many books he wrote.

about holding nationwide auditions and then cast a relative veteran, Gerald Campion, as the Fat Owl. By conventional standards, it has to be said, Campion made a somewhat implausible Bunter. At barely 12 stone, he was surely too thin; what was more, he was a married man of 30, with two small children of his own. None of this, however, deterred people from tuning in. Even as the Beatles were playing at the Cavern Club, millions of British children were rocking with laughter at the adventures of a suspiciously mature-looking public schoolboy.[23]

In a country where, thanks to the 1944 Education Act, millions of children now went to new grammar and secondary modern schools, Bunter's continuing hold on the national imagination says a great deal about the conservatism of popular tastes. Indeed, it is hard to think of any state-school story, at least until the advent of *Grange Hill*, that enjoyed the same affection. In the late 1950s the comic writer Anthony Buckeridge published four Rex Milligan books, set in a grammar school, but sales were disappointing and although the BBC made a short-lived series, it never took off. By contrast, Buckeridge's Jennings stories, set at a fictional prep school called Linbury Court, were enormously successful. The irony was that Buckeridge himself, who had been sent to boarding school by the Bank Clerks' Orphanage charity after his father's death at Arras in 1917, was not a fan of public schools. His own school, Seaford College in Sussex, had not been 'a very nourishing experience. No music, no drama, no art, nothing of that sort, and I remember always being hungry.' However, after becoming a teacher, he was inspired to write a play about a boy called Jennings, which he sent to the *Children's Hour* department at the BBC. By the early 1960s he had not only written sixty-two Jennings plays, all of which were broadcast on the radio, but was well on his way to producing twenty-two Jennings novels, which were also translated into French, German and Chinese. The extraordinary thing, though, is that Buckeridge remained a committed critic of boarding-school education, and claimed to be shocked when parents told him that his books had 'sold' boarding schools to their children. As one critic remarked, it was as though Biggles's creator Captain W. E. Johns had admitted that he was frightened of flying.[24]

When I first read the Jennings stories as a boy, they did not strike me as obviously dated, although perhaps that says more about West Midlands prep schools in the 1980s than it does about Buckeridge's books.

What is true, though, is that the Jennings novels occupy a kind of half-way house between Greyfriars's stiff-collared hierarchy and Hogwarts's relaxed informality. They have none of the religious earnestness of *Tom Brown's School Days* and none of the baroque extravagance of the Bunter stories. Today the schoolboy slang feels very dated – in the very first chapter of the first book, *Jennings Goes to School* (1950), the boys say things like 'We had a supersonic time, sir' or 'It's a jolly wizard job I'm not a chap I know at home's uncle' – but at the time, when compared with Bunter's Edwardian effusions, this probably felt refreshingly up-to-date. And although Buckeridge might have created a touchingly innocent world populated by autograph-hunting little boys, he was very careful not to exclude young readers who had never laid eyes on a private school. Greyfriars might have been an enclave of privilege, but Linbury Court feels very different. Indeed, as Buckeridge explained, he wanted it to stand in for every school – including, presumably, state schools. It would be a 'waste of time' to describe the school in detail, he says in the introduction to *Jennings Goes to School*, because 'if you are going to follow Jennings through his school career, you will be certain to alter the shape of the building so that it becomes, in imagination, your own school. Jennings' classroom will be your classroom; his desk, your desk.'[25]

Jennings himself is a boyish everyman:* we first see him through the eyes of the kindly teacher Mr Carter, who describes him as

> a small boy not unlike the dozens of other small boys who were lined up outside his room. His suit, socks and tie conformed exactly to the regulation pattern. His dark brown hair, which still bore the faintest trace of a parting, was no different from that of his fellows, and his face was the average sort of face worn by boys of his generation.

Far less muscular than either Tom Brown or Harry Wharton, he is a hero with whom young readers can immediately identify: decent, well-meaning and resolutely ordinary, and yet always getting the wrong end of the stick, falling into scrapes and annoying the irascible Mr Wilkins. Relatively unusually for a boarding-school story, *Jennings*

* His first name is never used; his initials are J. C. T., which stand for John Christopher Timothy, but everybody calls him 'Jennings'.

Goes to School explicitly acknowledges the possibility of homesickness. Not only do we learn that Jennings's father has written to the headmaster, worried that his son 'had never been away from home before', but his inseparable friend, the nerdy Darbishire, is moved almost to tears by 'the sight of his pyjamas, sponge bag and Bible lying on his hard iron bed in this unfamiliar room'. 'What on earth's the matter with you, Darbishire?' asks another boy. 'Nothing,' he says, through 'misty spectacles'. 'Well, nothing much, except I don't like this place. When I'm at home my father always comes and talks to me when I'm in bed and – well, it's all so different here, isn't it?' In real life, this would probably have been the cue for the other boys to make his existence a living hell. But Jennings does his best to cheer him up. 'Oh, I don't know,' he says reassuringly, 'we'll probably get used to it in three or four years.'[26]

To anyone familiar with the adventures of Jennings and Darbishire, let alone Tom Brown or Harry Wharton, the world of Harry Potter feels like very well-trodden ground. That is not to deny, of course, that there are superficial differences. J. K. Rowling's admirers often make great play of her achievement in democratizing the school story, and Hogwarts certainly feels much more contemporary than Greyfriars or Linley Court. Even before Harry gets the train to school, he notices a boy with dreadlocks, while other pupils include Parvati Patil, Cho Chang and Viktor Krum. But this can be easily overstated. After all, Billy Bunter's classmates included not just Hurree Jamset Ram Singh and Fisher T. Fish, but boys from China (Wun Lung), France (Napoleon Dupont), Ireland (Michael Desmond), New Zealand (Tom Brown, would you believe) and South Africa (Piet Delarey), as well as a Jewish boy called Montague Newland. By these standards, Hogwarts looks almost monocultural.[27]

Similarly, although it is true that Quidditch, the school's emblematic sport, is open to girls as well as boys, Rowling's principal female character, Hermione Granger, is basically a stereotypical annoying bluestocking. Introduced to us as a girl with a 'bossy sort of voice' and 'rather large front teeth' (i.e. nothing like Emma Watson), she really is the most dreadful goody-goody, forever learning the set texts, colour-coding her notes and lecturing the boys about the importance of revising for their exams. As the critic Richard Jenkyns remarks, she is 'a

schoolboy's idea of a schoolgirl', like something out of the Molesworth books. In fact, given that Rowling wrote the first Harry Potter stories as a single mother, it is surprising how male-dominated they are. In Jenkyns's words, 'there is plenty of the Frank Richards spirit, but not a trace of Angela Brazil or Enid Blyton; if readers did not know that Rowling was female, few would have guessed it'. As for the boys, Ron Weasley is the sixth member of his family to have gone to Hogwarts, and feels under pressure to emulate his brothers Bill, who was head boy, Charlie, who was captain of Quidditch, and Percy, who has just become a prefect. And although Harry Potter might appear to be just another boy from the suburban Home Counties, his parents both went to Hogwarts, and his mother was even head girl. He is, we eventually discover, descended from a long line of wizards, stretching all the way back to the legendary Peverell brothers. Indeed, while Tom Brown, Harry Wharton and Jennings are presented to us as thoroughly ordinary, the whole point about Harry Potter is that he is thoroughly *extraordinary*. From his magic powers to the scar on his forehead, he is a boy apart.[28]

The most striking thing about Rowling's first book, *Harry Potter and the Philosopher's Stone*, is how astonishingly loyal it is to the boarding-school formula. After an awful lot of magical throat-clearing – pace and brevity are not Rowling's strong points, though I may not necessarily be the best person to make that observation – Harry heads off to Hogwarts, armed with all the 'necessary books and equipment' set out in his letter of acceptance, including three sets of robes, a hat, a cloak, a wand, a telescope and a cauldron, among other things. Some readers might think it odd that forty pages earlier, Rowling mocked Dudley Dursley's private school for its antiquated uniform ('maroon tailcoats, orange knickerbockers and flat straw hats'), since Harry's boarding-school uniform is no less ridiculous. Anyway, he eventually arrives at his new school, which is based in a medieval castle and was founded before the Battle of Hastings.* Jostling with all the other new boys and girls, he endures a welcome speech from

* It would probably be unbearably pedantic to observe that this makes Hogwarts very odd, since there were no castles in Britain until the Normans arrived. In fact, the first Scottish castles were not built until about 1200. Why did Hogwarts's founders even need a castle, anyway?

Professor McGonagall and waits nervously while they are all sorted into boarding-school houses. He goes up to the dorm – the kind of place that Bunter or Jennings would instantly recognize, although they never had four-poster beds – to find his trunk already installed by his bed. He attends his first lessons, taught by the usual mixture of boring, endearing and terrifying teachers. He takes exams: some written, with an Anti-Cheating quill; some practical, such as a test to see if he can turn a mouse into a snuff-box. He endures the taunts of the class bully, the snobbish Draco Malfoy, who is not nearly as frightening as Greyfriars's beastly Gerald Loder. And of course he plays Quidditch, establishing his reputation, like so many public-school heroes before him, on the sports field, not in the classroom. For in Quidditch, as Thomas Hughes might have put it, is 'the whole sum of school-boy existence gathered up into one straining, struggling half-hour, a half-hour worth a year of common life'.[29]

In fact, it is hard to read Rowling's Quidditch sequences without being reminded of *Tom Brown's School Days*. During the earlier novel's climactic cricket match, Tom, Arthur and one of their masters discuss the virtues of the game:

'Come, none of your irony, Brown,' answers the master. 'I'm beginning to understand the game scientifically. What a noble game it is too.'

'Isn't it? But it's more than a game. It's an institution,' said Tom.

'Yes,' said Arthur, 'the birthright of British boys old and young, as *habeas corpus* and trial by jury are of British men.'

'The discipline and reliance on one another which it teaches is so valuable, I think,' went on the master, 'it ought to be such an unselfish game. It merges the individual in the eleven; he doesn't play that he may win, but that his side may.'

'That's very true,' said Tom, 'and that's why foot-ball and cricket, now one comes to think of it, are such much better games than fives or hare-and-hounds, or any others where the object is to come in first or to win for oneself, and not that one's side may win.'

Here is Thomas Hughes's entire philosophy: selflessness, service, sportsmanship and teamwork. This is the ethos that underpins Henry Newbolt's poem 'Vitaï Lampada' (1892), in which an Old Cliftonian, remembering his days playing cricket for the school, rallies the British

troops in the blood-sodden desert of the Sudan with the cry 'Play up! play up! and play the game!' It is also the ethos that underpins the Harry Potter stories. In *Harry Potter and the Philosopher's Stone*, it is only through friendship, teamwork and self-sacrifice that Harry, Hermione and Ron emerge triumphant. 'Books! And cleverness!' says Hermione scornfully. 'There are more important things – friendship and bravery.' These are the values that Harry Wharton was sent to Greyfriars to acquire; that his friends, the Famous Five, have in abundance; and that Billy Bunter so conspicuously lacks. They are, in short, the stereotypical values of the Victorian public school.[30]

For some adult readers, J. K. Rowling's reliance on both a Victorian formula and a Victorian ethos represents a fatal failure of the imagination. Reviewing *Harry Potter and the Goblet of Fire* (2000), the American critic Harold Bloom complained that her 'tiresome' stories were merely *Tom Brown's School Days* reimagined 'in the magical mirror of Tolkien', while the novelist Stephen King complained that her 'amusing inventions' had none of the counterbalancing darkness of Tolkien and Lewis, leaving Hogwarts as merely a 'kind of Never-Never-Land'. In his all-out assault on the Potter phenomenon after the Whitbread Prize controversy, Anthony Holden even claimed that the previous book, *Harry Potter and the Prisoner of Azkaban*, was merely 'a tedious, clunkily written version of Billy Bunter on broomsticks', utterly lacking in surprise or suspense. All in all, he wrote, her series was 'essentially patronising, very conservative, highly derivative, dispiritingly nostalgic for a bygone Britain which only ever existed at Greyfriars and St Trinian's'.[31]

This seems to me very unfair. The Billy Bunter stories are much better than that. They may have been conservative, formulaic and somewhat eccentrically written, but the best examples have a charm, an innocence, a lightness and – crucially – a sense of humour that is almost entirely lacking from the Harry Potter saga. As for the characters, none of Rowling's creations comes even vaguely close to matching the richness and humanity of Bunter himself, surely one of the great comic figures in all English literature. Harry? Hermione? Who can fail to pity Daniel Radcliffe and Emma Watson, struggling to breathe some life into these cardboard cutouts? And by comparison with her predecessors' books, even Rowling's moral lessons seem flat and unconvincing. Whatever you think of Thomas Hughes's evangelical Christianity, there is no

doubting the earnest conviction of his extended sermons about loyalty and brotherhood. When Tom goes into Rugby's chapel at the end of the novel to say a prayer for Dr Arnold, the tears rolling down his cheeks as he kneels at the altar and feels 'the drawing of the bond which links all living souls together in one brotherhood', there is a real intensity to Hughes's writing, a genuine sense of commitment and mission. The prose may have dated, but the power remains. By contrast, Rowling's lectures are so thin as to be virtually transparent. Quoting two examples – 'It takes a great deal of bravery to stand up to our enemies, but just as much to stand up to our friends', and 'It is our choices, Harry, that show what we truly are, far more than our abilities' – the critic Alexandra Mullen suggests that they sound like 'sitcom sound bites'. To me they sound more like the kind of thing that primary-school headmasters come out with at the end of term, or perhaps the kind of thing that Tony Blair might once have told his party conference. I am not sure which is worse.[32]

None of this is meant to deny that the Harry Potter books had an enormous effect on an entire generation of children, who clearly loved them just as much as their great-grandparents had adored the *Magnet* and the *Gem*. Yet perhaps Rowling's most notable achievement was something that she never intended. In his blistering attack at the turn of the twenty-first century, Anthony Holden had lamented that she had sent her hero to a private boarding school rather than 'a comprehensive, or an embattled secondary modern or a solid old-fashioned grammar – a school of the kind with which most of those millions of young readers can identify'. Perhaps he had just seen the latest boarding-school attendance figures, which showed that after a decade of falling numbers in the 1990s, public-school recruitment had taken a turn for the better – thanks, at least in part, to the so-called 'Harry Potter effect'. Uppingham's headmaster, for example, reported that 'most of the children' he met had read the books, which had given them 'a sense that boarding is quite exciting'. By promoting the idea that boarding schools were 'fun', agreed the campaign director of the Boarding Education Alliance, Rowling's books 'have probably done more for boarding than anything else we could have imagined'.

So perhaps it was no surprise that when, ten years later, Rowling wrote a column in *The Times* imploring people to reject David Cameron, the conservative gadfly Toby Young published a mischievous

riposte outing her as a 'closet Tory'. Hogwarts, he wrote, is 'a micro-cosm of exactly what old-fashioned Tories would like Britain to be. It's a rigidly hierarchical society, presided over by a benign, but stern patri-cian figure – a sort of wizardly version of Harold Macmillan – in which everybody knows their place'. Not even Evelyn Waugh, Young con-cluded, could have done 'a better job of conjuring up a romantic portrait of a Tory Britain. You really should vote for Dave.'[33]

Overleaf: An Englishman – or rather, a Scotsman – abroad: Sean Connery's James Bond enjoys the local attention in *You Only Live Twice* (1967).

7

The Adventures of
Peregrine Carruthers

THE CLUBLAND HERO

*He got his book out of his suitcase; it was the latest Bulldog
Drummond adventure story.*

Charlie Higson, *SilverFin* (2005)

By far the most celebrated of all Britain's public-school heroes arrived
at Eton in 1933. He is introduced to us as a tall, slim boy with 'pale,
grey-blue eyes and black hair', one lock falling 'over his right eye like a
black comma'. Like any boy on his first day at a new school, he is nerv-
ous and hesitant; we see him standing alone in a crowd of shouting
schoolboys, wishing 'he were somewhere else'. He is our Tom Brown,
our everyman, whether quailing before his new housemaster ('I am to
be your father, your priest and your God') or listening to his room-mate,
Pritpal Nandra, who shows him to his study and explains Eton's arcane
rituals. Pritpal is really an updated version of Hurree Jamset Ram Singh,
although he sounds more like a professional tour guide. 'This is Upper
School. The heart of Eton,' he drones. 'The statue in the middle is the
school founder, King Henry VI. And that's Lupton's Tower behind him.
That clock will rule your life!'

The new boy meets his own Flashman, too: a rich American loud-
mouth called George Hellebore, who looks as if he dines every day on
'orange juice and milk and fat steaks' and boasts 'sun-tanned skin' and
'gleaming white teeth'. Even Hellebore's father, a thoroughly bad egg,
mocks our hero as a sissy and, somewhat implausibly, you might think,
challenges him to a fight. But in the end the new boy prevails, as new
boys always do – not least by defeating young Hellebore in a

Ian Fleming on the beach outside Goldeneye, 1964. In reality, a less plausible machete-thrower can scarcely be imagined.

cross-country race in which the American, aided by his father, had tried to cheat. In the book's final scene, another staple of schoolboy fiction, our hero stares down Hellebore's cronies. 'In the end,' he thinks, 'they were just boys. Like himself. A little bigger, perhaps, but just boys.' The bullies are left 'standing there, not quite sure what had happened, how this younger boy had so unsettled them; but they had seen in his eyes something cold and frightening'. His name, of course, is Bond.[1]

We rarely think of James Bond as a public schoolboy, and this account of his schooldays comes not from one of Ian Fleming's thrillers, but from the first of Charlie Higson's 'Young Bond' books, which were commissioned by Fleming's estate in 2005. In Fleming's first book, *Casino Royale* (1953), we learn almost nothing about Bond's past at all. Indeed, it is not until the twelfth novel, *You Only Live Twice* (1964), that we discover the truth about Bond's roots. He has disappeared, presumed dead, during a mission to Japan, so M writes an obituary for *The Times*. It turns out that Bond is half Scottish and half Swiss, being the son of Andrew Bond of Glencoe, a representative of the Vickers arms firm, and Monique Delacroix, from the Canton de Vaud. Until he was 11, he went to school abroad, where he learned his fluent French and German. But then his parents were killed in a climbing accident and his aunt sent him to Eton, 'for which College he had been entered at birth by his father'. Alas, he was kicked out after only two terms ('halves' in Eton jargon) after 'some alleged trouble with one of the boys' maids'. So off he went to Fettes in Scotland – Tony Blair's alma mater, where a young Sean Connery used to deliver milk – where he was notable for his boxing and judo skills. It seems that Bond also studied briefly in Geneva, but he was evidently no academic. His future lay in the Royal Navy and the Secret Intelligence Service.[2]

Although Bond fans have written entire books discussing the character's origins, the implication of M's obituary is pretty simple: Bond is effectively a sexed-up, souped-up and generally superior version of Ian Fleming. His Scottish roots, never mentioned until *You Only Live Twice*, are often seen as a respectful nod to Sean Connery. But Fleming himself had Scottish ancestry. His grandfather, Robert Fleming, had been born in the slums of Dundee in 1845 and was a model of Caledonian rectitude, financial acumen and self-improvement. After working his way up to become a local jute merchant's bookkeeper, Robert began overseeing

the firm's American investments and then set up his own investment trust. He moved south to Mayfair, bought an Oxfordshire country estate and sent his sons to Eton and Oxford. The elder boy, Valentine, seemed the quintessential Edwardian gentleman: handsome, popular and sporting. Having become a barrister and a partner in his father's merchant bank, he was elected Conservative MP for Henley. When the Great War broke out he wasted no time in joining up, but in 1917 he was hit by a German shell in Picardy, leaving four young sons. Valentine's second son, who was only 8 when his father was killed, was Ian. In later years, wherever he lived, Ian Fleming always displayed a framed copy of the generous tribute that his father's friend Winston Churchill had written in *The Times*. His older brother Peter, meanwhile, kept Valentine's sword in his umbrella rack. Indeed, if the pressure of living up to Robert and Valentine were not bad enough, Peter was the older brother from hell: an academic star at Eton, a first-class student at Oxford, a fearless explorer of the Amazon, an intrepid foreign correspondent and a travel writer of rare popularity. It was little wonder that poor Ian cut such a melancholy figure.[3]

Fleming arrived at Eton in 1921, some twelve years earlier than Charlie Higson's Bond. His previous establishment, the infamously brutal Durnford School in Dorset, with its culture of bullying and beatings, made Evelyn Waugh's Llanabba look like a holiday camp, so his new school came as a welcome improvement. At Eton he distinguished himself on the sports field, where he proved an excellent cricketer, long jumper and distance runner. Unfortunately, in the classroom, unlike the effortless Peter, he was a bit of a dud, so his mother enrolled him in the school's Army Class, which prepared boys for the officer training colleges at Sandhurst and Woolwich. But Sandhurst proved something of a disaster. Fleming chafed at the strict regulations, and after contracting gonorrhoea from a Soho prostitute, he allowed his mother to browbeat him into pulling out. And this, more or less, was the pattern for the next two decades. He took the entrance examination for the Foreign Office, and failed to get in. He went into banking, and failed at that too. He went into stockbroking, but never settled. The war provided a welcome break from this rather miserable cycle, with Fleming serving as the personal assistant to the Royal Navy's intelligence chief, Rear Admiral John Godfrey. Indeed, this was probably the high point of his life: writing secret reports, liaising with American intelligence, planning sabotage

operations, directing Commando units, and so on. But then the war ended, and it was back to reality. The early 1950s found Fleming, now in his forties, dividing his time between his Jamaican retreat, Goldeneye, and London, where he ran the team of foreign correspondents for the Kemsley newspaper group, which included the *Sunday Times*. By the elevated standards of his grandfather, father and brother, he was a waste of space. Indeed, with his cocktails and his cigarette holder, he cut a strikingly camp and ineffective figure: not for nothing does one Bond expert* call him a 'handsome but banal philandering toff ... almost a parody of a less talented younger brother'.[4]

The purpose of all this is not merely to show that Fleming wrote the Bond books as a gigantic exercise in wish-fulfilment, but to make the point that they were written out of a very particular social experience, which was funded by Fleming's family money and would have seemed utterly fantastical to most of his readers. Perhaps this is merely to state the obvious. And yet one of the most common things written about James Bond, repeated so often that it has become a cliché (including, I have to admit, by me), is that he is the ultimate 'classless' hero. Greeting the release of *Skyfall* in 2012, *The Economist* declared that Bond had begun life as 'an aspirational, thoroughly English figure', who later, by adding a Scottish dimension, became 'elegant and classless, but also a roving outsider'. In his fine book on Fleming, Ben Macintyre writes that the 'Scottish-born Bond, for all his clubbable ways and public school education, is intended to be classless (or as classless as an upper-class man like Fleming could make him)'. Similarly, the film historian James Chapman calls the Bond of the films 'a modern, virile, classless character'. Even the Bond of the books, he adds, was written as a 'modern, to some extent classless, hero' – a professional 'civil servant', no less.†[5]

But is this really true? Given Fleming's background, it would have been very odd for him to have created a genuinely classless wish-fulfilment figure. Between May 1908, when he was born in a house on Park Lane, and February 1952, when he sat down at Goldeneye to begin work on *Casino Royale*, he had enjoyed a life of immense privilege. He spent his

* The editor of this book, in fact.

† Professor Chapman's excellent essay appears in an edited collection. Among the other pieces is an essay by an American scholar entitled '"Alimentary, Dr. Leiter": Anal Anxiety in *Diamonds Are Forever*'. No connoisseur of academic writing can afford to miss it.

childhood in a Georgian house beside Hampstead Heath, which had once belonged to Pitt the Elder, and Braziers Park in Oxfordshire, a Gothic Revival mansion, which, as his biographer puts it, seemed 'a child's paradise, with dedicated nurseries and playrooms, its maze of passages and cupboards, its stables and kennels . . . its hidden pathways and its rolling acres of woodland'. It is true that a few people might have turned their noses up at the family's Dundee roots, but by conventional standards Fleming moved in a distinctly upper-class world: Eton and Sandhurst, skiing and cocktails, stockbroker friends and society parties. Even his wife, the glamorous Ann Charteris, had originally been married to the third Baron O'Neill and subsequently to the second Viscount Rothermere. So if he *had* created a genuinely classless hero, a secret agent who transcended the innumerable social distinctions that blighted life in Britain in the 1950s, it would have represented a tremendous feat of imagination – especially when you consider that Fleming spent half his time in Jamaica hanging around with friends like Noël Coward, and the other six months in London hobnobbing with his wife's cut-glass cronies.[6]

But of course he did no such thing. Even the title of the first Bond book, published in April 1953, gives the game away. How many of Fleming's readers had ever set foot in a casino, never mind one in a town like the elegant French resort of 'Royale-les-Eaux'? It is true that we discover remarkably little about Bond's background in the first book; but it is hard to imagine many readers reaching the end in the belief that he is anything other than upper-class. On the first page we meet him playing roulette; on the second he collects a sheaf of hundred-thousand-franc notes, taking his winnings for the last two days to 'exactly three million'. On his way out, he gives a thousand francs to the cloakroom attendant. He is staying at the Hotel Splendide, where he receives a telegram with the news that another 10 million francs is on its way. Now the story flashes back to London and his meeting with M, who has ordered him to bankrupt Le Chiffre, the villain, at baccarat. Bond, we are led to understand, is the kind of man who plays a lot of baccarat, not the kind of man who spends his evenings at working men's clubs in Barnsley. Then back to the present. Bond has breakfast: 'half a pint of iced orange juice, three scrambled eggs and bacon and a double portion of coffee without sugar', as well as his first cigarette, 'a Balkan and Turkish mixture made for him by Morlands of Grosvenor Street'. So he

is the kind of man who has cigarettes especially made by a Mayfair tobacconist, as well as one who speaks French and goes to casinos! Later, he orders 'half an avocado pear with a little French dressing', a luxury almost unimaginable to most of his readers in the straitened, ration-bound circumstances of the early 1950s, but one perfectly imaginable to a clubland regular – or, indeed, to somebody writing in the West Indies. To be sure, *Casino Royale* is, by the standards of the later Bond books, surprisingly mundane, even a bit drab. But even the first few pages, writes one critic, hammer the point home: Bond's 'absolute knowledge about food, about sex, about foreign countries, clothing, drink' – the kind of knowledge that you only get with money, birth and breeding.[7]

In 1958, giving an interview to the *Manchester Guardian* to publicize his sixth novel, Fleming claimed that he had picked 'the simplest, dullest, plainest-sounding name I could find'. 'James Bond', he said, was 'much better than something more interesting, like "Peregrine Carruthers". Exotic things would happen to and around him, but he would be a neutral figure – an anonymous, blunt instrument wielded by a government department.' It is true that 'James Bond' is much less obviously upper-class than 'Peregrine Carruthers', just as it is true that Bond does not, say, wear a monocle or travel with an army of servants. Even so, it is worth noting that the *real* James Bond – the eminent American ornithologist whose book *Birds of the West Indies* lay on Fleming's desk and inspired his character's name – could hardly have cut a more patrician figure. Born in 1900, the real Bond went to a prestigious boarding school in New Hampshire and then, after moving to England at the age of 14, to Harrow and Trinity College, Cambridge. There he reportedly kept a 'hunting dog' and was the only American invited to join the exclusive Pitt Club, whose previous members included Edward VII, George V and John Maynard Keynes. He was no more classless, in other words, than his fictional namesake.[8]

As you read the Bond books, in fact, the central character looks less and less like Fleming's 'anonymous, blunt instrument' and more like the Old Etonian of M's obituary. With the glaring exception of his sexual morality, his values are those of a conservative, middle-aged member of the British upper class: the Royal Navy, the Empire, tradition, *The Times*. As the historian David Cannadine points out, Bond's Britain is the 'Establishment England' represented by politicians such as Sir

Anthony Eden, the luckless Conservative Prime Minister who had been groomed to succeed Churchill but was forced to recuperate at Goldeneye after the disaster of Suez. When Bond goes for a walk on the Kentish coast with the heroine Gala Brand in *Moonraker* (1955), the only book set entirely in Britain, he contemplates this 'carpet of green turf, bright with small wildflowers' sliding down to the 'sparkling blue of the Straits ... a panorama full of colour and excitement and romance', sounding not unlike Stanley Baldwin. When he daydreams about England in *Dr No* (1958), he pictures 'a world of tennis courts and lily ponds and kings and queens', like something from a Noël Coward comedy. And when he thinks about politics, his instincts are clearly Conservative. (Fleming himself, for all his claims to be 'non-political', was an instinctive Tory, writing in the *Spectator* that 'taxation, controls and certain features of the Welfare State' had 'turned the majority of us into petty criminals, liars and work-dodgers'.) Indeed, by the time we get to *Thunderball* (1961), the gloves have come off. Contemplating a pimply young taxi driver in a 'black leather windcheater', Bond muses about the 'cheap self-assertiveness of young labour since the war'. This youth, he thinks, 'makes about twenty pounds a week, despises his parents, and would like to be Tommy Steele'. But 'it's not his fault. He was born into the buyer's market of the Welfare State.' Had Bond tired of life in the Secret Service, he could have got a job writing editorials for the *Daily Telegraph*.[9]

In his political and cultural conservatism, Bond conforms absolutely to type. As reviewers often remarked, the character owed a great deal to the 'clubland heroes' of the interwar years, such as John Buchan's Richard Hannay and Sapper's Bulldog Drummond, whose adventures had delighted Fleming at school. 'They were rich, belonged to clubs, had servants and fast cars,' writes Richard Usborne in his classic study of the genre. As Usborne notes, there was always in the background the shadow of the public-school playing field. Bulldog Drummond has vaguely aristocratic connections and competed in the finals of the Public School Heavyweight Boxing, while Dornford Yates's hero Jonah Mansell went to Eton and was the 'outstanding schoolboy boxer of his day'. As for Hannay, he was brought up in South Africa, but put his son down for Eton, no doubt on the advice of his friend Sandy Arbuthnot, another Old Etonian. In each case, Usborne writes, their ethos was that of the 'public school prefects' room': brave, gallant, unswervingly

patriotic and unthinkingly conventional. Where they had once punished other boys 'for letting down the tone of the school', there were now 'crooks, rotters and foreigners to punish, sometimes for the good of England, sometimes just because they were crooks, rotters or foreigners'. They claimed to be anti-political, but this being the 1920s their targets tended to be on the left. Typically they took on Jews, Communists and Russians in various combinations: enemies of England, whose villainy – as in the Bond books – was usually suggested by hideous deformities of one kind or another. The job done, they retired to their West End clubs: fortresses of masculine endeavour, enclaves of sanity in a changing world, with no women to spoil the atmosphere and a reliable porter to guard the gate against 'cads, creditors and hunch-backed foreigners'.[10]

If Bond has a vision of paradise, it is Blades, the gentleman's club where he dines with M at the beginning of *Moonraker*. Fleming based it largely on his own club, Boodle's. It was founded, he tells us, just off St James's Street in or around 1778. 'It is not as aristocratic as it was, the redistribution of wealth has seen to that' – Fleming here in *Daily Telegraph* territory again – 'but it is still the most exclusive club in London.' Membership is limited to just 200, and there are only two criteria: a member must 'behave like a gentleman' and must be able to 'show' £100,000 in cash or securities (the equivalent of at least £6 million today). But as Bond reflects, there are compensations, for Blades offers 'the luxury of the Victorian age'.

> If a member is staying overnight, his notes and small change are taken away by the valet who brings the early morning tea and *The Times* and are replaced with new money. No newspaper comes to the reading room before it has been ironed. Floris provides the soaps and lotions in the lavatories and bedrooms; there is a direct wire to Ladbroke's from the porter's lodge; the club has the finest tents and boxes at the principal race meetings, at Lords, Henley and Wimbledon, and members travelling abroad have automatic membership of the leading club in every foreign capital.

But there is a worm in paradise: the industrialist Sir Hugo Drax, whom M suspects of cheating at cards. When Bond investigates, he discovers that not only is Drax a 'bullying, boorish, loud-mouthed vulgarian', but he is a fanatical Nazi, Graf Hugo von der Drache. In a marvellously

suggestive twist, it emerges that Drax has hated England ever since boarding school, where he was bullied for his German name and unfortunate features. Bond, of course, reacts with the sensitivity you would expect. 'Being bullied at school and so on,' he tells Drax sarcastically. 'Extraordinary the effect it has on a child . . . now let's get on with this farce, you great hairy-faced lunatic.'[11]

What gives Drax away is that he does not know how to behave like a gentleman. By contrast, Bond always knows *exactly* how to behave, as one would expect of a man educated at Eton and Fettes. Everything is just so and just right. Bond spends his evenings playing cards or 'making love, with rather cold passion', while at weekends he plays golf. He wears bespoke dark blue suits or sleeveless dark blue Sea Island cotton shirts and tropical worsted trousers. He uses Pinaud Elixir shampoo, drives a Mark II Continental Bentley, and consumes Taittinger Blanc de Blancs Brut '43 and caviar, pink champagne and stone crabs, or sausage with Macon and Riquewihr. Even breakfast in his Chelsea flat is an extravagant social ritual, with his Scottish housekeeper bringing him 'coffee from De Bry in New Oxford Street' as well as 'Tiptree "Little Scarlet" strawberry jam; Cooper's Vintage Oxford marmalade and Norwegian Heather Honey from Fortnum's. The coffee pot and the silver on the tray were Queen Anne, and the china was Minton, of the same dark blue and gold and white as the egg-cup.' This passage was written at the beginning of 1956, barely eighteen months after the government had scrapped the last food rationing. Only gradually was the great motor of affluence beginning to transform ordinary life: for many people, everyday reality was still damp and dreary. It is no wonder, then, that readers delighted in the adventures of a secret agent who lived so lavishly and with such little thought for cost. But Fleming was not writing about the lifestyle of the aspirational middle classes; he was luxuriating in the pleasures of the very rich. All things considered, his Bond is no more a classless hero than Bertie Wooster is a horny-handed son of toil.[12]

RED WINE WITH FISH

England! The Empire! MI6! You're living in a ruin as well; you just don't know it yet.

Raoul Silva (Javier Bardem), in *Skyfall* (2012)

James Bond plays Lawrence of Arabia: Roger Moore at his eyebrow-raising peak in
The Spy Who Loved Me (1977).

Bond's ascent to become the supreme fictional symbol of Britishness in the second half of the twentieth century was far from inevitable. Early sales were less than spectacular, and *Casino Royale* was rejected by three American publishers before being brought out, to general indifference, by Jonathan Cape. For the next three years, although Fleming produced a book every year, the Bond books failed to trouble the compilers of the bestseller lists. Sales rocketed after Pan brought out *Casino Royale* as a cheap mass-market paperback in 1958, tapping the growing affluence of millions of middle-class readers, and received a further boost when the *Express* began running a comic-strip serial based on *From Russia, with Love* (1957). But, as Fleming knew, the real trick was to get Bond into the cinema. As early as January 1954, he had been contacted by the veteran producer Sir Alexander Korda, who had seen a proof of *Live and Let Die* and wanted Fleming to write something especially for the screen. In his reply, Fleming confided that his next book, *Moonraker*, was based on 'a film story I've had in my mind since the war'. Alas, the Korda connection came to nothing. But then, in November 1955, the Rank Organisation offered him £5,000 for *Moonraker*. It seemed an obvious marriage: the adventures of an upper-class British secret agent, made by the most celebrated film company in the land. But Rank's script department failed to produce a workable adaptation, and even though Fleming wrote a draft screenplay himself, the negotiations dribbled into the sand.[13]

As Fleming's biographer Andrew Lycett puts it, Rank's failure to secure the Bond rights compares with Decca turning down the Beatles. But if Rank *had* secured the Bond rights, the chances are that the character would be largely forgotten today. By this point, the Rank Organisation had largely given up on making big-budget pictures for the American market, and had they been given the chance to turn *Moonraker* into a film, the chances are that it would have been a relatively small-scale affair, with Bond played by a company stalwart such as Kenneth More or Dirk Bogarde. Instead, Fleming had to wait for his film deal until 1961, selling the Bond rights to the Canadian–American partnership of Harry Saltzman and the memorably named Albert R. Broccoli. The first film, *Dr No*, was scheduled for production the following January. In the meantime, they had to find their Bond.[14]

Fleming had very clear ideas about the kind of man who ought to play his secret agent. His biographers often list several names, from

James Stewart and James Mason to Richard Todd and Richard Burton, but the one that recurs most often is his friend David Niven. Although Niven eventually did get to play a retired Bond in the lamentable *Casino Royale* spoof version in 1967, the fact that Fleming seriously considered him as Bond seems utterly fantastical. In 1961 Niven had recently turned 50, and although he had enjoyed a tremendously successful film career, picking up an Oscar in 1958 for his role in the Rattigan adaptation *Separate Tables*, he specialized in playing raffish, mildly ineffectual gentlemen amateurs. In fact, there was more steel behind the smile than people realized: on the outbreak of the Second World War, Niven had abandoned a lucrative Hollywood contract to return home and join the British army, first in the Rifle Brigade and then the Commandos. On screen, however, his persona was very different. If you needed somebody to carry off a dressing gown, Niven was your man, but he hardly made a plausible killer.

The fact that Fleming championed his cause, therefore, speaks volumes about the author's attitude to his own character. What mattered was that Niven was the right social type. Like Fleming he had lost his father in the Great War, and like Fleming he was sent to boarding school, initially at Heatherdown in Berkshire, later a favourite of the Royal Family. He would have gone to Eton, where he might have met Fleming, had he not been expelled from Heatherdown for stealing. Instead he had to go to Stowe and then Sandhurst, where he missed Fleming by months. If Niven had played Bond, therefore, he would certainly have brought out the character's upper-class suavity. Perhaps, in some alternative universe, there is a long-running Bond franchise in which Niven passed the torch to first Peter Wyngarde and then Peter Bowles, thereby confirming the moustache as the supreme symbol of style and virility.[15]

Why did the producers pick Sean Connery, a former milkman, sailor, lorry driver, labourer and coffin polisher from Edinburgh, whose film career had been solid rather than spectacular? The obvious answer is that he was cheap. The original budget for *Dr No* was just under $1 million; to put that into context, Connery's previous film, *The Longest Day*, had cost $8 million, while among other films made at the same time *How the West Was Won* cost $14 million, *Lawrence of Arabia* $15 million and *Cleopatra* $44 million. Even if the producers had wanted David Niven or James Mason or Cary Grant, they probably could not have afforded them. In any case, the prospect of an

established Hollywood star tying himself to an unproven film franchise based on a series of novels by a British writer was highly unlikely, to say the least. According to Connery's biographer Christopher Bray, his most plausible rival was probably Patrick McGoohan, who already played the secret agent John Drake in the ITV series *Danger Man*. But McGoohan disliked Bond's sexual immorality, leaving the door open for Connery.

At the time, Broccoli was worried that the Scottish actor looked like a 'bricklayer'. But the film's director, Terence Young, had worked with Connery in the 1950s and urged him to come to the audition in a suit. In fact, Connery arrived in a 'sort of lumber jacket', and refused to make any concessions to the producers' expectations of suave decorum. But it was precisely this attitude – slightly rebellious, unrepentantly masculine, effortlessly physical – that got him the part. Saltzman remembered that as Connery spoke 'he'd bang his fist on the table, the desk, or his thigh, and we knew his guy had something . . . He's got balls.' And as Broccoli watched Connery stroll away down the street, he marvelled at the actor's 'sheer self-confidence . . . He walked like the most arrogant son-of-a-gun you've ever seen – as if he owned every bit of Jermyn Street from Regent Street to St James's. "That's our Bond," I said.'[16]

The revealing thing, however, is what happened next. Connery, the son of a factory worker and a cleaner, who had left school at the age of just 13, could hardly have had a less patrician background. But the production team immediately set about changing his image. The key figure was Terence Young, the son of the deputy police commissioner in Shanghai's International Settlement, who had been sent to boarding school before reading history at Cambridge and serving as a tank commander in the Irish Guards during the Second World War. 'I had a very clear idea of what an Old Etonian should be,' Young said later. 'I was a Guards officer during the war, and I thought I knew how Bond should behave.' In effect, therefore, he turned Connery into a junior version of himself. He took him to dinner in the West End; he took him to his favourite shirt makers, Turnbull & Asser, on Jermyn Street; and he took him to his tailor, Anthony Sinclair, just off Savile Row, who gave Connery precisely the kind of smart dark suit – with a fitted waist, slightly longer jacket and narrow trousers – favoured by the old officer class. Legend has it that Young even ordered Connery to sleep in the suit so that it would become a second skin. And by the time the actor began filming in

January 1962, the transformation was complete. His fellow cast members even joked that when the cameras were rolling, he was essentially doing a Terence Young impersonation.[17]

There is no doubt that by casting Connery the producers blurred the upper-class edges of Fleming's character. When *Dr No* reached the screen in October 1962, many reviewers were clearly expecting a Niven-style Bond. *The Times*'s critic John Russell Taylor, for example, wondered 'whether either [James Bond's] admirers or his detractors will recognize him', lamenting his 'faint Irish-American look and sound, which somehow spoils the image'. But since the newspapers played up Connery's humble Scottish origins, audiences were encouraged to see him as a working-class boy made good, like an ultra-successful version of *Room at the Top*'s cocky, promiscuous and materialistic Joe Lampton. The film historian James Chapman even calls him 'Joe Lampton's fantasy alter ego', noting that while Joe can only dream of having 'a girl with a Riviera tan and a Lagonda', Connery's Bond has as many suntanned girls and sports cars as any man could want. Even a decade earlier, the proletarian Joe Lampton image might have been disastrous for the film's prospects. But in the autumn of 1962, with the vogue for working-class realism at its peak, and the papers feverishly denouncing Britain's supposedly stagnant and anachronistic Establishment, Connery's Bond struck a chord. Before long, even *The Times* – Bond's favourite paper – had come around. A year later, John Russell Taylor's review of *From Russia with Love* repeated that 'Mr. Connery is not everyone's idea of Bond', but allowed that 'he looks handsome and tough enough to live up to the basic requirements'. But his review of *Goldfinger* (1964) did not mention Connery at all, and after watching *Thunderball* in December 1965, he remarked only that 'Sean Connery, as usual, presides with unshakable confidence over the whole proceedings'. And by the time *You Only Live Twice* reached the screen in the summer of 1967, the game was up. 'There is no point in arguing,' Taylor admitted: 'by now Sean Connery, as the posters have it, just *is* James Bond.'[18]

All the same, the classlessness of Connery's Bond is often immensely exaggerated. Take his first appearance in *Dr No*, probably one of the most famous scenes in popular cinema, which was designed to introduce the character to a mass audience. We meet Bond not in his flat or his office, or in the middle of some exciting operation, but in – surprise,

surprise – a casino. So far, all very *Casino Royale*: the difference, though, is that Bond is here for pleasure. This is his natural habitat. As the camera moves across the room, we get a sense of the atmosphere: bow-tied waiters carrying silver trays, ladies in elegant evening gowns, balding men in smart dinner jackets. The average age of the clientele appears to be about somewhere north of 70, and it is safe to say very few of them read the *Daily Mirror*. The camera drifts towards one particular table, where we find Sylvia Trench (Eunice Grayson), resplendent in off-the-shoulder red, surrounded by men who might be an association of Brylcreem enthusiasts, or perhaps an assortment of especially seedy government ministers. The game continues; most of the dialogue by this point has been in French ('*Carte*', '*C'est suivi*', '*Neuf la banque*', etc.). Sylvia runs out of chips and asks for 'another thousand'. Now, for the first time, Bond speaks: 'I admire your courage, Miss – er . . .' She gives her name ('Trench, Sylvia Trench') and asks for his; only then does he say the famous words: 'Bond, James Bond.'* For the first time we see him, a dark, handsome, slightly orange man in a well-cut dinner jacket, a cigarette in his mouth. The game continues. Sylvia raises the limit, Bond has 'no objection', and there is a bit of flirtatious banter. Then Bond gets a tap on the shoulder and is handed a note. 'André, I must pass the shoe,' he says casually. On his way out, there is more chitchat with Sylvia: 'Tell me, Miss Trench, do you play any other games? I mean, besides *chemin de fer*.' 'Golf, amongst other things,' she says, and they make a date for golf and dinner. 'Splendid,' says Bond. 'My number's on the card.'

We are, admittedly, only moments into the film, but there has been absolutely nothing to suggest that Connery's Bond is anything other than upper-class, with the possible exception of his accent – but even that is so soft that it is easy to miss it. So far we know that he wears a dinner jacket, spends his evenings at casinos playing for high stakes, has an eye for the ladies, plays golf and carries a business card. Indeed, nothing in the rest of the film dispels our original impression. When Bond grabs a champagne bottle to use as a weapon in Dr No's lair, the villain says reprovingly: 'That's a Dom Perignon '55: it would be a pity

* Today the formula 'Bond, James Bond' has become a cliché. But how many people remember that the line was born as a slightly creepy bit of amorous repartee, since Bond is merely mimicking Sylvia?

to break it.' Bond replies: 'I prefer the '53 myself.' Indeed, the scenes in Jamaica struck the critic Raymond Durgnat as pure old-fashioned imperialism. 'If you have forelocks, prepare to touch them now,' Durgnat remarked, 'as Bond glides along the Establishment's Old Boy Net . . . We might almost be back with Lieutenant Kenneth More on the North-West Frontier.'

And although Connery's Bond is more physical than most gentlemen heroes, and certainly far rougher and tougher than Niven would have been, his trappings and qualities are those of the rich upper class. His accent is the only classless thing about him, a kind of vocal equivalent of his wetsuit in the opening moments of *Goldfinger*, which he promptly removes to reveal his dinner jacket. His tastes are conservative: only a few minutes later, he tells Jill Masterson: 'My dear girl, there are some things that just aren't done, such as drinking Dom Perignon '53 above the temperature of 38 degrees Fahrenheit. That's just as bad as listening to the Beatles without earmuffs.' And, as in the novels, he is primed to detect social interlopers. 'Red wine with fish,' he remarks in *From Russia with Love*, just after unmasking the assassin Red Grant. 'That should have told me something.'[19]

The remarkable thing about Bond is how little he has changed. The Empire might have disappeared, Britain might have joined the European Union and the face of the country might have changed almost beyond recognition, but as a character, and as a globally recognized symbol of Britishness, Bond has remained extraordinarily consistent. By and large, the producers have always fought shy of casting upper-class Englishmen, as if conscious that Bond's screen appeal lies in the hint of tension between the actor's background and the character's privileged backstory. When Connery finally hung up his Walther PPK, they cast, in turn, an Australian car-salesman-turned-model (George Lazenby), a grammar-school boy from Stockwell (Roger Moore), a Welsh-born Shakespearean actor (Timothy Dalton), an Irish-born comprehensive-school boy (Pierce Brosnan) and a pub landlord's son from the Wirral (Daniel Craig). Yet all five were essentially playing the same upper-class character, the kind of man who, as we learn in *Skyfall*, was brought up on a Scottish Highland estate with a gamekeeper who taught him how to shoot. MI6 moves to a grand headquarters in Vauxhall, Q becomes a computer geek and M becomes a woman, but Bond remains essentially the same. Thus Dalton's relatively puritanical Bond,

sent to pick up a Harrods hamper for a Soviet defector, turns his nose up at M's 'questionable' choice of champagne, preferring to buy Bollinger RD instead. Even Lazenby's unpolished Bond, snatching a quick bite of caviar after beating up a henchman, can immediately identify it as 'Royal Beluga, north of the Caspian'. Of course the nuances depend on the actor: in a revealing metaphor, the critic Alexander Walker once remarked that by swapping Connery for Moore, the producers had substituted 'the head prefect for the school bully ... Roger would have gone all out to win the race for the school; so would Sean, but probably by nobbling his competitor in the locker room.' The real point, though, is that they were both running for Eton.[20]

The fact that Bond has changed so little, but remains so popular, speaks volumes about the continuity of British cultural life since Fleming first put pen to paper.* Paying tribute to Connery's version, the American novelist Jay McInerney once called him 'witty and well-dressed and unflappable', a masculine icon 'whose first impulse, after killing a man, was to straighten his tie'. Half a century later, having ripped the roof off a moving train and jumped aboard in pursuit of an enemy agent, Daniel Craig's Bond's first impulse was to adjust his cuffs. For McInerney, Connery's Bond was the ultimate role model, 'a cultured man who knew how to navigate a wine list, how to field-strip a Beretta, and how to seduce women'. Precisely the same things might be said about Craig's Bond, too.

And the underlying point is that Bond does not just 'happen' to be a member of the British elite. His membership of that elite, with all the confidence and taste and style that implies, is at the very heart of his appeal. It is what makes him different from American dullards such as Jack Ryan and Jason Bourne, who might challenge his box-office popularity for a few years, but always fade into obscurity eventually. Nobody fantasizes about being Jason Bourne, but there can be few men who have not, somewhere at the back of their minds, dreamed of being James Bond. It is *because* Bond belongs to the elite that he knows his way around a wine list. If he had been born on the back streets of Bolton, or had worked his way up from suburban Sutton Coldfield, he would not

* It is surely no coincidence, by the way, that the film in which Bond moves furthest away from upper-class Britishness, the *Miami Vice* pastiche *Licence to Kill* (1989), was, in box-office terms, by far the least successful.

be the same man at all. His elitism is not just what makes him tick, it is what makes him special. From the opening sentences of Fleming's first book to the last scene of *Skyfall*, there has never been a more seductive advertisement for the upper-class Establishment.[21]

LAST STAND AT GANDAMAK

I thought, by God, how little you know, or you wouldn't be cheering me. You'd be howling for my blood, you honest, sturdy asses – and then again, maybe you wouldn't, for if you knew the truth about me, you wouldn't believe it.

George MacDonald Fraser,
Flashman in the Great Game (1975)

Even during Fleming's lifetime, Bond's role as the pre-eminent fictional representative of British heroism did not go unchallenged. The literary scholar Bernard Bergonzi even compared the 'vulgarity', 'voyeurism' and 'sado-masochism' of *Moonraker* with the 'subdued images of the perfectly self-assured gentlemanly life that we find in Buchan or even Sapper', which must surely have been the last time that anyone said anything complimentary about Bulldog Drummond. Paul Johnson, meanwhile, proclaimed *Dr No* 'the nastiest book I have ever read', explaining that its three central ingredients were 'the sadism of a school boy bully, the mechanical two-dimensional sex-longings of a frustrated adolescent, and the crude, snob-cravings of a suburban adult'. And it is surely not too fanciful to see the spy novels of John le Carré, with their lonely, damaged anti-heroes, their rain-swept urban landscapes, their themes of disappointment, deception and betrayal, as an extended riposte to Fleming's fantasy world. In their different ways, le Carré's spies are all anti-Bonds: George Smiley, brooding and shabby, a 'shrunken toad' abandoned by his wife; doomed Alec Leamas, who thinks that spies are 'pansies, sadists and drunkards, people who play cowboys and Indians to brighten their rotten lives'; even poor Jerry Westerby, the 'honourable schoolboy', an incurable romantic heading for disaster. Indeed, le Carré once told the BBC that Bond was not a spy at all, but an 'international gangster'. This sort of thing went down very badly with Fleming's fans, though. After reading that le Carré had called

Harry Flashman (Malcolm McDowell), doing what he does best, in the film *Royal Flash* (1975).

Bond 'the ultimate prostitute', Kingsley Amis told Philip Larkin that the former spy's verdict was a 'piece of bubbling dogshit'.[22]

Perhaps the most plausible candidate to dethrone Bond, at least for a time, was Len Deighton's spy-as-everyman, Harry Palmer, who first appeared in his book *The Ipcress File* in 1962.* Deighton's background was very different to Fleming's: born to a chauffeur and a cook in 1929, he had trained as an illustrator at the Royal College of Art before moving into advertising. Not surprisingly, therefore, his central character is more Jim Dixon than Bulldog Drummond. A working-class Burnley grammar-school boy, Harry Palmer studied maths and economics at a provincial university. Vaguely left-wing and cheekily anti-Establishment, he reads the *New Statesman*, the *Daily Worker* and *History Today*, and spends much of his time plotting a pay rise and trying to fiddle his expenses. When his boss offers him a new assignment, he says mockingly: 'If it doesn't demand a classical education I might be able to grope around it.' Even his department, the bureaucratic WOOC(P), operates in surroundings M would hardly have tolerated: a couple of rooms in a Soho office block with a dirty door and cracked linoleum floors, with refreshment from a jar of Nescafé. Indeed, the opening scene of the film adaptation, made by the Canadian director Sidney Furie and the Bond producer Harry Saltzman in 1965, seems calculated to put as much difference between itself and Bond as possible, as the bespectacled, pyjama-clad Michael Caine grinds his coffee beans, boils his kettle and studies his copy of the *Sun* (at the time, a self-consciously fashionable broadsheet). At one point, he even goes to the supermarket, where he debates the best variety of mushrooms with his superior. James Bond would not have been seen dead in a supermarket.[23]

Although *The Ipcress File* never came close to matching the box-office takings of *Goldfinger* or *Thunderball*, it was successful enough for Saltzman to invest in two sequels, while Deighton published a further five Palmer novels. By comparison with Bond, however, Harry Palmer never really caught on. Perhaps he was too domesticated, too unglamorous, too downright ordinary; perhaps the principle of the dashing gentleman adventurer, as opposed to the grumbling grammar-school

* In Deighton's novels the character has no name; he only acquired the name 'Harry Palmer' in the Michael Caine films. But since everybody knows him as Harry Palmer, it would be weird to insist on his anonymity.

spy, was too deeply embedded in the British imagination. Indeed, if there is a post-war Harry who genuinely rivals Bond as an adventurer, seducer, bon viveur and all-round source of entertainment, then it is not Len Deighton's cheeky outsider but another public schoolboy – indeed, one of the most celebrated public schoolboys of all. Christopher Hitchens once remarked that *this* Harry's adventures, with their reliable formula of a 'horrific villain, a brush with an unthinkably agonizing death, and a bodacious female', often read like 'pure Ian Fleming'. The difference, though, is that while Bond is forever itching to employ his licence to kill, his rival is forever trying to run away. In his own words, he is 'a scoundrel, a liar, a cheat, a thief, a coward – and oh yes, a toady'. And yet, in his way, Harry Flashman might just be the most interesting, and certainly the most amusing, hero in modern British fiction.[24]

The odd thing about Flashman is that, although many people immediately recognize him as the bullying arch-enemy in *Tom Brown's School Days*, his role in Thomas Hughes's book is surprisingly slight. He makes his first real appearance in the sixth chapter, where he delights in tossing the younger boys in a blanket. Two chapters later, we are told that he was 'about seventeen years old, and big and strong of his age'. Tom calls him 'that blackguard Flashman, who never speaks to one without a kick or an oath', while young East has him down for a 'cowardly brute'. The narrator, meanwhile, makes his disapproval very plain:

> He played well at all games where pluck wasn't much wanted, and managed generally to keep up appearances where it was; and having a bluff off-hand manner, which passed for heartiness, and considerable powers of being pleasant when he liked, went down with the school in general for a good fellow enough. Even in the School-house, by dint of his command of money, the constant supply of good things which he kept up, and his adroit toadyism, he had managed to make himself not only tolerated but rather popular amongst his own contemporaries; although young Brooke scarcely spoke to him, and one or two others of the right sort shewed their opinions of him whenever a chance offered. But the wrong sort happened to be in the ascendant just now, and so Flashman was a formidable enemy for small boys.

More George Hellebore or Draco Malfoy, therefore, than James Bond. But although Flashman is arguably the book's most memorable character, he actually appears very little. There is, of course, the unforgettable

moment when he and his cronies roast Tom before the fire ('Very well then; let's roast him'), with Flashman 'drawing his trousers tight by way of extra torture'. But in the very next chapter, only halfway through the book, Flashman is yanked from the stage. We are told that after 'regaling himself on gin-punch', he was persuaded to take 'a glass of beer' at the pub and became 'beastly drunk'. When a master discovers him, that is the end of that: 'the Doctor, who had long had his eye on Flashman, arranged for his withdrawal next morning'.[25]

So, for the next 112 years, Flashman skulked in the literary equivalent of the gutter: a braggart and a bully who couldn't even handle his drink. And then, quite unexpectedly, he was back. Carefully wrapped in oilskin, his memoirs were discovered in a tea chest after a house sale in Ashby, Leicestershire, together with a cutting – the famous 'Flashy became beastly drunk' passage – from the first edition of Hughes's book. Having spent decades seething about Hughes's portrait, Flashman wastes no time in setting the record straight:

> Hughes got it wrong, in one important sense. You will have read, in *Tom Brown*, how I was expelled from Rugby School for drunkenness, which is true enough, but when Hughes alleges that this was the result of my deliberately pouring beer on top of gin-punch, he is in error. I knew better than to mix my drinks, even at seventeen.
>
> I mention this, not in self-defence, but in the interests of strict truth. This story will be completely truthful; I am breaking the habit of eighty years.

But Flashman's own account of his disgrace is not so very different. He certainly was beastly drunk, he says, but he never meant to mix his drinks: his friend ordered beer before Flashman knew what he was 'properly doing'. For the first time we discover what was said at that fateful audience with Dr Arnold, whose pale face, Flashman says, 'carried that disgusted look that he kept for these occasions'. When Arnold, denouncing him as 'an evil influence in the school', declares his intention to kick Flashman out, there follows a marvellous exchange:

> 'But, sir,' I said, still blubbering, 'it will break my mother's heart!'
> He went pale as a ghost, and I fell back. I thought he was going to hit me.
> 'Blasphemous wretch!' he cried – he had a great pulpit trick with phrases like those – 'your mother has been dead these many years, and do

you dare to plead her name – a name that should be sacred to you – in defence of your abominations? You have killed any spark of pity I had for you!'

At last Arnold gets a grip on himself, and even produces a lot of schoolmasterly stuff about how Flashman can redeem himself ('you are young, Flashman, and there is time yet ... You have fallen very low, but you can be raised up again ...'). He went on like this, Flashman recalls, 'for some time, like the pious old hypocrite that he was. For he was a hypocrite, I think, like most of his generation. Either that or he was more foolish than he looked, for he was wasting his piety on me.'[26]

Even in this first chapter – for this is, of course, a book, published by the former soldier and journalist George MacDonald Fraser in 1969 – it is clear that this is a Victorian novel of a very unusual kind. It is hard to think of any other school story in which the hero behaves so badly but shows so little shame, and impossible to think of one in which he describes his headmaster – especially one of Arnold's towering reputation – as a pious hypocrite. To add insult to injury, Flashman notes that he was recently invited back to Rugby to hand out the prizes: his expulsion, he says, was not even mentioned, 'which shows that they are just as big hypocrites now as they were in Arnold's day'. Indeed, by the end of the second chapter he has not only lied to Dr Arnold, turned down Scud East's offer of a parting handshake and seduced his father's mistress ('we bounced around in rare style, first one on top and then the other'), but he even hits her twice in the face when she turns down his request for another bout. It is hard to think of any scene more perfectly designed to challenge the moral conventions of the Victorian age, or indeed one that would have more thoroughly shocked Victorian readers. Again, Flashman is completely unrepentant. When she calls him a coward, he spits: 'It's not cowardly to punish an insolent whore. D'you want some more?'[27]

Yet the twist is that Flashman is a pillar of society, respected and admired: why else would he have been invited to dole out the prizes at Rugby, or to give a speech on, of all things, 'Courage'? As early as the book's second paragraph, he tells us that he has 'a knighthood, a Victoria Cross, high rank, and some popular fame'. Flashman, in other words, is the quintessential imperial hero – so how can he be a man who thinks nothing of debauching his father's mistress before whacking her

across the face? And it is this confusion, this tension between reputation and reality, that Fraser's novel exploits for brilliant effect.

It is not just that he is rewriting *Tom Brown's School Days* – indeed the entire canon of Victorian heroic fiction, from Haggard to Henty – from the perspective of an utter reprobate. It is not even that he is rewriting Victorian imperial history to expose the cruelties and hypocrisies of Britain's past. It is that in Flashman he creates an adventurer whose double life is unlike that of any other hero in modern popular fiction. James Bond appears to be a leisured playboy, but is actually a ruthless killer. George Smiley appears to be a shabby cuckold, but is actually a brilliant spymaster. Harry Palmer appears to be a dull civil servant, but is actually a brave secret agent. But Flashman turns all that on its head. To his Victorian contemporaries, he is the incarnation of the manly Christian virtues: handsome, athletic, fearless, chivalrous, a very perfect gentle knight. 'We have heard the most *glowing* reports of your gallantry,' says Queen Victoria at the end of the first book, awarding Flashman a medal for his heroism during the retreat from Kabul in 1842. But we know that he is actually a thoroughgoing, copper-bottomed rotter. He might have been found, half-dead, clutching the Union Jack in the ruins of Piper's Fort, but we know that he spent most of the battle sobbing with terror, and that in reality he was trying to surrender the flag to the Afghans ('Here, take the bloody thing; I don't want it. Please take it, I give in'). This is the great joke of Fraser's project: we know it, but they don't.[28]

Such was the success of *Flashman* that George MacDonald Fraser was able to give up journalism, turning out ten more Flashman books and a volume of short stories by his death in 2008. Indeed, few British popular novelists of the last few decades, with the possible exception of Patrick O'Brian, have inspired such gushing praise from their admirers, who included P. G. Wodehouse, Kingsley Amis, Christopher Hitchens and Max Hastings. In his obituary, the critic D. J. Taylor even likened Fraser, a 'genuine literary artist', to his fellow Scottish writers Tobias Smollett and Robert Louis Stevenson. It is true that the Flashman books probably appealed above all to men of a conservative disposition, not least because of the hero's often outrageously reactionary, indeed frankly sexist and racist, views. Even Fraser's editor admitted that he knew 'of only eight women in 45 years who professed to have been seduced by them'. But not only do they present an intricately detailed fictional

history of the British Empire, they are also beautifully written, and certainly far more impressive than Fleming's Bond books. The Bond books, after all, are essentially one-dimensional fantasies, shot through with an acute nostalgia for British power. But Fraser's books are both subtler and more nuanced. Not only do they chronicle a series of hugely colourful historical escapades – the Charge of the Light Brigade, the Indian Mutiny, the Battle of the Little Bighorn, the sack of Peking's Summer Palace – complete with as much sex, violence and generally disgraceful behaviour as even the lustiest reader could want; they also represent a gleeful alternative history of Victorian Britain, in which almost every virtue is systematically exposed as the rankest hypocrisy. As the former ambassador Sir Allan Ramsay once remarked, 'What they offer is as clear-eyed and unsentimental a portrait of the age as one is likely to find anywhere.' Nobody, I think, would ever say that about the Bond books.[29]

Part of the cleverness of the Flashman stories is the way that they debunk our existing literary and artistic visions of the Victorian era. It is impossible to read Flashman's account of the disastrous retreat from Kabul, for example, without thinking of William Barnes Wollen's painting *The Last Stand of the 44th Regiment at Gundamuck* (1898). When Flashman himself sees it many years later, he reflects:

> No doubt it is very fine and stirs martial thoughts in the glory-blown asses who look at it; my only thought when I saw it was, 'You poor bloody fools!' and I said so, to the disgust of other viewers. But I was there [i.e. at Gandamak], you see, shivering with horror as I watched, unlike the good Londoners, who let the roughnecks and jailbirds keep their empire for them.

In *Flashman in the Great Game* (1975), which is set during the Indian Mutiny, he spots himself in Thomas Jones Barker's painting *The Relief of Lucknow* (1859). The scene, says Flashy:

> looked very gallant, and has since been commemorated in oils, with camels and niggers looking on admiringly, and the Chiefs all shaking hands. (I'm there, too, like John the Baptist on horseback, with one aimless hand up in the air, which is rot, because at the time I was squatting in the latrine working the dysentery bugs out of my system and wishing I was dead.)

And if readers suspect that *Royal Flash* (1970) – which was made into a ropey film five years later – owes rather too much to Anthony Hope's

Ruritanian adventure *The Prisoner of Zenda* (1894), all is explained when Flashman reports that he confided the story to 'young Hawkins, the lawyer – I must have been well foxed, or he was damned persuasive – and he has used it for the stuff of one of his romances, which sells very well, I'm told.' Hope's full name was Anthony Hope Hawkins.[30]

But it is the shadow of *Tom Brown's School Days* that hangs most heavily over the Flashman novels, and not just for the obvious reasons. For if *Tom Brown's School Days* was the supreme distillation of the Victorian faith in masculine virtue and muscular Christianity, then the Flashman novels could hardly be a more entertaining and resounding rebuttal. Hughes's book was written to call boys to 'the worship of Him who is the King and Lord of heroes'. Yet Flashman, unusually for a public-school-educated Victorian, has nothing but contempt for Christianity, repeatedly referring to himself as a 'pagan', and once remarking that 'the heathen creeds, for all their nonsensical mumbo-jumbo, were as good as any for keeping the rabble in order, and what else is religion for?' The cult of courage leaves him cold: bravery, he remarks, is merely 'half-panic, half-lunacy (in my case, *all* panic)'. He has no illusions about the virtues and vices of Empire: behind British imperialism, he thinks, lies a compound of 'greed and Christianity, decency and villainy, policy and lunacy, deep design and blind chance, pride and trade, blunder and curiosity, passion, ignorance, chivalry and expediency, honest pursuit of right, and determination to keep the bloody Frogs out'.[31]

Above all, and perhaps most shockingly for sensitive readers, Flashman does not possess the slightest ounce, the meanest atom, of chivalry. When, having seduced his father's mistress, he smacks her in the face, he is merely setting the tone for the debauchery, callousness and selfishness to come. In *Flashman and the Redskins* (1982), for example, he does not hesitate to sell Cleonie Grouard, who is already pregnant with his child, into Navajo slavery. And when, in *Flashman at the Charge* (1973), he and his former schoolmate Scud East are fleeing Cossack pursuers through the snow on a sleigh, he thinks nothing of throwing Valla – sleeping naked, wrapped in furs, having just enjoyed a taste of Flashy's mettle – overboard to lighten their load. 'What did you do? What did you throw out?' East yells in horror. Flashman's reply is priceless. 'Useless baggage!' he shouts back. 'Never mind, man! Drive for your life!'[32]

Alas, poor East never learns his lesson, and in the very next volume, *Flashman in the Great Game*, Dr Arnold's devoted pupil winds up dead

at the siege of Cawnpore: the flower of Christian manliness, breathing his last with a bayonet in his back. His last words are: 'Flashman . . . tell the doctor.' Someone says that there is no doctor to hand, but Flashman knows that East is talking about somebody else, 'a schoolmaster, but he's dead'. And then Flashman shows that somewhere, beneath the bluster, he does have a heart after all:

> East gave a little ghost of a smile, and his hand tightened, and then went loose in mine – and I found I was blubbering and gasping, and thinking about Rugby, and hot murphies at Sally's shop, and a small fag limping along pathetically after the players at Big Side – because he couldn't play himself, you see, being lame. I'd hated the little bastard, too, man and boy, for his smug manly piety – but you don't see a child you've known all your life die every day. Maybe that was why I wept, maybe it was the shock and horror of what had been happening. I don't know.

In its way, this scene is just as powerful as any anti-war diatribe of the 1960s.[33]

East is not the only Old Rugbeian whom Flashman encounters during his adventures. At the beginning of *Flashman's Lady* (1977), Fraser's anti-hero is drinking in a Regent Street tavern when he bumps into a familiar figure, 'brown-faced and square-chinned, with a keen look about him, as though he couldn't wait to have a cold tub and a ten-mile walk. A Christian, I shouldn't wonder.' When this terrifying apparition mutters something about roasting over a common-room fire, Flashman knows him: it is, of course, Tom Brown, now a 'hulking lout'. Fortunately Tom appears 'to be Christian as well as muscular, having swallowed Arnold's lunatic doctrine of love-thine-enemy'. Indeed, tears springing to his eyes, he apologizes for 'thinking ill' of his old tormentor. Like everyone else, Tom has fallen for the Flashman myth, and not only does he insist on shaking the latter's hand, 'looking misty and noble, virtue just oozing out of him', he invites him to play for the Old Rugbeians' cricket team at Lord's. This is too fine a moment for Flashman not to ruin it. As they part, he cannot resist telling a horrified Tom that he is off 'riding' in Haymarket: 'A few English mounts, but mostly French fillies. Riding silks black and scarlet, splendid exercise, but d——d exhausting.' Poor Tom! 'Flashman,' he begs, a Christian to the last, 'don't go to – to that place, I beseech you. It ain't worthy.' 'How would you know?' says Flashman. 'See you at Lord's.'[34]

When M writes Bond's obituary in *You Only Live Twice*, there is a lovely moment in which he acknowledges that Bond has become a fictional character. The publicity surrounding his adventures, says M, was such that 'a series of popular books came to be written around him by a personal friend and former colleague of James Bond. If the quality of these books, or their degree of veracity, had been any higher, the author would certainly have been prosecuted under the Official Secrets Act.' It is a sign of the 'disdain in which these fictions are held at the Ministry, that action has not yet ... been taken against the author and publisher of these high-flown and romanticized caricatures'.[35]

By Fleming's standards, at least, this is quite funny. But in *Flashman in the Great Game*, Fraser goes one better. Having escaped from India with his skin intact, Flashman has been awarded the Victoria Cross and a knighthood. His reputation is at its peak. Then he opens a new book that Lord Cardigan has rather sneakily given to his wife, and the words hit him like a bucket of iced water:

> *'But that blackguard Flashman, who never speaks to one without a kick or an oath –'*
>
> *'The cowardly brute,' broke in East, 'how I hate him! And he knows it, too; he knows that you and I think him a coward.'*
>
> I stared at the page dumbfounded. Flashman? East? What the blind blue blazes was this? I turned the book over to look at the title: 'Tom Brown's School Days', it said, 'by an Old Boy'. Who the hell was Tom Brown?

Horrified, Flashman reads on, 'red and roaring with rage by this time, barely able to see the pages. By God, here was infamy! Page after foul page, traducing me in the most odious terms – for there wasn't a doubt I was the villain referred to ... for all the world to read about and detest!' And as he reads about his schoolboy exploits, so Tom Brown, whom he seems to have forgotten since their last meeting,* returns to mind, a 'pious, crawling little toad-eater who prayed like clockwork and was forever sucking up to Arnold and Brooke – "yes, sir, please, sir, I'm a bloody Christian, sir," along with his pal East'. As for Thomas

* The explanation, incidentally, is that Fraser wrote the books out of sequence: although *Flashman in the Great Game* is set after *Flashman's Lady* – the dates are 1856–8 and 1842–5 – it was written first.

Hughes, Flashman does not at first finger him for the culprit. But our hero can guess what sort of person he is: 'probably some greasy little sneak whom I'd disciplined for his own good, or knocked about in boyish fun . . . well, by heaven he'd pay for it!' It is a glorious moment, one of the funniest in the entire sequence. For, as Flashman has to admit, with the candour that makes him so devilishly likeable, 'it was all too true, that was the trouble'.[36]

Fraser was neither the first author, nor the last, to have some fun with the Victorian canon. Indeed, turning the Victorians on their head has become something of an obsession for literary novelists since the 1960s; just think of, say, Jean Rhys's *Wide Sargasso Sea* (1966), John Fowles's *The French Lieutenant's Woman* (1969), A. S. Byatt's *Possession* (1990) or Sarah Waters's *Fingersmith* (2002). In part this is a testament, I think, to the lasting power of the Lytton Strachey stereotype, all starched collars and rank hypocrisy, which provides self-consciously modern (or rather, post-modern) writers with a tempting subject and an easy target. But it also reflects the deep and enduring imprint of Victorian culture upon our own. When Fraser wrote *Flashman*, he could be reasonably confident that his readers would spot and enjoy the references, even though some American reviewers apparently believed the novel to be a genuine memoir. And of course the fun of Flashman's narrative is not just the interplay between past and present, but the fact that even now his antics are just a tiny bit shocking. It is the enduring legacy of imperial fiction – including, and perhaps especially, the adventures of James Bond – that makes Flashman seem so refreshingly different. Fraser knew the power of Bond as well as anybody: he had, after all, written an early draft of the screenplay for *Octopussy* (1983), in which Roger Moore, cool and unflappable in the heat of a frankly rather caricatured India, has never been more debonair. In Flashman, Fraser created the absolute antithesis of Fleming's literary hero: cowardly where Bond is courageous; selfish where Bond is gallant; the very opposite, in fact, of a gentleman. But without Bond and his peers, without their code of honour, courage, patriotism and duty, the Flashman stories would merely be kicking against the past. The underlying implication of the Flashman stories is not, in reality, the ebbing power of the public-school code. It is the fact of its survival.

PART THREE

We Are the Martians

British Culture in the Shadow of the Past

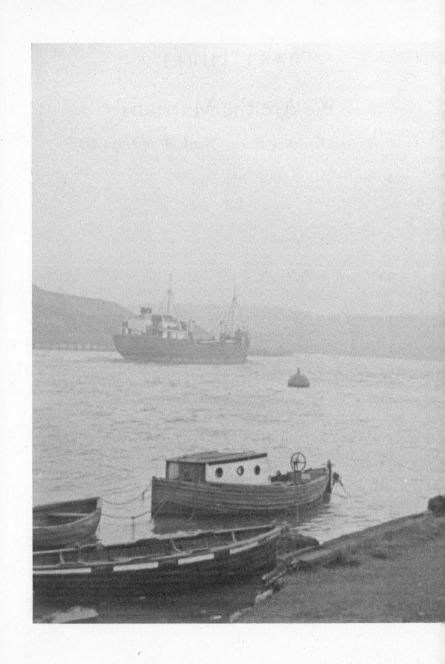

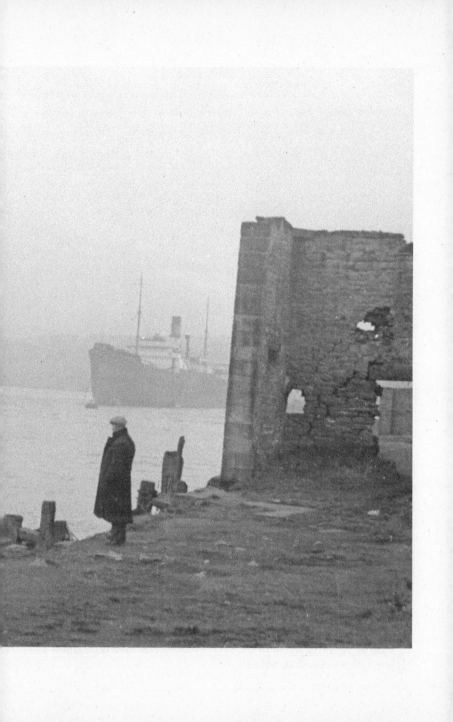

Previous pages: The port of Jarrow, 1938: a working-class town in the grip of 'a perpetual penniless bleak Sabbath'.

8

All Back Alleys and Booze

THE UNQUIET DEAD

BILL TURNBULL: *So do you think you can top last year's Christmas special?*

SIAN WILLIAMS: *And can you tell us anything about it?*

CHARLES DICKENS: *Well, all I can say now is that it involves ghosts; and the past, the present and future, all at the same time.*

Doctor Who, 'The Wedding of River Song' (2011)

It is Christmas Eve 1869. In a dressing room in Cardiff, the most celebrated writer of the age waits for his call. He is old, tired, disillusioned; his eyelids heavy, his beard flecked with grey. 'On and on I go, the same old show,' he murmurs sadly. 'I am like a ghost, condemned to repeat myself for all eternity ... Even my imagination grows stale.' On stage, in front of a packed house, he begins reading from one of his best-loved stories. But just as he is describing a moment of extraordinary transformation ('It looked at Scrooge as Marley used to look. It looked like –'), consternation breaks out in the theatre. It appears that one member of the audience is, in fact, a ghost. With people fleeing the theatre in terror, the writer retreats to his coach. But there, to his horror, he finds himself trapped with a stranger in, of all things, a black leather jacket. 'Dickens? Charles Dickens?' asks the stranger enthusiastically.

You're brilliant, you are. Completely 100 per cent brilliant. I've read them all. *Great Expectations, Oliver Twist* and what's the other one, the one

In Dickens's shadow: Magwitch (Finlay Currie) and Pip (Anthony Wager) in David Lean's brilliant Expressionist version of *Great Expectations* (1946).

with the ghost? . . . 'The Signal-Man', that's it. Terrifying! The best short story ever written. You're a genius . . . Mind you, I've got to say, that American bit in *Martin Chuzzlewit*, what's that about? Was that just padding or what?

When, in the spring of 2005, *Doctor Who* returned to the small screen after a long hiatus, its third episode, 'The Unquiet Dead', took great delight in bringing together two of the great figures in modern British popular culture. Today the place of the time-travelling Doctor in the national imagination can hardly be exaggerated, and its revival has been such a success that there can be few people who have never heard of the TARDIS, the Daleks or, indeed, the Doctor himself. But this was not quite true when the Charles Dickens episode went out. Since the programme had been off the air, with one brief exception, ever since 1989, an entire generation of children had grown up oblivious to the time traveller's appeal. The show had been running for only two weeks: this was its first trip back in time, a demonstration not just of the capabilities of the TARDIS but of the programme's ambition to recreate the past. The producers could have set the episode anywhere, at any time in history. They could have thrown the Doctor together with anybody from Elizabeth I to Winston Churchill – to name just two historical superstars who later appeared in the show. So why did they pick the Victorian era? And why pick Charles Dickens, a writer who had died some 135 years earlier?

The answer is obvious. Although Dickens wrote many of his best books in the 1840s and 1850s, very few twentieth- or twenty-first-century cultural figures can rival his place in the popular imagination. Even during his lifetime, his fame was simply extraordinary, far outstripping that of any other writer of the day. He was more than a literary colossus; he was a cultural phenomenon. 'Dickens', writes the critic Robert Giddings, 'completely entered the bloodstream of our national culture at a very early stage, long before newspaper photographs turned people into celebrities.' A tireless campaigner for political and social reform, he was rarely far from the public platform, whether in print or on the stage. He gave readings and performances; he wrote for the papers; he addressed vast, adoring audiences; his name, his face, his characters all became firmly fixed in the national imagination. Even when he visited rural Wales, people recognized him. 'Blow me if that ain't Charles Dickens!' yelled a little boy who spotted him in the crowd.

Not even death could dim his lustre. By the end of the nineteenth century, he was the most widely stocked author in Welsh miners' libraries; two of his books were among the four most borrowed titles at Belfast Public Library; and working-class memoirists unfailingly identified him as the one writer whom they all knew and loved. In 1918 a survey of manual workers in Sheffield found that Charles Dickens's name was more widely recognized than that of any other historical figure or event. More people had heard of him than had heard of Shakespeare, Gladstone or Napoleon; than the Battle of Hastings, Magna Carta or the French Revolution. As Giddings notes, the years went by but the Dickens industry rolled on, gigantic and unstoppable: stage shows, cigarette cards, Christmas cards, cheap paperbacks, radio serials, television adaptations, Hollywood films, even £5 banknotes. 'The common man', wrote an admiring George Orwell in 1940, 'is still living in the mental world of Dickens.' He was 'an institution that there is no getting away from ... Whether you approve of him or not, he is *there*, like the Nelson Column.'[1]

Although Orwell wrote those words well over half a century ago, they are probably as true today as ever. New technology brought Dickens's qualities – his boundless comic energy, his extraordinarily colourful characters, his addictively melodramatic plots, his scathing political satire, his gloriously flamboyant vision of Britain in an age of tremendous social and economic change – to people who would probably never have bothered to wade through hundreds of pages of Victorian prose. In the early 1930s, his novels were read in instalments on the radio, and by the end of the decade the BBC had already begun turning them into radio dramas, kicking off with *The Pickwick Papers* and *David Copperfield*. The first cinematic interpretation of his work appeared as early as 1901, but it was David Lean's Expressionist versions of *Great Expectations* (1946) and *Oliver Twist* (1948) that really established Dickens's presence on the big screen. There was a big-budget West End musical, *Oliver!* (1960), later an Oscar-winning film; there was a hugely acclaimed Royal Shakespeare Company version of *Nicholas Nickleby* (1980), which went on for more than eight hours; and, of course, there were innumerable television adaptations. Indeed, for anybody growing up between the 1960s and the 1990s, Dickens was always there, a fixture of the Sunday night 'classic serial' slot. When the BBC broadcast *Bleak House* in 2005, sliced into fast-moving half-hour episodes to

follow *EastEnders*, the first episode attracted 6.6 million viewers and the rest an average of 5.9 million. Six years later, the BBC's version of *Great Expectations* also drew 6.6 million viewers. To put it another way, more than one in four people watching television, two days after Christmas 2011, chose to watch an adaptation of a book first published in 1861. As if that were not enough, the novelist had by now reappeared in *Doctor Who*, popping up on *BBC Breakfast* in a bizarre sequence set in an alternative universe.[2]

For Orwell, writing in 1940, there was only one plausible 'modern equivalent' to Dickens. This was a novelist who, like Dickens, had emerged from the lower middle classes of southern England to become an astonishingly prolific author of novels, short stories, journalistic tirades and impassioned political essays. Growing up in the 1870s, H. G. Wells had owned an illustrated edition of Dickens's collected works, which he read with gusto. In many ways, in fact, his career looks like a rerun of his predecessor's. Like Dickens, Wells was the beloved son of a family struggling to cling on to their hard-won respectability in a miserable economic climate. Dickens's father was sent to the Marshalsea prison for debt, a humiliating experience seared into his son's memory. Wells's father, a shopkeeper and occasional professional cricketer, constantly battled to make ends meet. As funds ran out, Dickens was sent to work in Warren's blacking factory, while Wells was despatched to become an apprentice at a drapery emporium in Southsea. Determined to make their mark on the world, both men became inexhaustible journalists, comic novelists and political pundits. Wells initially won fame for his 'scientific romances', such as *The Time Machine* (1895), *The Island of Doctor Moreau* (1896) and *The War of the Worlds* (1898). But in a sign of his debt to Dickens, he also fancied himself as a social chronicler, anatomizing the spirit of the Edwardian age in comic novels such as *Kipps* (1905) and *The History of Mr Polly* (1910). In the latter, the narrator notes in some disbelief that Mr Polly 'never took at all kindly to Dickens ... I am puzzled by his insensibility to Dickens, and I record it as a good historian should, with an admission of my perplexity.' But of course this is an in-joke: as numerous critics have pointed out, Wells's book could hardly have been more closely modelled on Dickens's rags-to-riches novels.[3]

Like Dickens, Wells cast a mighty shadow. A year after writing his

famous essay on Dickens, George Orwell wrote of Wells in strikingly similar terms:

> Back in the nineteen-hundreds it was a wonderful experience for a boy to discover H. G. Wells. There you were, in a world of pedants, clergymen and golfers, with your future employers exhorting you to 'get on or get out,' your parents systematically warping your sexual life, and your dull-witted schoolmasters sniggering over their Latin tags; and here was this wonderful man who could tell you about the inhabitants of the planets and the bottom of the sea, and who *knew* that the future was not going to be what respectable people imagined.

Alas, Orwell now thought that Wells had gone off the boil, as indeed he had. Even so, he wrote:

> Thinking people who were born about the beginning of this century are in some sense Wells's own creation. How much influence any mere writer has, and especially a 'popular' writer whose work takes effect quickly, is questionable, but I doubt whether anyone who was writing books between 1900 and 1920, at any rate in the English language, influenced the young so much. The minds of all of us, and therefore the physical world, would be perceptibly different if Wells had never existed.

This was more than journalistic hyperbole. Contemporary evidence shows that, like Dickens, Wells was extraordinarily popular with aspirational lower-middle-class and working-class readers. A survey of London Workers' Education Association students in 1936, for example, found that Wells was easily the most popular writer among male students, beating D. H. Lawrence and John Galsworthy, and third among female students, behind Galsworthy and Hugh Walpole. And like Dickens, Wells had an immense impact, not just on literature, but on popular culture more generally. *The War of the Worlds* alone – the first and most influential 'alien invasion' story – has been made into numerous films, radio series, television series, comic books, video games and, of course, a tremendous musical (Jeff Wayne!), while almost every time-travel story ever written has drawn, in some way, on *The Time Machine*. Science fiction – arguably the genre, more than any other, through which writers and filmmakers have best explored the anxieties of the modern age – would be almost unrecognizable without Wells, who did most to

popularize it. It was little wonder that, in 1985, he became the first writer to appear in *Doctor Who*, a series that owes him an enormous intellectual debt. In 'Timelash', Wells is catapulted to the planet Karfel in the far future, where he encounters, among other things, a race of monsters, the Morlox. Alas, his realization was rather less successful than Simon Callow's appearance as Charles Dickens; indeed, 'Timelash' is generally regarded as *Doctor Who*'s absolute nadir, a shameful farrago of preposterous acting, terrible hairstyles, ludicrous dialogue and bargain-basement sets. Oddly, though, all that makes it remarkably enjoyable, at least if you are in a forgiving mood.[4]

At its heart, Part Three explores not merely the long influence of Dickens and Wells, but their habit of popping up in very unlikely places. To take one example, Agatha Christie and Mervyn Peake could hardly have been more dissimilar, both as individuals and as writers. But both had grown up as ardent Dickens admirers, and both loved *Bleak House* more than any other book. To take another odd couple, William Golding and John Wyndham came to national attention in the 1950s with books that in style and tone could scarcely have been more different. But both, at some basic level, were grappling with Wells's legacy. All four of these writers feature in the following pages, as do Catherine Cookson, whose admirers often hailed her as Tyneside's answer to Charles Dickens, and J. R. R. Tolkien, whose anti-technological pessimism touched on many of the same themes that obsessed Wells during the years after the First World War.

Some of these figures – Cookson, Christie and Tolkien in particular – have rather chequered critical reputations, to put it mildly. In terms of sales and impact, however, they are simply impossible to ignore: whether you like them or not, British popular culture without Christie or Tolkien would be almost unimaginably different. But one of the remarkable things about both Dickens and Wells is that their influence was not confined to the page. Part Three ends with *Doctor Who*, which is not just the longest-running science-fiction series of all time, but one of British television's most popular and lucrative international exports. But we begin with its only genuine rival for the title of Britain's most successful television creation: the show that, more than any other, has offered a private counterpoint to the public events of the last half-century. John Betjeman even compared it with *The Pickwick Papers*. It began life as *Florizel Street*, but we know it as *Coronation Street*.

A DRAGON IN A HAIR-NET

Manchester produces what to me is The Pickwick Papers. *That is to say,* Coronation Street. *Mondays and Wednesdays, I live for them. Thank God, half past seven tonight and I shall be in paradise . . .*

John Betjeman, quoted in *New Society*, 3 April 1980

When the BBC unveiled their £8 million, fifteen-part adaptation of *Bleak House* in the autumn of 2005, they did so with a fanfare never before accorded to a Dickens serial. The cast, including household names such as Gillian Anderson, Charles Dance, Timothy West and Pauline Collins, as well as more unconventional choices such as Catherine Tate and Johnny Vegas, was one thing. What really attracted the attention of the press, though, was the format: half-hour episodes, running twice a week after the BBC's most popular show, *EastEnders*. For the first time, explained the press pack, this was Dickens as he really ought to be seen, targeted at a younger audience and packaged 'soap-opera style'.

As the producer, Nigel Stafford-Clark, explained: 'We've set out to bring Dickens back to the audience for which he was writing . . . He was unashamedly writing for a mainstream popular audience and that tends to get slightly forgotten today because his books have become classics.' Indeed, he went on:

By the time he wrote *Bleak House*, Charles Dickens was very well established and there was enormous excitement and anticipation about each instalment.

People were excited in the way that they are now about a new series of a popular television drama like *Spooks* or *Shameless*.

If Charles Dickens were alive today, he would probably be writing big signature dramas like *State of Play* or *Shameless*. He would be writing for television because he recognised a popular medium when he saw it.

He was absolutely tuned in to the needs of an audience so he wrote for serialisation; he used cliff-hangers as a way of getting an audience to come back for the next episode.

In his view that a twenty-first-century Dickens would be writing for television, Stafford-Clark was far from alone. Even the series' screenwriter,

The actress Violet Carson, better known as *Coronation Street*'s Ena Sharples, belatedly celebrates the show's tenth anniversary at the Savoy Hotel, 1971.

Andrew Davies, told the press that 'if Dickens was alive today, he'd be writing for *EastEnders*'. His words had the *Guardian*'s Peter Preston nodding with approval. All this, he thought, was a reminder that it was wrong to sneer at supposedly 'genre' fiction, for, back in the nineteenth century, Dickens was seen as a 'mere spinner of yarns for the masses, a downmarket plucker of heartstrings'. What if Dickens were alive today? 'He would be writing soaps or near-soaps week by week, just as he wrote some of his greatest books for magazines chapter by chapter. He might even be the resident genius behind *Coronation Street*.'[5]

As anybody even vaguely familiar with Dickens will know, all this really is the most terrible tosh. 'If Dickens did write *EastEnders*,' the novelist Philip Hensher drily remarked in 2005, 'it would be so very much improved in quality as to be unrecognisable.' More to the point, though, the idea that Dickens was really a Victorian soap-opera writer, which television insiders never tire of repeating, is so wide of the mark as to be almost beneath serious analysis. As Robert Giddings had already pointed out in a withering essay seven years earlier, Dickens was not, as television executives like to claim, a uniquely visual writer, for his 'stock in trade was words. He thought in words. He created and describes his world in words.' In the fog-bound opening of *Bleak House*, one of the most celebrated passages in all English literature, the effect is entirely literary and almost impossible to reproduce on screen. Perhaps this explains why Dickens was such a dud at writing drama. If he had been merely a television writer *manqué*, then he might have been expected to pour his energies into the theatre, not the novel. In fact, his early efforts at writing for the stage were ineffective and rapidly disappeared from view. He was good at writing novels, not dramas; what made him a great writer was his literary flair, not his supposedly preternatural grasp of the principles of television. It is, of course, true that Dickens published in serial form. *The Pickwick Papers*, the initial instalment of which appeared in March 1836, is often described as the first serial bestseller, shifting a staggering 40,000 copies a month. But 'as any schoolboy knows', writes Giddings, 'the serialization of fiction was a standard method of literary production' in Dickens's day. William Makepeace Thackeray published in serial form; so did Wilkie Collins, George Eliot and Thomas Hardy. No sane person would suggest they were really frustrated screenwriters.[6]

In fact, the closer you look at the Dickens–soap opera comparison,

the more it tells you about the *differences* between British culture in the mid-nineteenth century and its equivalent in the decades after the Second World War. From *Coronation Street* to *EastEnders*, soap operas have typically been aimed at a mass working-class audience. But whatever BBC producers might think, Dickens did not initially write for working-class readers, for the glaringly obvious reason that millions of them could not read. In 1840, when Dickens had already published *The Pickwick Papers*, *Oliver Twist* and *Nicholas Nickleby*, one in three men and half of all women had to make a rough mark in the marriage register because they could not write their names. As Giddings observes, each instalment of, say, *Bleak House* cost about £5 in today's money, which made it far too expensive for ordinary working-class readers. Little wonder, then, that the accompanying advertisements, unlike the advertisements that run on ITV during *Coronation Street*'s commercial breaks, were targeted at middle-class readers with money to burn.

And there are other obvious differences, too. Soaps are open-ended, with endlessly recurring themes and storylines. But Dickens's novels were often tightly plotted, the narrative moving inexorably towards resolution. Soaps like *Coronation Street* are doggedly realistic, or at least try to be: the characters are meant to be just like people you might meet at the bus stop. Dickens's characters, by contrast, are often caricatures, grotesques, outrageous concoctions that you might never meet in a million years. Soaps usually steer well clear of political didacticism, because they are anxious not to alienate their audience. Dickens, however, was perfectly happy to hammer his readers with a political message. When the homeless, poverty-stricken boy Jo dies in *Bleak House*, the chapter ends like this: 'Dead, your Majesty. Dead, my lords and gentlemen. Dead, right reverends and wrong reverends of every order. Dead, men and women, born with heavenly compassion in your hearts. And dying thus around us every day.' It is hard to imagine an episode of *EastEnders* finishing quite like that.[7]

There are two obvious reasons why television producers persistently claim that Dickens is really a soap-opera writer. The first is that, even though television has been by far the most important cultural medium of the last half-century, it has always suffered from the snobbery of people who think it intrinsically shallow and dumbed-down. During the mid-1950s, when television was becoming ubiquitous, doctors and columnists diagnosed such imaginary conditions as 'TV Neck', 'TV

Crouch', 'TV Dyspepsia' and 'TV Stutter', while the Oxford don Sir Maurice Bowra spoke for his fellow highbrows when he quipped that 'all television corrupts and absolute television corrupts absolutely'. Claiming Dickens as a prototypical television writer, therefore, is a very good way for broadcasting executives to fend off the criticism that television is somehow inherently trivial, and indeed to inflate their sense of their own cultural importance.[8]

But of course there is another reason for the Dickens–soap comparison, which is that executives are all too aware that Victorian literature, even on television, might be perceived as excruciatingly worthy. The trick, therefore, is to sell it as merely another version of the most dependably successful, crowd-pleasing narratives of the modern age. For whether you like them or not, that is exactly what soap operas are. When you look at the viewing figures for the last fifty years, there is really only one constant. Other shows come and go, from *Dad's Army* (1968–77) and *Colditz* (1972–4) to *Midsomer Murders* (since 1997) and *Downton Abbey* (2010–15), but for longevity and consistency there is nothing to touch the soap opera. By the beginning of the twenty-first century, some 32 million people were watching soap operas every week, while three out of four people watch a soap opera every month. As Dorothy Hobson, the foremost academic expert on soap operas, puts it, 'no other form has lasted and had such resonance with the audience'.[9]

Of all Britain's soap operas, by far the most successful is *Coronation Street*. It has been running continuously since the end of 1960, generating vast amounts of advertising revenue for Granada and ITV, and becoming, for many viewers, the definitive fictional account of life in the working-class North of England. Probably no other narrative has been so deeply woven into the lives of its viewers. During its first three decades, *Coronation Street* was watched by least a third of the national population, and even in an age when the national audience has almost completely fragmented, it still attracts audiences of up to 10 million. Not surprisingly, politicians have often tried to climb aboard the bandwagon. Jim Callaghan once told the show's resident vamp, Pat Phoenix, that he thought her 'the sexiest thing on television', even though he had never watched the programme in his life. Tony Blair, meanwhile, lent his support to the campaign to 'Free the Weatherfield One' after Deirdre Rachid's unfortunate brush with the law. Even Margaret Thatcher, in a moment of supreme implausibility, claimed to be a great admirer of the

show. Her favourite programmes, she told Trevor McDonald during an interview for the *TV Times*, were 'detective stories, you know, Hercule Poirot, anything like that'. But she had a soft spot, she confided, for the people of Weatherfield:

> We have watched *Coronation Street* because the characters are absolutely terrific and when I went to see the set and saw [the] Rovers Return and saw Alf Roberts's shop and met some of the people it really came alive for me, much much more than just watching it. And you have no idea, well you have because you are in the business, the difference between actually seeing it and seeing it on the screen. It comes alive, the characters come alive, and then of course you speak to them. It was fascinating, I loved it.

It is not surprising that she should have singled out Alf Roberts, the street's grocer, because of course her own father was also called Alfred Roberts (not 'Alf', though!) and ran a grocer's shop in Grantham. Slightly bizarrely, McDonald asked her which character she would like to play in *Coronation Street* if her career took an unexpected turn and she was forced on to the boards. 'Oh goodness me, I do not know,' she exclaimed, 'but obviously I would have a particular interest in the grocery shop!'[10]

The genesis of *Coronation Street* has become a legend in its own right. The story goes that one day in 1960 a 23-year-old Granada scriptwriter, Tony Warren, was grumbling to his boss, Harry Elton, about having to work on the studio's new series based on Captain W. E. Johns's Biggles adventures. In the most dramatic version of the story, Warren installed himself on top of one of Elton's filing cabinets and refused to budge until his boss allowed him to 'write what I want to write'. 'What is it that you want to write?' Elton asked. 'Well, I know about a street out there,' Warren said, waving vaguely at the window. 'Well, get down off the filing cabinet and write me a script,' Elton replied. 'You've got twenty-four hours.' Warren duly presented himself in Elton's office the next day with a sample script for a series about people in an ordinary Manchester street. He called it *Florizel Street*, having borrowed the name from one of the princes in the tale of Sleeping Beauty. The name stuck until shortly before transmission, when – again according to legend – a Granada tea lady remarked that it sounded like a disinfectant. The producers therefore decided to pick a name reflecting the era when they imagined their street had been built, at the turn of the

twentieth century. Two moments stood out: Victoria's Diamond Jubilee in June 1897 and the coronation of her son, Edward VII, in August 1902. The production team voted for the Jubilee. But the next day the show's first producer, Stuart Latham, pulled rank, and *Coronation Street* it was.[11]

Although Tony Warren rapidly fell out with the producers of *Coronation Street*, and even became a fierce critic of the show he had created, his status as its founding father (or Ena Sharples's father, as the title of his autobiography put it) is not in serious doubt. Contrary to myth, he was not working-class and had never lived in a terraced house. In fact, he grew up in Pendlebury, a middle-class suburb of Salford, the son of a fruit importer who spent the Second World War in military intelligence. After some success as a child actor, Warren found adult roles hard to come by and moved into scriptwriting instead. All the evidence is that he had already been thinking of the *Coronation Street* idea before his famous meeting with Harry Elton. Warren himself recalled that he had begun jotting down some notes a few weeks earlier while on holiday in the Highlands, ferociously working on what became the first script while on the train home. But another producer, Olive Shapley, who worked for the BBC, remembered him mentioning the idea a year earlier while they were dozing on a late-night train from London to Manchester. 'At about Crewe,' she wrote, 'Tony suddenly woke me up saying, "Olive, I've got this wonderful idea for a television series. I can see a little back street in Salford, with a pub at one end and a shop at the other, and all the lives of the people there, just ordinary things and . . ."' She merely 'looked at him blearily' and said: 'Oh Tony, how boring! Go back to sleep.' Decades later, Warren gave her a copy of a book celebrating the show's first twenty-five years. 'For Olive,' read the inscription, 'who failed to see the point of *Coronation Street* on a railway train, on a dark wet night in the late 1950s.'[12]

In many ways *Coronation Street* has changed remarkably little from Warren's initial conception. When he handed his first script to Harry Elton, it was accompanied by a memo setting out the point of the series. 'A fascinating freemasonry, a volume of unwritten rules,' it began. 'These are the driving forces behind life in a working-class street in the north of England. To the uninitiated outsider, all this would be completely incomprehensible. The purpose of *Florizel Street* is to entertain by examining a community of this kind and initiating the viewer into

the ways of the people who live there.' This made the series sound like an anthropological documentary. And perhaps, at some level, it was. Having won the ITV franchise for the North of England in 1954, Granada were keen to increase their self-consciously 'northern' content, which meant that Warren's idea fitted in perfectly. Indeed, he was at pains to stress how seriously he had taken his research. 'Apart from listening to people in pubs and clubs,' he later explained, 'I also "kept observation" in an off-licence, talked to people in buses and trains, wandered through street markets, made three trips to Blackpool illuminations, and went on a "mystery" coach outing, which turned out to be a fourth visit to Blackpool.' His aim, he added, was not to mock or misrepresent the North, but to give 'a true picture of life there and the people's basic friendliness and humour'.[13]

What all this shows is just how closely the basic idea for *Coronation Street* reflected the wider cultural climate of the late 1950s and early 1960s. Social investigations were all the rage; so too was 'kitchen sink' realism, both on the page and on screen. It is not true, as it is often claimed, that *Coronation Street* was the first time working-class lives had been shown on television. As Sean Egan points out in his history of *Coronation Street*, Warren's original idea bore considerable resemblance to a play by Bill Naughton called *June Evening*, which follows the residents of a terraced street in Bolton on one evening in 1921. Naughton's street not only boasts a shop on the corner, just like *Coronation Street*, but a family called Tatlock. Since Naughton's play was broadcast on the radio in 1958 and then by BBC Television in 1960, it is perfectly possible that Warren was influenced by it, if only unconsciously.

On ITV, meanwhile, millions of viewers had seen plenty of working-class characters in the Sunday evening *Armchair Theatre* slot, which promoted young writers such as Harold Pinter and Alun Owen. Indeed, *Armchair Theatre* had established such a reputation for kitchen sink drama that the press nicknamed its producer, the Canadian-born Sydney Newman, 'the dustbin man'. And even in the cinema, provincial working-class realism was very much in fashion: in 1959 alone, audiences had flocked to adaptations of John Osborne's play *Look Back in Anger* and John Braine's novel *Room at the Top*, while the film adaptation of Alan Sillitoe's book *Saturday Night and Sunday Morning* was released barely six weeks before *Coronation Street*'s first episode. Indeed, when Granada made an unsuccessful bid to sell the series in the

United States in 1962, they played up its resemblance to the films of the British New Wave. According to their full-page advertisement in the Hollywood paper *Variety*, it was 'a working-class saga with the vinegary bite of reality', set in 'an Angry Young Man milieu'. The truth, however, is that viewers would have to look very hard to find even the faintest trace of an angry young man.[14]

The first episode of *Coronation Street* went out on 9 December 1960. By modern standards, much of it looks positively antediluvian. In Egan's words, 'the show creaks with age in just about every scene', from 'the iron till in the shop; the open fire in the Barlows' home; [and] Albert Tatlock's unlocked back door' to 'the cigarette and pipe smoke in which the characters are wreathed'. Even the currency – pounds, shillings and pence – now belongs to history. Yet, at the time, the show was perfectly poised between past and present. The opening music – slow, mournful brass, immediately evocative of the bands then still popular in the North – feels like a lament for a vanishing world. The look of the street itself, a line of brick back-to-backs untouched by slum clearance or high-rise development, would have seemed old-fashioned even in 1960. So too would the cobbles, a defiantly nostalgic touch at a time when so many streets were being smothered in tarmac. Cobbles had not yet been rehabilitated as a badge of authenticity; to the fashionable modernizers of the day, as the historian Raphael Samuel observes, they seemed instead 'a byword of urban squalor'.[15]

Yet at the heart of the first episode is a character who could hardly have been a better representative of the social changes sweeping Britain in the 1950s and 1960s. This is Kenneth Barlow (played, of course, by William Roache): a bright grammar-school boy who has won a place at university, but is struggling to reconcile his new social aspirations with the working-class values of his father, Frank. In the episode's most memorable scene, Kenneth ostentatiously winces when Frank pours brown sauce all over his evening meal. 'What's that snooty expression for?' says his father. 'Don't they do this at college then? I bet they don't eat in their shirt-sleeves either. I've been noticing you looking at me . . . We're not good enough for you.' Kenneth, it turns out, has already been complaining about his parents' fondness for bread and butter and cups of tea with their evening meals. 'You'd better watch out, Ida,' says Frank to his wife. 'He'll be having you change into evening gowns to eat your meals next.' But Kenneth gets his comeuppance at the end of the

episode, when his well-heeled university girlfriend arrives unexpectedly to find Frank mending a bicycle in the living room. The very last shot shows Kenneth in the doorway, struggling to hide his horror: a perfect encapsulation of the anxieties engendered by mass education and social mobility.

In December 1960, the situation would surely have struck millions of viewers as very familiar. Indeed, five years later it was the basis for Dennis Potter's BBC1 play *Stand Up, Nigel Barton*, in which Keith Barron's Nigel, a thinly fictionalized version of his creator, finds himself 'between two worlds', trapped between the working-class values of his coal-mining community and the exciting opportunities afforded by grammar school and Oxford. But it was not entirely new: in Dickens's novel *Great Expectations* (1861) there is a memorable scene when Pip, having come into money, feels embarrassed by his old friend Joe Gargery's manners. Like Ken Barlow, Pip has become distinctly snooty; he has 'neither the good sense nor the good feeling' to mask his irritation with Joe, and feels 'impatient of him and out of temper with him'. It is clearly Joe who commands our sympathy, just as in *Stand Up, Nigel Barton* we are naturally drawn to Nigel's father, Harry, a quiet, serious miner, instead of his prickly, ambitious, annoyingly self-righteous son. And in *Coronation Street*, too, it is Frank who appears more obviously likeable, while Ken is really a bit of a snob. So here, at least, the comparison between Dickens and *Coronation Street* is not entirely ridiculous.[16]

The other striking thing about the first episode of *Coronation Street* is the prominence of its female characters. This was no accident. The very first soap operas, which ran on American radio in the 1930s, were deliberately written for housewives. The advertisements accompanying them were aimed at housewives, too: hence the association with soap. The first long-running British soap opera, the BBC's radio series *Mrs Dale's Diary* (1948–69), was about a woman, and it was broadcast at those times – eleven in the morning and four in the afternoon – when schedulers thought housewives would be sitting down for a break. Indeed, it is no exaggeration to say that, until the 1980s, soap operas were not only written for women but revolved almost entirely around women's everyday anxieties (which might, of course, involve men). When *Emmerdale Farm* began in 1972, for example, it was dominated by the matriarch Annie Sugden, while *Crossroads*' Meg Richardson was one of the most popular fictional characters, in any genre, of the

1960s and 1970s. As for *Coronation Street*, it boasted not just one strong female character but an Amazonian host, from the glamorous, man-eating Elsie Tanner to the Greek chorus of Ena Sharples, Minnie Caldwell and Martha Longhurst, semi-permanently installed in the snug of the Rovers Return. All three, as Dorothy Hobson remarks, 'had lived through the First World War, the Depression and the Second World War', and therefore 'represented the working class who were born at the beginning of the century'. Indeed, almost all accounts of *Coronation Street*'s early days agree that it was these characters, not Ken Barlow, that were the key to its appeal. In April 1961, the *Daily Mirror*'s critic Richard Sear, heaping praise on 'Ena Sharples, a dragon in a hair-net, Elsie Tanner, an attractive, faintly-blowsy widow, and the rest of the scheming hussies', even called it 'the most woman-dominated pro- gramme I have ever seen. Its clever, tangy dialogue, written at a trivial level, might have been gathered by women, for women, over any back- yard fence.'[17]

The *Mirror*'s admiration represented something of a U-turn, since at first the paper had been very sniffy about *Coronation Street*. Reviewing the second episode, the television critic of its northern edition, Ken Irwin, thought that if Warren had really been spending time with ordi- nary people, then he had chosen 'the wrong folk. For there is little reality in his new serial, which, apparently, we will have to suffer twice a week.' The paper's main critic, Jack Bell, struck a similar note: who could pos- sibly want 'continuous slice-of-life domestic drudgery two evenings a week'? Other early reviews were more encouraging. The *Manchester Guardian* proclaimed it 'funny and forthright', while the *Sunday Times*, with commendable foresight, thought it was '"Emergency – Ward 10" and "Mrs Dale's Diary" and "The Grove Family" and Wilfred Pickles and Kipps and Armchair Theatre at its most socially-conscious all rolled into one great cosy Hall of Mirrors, in which the population can see itself, with the profound satisfaction of recognition, every Friday night for ever and ever'. One early viewer, the schoolteacher and future televi- sion presenter Russell Harty, put it more simply. 'I've just seen this wonderful thing on TV,' he told the boarders at Giggleswick School in Yorkshire. 'It's about a street in Manchester and there's a woman with a hairnet in it.'[18]

At one level, the critics' views were completely irrelevant. From the very beginning, the public clearly loved *Coronation Street*. When the

producers killed off Ken Barlow's mother, Ida, in September 1961, more than 15 million people watched the episode showing her funeral. The following year, no fewer than fifty-seven episodes topped the week's ratings, more than there were weeks in the year.* And so, for the next quarter-century, the show's dominance was virtually unchallenged, with audiences rarely falling below 10 million and often peaking above 20 million. In 1967 Elsie Tanner's wedding drew almost 21 million viewers; in 1986 almost 23 million watched the Rovers Return go up in flames; and three years later some 27 million people watched the hunt for the tormented Alan Bradley, who had tried to murder Rita Fairclough. Even in 2014, in an age when audiences across the board were in deep decline, *Coronation Street*'s audience never fell beneath 5.75 million and occasionally reached almost 10 million, an extraordinary figure by the standards of the day, especially for a series more than half a century old. Even in terms of longevity, the programme's success is simply phenomenal. By the time of its fifty-fourth birthday in December 2014, it had run for a staggering 8,528 episodes, charting the lives of hundreds of characters, all living in and around the same northern street. No bestselling saga, no Booker Prize winner, no concept album, no video game has ever told a story of such stupendous length to such a vast and loyal audience.[19]

The real question with *Coronation Street* is whether people like it (a) because it is so realistic, or (b) because it is not realistic at all.† Tony Warren, as we have seen, was determined to present 'a true picture of life': hence all those research trips to Blackpool. Even after Warren had been eased out, the producers still prided themselves on the show's realism: one told the *Spectator* in December 1961 that it spoke in 'a demotic accent in an entirely democratic world'. 'It echoes our audience; it's very true to life,' agreed David Liddiment, who became executive producer more than two decades later. This has been a common refrain: writing to the *TV Times* in March 1961, one satisfied viewer unwittingly echoed Warren's phrase, enthusing that the show gave a 'true picture of life'. Even the *Observer*'s critic Maurice Richardson thought that the

* The explanation is that sometimes the week's two *Coronation Street* episodes finished dead level at the top, so they were counted twice.

† There is also the question of what constitutes realism. Life is too short to get into that now.

programme's carefully crafted atmosphere of 'Verisimilitude Plus' ele-
vated it above any other series on television, allowing it to capture 'the
rugged ambience of North-country working and lower middle class
life', and making it 'much more like real life than most of what you see
on television except the real thing'. And although the left-leaning
Observer might have been expected to look kindly on a series about a
working-class street, who would have thought that the *Spectator* would
be so positive? *Coronation Street*, declared its television critic, Derek
Hill, on the programme's first birthday, 'is consistently wittier, healthier
and quite simply better than any of television's supposedly respectable
series'. What audiences loved about it, he thought, were 'the familiar
elements in the particular', anchored in a recognizable working-class
community. (Interestingly, though, Hill also thought that 'the characters
have a Dickensian variety and complexity', a very early example of the
Dickens–soap parallel.) All in all, he declared, Warren's brainchild was
simply 'the most extraordinary phenomenon in the history of British
popular culture'.[20]

Yet right from the beginning some critics argued precisely the oppo-
site. Indeed, the debate about the merits of *Coronation Street*, which
began within months of the programme's first appearance, is a good
example of a long-simmering dispute about the very point of popular
culture. As far back as the 1860s, the critic Matthew Arnold – the son
of Rugby's legendary headmaster – had insisted that the proper aim of
culture was not mere escapism or amusement, but to educate the mind
and elevate the soul towards, as he put it, 'sweetness, light and
perfection'.* What we might call the Arnold tendency has never disap-
peared. From Paul Johnson's tirades against the Beatles and James Bond
to more recent commentators' contempt for, say, rap music and video
games, there have always been plenty of intellectuals horrified by the
alleged shallowness and stupidity of ordinary people's cultural tastes.
Indeed, for all their popularity, the authors discussed in the following
pages – Catherine Cookson, Agatha Christie, J. R. R. Tolkien and John
Wyndham – all suffered mightily at the hands of highbrow critics

* Interestingly, though, Arnold was something of a Dickens fan, contrasting the 'gaiety,
invention [and] life' of *David Copperfield* with the 'contemporary rubbish which is shot so
plentifully all around us'. See Matthew Arnold, 'The Incompatibles' (1881), in *Complete
Prose Works*, vol. 9: *English Literature and Irish Politics*, ed. R. H. Super (Ann Arbor, MI,
1973), p. 273.

horrified that the public insisted on buying books that they *wanted* to read instead of those that they *ought* to read. This was, in essence, the approach that the *New Statesman*'s critic Clancy Sigal, perhaps *Coronation Street*'s most devoted foe, brought to television. That he was writing about television at all is something of a mystery, given that, as he told his readers, it was a 'tragedy', 'polluted water' and a 'positively destructive force'. 'Legitimate artists', he thought, 'ought to keep away from television.' As for *Coronation Street*, he considered it:

> a lie from start to finish ... The life it shows is false on its surface and false in its core. It is false in the very ordinariness and regularity of its working-class dialogue ... It is false in omitting the passion and joy and complexity of life ... It is profoundly patronizing in that it depicts working-class people as entirely and without qualification circumscribed and defined by the life of their simple-minded dialogue ...

And so on, and so on, until his arresting payoff: '*Coronation Street* gently rapes you.'[21]

Not surprisingly, many people took great offence at being told that by watching *Coronation Street* they were allowing themselves to be violated. In a withering letter the following week, one reader, John Killeen, blasted away at Sigal's thesis. If Sigal thought *Coronation Street* was false, Killeen wrote, he was merely showing his utter ignorance of working-class life. Having lived 'for nearly 30 years in a back-to-back house with an outside shared lavatory, a bath in the scullery and no garden', albeit in West Yorkshire rather than Manchester, Killeen thought the series gave a 'reasonably convincing' idea of life in those areas of the working-class North not yet scarred by redevelopment. The 'modern town planner and builder', he added, ought to watch it and learn the appropriate lessons, although he knew this was 'too vain a hope'.[22]

As it happens, the issue of redevelopment was something of an elephant in the room during *Coronation Street*'s first decade. Since 1945, some 80,000 terraced houses had been demolished annually, and by the year *Coronation Street* began, high-rise flats already accounted for 15 per cent of all new council houses. Yet Coronation Street itself remained oddly untouched and unchanging. In 1961 the producers did include a storyline in which Ena Sharples discovers that the street is scheduled for demolition, only for other residents to point out that she has misread 'Coronation Terrace' as 'Coronation Street'. In reality,

though, as reviewers often pointed out, the street would probably have been pulled down by the end of the decade and replaced with high-rise tower blocks. Indeed, by the following decade, the street's very survival was probably the most unrealistic thing of all.[23]

What is certainly true is that, although *Coronation Street* has always worked hard to create the illusion of naturalism, it has never lived up to Warren's idealistic ambition to provide a kind of documentary realism. The relatively downbeat, gritty authenticity of his opening episodes quickly fell by the wayside, and as early as 1963 he told *Woman's Hour* that it had become too 'glamorised' and bore 'very little relation to the original idea'. As another early reviewer remarked in Newcastle's *Sunday Sun*, a genuinely realistic account of working-class life would have shown at least one or two drunken, wife-beating husbands, 'sloppy, ill-kempt wives who slouch around houses that are nauseating to the sight and nostrils', and mean-spirited neighbours who 'resent and despise each other so much that they almost delight in others' misfortunes, and would never offer a helping hand'. It is perfectly understandable why the producers shied away from such things: they wanted to strike a friendly, nostalgic note that would suck viewers in, not repel them by forcing them to confront the uglier side of city life.

The show's reluctance to introduce immigrant characters, for example, is highly revealing. As early as 1963, the production team discussed bringing in a 'coloured family'. But the producer, Harry Kershaw, said no. 'If you're going to be real about it,' he pointed out, 'you're going to have the coloured people called yobbos and [there are] going to be racial remarks directed at them in the Rovers Return and so on.' The subject came up again at the end of the decade, when a new production team briefly contemplated storylines covering such hot topics as unmarried mothers, drug abuse and racism. 'You can't just put a coloured family in a street and expect everybody to say, "How do? How lovely to see you,"' pointed out one of the scriptwriters, the working-class novelist Stan Barstow. But of course this made it much harder for them to claim that the series was genuinely realistic. 'Where are the Pakistani family, the beaten wife and the woman with eight children?' wondered the *Sun* in 1967.[24]

The truth is that, like any soap opera, *Coronation Street* has always pulled off a delicate balancing act: just enough so-called realism to give viewers a warm sense of recognition, but also just enough melodrama to feed their craving for narrative without disappearing into the realms

of fantasy. Sir Denis Forman, who ran Granada during the 1970s and 1980s, once remarked that it 'conned people into thinking that it was documentary but it wasn't, it was unreal ... It was highly dramatic. It was a vision of a kind of working-class world that never really existed.' And that last point is surely crucial. Even when it started in 1960, *Coronation Street* was looking over its shoulder to an imagined working-class past of warm hearths, shrewd housewives and friendly neighbours. In his history of the show, Sean Egan reproduces a picture of the leading cast ten years later. There are fourteen people in the picture: only four of them, at most, look under 30, and many of the others look like characters from a George Formby film. When the musician Dave Browning, who played the cornet in the original theme tune,* saw the first episode, he thought to himself: 'Well, it's going back to my aunties.' The very look of the street conjured a world that in many towns and cities had already disappeared: a tight-knit working-class community in which change came only slowly and gently, if at all. One of the show's chief scriptwriters, Adele Rose, admitted that it portrayed 'a Britain that doesn't exist any more', but thought 'that is why people want to watch – because it gives them a kind of reassurance to know there is a community where people pop in and out of each other's houses and help each other out'. And in this context the common criticism that *Coronation Street* is too nostalgic misses the mark. Right from the beginning, nostalgia was the point.[25]

There have, of course, been successful soap operas which took a more aggressively 'realistic' – by which people usually mean 'gritty and confrontational' – approach. *Brookside*, which ran on Channel 4 from 1982 to 2003, was conceived from the start as much more controversial and hard-hitting than its Granada rival, and its creator, Phil Redmond, insisted that scriptwriters must be willing 'to tackle so-called difficult subjects or social issues'. (Infamously, these included the murder of the abusive Trevor Jordache by his wife and children, who buried his body beneath their patio.) As for the BBC's *EastEnders*, which began in 1985, it had already covered 'unemployment, imprisonment, rape, drugs, alcoholism, attempted suicide, crime, murder, homosexuality, infidelity,

* Or did he? This is one of those tiny but ferociously contested details that people have been arguing about ever since. Both Browning and a man called Ronnie Hunt recorded versions of the theme, and nobody seems entirely sure which was used.

divorce, AIDS, abortion, ageing and death' before it was even 7 years old. The BBC made no secret of their desire to stir up controversy: as the show's first producer, Julia Smith, explained, 'we decided to go for a realistic, fairly outspoken type of drama which could encompass stories about homosexuality, rape, unemployment, racial prejudice, etc., in a believable context'. Whether this makes it more realistic, of course, is a moot point. In any case, *Brookside* and *EastEnders* were the products of a decade in which community was widely thought to have broken down, and both reflected the fractious, aggressive political tone of the Thatcher years. *Coronation Street*, by contrast, was born in an age of full employment, social mobility and rapidly rising living standards. And although those brought social and cultural tensions of their own, it is the show's basically optimistic, warm-hearted nature that has always endeared it to its admirers.[26]

But the show's biggest asset has always been the fact that it is set in the North. It is true that, even in 1960, some viewers thought it presented a caricatured image of northern life: when Harry Elton showed the first episode to Granada's programme committee, one told him that the cast sounded like 'Old Mother Riley and George Formby', while the company chairman, Sidney Bernstein, asked in disbelief: 'Is this the image of Granadaland that we want to project to the rest of the country?' One Liverpool paper lamented that it presented an image of the North as 'all back alleys and booze', while a local councillor even complained that 'people who see *Coronation Street* think we are all married to Hilda Ogden, wear clogs and have outside loos'. But the show's exaggerated setting was, and remains, absolutely crucial to its appeal.[27]

Coronation Street was created at a very unusual moment in post-war cultural history. Between the mid-1950s and the mid-1960s, as the economy boomed, the developers got to work and millions of people splashed out on new homes, cars, fashions and appliances, the look and atmosphere of British life appeared to be changing with dizzying speed. In an age of change, the urban, industrial North became a symbol of what was being lost: an imagined world of honesty, authenticity and working-class community, a world where people spoke plainly and stood by their word, reflected in everything from Richard Hoggart's book *The Uses of Literacy* to the rise of the Beatles. This was a caricature, of course: the historian Raphael Samuel calls it 'urban pastoral', evoking a settled, united community that had never really existed. But it was precisely

what millions of people, northern and southern alike, wanted to hear: that there had once been, and still was, a place where people knew their neighbours. And it was *Coronation Street*, more than anything else, that hammered home that message. The series has lasted not because it shows Britain as it is, but because it shows Britain as people would like it to be. It may not be entirely realistic, but to millions of viewers it *does* feel true to life. In this respect, the comparison with Dickens is not entirely unmerited. 'Dickens's London may be different from actual London,' the literary critic Lord David Cecil once remarked, 'but it is just as real, its streets are of firm brick, its inhabitants genuine flesh and blood ... It does not matter that Dickens's world is not lifelike; it is alive.'[28]

YOU HAVEN'T GOT NO DA

> *She shrugged. 'You're soft in the head. You know that? It's them books you're readin'. Mr Dickens is gettin' at you. Help the poor. My God! What does he know about it? The only thing I feel about Mr Dickens is he's makin' his money out of exposing misery.'*
>
> Catherine Cookson, *The Rag Nymph* (1991)

On 20 June 1986, at a country-house hotel in Northumberland, the most popular writer in Britain celebrated her eightieth birthday. Many of her guests had taken the train up from London, and the national television news had sent a team to mark the occasion. The cameras rolled, the orchestra played, and the diners tucked in to their lavish fare: cucumber mousse, wine and morello cherry soup, beef wellington, pineapple and strawberries with kirsch, and brandy snaps filled with brandy cream and orange, all washed down with bottles of Burgundy. On the tables were copies of a handsomely illustrated book to mark the occasion. And on the top table sat the elderly author herself, surrounded by a host of publishing bigwigs: the chairman and managing director of her hardback publisher, Heinemann, as well as her editor at her paperback imprint, Corgi, and the boss of Corgi's new hardback sibling, Bantam. The atmosphere was all laughter and backslapping. Little did the men from Heinemann know that, even as the wine was flowing and the tributes were pouring in, Bantam were lining up a deal to snatch Britain's best-selling author from her old hardback publisher. The news broke just

Catherine Cookson, the most popular British novelist of her age, photographed at home in 1979.

weeks later. At the time, it was one of the most lucrative book deals ever signed. 'I don't think anyone is worth that sort of money,' the author told her local newspaper. 'I'd write if I wasn't paid a penny.' Fortunately for her, though, that was not a realistic possibility. To the 80-year-old Catherine Cookson, her new deal was worth no less than £4 million.[29]

Even at the time, Cookson's books provoked fierce opinions. To her admirers, she was Dickens's modern heir: 'the people's writer of this generation ... the voice of the North as Dickens was the literary presenter of London'. To her critics, she offered nothing more than formulaic romantic sagas, predictably plotted and flatly narrated. When Granada, the company that made *Coronation Street*, decided to adapt three of her historical novels as *The Mallens* in 1979, the *Daily Express* could barely contain its disbelief. 'Her literary style', remarked the paper's television critic, 'can best be described as Barbara Cartland with rape and pillage added. Why Granada got involved in such a load of old tripe is difficult to understand.' What really infuriated her critics, though, was that she was so astonishingly popular. By 1981 she had sold some 28 million books; by the time of her death in 1998, the total had risen to a whopping 123 million. For almost two decades, libraries reported that she was the most borrowed author in the country; at one point in the mid-1980s, some thirty-five out of the top hundred books borrowed from Britain's libraries had her name on the cover. She was not just a rich woman, but a *very* rich one: by some calculations, the eleventh richest in the country, outstripped only by the Queen and a handful of supermarket and shipping heiresses. Cookson was more than a writer; she was a commercial phenomenon.[30]

Catherine Cookson is a key figure in modern Britain's cultural story not just because she was so popular, but for two additional reasons. First, she appealed to millions of people who are almost always left out of accounts of our popular culture, specifically older, often working-class women. Second, her success demolishes the idea that popular culture always ignores the experiences of people at the very bottom of society. There are plenty of more 'respectable' examples – the novels of Barry Hines, say, or the films of Ken Loach – but in terms of reach and popularity they do not even come close. Given Cookson's background, audience and subject matter, it is a puzzle why she has been so completely ignored by left-wing writers. To take just one example, Selina Todd's tub-thumping book *The People* (2014), which purports to be a definitive account of

working-class life in Britain in the twentieth century, does not contain a single mention of the most successful working-class writer of the age. The most plausible explanation is that unlike, say, the films of the Oxford-educated Loach, Cookson's books never romanticize her working-class characters. The people in her novels may be downtrodden, but they are also just as coarse, greedy, venal and mean-spirited as anybody else. Some are warm-hearted and open-minded; others, however, are alcoholics, rapists, blackmailers, thieves and liars. They are not saints, and still less are they noble savages. They are human beings.

To millions of readers, many if not most of them working-class, this was fair enough. But 'for literary intellectuals', as the critic John Carey wryly observed in the *Sunday Times*, 'Dame Catherine Cookson is an upsetting phenomenon'. To take a nice example, the social historian Rosalind Mitchison once reviewed Cookson's novel *The Gillyvors* (1990), which chronicles the life of a poor family in nineteenth-century rural County Durham, in the *London Review of Books*. Professor Mitchison was outraged by Cookson's portrayal of her working-class characters as 'an underclass, impoverished, vermin-struck and illiterate', though the accuracy of her review may have been slightly undermined by the fact that she got the title wrong, consistently calling it *The Gillyflors*. In any case, a neutral observer might be more likely to trust Cookson, who had grown up in County Durham in grinding poverty, rather than Professor Mitchison, who had been born into an academic family and educated at the Dragon School in Oxford, Channing School in Highgate and Lady Margaret Hall, Oxford. The truth is that, as Carey points out, Cookson's life story – the basis, one way or another, for almost all her novels – contradicted a 'cherished intellectual myth. The essence of this myth is that the working class possesses moral and cultural worth, whereas the middle class is despicable. Cookson's experience indicates the reverse. Having sampled working-class life, she strained every nerve to get out of it.'[31]

Cookson's early life was so unremittingly awful that it sounds like something from a novel – or, in her case, eighty-nine novels. She was born in South Shields in 1906, close to the great Tyne Dock, and brought up nearby in East Jarrow. This was an area dominated not merely by ships but by coal: 7 million tonnes from the nearby Durham collieries passed through the dock every year. The most famous early twentieth-century portrait of Jarrow dates from the 1930s, when J. B. Priestley called it 'a mean little conglomeration of narrow monotonous streets of stunted and

ugly houses, a barracks cynically put together so that shipbuilding workers could get some food and sleep between shifts'. At the time, the town was in the grip of the Depression: to Priestley, it 'looked as if it had entered a perpetual penniless bleak Sabbath'. The men, he wrote, 'wore the drawn masks of prisoners of war'; indeed, 'a stranger from a distant civilization, observing the condition of the place and its people, would have arrived at once at the conclusion that Jarrow had deeply offended some celestial emperor of the island and was now being punished'.

But even though Priestley was writing in the 1930s, the town was not so different in Cookson's day. When she was born, eight years before the First World War, the heavy industries on which Jarrow depended had already passed their peak, and unemployment was already becoming a problem. In her novels, she depicts it as a hard, cold, unforgiving town, greasy with rain and soot, at once economically insecure and culturally insular. The men are hard-drinking and violent, the women stoical and long-suffering. Superficially it might look similar to the landscape of *Coronation Street*, a network of cramped, brick, terraced streets. But the atmosphere could scarcely be more different.[32]

Unlike many writers who observed the urban working class from without, Cookson never portrayed them as a united, homogeneous group. She grew up in a neighbourhood known as the New Buildings, which features in her novels as the Fifteen Streets, where even the slightest difference in status took on gigantic significance. Drinking, smoking, church-going and chapel-going were all heavily freighted with class connotations, impenetrable to an outsider but immensely important to the area's residents. Between the respectable families at the top and the underclass at the bottom, there yawned a great gulf. Cookson's family, the McMullens, belonged to the underclass. They were Irish Catholics who had moved to Tyneside after the potato famine, and even decades later they clung fiercely to their Catholic identity. Cookson's grandfather, John McMullen, who worked in the Tyne Dock shovelling iron ore, always hated Protestants, even though he worked alongside them. In Cookson's words, 'he was a drunken, bigoted, ignorant old Irishman'. In the street he had a reputation as a drinker and a fighter, a man to avoid. 'There was only one slum, *theirs*, the McMullens',' a neighbour told one of her biographers. 'East Jarrow was one of those places where everybody helped everybody else – everybody except the McMullens.'[33]

It was in John McMullen's house that Catherine ('Katie') was born in

1906. The single most important fact about her, which hung over her for the rest of her life, is that she was illegitimate. Her mother, Kate, who had literally walked the streets barefoot as a child, begging for scraps from the neighbours, had started work at a Gateshead inn but then became pregnant. As was not uncommon in those days, Kate gave the child to her parents, who brought her up as their own. So, for the first few years of her life, Cookson believed that her grandparents were her parents, and that Kate, her mother, was actually her sister. She only found out the truth in the most horrible way imaginable, from the jibes and sneers of their neighbours. 'You're a bastard,' one woman told her after the 6-year-old Katie had knocked on her door and run away once too often. 'Inside and out you're a bastard.'

A little later, after Katie threatened to run to her mother during a dispute with another girl, the latter said: 'She's not your ma. If you want to know, she's your grandma ... your Kate's your ma, and she drinks and YOU haven't GOT NO DA, me ma says so.' The other girls then took up the cry: 'You haven't got no da! You haven't got no da!' In her autobiography *Our Kate*, Cookson wrote that only somebody who had lived through such an experience could know 'how it shatters for always the whole world of childhood and reverberates through the rest of life'. At the time, she took refuge in her family's outside toilet, burning with shame. But in a sense, her entire literary career, which made her such vast amounts of money, was an attempt to come to terms with the shock and humiliation of that moment in the street.[34]

To say that Cookson's early life was tough would be an understatement of monumental proportions. Her grandfather was drunken and violent, her grandmother was cold and silent, and her mother, too, had become a drunk. By the age of 8, little Katie was already running errands for her mother, whether taking clothes to the pawnshop or fetching beer from the local pub. With money tight, she was sent to scavenge on the local rubbish tip, collecting cinders and fragments of coke for the fire. At home, meanwhile, she lived in fear. The theme of domestic abuse recurs again and again in her books, and there are numerous instances of whippings and beatings. Later, Cookson said that at the back of her subconscious was a sense of 'deep aggression, against my early suffering, against my mother, against someone who did me a great evil that I have never written about'. She never quite spelled out what this 'great evil' was, but her biographers Piers Dudgeon and Kathleen Jones agree

that Cookson's mother may well have sexually abused her as a child. This is just speculation, of course. Even so, the fact remains that Katie McMullen grew up in almost unimaginable poverty, fear and misery. With no books in the household, she sought sanctuary in her imagination, endlessly fantasizing about her missing father. In her dreams, he was a gentleman who would one day whisk her away to happiness and comfort. 'It was him in me', she wrote later, 'that pushed and pulled me out of the drabness of my early existence.'[35]

The institution to which Cookson escaped was, of all places, the local workhouse. Having left school at 13, she worked first as a domestic servant and then in the workhouse laundry. There too she found the mental space to dream of a different life, and to take her first steps towards making it a reality. By any standards her self-belief and work ethic were impressive, but given where she had come from they were simply exceptional. Ignoring the sneers of the workhouse staff, she bought a second-hand violin and paid for private French lessons. A keen reader, she became transfixed by the correspondence of the Earl of Chesterfield, an eighteenth-century Whig politician and Grand Tourist who had sent his illegitimate son more than 400 letters about literature, politics and conduct. This, she said later, was her real education: 'With Lord Chesterfield I read my first mythology. I learned my first real history and geography. With Lord Chesterfield I went travelling the world.' And, for the rest of her life, Lord Chesterfield remained her touchstone and her tutor, a moral guide whose emphasis on self-improvement and self-realization chimed with her own deep-seated ambitions. It is perhaps tempting to scoff at the thought of a workhouse laundress poring earnestly over the letters of an eighteenth-century peer. 'While the mining families of South Shields starved,' the historian Robert Colls writes disapprovingly, 'St Catherine was reading a Lord and planning to marry a Duke.' But she was far from unusual. At the time Lord Chesterfield's letters were regarded as something of a classic, being particularly popular with earnest self-improvers from all classes. Indeed, this was an age when working-class autodidacts were desperate for instruction and comfort of any kind, no matter how incongruous. And given how reality had treated her, who can blame her for retreating into fantasy?[36]

Cookson began writing as a form of therapy. In 1929 she had finally booked her ticket out of Jarrow, securing a new job in a workhouse in Essex, just outside Clacton-on-Sea. She ended up in Hastings, where she

married a teacher at the local grammar school, Tom Cookson. But fate still had it in for her, and in the early 1940s she suffered four miscarriages within five years. In fact, she was suffering from a rare vascular condition that caused episodes of severe bleeding. Not surprisingly, her physical and mental health was fragile: increasingly emaciated, she suffered a serious fall and then a nervous breakdown. Quite apart from the trauma of losing four babies, the long nightmare of her childhood was catching up with her.

By 1945 she had admitted herself to a local psychiatric hospital, where she underwent a course of electric shock treatment. When she got out, she dabbled in spiritualism, becoming a disciple of the celebrity faith healer Harry Edwards. But she also found release in the Hastings Writers' Circle, an amateur group who used to read their work aloud. It was for this group that she wrote her first story set in the working-class north-east, and when that went down well she decided to try her hand at a novel, closely modelled on her own life. A visiting writer recommended his agent, and her manuscript ended up with an editor at Macdonald, who read the first chapter, found it much 'too grim' and told his secretary to post it back. In the kind of twist that sounds too good to be true, the secretary glanced at the first page, took the manuscript home and sat up all night until she had finished it. The next morning, she asked her boss to give it another chance. So he did.[37]

As any reader of Cookson's first two books, *Kate Hannigan* (1950) and *The Fifteen Streets* (1952), will immediately recognize, her books were basically veiled autobiographies. At first she had flirted with the idea of writing about 'lords and ladies', but her success at the Hastings workshop persuaded her to write about the world she knew. As she explained in her autobiography: 'I had to face [the] fact ... that I wouldn't write a word that anyone would really want to read until I threw off the pseudo-lady and accepted my early environment, me granda, the pawn, the beer carrying, the cinder picking, Kate's drinking, and of course my birth, for it was those things that had gone to make me.' All these things, one way and another, appear in her first two books. Indeed, *Kate Hannigan*, set in the Fifteen Streets, opens with the thing that obsessed Cookson more than any other: her illegitimacy. The first chapter begins with 'a trollop going to bring a bastard into the world', as Kate Hannigan gives birth to a baby girl. Downstairs wait the child's future grandparents: Sarah, weary and long-suffering, and Tim, 'who put the fear of God into everybody in the fifteen streets with his

swearing and bashing'. The atmosphere could hardly be darker: later, in one horribly memorable scene, Kate's daughter, Annie, wakes to hear 'her granda's voice, low and terrible with menace ... then her grandma's voice, thick and full of something that struck greater terror into Annie's heart', crying: 'Don't! Oh, don't! I won't! I won't!'[38]

By the standards of 1950, this was very strong stuff. And like almost everything else in the novel, it was clearly anchored in Cookson's own experience. If anything, *The Fifteen Streets* is even grimmer. Cookson claimed later that the idea had come to her all in one go, 'from some spirit deep within me', after she had prayed to God for inspiration. This seems an excessively melodramatic way to explain what is essentially another disguised autobiography. The setting is the same, the characters are very similar – stoical matriarch, useless drunken husband, idealistic daughter, and so on – and many of the most memorable events are drawn straight from Cookson's childhood. In Chapter 5, for example, bright little Katie O'Brien is asked by her mother to go to the pawnshop, recalling Cookson's humiliating weekly trips to pawn clothes for her mother. Katie feels an overriding sense of shame: 'to walk up the dock bank, under the knowledgeable stares of the men idling there against the railings caused her throat to move in and out; and to meet any of her schoolmates on the journey made her want to die'. But she forces herself to do it. On her return journey she stops at the corner shop for some matches, and while the shopkeeper's back is turned, yields to temptation and steals a copy of her favourite comic. This too is drawn from experience: as one biographer puts it, the young Cookson was an 'accomplished thief', mastering the art of paying for just one comic while hiding two or three others inside the pages. At the time, Cookson felt sufficiently guilty to confess her crime to a visiting priest, who told her: 'It's a wonder you're not in hell's flames burning, child.' And in the novel, Katie feels a terrible sense of shame, vomiting with anxiety while the comic falls into the gutter and becomes 'fouled with the sick'.[39]

As all this suggests, Cookson's books often make remarkably depressing reading. Like so many stories rooted in the terraced streets of northern England – *Coronation Street* being an obvious example – they are dominated by strong, self-willed women. Unlike *Coronation Street*, though, Cookson portrays the old world of the working-class North as poor, violent and often stiflingly narrow-minded. In the astoundingly dark *Katie Mulholland* (1967), the title character is raped as a teenager

by her employer's son and forced into a loveless marriage with an older man, who beats her black and blue. When he dies, her father is hanged for his murder, while Katie's daughter is taken away and taught to hate her. Left alone with her unemployed brother and disabled sister, she prostitutes herself to a sailor and is falsely imprisoned for running a brothel, while her sister is dragged off to the workhouse. When she gets out, she discovers that her daughter has unwittingly made an incestuous marriage to her own half-brother – the son of the man who initially raped Katie. All in all, the story is so bleak it makes the Barlow household look like Buckingham Palace. But Cookson's philosophy, born of her miserable childhood, was always extraordinarily fatalistic. In *The Fifteen Streets*, the hero, John O'Brien, reflects sadly on the ambitions of his clever little sister, Katie, who dreams of becoming a teacher. 'She would go into a place at fourteen like the other lasses, and the bright eagerness would die,' he thinks. 'It was funny but that was all life amounted to . . . working for food and warmth; and when the futility of this was made evident, blotting it out with drink.' Alas, Katie never makes it that far. She dies.[40]

Despite Cookson's much-quoted hatred of religious intolerance, her own moral values were strikingly conservative, as might have been expected of someone born into a strict Catholic family in 1906. She was not an admirer of the so-called 'sexual revolution', and her novels are full of fallen women whose lives are blighted by their lack of self-control. Neither was she a feminist: her male heroes tend to be strong, silent, self-improving paragons, to whom the heroines must completely subordinate themselves. Social upstarts are invariably punished: whenever a character gets ideas above his station, putting on fancy clothes or affecting a superior accent, then you know Nemesis is on her way. As for the idea of political change – socialism or trade unionism – it is almost non-existent. What distinguishes Cookson's heroes is their commitment to self-help, based above all on self-control, self-denial and sheer hard work. Like a latter-day Samuel Smiles, she was convinced that individual education was the only way out. A good example is one of her most popular heroines, Tilly Trotter, who features in three books published between 1980 and 1982. Growing up in the rural Victorian north-east, Tilly is set apart from her peers because she can read and write. In the village, jealous women accuse her of being a witch, while the men try to put her back in her box by raping her – a classic Cookson device. One

man remarks that 'it wouldn't surprise me if one day she decided to wear trousers', although Cookson being Cookson, that would probably only inflame the local rapists. But it is Tilly's education that saves her, allowing her to find love with a local miner, Mark Sopwith, who has similarly dragged himself up through hard work and self-education. Mark is socially a little above her, but not too much: the perfect husband, from Cookson's point of view.[41]

Many years later, Cookson was asked if she saw herself as a romantic novelist. 'What nonsense that is!' she replied. 'My books are social histories of the north, full of the bitterness of reality and no fancy frills.' Similarly, when the University of Newcastle gave her an honorary degree, it was for her 'work dealing with the everyday lives and vicissitudes of the people of this Northern area of England'. But are her books really about the North, or are they just about her? There is surprisingly little sense of place: for Robert Colls, a Geordie born and bred, 'Kate Hannigan's Jarrow could be anywhere hard and grimy'. Despite her claims, there is no sense of history: there is never any hint of change or development, there are virtually no allusions to events like the General Strike of 1926, and there is not the slightest hint of the transformation in working-class life after Cookson left Jarrow, from the advent of affluence and full employment to the dramatic decline of mining and shipbuilding. 'Her North East', writes Colls, 'is forever 1929.'

Perhaps this was only natural: after all, Cookson wrote the vast majority of her books in Hastings, where she lived for almost half a century. Colls suggests that, if Cookson was a regional writer, 'then the region she had in mind when writing was the mental landscape of her female readers'. I would go further: if there was such a thing as 'Catherine Cookson Country', then it was the battle-scarred landscape of her own childhood. Almost all her books are about the same things: the taint of illegitimacy; the tension between mother and child; the stifling atmosphere of superstition and bigotry; the inevitable friction between the expectations of the community and the ambitions of the individual. To put it another way, all her books are about Catherine Cookson. It is hard to think of any post-war entertainer who made quite so much money from being quite so self-absorbed, except perhaps John Lennon.[42]

Although Cookson's books almost always have a romantic dimension, it is strange that they are so often dismissed as 'romantic' fiction. Many of them could hardly be less romantic, addressing the kind of

themes that *Coronation Street*'s producers regarded as far too controversial, such as wife-beating, child abuse, rape and incest. Only occasionally do her heroes and heroines find true love, and they suffer far more than their equivalents in, say, Barbara Cartland. Often they do not even manage to escape their stifling environment. Readers of *The Fifteen Streets*, for example, might expect the book to end with its hero, the noble-hearted, self-improving John, leaving behind the narrow streets of working-class Jarrow and starting afresh with the love of his life, the educated, middle-class Mary. In fact, quite the opposite happens. It is Mary who is forced to move into the Fifteen Streets, effectively coming down to John's level.

In the final pages of the book, her new mother-in-law, Mary Ellen, who is helping her to move in, deliberately smashes Mary's nude statuette, a symbol of her elevated, middle-class artistic values. 'I had to do it, lass,' says Mary Ellen as her daughter-in-law stares in horror at the debris. 'They wouldn't understand around these doors.' Now Mary realizes the consequences of her decision. Her life is going to change in ways she had never imagined, and 'not only her actions, but her thoughts must be restricted'. A few moments later John comes in and the book ends with a reassuringly romantic embrace. 'His arms, telling his hunger, crushed her to him,' Cookson writes. 'The faint perfume of her body mingled with the acrid smell of iron ore, and in the ever increasing murmur of his endearments and the searching of his lips her words were lost.' This could be Barbara Cartland – except, of course, for the acrid smell of iron ore.[43]

For some of Cookson's admirers, the writer she really resembled was not Cartland but Charles Dickens. The American critic Julie Anne Taddeo suggests that she wrote 'Dickensian-style tales of bastardy, deprivation, and eventual success for the deserving few', while her biographer Kathleen Jones claims that the Tyne 'was as inspirational for Catherine Cookson as the Thames was for Dickens'. Meanwhile, her most sympathetic biographer, Piers Dudgeon, develops an elaborate parallel between Cookson and Dickens. He points out that Dickens, like Cookson, was a bright, sensitive, idealistic child, who found it difficult to make friends and struck other people as a bit odd: 'a queer small boy', in fact. He compares Dickens's ordeal in the blacking factory, when his father had been imprisoned for debt, with Cookson's childhood misfortunes in the streets of Jarrow, and suggests that they had the same consequences: 'rejection, alienation, misery, humiliation, shame'.

He argues that Cookson, like Dickens, wrote to exorcise the demons of her childhood, drawing her characters from her memories of real working-class life, and evoking what Dickens, reflecting on his own youth, called 'wild prodigies of wickedness, want and beggary'. And although he concedes that there is something of a gulf between Dickens's prose and Cookson's, he actually thinks this works in Cookson's favour. Dickens's art, he suggests, is 'more of a performance: we see his most vibrant characters, but we don't always feel we have met them in real life in quite the same way'. Cookson, by contrast, 'reveals the lives of ordinary people', while reminding us that 'no one is ordinary'.[44]

Whatever you might think of all this, Dudgeon deserves credit for his sheer nerve. All the same, the Dickens comparison seems to me monumentally unconvincing. The two writers' backgrounds, for example, were completely different. Cookson grew up in what we would now call the underclass, but Dickens's father was a clerk in the Navy Pay Office. 'Mentally', George Orwell wrote of Dickens, 'he belongs to the small urban bourgeoisie', which explains why most of his genuinely working-class characters are 'either laughable or slightly wicked'. As writers, meanwhile, the two were so different that they belong on different planets. Cookson's books are better written than her critics allow, but her style is at best lean and at worst purely functional. By the late 1960s she was already dictating her books into a tape recorder, which is not, perhaps, the best way to hone your style. Where the comparison really founders – as with *Coronation Street* – is in the idea that Dickens was basically a social realist earnestly chronicling the lives of the very poor. But this seems to me a complete misunderstanding. Dickens was not a realist, but a comic writer, bursting with life and brio. As Martin Amis, a much more plausible candidate to be Dickens's post-war heir, told interviewers when promoting his book *Lionel Asbo: State of England* (2012), Dickens's world is 'more demotic, melodramatic – a world of strange transformations, of long journeys from which people return very much altered . . . cartoonish and exaggerated and hugely energetic'. Nobody could say that of Catherine Cookson.[45]

Perhaps a more fitting comparison, as John Carey observes, might be the writers Guy de Maupassant and Émile Zola, whose novels often wallowed knee-deep in grime and vice and poverty, or indeed their shamefully underrated admirer Arnold Bennett, whose greatest books captured the lives of ordinary people in the Potteries. The truth,

however, is that for all her merits, Cookson is not remotely in their league. Her books are more like the melodramas of early twentieth-century authors such as Warwick Deeping or Elinor Glyn, of whom she was a great fan. Yet the fact that her admirers have so often compared her with the great names of Victorian fiction is highly revealing. What it suggests is an enduring and, in my view, unnecessary insecurity about supposedly middlebrow fiction, especially when it is written by and for women.

But Cookson's fans have no reason to feel defensive, for her books have given far more pleasure to far more people than any number of literary prize-winners. Stylistically they are non-existent, but that probably worked to her advantage, allowing her to reach a wider audience than if they had been more elaborately written. In Colls's words, they address 'some of the great moral themes of all art; namely virtue, talent, truth and fulfilment' – not in an immensely sophisticated way, perhaps, but in one that made sense to millions of ordinary readers. After interviewing numerous Cookson fans, Julie Anne Taddeo found that her books struck a chord with readers who remembered the north-east before the arrival of tower blocks and the decline of industry, and felt that 'the former spirit of neighborliness has been lost'. But Taddeo also suggests that Cookson's moral conservatism appealed to readers who shared her belief in hard work, sexual restraint and individual self-improvement. What they found in her historical novels was 'an affirmation of the very same values they hold dear in the present'.[46]

In Cookson's book *The Rag Nymph* (1991), set in the Victorian era, two slum-dwelling characters argue about Charles Dickens. Young Ben is a great Dickens fan, but Aggie, a 'rag lady', thinks that 'he's makin' his money out of exposing misery'. In fact, by the time Cookson wrote those words, she was already one of the richest women in Britain, having made a very handsome living from 'exposing misery'. It seems unlikely that she appreciated the irony; all the evidence is that she took herself immensely seriously.* In any case, as early as 1969 she was making so much money that she found herself eligible for supertax at 95 per cent, the same rate

* On one occasion, when her husband Tom's parents came to visit, she made them sit and listen to a tape of her making an emotional speech about her early life. Alas, they were conspicuously unmoved, probably because they had heard it all before, or perhaps because they resented having to listen to their daughter-in-law talking about herself again. They were never invited back, which says a great deal about her egotism and self-absorption, but not very much for her husband's backbone.

that had provoked George Harrison to write 'Taxman'. By now she had a boat, a billiard room and even a swimming pool. And yet the more money she made, the more her publishers traded on her poverty-stricken childhood, playing up her novels' autobiographical elements as a guarantee of authenticity. Indeed, by the time she turned 80, South Tyneside itself had been officially renamed 'Catherine Cookson Country', catering for the coachloads of tourists pouring in from home and abroad. In the South Shields Museum, the local authority built a £50,000 replica of her childhood home, complete with scullery and tin basin. As people often joked, with the docks and the mines having closed down, the biggest industry on South Tyneside was now Cookson herself.[47]

Of all the cultural success stories discussed in this book, however, Cookson seems the most likely to fall back into relative obscurity. During her lifetime, much of her clout derived from her extraordinary dominance of the library charts, which undoubtedly reflected her appeal to older working-class readers. But no sooner had she died than her crown began to slip. After a seventeen-year reign at the top, she fell to fourth place in 2004, behind the children's writer Jacqueline Wilson and the romantic novelists Danielle Steel and Josephine Cox. Then her popularity sank like a stone. Within five years there was not a single one of her books among the 100 most borrowed titles, and by 2011 she had fallen to a mere 147th in the list of Britain's most borrowed authors. As South Tyneside's mayor, Eileen Leask, told the *Daily Mail*, people no longer connected with her books. 'She had a very hard life,' Mrs Leask explained, 'partly because she was illegitimate, but that is a stigma people simply can't relate to any more.'

There was probably a lot of truth in this. Like Cookson herself, the readers who remembered the north-east in the 1920s and 1930s were gone. Few people could immediately recall the grim, poverty-stricken world she had written about with such feeling, and few felt a sense of nostalgia for the Tyne Dock in its pomp. Her appeal had reflected the extraordinary social changes of the post-war decades, tapping the anxieties of readers whose physical and moral landscape was shifting around them. But now, as Mrs Leask put it, 'people have moved on'. At the beginning of 2012, South Tyneside began to take down the signs welcoming visitors to 'Catherine Cookson Country'. In the *Mail*, her biographer Piers Dudgeon howled with fury. But the truth is that, to many visitors, her name no longer meant anything at all.[48]

Previous pages: 'Man produces evil as a bee produces honey': Ralph (James Aubrey) and Piggy (Hugh Edwards) in the film version of William Golding's *Lord of the Flies* (1963).

9

The Mark of Cain

TODAY I KILLED GRANDFATHER

'One does see so much evil in a village,' murmured Miss Marple
in an explanatory voice.

Agatha Christie, *The Body in the Library* (1942)

For all her success, Catherine Cookson was not even close to being the
bestselling British writer of the twentieth century. Indeed, the largest esti-
mate for her total book sales, 123 million, looks positively puny compared
with the estimated 2 *billion* books, translated into more than 100 lan-
guages, claimed for the most successful British writer of the century. This
was another woman – and a Victorian woman at that, having been born
in 1890. In fact, no matter how you slice the figures, there is simply no
getting away from the stark, awe-inspiring facts of Agatha Christie's
success. By the time Christie turned 60, she had already shifted some
50 million books worldwide, and even after her death her name contin-
ued to sell books in almost every country on earth. She was, wrote the
journalist Francis Wyndham in 1966, the 'best of all sellers ... abstract,
enigmatic, logical and completely ruthless'. The critic Robert Barnard,
himself a fine crime writer, was once relaxing on an Italian beach when he
saw a middle-aged local woman reading one of the Miss Marple books in
translation. Two days later, having returned home to Tromsø, north of the
Arctic Circle, Barnard spotted a teenage girl in a deck chair, reading ... a
book about Miss Marple, this time in Norwegian. In his words, Christie
is read by 'miners, shop assistants and old-age pensioners', as well as 'aca-
demics, politicians, scientists and artists'. Probably no British writer, not
even Dickens, has ever enjoyed such universal appeal.[1]

Appointment with death: the actress June Duprez in the film version of Agatha Christie's *And Then There Were None* (1945).

Among people who fancy themselves as great intellectuals, Christie's popularity has always been a standing affront. She was very conscious of her reputation: having been awarded the CBE in 1956, she told a friend: 'I feel it's one up to the Low Brows!' Even so, it is hard to think of any author who has been so successful for so long – it is, after all, almost forty years since her death, and almost a century since she started work on her first novel – while inspiring such contempt from her critics. In 1944 the American critic Edmund Wilson, who specialized in writing off authors who then proved enormously popular, claimed that her prose was 'of a mawkishness and banality which seems to be almost literally impossible to read'. Three decades later, Bernard Levin agreed: her books were 'unreadable . . . rubbish . . . not one of [them] worth the time of an intelligent adult'.

And so the abuse has piled up, year after year. For the columnist Polly Toynbee, Christie's books are 'suffused with a peculiar English snobbery' and located in 'a realm of quite extraordinary fantasy, firmly set among the middle classes, on the uncomfortable presumption, perhaps, that the lower classes are too boring to write books about, or that crime among them is too common to merit attention'. For the writer Iain Sinclair, meanwhile, Christie 'conjured compensatory fantasies, parallel worlds where bluestockings, erudite medics and village busybodies stood alone against a conspiracy of social climbers, artsy-fartsy pinkos, dagos with garlic breath, Hebrew financiers and allround wrong'uns'. Even her fellow crime writers, no doubt jealous of her sales, love to sneer at her. Michael Dibdin thought Christie's characters 'devoid of any emotional depth' and her plots 'all basically the same'. Ruth Rendell said that whenever she read an Agatha Christie, 'I don't feel as though I have a piece of fiction worthy of the name in front of me.' P. D. James described her simply as 'such a bad writer'.[2]

As anybody who has read even a handful of Christie's books will know, the most common charge – that she is, as Polly Toynbee argues, a supremely snobbish writer – is flat-out wrong.* It is true that her first thrillers, such as *The Secret Adversary* (1922) and *The Secret of Chimneys* (1925), are often highly conservative in a paranoid sort of way,

* I am well aware that some readers will not have devoured all – or even any – of Christie's books. So it seems only fair at this point to issue a warning. In the section that follows, I am going to give away some of the endings – not because I want to spoil them, but because it is impossible to discuss Christie seriously without talking about her killers.

with characters muttering darkly about the sinister wiles of 'Hebraic people, yellow-faced financiers in city offices'. In Christie's defence, this was far from unusual in the thrillers of the 1920s: just think of the attitudes in, say, the Bulldog Drummond stories. But it is simply not true that her books are extended apologias for the upper classes. As Barnard points out, her aristocrats are usually faintly ridiculous figures, while in *One, Two, Buckle My Shoe* (1940), the conservative businessman Alistair Blunt – a man, says Poirot, who stands 'for all the things that to my mind are important. For sanity and balance and stability and honest dealing' – actually turns out to be the murderer!

And what about Poirot himself, such a strange, unexpected figure compared with his crime-solving predecessors? After all, most of the heroes of the so-called Golden Age of detective fiction during the 1920s and 1930s tended to be foppish Oxbridge types. Ngaio Marsh's usual protagonist was the gentleman detective Roderick Alleyn, the younger brother of a baronet, who studied at Oxford; Margery Allingham's books featured another gentleman sleuth, Albert Campion (Rugby and St Ignatius's College, Cambridge); and Dorothy L. Sayers created the immensely irritating Lord Peter Wimsey (Eton and Balliol, Oxford). But Christie established her reputation with a detective who could hardly have been more different: a Belgian immigrant who stands only five feet four inches tall, lives in a brand-new modernist flat and is physically incapable of even the slightest heroics. The epitome of the bourgeois 'little man', he never even went to public school.[3]

As the critic Alison Light points out, the fact that Christie created such an unconventional hero ought to make us question the idle, ill-informed stereotype that her books are all about people with cut-glass accents sipping cocktails on country-house lawns. In fact, this image owes more to the glossy Hollywood and BBC adaptations of her books than to the novels themselves. Unlike some of her competitors' stories, her books were obviously written for a very broad audience: the kind of people who might read them in the lounge, not the drawing room. There are none of the patrician trappings that you find in Dorothy L. Sayers or Margery Allingham, and none of the obsessions with luxury and high living that you find in Ian Fleming. In fact, surprisingly few of Christie's books are set in grand country houses; instead, the typical setting might be a small provincial town, or perhaps an archaeological dig in the Middle East. It is true that her characters are overwhelmingly middle-class. Most

fictional characters before the 1960s were middle-class; probably most fictional characters created today are middle-class, too. But as Light notes, Christie's characters include not just 'retired colonels and vicar's ladies', but 'secretaries, commercial salesmen, shopkeepers, receptionists, shop-girls, nurses, solicitors, housewives, doctors and dentists'. Unusually for a Golden Age novelist, she rarely treats them condescendingly or as subjects for low comedy. She never sneers at the suburban middle classes, as so many writers of her generation did, and never mocks the aspirations of social upstarts and parvenus, as even Catherine Cookson did. And when domestic servants appear, they are almost always treated sympathetically, and are almost never the killers.

The other charge levelled at Christie is that she is just a bad writer. Once again, though, this seems grossly unfair: indeed, at the risk of outraging any remaining highbrow readers, I would argue that some of her best books, such as *Five Little Pigs* (1942), *The Moving Finger* (1942) or *The Hollow* (1946), are downright well written. Her prose style, like Cookson's, may seem flat and undemonstrative, but it is perfectly calibrated for the task in hand. Alison Light suggests that, to readers after the First World War, Christie's simple, clean style seemed refreshingly modern. In an age that had turned its back on grandiose romanticism, here was a new kind of suburban domestic realism, shunning the excesses of the past and restoring order and decency to the English household: a kind of literary equivalent of Stanley Baldwin. That seems pretty persuasive, but it does not explain why Christie has lasted so well. And to that the only possible answer is that she was very good at her job. Not only was she a supremely disciplined writer, she was an extremely clever one. Even her critics have to concede that she was brilliant at setting puzzles, but they often insist that her characters were mere stereotypes. This is to miss the point: time after time, she feeds us stereotypes only to trick us, fooling us into seeing her characters as mere stock figures before revealing the complexity beneath the facade.[4]

Most of Christie's biographers agree that, at some level, her detective novels reflect a deep-seated longing to banish the emotional instability that had blighted her early life. She was born in Torquay in 1890 to an American stockbroker and his Belfast-born wife, who brought her up in upper-middle-class comfort. Alas, her father was dogged by illness and died when Agatha was just 11. Perhaps this early tragedy explains the

conflict that so often erupts inside Christie's fictional families, with violent death unexpectedly shattering the illusion of domestic respectability. Many years later, a correspondent to the *London Review of Books* suggested, plausibly enough in my view, that Christie was a 'classic victim of unresolved loss', with her books representing a long struggle to explain the mystery of death. Perhaps this is to sink too deeply into the muddy waters of amateur psychology. What is certainly true, though, is that even as a young woman Christie was well aware of life's potential for violence and suffering. Her critics sometimes claim that she was ignorant of real life; what they forget is that she worked as a volunteer nurse during the First World War, treating young men whose bodies had been shattered on the Western Front. For a sheltered young woman, it is hard to imagine a more visceral introduction to what her most recent biographer, Laura Thompson, calls 'the dirt and blood and phlegm' of real life.

Even Christie's most effective narrative device – the love triangle that appears in novels such as *Death on the Nile*, *Sad Cypress*, *Evil under the Sun* and *Five Little Pigs* – was firmly rooted in reality: specifically, the trauma of her divorce from her first husband, the debonair Archie Christie, who in 1926 abandoned her for a much younger woman. It was the shock of this betrayal that precipitated Christie's famous vanishing act, when she disappeared from her Surrey home, leaving her car by the edge of a lake, and took refuge in a hotel in Harrogate. And although she subsequently got married to the archaeologist Max Mallowan, her obsession with infidelity and betrayal suggests that the scars never truly healed. She had, remarked P. D. James, 'a psychological need to bring order out of disorder . . . I think maybe every one of [her books] is a kind of catharsis. All of them, a little catharsis.'[5]

One of the common misconceptions about Christie's books is that they represent a kind of escapism. Iain Sinclair, for example, thought that she invented 'compensatory fantasies, parallel worlds'. Yet the careful reader can hardly avoid being struck by the naturalistic ordinariness of her characters and their settings, from the rural vicarage to the suburban villa. As Christie well knew, most murders are committed within the family; statistically, you are most likely to be murdered by your husband or wife. Time and again, an exotic premise turns out to be a red herring. In her splendid book *The ABC Murders* (1936), for

example, we think we are reading about a serial killer, apparently picking his victims from an ABC Railway Guide – Alice Ascher in Andover, Betty Barnard in Bexhill, Sir Carmichael Clarke in Churston – only to discover that we are really dealing with that most banal of killers, a younger brother who wants to get his hands on the family money. Indeed, for all the complexity of Christie's puzzles, her murderers' motives often boil down to those two time-honoured favourites, sexual jealousy and financial greed. When the Belgian scholar Aagje Verbogen examined the Miss Marple books in detail, she found that Christie used only four motives: money, sex, fear of exposure and revenge, with money by far the most frequent. Rather puncturing the image of Christie as a snob, her killers are overwhelmingly middle-class: of fourteen murderers in the Marple books, Verbogen identifies seven as middle-middle-class, four as upper-middle-class and one as lower-middle-class, with just one aristocratic murderer and none from the working classes.[6]

Even Christie's murder weapons are strikingly mundane. Her favourite, born of her experience working in a dispensary in the 1910s, was poison. In the Miss Marple books, almost half the victims are carried off by poison: arsenic, digitalin, sleeping pills, and so on. But Christie's other weapons are often remarkably domestic, the kinds of things that middle-class readers would have used every day in the 1930s and 1940s: a steak knife, a satin waistband, even a kitchen skewer. Alison Light suggests that Christie took a 'morbid pleasure in choosing the banal impedimenta of home life and wreaking havoc with them', from a tennis racquet (*Towards Zero*, 1944) to a paperweight (*Hickory Dickory Dock*, 1955). What her books offer, in other words, is the violence of the twentieth century, gently toned down and introduced into the heart of the suburban household. In Robert Barnard's words, 'she brought murder into the home, where it belonged, seeing the murderous glint in the eye of the self-effacing bank clerk, the homicidal madness in the flutterings of the genteel lady companion'. If this is mere escapism, what would realism look like?[7]

On the screen, producers have naturally tended to favour those Christie books set in exotic Bond-esque locations, such as *Murder on the Orient Express* (filmed in 1974) and *Death on the Nile* (1978). For my money, however, Christie's most effective and evocative stories tend to have more humdrum settings. Perhaps her classic setting is the rural southern

English village – St Mary Mead, Chipping Cleghorn, Much Deeping, Wychwood-under-Ashe – which Barnard jokingly nicknamed 'Mayhem Parva'. On the high street, well-dressed ladies bustle from butcher's to baker's; in the vicarage, the doctor and his wife have just popped in for tea. On the surface everything seems civilized, quiet and terribly English, the very picture of a pastoral idyll. And yet, as Christie shows, especially in her books written after the Second World War, this is a world being transformed by social change.[8]

Take one of her most memorable books, *A Murder Is Announced*. This was published in 1950, five years after the landslide that had brought Clement Attlee's Labour government to power, and as a social document it could hardly be more revealing. Ostensibly Chipping Cleghorn is yet another generic rural village, unchanged by the passage of time. Yet, in this age of austerity, the residents live much more carefully than they might have done before the Second World War. There are fewer servants, and there is a slight but palpable air of anxiety. 'The world', says Miss Marple sadly, 'has changed since the war.' For as she explains to Inspector Craddock:

> Fifteen years ago one *knew* who everybody was. The Bantrys in the big house – and the Hartnells and the Price Ridleys and the Weatherbys ... They were people whose fathers and mothers and grandfathers and grandmothers, or whose aunts and uncles, had lived there before them ... If anybody new – really new – really a stranger – came, well, they stuck out – everybody wondered about them and didn't rest till they found out ...
>
> But it's not like that any more. Every village and small country place is full of people who've just come and settled there without any ties to bring them. The big houses have been sold, and the cottages have been converted and changed. And people just come – and all you know about them is what they say of themselves. They've come, you see, from all over the world. People from India and Hong Kong and China, and people who used to live in France and Italy in little cheap places and odd islands. And people who've made a little money and can afford to retire. But nobody *knows* any more who anyone is.

The inspector immediately sees her point. Under the pressures of war, austerity and socialist reform, the threads binding the rural English middle classes together have gradually unravelled:

He didn't *know*. There were just faces and personalities and they were backed up by ration books and identity cards – nice neat identity cards with numbers on them, without photographs or fingerprints. Anybody who took the trouble could have a suitable identity card – and partly because of that, the subtler links that had held together English social rural life had fallen apart. In a town nobody expected to know his neighbour. In the country now nobody knew his neighbour either, though possibly he still thought he did . . .[9]

Despite appearances, therefore, Chipping Cleghorn has become a society of strangers, just like any of Britain's big cities. And although it is tempting to dismiss all this as the neurotic anxiety of the conservative middle classes, alarmed by the social changes of the Attlee years, there is surely more to it than that. Even in *The Murder of Roger Ackroyd*, which was published in 1926, Christie had played on the same fears of an increasingly atomized, anonymous society, a world of fluid identities in which nobody can be entirely sure of anybody else. This time the village is King's Abbot; once again, nobody is quite who he seems. The murder victim, Roger Ackroyd, appears to be a quintessential country gentleman, but is in fact a rich self-made industrialist. His maid, Ursula Bourne, actually comes from a family of 'distressed Irish gentlefolk', while his housekeeper is hiding the secret of her son's drug addiction. Above all, the newcomer who lives at The Larches – whom the narrator identifies as a 'retired hairdresser' – is actually the private detective Hercule Poirot. Almost everybody, in other words, is a migrant, a refugee, an impostor, a stranger. What better reflection of the nagging anxieties of a society being transformed by physical, economic and social mobility? 'You simply cannot *afford* to believe everything that people tell you,' says Miss Marple in *The Body in the Library* (1942). 'When there's anything fishy about, I never believe any one at all! You see, I know human nature so well.'[10]

If Poirot makes an unconventional Golden Age detective, then Miss Marple – the very picture of a little old lady, with 'snow white hair and a pink crinkled face and very soft innocent blue eyes' – is arguably an even more iconoclastic central character. It is hard to imagine a greater contrast with Albert Campion or Peter Wimsey, or indeed with Sherlock Holmes. Yet what makes her such a satisfying figure is not her forensic detective skill, but her bleakly unsentimental view of human nature.

Other characters often find her implausible and irritating: no sooner does she appear in the narrative than she starts wittering on about people she used to know in St Mary Mead: 'the young maidservant at Mr Harbottle's', for example, or 'Mr Badger who had the chemist's shop'. To Christie's policemen, Miss Marple's reliance on a stock of village anecdotes often seems downright laughable. But it is precisely because she has such a long experience of human nature that she is able to pick out the killer. As she explains in the first Miss Marple novel, *The Murder at the Vicarage* (1930), 'the only way is to compare people with other people you have known or come across. You'd be surprised if you knew how very few distinct types there are in all.' This theme recurs in almost all Miss Marple's appearances. 'Human nature', she tells her sceptical nephew in the short story 'The Thumb Mark of St Peter' (1932), 'is much the same everywhere, and, of course, one has opportunities of observing it at closer quarters in a village.' And although other characters often picture her as a sweet, cosy old lady, Miss Marple's long contemplation of human conduct leads her to some remarkably gloomy conclusions. 'I'm afraid that I have a tendency always to believe the *worst*,' she says in *A Murder Is Announced*. 'Not a nice trait. But so often justified by subsequent events.'[11]

It is a shame that the screen adaptations of the Miss Marple books, from the galloping Margaret Rutherford films and the BBC's stately Joan Hickson adaptations to the terrible ITV series starring Geraldine McEwan and Julia Mackenzie, have encouraged a misleading image of Christie's most compelling detective. Deep down, there is nothing cosy about the Miss Marple stories. A good example is *The Moving Finger* (1942), unquestionably one of Christie's darkest and best books. The setting is a sleepy West Country village, Lymstock, to which Jerry and Joanna Burton, a brother and sister from London, have moved to help him recover from his plane-crash injuries. Lymstock is 'so sweet and funny and old-world', gushes Joanna in the first chapter. 'You just can't think of anything nasty happening here, can you?' Just two pages later, however, they get the first of a series of coarse, aggressive anonymous letters. 'What is this place?' asks a disbelieving Joanna. 'It looks the most innocent sleepy harmless little bit of England you can imagine.' Driving through the village, Jerry wonders which of the 'sturdy country women' is 'going about with a load of spite and malice behind her placid brow'. As the letters continue, he reflects that Lymstock may look 'as

peaceful and as innocent as the Garden of Eden', but it is 'full of festering poison'. And as people start to die, so Jerry notes 'a half-scared, half-avid gleam in almost everybody's eye. Neighbour looked at neighbour.' It is at this point, two-thirds of the way through, that Miss Marple shows up with her stock of village parallels. 'One sees a good deal of human nature living in a village all the year round,' she explains after unmasking the killer. 'The great thing is in these cases to keep an absolutely open mind. Most crimes, you see, are so absurdly simple. This one was. Quite sane and straightforward – and quite understandable – in an unpleasant way, of course.'[12]

Miss Marple is a Victorian, as was her creator. Agatha Christie was already 10 years old when Queen Victoria died and a woman of 23 when the Great War broke out. And although Christie seems perhaps *the* quintessential twentieth-century author, writing for a mass suburban readership from the 1920s to the 1970s, her books naturally bear the stamp of the Victorian novels that she had loved as a child. Detective fiction itself was a nineteenth-century invention, reflecting the Victorians' intense anxieties about crime and disorder in a rapidly urbanizing industrial society. In sensational newspapers and penny broadsides, nineteenth-century readers had lapped up stories of suburban poisonings, slaughtered children, bodies on trains and corpses dredged from rivers. Curious tourists mobbed the scenes of infamous murders; bloodthirsty crowds would gather for hours before the execution of some celebrity criminal. 'Scratch John Bull', remarked the *Pall Mall Gazette* in 1888, 'and you find the ancient Briton who revels in blood, who loves to dip deep into a murder, and devours the details of a hanging. If you doubt it, ask the clerks at Mr. Smith's bookstalls, ask the men and women and boys who sell newspapers in the street.' Indeed, fuelled by plays, novels and the popular press, the public appetite for murder seemed unquenchable. One of the most popular of all sensation novelists, Mary Elizabeth Braddon, lamented that the 'amount of crime, treachery, murder and slow poisoning' demanded by her readers was 'something terrible', although that did not stop her cashing in on it. 'We are a trading community – a commercial people,' declared *Punch* in 1842, in a piece aptly entitled 'Blood'. 'Murder is, doubtless, a very shocking offence; nevertheless, as what is done is not to be undone, let us make our money of it. Hereupon, we turn a murderer into a commodity, and open an account with homicide.'[13]

It is hard to imagine Christie herself saying anything quite so brazen. Even so, her debt to her Victorian predecessors, notably Wilkie Collins, is incontestable. The country-house setting; the apparently insoluble puzzle; the trail of red herrings; the list of suspects; the hapless local police; the brilliant detective; the final twist – all this came from Collins's book *The Moonstone* (1868). And like Victorian writers such as Collins, Christie aimed her stories at a middle-class readership, simultaneously titillating them with the complexity of her puzzles and reassuring them through the figure of the detective, the champion of order and method against violence and chaos. In P. D. James's book *Devices and Desires* (1989), her detective Adam Dalgliesh reflects that solving crimes provides 'a comforting illusion of a moral universe in which innocence could be avenged, right vindicated, order restored'. In an essay for the *Spectator* in 1970, meanwhile, the critic Anthony Lejeune suggested that detectives 'move, untouched, incorruptible, undefeated, among the mysteries of life and death, teaching us in a parable that there is a reason for everything, that puzzles were made to be solved, that what seems like chaos may be only the observed effects of unknown causes; in short, that the world, instead of being as meaningless as a modern novel, may be like a good detective story, in which the truth and a happy ending are kept for the final chapter.' As it happens, he was writing about Poirot and Miss Marple, but he might easily have been discussing Victorian detectives such as Sergeant Cuff and Sherlock Holmes, or indeed later equivalents such as Ruth Rendell's Inspector Wexford, Ian Rankin's Inspector Rebus or even Val McDermid's Dr Tony Hill. The details, the characters and the setting could hardly be more different, and modern writers are often quick to distance themselves from their predecessors. In essence, though, the detective novel has changed remarkably little.[14]

When Christie was growing up in Torquay at the turn of the twentieth century, her favourite writer had been Charles Dickens. Her mother, she recalled decades later, used to read Dickens aloud to her, instilling a 'passion' that she never lost. In 1962 the American studio MGM, which had already started butchering her Miss Marple stories, paid her a handsome £10,000 (perhaps £400,000 in today's money) to write a screenplay of *Bleak House*. She enjoyed the work but hated the interference; although the screenplay was finished, it never saw the light of day. It is naturally tempting to wonder what Christie's version would have

looked like. At the very least it seems probable that she would have played up the detective elements, emphasizing the mystery surrounding Lady Dedlock and turning Inspector Bucket into a more prominent character. We will probably never know. But even though Christie's novels contain plenty of elements borrowed from Victorian sensation fiction – lost wills, secret marriages, hidden identities, stolen jewels and mad relatives – her deliberately flat, muted style made her a very unlikely adaptor of such a flamboyant predecessor. Indeed, by banishing her *Bleak House* treatment to the equivalent of a locked desk drawer, MGM may well have been doing her something of a favour.[15]

Dickens's place in the literary pantheon is such that probably all writers, no matter how inept, like to regard him as a kindred spirit. But it is easy to see why Christie felt a special affinity with an author who, like her, had known trauma and humiliation in his youth, wrote prolifically for a largely middle-class readership and was fascinated – even obsessed – with crime. Dickens's books are full of murderers, pickpockets, fraudsters and convicts; almost every novel contains a crime of some kind. As a young man, he briefly flirted with a career as a metropolitan magistrate; as a journalist, he accompanied the police on raids in the East End and night patrols in Liverpool, as well as undertaking his famous night walks through some of the capital's most notorious crime zones. He had enormous, even exaggerated respect for the police: one colleague wrote that he had 'a curious and almost morbid partiality for communing with and entertaining police officers'. A particular favourite was the Metropolitan Police's Charles Frederick Field, about whom Dickens wrote the essay 'On Duty with Inspector Field' (1851). It was Field who almost certainly inspired the character of Inspector Bucket in *Bleak House*, the first police detective in British fiction. Unlike Christie's hapless Inspector Japp (who is basically a modernized version of Sherlock Holmes's collaborator Lestrade), Inspector Bucket is a supremely canny operator. 'Time and place cannot bind Mr. Bucket,' says Dickens. 'Like man in the abstract, he is here to-day and gone to-morrow – but, very unlike man indeed, he is here again the next day.' But it would be going much too far to call *Bleak House* a detective novel: Inspector Bucket is really only an incidental character, and Dickens's friend Wilkie Collins has a much better claim to be the intellectual godfather of the whodunnit. It is of course possible that Dickens intended his last book, *The Mystery of Edwin Drood*, to be a

Moonstone-style murder mystery; but since he died in 1870 before fin-
ishing it, we will never know.[16]

What is true, though, is that Dickens was obsessed by murder. John
Carey, who describes Dickens as having 'violent and murderous
instincts', has shown how his prose comes alive, fizzing with energy and
excitement, when he writes about a child murder in 'The Clock-Case'
(1840), or Bill Sikes's murder of Nancy in *Oliver Twist* (1838), or Jonas
Chuzzlewit's murder of Montague Tigg in *Martin Chuzzlewit* (1844).
And when Dickens was not pouring out torrents of bloodthirsty prose,
he found himself drawn to public executions. In Rome he saw a young
man guillotined, meticulously recording everything from the flies that
gathered around the head to the expression of the eyes after the blade
had fallen. In London he saw a husband and wife, who had killed their
friend for his money, hanged outside the Horsemonger Lane Gaol, not-
ing the curious differences between their dangling bodies. In Switzerland
he saw a man beheaded; in New York he even asked to be shown
the yard where prisoners were hanged. Dead bodies, too, fired his imagi-
nation; his novels are full of corpses, coffins, undertakers and
waxworks.

But instead of emphasizing the parallels between Dickens and Chris-
tie, all of this actually points to a revealing difference. Although Christie
wrote about murder, the moment of death is surprisingly rarely
shown. As a nurse in the First World War, she knew all about blood-
ied and broken bodies, but the appeal of her books to middle-class
readers partly derives from the fact that violence never intrudes too dis-
tressingly. Her victims die in their sleep from poison, or are shot through
the forehead, leaving a small, perfectly shaped bullet-hole, or are struck
down long before the narrator arrives on the scene. The corpse never
lingers, to fester and rot, but is rapidly whisked off stage and never men-
tioned again. Where Dickens saw death, Christie saw disorder; while he
was fascinated by murder, she was more interested in motive.[17]

What Dickens and Christie had in common, though, was their
deep-seated moral conservatism. In *4.50 from Paddington* (1957),
which was written during a short moratorium for the death penalty,
Miss Marple vigorously laments the fact that the killer will escape the
rope. He was, she says, 'bold and audacious and cruel and greedy, and I
am really very, very sorry ... that they have abolished capital punish-
ment because I do feel that if there is anyone who ought to hang, it is

Dr Quimper'. As Robert Barnard points out, Miss Marple is expressing here the views of her creator, who wrote in her autobiography that people who killed were 'evil', representing 'nothing except hate'; and that even if they might deserve pity, 'you cannot spare them any more than you could spare the man who staggers out from a plague-stricken village in the Middle Ages to mix with innocent and healthy children in a nearby village'.[18]

To many readers Christie's views on law and order probably sound as old-fashioned as her earlier treatment of Russian revolutionaries and Jewish financiers. But Dickens would almost certainly have approved. For all his fascination with crime, he greatly deprecated the 'morbid sympathy for criminals', loathed what he called the 'ruffian class', and kept large dogs chained beside his gates to intimidate vagrants. As Carey observes, he thought bigamists and sex-offenders should be flogged, and after flirting with opposition to capital punishment, ended up as a keen supporter. And, like Christie, Dickens believed in evil. In the first preface to *Oliver Twist*, written in 1841, he tried to fend off criticisms that Bill Sikes was a caricature by insisting that there were 'in the world some insensible and callous natures that do become, at last, utterly and irredeemably bad'. But when Dickens revised the preface twenty-six years later, he subtly changed the wording. Now he wrote of 'some insensible and callous natures that do become utterly and *incurably* bad'. The shift from 'irredeemably' to 'incurably' is a small but telling one. In a quarter of a century, Dickens had moved from seeing Sikes as a moral outrage to seeing him as a kind of disease: the equivalent, perhaps, of smallpox or cholera – or, indeed, of the plague that Christie describes in her autobiography.[19]

But while Dickens and Christie both believed in evil, there was a telling distinction in the way they handled it. Dickens draws a clear line between good and evil: even in a book as rich and sophisticated as *Bleak House*, there is a world of difference between, say, Mr Tulkinghorn and Mr Vholes on the one hand, and John Jarndyce and Allan Woodcourt on the other. To put it bluntly, Dickens's villains are almost always recognizably, even *physically*, villainous, from the scowling bruiser Bill Sikes to the malevolent dwarf Daniel Quilp, who appears in *The Old Curiosity Shop* (1841). But Christie's killers are not freaks, lunatics or grotesques. In her fictional universe, what makes evil so frightening is not that it seems so ugly, but that it appears so *normal*.

'I've no patience with this saying that all people who commit crimes are mad,' says the sensible Miss Hinchliffe in *A Murder Is Announced*. 'Horribly and intelligently sane – that's what I think a criminal is!' But Christie goes even further. When Miss Marple digs into her store of village anecdotes, it is to illustrate the point that, as any historian of the twentieth century knows, we are *all* capable of killing. We are all prey to the passions that drive her murderers: financial avarice, sexual jealousy, the desire for respectability, the fear of exposure. And this, of course, is the point of the detective novel: in order to keep us guessing, nobody, not even the narrator, the policeman or even the detective, can be entirely above suspicion. A murder takes place inside a family – and *any* of them might have done it.[20]

It is this intensely pessimistic view of humanity – far more pessimistic than anything you find in Dickens – that distinguishes some of Christie's most memorable books. Take her 'special favourite', *Crooked House* (1949), which breaks one of modern society's great taboos. The victim is the rich paterfamilias Aristide Leonides, and the suspects include virtually his entire family. There is a hint of the solution early on, when the narrator, Charles Hayward, asks his father, the assistant commissioner at Scotland Yard, what murderers are like. 'Some of them', his father says, 'have been thoroughly nice chaps.' He goes on:

> One feels, very often, as though these nice ordinary chaps had been overtaken, as it were, by murder, almost accidentally. They've been in a tight place, or they've wanted something very badly, money or a woman – and they've killed to get it. The brake that operates with most of us doesn't operate with them. A child, you know, translates desire into action without compunction. A child is angry with its kitten, says 'I'll kill you,' and hits it on the head with a hammer – and then breaks its heart because the kitten doesn't come alive again! Lots of kids try to take a baby out of a pram and 'drown it', because it usurps attention – or interferes with their pleasures. They get – very early – to a stage when they know that that is 'wrong' – that is, that it will be punished. Later, they get to *feel* that it is wrong. But some people, I suspect, remain morally immature. They continue to be aware that murder is wrong, but they do not feel it ... And that, perhaps, is the mark of Cain.

This is not only a compelling statement of Christie's personal philosophy, it is a clue to the identity of the killer. But it is not until almost a

hundred pages later that Charles opens the journal belonging to Leonides' 12-year-old granddaughter, the precocious Josephine, and reads in horror the shattering words: '*Today I killed grandfather.*' Aristide Leonides, it turns out, refused to pay for her ballet lessons; so she killed him. Her childish spelling ('bally dancing') somehow makes her confession even more disturbing.[21]

Even today, few detective novelists would dare to use a child as a killer, even though cases such as the death of James Bulger have made us painfully aware that some children, at least, are perfectly capable of murder. Like the Victorians, most of us prefer to see childhood as a golden age of purity and innocence. An interesting exception was another crime writer, the Conservative peer P. D. James, who once told an interviewer that she believed in original sin: 'I don't think we come into the world as unselfish, kind and loving. I think we come in as selfish little animals.' If anything, Christie's view of human nature was even grimmer. From cradle to grave, she believed, human beings were capable of great wickedness. 'There are such strange things buried down in the unconscious. A lust for power – a lust for cruelty – a savage desire to tear and rend,' says the French psychologist Dr Gerard in *Appointment with Death* (1938). 'We shut the door on them and deny them conscious life, but sometimes they are too strong.' Christie knew, of course, that in some quarters the idea of evil had become deeply unfashionable. Even during her heyday, plenty of people disputed that such a thing existed at all. But Christie was convinced that she knew better. Miss Marple, her most reliable mouthpiece, is always being teased for her bleak view of humanity. 'My nephew Raymond tells me (in fun, of course, and quite affectionately) that I have a mind like a sink,' she admits in *The Body in the Library*. 'He says that most Victorians have. All I can say is that the Victorians knew a good deal about human nature.'[22]

EVIL UNDER THE SUN

There isn't anyone to help you. Only me. And I'm the Beast . . .
You knew, didn't you? I'm part of you? Close, close, close! I'm
the reason why it's no go? Why things are what they are?
William Golding, *Lord of the Flies* (1954)

William Golding, perhaps the supreme anatomist of man's capacity for evil, at home in Wiltshire, 1964.

We rarely think of Agatha Christie as a war writer. Yet like so many of the authors who dominated the British imagination in the twentieth century, Christie spent her adult life in the shadow of the world wars. The first broke out when she was only 23. Her fiancé, Archie, was already in the Royal Flying Corps; they were married on Christmas Eve 1914 while he was on leave, but saw little of each other over the next four years. In Christie's novel *Unfinished Portrait*, published under the name Mary Westmacott in 1934, the heroine, Celia, gazes thoughtfully at her husband: 'Dermot in khaki – a different Dermot ... very jerky and flippant, with haunted eyes. No one knows about this new war – it's the kind of war where *no one might come back.*'

In the meantime, Christie threw herself into her nursing duties. In an interview for the Imperial War Museum, she remembered clearing up the 'things lying around' after amputations, 'the legs or the arms', which had to be thrown into the hospital furnace. She made it sound perfectly normal ('there are so many odd things that you have to do in hospital'), but how could it *not* have been a shock to a sheltered young woman in her mid-twenties? Then came two decades of uneasy peace; and then it all happened again. Her second husband, the archaeologist Max Mallowan, went out to North Africa with the RAF. Their Devon house, Greenway, was taken over by the Admiralty, and Christie herself moved to London, where she lived through the Blitz. One night her windows were blown in during an air raid. By the time it was all over, she was almost 55. She had seen two world wars now; like so many people of her generation, she had got used to the newspaper reports of carnage and slaughter, the letters of condolence to friends and relatives, the endless lists of the dead.[23]

War hangs heavy over Christie's novels. In *Taken at the Flood*, published in 1948, the heroine, Lynn, has been serving abroad with the Wrens, but is shocked by the atmosphere when she returns to England. 'There were waves in the air of feeling – a strong electrical current of – what was it? Hate? Could it really be *hate*? Something at any rate – destructive.' This, she thinks, is 'the aftermath war has left. Ill will. Ill feeling. It's everywhere.' It is a mood – traumatized, bitter, resentful, suspicious – that seeps into almost every page of the book. One way or another, almost all the characters have been wrenched out of their ordinary lives by the war. Adversity has stretched them to the limit. 'What a person really *is*, is only apparent when the test comes – that is

the moment when you stand or fall on your own feet,' says Hercule Poirot – himself a victim of war, having fled to England after the German invasion of Belgium in 1914. Perhaps it is no wonder that Poirot, like his creator, has such a bleak view of human nature. When one character describes another as 'quite harmless', he says gently: 'Is anybody – ever – quite harmless?' And when he reveals the solution to the mystery at the end of the novel, he takes up one of Christie's favourite themes. 'What causes crime?' he asks rhetorically. 'What inbred predisposition does there have to be? Is every one capable of crime – of some crime?' There is no telling, he says, 'what a human character is, until the test comes. To most of us the test comes quite early in life. A man is confronted quite soon with the necessity to stand on his own feet, to face dangers and difficulties and to take his own line of dealing with them.' It is tempting to wonder how many people, reading those words in 1948, thought immediately of their own experiences during almost six long years of war.[24]

In her fascination with the legacy of war, Christie was far from unusual. 'It's all so safe and civilized and cosy,' says Joe Lampton's mistress, Alice, in John Braine's novel *Room at the Top* (1957). 'All these men, so well-mannered and mild and agreeable – but what's behind it all? Violence and death. They've seen things which you think would drive anyone mad. And yet there's no trace. There's blood on everyone's hands, that's what it amounts to.' Even Joe himself, remembered today as such a modern, hedonistic figure, a thrusting portent of the values of the 1960s, is troubled by memories of the war. A former RAF airman whose parents were killed in a German air raid, he can never quite get the conflict out of his head. Having lunch with his future father-in-law, he has a sudden flashback to a 'trip over Cologne', when 'the bomb-aimer got a faceful of flak. I say a faceful because that takes the curse off it somehow; it was actually a bit of metal about two inches square that scooped out his eyes and most of his nose.' To twenty-first-century readers, used to seeing VE Day as a full stop and the next decade as a new start, the passage strikes a jarring, uncomfortable note. But to readers in 1957 it would probably have felt all too authentic.[25]

For although Britain emerged from the two world wars with fewer scars than any other major European combatant, the experience nevertheless left an indelible mark, not just in Westminster and Whitehall, or even in cemeteries and on battlegrounds, but on the national

imagination itself. Take, for example, Benjamin Britten's opera *Peter Grimes*, set in a fishing village haunted by violence and suspicion, which has a good claim to be one of the great British masterpieces of the twentieth century. Although *Grimes* is based on a nineteenth-century poem by the Suffolk-born George Crabbe, Britten wrote most of it in London between 1942 and 1945, when the capital still lived in the shadow of the Luftwaffe. The titular central character, a strange, tortured fisherman feared and hated by his neighbours, obviously reflects Britten's own sense of isolation, not only as a homosexual man in a society where such behaviour was still illegal, but as a pacifist who had registered as a conscientious objector in order to avoid conscription. For Britten, the war represented an unusually personal ordeal: while other men felt united in a common cause, he had been driven even further to the margins. This is the experience of Peter Grimes, his tragic protagonist. Grimes, said Britten's companion and collaborator Peter Pears, for whom the role was written, is 'an ordinary weak person who, being at odds with the society in which he finds himself, tries to overcome it and, in doing so, offends against the conventional code, is classed by society as a criminal, and destroyed as such'. This is an eternal theme, but one to which the horrors of war had lent extraordinary urgency.[26]

Peter Grimes could scarcely be a darker reflection of the nightmare of the 1940s. At a time when the newspapers were full of human cruelty – executions, concentration camps, pogroms and persecutions – Grimes's village, like Christie's Britain in *Taken at the Flood*, seems poisoned by suspicion. For Britten's biographer Paul Kildea, the opera's libretto, written by the composer's friend Montagu Slater, a committed Communist, is a 'metaphor for the savagery of war', animated by 'the viciousness of the villagers, with their gang mentality, high-street morality and lynching tendency'. It was fitting, therefore, that just weeks after the opera's premiere at Sadler's Wells in June 1945, Britten accompanied Yehudi Menuhin to play for the men and women, ravaged, skeletal and malnourished, who had survived the Nazi camp at Bergen-Belsen. Afterwards, Britten never liked to talk publicly about what he had seen, saying only that it had been a 'terrifying experience'. Peter Pears, however, thought that Belsen 'coloured everything' that he wrote. And although *Grimes* was finished weeks before Britten travelled to Germany, his experience threw into sharp relief the themes that had preoccupied him for the previous four years. *Peter Grimes*, declared

Edmund Wilson, who was visiting London at the time of the first production, 'could have been written in no other age, and it is one of the very few works of art that have seemed to me, so far, to have spoken for the blind anguish, the hateful rancors and the will to destruction of these horrible years'. By the end of the opera, Wilson wrote, 'you have decided that Peter Grimes is the whole of bombing, machine-gunning, mining, torpedoing, ambushing humanity, which talks about a guaranteed standard of living yet does nothing but wreck its own works, degrade or pervert its own moral life and reduce itself to starvation'.[27]

Peter Grimes was the product of a musical genius at the height of his powers. But it is also a very good example of the bleakness, the pessimism, even the paranoia shared by so many artists and writers in the years after the Second World War. The horrors of Belsen, for example, had also made a profound impression on a war artist called Mervyn Peake, who spent two weeks touring the ruins of Germany in June 1945. Like Britten, Peake was traumatized by what he saw: thousands of inmates, starved and spectral, many dying of typhus before his eyes. Later, he produced a haunting sketch of a stricken girl, 'her limbs like pipes, her head a china skull', which accompanied his poem 'The Consumptive, Belsen 1945'. Afterwards, his wife said, 'he was quieter, more inward-looking, as if he had lost ... his confidence in life itself'. Elsewhere, Peake was stunned by the 'unutterable devastation' of Germany's great cities, beside which the bombing of London seemed 'absolutely nothing'. Cologne, for example, appeared 'like a shattered life – a memory torn out'. He was struck, he told his wife, by the contrast between the city's cathedral, 'a tall poem of stone with [the] sudden, inspired flair of the lyric and yet with the staying power, mammoth qualities and abundance of the epic', and the surrounding city, 'broken to pieces'. Everywhere he sensed 'the sweet, pungent, musty smell of death'. Reading these words, it is hard not to think of Gormenghast, the crumbling, sepulchral castle which first appears in his book *Titus Groan* (1946), with its great Tower of Flints, the stone stained by black ivy, rising 'like a mutilated finger from among the fists of knuckled masonry'. To many modern readers, Gormenghast feels like something from a nightmare. But, as Peake knew, nightmares were all too real.[28]

The most powerful vision of human evil in the decade after the Second World War, however, was surely William Golding's *Lord of the Flies*, which was published in the autumn of 1954. Like Peake, Golding was

part of the generation whose lives were torn apart by the trauma of the war; indeed, the two men were almost exact contemporaries, having been born two months apart in the second half of 1911. Golding, who had studied at Oxford before becoming a schoolteacher, joined the Royal Navy at the end of 1940 and was almost immediately plunged into the dramatic hunt for the German battleship *Bismarck*. But he never saw the war as a great adventure; his predominant feelings, according to John Carey's biography, were 'misery, humiliation and fear'. On D-Day he commanded his own rocket ship, and he somehow emerged unscathed from the slaughter at Walcheren in October 1944, when twenty out of twenty-seven ships were sunk or badly damaged during the Allied landings on the Dutch coast. For the rest of his life Golding was haunted by what he called 'memories that dim the sunlight': a man clinging to the side of a sinking ship, crying 'my legs have gone'; 'ships mined, ships blowing up into a Christmas tree of exploding ammunition, ships burning, sinking – and smoke everywhere slashed by sudden spats of tracer over the shell fountains and the broken, drowning men'. It may be that, like so many men who lived while others died, he felt guilty. Certainly the war sharpened his inclination towards morbid self-criticism. It was the war, he said later, that showed him his own 'viciousness' and 'cruelty'. He 'understood the Nazis', he explained, 'because I am of that sort by nature'. It was 'partly out of that sad self-knowledge' that he wrote *Lord of the Flies*.[29]

The story behind *Lord of the Flies* is one with which all aspiring writers ought to be familiar. Golding, who had returned to teaching after the war, had already written three novels, all of which had been summarily rejected. He had the idea for *Lord of the Flies* after reading *Treasure Island* and *The Coral Island* to his children. It would be good, he told his wife one evening, to write a book about 'children on an island, children who behave in the way children really would behave'. He duly sent his manuscript, entitled 'Strangers from Within', to Faber and Faber, but their professional reader hated it. 'Absurd & uninteresting fantasy,' she scribbled in green biro. 'Rubbish & dull. Pointless.' However, the firm's brilliant young editor Charles Monteith fished the manuscript out of the reject pile, saw its potential and persuaded his colleagues to offer Golding a deal, providing that he made substantial changes. It was just as well that he did, because *Lord of the Flies* is one of the outstanding books in all post-war British literature. In part, its fame is based on the

fact that it is very popular in schools, not only because it is short, but because it has an immediate appeal to teenage readers. But few books better capture the dark side of the century that saw two of the bloodiest conflicts in human history, as well as the Holocaust and the nuclear arms race.[30]

Like Agatha Christie in *Crooked House*, which had been published five years earlier, Golding tore apart the fiction of childhood innocence. I first read *Lord of the Flies* as a child, having vaguely assumed that it must be a bit like *The Lord of the Rings*, and was terrified by it. Golding's book may be about children, but its themes could hardly be more grown-up. His characters, stranded on their desert island, are hunters and killers, driven by their fear of the Beast and their lust for blood. In a lecture in Los Angeles in 1961, he explained his rationale:

> Before the Second World War I believed in the perfectibility of social man ... but after the war I did not because I was unable to. I had discovered what one man could do to another. I am not talking of one man killing another with a gun, or dropping a bomb on him or blowing him up or torpedoing him. I am thinking of the vileness beyond all words that went on, year after year, in the totalitarian states. It is bad enough to say that so many Jews were exterminated in this way and that, so many people liquidated – lovely, elegant word – but there were things done during that period from which I still have to avert my mind lest I should be physically sick. They were not done by the headhunters of New Guinea or by some primitive tribe in the Amazon. They were done, skilfully, coldly, by educated men, doctors, lawyers, by men with a tradition of civilization behind them, to beings of their own kind ... I must say that anyone who moved through those years without understanding that man produces evil as a bee produces honey, must have been blind or wrong in the head.

Strong stuff, but who, contemplating the atrocities of the 1930s and 1940s, could possibly disagree? 'Man', Golding said firmly, 'is a fallen being. He is gripped by original sin.' He said this as a 'son, brother, and father' who had 'lived for many years with small boys', and knew them with 'awful precision'.[31]

What he did not add, perhaps because he did not need to spell it out, was that the boys in *Lord of the Flies* were portraits of himself. In private he often remarked that if he had been born in Germany he would

have been a Nazi. Like many men who have seen combat, Golding knew his own capacity for evil, and it is this theme, one way or another, that animates all his books, from *The Inheritors* and *The Spire* to *Darkness Visible* and *Rites of Passage*. As Frank Kermode told listeners to the BBC Third Programme in 1956, Golding's greatness as a novelist lay not just in his mastery of the written word, but in his recognition that 'human consciousness is a biological asset purchased at terrible price – the knowledge of evil'.[32]

The idea of man as a fallen creature, a bloodthirsty savage beneath a veneer of civilization, was a very popular one in the culture of the 1950s and 1960s. Just think of the narrator, Alex, in Anthony Burgess's novel *A Clockwork Orange* (1962), a gleeful, unrepentant teenage delinquent, glorying in rape, ultra-violence and Beethoven.* This was, of course, an old idea, rooted in the Catholic doctrine of original sin and given fresh impetus in the nineteenth century by the rise of Darwinism. Even Dr Arnold, seeing boys gathered around the school-house fire, used to mutter that he saw 'the Devil in the midst of them', while there are few more powerful visions of the beast within than Robert Louis Stevenson's story *The Strange Case of Dr Jekyll and Mr Hyde* (1886), in which the 'well-made, smooth-faced' Jekyll struggles to suppress his inner monster, the deformed, homicidal Hyde. All the same, there is no doubt that the world wars had dealt a death blow to the Victorians' counterbalancing faith in progress and perfectibility. Plenty of people wondered how the appalling atrocities of the death camps could possibly have happened, while thousands more struggled to come to terms with the looming menace of nuclear annihilation in yet another world war. And when they read about, say, the trial of Adolf Eichmann or the bloodshed in Vietnam, the news only reinforced their pessimism about human nature. As one correspondent wrote to the *New Statesman* in 1966, after the revelation of the Moors murders, such events forced the typical citizen 'to know the things of which his fellow men are capable and thus to understand how precarious are man's defences against his own savagery'.[33]

* The novel, unlike Stanley Kubrick's controversial film, has a nominally happy ending, since Alex eventually grows up, tires of his life of crime and contemplates starting a family. But as Alex admits, his son will probably succumb to the lust for violence too, as will his son after him, 'and so it would itty on to like the end of the world, round and round and round'.

Perhaps this helps to explain one of the unlikelier publishing success stories of the period, the vogue for popular anthropology, from Konrad Lorenz's book *On Aggression* (1966), which argued that human beings were condemned by nature to fight for territory, to Desmond Morris's unexpected bestseller *The Naked Ape* (1967), which devoted one of its eight chapters to 'Fighting'. These idea proved particularly popular in the theatre: reflecting shortly after the end of the decade on the playwrights of the 1960s, the critic John Russell Taylor wryly remarked that 'again and again' they had been drawn to 'such subjects as child murder, sex murder, rape, homosexuality, transvestism, religious mania, power mania, sadism [and] masochism'. Indeed, there are few better examples of the lingering influence of the Second World War than the work of Harold Pinter, who as a Jewish boy growing up in the 1930s and 1940s was naturally fascinated by the theme of violence suddenly bursting into the domestic interior. In his play *The Caretaker* (1960), the theme of fighting for territory could hardly be more explicit. 'You're violent, you're erratic, you're just completely unpredictable,' says Mick to the tramp, Davies, during their climactic confrontation. 'You're nothing else but a wild animal, when you come down to it. You're a barbarian.'[34]

If there is one post-war vision of man's fallen state with which twenty-first-century readers are most familiar, though, it is surely J. R. R. Tolkien's Gollum. Whatever you may think of Tolkien, Gollum is a superb invention, at once utterly repellent and strangely sympathetic. His backstory, as explained by the wizard Gandalf in the opening pages of *The Lord of the Rings*, is a blend of the fall of Adam, doomed by his thirst for knowledge, and the story of Cain, condemned to wander the earth after murdering his brother. Gollum, says Gandalf, once belonged to a 'clever-handed and quiet-footed little people', not unlike hobbits, who lived along the banks of Middle-earth's Great River. Then called Sméagol, he was the 'most inquisitive and curious-minded' member of his family, forever burrowing and tunnelling. One day, out fishing with his best friend, Sméagol took a fancy to a gold ring that his friend found in the river bed and strangled him, 'because the gold looked so bright and beautiful'. The ring made him invisible: he used it to spy on people, and 'put his knowledge to crooked and malicious uses'. He became a thief and an outcast, skulking in the shadows; obsessed with his prize, he shrank from the sunlight and 'wormed his way like a maggot into the

heart of the hills'. Soon he was no longer Sméagol, but Gollum: a vicious, bestial, crawling thing, the embodiment of greed, cruelty and addiction.

As numerous writers have pointed out, Gollum was almost certainly inspired by the monster Grendel in *Beowulf*, the Anglo-Saxon epic poem to which Tolkien devoted his scholarly career. Grendel is not only a deformed, semi-human monster, he is explicitly described as the descendant of Cain. But Gollum is also Tolkien's equivalent of Mr Hyde. When Frodo, the hero of *The Lord of the Rings*, hears Gandalf's story, he is horrified by the 'abominable notion' that such a monster could once have been a hobbit. Gandalf, however, demurs: it is, he says, 'a sad story . . . and it might have happened to others, even to some hobbits that I have known'. The point is not that Gollum was extraordinary; it is that, in yielding to temptation, he was all too ordinary. Later, on their quest to destroy the Ring, Frodo and his friend Sam fall in with Gollum, who accompanies them on their journey. But Tolkien is too good a writer to present him merely as the embodiment of evil. Frodo takes to calling him Sméagol, and there are hints that deep down, for all his degradation, his old self has not entirely been destroyed. Late in the book, there is a brief but oddly moving moment – characteristically omitted from the films – in which Gollum sees the two hobbits sleeping, huddled together for comfort. His eyes lose their hungry gleam; suddenly they look 'dim and grey, old and tired'. He turns away, and then comes back, 'and slowly putting out a trembling hand, very cautiously he touched Frodo's knee – but almost the touch was a caress'. Just for a second, he is Sméagol again: an 'old weary hobbit, shrunken by the years that had carried him far beyond his time, beyond friends and kin, and the fields and streams of youth, an old starved pitiable thing'. But then, almost immediately, the spell is broken. Sam wakes, sees him pawing at Frodo and jumps to the wrong conclusion. Sméagol disappears, and Gollum returns.[35]

But while there are hints that, were it not for his addiction, Gollum might be more like Frodo, Tolkien also shows how, under the influence of the Ring, Frodo is becoming more and more like Gollum. Being a decent, humble sort, Frodo has a better chance than anybody else of holding out against the power of evil. But contrary to what Tolkien's foes like to claim, *The Lord of the Rings* shows very clearly that not even the most righteous are safe from the demons that lurk within us

all. Increasingly irritable and erratic, Frodo becomes fixated on the Ring, even calling it his 'precious', as Gollum does. And in the novel's climactic scene, when Frodo reaches Mount Doom and prepares to destroy the Dark Lord's magic weapon, his resistance crumbles completely. Speaking in a voice 'clearer and more powerful' than he has ever used before, he claims the Ring as his own. This is, by any standards, a remarkable scene: after an epic journey, lasting almost a thousand pages, the hero finally cracks. As Tolkien himself put it in a letter to a fan, Frodo 'did not endure to the end; he gave in, ratted'. Only through the intervention of providence – Gollum reappearing, biting off Frodo's finger with the Ring and then falling to his death inside the mountain – does the quest reach the desired conclusion. When you think about it, this is a pretty downbeat ending, especially if you do not share Tolkien's faith in divine grace. But it is true not just to Tolkien's personal theology, but to his own experience in the crucible of the Somme. Like so many veterans of the world wars, he knew the reality of human wickedness and human weakness.[36]

THE WAR OF THE MACHINES

A small knowledge of human history depresses one with the sense of the everlasting mass and weight of human iniquity: old, old, dreary, endless repetitive unchanging incurable wickedness. All towns, all villages, all habitations of men – sinks!

J. R. R. Tolkien, writing to his son
Christopher, 14 May 1944

Taking Tolkien seriously is inevitably complicated by the fact that he has long been associated in the public mind with a sweaty, furtive gang of misfits and weirdoes – by which I mean those critics who for more than half a century have been sneering at his books and their readers. Self-consciously highbrow types often have surprisingly intolerant views about what other people ought to be writing, and when the first volume of *The Lord of the Rings* was published in the summer of 1954, a few weeks before *Lord of the Flies*, many were appalled by its nostalgic medievalism. A prime example was the American modernist Edmund Wilson, who in a hilariously wrong-headed review for *The Nation*

J. R. R. Tolkien, photographed as an Oxford don in the early 1940s, when he was hard at work on *The Lord of the Rings*.

dismissed Tolkien's book as 'juvenile trash', marked by – of all things! – an 'impotence of imagination'. In the *New Statesman*, meanwhile, Maurice Richardson, himself a writer of surreal fantasy stories, conceded that *The Lord of the Rings* might appeal to 'very leisured boys', but claimed that it made him want to march through the streets carrying the sign: 'Adults of all ages! Unite against the infantilist invasion.' Even decades later, long after Tolkien's book had become an international cultural phenomenon, the academic medievalist Peter Godman was still assuring readers of the *London Review of Books* that it was merely an 'entertaining diversion for pre-teenage children'. Michael Moorcock, likening it to the works of A. A. Milne, dismissed *The Lord of the Rings* as 'a pernicious confirmation of the values of a morally bankrupt middle class', while Philip Pullman, always keen to sneer at those authors from whom he had borrowed so liberally, called it 'trivial', and 'not worth arguing with'. Yet none of this, of course, has ever made the slightest dent in Tolkien's popularity.[37]

Whether you like Tolkien's books or not, they are among the great cultural phenomena of the age. Far from being merely a book for pre-teenage children, *The Lord of the Rings* has been read and reread by generations of adults, inspiring more enthusiasm than probably any other contemporary title. Literary intellectuals love to sneer at polls and surveys, but historians cannot afford to do so: all the evidence shows that if one book, more than any other, captured the Western imagination after the mid-1950s, that book was *The Lord of the Rings*. In his trenchant defence of Tolkien, the literary scholar Tom Shippey suggests that much of the criticism is rooted in pure social and intellectual condescension, not unlike the snobbery that upper-class grotesques like Virginia Woolf directed at his fellow Midlander Arnold Bennett in the early part of the century.* The difference, though, is that while Bennett's reputation, tragically and very unfairly, has never quite recovered, Tolkien's star remains undimmed. Not even Peter Jackson's shameful *Hobbit* adaptations have damaged his popularity. Shippey suggests that, in the future, literary historians will rank *The Lord of the Rings* alongside

* For instance, he points out that the derogatory term 'anoraks' – aimed not just at Tolkien's admirers, of course, but at fans of fantasy and science fiction more generally – has a very obvious class connotation. Anoraks were originally associated with train spotters, who tended to come from urban working-class and lower-middle-class backgrounds.

other twentieth-century classics such as Orwell's *Nineteen Eighty-Four*, *Lord of the Flies* and Kurt Vonnegut's *Slaughterhouse-Five*. But there is an obvious difference. *The Lord of the Rings* is much more popular.[38]

One of the things about *The Lord of the Rings* that most annoys its critics is that it is so unrepentantly backward-looking. But it probably could never have been otherwise. For good private reasons, Tolkien was a fundamentally backward-looking person. He was born to English parents in Bloemfontein, then the capital of the Orange Free State, in 1892, which made him sixteen months younger than Agatha Christie. When little Ronald (as he was known) was 3, his mother, Mabel, brought him back from South Africa to her native Birmingham. The plan was for his father, Arthur, to join them later. But Arthur was killed by rheumatic fever before he even boarded ship, so Mabel raised her two boys alone in the village of Sarehole, then in north Worcestershire, on the fringes of the great Midlands metropolis. Tolkien had a very happy middle-class childhood, devouring the great Victorian children's classics and excitedly exploring the countryside near his home, including Sarehole's old mill, the bog at nearby Moseley and Worcestershire's Clent, Lickey and Malvern Hills. But in November 1904 his mother succumbed to diabetes, which was then often fatal. At the age of 12, Tolkien was an orphan. His mother had entrusted her boys to her Catholic priest, who arranged for them to move in with their aunt in Stirling Road, Edgbaston. But their new home, close to Birmingham's present-day Five Ways roundabout, felt very different from the sleepy tranquillity they had known in Sarehole. They had moved from the city's leafy fringes to its grey industrial heart: when Tolkien looked out of the window, he saw not trees and hills, but 'almost unbroken rooftops with the factory chimneys beyond'. It was little wonder that, from the first moment he put pen to paper, his fiction was dominated by a heartfelt nostalgia.[39]

An amateur psychologist could have a field day with the fact that both J. R. R. Tolkien and Agatha Christie lost parents in their childhood and nursed a sense of loss for the rest of their careers. (Perhaps even more remarkable is the fact that the only writers of their generation to rival them in terms of sales – Enid Blyton, who was born in 1897; Barbara Cartland, who was born in 1901; and of course Catherine Cookson, born in 1906 – all had similar memories of loss and upheaval. Cookson hated her mother and never knew her father, Blyton's father walked out

when she was 13, and Cartland's father was killed in Flanders when she was a teenager.) On the surface, it would be hard to imagine two writers more different than Tolkien, lost in a medieval landscape of trolls, orcs and dragons, and Christie, meticulously working out the details of the murder at the vicarage. What they had in common, though, was that although they continued writing into the early 1970s, they were most deeply influenced by the popular fiction of late Victorian Britain. Tolkien's particular favourites were the fantastic fairy stories of George MacDonald, notably *The Princess and the Goblin* (1872), and the folk and fairy stories collected by the Scottish poet Andrew Lang. Today fairy stories have a rather weedy, effeminate image: a century ago, however, this was not the case at all. As the Tolkien scholar John Garth notes, many of the soldiers who fought for Britain on the Western Front had been reared on the tales of MacDonald and Lang, as well as J. M. Barrie's *Peter Pan*. Tolkien's other great enthusiasm, meanwhile, was more stereotypically masculine: the rousing adventure stories of H. Rider Haggard.* The American critic Jared Lobdell has even argued that when considering Tolkien's influences, Haggard's should be 'the first name' on the list, and that when Tolkien began work on the *Lord of the Rings*, his real aim was to produce 'an adventure story in the Edwardian mode', not unlike Haggard's rip-roaring romances *King Solomon's Mines* (1885) and *She* (1887).[40]

The most obvious influence on Tolkien, though, was that Victorian one-man industry, William Morris. It is a pretty safe bet that when most people see Morris's name today, they think: 'Wallpaper.' But in the first years of the twentieth century, what earnest young men like Tolkien loved about Morris was his nostalgic idealism: his evocation of a lost medieval paradise, a world of chivalry and romance that threw the harsh realities of modern, materialistic industrial Britain into stark relief. Both Morris and his friend Edward Burne-Jones were arch-medievalists, besotted with the legends of King Arthur and, in Morris's case, the ancient myths of northern

* Indeed, if there is one author whose influence on modern popular culture is more underestimated than any other, it is surely Rider Haggard. *She* alone was translated into forty-four languages and sold an estimated 100 million copies. Not only is it one of the bestselling books of all time, it provided the template for countless stories of underground cities and vanished kingdoms, from Conan Doyle's book *The Lost World* (1912) and Steven Spielberg's *Indiana Jones* films to recent video-game franchises such as *Uncharted* and *Tomb Raider*.

Europe. In 1876 Morris had published *The Story of Sigurd the Volsung and the Fall of the Nibelungs*, adapted from the Old Norse sagas that won so much international popularity in the late Victorian period. Largely forgotten today, Morris's epic poem made an enormous impression on his contemporaries. Tolkien seems to have first read Morris at King Edward's, the outstanding Birmingham boys' school that had previously educated Burne-Jones. Addressing the King Edward's literary society, the young Tolkien even claimed that the story of Sigurd the dragon-slayer – the Norse equivalent of Wagner's Siegfried – represented 'the highest epic genius struggling out of savagery into complete and conscious humanity'.

And while other boys grew out of their obsession with the legends of the ancient North, Tolkien's fascination only deepened. After going up to Oxford in 1911, he began writing his own version of the Finnish national epic, the *Kalevala*, in a distinctly Morris-esque blend of prose and poetry. When his college, Exeter, awarded him a prize, he spent the money on a pile of Morris books, notably the epic poem *The Life and Death of Jason*, the proto-fantasy novel *The House of the Wolfings* and Morris's translation of the *Volsunga Saga*. Indeed, to the end of his life, Tolkien continued to write in a style heavily influenced by Morris, not just mixing prose and verse, but deliberately imitating the vocabulary and rhythms of the medieval epic. In this sense, it was as though his clock had stopped before the Great War.[41]

Other clocks, however, ticked on. On 7 June 1914 Tolkien and his fellow students enjoyed a lavish dinner to celebrate Exeter's 600th anniversary. Two years later, on 7 June 1916, he awoke in northern France, having just landed on a troop transport from Folkestone. Tolkien was 24 years old, an Oxford graduate with a young wife. He ought to have been establishing a name for himself in his chosen career: academic philology, the study of language. Instead, he was a signals officer in the 11th Lancashire Fusiliers, commanding miners and weavers from the industrial north-west. But this was not war as it had been portrayed in the adventure stories he had loved as a boy; this was carnage on an industrial scale. In early July his unit moved to the Somme, and there Tolkien remained until the end of October, when he was invalided home with trench fever. What he experienced there was a chaotic, muddy, bloody nightmare. Tolkien himself might easily have been killed: in the three and a half months he spent on the Somme, his battalion lost almost 600 men. Unpleasant as trench fever might have seemed, it was

probably the best thing that ever happened to him. For the war fell like a scythe on his generation. Among the dead were no fewer than 243 boys from King Edward's, as well as 141 young men from Exeter College. John Garth opens his book *Tolkien and the Great War* with a rugby match between the Old Edwardians and the school's first fifteen, played in December 1913. Tolkien himself captained the old boys' team. Within five years, four of his teammates had been killed and four more badly wounded. The sense of loss haunted him for the rest of his life. 'To be caught in youth by 1914 was no less hideous an experience than to be involved in 1939 and the following years,' he wrote in the foreword to the second edition of *The Lord of the Rings*. 'By 1918 all but one of my close friends were dead.'[42]

There is no doubt that the Great War was one of the genuinely defining moments in Tolkien's life, as it was for so many other young men. The extraordinary thing, though, is that it was at precisely this point, amid the horror and suffering of war, that he began work on his great cycle of Middle-earth stories. Years later, in a letter to his son Christopher, then serving with the RAF in another world war, Tolkien recalled that he had begun writing 'in grimy canteens, at lectures in cold fogs, in huts full of blasphemy and smut, or by candle light in bell-tents, even some down in dugouts under shell fire'. And despite the lazy assertions of the Philip Pullman tendency, Tolkien never saw his work as pure escapism: quite the opposite, in fact. He had begun writing, he explained, 'to express [my] *feeling* about good, evil, fair, foul in some way: to rationalize it, and prevent it just festering'. Given that this was the age of high modernism, it might seem odd that Tolkien should have chosen to express his feelings in the form of a pseudo-medieval fantasy. But unlike many writers of his generation, he remained true to the principles of Morris and Burne-Jones. For Ezra Pound and his fellow modernists, the only way to deal with the horrors of the modern world was to 'make it new'. For Tolkien, however, the reverse was true. More than ever, he believed that medievalism, myth and fantasy offered the only salvation from the corruption of industrial society. And far from shaking his faith, the slaughter on the Somme had only strengthened his belief that to make sense of this shattered, bleeding world, he must look backwards to the great legends of the North.[43]

Tolkien's first story, 'The Fall of Gondolin', which was not published until after his death, is very obviously stamped with his wartime

experience. To cut a long story short, it tells how Gondolin, the hidden stronghold of the Elves, is betrayed to Melko, the lord of evil, whose forces storm the city and massacre most of its inhabitants.* As John Garth notes, the grim tone undoubtedly owes a great deal to the fact that Tolkien wrote it in 1917 while recuperating in hospital, but there are other clear parallels with his experience on the Somme. Among Melko's siege engines are great iron dragons, impervious to arrows or fire, which bear a distinct resemblance to the tanks that first appeared on the Western Front in September 1916. Observers often compared these first tanks to monsters or dragons; one war correspondent wrote that they seemed like something from 'fairy-tales of war by H. G. Wells'. As for Melko himself, he personifies the evils of industrialized warfare. Garth even suggests that 'with his dreams of world dominion, his spies, his vast armies [and] his industrial slaves', he is like some diabolical foreshadowing of the totalitarian regimes that would shortly take power in a war-ravaged Russia and a broken Germany.[44]

The book that most fully reflects Tolkien's wartime experience, though, is of course *The Lord of the Rings*. The odd thing is that it was never meant to turn out that way. Tolkien began work on it at the end of the 1930s as a sequel to his lovely children's book *The Hobbit* (1937), which had proved an unexpected popular hit. Unlike the dark legends of Middle-earth on which he had been working for years, Tolkien's story of a diminutive middle-class burglar, press-ganged into an adventure by a group of treasure-seeking dwarves, was very obviously aimed at younger readers. Like so many children's classics, it had basically started life as a bedtime story. But the sequel rapidly got out of control. By the end of 1939, with Europe having been plunged into another war, Tolkien's hobbits had barely got to Rivendell. Even two years later, with Hitler's army at the gates of Moscow, they were still on the Great River, which meant that Tolkien was barely a third of the way through. And from the very first chapter, the book had a noticeably darker tone than its predecessor. When it finally appeared in the 1950s, many readers naturally concluded that it had been influenced by the coming of the Second

* Readers who struggle to take Tolkien seriously may have even more difficulty with this story, since at this stage he used the word 'Gnomes' instead of 'Elves'. Despite my best efforts, I am afraid I found it very hard to banish the image of Victor Meldrew taking delivery of 263 garden gnomes in *One Foot in the Grave*.

World War. But Tolkien bitterly resisted suggestions that he had been affected by the grim international climate. In the foreword to the second edition, he insisted that the opening chapter, 'The Shadow of the Past', had been 'written long before the foreshadow of 1939 had yet become a threat of inevitable disaster'. Even if there had been no second war, he maintained, 'the book would have developed along essentially the same lines'.[45]

Novelists naturally hate being told that, far from being the fruit of their uniquely fertile imagination, their books are actually the products of a wider political and cultural climate. Even so, it would seem perverse to deny that the two world wars and the politics of the 1930s left their mark on *The Lord of the Rings*. The basic story – a group of cheerful young companions leave their native land, a country of rolling hills and welcoming villages, to fight for justice in a nightmarish inferno of monsters and machines – mirrors the experience of Tolkien and his friends during the First World War. The book's most important friendship – between Frodo, the hobbit who has pledged to destroy Sauron's Ring, and his faithful gardener, Sam Gamgee – seems obviously modelled on the relationship between a young British officer and his loyal batman. And as the book continues, the mood getting ever darker, even the landscapes seem inspired by the horrors of the Somme. Take Tolkien's description of the Dead Marshes, across which Frodo and Sam stagger to get to Mordor:

> It was dreary and wearisome. Cold clammy winter still held sway in this forsaken country. The only green was the scum of livid weed on the dark greasy surfaces of the sullen waters. Dead grasses and rotting reeds loomed up in the mists like ragged shadows of long-forgotten summers ...
>
> Hurrying forward again, Sam tripped, catching his foot in some old root or tussock. He fell and came heavily on his hands, which sank deep into sticky ooze, so that his face was brought close to the surface of the dark mere. There was a faint hiss, a noisome smell went up, the lights flickered and danced and swirled ... Wrenching his hands out of the bog, he sprang back with a cry. 'There are dead things, dead faces in the water,' he said with horror. 'Dead faces!'

In almost every detail, from the cold and the stench to the sticky ooze and, above all, the dead faces, this could be a ruined battlefield on the

Western Front. This is not to say that Tolkien deliberately meant to evoke a parallel with the First World War. But it would have been very odd if such a searing experience had not found its way into his fiction, especially since he was writing at a time when his two sons were fighting for their country.[46]

Yet *The Lord of the Rings* is not just a war book. It is also very obviously an anti-industrial book, shaped by Tolkien's memories of Edwardian Birmingham, with its forges, factories and chimneys. As a disciple of the Victorian medievalists, he was always bound to loathe modern industry, since opposition to the machine age came as part of the package. But his antipathy to all things mechanical was all the more intense because he identified them – understandably enough – with war. He had a particular horror of aerial bombing, which, like many people of his generation, he regarded as especially wicked. And although Tolkien objected when other people drew parallels between the events of *The Lord of the Rings* and the course of the Second World War, he often did so himself in letters to his son Christopher. Again and again he warned that, by adopting the methods of modern industrialized warfare, the Allies had chosen the path of evil. 'We are attempting to conquer Sauron with the Ring. And we shall (it seems) succeed,' he wrote in May 1944. 'But the penalty is, as you will know, to breed new Saurons, and slowly turn Men and Elves into Orcs.'

Two months later he returned to the theme, telling his son that Man's fallen state – Tolkien was a staunch Catholic – meant that 'our devices not only fail of their desire but turn to new and horrible evil. So we come inevitably from Daedalus and Icarus to the Giant Bomber.' Even as the end of the war approached, Tolkien's mood remained bleak. This, he wrote sadly, had been, 'the first War of the Machines . . . leaving, alas, everyone the poorer, many bereaved or maimed and millions dead, and only one thing triumphant: the Machines'. And when he heard the news of Hiroshima and Nagasaki, it merely confirmed his long-standing belief that scientific arrogance would lead only to catastrophe. He was 'stunned', he wrote, to hear of such a devastating weapon. 'The utter folly of these lunatic physicists to consent to do such work for war purposes: calmly plotting the destruction of the world!'[47]

To his critics, Tolkien's anti-technological pessimism looks like the reactionary nostalgia of a backward-looking Catholic conservative, still living in the mental universe of Morris, Ruskin and Carlyle. But there is,

I think, more to it than that. Tolkien began work on *The Lord of the Rings* during a very distinctive historical moment: the mid-to-late 1930s. For the historian Richard Overy, this was the 'morbid age', marked by deep anxiety about the future of Western civilization, a sense of shock at the suffering of the Great War and 'a strong presentiment of impending disaster'. We often think of Tolkien as a man out of time, a tweedy throwback holed up with his Old Norse sagas. But in his bleak view of the omnipresence of evil and the horrors of war, he was actually thoroughly modern. Whenever he opened the newspaper, glanced at a literary periodical or talked to his Oxford colleagues at high table, Tolkien would have heard the same refrain.

In his book *The Morbid Age*, Overy lists countless examples of inter-war intellectuals who believed that human beings were genetically programmed for war and destruction, that Western society was decadent and degenerate, and that the future held only decline. The historian Arnold Toynbee, for example, believed that Western Europe was repeating the errors that had brought the Roman Empire to ruin, while the financier Sir Basil Blackett forecast the 'world collapse of civilisation' and warned that 'chaos will overtake us'. The titles of the lectures offered by the Hampstead Ethical Institute offer a telling glimpse of the mood in intellectual circles: 'Can Civilisation Be Saved?', 'The Tragedy of Human Existence', 'The Decay of Moral Culture'. Even the dominant political figure of the age, the Conservative leader Stanley Baldwin – an eminently solid, sensible figure, with his country tweeds and reassuring manner – often struck a remarkably pessimistic note. Like Tolkien, his fellow West Midlander, Baldwin had a particular dread of air power, insisting that 'the bomber will always get through'. Addressing a London banquet in 1936, months before his retirement as Prime Minister, Baldwin devoted much of his speech to the dangers of war. 'In the long run', he warned, war would mean 'a degradation of the life of the people. It means misery untold compared with which the misery of the last war was happiness, and it means, in the end, anarchy and a world revolution, and we all know it.'[48]

Tolkien was also thoroughly modern in his fear of science, which many of his intellectual contemporaries (and not just fellow medievalists such as C. S. Lewis) saw as a force for death and destruction. It was science, they pointed out, that had given the world mustard gas, the machine gun, the submarine, the tank and the bomber. Aldous Huxley's

novel *Brave New World* (1932), for example, could hardly have been a more disturbing vision of a society transformed by science and industry, a world of castes, drugs and social conditioning, in which Henry Ford and Sigmund Freud have been elevated to virtual demigods. In another dystopian novel, *Ape and Essence* (1948), set after a third world war, Huxley has one character muse on the culpability of science. 'Take the scientists, for example,' he says. 'Good, well-meaning men, for the most part. But [the Devil] got hold of them all the same – got hold of them at the point where they ceased to be human beings and became specialists. Hence . . . those bombs.' Not so different, perhaps, from Tolkien's view that mankind had 'come inevitably from Daedalus and Icarus to the Giant Bomber'.[49]

Yet the writer who did most to popularize the idea of science as a threat to human survival was the very man who had once been seen as its greatest enthusiast. The 'spectacular catastrophe' of the war, wrote H. G. Wells in *The Salvaging of Civilisation* (1921), had shattered the illusion of 'necessary and invincible progress'. At the time, the author of *The Time Machine* and *The War of the Worlds* was one of the best-known writers in the world. But now Wells's tone was becoming increasingly doom-laden, and by the 1930s his writings were full of grim prophecies of war, plague and environmental disaster. The most celebrated example is his future-historical book *The Shape of Things to Come* (1933), which positively wallows in catastrophe. Showing occasional flashes of impressive prescience, Wells predicts that a second world war will break out in January 1940 over Danzig, with Poland and Germany locked in gruelling conflict for the next ten years, while the Americans and the Japanese fight to control the Pacific. The war takes a heavy toll: international order breaks down, anarchy sweeps the planet and eventually most of humanity is killed off in a devastating plague.

Wells being Wells, he cannot restrain himself from inventing a utopian ending, with a benevolent 'Dictatorship of the Air' rebuilding society on a rational, scientific basis. What sticks in the mind, though, are the scenes of apocalyptic misery in Wells's hypothetical 1950s: people 'walking about in the deserted towns, breaking into empty houses, returning to abandoned homes, exploring back streets littered with gnawed bones or fully-clad skeletons'. At the time, Wells still claimed to be an optimist, but his heart was not really in it. Indeed, by the outbreak of the Second World

War he had become almost self-parodically pessimistic, and his last book, *Mind at the End of Its Tether* (1945), ends with an image of mankind as 'a convoy lost in darkness on an unknown rocky coast, with quarrelling pirates in the chartroom and savages clambering up the sides of the ships to plunder and do evil as the whim may take them'. Not even Tolkien – who at least had the consolation of his Catholic faith – was quite that gloomy.[50]

By far the most striking example of Tolkien's anti-modern, anti-industrial pessimism comes in *The Lord of the Rings*'s penultimate chapter, 'The Scouring of the Shire'. Having destroyed the Ring and toppled Sauron's empire, the hobbits are on their way back to their little rural country, the Shire. The reader naturally expects that they will be greeted with open arms, and looks forward to a chapter of feasting, parties and dancing round the maypole. In fact, when the hobbits arrive at the bridge that marks the frontier of their native land, they find it firmly closed and the atmosphere 'all very gloomy and un-Shirelike'. It soon transpires that the Shire has become a primitive police state, ostensibly run by Frodo's greedy relative Lotho Sackville-Baggins ('the Chief'), but in reality governed by the fugitive wizard Saruman, who now calls himself Sharkey. The pastoral Eden that the hobbits left behind is no more; ugly brick factories now squat over the landscape, while the skies are darkened with clouds of black smoke. Horrified, Tolkien's four hobbits draw their swords and lead an uprising, culminating in a bloody melee with Saruman's ruffians. But there is nothing heroic about it; in stark contrast to earlier chapters in the book, the tone feels resolutely downbeat, and even the prose seems deliberately flat and mundane, with none of the elevated archaisms of earlier sections.[51]

For many readers, 'The Scouring of the Shire' has always been a puzzle, and when Peter Jackson adapted Tolkien's book for the cinema, he left it out completely. What this suggested was just how comprehensively Jackson had failed to grasp Tolkien's philosophical vision, a suspicion confirmed when the director managed to eliminate every last atom of charm from *The Hobbit*. Jackson's explanation was that the chapter was an oddity, an aberration, detracting from the book's great theme of the clash between good and evil. But this seems to me a basic misunderstanding of what *The Lord of the Rings* is about. Tolkien himself insisted that the chapter was a fundamental part of his vision: it was, he wrote in the foreword, 'an essential part of the plot, foreseen from the outset'. As we

have already seen, Tolkien's book is *not* a simplistic clash between good and evil: the supposedly wicked Gollum is still capable of kindness and pity, while Frodo, the book's hero, eventually succumbs to the power of the Ring. But it is 'The Scouring of the Shire' that really hammers the point home. It is not merely the chapter that best expresses Tolkien's cultural and political convictions; it is the chapter that elevates the book from a Haggard-style adventure story into something much darker and more modern.[52]

When *The Lord of the Rings* was first published, many readers interpreted 'The Scouring of the Shire' as a coded attack on Clement Attlee's post-war Labour government, with its ration books and council houses. And although Tolkien angrily denied that he had been writing a political parable, there *is* an obvious political subtext. One of the Chief's innovations, we discover, has been to send out 'gatherers' and 'sharers', who go around 'counting and measuring and taking off to storage', so that ordinary farmers 'never see most of the stuff again'. The inns have all been closed because 'the Chief doesn't hold with beer'. The authorities have recruited 'hundreds of Shirriffs' (i.e. policemen), some of whom like 'minding other folk's business and talking big', while others are doing 'spy-work for the Chief and his Men'. And 'if any of us small folk stand up for our rights, they drag him off to the Lockholes'. It is no wonder that some readers interpreted this as a veiled attack on socialism; even as Tolkien was working on the later chapters of *The Lord of the Rings*, Winston Churchill was warning the electorate that a Labour government would eventually 'have to fall back on some form of Gestapo'. But if Tolkien had a political target, it was probably government *per se* rather than the Attlee administration in particular. Deep down he saw himself as a conservative anarchist, a curious blend of the traditional and the libertarian. 'The most improper job of any man', he told his son in 1943, was 'bossing other men'; indeed, he would 'arrest anybody who uses the word State'.[53]

There is more to 'The Scouring of the Shire', though, than Tolkien's discontent with the expansion of Whitehall bureaucracy. Even today it is almost impossible to miss the echoes of events in Europe during the late 1930s and early 1940s, the age of appeasement, occupation, collaboration and resistance. When Tolkien describes the passivity and acquiescence of the Shire's downtrodden residents, he sounds like an anti-appeasement firebrand lamenting the mood in Neville

Chamberlain's Britain, or like somebody describing the atmosphere in France under Nazi occupation. The hobbits have lost the will to fight; they have shrunk 'under cover'. They have, says Merry, 'been comfortable so long they don't know what to do. They just want a match, though, and they'll go up in fire.' So it proves. Indeed, once the uprising begins, Farmer Cotton tells a foreign ruffian: 'This isn't your country, and you're not wanted.'[54]

And yet the most obvious parallel is not with the Second World War, but with the First – the war in which Tolkien himself had fought, and which loomed like a great black cloud over everything he wrote. In his description of four decorated veterans returning after a long ordeal to an indifferent, even contemptuous welcome – the borders closed, the lights darkened, even the pubs shut – Tolkien was surely thinking, if only unconsciously, of the miserable reception for Britain's returning heroes after the armistice of 1918. The Prime Minister, David Lloyd George, had promised them a 'land fit for heroes'. What they got, however, was a country scarred by strikes and blighted by mass unemployment, which explains the mood of intense disillusionment that settled over many veterans in the course of the 1920s. And as Tolkien well knew, not even victory could wipe away the memory of so much suffering. It is a common refrain among his critics that his heroes are saintly, superhuman figures who never get hurt and never feel pain. But these people cannot have read the book, because Tolkien's portrait of Frodo – pale, distracted, preoccupied by his wounds, haunted by his memories – reads like a description of a man with shell-shock. In the final pages of the book, when Frodo sails away into the West, his friend Sam says tearfully: 'But I thought you were going to enjoy the Shire, too, for years and years, after all you have done.' Frodo's response does not sound to me like that of a man untouched by suffering. 'So I thought too, once,' he says. 'But I have been too deeply hurt, Sam. I tried to save the Shire, and it has been saved, but not for me.'[55]

Above all, 'The Scouring of the Shire' is a bitter lament for the countryside that Tolkien had known and loved as a boy. The hobbits' first real shock comes when they arrive in the village of Bywater and find the familiar cottages demolished, burned down or abandoned. A line of 'ugly new houses' runs along the village's wide pool, while the ancient trees have been felled. Up the road, they see 'a tall chimney of brick in the distance . . . pouring out black smoke into the evening air'. Farmer

Cotton warns them that in Frodo's and Sam's home, Hobbiton, the lovely old mill has been pulled down and replaced with a bigger one, full of 'wheels and outlandish contraptions', always 'a-hammering and a-letting out a smoke and a stench'. But even this cannot prepare them for the sight:

> It was one of the saddest hours in their lives. The great chimney rose up before them; and as they drew near the old village across the Water, through rows of new mean houses along each side of the road, they saw the new mill in all its frowning and dirty ugliness: a great brick building straddling the stream, which it fouled with a steaming and stinking over-flow. All along the Bywater Road every tree had been felled ... All the chestnuts were gone. The banks and hedgerows were broken. Great wag-ons were standing in disorder in a field beaten bare of grass. Bagshot Row was a yawning sand and gravel quarry.

This, says Sam, is 'worse than Mordor, much worse in a way. It comes home to you, as they say; because it is home, and you remember it before it was all ruined.' 'Yes,' replies Frodo, 'this is Mordor.'[56]

This is more than Tolkien's habitual anti-industrial nostalgia. For the boy from the suburbs of Birmingham, this was personal. The Shire, he once told his publisher, was 'more or less a Warwickshire village of about the period of the Diamond Jubilee'. This was precisely the point that Tolkien, then 5 years old, was living in Sarehole, during the happy years before the death of his mother.* Interviewed in 1966, he described it as 'a lost paradise. There was an old mill that really did grind corn with two millers, a great big pond with swans on it, a sandpit, a won-derful dell with flowers, a few old-fashioned village houses and, further away, a stream with another mill. I always knew it would go – and it did.' This was no exaggeration. As early as 1911, Sarehole had been officially absorbed into Birmingham, and by the following decade the fields he had known so well were being smothered by miles of suburban housing. For Tolkien, who had always romanticized the countryside he had known as a boy, this was nothing short of a tragedy. In 1933,

* It is odd that Tolkien several times described Sarehole as having been in Warwickshire. It was, admittedly, close to the Warwickshire border. But in reality it belonged to Worcestershire until 1911, when the areas of King's Norton, Northfield and Yardley were transferred to the expanding city of Birmingham.

driving to visit relatives in Birmingham, he went back to his old haunts and found them changed beyond recognition. The area, he wrote, had become a 'huge tram-ridden meaningless suburb', and the 'beloved lanes of childhood' were now 'a sea of new red-brick'. The old crossing near the mill, with its lovely bluebells, was 'alive with motor cars and red lights'; the miller's house was now a petrol station. This was his Shire, all gone.[57]

In this, as in so much else, Tolkien was a man of his time. Nostalgic visions of a rural 'Deep England' played a central part in the culture of the early twentieth century, from the music of Edward Elgar and Vaughan Williams to the poems of Rupert Brooke and Edward Thomas. Tolkien's hobbits bear a distinct resemblance to the yeomen and farm workers romanticized by artists such as William Morris and Eric Gill, or even by the Irish poet W. B. Yeats, for whom they epitomized the supposedly simpler, healthier, more authentic virtues of the rural life. And in his lament that an old world was falling victim to the factory and the bulldozer, Tolkien was far from alone. As John Carey observes, early twentieth-century writers often came, like Tolkien, from middle-class families in 'old-style green outer suburbs': precisely those places which fell victim to new housing developments after the First World War. In the recollections of writers such as E. Nesbit, E. M. Forster, Graham Greene and Evelyn Waugh, the theme of a ruined paradise recurs again and again.

But the best example is H. G. Wells, who was born in Bromley, Kent, in 1866, at precisely the point when the railway was unleashing an orgy of development. 'All my childish memories', says the narrator in Wells's semi-autobiographical novel *The New Machiavelli* (1911), 'are of digging and wheeling, of woods invaded by building, roads gashed open and littered with iron pipes amidst a fearful smell of gas, of men peeped at and seen toiling away deep down in excavations, of hedges broken down and replaced by planks, of wheelbarrows and builders' sheds, of rivulets overtaken and swallowed up by drain-pipes.' His equivalent of Tolkien's mill is the Ravensbrook, once 'a beautiful stream', now full of 'old iron, rusty cans, abandoned boots and the like'. By the time Wells turned 11, 'all the delight and beauty of it was destroyed'. There is a nice parallel here with Tolkien. 'The country in which I lived in childhood', he wrote in the foreword to *The Lord of the Rings*, 'was being shabbily destroyed before I was ten.'[58]

The enduring appeal of Tolkien's most celebrated book is only partly due, then, to its qualities as a tremendously exciting adventure story. Its underlying themes could hardly have been better chosen to appeal to a mass readership anxious about the consequences of science, the environmental costs of industry, the dangers of war and the fate of the 'little man' in the face of the vast, impersonal forces reshaping Western societies in the second half of the twentieth century. Other fantasy writers of Tolkien's generation often had similar concerns: just think of the dystopian vision of Narnia conjured by the Ape in C. S. Lewis's book *The Last Battle* (1956), an authoritarian future of 'roads and big cities and schools and offices and whips and muzzles and saddles and cages and kennels and prisons'. The real master of the post-war dystopia, though, was a writer whose nightmarish visions of social breakdown and ecological disaster haunted the British imagination in the 1950s. Like Tolkien, he was a Birmingham boy, and like Tolkien, he capitalized on a profound anxiety about the dangers of scientific hubris and the fragility of modern civilization. But while Tolkien's most successful book depicts a world in which human arrogance has turned nature into a wasteland, John Wyndham's most celebrated novel flips that picture on its head. In *The Day of the Triffids*, nature takes its revenge.[59]

Previous pages: Mars attacks: an illustration for an early French edition of H. G. Wells's *The War of the Worlds* (1898), surely one of the most influential British novels of all time.

IO

The Door in the Wall

DEAD LONDON

Above it all rose the Houses of Parliament, with the hands of the clock stopped at three minutes past six ... Alongside, the Thames flowed imperturbably on. So it would flow until the day the Embankments crumbled and the water spread out and Westminster became once more an island in a marsh.

John Wyndham, *The Day of the Triffids* (1951)

A man wakes up in a hospital bed. Weak and groggy from a long sleep, he cries for help, but there is no answer. He wonders what day it is and where everybody has gone. He drags himself out of bed and calls down the hall. Silence. He staggers down the corridor. There is nobody there. He wanders through the hospital, shocked by the scenes of disorder, the medical equipment strewn on the floor, the blood, the chaos. Slowly but surely the awful reality begins to sink in: while he has been sleeping, something terrible has happened. Later, we see him wandering the streets of London. The city is deserted, its great squares empty, its shop windows smashed. On Westminster Bridge nothing moves. The Palace of Westminster still stands, proud and forbidding, but no lights burn in its windows; no shadows move behind the glass. The trees sway gently in the breeze and the river rolls inexorably towards the sea, but otherwise there is no sign of life. There is only the terrible, all-encompassing silence and the lonely figure of the man, stumbling through a city of the dead.

So begins Danny Boyle's film *28 Days Later* (2002), a post-apocalyptic thriller about a future Britain overrun by zombies thanks to the

'Nature is ruthless, hideous and cruel beyond belief': the terrifying blond Children in the film version of *The Midwich Cuckoos*, which was released as *Village of the Damned* (1960).

accidental release of a highly contagious man-made virus.* But as Boyle cheerfully admitted, his screenwriter, the novelist Alex Garland, had borrowed the idea from a book that was already half a century old: John Wyndham's science-fiction novel *The Day of the Triffids*.

In Wyndham's book, published in 1951, the menace comes not from zombies but from giant, genetically modified, walking plants. For years mankind has been breeding these 'triffids' for their oil. But after a strange, unexplained meteor shower – possibly connected to orbiting weapons satellites – almost everybody on the planet becomes blind overnight. The only exceptions are people like the narrator, Bill Masen, who never saw the meteors. As the book continues, he makes contact with other survivors, escaping not just the looters and scavengers roaming the streets of London but also the triffids, which have now developed into killers, viciously striking at their blind prey. Now Bill, a biologist who once worked with the triffids, sees them for what they really are: 'Horrible alien things which some of us had somehow created and which the rest of us in our careless greed had cultured all over the world.' With a few friends, he flees to sanctuary on the Isle of Wight. And one day, he promises in the novel's rousing final line, 'we, or our children, or their children, will cross the narrow straits on the great crusade to drive the triffids back and back with ceaseless destruction until we have wiped the last one of them from the face of the land that they have usurped'.[1]

When, a few years after its publication, a BBC interviewer asked Wyndham to explain the genesis of *The Day of the Triffids*, his answer was characteristically unpretentious. The idea, he said,

> came one night when I was walking along a dark lane in the country and the hedges were only just distinguishable against the sky, and the higher things sticking up from the hedges became rather menacing. One felt that they might come over and strike down, or if they had stings, sting at one. So that the whole thing eventually grew out of that.

The result was one of the most exciting and influential stories in science-fiction history. When Bill Masen stumbles through the hospital,

* There is also a remarkably similar opening in the American comic book and television series *The Walking Dead*, the only difference being that it is set in Atlanta, Georgia, rather than London. But the set-up is almost exactly the same: a man in a hospital waking after a long coma, confused and alone, to find that civilization has fallen apart.

when he makes his way through a city in chaos, when he makes a desperate return to London to hunt for supplies, it is hard to stop yourself from skipping ahead to find out what happens next. And as in so many post-apocalyptic fantasies, it is impossible not to feel a thrill of terror and excitement at the thought of society in ruins, the old conventions shattered, the old morals abandoned. One character likens the disaster to the Flood. Masen, more prosaically, reflects: 'My way of life, my plans, ambitions, every expectation I had had, they were all wiped out at a stroke.' With his feisty love interest, Josella, he manages to cling on to some shreds of normality, even establishing a temporary base at an old farmhouse in Sussex before their final escape to the Isle of Wight. Similarly, in *28 Days Later*, the three survivors from the zombie plague establish a base in a remote cottage somewhere in the North of England. Both stories end on an implausibly optimistic note. But it is not the end you remember: it is the terror that comes beforehand.[2]

Born in 1903, John Wyndham was yet another writer from a broken home; indeed, it is tempting to suggest that if your parents are still happily married by the time you turn 18, you can wave goodbye to any thought of selling millions of books. The son of a barrister, he grew up in the suburbs of Birmingham until he was 8, when his parents separated.* For the next few years, Wyndham drifted from one boarding school to another, ending up at the progressive Bedales – later the alma mater of such cultural titans as Daniel Day-Lewis, Lily Allen and Gyles Brandreth. In his perceptive essay on Wyndham, the science-fiction writer Christopher Priest suggests that it is 'possible to glimpse ... the child of estranged parents, certainly hurt and depressed by what happened, probably suffering feelings of guilt'. It is certainly true that Wyndham returns again and again to the theme of the isolated, awkward or unusual child: the telepathic mutants in *The Chrysalids* (1955), for example, or the sinister alien Children in *The Midwich Cuckoos* (1957), or the adopted little boy Matthew in *Chocky* (1968), with his imaginary friend. But Wyndham's fiction can also be read as a tribute to the liberal values he learned at Bedales, where he seems to have been very happy. His biographer, David Ketterer, suggests that Bedales was his 'idea of utopia'. A pioneering co-educational boarding school, it was

* His full name was actually John Wyndham Parkes Lucas Beynon Harris, which is a bit of a mouthful. John Wyndham was only one of several pen names.

anti-competitive, anti-religious and proto-feminist. Its founder, John Haden Badley, who was still headmaster during Wyndham's day, was another son of the West Midlands, having been born in Dudley, and was also another devotee of William Morris, whose Arts and Crafts philosophy was reflected in the school's curriculum. *

After Wyndham left school, he spent a long period faffing about without really accomplishing anything worthwhile. Although he dabbled in various careers – farming, law, commercial art, advertising – he never stuck to anything, partly because he was cossetted by a small private income. By the mid-1920s he had started to write, and a few years later he sold some short science-fiction stories to American pulp magazines such as *Amazing Stories* and *Thrilling Wonder Stories*. These early tales were not very distinguished: Priest describes them as typical 'adventure stories about rocketry, death rays, voyages to other planets, lost races living in subterranean worlds'; or, to put it more bluntly, 'Martians chasing young women wearing no more than a bathing costume and a fish-bowl over their heads'. Later, Wyndham seems to have been faintly ashamed of them; but we are getting ahead of ourselves. The key break in his career was the Second World War, when he served in the Royal Signals and saw action in Normandy. When it was all over, he decided to reinvent himself. Having previously published as John Beynon or John Beynon Harris – as he joked later, 'I'd disgraced all my other pseudonyms' – he adopted the name John Wyndham and began work on a story with the working title 'Revolt of the Triffids'.[3]

For Wyndham, it was crucially important that *The Day of the Triffids* was published by Michael Joseph. This was a respectable mainstream hardback publisher; its other authors included names such as Joyce Cary, H. E. Bates, C. S. Forester and Vita Sackville-West. This meant Wyndham could escape association with pulp science fiction and reach a potentially much broader audience, including thousands of readers who would never have dreamed of picking up *Thrilling Wonder Stories*. Indeed, Wyndham did as much to distance himself from pulp science fiction as possible; as Priest notes, the blurbs for his Penguin paperbacks even claimed that he was writing 'a modified form of what is unhappily

* Perhaps our entire contemporary popular culture can be traced back to William Morris and the soil of the West Midlands, though since Morris himself came from Walthamstow, this argument might not be the most robust ever made.

known as "science fiction"'. Wyndham himself thought the term smacked of 'galactic gangsters', and preferred 'logical fantasy'. Meanwhile, his publishers presented him as the 'true successor' to H. G. Wells, whose scientific romances were much more respectable. Reviewing *The Day of the Triffids* for the *Observer*, for example, the novelist and critic Marghanita Laski wrote that it was 'such a very jolly and exciting piece of – I suppose one should call it science-fiction, that it recalls the great days of H. G. Wells'. When Michael Joseph ran adverts for *The Day of the Triffids*, they abbreviated her quotation to 'Recalls the great days of H. G. Wells'. This was a very canny strategy. The children's writer Philip Reeve recalled that in the late 1970s, when he was growing up in Brighton, the first science-fiction writer he read was H. G. Wells, and the second was John Wyndham. 'The reason for that', he explained, 'was simple; like Wells, Wyndham was *respectable*. There were no lurid paintings of bug-eyed monsters or space-princesses in boilerplate bikinis on the jackets of his novels; they were sober, orange-and-white Penguins, which sat comfortably on my parents' bookshelves alongside the works of writers like Eric Ambler, Neville [*sic*] Shute and Hammond Innes.'[4]

The Day of the Triffids was a tremendous success. In her *Observer* review, Laski invited readers to speculate why there were 'so many novels based on the end of our civilisation', but the answer is surely obvious. When the book came out in December 1951, it was barely six years since the bombing of Hiroshima and Nagasaki and only two years since the Soviet Union had tested its first atom bomb, while the Americans were only months away from exploding their first hydrogen bomb. With memories of the Second World War still raw, it is little wonder that the idea of apocalyptic social breakdown seemed so resonant. Yet not even Wyndham could have anticipated how *The Day of the Triffids* would transform his reputation. By 1958 it had sold 100,000 copies; ten years later, half a million. In 1957 the BBC made the first of three radio adaptations of the novel, while the Bond producer Albert R. Broccoli snapped up the film rights.*

By now Wyndham was becoming a household name. When *The Times* ran a long feature about British science fiction in September

* As it happened, though, Broccoli's film was never made, and cinemagoers had to be content with a dodgy British version made by the Rank Organisation.

1958, the anonymous writer lamented that the genre seemed to be in the doldrums, with book sales having tailed off and even the Science Fiction Luncheon Club apparently moribund. But Wyndham, he noted, was the shining exception. Two years later, in an editorial discussing the death of H. G. Wells's scientific optimism, *The Times* singled Wyndham out as the supreme British prophet of the new 'age of pessimism'. And in September 1960 he was even interviewed on the BBC's *Tonight* show, which also featured Alan Whicker and Cliff Michelmore reading solemnly from his books. The footage shows an unremarkable, mild-mannered man, who looks a bit like a provincial solicitor. Again he distances himself from American-style science fiction. 'Your English reader does not care for the idea of space ships. I don't quite know why,' he says. 'Your American reader loves space ships, but in England you don't.' The interviewer asks if he is ever appalled by his own apocalyptic fantasies. No, says a smiling Wyndham: 'These aren't frightening.'[5]

Although some people undoubtedly found Wyndham's books frightening – and as a child, I was absolutely terrified by the BBC's television adaptation of *The Day of the Triffids* in 1981 – plenty of critics found them nowhere near frightening enough. To the younger science-fiction writers who came of age in the 1960s and 1970s, Wyndham made a satisfyingly rich, successful and established target. Both *The Day of the Triffids* and *The Kraken Wakes* (1953), wrote the science-fiction novelist Brian Aldiss in his history of the genre, were 'totally devoid of ideas but read smoothly, and thus reached a maximum audience, who enjoyed cosy catastrophes'.* Those last two words have hung round Wyndham's neck ever since. 'The essence of cosy catastrophe', explained Aldiss, 'is that the hero should have a pretty good time (a girl, free suites at the Savoy, automobiles for the taking) while everyone else is dying off.' And, for some critics, Wyndham's reputation has never recovered: he is, alas, too middle-class, too respectable, too safe and – yes – too *cosy*.[6]

The idea of *The Day of the Triffids* as a cosy book seems to me very odd indeed. *My Family and Other Animals* is a cosy book. *A Year in Provence* is a cosy book. *Chocolat* is a cosy book. But *The Day of the Triffids*? A novel that begins with a man in hospital, half-blinded by a giant plant, discovering that the world has fallen apart while he was

* I used the word 'wrote' instead of 'sneered' there, but only because I am already dangerously close to the UN-approved limit on the number of sneering critics in one book.

asleep? By the end of the first chapter, our hero has already helped two people – a doctor and a pub landlord – to kill themselves, which hardly strikes me as an opening worthy of, say, James Herriot. In the third chapter, Masen hears a piano playing in the distance, and a girl's voice singing; and then the sound of sobbing, 'softly, helplessly, forlorn, heart-broken'. A little later, he sees a young couple, now completely blind, emerging from hiding in a block of flats. The man opens the fire-escape window, takes his girlfriend in his arms, tells her he loves her – and then leaps out, sending them both to certain death. On another occasion, a girl of eighteen, blinded on her birthday, offers herself to Masen, and then, having been gently rebuffed, begs him to 'get me something – to finish it'. He gets her pills from the chemist and hands them to her. 'So futile,' she says, 'and it might all have been so different.' As he leaves, he looks down at her 'lying there', and reflects bitterly on the sense of waste. If this is a cosy book, I would hate to read a non-cosy one.[7]

What is true is that Wyndham was not entirely original. Masen's adventures in London – eerily desolate and deserted, the great palaces standing empty, the shops looted, the parks infested with triffids – are immediately reminiscent of the chapter 'Dead London' in *The War of the Worlds*. Here, H. G. Wells's narrator finds himself in the capital, which has been overrun by the Martians' red weed:

> Where there was no black powder, it was curiously like a Sunday in the City, with the closed shops, the houses locked up and the blinds drawn, the desertion, and the stillness. In some places plunderers had been at work, but rarely at other than the provision and wine shops. A jeweller's window had been broken open in one place, but apparently the thief had been disturbed, and a number of gold chains and a watch lay scattered on the pavement. I did not trouble to touch them. Farther on was a tattered woman in a heap on a doorstep; the hand that hung over her knee was gashed and bled down her rusty brown dress, and a smashed magnum of champagne formed a pool across the pavement. She seemed asleep, but she was dead.
>
> The farther I penetrated into London, the profounder grew the still-ness. But it was not so much the stillness of death – it was the stillness of suspense, of expectation ... It was a city condemned and derelict ...

Even the narrators' reactions are remarkably similar. In *The War of the Worlds*, Wells's narrator wonders why he is 'wandering alone in this city

of the dead ... I felt intolerably lonely. My mind ran on old friends that I had forgotten for years. I thought of the poisons in the chemists' shops, of the liquors the wine merchants stored.' There is a similar moment in *The Day of the Triffids*, though only after Bill has left London. 'Now I was really on my own,' he says:

> I could not shut out the sense of loneliness ... Until then I had always thought of loneliness as something negative – an absence of company, and, of course, something temporary ... That day I had learned that it was much more. It was something which could press and oppress, could distort the ordinary, and play tricks with the mind.[8]

Even in the 1890s, the idea of London being destroyed by some terrible disaster was nothing new. Indeed, at the heart of all apocalyptic fantasies are memories of Biblical episodes such as the Flood, the fate of Sodom and Gomorrah and the Book of Revelation. Such stories had a particular appeal to the Victorians, perhaps because, conscious of their pride in their achievements, they wanted to remind themselves of the dangers of hubris. *The War of the Worlds* itself first appeared in serial form in the spring and summer of 1897, at precisely the point when Victorian self-confidence was reaching its apotheosis in the pageantry of the Diamond Jubilee. Yet Wells was not alone in predicting that the glory of Empire would soon fade into oblivion. Even as Victorian readers were devouring the first chapters of Wells's science-fiction classic, Rudyard Kipling was working on his poem 'Recessional', a bleak warning that one day, after all 'the tumult and the shouting' had died down, the Empire's pomp and glory would be reduced to dust. As Kipling told a friend, a 'great smash' was coming, although he believed Britain would pull through, saved by 'the common people – the third-class carriages'. All this is often taken as evidence of his unusual far-sightedness, but actually it was pretty typical. As one historian puts it, the Victorians 'seemed almost to revel in a good disaster'.[9]

The most celebrated example, which undoubtedly influenced both *The War of the Worlds* and *The Day of the Triffids*, was Richard Jefferies's book *After London*, published in 1885. The premise is that a terrible, unidentified catastrophe has killed millions, emptying the cities and plunging England back into the world of the Middle Ages. The opening lines read like something by Wyndham himself: 'The old men say their fathers told them that soon after the fields were left to

themselves a change began to be visible. It became green everywhere in the first spring, after London ended, so that all the country looked alike.' And, as in *The War of the Worlds* and *The Day of the Triffids*, the book's most memorable passages come when the narrator visits a shattered, deserted London. The area is almost completely flooded; all he sees are the fragile, powdery ruins of what had once been houses, and the ghostly white remains of what had once been skeletons:

> He passed a few yards to one side of them, and stumbled over a heap of something which he did not observe, as it was black like the level ground. It emitted a metallic sound, and looking he saw that he had kicked his foot against a great heap of money. The coins were black as ink; he picked up a handful and went on ... He now at last began to realize his position; the finding of the heap of blackened money touched a chord of memory. These skeletons were the miserable relics of men who had ventured, in search of ancient treasures, into the deadly marshes over the site of the mightiest city of former days. The deserted and utterly extinct city of London was under his feet ... The earth on which he walked, the black earth, leaving phosphoric footmarks behind him, was composed of the mouldered bodies of millions of men who had passed away in the centuries during which the city existed. He shuddered as he moved; he hastened, yet could not go fast, his numbed limbs would not permit him.

Jefferies was basically a nostalgic ruralist. His book's subtitle was *Wild England*, and his real interest lay in showing how his native land might one day return to its original state. But his vision of nature overturning man's industrial supremacy captured the imagination of readers who shared his unease with modern urban life. William Morris even wrote that 'absurd hopes curled around my heart as I read it ... I want to see the game played out.'[10]

The fact that Wells and Wyndham were clearly indebted to *After London* does not, of course, mean that they were mere imitators. Wells's catastrophes – the Martian invasion in *The War of the Worlds*, the last moments of mankind's descendants in *The Time Machine*, the collapse of civilization in *The War in the Air* (1908), the nuclear holocaust in *The World Set Free* (1914), the destruction of international order in *The Shape of Things to Come* – have a flavour all their own, inspired not just by the context of the two world wars, but by Wells's own political and scientific obsessions. *The War of the Worlds*, for example, should

really be read as a particularly imaginative example of the invasion literature that was so popular in late Victorian and Edwardian Britain, such as George Tomkyns Chesney's *The Battle of Dorking* (1871) or William Le Queux's *The Invasion of 1910* (1906). Originally inspired by the shock of the Franco-Prussian War, invasion stories reflected widespread fears of national degeneration and imperial decline; in a sense, even Bram Stoker's vampire thriller *Dracula* (1897) can be seen as an invasion story. As for *The Time Machine*, it is a thinly veiled expression not just of Wells's political principles – the conflict between the rather foppish Eloi and the bestial Morlocks being an exaggerated version of the growing tensions between capital and labour in late Victorian Britain – but of his fascination with Darwinian evolution. In revealing the Morlocks as the predators and the Eloi as their prey, Wells turns the competitive spirit on its head, while the final images of the extinction of life on earth, and indeed the death of the planet itself, are like some ghastly parody of the Christian apocalypse. And although Wells is commonly seen as one of literature's great utopians, his Time Traveller could hardly be more pessimistic. He 'thought but cheerlessly of the Advancement of Mankind,' says the narrator, 'and saw in the growing pile of civilisation only a foolish heaping that must inevitably fall back upon and destroy its makers in the end'.[11]

For Wyndham, writing more than half a century after Wells had published his first scientific romances, the social and political context was very different. Wells had come of age during the heyday of Empire, but by the time Wyndham published *The Day of the Triffids*, Britain's imperial hegemony was crumbling fast. It is little wonder that his books feel more insular, more introverted; as Christopher Priest puts it, these are 'global catastrophes, glimpsed locally'. In different ways, meanwhile, most of Wyndham's books reflect the intense nuclear paranoia of the Cold War. The triffids appear to have been engineered in the Soviet Union, while the narrator suspects that the disaster that sends mankind blind was triggered by the Russians' space-based satellite weapons system. In *The Kraken Wakes* (1953), the story of a gradual invasion by a group of unseen aliens, the United States and the Soviet Union blame the first attacks on one another, and their suspicions almost send the world lurching into a third world war. In *The Chrysalids*, which follows a group of telepathic children in the wilds of northern Canada, we find ourselves in a world recovering from a nuclear holocaust. And in *The*

Midwich Cuckoos, the story of a strange group of alien Children who are born into a sleepy English village, we discover that the Soviet authorities have destroyed their own settlement of alien Children with an 'atomic cannon'.[12]

The Midwich Cuckoos is a very good example of a story that, while apparently timeless, is very precisely located in its social and political context. In some respects it feels like a Second World War book. Not only does the narrator recall 'the beaches, the Ardennes, the Reichswald, and the Rhine', but the critic Adam Roberts has even suggested that the final scene, in which the Children, having been identified as a threat to civilization, are cold-bloodedly slaughtered, evokes the murder of Jewish children in the Holocaust. At the same time, though, the mutual incomprehension of bewildered adults and assertive children anticipates the 'generation gap' fears of the decade to come. The diary of Wyndham's wife shows that he wrote the book during the second half of 1956 and first weeks of 1957: precisely the point, in other words, when the newspapers were wringing their hands about the effects of rock and roll on the morals of British's teenagers. The headlines were full of juvenile delinquents and Teddy Boys, while the release of Bill Haley's film *Rock around the Clock* provoked scenes of mild disorder in cinemas across the country, which were then wildly exaggerated by the papers. And while Wyndham's alien Children are conspicuously larger, healthier and more mature than their human equivalents, so too were the adolescents of the 1950s. 'Today's adolescents', explained a government report at the end of the decade, 'are taller and heavier than those of previous generations, and they mature earlier.' The *Daily Mirror* put it rather more melodramatically: 'Our Children Are Changing.' Perhaps it is not surprising, then, that so many readers were drawn to a story about weird children taking over a sleepy English village, ignoring their parents and upsetting the neighbours.[13]

Wyndham never hid his debt to H. G. Wells; indeed, he was positively proud of it. In *The Midwich Cuckoos*, the urbane Gordon Zellaby, a thinly veiled self-portrait of Wyndham himself, lectures his friends on the significance of 'H. G.'s Martians ... the prototype of innumerable invasions'. One very obvious similarity was Wyndham's skill at combining the extraordinary and the everyday, locating his alien invasions in the most mundane settings imaginable: a London hospital, a rural village, an ordinary middle-class household, and so on. This was a trick

borrowed from Wells: *The War of the Worlds*, for example, begins on Horsell Common, outside Woking, while much of the action unfolds in suburban Surrey. As in Wells's books, Wyndham's fantastic situations are narrated in calm, sober, realistic prose, while his narrators themselves tend to be entirely unremarkable and seem always one step removed from the action. Both writers were keen on framing devices that play down the sense of fantasy. The story of *The Time Machine*, for example, is told not by the Time Traveller himself but by a more level-headed friend, while both *The Day of the Triffids* and *The Midwich Cuckoos* have rather dull, almost forgettable narrators, who are largely reporting what other people have told them. Even Wyndham's alien creations initially appear to be reassuringly mundane: plants in *The Day of the Triffids*, children in *The Chrysalids* and *The Midwich Cuckoos*.[14]

The more interesting parallel between Wyndham and Wells, though, is their shared fascination with evolutionary biology. Indeed, if Wyndham's books have an underlying theme, it is the Victorian idea of the survival of the fittest. Beneath the veneer of civilization, life is a pitiless Darwinian competition for resources and survival. 'It was bound to happen some time in some way,' Bill tells Josella in *The Day of the Triffids*. 'It's an unnatural thought that one type of creature should dominate perpetually ... Life has to be dynamic and not static. Change is bound to come one way or another.' *The Chrysalids*, which strikes me as the most imaginative of all Wyndham's scientific romances, makes the same point, only more strongly. The central conflict pits a group of telepathic children (mutants, basically) against the rest of humanity. Towards the end of the book, they make contact with a woman from the telepathic community in Sealand (i.e. New Zealand), who comes out with great tracts of homespun Darwinian wisdom: 'The living form defies evolution at its peril; if it does not adapt, it will be broken. The idea of completed man is the supreme vanity: the finished image is a sacrilegious myth ... The essential quality of life is living; the essential quality of living is change; change is evolution; and we are part of it.' The old humans, she says, hate the children because they are 'aware of danger to their species. They can see quite well that if it is to survive, they have not only to preserve it from deterioration, but they must protect it from the even more serious threat of the superior variant. For ours *is* a superior variant, and we are only just beginning.'[15]

It is an interesting coincidence that *The Chrysalids* came out in exactly the same year, 1955, as William Golding's book *The Inheritors*. For while *The Chrysalids* is narrated by young David, a representative of the superior species who will one day defeat and destroy mankind, Golding's brilliantly inventive book approaches the Darwinian struggle for survival from the opposite perspective: that of the losers. Set in the Stone Age, it tells the story of Lok, a Neanderthal who observes with bewildered horror the rise of another 'superior variant': *Homo sapiens*. The fact that the two books were published at the same time is surely more than a fluke, and it is tempting to suggest that the horrors of the Second World War had set both writers thinking about violence and competition, not just in human affairs, but in nature more generally. The other obvious link is the influence of H. G. Wells. According to John Carey, Golding's father, Alec, a high-minded progressive of the most excruciatingly earnest kind, had been a 'keen Wellsian', and Golding naturally enjoyed kicking his father's hero. In his *Outline of History* (1920), Wells, the great enthusiast for scientific progress, had contemptuously dismissed the Neanderthals, on the basis of no evidence at all, as ugly, cannibalistic monsters. Golding thought this 'uproariously funny', and used Wells's passage as the epigraph for *The Inheritors*. His book shows the Neanderthals as gentle, peaceful and slow, more like human toddlers than bestial Morlocks. This is the ascent of man, but told as a tragedy.[16]

Wyndham's next book, *The Midwich Cuckoos*, repeats the theme of a small group of children who represent an existential threat to the human race and come to be feared and hated. This time, however, Wyndham switches sides, and the story is told from the perspective of their adult adversaries. In that sense, therefore, it adopts the same viewpoint as *The Inheritors*: that of the inferior species, threatened by the new variant. But while the Neanderthal Lok struggles to make sense of the 'new people', Gordon Zellaby rapidly grasps the nature of the threat. Like the Sealand woman in *The Chrysalids*, Zellaby has evidently been reading an awful lot of stuff about the survival of the fittest. Human civilization, he says, is 'biologically speaking, a form of decadence'; it would have been 'better for our development had we had to contend with some other sapient, or at least semi-sapient, species'. We need to wake up and realize that 'Nature is ruthless, hideous and cruel beyond belief', otherwise 'we, like the other lords of creation before us, will one

day be replaced'. There is absolutely no suggestion, incidentally, that the Children are evil; they are, in fact, no more evil than Wells's Martians. Indeed, the narrator of *The War of the Worlds* not only lectures us about mankind's 'vanity', he explicitly warns us against judging the Martians too harshly, since 'we men, the creatures who inhabit this earth, must be to them at least as alien and lowly as are the monkeys and lemurs to us'. Both books, in other words, depict a merciless struggle for survival, but *not* one with a moral dimension. And while the narrator in *The Midwich Cuckoos* cannot bring himself to see the Children as anything other than children, the horribly clear-sighted Zellaby elects to destroy them in a suicide bombing – an act, by most people's standards, of mass infanticide, if not genocide. 'If you want to keep alive in the jungle,' reads his farewell note, 'you must live as the jungle does.'[17]

Wyndham's moment in the sun was surprisingly short. His four most popular novels were all published in just six years in the mid-1950s, and although he enjoyed a last hurrah with *Chocky* in 1968, he died a year later. Yet even Brian Aldiss, hardly an uncritical admirer, concedes that his 'importance in the rebirth of British science fiction after the Second World War was second to none', while his influence on cinema and television can hardly be overstated. It was Wyndham who, after years of neglect, reintroduced science fiction to a mass, mainstream readership. It was Wyndham, too, who effectively laid down the template for the post-apocalyptic stories in which British science fiction has specialized ever since, with their familiar scenes of deserted cities, terrified survivors and rural sanctuaries. Crucially, it was also Wyndham who really established the *tone* of British science fiction: realistic, believable and quietly unsettling, trading, in Christopher Priest's words, in 'the odd rather than the fantastic, the disturbing rather than the horrific, the remarkable rather than the outrageous'. It is true, of course, that Wyndham borrowed liberally from H. G. Wells, but there are a lot worse fates than to be Wells's literary heir. Indeed, among general audiences, his influence was probably outstripped only by the science-fiction screenwriter Nigel Kneale, whose *Quatermass* serials drove millions of viewers behind the sofa during the 1950s. It was not surprising, therefore, that when the BBC began to explore the possibility of making more science fiction a few years later, one of Wyndham's books seemed the obvious choice. By this stage, however, the prime candidate, *The Midwich Cuckoos*, had already been adapted for the cinema. So, inspired by Wells's book *The*

Time Machine, the BBC began to work on their own project instead. This was *Doctor Who*.[18]

THE CHRONIC ARGONAUT

It's been jolly interesting, wouldn't you say? Most of the corpses around here are jolly dull. Now I've got a couple of inscrutable Chinks and a poor perisher who was chewed by a giant rat, having been stabbed by a midget.

Professor Litefoot, in *Doctor Who*,
'The Talons of Weng-Chiang' (1977)

As most historians readily admit, the past could easily have been very different. If the Anglo-Saxons had been armed with atomic bazookas in 1066, then they could easily have obliterated Harald Hardrada's marauding Vikings before they even reached Stamford Bridge, thereby freeing King Harold to wipe the floor with the Normans at the Battle of Hastings. Similarly, had King John been replaced by a shape-shifting robot, then he might have been deposed long before Runnymede and Magna Carta in 1215. On the other hand, some of history's greatest mysteries have surprisingly simple explanations. Palaeontologists have long argued, for example, about what happened to the dinosaurs. The answer is that they were wiped out by a crashing space freighter, which was meant to destroy an interstellar summit in the far future but ended up being thrown backwards in time. Classicists, meanwhile, love to debate the accuracy of Homer's account of the Trojan War. But the war really happened, and Odysseus got the idea for the wooden horse from a visiting time traveller – the same man who later gave the Emperor Nero the idea for burning down Rome in AD 64. Another famous con-flagration, the Great Fire of London in 1666, was started by exploding equipment belonging to a group of alien reptiles. The mystery of the *Mary Celeste* in 1872 is no mystery at all: the crew jumped overboard because they were terrified by the unexpected appearance of some Daleks. Queen Victoria's suspected haemophilia was actually a mild form of lycanthropy, which she contracted from a rampaging werewolf. Even the mystery of Agatha Christie's disappearance in December 1926 is easily solved. Far from fleeing her adulterous husband, she was,

Exterminate! A suitably wide-eyed Tom Baker poses with the Doctor's deadliest adversaries outside BBC Television Centre, 1975.

in fact, suffering amnesia after the collapse of her telepathic link with an alien wasp.

Such, at any rate, is history according to the most celebrated television series Britain has ever produced, now more than half a century old. When *Doctor Who* was first broadcast in the autumn of 1963, not even its creators could have imagined that it would become such a fixture of the modern British imagination. Even though it was made by the BBC's drama department, the audience was always dominated by children, which meant that it never enjoyed the respectability of more serious programmes that are now almost completely forgotten. Yet, by the end of 2014, the show's various producers had told more than 250 discrete stories over some 813 individual episodes, a record unmatched by any other television drama series. Only *Coronation Street* has been running longer; the difference, though, is that while life in Weatherfield follows a tried and tested, indeed utterly predictable, template, *Doctor Who*'s format changes at least every few weeks. No comparable series has ever told such an eclectic variety of stories, from jolly historical comedies and thrilling space adventures to quirky morality tales and tub-thumping political allegories. 'You change everything, all the time,' remarked Steven Moffat, the show's chief creative force during the 2010s, unconsciously sounding like one of John Wyndham's Darwinist heroes. '*Doctor Who* is about change. Change is part of *Doctor Who*'s formula. It must change.'[19]

From a historian's point of view, the combination of *Doctor Who*'s longevity and its emphasis on change makes it an almost unparalleled social and cultural barometer, dutifully following the course of liberal middle-class opinion from the 1960s to the present. Many early stories – most obviously 'The Dalek Invasion of Earth' (1964), in which the Doctor's adversaries overrun and occupy twenty-second-century London – were haunted by memories of the Second World War. Very quickly, however, the look and tone began to change, constantly evolving to reflect the preoccupations of the day. So when the Cybermen attack London in 'The Invasion' (1968), the Doctor and his friends rely not on a hard-bitten band of resistance fighters, as in the earlier story, but on a painfully trendy Swinging London-style dolly bird, while the same year's 'The Mind Robber', in which the TARDIS falls into the Lewis Carroll-like Land of Fiction, is as striking an example of late-Sixties psychedelia as you could hope to find.

Indeed, many of the show's best-remembered stories have captured the political and aesthetic obsessions of a particular moment. During Jon Pertwee's reign as the Doctor from 1970 to 1974, the show not only attacked the legacy of European colonialism ('The Mutants'), but twice visited the planet Peladon to deliver earnest allegorical lectures about contemporary politics, namely the debate about joining the European Community ('The Curse of Peladon') and the importance of settling with Britain's striking miners ('The Monster of Peladon'). Pertwee's most celebrated story, though, was probably 'The Green Death' (1973), remembered by a generation as 'the one with the maggots'. But it is also a prize specimen of the eco-friendly earnestness of the day, pitting a hippyish commune of long-haired, lentil-loving scientists ('Wholeweal') against a multinational corporate giant called Global Chemicals. And even in the twenty-first century, the series often wears its *Guardian*-letters-page politics very obviously on its sleeve. In twenty-first-century *Doctor Who*, multinational corporations are usually fronts for wicked conspiracies, while politicians tend to be self-deluding dupes or alien impersonators. The media, inevitably, are controlled by a giant slug.[20]

What has certainly changed, though, is *Doctor Who*'s status within the BBC and indeed within British popular culture more generally. When I started watching the series, genuinely cowering behind the sofa in terror as the Marshmen rose from the swamps of Alzarius in October 1980, it was generally regarded with a kind of amused derision, commensurate with its reputation as a clever but ultimately silly children's programme.* In stark contrast with today's multi-million-pound phenomenon, the series had a relatively small budget, appeared with very little fanfare and was made virtually on the hoof. Indeed, by comparison with much better funded ITV series such as *The Avengers* or *The Prisoner*, the first episodes of *Doctor Who* often look more like some long-forgotten serial from the 1930s than a beloved classic of the 1960s. For all their ingenuity, many of the early episodes now seem comically badly made, with booms lurching madly into shot, cameras crashing

* When, many years later, I watched this story for the first time since 1980, I was shocked and embarrassed to see not the grittily realistic, deeply disturbing material imprinted on my childhood memory, but a gaggle of extras in bubble-wrap suits, lurching very, very slowly towards the camera. As the show's then producer notoriously remarked, 'the memory cheats' . . .

into bits of set and crew members coughing and spluttering in the background. Meanwhile, the first Doctor, William Hartnell, was notorious for garbling or forgetting his lines, which means that some exchanges are literally laughable. 'The Daleks', he warns seriously in one episode, 'will stop at *anything* to prevent us!' His best moment, however, came when he tried to warn his first companions, the schoolteachers Ian and Barbara, about the dangers of borrowing a Dalek time machine. 'You'll end up as a couple of burnt cinders floating around in Spain,' he begins, evoking an irresistible image of the two teachers, suntanned almost beyond recognition, drifting around the fleshpots of the Costa del Sol. Alas, a moment later, Hartnell realizes his mistake. 'In, er, space!'*

Doctor Who was born at an unusual moment in the BBC's history. Television had become a mass phenomenon in the mid-1950s, but the corporation initially struggled to compete with its advertising-funded rival, ITV, which had no qualms about attracting audiences with a populist diet of quiz shows and American imports, as well, of course, as *Coronation Street*. In an attempt to overhaul its fusty, Reithian image, the BBC poached the Associated British Corporation's head of drama, the Canadian-born Sydney Newman, formerly *Armchair Theatre*'s kitchen-sink supremo.

Although his name is now largely forgotten, this colourful, mustachioed Canadian was an excellent example of the unsung heroes – 'facilitators', in today's jargon – without whom British popular culture would never have been so successful. When he arrived at the BBC at the end of 1962, his chief priority was to drag the corporation's drama output into the new decade, tackling contemporary subjects such as the impact of affluence, the pressures of modern family life and the growing controversies over sexual and religious morality. 'Look back not in anger, nor forward in fear, but around with awareness,' read a card he sent to all his BBC producers. But Newman faced more mundane challenges, too. One was to find a drama programme to bridge the gap between the BBC's Saturday-afternoon sports flagship, *Grandstand*, and its teenage pop-music show, *Juke Box Jury*. 'The problem was, as I saw it, that it had to be a children's programme and still attract adults and teenagers,' he later reflected. 'And also, as a children's programme,

* There is an entire website devoted to the show's bloopers at www.timelash.com/bloopers/.

I was intent upon it containing basic factual information that could be described as educational – or, at least, mind-opening for them.'[21]

As it happened, the BBC had been mulling over a possible idea for several months before Newman's arrival. In the spring of 1962 the drama department had commissioned an internal report on the potential of science fiction on television. The report's authors, Alice Frick and Donald Bull, did not have much to go on. So far there had been very little televised science fiction at all, with the notable exceptions of Nigel Kneale's *Quatermass* serials. Not surprisingly, therefore, their report was extremely cautious. The appeal of the *Quatermass* stories, they thought, lay 'in the ironmongery – the apparatus, the magic – and in the excitement of the unexpected'. But audiences were 'as yet not interested in the mere exploitation of ideas'. What they wanted was old-fashioned human interest.

> As a rider to the above, it is significant that SF is not itself a wildly popular branch of fiction – nothing like, for example, detective and thriller fiction. It doesn't appeal much to women and largely finds its public in the technically minded younger groups. SF is a most fruitful and exciting area of exploration – but so far has not shown itself capable of supporting a large population . . .
>
> This points to the need to use great care and judgement in shaping SF for a mass audience. It isn't an automatic winner . . .
>
> For the present we conclude that SF TV must be rooted in the contemporary scene, and like any other kind of drama deal with human beings in a situation that evokes identification and sympathy.

The one writer whom Frick and Bull singled out as a model was John Wyndham, the master of 'the broad mid-section of SF writing', which they defined as the 'Threat and Disaster school'. This, they thought, was the kind of science fiction most appealing to a wide, non-nerdy audience. But 'Wyndham's books were studied in the Department on an earlier occasion, and we decided that with one exception they offered us nothing directly usable on TV'. The exception was *The Midwich Cuckoos*. Unfortunately MGM had already released a film version, *Village of the Damned* (1960), which meant it was now impossible for the BBC to get the rights.[22]

In the next twelve months, *Doctor Who* began to take shape. Indeed, it was that very rare beast: a brilliant idea designed by committee. In July 1962 a second BBC report suggested that any science-fiction series

should at all costs avoid 'Bug-Eyed Monsters' and 'Tin Robots'. The authors, Alice Frick and John Braybon, thought that 'two types of plot are reasonably outstanding, namely those dealing with telepaths ... and those dealing with time travelling ... This latter one is particularly attractive as a series, since individual plots can easily be tackled by a variety of script-writers; it's the *Z Cars* of science fiction.' Then, as is often the way at the BBC, nothing happened for months. But on 26 March 1963, with Sydney Newman casting about for a series to follow *Grandstand*, Frick and Braybon had a meeting at Television Centre with the Head of Serials, Donald Wilson, and a BBC staff writer called C. E. ('Bunny') Webber.* They discussed alternatives to the time-travel idea: Frick liked the thought of a flying saucer, 'a more modern vehicle than a time machine', while Braybon favoured 'a world body of scientific trouble-shooters, established to keep scientific experiments under control'. But evidently Donald Wilson preferred the time machine. 'It should be a machine', the minutes recorded, 'not only for going forward and backwards in time, but into space, and into all kinds of matter (e.g. a drop of oil, a molecule, under the ocean, etc.).' Here was the genesis of perhaps the most celebrated machine in all British fiction: the Doctor's TARDIS.[23]

Over the next few weeks, Bunny Webber tried to turn these rather vague ideas into something resembling a viable television series. His first attempt, a show called 'The Troubleshooters', was a false start, although his suggested characters – a 'handsome young man hero', a 'welldressed heroine aged about 30' and a 'maturer man, 35–40, with some "character" twist' – pointed in the right direction. But by early May 1963, under Newman's guidance, he had come up with something loosely resembling *Doctor Who*. There should, he suggested, be four main characters:

BRIDGET (BIDDY) A with-it girl of 15, reaching the end of her Secondary School career, eager for life, lower-than-middle class. Avoid dialect, use neutral accent laced with latest teenage slang.

* Nothing captures the sense of a bygone era, of course, better than poor Webber's nickname. But how could he have known that it would make it impossible for future generations to take him seriously?

| MISS MCGOVERN (LOLA) | 24. Mistress at Biddy's school. Timid but capable of sudden rabbit courage. Modest, with plenty of normal desires. Although she tends to be the one who gets into trouble, she is not to be guyed: she also is a loyalty character. |
| CLIFF | 27 or 28. Master at the same school. Might be classed as ancient by teenagers except that he is physically perfect, strong and courageous, a gorgeous dish ... |

These are the characters we know and sympathise with, the ordinary people to whom extraordinary things happen.* The fourth basic character remains always something of a mystery, and is seen by us rather through the eyes of the other three ...

| DR. WHO | A frail old man lost in space and time. They give him this name because they don't know who he is. He seems not to remember where he has come from; he is suspicious and capable of sudden malignance; he seems to have some undefined enemy; he is searching for something as well as fleeing from something. He has a 'machine' which enables them to travel together through time, through space, and through matter. |

Webber's initial thought was that the Doctor's machine should be invisible, 'a shape of nothingness'. Newman did not like this at all. 'Not visual. How to do?' he scrawled on the memo. 'Need tangible symbol.' So Webber had another go at the machine. 'When first seen, this ship has the appearance of a police telephone box standing in the street, but anyone entering it finds himself inside an extensive electronic contrivance,' he suggested a few weeks later. 'Though it looks impressive, it is an old beat-up model which Dr. Who stole when he escaped from his own

* Biddy, Lola and Cliff evolved into the Doctor's first three companions: his granddaughter Susan and her teachers, Barbara Wright and Ian Chesterton.

galaxy in the year 5733; it is uncertain in performance; moreover, Dr. Who isn't quite sure how to work it, so they have to learn by trial and error.'

This, of course, is pretty much exactly the same machine that appears on Saturday evenings today. In other respects, though, the initial plan for *Doctor Who* was strikingly different from the formula that has endured for more than fifty years. In Bunny Webber's plan, the character is not 'the Doctor'; he is 'Dr. Who'. The series is named after him, but he is very far from being the central character. He is an enigma, seen through the eyes of Biddy, Lola and Cliff, the real heroes of the story. In Webber's first draft, he is a scientist from the future, who stole his time machine in order to search 'for a society or for a physical condition which is ideal, and having found it, to stay there'. (This is all a bit bizarre; you can see why Newman demanded a rewrite.) In the second draft, Webber adds that Dr Who is 'about 650 years old'. He is 'frail looking but wiry and tough like an old turkey', while 'his watery blue eyes are continually looking around in bewilderment and occasionally a look of utter malevolence clouds his face as he suspects his earthly friends of being part of some conspiracy'. This seems a very long way from the character played by David Tennant or Matt Smith; there are, of course, superficial resemblances, but nobody could seriously argue that Smith's Doctor is even vaguely malevolent.

And evidently Webber envisaged a very different tone from the teatime terrors that generations of British children came to know so well. 'Was it by means of Dr. Who's machine that Aladdin's palace sailed through the air?' he wonders. 'Was Merlin Dr. Who? Was Cinderella's Godmother Dr. Who's wife chasing him through time? Jacob Marley was Dr. Who slightly tipsy, but what other tricks did he get up to that Yuletide?' Newman did not like this at all ('silly and condescending'). He wanted stories, he scribbled, that were based on 'educational experience – drama based upon and stemming from factual material and scientific phenomena and actual social history of past and future'. To put it another way, while Webber envisaged *Doctor Who* as a comic fairytale, Newman wanted something much more didactic, even Reithian. What neither of them really wanted, ironically, was melodramatic science fiction. Newman was adamantly opposed to 'Bug-Eyed Monsters', while Webber's formula explicitly stated: 'We are not writing Science Fiction'. No doubt this explains why he was so

reluctant to show the time machine; it smacked too much of science fiction.[24]

If *Doctor Who* had been made along the lines agreed by Newman and Webber, it would probably have died relatively quickly. So it was enormously fortunate that in the 27-year-old Verity Lambert – then not merely the BBC's youngest drama producer, but its only *female* drama producer – Newman appointed somebody with the backbone to ignore his advice. Contrary to Webber's blueprint, Lambert borrowed freely from the science-fiction canon, and contrary to Newman's instructions, she heavily promoted both 'Tin Robots' and 'Bug-Eyed Monsters', with the Daleks appearing in the series' second story. The interesting thing, though, is that despite Lambert's modernity – as a young Jewish woman, she could hardly have been a more visible symbol of the changes sweeping through the BBC in the early 1960s – she remained loyal to some elements of the original plan. The most obvious was the Doctor himself. To play the titular role, Lambert cast the character actor William Hartnell, who specialized in playing small-town heavies or gruff sergeant-major types. Hartnell was only 55, but he played the Doctor as a distinctly elderly man, aided by a flowing white wig. As per Webber's plan, Hartnell started off emphasizing the character's blend of 'bewilderment' and 'malevolence'. Indeed, in the show's untransmitted pilot episode, Hartnell often appears distinctly aggressive. But the rough edges rapidly disappeared, and the Doctor settled down to become an eccentric, distracted but essentially kindly figure. There was a simple but revealing tweak to his costume, too. In the untransmitted pilot, Hartnell wears an ordinary dark suit and tie; in the version that went out on Saturday 23 November 1963, however, he wears a long frock coat, waistcoat and flowing necktie. The effect is to turn him from an unsettling contemporary figure into a recognizable stereotype, the late Victorian or Edwardian gentleman inventor or explorer. And this, when you strip away a lot of the ersatz rubbish about Gallifrey and the Time Lords, is what the Doctor has remained: the direct descendant of the mysterious, anonymous Time Traveller in H. G. Wells's novel *The Time Machine*.[25]

Doctor Who's debt to *The Time Machine* is so obvious that it seems barely worth pointing it out. The BBC's audience research report on the opening episode, 'An Unearthly Child', mentioned it in the very first sentence, quoting a 'retired Naval Officer' who had described the show as

a 'cross between Wells' Time Machine and a space-age Old Curiosity Shop, with a touch of Mack Sennett comedy'. Since we are always being told how thrillingly modern *Doctor Who* was, this old salt's views come as a refreshing tonic. It was, he told the BBC, 'in the grand style of the old pre-talkie films to see a dear old Police Box being hurtled through space and landing on Mars or somewhere. I almost expected to see a batch of Keystone Cops emerge on to the Martian landscape.'

And it is hard to resist the suspicion that, during the first few weeks of *Doctor Who*, many older viewers must have experienced not the shock of the new, but the comfort of the familiar. Wells's Time Traveller, like Hartnell's Doctor, is eccentric, intelligent, wilful, reckless, but ultimately good-natured. We first meet the Time Traveller in a late Victorian dining room, his grey eyes gleaming in the light from the fireplace, and the scene when we first meet the Doctor is not as different as it might seem. When his uninvited guests, Ian and Barbara (no longer Cliff and Lola), burst into the TARDIS, they are shocked by its futuristic modernity. But we also glimpse its typically Victorian furniture: a carved wooden plant stand, an elegant ormolu clock, a heavy mahogany chair – the kind of things that would have seemed entirely natural in the Time Traveller's dining room.[26]

The TARDIS itself, too, has a distinctly Victorian lineage. Wells's first stab at a time machine, the contraption in his short story 'The Chronic Argonauts' (1888), is 'a peculiar erection of brass and ebony and ivory'. By the time he reworked the story as *The Time Machine*, seven years later, it had evolved into a kind of bicycle, reflecting the extraordinary public impact of the 'freedom machine', as it was nicknamed, in the mid-1890s. But just as Wells's machine has something of the mundane about it, so too does the TARDIS: a battered blue police box, hiding an unimaginable secret. At the time, the idea of a gateway to the beyond, hidden in the world of the everyday, would naturally have made many viewers think of the wardrobe in C. S. Lewis's fantasy *The Lion, the Witch and the Wardrobe*, which had been published in 1950. When I first watched *Doctor Who* at the end of the 1970s, I immediately thought of the mysterious costume shop in the television series *Mr Benn* (1971–2), inside which the hero invariably finds the door that 'leads to an adventure'. But Wells had already used a similar device in his short story 'The Door in the Wall' (1906). In this story, the hero finds an ordinary green door, almost unnoticed amid the hustle and bustle of late

Victorian London, through which he passes into 'a world with a different quality, a warmer, more penetrating and mellower light, with a faint clear gladness in its air, and wisps of sun-touched cloud in the blueness of its sky'. Whether this mysterious door is a gateway to heaven, or, as the narrator suggests in the story's final lines, a portal to 'darkness, danger and death', remains ambiguous. The same, I suppose, might be said of the scuffed blue door of the TARDIS, especially for the unfortunate minority of the Doctor's companions who come to a sticky end.[27]

Wells's influence is also very marked when it comes to *Doctor Who*'s other lasting contribution to British cultural iconography: the Daleks. Whether *Doctor Who* would ever have caught on without them is doubtful. The first story had been reasonably promising, attracting around 6 million viewers; after the second story, 'The Daleks', audiences jumped to more than 10 million. The machines' creator, the screenwriter Terry Nation, was always a bit vague about his inspirations, identifying them both as the Nazis and as simply 'Them ... them as government, as officialdom, as that unhearing, unthinking, blanked-out face of authority that will destroy you because it *wants* to destroy you'. But as the historian James Chapman observes, the original synopsis for the story rather downplays the Daleks. Nation's initial plan was to write a story about a 'world ruined by a "Neutron bomb"' and now inhabited by two races, 'the first living in an underground city, protected by anti-radiation suits, and the second living miserably in the petrified forest among lifeless plants and crystallised flowers'. The plot would see 'the Travellers' becoming involved in this life-or-death struggle between the two races, 'the beauty and grace of one unevenly matched against the brilliant intelligence but malignant evil of the other'.[28]

This is classic early-Sixties post-apocalyptic stuff, bearing the heavy imprint of the Cold War. Nation's biographer, Alwyn Turner, points out that he was writing not merely in the aftermath of the Cuban Missile Crisis, but at the very moment when the superpowers were signing the first nuclear test ban treaty. Indeed, the promise of détente after years of confrontation even made it into Nation's original storyline, which envisaged that, in the final episode of the serial, the Doctor would discover that the Daleks and the Thals had originally been tricked into war by some alien third party, leaving the two bitter enemies to clasp hands (or rather, hand and sink plunger) and get on with rebuilding their planet. Fortunately this rather drippy ending was rapidly jettisoned,

freeing the Daleks to become the most popular monsters in British television history.[29]

Like many bright children growing up before the Second World War, Terry Nation, who had been born in Cardiff in 1930, was an enthusiastic admirer of H. G. Wells, John Buchan and Rider Haggard. His stories for *Doctor Who* drew liberally on these childhood favourites, and on Wells in particular. The basic set-up of 'The Daleks' is closely modelled on *The Time Machine*'s vision of the earth in the year 802701, with Nation's pacifist, forest-dwelling Thals standing in for the gentle Eloi, and the predatory Daleks for the subterranean Morlocks. Of course the Daleks look nothing like the Morlocks, although the names are not entirely dissimilar. But they do look very like the Martian invaders in *The War of the Worlds*. The moment when the first Martian emerges on Horsell Common is one of the great set pieces in all popular fiction, even more chilling than the first appearance of the Daleks:

> I think everyone expected to see a man emerge – possibly something a little unlike us terrestrial men, but in all essentials a man. I know I did. But, looking, I presently saw something stirring within the shadow: greyish billowy movements, one above another, and then two luminous disks – like eyes. Then something resembling a little grey snake, about the thickness of a walking stick, coiled up out of the writhing middle, and wriggled in the air towards me – and then another . . .
>
> Those who have never seen a living Martian can scarcely imagine the strange horror of its appearance. The peculiar V-shaped mouth with its pointed upper lip, the absence of brow ridges, the absence of a chin beneath the wedgelike lower lip, the incessant quivering of this mouth, the Gorgon groups of tentacles, the tumultuous breathing of the lungs in a strange atmosphere, the evident heaviness and painfulness of movement due to the greater gravitational energy of the earth – above all, the extraordinary intensity of the immense eyes – were at once vital, intense, inhuman, crippled and monstrous.

Wells was very good at monsters: his fiction is full of images of hideously swollen ants, crabs, octopuses and the like, the stuff of every child's nightmares. His Martians are cut from the same cloth: chillingly, skin-crawlingly inhuman, but unarguably organic. Contrary to the impression given by most illustrations, they are not robots. But neither are the Daleks. In his first treatment, Nation described the Dalek as a

'frog-like animal' living inside a metallic travel machine, and although they now look more like octopuses, their basic design has remained remarkably consistent ever since.[30]

Both the Martians and the Daleks represent that quintessential Wellsian obsession, the triumph of evolution. The Martians appear to have evolved naturally over time. But the Daleks, as we discover in Nation's story 'Genesis of the Daleks' (1975), were engineered by the scientist Davros, who accelerated evolution to produce the 'final mutational form', with all traces of conscience and compassion removed. Both species can communicate telepathically, and both are supremely efficient. The Martians, says Wells's narrator, have 'little or no sense of fatigue' and can work for twenty-four hours without sleep. 'They were heads – merely heads. Entrails they had none. They did not eat, much less digest. Instead, they took the fresh, living blood of other creatures, and *injected* it into their own veins.' Much of this is true of the Daleks, too, except for the bit about the blood. And although the Martians could hardly appear more physically horrific, Wells explicitly refuses to pass an easy moral judgement. Life, says his narrator, is an 'incessant struggle for existence' (that theme again!):

> Before we judge of them too harshly we must remember what ruthless and utter destruction our own species has wrought, not only upon animals, such as the vanished bison and the dodo, but upon its inferior races. The Tasmanians, in spite of their human likeness, were entirely swept out of existence in a war of extermination waged by European immigrants, in the space of fifty years. Are we such apostles of mercy as to complain if the Martians warred in the same spirit?[31]

This, as we have seen, was the underlying theme of John Wyndham's books in the 1950s, and it is not really so different from the bleak message of books like *Lord of the Flies*. In a fallen world, where species battle unendingly for survival, we are all killers. As Nigel Kneale's Professor Quatermass remarks in a slightly different context in *Quatermass and the Pit*: 'We are the Martians.'

And although *Doctor Who* rarely develops this idea with similar force, it is always there, half-buried beneath the surface. Look, for instance, at the speech that Terry Nation gives to the Daleks' creator in 'Genesis of the Daleks'. 'They are conditioned simply to survive,' says Davros. 'They can survive only by becoming the dominant species.

When all other life forms are suppressed, when the Daleks are the supreme rulers of the universe, then you will have peace. Wars will end. They are the power not of evil, but of good.' The Doctor, needless to say, is having none of it. Yet time after time, especially in the twenty-first century, the series has returned to the Wellsian idea that the Daleks merely exhibit, in exaggerated form, mankind's well-documented thirst for mastery, conquest and killing. Indeed, in the frankly shoddy episodes 'Daleks in Manhattan' and 'Evolution of the Daleks' (2007), the aliens try to improve themselves by creating Dalek–human hybrids. 'We must adapt to survive,' explains their leader. They choose to borrow from humanity not merely because mankind is history's great survivor, but because humans are so similar to Daleks. 'I feel everything we wanted from mankind, which is ambition, hatred, aggression and war – such a genius for war,' says the new hybrid, the effect only slightly spoiled by the fact that we are watching a man in a suit with a rubber squid on his head. 'At heart this species is so very – *Dalek*!'

There were very good reasons for *Doctor Who* to rely so heavily on Wells for inspiration. The themes of *The Time Machine*, *The War of the Worlds* and *The Island of Doctor Moreau* – the dangers of technology, the power of nature, the thrill of experimentation, the fear of invasion, the boundaries between man and animal, the desire to play God – have barely dated at all. Indeed, in many ways they seem just as powerful today as they did in the 1890s. And deep down, what made the BBC's new time-travel show so successful was its ability to repackage these themes for a broad national audience, within the context of a crowd-pleasing, child-friendly melodrama. Dedicated science-fiction buffs sometimes complain that *Doctor Who* is not 'real' science fiction, but this is to miss the point. Right from the beginning, the series has always been at its best when it has stuck most closely to its late Victorian inspirations: the scientific romances of authors such as Wells and Conan Doyle, an intoxicating blend of adventure stories, exploration narratives, scientific parables and Gothic shockers, written for the newly literate nineteenth-century masses. And for a series that often looks like the purest escapism – a trip to a space station in the year 5 billion; an excursion to Mexico in the last days of the Aztecs; a jaunt to Provence to meet Vincent van Gogh – it has always adhered to the formula that Wells invented and Wyndham perfected: the combination of the everyday and the extraordinary, the mundane and the fantastic. The third

Doctor, Jon Pertwee, put it best. Outer space, Pertwee told an interviewer, was all very well. But nothing frightened an audience more than finding 'a Yeti on your loo in Tooting Bec'.[32]

Even the Doctor himself, despite all his regenerations, remains a recognizably late Victorian figure, venturing out across the universe to comfort the helpless and confront the wicked: at once missionary, detective and adventurer, like Dr Livingstone, Sherlock Holmes and Allan Quatermain rolled into one. The debt to Wells's Time Traveller is obvious, but there is also, I think, more than a dash of Professor Van Helsing, the eccentric Dutchman in Bram Stoker's *Dracula*, who is introduced to us as follows:

> He is a seemingly arbitrary man, but this is because he knows what he is talking about better than any one else. He is a philosopher and a metaphysician, and one of the most advanced scientists of his day; and he has, I believe, an absolutely open mind. This, with an iron nerve, a temper of the ice brook, an indomitable resolution, self-command, and toleration exalted from virtues to blessings, and the kindliest and truest heart that beats – these form his equipment for the noble work that he is doing for mankind – work both in theory and practice, for his views are as wide as his all-embracing sympathy.

It is no accident that although the Doctor's costumes appear to vary wildly, he most commonly dresses in the kind of outfit that Holmes or Van Helsing might have favoured: a long, dark coat, a white shirt, a waistcoat and a pair of sensible crime-fighting shoes or vampire-hunting boots. It is surely no coincidence, either, that the only actor to have played the Doctor on film, Peter Cushing, not only played Sherlock Holmes in Hammer's *The Hound of the Baskervilles* (1959) but also played Van Helsing in the studio's endless versions of the Dracula story. Barely a year after surrendering his TARDIS key, Tom Baker, too, played Sherlock Holmes in the BBC serial *The Hound of the Baskervilles* (1982). And even Peter Capaldi, the current Doctor, has tried his hand at Sherlock Holmes, if only in a short sketch in 1995 in *The Alexei Sayle Show*.[33]

It would be easy to go through *Doctor Who*'s history, episode by episode, and point out the debts to Wells and his rivals. The idea of humanity evolving into two separate species, Eloi and Morlocks, for example, recurs again and again. In 'The Savages' (1966), the Doctor

and his friends land on an unnamed planet where the technologically advanced Elders prey on their supposedly savage cousins; while in 'Utopia' (2007), the last survivors of humanity are besieged by the bestial Futurekind, a tribe of grungy cannibals with lamentably ill-maintained teeth. 'It's feared they are what we will become, unless we reach Utopia,' one of the humans explains.* Since Wells spent so much of his career dreaming up one utopia after another, this feels pleasingly familiar. Alas, when the humans get to Utopia, it proves to be even bleaker than the vision of the last days of humanity in Wells's book *The Time Machine*. 'You should have seen it, Doctor. Furnaces burning. The last of humanity screaming at the dark,' says his arch-enemy, the Master.

Evolution then takes a chilling twist, with human beings turning into the Toclafane: cruel, capricious little heads, encased in metal flying machines. In essence, they are the Daleks all over again – as are the Cybermen, human beings who have gradually replaced flesh and blood with steel and plastic, removing all emotions and turning themselves into pitiless Darwinian survivalists. Indeed, a dedicated viewer of *Doctor Who* might well conclude that the series takes a remarkably bleak view of mankind, constantly presenting us with visions of human beings who have evolved or turned themselves into merciless, emotionless monsters. The Doctor himself refuses to believe it; he is always telling us how inventive and indomitable we are, waxing lyrical about our great qualities of pity and compassion. But he has not been watching his own series. Indeed, if human beings were really as virtuous as he believes, his adventures would have come to a grinding halt years ago.[34]

Doctor Who was far from alone in relying so heavily on the scientific romances of the nineteenth century. From Hammer horror films to space-age comics, from robots and cyborgs to mad scientists and alien empires, twentieth-century popular culture was steeped in the influence of Wells and his contemporaries. As a show with an exacting production schedule, limited resources and little time to experiment or develop new ideas, *Doctor Who* was always going to be heavily dependent on established stories and situations, which inevitably meant a lot of borrowing. This is not to say that the series remained trapped in the Victorian era: its gender politics, for example, would surely have struck Victorian viewers as outlandish or offensive, although the extravagantly

* Yes, I know: actually a Time Lord, the Master, but he doesn't know it at this stage.

promiscuous Wells would have probably rather enjoyed being locked in the TARDIS with some of the Doctor's more nubile companions. But it is striking that of all the time periods the series has visited, the Victorian era has been by far the most popular, from the lost Patrick Troughton story 'The Evil of the Daleks' (1967), in which the malevolent pepper-pots gatecrash a Victorian inventor's attempts to build his own time machine, to Peter Capaldi's debut episode 'Deep Breath' (2014), which sees a body-snatching cyborg prowling the streets of mid-Victorian London. In fact, whenever the TARDIS lands in the nineteenth century, the gas-lights flare, the fog hangs heavy and, in the shadows, a diabolical criminal prepares to strike. Even alien planets sometimes turn out to bear an uncanny resemblance to Victorian London. In 'A Christmas Carol' (2010), for example, the setting is a distant planet in the forty-fourth century; yet the aesthetic, complete with wing collars and street urchins, could hardly be more Dickensian.[35]

It is fitting, then, that the story that captures *Doctor Who*'s appeal better than any other is positively drenched in Victoriana. Broadcast in six parts between February and April 1977, 'The Talons of Weng-Chiang' plunges the Doctor and his companion, Leela, into the swirling fog of late Victorian London, a world of packed music halls, mysterious murders and disappearing women. Far from hiding its debts to Conan Doyle and his contemporaries, the story positively glories in them, and the result is a hugely entertaining pastiche of Sherlock Holmes, Jack the Ripper, *Dracula*, *The Phantom of the Opera* and Sax Rohmer's Fu Man-chu stories, with a bizarre science-fiction element thrown into the mix for good measure. The Doctor wears a deerstalker and Inverness cape; there is a housekeeper called Mrs Hudson; a ghost haunts the Palace Theatre; a Limehouse laundry is a front for a sinister Chinese cult; a ventriloquist's dummy turns out to be a bloodthirsty assassin; and there is even an oblique reference to the Giant Rat of Sumatra, the holy grail of Sherlock Holmes enthusiasts – portrayed, in this instance, by a frankly hilarious puppet. The villain, a combination of the Ripper, Moriarty and the Phantom, disguised as the Chinese deity Weng-Chiang, turns out to be one Magnus Greel, a war criminal from the far future, 'the infamous Minister of Justice, the Butcher of Brisbane'. 'How can you in the nineteenth century know anything of the fifty-first?' an incredulous Greel asks the Doctor. 'I was with the Filipino army', the time traveller says solemnly, 'at the final advance on Reykjavik.' This extraordinary

exchange sounds like the stuff of countless pulp science-fiction thrillers, but the fact that it is being delivered by two men dressed as Sherlock Holmes and a Chinese god in late Victorian London gives it a rich and strange flavour all its own. Perhaps only a show as eclectic as *Doctor Who* could get away with it.

And this really is the essence of *Doctor Who*'s appeal: its distillation of a century's worth of pulp fiction, scientific romances and adventure stories, gently sanitized for family viewing. Indeed, 'The Talons of Weng-Chiang' works rather well as a microcosm not merely of *Doctor Who* but of British popular culture itself. For all the cleverness of the script, which is stuffed with allusions to everything from *The Importance of Being Earnest* to *The Cabinet of Dr Caligari*, the emphasis is firmly on crowd-pleasing entertainment. At its peak the story attracted more than 11 million viewers, many of whom probably completely missed most of the allusions. But it is the density of those allusions that gives the story its richness and depth. And not only is it firmly rooted in the literature and music of the Victorian period, but its themes – the consequences of empire, the dangers of science, the horrors of war, the omnipresence of evil – are precisely those that have obsessed so many writers and artists in the last sixty years. It is just possible to imagine a French or American version of the same story, the former stranger and more cerebral, the latter flashier and more frenetic, but neither would have had the same appeal or been quite as fun. In fact, it is hard to think of any other country that could have produced a show such as *Doctor Who*, at once trivial and serious, sentimental and spine chilling, childishly silly and painfully earnest, unashamedly clever and yet unrepentantly populist. The scripts have sometimes been ropey, the acting eccentric and the special effects wildly over-ambitious. But there has, I think, never been a better window into the British imagination.

PART FOUR

Going to the Top

*British Culture and the Triumph
of the Self*

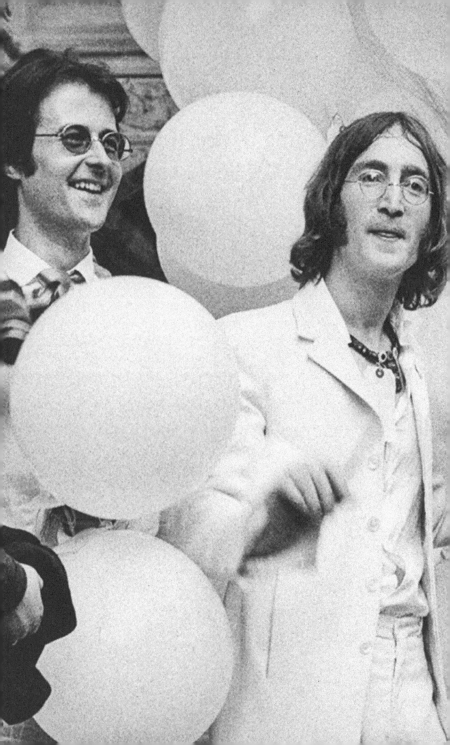

Previous pages: Modest and unassuming as ever, John Lennon and Yoko Ono arrive for the opening of Lennon's exhibition 'You Are Here' at the Robert Fraser Gallery, 1968.

I I

Working-Class Heroes

SELF-PORTRAIT OF A GENIUS

*People like me are aware of their so-called genius at ten, eight,
nine . . . I always wondered, 'Why has nobody discovered me?'*
John Lennon, interviewed in *Rolling Stone*,
4 February 1971

It is a chilling thought that, if one song defines our age, it may well be
John Lennon's ballad 'Imagine'. Written in the spring of 1971, not long
after the Beatles had formally split up, Lennon's utopian fantasy has
become one of the most immediately recognizable cultural products of
the last half-century. Again and again, polls and surveys have consist-
ently shown that few other songs have struck such a chord with so
many people. When, for instance, the BBC conducted a poll to find 'the
nation's favourite song lyric' in 1999, 'Imagine' was a clear winner,
prompting Lennon's widow, Yoko Ono, to declare herself 'choked up'
with pride. Three years later, another poll of some 30,000 people placed
it second behind 'Bohemian Rhapsody', but in 2005 a survey for Virgin
Radio saw Lennon's anthem return to the top spot. Overseas, too, few
songs rival its emotional hegemony. In January 2005 a poll by the Cana-
dian Broadcasting Company named it the greatest song of the previous
century, while a poll of Australians by Channel Nine produced the same
result. In the United States, meanwhile, the American rock bible *Rolling
Stone* proclaimed it the third greatest song of all time, behind '(I Can't
Get No) Satisfaction' and 'Like a Rolling Stone'. The song, said the
magazine in a gushing tribute, is 'an enduring hymn of solace and prom-
ise that has carried us through extreme grief, from the shock of Lennon's

A hoe-wielding John Lennon threatens – sorry, 'poses with' – his wife Cynthia and son Julian in their mansion in Weybridge, Surrey, 1964.

own death in 1980 to the unspeakable horror of September 11th. It is now impossible to imagine a world without "Imagine".[1]

In a world where there really were no possessions, it might be interesting to reprint the lyrics of 'Imagine' and subject them to close analysis. Alas, in an age sadly still oppressed by capitalist conventions such as copyright fees, the prospect of paying for another fur coat for Yoko Ono leaves me less than enthusiastic. But perhaps that is just as well, since there is really not very much to say. There are only three six-line verses, each based on a different idea: no religion, no countries, no possessions. Although the song's admirers often praise its romantic utopianism, its vision of an alternative future is entirely negative: no greed, no hunger, no this, no that. Perhaps it would be unforgivably literal-minded to point out that a world without religions, countries, possessions, war or hunger would, almost by definition, be a world without any human beings in it. The radio presenter Robert Elms surely had it right when, interviewed for an *Arena* documentary on the song in 2003, he suggested that 'Imagine' offered only 'the politics of the infants' school' and 'the sort of thing Miss World contestants say'.

Yet the things that Miss World contestants say – wishing for world peace, disdaining material ambition, waxing lyrical about small children and animals – are precisely what many people like to hear. That is, after all, why 'Imagine' is so popular. And it would be too easy to dismiss its listeners as gullible dupes, seduced by the adolescent whining of a country-house millionaire. The song has, after all, been picked some twenty-four times on *Desert Island Discs*, championed by an unlikely assortment of guests from the Labour politicians Neil Kinnock and Dennis Skinner to the actors Bob Hoskins and Christopher Reeve, the actresses Alison Steadman and Maureen Lipman, the poet Linton Kwesi Johnson and the zoologist Desmond Morris. The fact that all these people – highly intelligent, extremely successful, and some of them very well off – were so drawn to Lennon's vision speaks volumes about the enduring power of sentimental utopianism, however mawkishly expressed.[2]

Far more than any other rock star of his generation, and more even than his fellow Beatles, John Lennon is a figure of colossal symbolic importance. Nobody better embodies modern Britain's obsessions with identity and self-realization, our fealty to the cult of the individual. When he was murdered in December 1980, the outpouring of international mourning transcended even the ideological barriers of the Cold

War: while an estimated 100,000 people prayed for peace in New York's Central Park, Soviet police had to break up a demonstration of several hundred people in Moscow's Sparrow Hills park. More than twenty years later, a poll of some 400,000 people for the BBC's *Great Britons* programme placed Lennon eighth in the all-time list, ahead of such patriotic icons as Horatio Nelson, Oliver Cromwell, the Duke of Wellington and Alfred the Great. Indeed, even though the music Lennon recorded without the other Beatles has largely disappeared from view – who today listens to *Two Virgins* or *Double Fantasy*? – his reputation as a champion of rebelliousness and idealism remains undiminished. When Liverpool's Speke Airport was named after him in 2001, it was the first time an individual had given his name to a British airport. As usual, Yoko Ono was on hand with a quotation from 'Imagine': 'I hope the airport will send a great message to all corners of the world. As John said, there is no hell below us, above us only sky.' Lennon himself, who left Liverpool as soon as he could and spent the last decade of his life in New York, would have probably found the whole thing highly amusing. But critics who claimed that he had no connection with the airport were wide of the mark. As a teenager, Lennon had briefly held a summer job in the airport restaurant, where he used to spit in the cheese sandwiches.[3]

As a historical figure, what makes Lennon so interesting is that he embodied so many themes of Britain's social and cultural life in the decades after the Second World War. Born in October 1940, the son of a merchant seaman, he was brought up by his aunt and uncle in the unremarkable suburban neighbourhood of Woolton, Liverpool. Having passed his eleven-plus, he went to grammar school and then to art college, profiting from the new educational opportunities for the children of the war years. Like most of his peers, the young Lennon rarely travelled outside his home town: when the Beatles were offered their first residency in Hamburg in 1960, he had never been abroad and needed special dispensation to get his passport processed in time. At this stage, the first two decades of his life had been defined entirely by Liverpool: the suburban estates, the narrow terraces and the crumbling docks; the coffee bars, the church fetes and the dance halls; the green buses, the Mersey ferry and the creeping fog. Like so many British boys growing up in the 1950s, he had been obsessed with all things American: the films, the music, the fashions. As a teenager, he modelled himself on

Elvis Presley and James Dean, with their leather jackets and carefully greased hair. He was the embodiment of everything that J. Arthur Rank had been striving to prevent: a cynical, disaffected, violent young man, deliberately copying what he saw on the big screen. 'Not only did we dress like James Dean and walk around like that,' Lennon said later, discussing his rough treatment of his first girlfriends, 'but we acted out those cinematic charades. The he-man was supposed to smack a girl across the face, make her succumb in tears and then make love. Most of the guys in Liverpool thought that's how you do it.'[4]

But Lennon's journey through life was much stranger and more surprising than anything he had seen at the cinema. Within the space of barely three years – the time it took his contemporaries to finish their degrees – he was catapulted out of his class and his background. First came Hamburg, then Liverpool again, and then stardom. Lennon bought a mansion in the Surrey stockbroker belt; he went to the United States; he visited Australia, New Zealand and Hong Kong. He smoked cannabis with Bob Dylan; he went to Buckingham Palace to collect the MBE; he became obsessed with LSD. By now he had left suburban Liverpool far behind. With the other Beatles, Lennon travelled to Rishikesh in northern India to sit at the feet of the Maharishi Mahesh Yogi. He began living with a Japanese conceptual artist; he exhibited his artworks in a Mayfair gallery; he moved to New York; he became a heroin addict, a peace activist and a target of the FBI. Like his collaborator, friend and rival Paul McCartney, Lennon was eternally curious, but he was also extraordinarily restless, always moving on impatiently to the next phase. He was only 40 when he died, yet the second half of his life had been packed with so many incidents, so many issues and interests, that it felt like several stories packed into one: the poor boy made good, the dabbler in Oriental spirituality, the convert to Californian drug culture, the Englishman abroad.

In his move to the United States, his battles with the American authorities, his enthusiasm for drugs and his fascination with the East, Lennon recalled Charlie Chaplin and Aldous Huxley. The latter had appeared on the cover of *Sgt Pepper's Lonely Hearts Club Band*, and in March 1966, impressed by Huxley's mescaline experiments, Lennon had described him as 'the new guvnor'. In their different ways, Huxley and Lennon both left a deep imprint on the culture of the twentieth century. Huxley's prominence might perhaps have been predicted: educated at

Eton and Balliol, he was not only the grandson of the great Victorian biologist Thomas Huxley, 'Darwin's bulldog', but the great-grandson of Rugby's Dr Arnold. But whoever would have predicted that John Lennon, the grandson of a shipping clerk, educated at Quarry Bank High School, would leave such a mark? Perhaps only one man: Lennon himself. 'When I was about 12, I used to think I must be a genius, but nobody's noticed,' Lennon told *Rolling Stone* in late 1970. 'If there is such a thing as genius – which is what . . . what the fuck is it? – I am one, and if there isn't, I don't care.'[5]

Had Lennon not been such a talented songwriter, his belief in his own genius would have sounded like the ravings of a madman. His admirers like to remember him as a man of bracing cynicism and withering wit, forever debunking convention and deflating pretension. But when Lennon talked about himself and his talent he often seemed in deadly earnest. What distinguished his career, in fact, was not merely ability and self-belief, but a quite astonishing degree of self-absorption. Like many people who are devoted absolutely to themselves, he lived entirely in the present, with no patience for the pleasures of nostalgia. In an interview with *Playboy* only a few weeks before he died, he insisted that he only thought about the past 'inasmuch as it gave me pleasure or helped me grow psychologically. That is the only thing that interests me about yesterday. I don't believe in yesterday, by the way. You know I don't believe in yesterday. I am only interested in what I am doing now.' This was the mantra of self-sufficiency, self-fulfilment and self-help. But it also conformed remarkably accurately to the template of the romantic artist, the lone genius whose unique insight, sensitivity and imagination set him apart from the common herd. For Lennon, as for artists and intellectuals from Goethe and Byron to Wagner and Woolf, art was less about entertainment than about self-fulfilment, the aim being not to please the audience but to demonstrate his own moral and artistic superiority. In this respect the Beatles would never have been enough for him, because a self-styled artist could not possibly tolerate being merely one-quarter of the most successful group of all time.[6]

It is telling that, as the years went by, Lennon became ever more baffled and irritated by Paul McCartney's habit of writing songs about *other people*, which violated his conviction that great artists are only interested in themselves. 'He makes 'em up like a novelist,' Lennon said scornfully in 1980. 'You hear lots of McCartney-influenced songs on the

radio now. These stories about boring people doing boring things – being postmen and secretaries and writing home. I'm not interested in writing third-party songs. I like to write about me, 'cause I *know* me.' This was, on the face it, a remarkably solipsistic thing to say. Some of Lennon's admirers insist that this was merely Yoko Ono talking, and the great Beatles critic Ian MacDonald makes a persuasive case that, of all the 'dangerous ideas' with which the Japanese artist filled her husband's head, 'the most damaging was her belief that all art is about the artist and no one else'. But Lennon had always been a supreme individualist: a man apart, training to become high priest of the cult of the self. Even on his first day at Liverpool College of Art in September 1957, he had immediately stood out. 'Everyone was dressed the same,' one of his friends later recalled: 'navy blue, fawn or black duffel-coats, green polo-neck sweaters, and there was John Lennon striding around with a DA haircut, brothel-creepers, drape jacket. It was as if a Teddy Boy had walked in off the streets into this strange place where everyone else was dressed the same.' That was, of course, precisely the effect Lennon had wanted. 'I don't remember him being fired up by any particular artist,' another friend recalled: 'he was just *John*, sufficient being himself.'[7]

Much of Lennon's enduring appeal is based on his status as the quintessential outsider, the champion of the common man, thumbing his nose at the great and the good. After recording 'Working Class Hero' in the autumn of 1970, he told *Rolling Stone*'s Jann Wenner that he saw it as a 'revolutionary song ... for the people like me who are working class – whatever, upper or lower – who are supposed to be processed into the middle classes, through the machinery'. But this was pure self-mythologizing. Although Lennon's upbringing was a little unconventional – his father disappeared when he was five and his flighty mother handed him over to her sister and brother-in-law, Mimi and George Smith – it was hardly working-class. George Smith, a milkman and bookmaker, came from a family of dairy farmers. In the mid-1940s he and his wife had bought a semi-detached house in the middle-class suburb of Woolton, with an indoor bathroom, a telephone and even servants' bells. It was here, across the road from the Allerton Park golf course, that Lennon grew up. When, a few years later, the young Paul McCartney came to visit his new friend, he was immediately struck by the contrast with the council houses in which he had been raised. The Smiths had a bookcase containing Churchill's leather-bound histories of

the English-speaking peoples and the Second World War. They had pedigree cats. They had a relative who was a dentist. And their house even had a name: Mendips. 'That was very posh,' McCartney thought; 'no one had houses with names where I came from, you were numbers.'[8]

At the end of his life, Lennon himself freely conceded that his early life had been a long way from proletarian squalor. He had grown up, he told *Playboy*, 'in the suburbs in a nice semi-detached place with a small garden and doctors and lawyers and that ilk living around ... not the poor slummy kind of image that was projected in all the Beatles stories'. In class terms, he thought, 'it was about half a class higher than Paul, George and Ringo'. This was surely an underestimate, especially in the case of Ringo Starr, who grew up in a terraced house in the inner-city district of Dingle with his divorced mother, who worked as a cleaner and a barmaid. But there were good reasons for Lennon to downplay his relatively comfortable background. Although there have always been plenty of well-heeled rock stars – think, for example, of public schoolboys such as Peter Gabriel, Bruce Dickinson, Chris Martin and James Blunt – it is hard to present yourself as a suffering self-made artist if you grew up in a more expensive house than your fans.

British history is littered with examples of men and women from very humble backgrounds whose experience of poverty drove them to better themselves, from Richard Arkwright to Catherine Cookson. But Lennon's case was different. His thirst for self-reinvention and self-fulfilment was driven not by the experience of poverty but by the urges of his personality. It is tempting to point to his complicated family life, yet from a young age Lennon was brought up by kind, loving and financially comfortable relatives in a pleasant part of town. In 'Working Class Hero', he sang of the pain that comes when 'they make you feel small', the twenty-year torment of being 'tortured and scared', the suffering when 'they hit you at home and they hurt you at school'. But this was pure invention. In fact, Lennon's boyhood had been settled and loving. Far from making him feel small, his uncle, aunt and mother lavished attention on him, and by the standards of the day he was something of a spoiled child. ('This image of me as the orphan is garbage,' Lennon told *Playboy* in 1980, 'because I was well protected by my auntie and my uncle and they looked after me very well, thanks.') At school he hated and resented authority, but there is no evidence he was bullied or mistreated; if anything, he was the one doing the bullying. All in all, compared with, say, Charlie Chaplin, perhaps the only

twentieth-century Englishman who rivalled his worldwide popularity, he could scarcely have been better off. All his life, even at the height of his Hollywood fame, Chaplin had been driven by his memories of sleeping rough on the south London streets or in the Lambeth and Newington workhouses. But Lennon had no such memories. Nothing at home was pushing him to run away, except perhaps for the quiet suburban courtesies that so often irritate self-styled artists.[9]

The truth is that, from the very beginning, Lennon was a bad boy: disaffected, dissolute and idle, quick with his fists or with a cutting rebuke. By no stretch of the imagination was he a kind or sympathetic boy: even his most admiring biographers struggle to justify his cruel streak, his eagerness to taunt anybody different, his mockery of Jews and homosexuals, his weird obsession with dwarves and deformities. And although he showed flashes of irreverent, acerbic humour, he was simply too lazy to do well. After passing his eleven-plus – whatever else he was, he was certainly not an idiot – he soon plummeted to the bottom of his class. He briefly rallied, largely by bullying other boys into letting him copy their work, but by the age of 15 he had sunk to the foot of his grammar school's bottom stream. When, a year later, he first met Paul McCartney at the Woolton church fete, his bad-boy image was firmly established. To the young McCartney, Lennon seemed a thrillingly dangerous figure, a smoking, drinking, womanizing Teddy Boy, 'the fairground hero, the big lad riding the dodgems'. But it was little wonder that McCartney's father, Jim, saw it differently. 'He'll get you into trouble, son,' he warned grimly.[10]

It is tempting to wonder what might have become of John Lennon if he had been born only a decade or two earlier. His admirers will doubtless insist that his natural genius would always have found an outlet, but this seems very implausible. Unlike Paul McCartney, whose commitment to self-improvement was rooted in a ferocious work ethic, Lennon never had the self-discipline to sit down and work at something. Of course he was talented; that goes without saying. But he was also extraordinarily lucky. In the 1920s, a boy with his dire academic record – he failed all his O-levels, even art, which he was supposed to be good at – would have found it very difficult to get a decent start on the career ladder. And if he had been born only a few years earlier than in reality, he would have been called up for National Service, which would have probably torpedoed his musical career before it had even begun.

But it was Lennon's good fortune that the social and economic climate of the 1950s – grammar school and art college; full employment and summer jobs; dance halls, skiffle bars, record shops and rock music – gave him opportunities that he would never otherwise have enjoyed. Crucially, he reached the age of 20, which is when the Beatles first went to Hamburg, without ever having needed to get a proper full-time job. And then everything fell perfectly into place. Rising wages and technological change had created a new teenage-dominated market for the kind of music that Lennon liked and was good at. The recent development of television allowed him to reach a bigger audience than had previously been possible; the growth of air travel meant that he and his fellow Beatles could sell their wares to a genuinely global market; and the expansion of education gave him a willing and impressionable audience for his exhibitions of cultural and moral individualism. Even a decade or two earlier, almost none of this would have been possible.[11]

There is, of course, a popular argument that it was Lennon and his fellow Beatles who *created* this new world; that they effectively 'invented' the Sixties. But this strikes me as utterly unconvincing, rather like saying that Charles Dickens 'invented' the Victorian world of railways and magazines and circulating libraries. Had the Beatles not existed – had, say, Paul McCartney stayed away from the Woolton church fete in July 1957 – the story of the Sixties would been superficially different, but the underlying trends would have remained exactly the same. Some other British group would surely have seized public attention between roughly 1962 and 1964; some other band would have carried the Union Jack across the Atlantic; some other record company would have found a way of separating all those teenagers from all that money. It is true, of course, that the Beatles themselves became agents of change, promoting the popular fascination with soft drugs and Eastern religions, but there is at least a decent chance that somebody else would have played that role eventually.

By contrast, if Lennon and his colleagues had been born in 1910 or 1920, they would probably have remained in obscurity for the rest of their lives. Perhaps Paul McCartney would have become a teacher, as his father had always hoped. George Harrison might have followed his own father on to the Liverpool buses, while Ringo Starr might have stuck at his early job as a machinist. But Lennon remains a puzzle.

Perhaps it is a telling sign of the power of his image that while it is very easy to picture McCartney, Harrison and Starr pottering around the garden, doing the crossword puzzle on a Sunday or putting their feet up in front of the *Morecambe and Wise* Christmas special, the prospect of Lennon, say, working in an office is almost literally unimaginable.

But of course Lennon never had to face the realities of an ordinary working life. At an age when many young men of his era were barely out of university, he was already very rich indeed. By the time he was 25, he already owned a Rolls-Royce and a Ferrari. When he was filming *Help!* in Bond Street in the spring of 1965, the director asked him to run into Asprey's, the luxury jewellers, through one door and out through another. On the way, he contrived to spend some £600, the equivalent of about £20,000 today. A year later, when the *Evening Standard*'s Maureen Cleave visited the Weybridge house he shared with his wife Cynthia and their son Julian, she was struck by the unreal atmosphere of wealth and luxury. This was the interview in which Lennon made his infamous quip about the Beatles being 'more popular than Jesus'. But what is really revealing about it is his unashamed materialism:

The Weybridge community consists of the three married Beatles; they live there among the wooded hills and the stockbrokers. They have not worked since Christmas and their existence is secluded and curiously timeless. 'What day is it?' John Lennon asks with interest when you ring up with news from outside . . .

We did a speedy tour of the house, Julian panting along behind, clutching a large porcelain Siamese cat. John swept past the objects in which he had lost interest: 'That's Sidney' (a suit of armour); 'That's a hobby I had for a week' (a room full of model racing cars); 'Cyn won't let me get rid of that' (a fruit machine). In the sitting room are eight little green boxes with winking red lights; he bought them as Christmas presents but never got round to giving them away . . .

One feels that his possessions – to which he adds daily – have got the upper hand; all the tape recorders, the five television sets, the cars, the telephones of which he knows not a single number. The moment he approaches a switch it fuses; six of the winking boxes, guaranteed to last till next Christmas, have gone funny already. His cars – the Rolls, the Mini-Cooper (black wheels, black windows), the Ferrari (being painted black) – puzzle him. Then there's the swimming pool, the trees sloping

away beneath it. 'Nothing like what I ordered,' he said resignedly. He wanted the bottom to be a mirror. 'It's an amazing household,' he said. 'None of my gadgets really work except the gorilla suit – that's the only suit that fits me.'

It is worth emphasizing that Lennon showed not a hint of awkwardness when Cleave asked about his wealth. He was, he said proudly, 'famous and loaded'. Why did he want so much money? 'I want the money', he said, 'just to be rich. The only other way of getting it is to be born rich. If you have money, that's power without having to be powerful.' As he was talking, they were bowling through the countryside in his chauffeur-driven Rolls-Royce, complete with television, folding bed, telephone, writing desk and even a little fridge. When they got to London, he went to Asprey's and bought a giant games compendium. Then he went to Brian Epstein's office. 'Any presents?' he asked hopefully.[12]

This is not, of course, the John Lennon that his fans choose to remember. The real John Lennon, we are often told, was an artist, an idealist, an ascetic who disdained possessions and rejected the hypocrisies of the capitalist system. But this is nonsense. The real John Lennon had always craved money; the Beatles' most exhaustive chronicler, Mark Lewisohn, writes that Lennon's chief ambition was always 'to be rich', adding that 'John wanted money to avoid having to work'. For most of his early life, Lennon never showed the slightest hint of political idealism. As an art student, he never joined the Labour Party, or went on CND marches, or demonstrated against apartheid in South Africa. In fact, it was only after he had fulfilled his primary ambition, to become very rich indeed, that he began to indulge his artistic, political and spiritual enthusiasms. The turning point came in November 1966, when he met the Japanese conceptual artist Yoko Ono, whose works are mercifully beyond the scope of this book. And over the next three years, the two of them established the lasting image of Lennon the artistic idealist, from the much-mocked exhibition 'You Are Here' at the Robert Fraser Gallery in the summer of 1968 to the ludicrous spectacles of their bed-ins and bag-ins for peace a year later.[13]

Lennon and Ono routinely justified their attention-grabbing antics by insisting that they were designed to promote world peace, which had become a fashionable cause in the era of the Vietnam War. But, as almost everybody pointed out, this was obviously nonsense because

nothing they did advanced the cause of peace by so much as a millimetre. What they were interested in was not Vietnam but themselves. It is telling that their first bed-in for peace, which they staged during their honeymoon in March 1969, took place in the distinctly comfortable setting of the presidential suite in Amsterdam's Hilton Hotel. It was here that Ono shared with the world her plan to end the war in Indochina. American and Vietnamese troops, she said, should 'let their pants down. They would not feel like making war then – they would look ridiculous.' As Britain's bestselling paper, the *Daily Mirror*, pointed out, the only people who looked ridiculous were Lennon and Ono. They looked even more ridiculous the next day, when the hotel maid Maria de Soledade Alves, awkward and embarrassed in front of the cameras, had to turf them out of bed to change the sheets.[14]

By now Lennon and Ono had a taste for making themselves look absurd, although they never saw it that way. In May they staged a second bed-in for peace in Montreal, followed a few months later by a Hyde Park bag-in to protest against the hanging of James Hanratty in 1962.* Again, it is worth emphasizing that, far from being carefully planned to sway public opinion or change government policy, these antics could scarcely have been better designed to bring their respective causes into popular disrepute. They were, in fact, gigantic exercises in self-indulgence. When Lennon returned his MBE in November 1969, his letter to the Queen explained that he was protesting against 'Britain's involvement in the Nigeria-Biafra thing, against our support of America in Vietnam, and against Cold Turkey slipping down the charts'. No intelligent person could possibly have imagined that such a statement would change or impress public opinion. But that was beside the point, because Lennon and Ono were fundamentally not interested in what other people thought. Instead they withdrew ever further into a world of self-satisfied egocentricity, for instance by exhibiting a forty-two-minute film of Lennon's penis. With what was possibly unwitting aptness, they called it *Self-Portrait*.[15]

It takes a little effort to remember that at this stage Lennon was

* Hanratty had been hanged for the brutal kidnapping of a scientist and his mistress. The scientist was found dead in a lay-by on the A6, but his mistress, who had been raped, shot and left paralysed, survived. For years afterwards, Hanratty's supporters, led by the journalist Paul Foot, insisted on his innocence, but a DNA test in 2002 suggested that he had, after all, been guilty.

almost 30, while Ono was getting on for 40. They were not teenagers; they were grown adults with school-age children. Yet their guiding spirit remained an adolescent desire to shock their elders. When, in 1968, Lennon and Ono announced their plan to put their naked portraits on the cover of their album *Two Virgins*, a horrified Paul McCartney arranged a meeting for them with the head of EMI, Sir Joseph Lockwood. This was a very peculiar scene. In some ways Lockwood was like a younger version of J. Arthur Rank. Like Rank he came from a family of flour millers, having been born in 1904 in Southwell, Nottinghamshire, where his father ran a big local mill. Having left school at 16, he had worked in the family mill before moving to Chile, where he managed another mill. By the time Lockwood was 30 – the same age as the self-styled genius sitting across the desk – he had also managed a big mill in Belgium and was on the board of the Henry Simon mill empire, which he helped to build into the world's biggest flour-mill manufacturer. In the Second World War, Lockwood helped to produce and distribute food in liberated Europe, and in 1954 he joined EMI, which he turned into the biggest record firm in the world. The mind boggles at what this worldly businessman must have made of the lank-haired couple sitting opposite him. 'Well, aren't you shocked?' Lennon said. 'No, I've seen worse than this,' said Sir Joseph. 'So it's all right then, is it?' asked Lennon. 'No,' Sir Joseph said. What was the point of it? 'It's art,' said Yoko Ono. 'Well,' said Sir Joseph drily, 'I should find some better bodies to put on the cover than your two. They're not very attractive.' Then, with impeccable timing, he twisted the knife: 'Paul McCartney would look better naked than you.'[16]

On the surface, the confrontation between Lennon and Lockwood looks like a classic showdown between the champion of youthful rebellion and the incarnation of the stuffy old Establishment. In fact, the picture was rather more complicated: Lennon, after all, was not a teenager but a 29-year-old multi-millionaire, while Sir Joseph, despite his knighthood, was both Jewish and homosexual – two things that Lennon loved to mock. Still, the image of Lennon as the idealistic, free-thinking scourge of the Establishment is now indelibly imprinted on our collective consciousness. Indeed, the more the press ridiculed him, the more it added to his reputation as a man of lonely courage, victimized by the national newspapers. When, for instance, the *Mirror* mocked the Amsterdam bed-in as a 'daft, hairy and faintly ugh-inducing

charade', recoiling at the 'spectacle of two hairy hedonists spreading the gospel of peace as they "vibrate" all the way to the bank', or when *Time* magazine crowned him as one of the great bores of the age, a 'salvation-dispensing preacher for peace and porn', they were playing into Lennon's hands, strengthening his reputation as a misunderstood idealist defying the petty morals of conventional society.[17]

And this, of course, is the image that has endured. When in 2012 the *Guardian*'s art critic, Jonathan Jones, picked a photograph of Lennon as the 'iconic image of the second Elizabethan era', the picture showed the singer not in his Beatles pomp but lying beside his wife in the Amsterdam Hilton. And when the BBC asked the comedian Alan Davies to present a film about Lennon as part of its *Great Britons* series, the emphasis was firmly on the peace activist, not the schoolboy bully or the Weybridge millionaire. Lennon was, Davies told the *Liverpool Echo*, 'an icon of idealism, creativity and hope'. This was, and indeed is, a very popular view. 'John would get my vote', a local gallery owner told the paper, 'because of his ability to change the way the world thought about peace.'[18]

It was in this capacity, as a self-appointed prophet of world peace, that Lennon wrote 'Imagine'. The date was March 1971, and by now the Beatles had been defunct for eighteen months. Lennon himself called it an 'ad campaign for peace', but the song was very obviously inspired by Yoko Ono's little book of poems *Grapefruit* (1964), a surreal (and to my mind, artistically worthless) list of instructions such as 'Imagine the clouds dripping. Dig a hole in your garden to put them in', which was reprinted on the record sleeve.

In one of the many nice ironies that punctuated Lennon's career, this hymn to purity and simplicity was recorded at the purpose-built studio at his country house, Tittenhurst Park in Ascot. The couple had bought the house, which came with farmers' cottages, magnificent gardens and some 72 acres of land, in the summer of 1969 from the entrepreneur and chocolate heir Sir Peter Cadbury. At £145,000, it cost fully eight times as much as Keith Richards had paid for Redlands. But Lennon and Ono also spent at least £250,000 on various renovations, including a vast man-made lake that the singer could see from his bedroom window. At the very least this was an incongruously splendid setting from which to lecture the world on the importance of imagining no possessions. But, in an interview many years later, Ono rejected any hint of hypocrisy. The song, she said, was always meant on 'a more symbolic

level ... If the belonging is not a burden to you, if it does not interfere with your mental freedom then it's fine.' So that was all right.[19]

In August 1971, only weeks after Lennon had recorded 'Imagine', he and his wife moved to New York, where they eventually found an apartment in the hugely expensive Dakota building, overlooking Central Park. It was here, surrounded by the spoils of his long struggle for self-fulfilment, that John Lennon spent the last years of his life. By now he was the head of a property empire and the proud owner of a farm, a prize herd of Holstein cattle, a collection of ancient Egyptian relics and an original Renoir painting. While Ono worked nine-to-five at a desk literally inlaid with gold, her husband spent much of his time slumped in front of their gigantic television. The press often painted Lennon as a recluse. In fact, the couple were usually surrounded by people: as one friend put it, the place was always full of 'assistants, psychics, tarot card readers, masseurs, maids, acupuncturists, odd-job people', as well as one man whose sole job was to polish the apartment's brass doorknobs.

This was Lennon's dream, his promised land: a world of almost unlimited wealth, in which he never had to do any work. But some visitors were struck by the contrast between his millionaire lifestyle and the sentiments of his most famous song. When Elton John visited the apartment in the late 1970s, he was astounded to discover that Ono had a specially refrigerated room just for her vast collection of fur coats, which were lined up on 'those clothes racks like you see at Marks and Spencer'. In October 1980, to mark Lennon's fortieth birthday, Elton sent him a little verse:

> Imagine six apartments,
> It isn't hard to do.
> One is full of fur coats,
> The other's full of shoes.

An older friend, the Beatles' former personal assistant Neil Aspinall, once heard Lennon moaning about the costs of running his business empire. 'Imagine no possessions, John,' Aspinall said. Lennon glared back. 'It's only a bloody song,' he said.[20]

THE GHOST OF SAMUEL SMILES

Everything in England is young. We are an old people, but a young nation. Our trade is young; our engineering is young; and the civilisation of what are called 'the masses' has scarcely begun.

Samuel Smiles, *Lives of the Engineers* (1874)

On 30 December 1968, a few weeks after *Two Virgins* had been released to a largely hostile and uncomprehending public, John Lennon and Yoko Ono went to an art show in Piccadilly. Entitled 'Guildford Minus 40', the exhibition had been produced by a group of lecturers at the Guildford School of Art, all of whom had been either dismissed or suspended after supporting a long-running student sit-in. Hoping to secure maximum publicity for their cause, they had invited Lennon and Ono to open the show. But when a reporter from the *Guardian*, Dennis Barker, went along to watch, he was not enormously impressed by Lennon's commitment to the cause. Wearing a 'light fur coat, dirty black slacks, a green floral shoulder-bag and dirty tennis shoes', the singer strolled aimlessly across a carpet on which a notice read: 'Do not walk over this carpet.' The man from the *Guardian* moved in. Here at last was Lennon's chance to voice his support for the listening lecturers.

'I am from the "Guardian."' – 'Well, never mind.'
'Why did you come here?' – 'Because they asked me.'
'Well, why did you accept?' – 'Because I like them.'
'Any deeper reason?' – 'You can't get deeper than that.'
'Quite.' – 'I sympathise with them.'
'Yep. What are you going to do when you open the show?' – 'Wait and see.'
'Well, when are you going to do it?' – 'Now.'

At this point, Lennon and Ono began handing out pieces of paper. In baffled disbelief, Barker read the words: 'Fold it nine times – John Lennon, 1968'. 'Keep swinging!' Lennon said breezily, and then he and Ono made for the exit. 'Well,' Barker wrote, 'at least he didn't take his clothes off.'[21]

As a former art student, Lennon was always likely to sympathize with

Samuel Smiles, the author of *Self-Help*, looks appropriately chirpy in this cartoon from *Punch*, 1883.

the protesting lecturers, though they might have hoped for a rather more ringing statement of support. But although his artistic temperament has become a central part of his image, he had gone to Liverpool College of Art only with the greatest of reluctance. Art school was not Lennon's idea; it was his English teacher's, and his headmaster had to twist his arm to get him to apply. He only gave in because he could see no other alternative to getting a job, which was the last thing he wanted to do.

So it was that, in September 1957, cutting a rebellious figure in his Teddy Boy gear, Lennon first walked along Hope Street towards the grand Edwardian building that housed the city's art college. But if he hoped that this was the beginning of an easy life, he was to be disappointed. The tutors expected their students to follow an exacting curriculum of painting, drawing, lettering and architecture, which was not Lennon's idea of fun at all. Although he was a gifted caricaturist, his work consistently fell short; one lecturer recalled that when the students pinned up their work, 'John's effort was always hopeless – or he'd put up nothing at all.' And when he was finally kicked out after failing his third-year exams, nobody was in the least bit surprised.[22]

By the standards of the late 1950s – or, indeed, the early twenty-first century – art students, whose fees were then paid by the state, enjoyed considerable freedom. They could wander in and out of their buildings, dressed in whatever clothes they liked; they could smoke in class; they even drank with their tutors in the pub at lunchtime. As a result, art colleges appealed to vaguely bohemian young men and women who had not done especially well at school: eccentrics, misfits and idealists, many of them working-class boys and girls who rejected the idea of a working-class future. 'In England, if you're lucky you get into art school,' remarked Keith Richards, who started at Sidcup College of Art in 1959. 'It's somewhere they put you if they can't put you anywhere else. If you can't saw wood straight or file metal.'

But Richards, whose art school was really not very good, was being unduly dismissive. The art schools of the 1950s and 1960s were tremendous breeding grounds for creative talent, not merely in fine art – think of working-class boys made good such as Patrick Caulfield, David Hockney and Peter Blake – but in film, fashion and pop music. To take three random examples, Mary Quant studied at Goldsmiths, Vivienne Westwood at Harrow School of Art, and Ridley Scott at the Royal

College of Art, while the list of art-school-educated pop stars could go on and on, from Pete Townshend, Ray Davies and Eric Clapton to Roger Waters, Syd Barrett and Charlie Watts. And although Lennon was the only member of the Beatles who actually went to art college, Paul McCartney and George Harrison, both of whom were still at school, used to visit him in the canteen, looking self-consciously youthful in their schoolboy blazers. To the younger boys, it naturally seemed a place of thrillingly adult possibilities. 'There'd be chicks and arty types,' Harrison recalled. 'We could go in there and smoke without anyone giving us a bollocking.'[23]

All in all, the influence of the art schools on Britain's pop culture can hardly be exaggerated. As Ian MacDonald writes in the introduction to his great book on the Beatles, the colleges' 'anarchic-individualistic ethos' fostered a love of irony, parody and pastiche, as well as a fascination with collage and experimentation. So while most American musicians prided themselves on their seriousness and authenticity, their British counterparts tended to be much more playful. Not only did groups like the Beatles and the Kinks enjoy dressing up and putting on silly voices, but their songs were stuffed with allusions to favourite stories, snippets of doggerel and ironic jokes. Beatles fans still argue furiously whether *Sgt Pepper's Lonely Hearts Club Band* (1967) deserves its reputation as their greatest album. What is surely beyond dispute, though, is that no cultural product of the age better reflects the art schools' irreverence, ambition and sense of fun. And although it ebbed and flowed with cultural fashion, this ethos never quite went away. David Bowie, to pick an obvious example, owes a clear debt to the art-school spirit. But so did the Sex Pistols, who are commonly thought of as the sworn enemies of arty bohemianism. Their manager, Malcolm McLaren, was a former art-school boy; so was their bassist, Glen Matlock.[24]

'The instigators of punk', wrote the film director Derek Jarman (a graduate of the Slade School of Fine Art) in August 1976, 'are the same petit bourgeois art students who a few months ago were David Bowie and Bryan Ferry look-alikes – who've read a little art history, and adapted Dadaist typography and bad manners, and are now in the business of reproducing a fake street credibility.' And while posterity remembers punk as the sound of the late-1970s dole queue, their first and most fervent fans tended to be arty sixth-formers and college students, drawn to their alarming hairstyles and fashionably ripped T-shirts. 'A Punk Rock concert is simply the latter-day equivalent of the

old art school hops, pitched at a slightly different social level,' remarked *The Times*'s rock critic, Richard Williams, after seeing the Damned in July 1977. 'It is unabashedly an opportunity to wear fancy dress, to jump up and down oblivious to the welfare of one's neighbours and to score points for the best combination of pose and costume.'[25]

Most of Britain's most prestigious art schools were nineteenth-century foundations, reflecting the wealth and intellectual ambitions of the Victorian age. The Royal College of Art began life in 1837, while Saint Martin's School of Art was set up in 1854, the Slade in 1871 and the Central School of Art and Design in 1896. But the story of John Lennon's alma mater, the Liverpool College of Art, is particularly interesting. It began life in 1823 as part of England's first mechanics' institute, modelled on the institutions that had blossomed in the United States at the turn of the nineteenth century. Like its American models, the mechanics' institute was basically a cross between a lending library and an adult education college, aimed at skilled working men ('mechanics') who were eager to improve their technical, social and cultural knowledge, but could not afford to join a subscription library. Liverpool's version was the brainchild of a local publisher and philanthropist, Egerton Smith, and it proved an immediate hit. Within six months, reported the educational reformer and future Lord Chancellor Henry Brougham, it had collected a library of some 800 volumes. And after just two years it had more than 600 regular attendees, each of whom paid just over ten shillings a year for borrowing privileges and a wide range of evening classes. Indeed, for reformers like Brougham, committed to the education and uplift of the working classes, the mechanics' institutes seemed extraordinarily exciting. 'The establishment of a Mechanics' Institution at Liverpool', he declared in 1835, 'I look upon as one of the most important eras in the history of its people; as the origin from which may be expected to spring the greatest improvement in the arts and sciences, and the happiest results upon the condition and the morals of the people.' Nothing, he insisted, 'can exceed the importance of the pursuit in which we are now engaged'.[26]

The mechanics' institutes were monuments to working-class self-improvement. Supported by donations and subscriptions, they were especially popular in the industrial North: of some 700 mechanics' institutions, athenaeums and mutual improvement societies across the country in 1850, a third of them were in Lancashire and Yorkshire.

They were particularly good at attracting visiting speakers: in 1844, for example, the Liverpool Mechanics' Institute hosted Charles Dickens. The novelist was then at the height of his fame: the serialized versions of *The Old Curiosity Shop* and *Barnaby Rudge* had sold an estimated 70,000 copies a week, while his gruelling American tour two years earlier had attracted vast Beatlemania-style crowds. 'I can do nothing that I want to do, go nowhere where I want to go, and see nothing that I want to see. If I turn into the street, I am followed by a multitude,' he complained to a friend. John Lennon would have recognized that feeling.[27]

And yet, surprising as it may seem, Dickens was not the most successful writer to speak at the Liverpool Mechanics' Institute. For, just a couple of years later, Lennon's alma mater welcomed the one man in Victorian Britain who could confidently claim to have outsold the greatest novelist of the age. Published in 1859, his most famous book sold 20,000 copies in twelve months, rising to 55,000 copies after five years. By 1889 it had sold some 150,000 copies, and by the time he died in 1904 it had sold a staggering 258,000 copies. But those were only the British figures. Around the world it was the bestseller of the age, translated into French, German, Dutch, Danish, Spanish, Turkish, Japanese and Arabic. In Italy alone there were eighteen editions selling an estimated 75,000 copies, and there were multiple Indian versions, each in a different language. The author was Samuel Smiles; the book, with which his name is forever associated, was *Self-Help*.[28]

Today Samuel Smiles is usually remembered as the supreme exponent of Victorian individualism. Indeed, in his emphasis on individual self-improvement and self-realization, he is often seen as the godfather of Thatcherite materialism. To the twenty-first-century left, he is something of an ogre: the left-wing Labour MP Ken Purchase once announced that if he 'wanted to pick a fight, it would be with Samuel Smiles'. But far from shrugging off Smiles's legacy, the right have been perfectly happy to embrace him. In 1985 the Europhobic backbencher Bill Cash recommended *Self-Help* to his fellow MPs ('I was given much food for thought') and twelve years later, Teresa Gorman followed suit ('that classic of entrepreneurship . . . a wonderful book'). When Smiles's most famous book was republished in 1986, Sir Keith Joseph contributed a short introduction, and when Nigel Lawson tried to define Thatcherism in his autobiography, one of the essential ingredients was 'Victorian values (of the Samuel Smiles self-help variety)'.

Outside politics, meanwhile, Smiles still casts a long shadow. The 'self-help industry' is widely reported to be worth some $13 billion and almost every bookshop carries a range of self-help manuals, often written by Americans, from, say, *Chicken Soup for the Network Marketer's Soul* (I am not making this up, I promise) to the eye-catchingly titled *The Universe Doesn't Give a Flying Fuck about You*. Indeed, even though virtually nobody reads Smiles's books today, the rhetoric of self-help has become ubiquitous. Every Saturday night, talent shows hammer home the mantra that if you work hard and believe in yourself, fame and fortune will inevitably follow. 'Every youngster wants to be famous,' wrote Simon Cowell in his autobiography. And like his Victorian predecessor, Cowell produced an individual story of 'character and conduct' to illustrate the general rule: 'J. Lo, in particular, embodies the pop dream. Her rags-to-riches story proves that anyone can do great things with hard work, talent and a little luck.' All she really had to do, in fact, was believe in herself.[29]

The irony is that the original prophet of individual self-help would surely have been horrified by his successors' priorities. The author of *Self-Help* was actually a man of great evangelical zeal and moral principle, who began his adult life as something of a political radical. Samuel Smiles was a Scotsman, born in East Lothian in 1812 as one of eleven children. His family were strict Presbyterians, and although he later moved away from their rather austere theology, his work always had a Calvinist flavour. Initially a doctor, he moved to Leeds, where he lived for twenty years, became a prolific journalist and devoted himself to radical causes, notably the repeal of the Corn Laws, the reform of Parliament and the vote for working-class men. It was in this capacity, as an educated, professional man dedicated to political and social improvement, that Smiles began to attract attention as a lecturer.

In March 1845, according to his own account, a 'deputation of young men' from one of Leeds's Mutual Improvement Societies asked him to 'talk to them a bit'. Smiles duly went along and delivered a lecture entitled 'The Education of the Working Classes'. His aim, he wrote later, was to give them 'a few words of encouragement', and in good evangelical style he assured them that 'their happiness and well-being as individuals in after life, must necessarily depend mainly upon themselves – upon their own diligent self-culture, self-discipline, and self-control – and, above all, on that honest and upright performance of

individual duty, which is the glory of manly character'. This went down very well. Smiles was duly invited back to tell his audience about great men, past and present, who had triumphed through their own enterprise and effort. And it was these lectures that inspired his book *Self-Help*.[30]

Self-Help is often described as a book about success, but that is not quite right. It is really a book about the dignity and importance of *work*, a paean to honest labour as a moral mission. In a world being transformed by the machine, Smiles was keen to remind his readers that the old truths – thrift, self-discipline, sobriety, perseverance, dedication and faith – still held good. He was not a materialist but a moralist who believed that each individual held in his own hands the potential for personal reinvention and spiritual regeneration. The 'spirit of self-help, as exhibited in the energetic action of individuals', he wrote, 'has in all times been a marked feature of the English character, and furnishes the true measure of our power as a nation'. What he hated was the idea of removing individuals' responsibility for their own actions and their own destiny, for 'whatever is done *for* men and classes, to a certain extent takes away the stimulus and necessity of doing for themselves'. Only through the self-improvement of millions of individuals, he thought, would society be 'dragged up ... the result of free individual action, energy, and independence'. People had not just a right but a *duty* to better themselves, for only then would Britain prosper.

But that did not mean that each man should merely concentrate on his own affairs; quite the reverse. Although Smiles is often caricatured as the prophet of callous, narcissistic self-interest, he was actually a passionate believer in voluntary philanthropy to improve the lot of the poor. And although he is often seen as the rich man's favourite guru, this too is very wide of the mark. 'Far better and more respectable', he thought, 'is the good poor man than the bad rich one.' Riches and rank, he explained, had nothing do with gentlemanliness, for 'the poor man may be a true gentleman – in spirit and in daily life'. Indeed, Smiles's hero was the parvenu, the self-made man who never forgot the class from which he had sprung or his obligations to his fellow men. 'The parvenus,' he wrote in a later book, *Life and Labour* (1887), 'are of the people, belong to them, and spring from them. Indeed, they are the people themselves. In recognising the great parvenu spirit of this age we merely recognise what, in other words, is designated as the dignity of labour, the rights of industry, the power of intellect.'[31]

Self-Help made an enormous impact. Quite apart from the astonishing sales figures – according to the historian Asa Briggs, the book sold more copies than any novel of the nineteenth century – the book's title became a kind of popular catchphrase. Smiles had not invented it; in fact, he had probably borrowed it from Thomas Carlyle. But his book had caught the mood of Victorian self-improvement, the optimism of an age in which thousands, perhaps millions of working men genuinely believed that, through commitment and application, they could change their lives for the better. Interestingly, it struck a particular chord with precisely those people whose ideological descendants most reviled it: early socialists, working men's representatives and trade union leaders, who admired Smiles's positive message, contempt for inherited wealth and deep faith in the potential of the ordinary man. Among his fans were two early Labour MPs – William Johnson, a former coal miner, and Thomas Summerbell, a former errand boy – as well as the party's first Prime Minister, Ramsay MacDonald, who as the illegitimate son of a Scottish farm servant was the very epitome of the self-made man.

At Wormwood Scrubs, *Self-Help* was reportedly the most popular title in the prison library. And in his book on the intellectual lives of the British working classes, Jonathan Rose tells the moving story of a man called George Gregory, who was born to an illiterate Somerset miner and a devoutly religious servant girl in 1888. Having left school when he was 12 to go down the mine, Gregory came across *Self-Help* a few years later. It quite literally changed his life. For the first time, Gregory wrote later, 'I began to see myself as an individual, and how I may be able to make a break from the general situation of which I had regarded myself as an inseparable part'. Inspired by Smiles's examples, he went back to his old school for evening classes and became, among other things, a great reader, a trade union organizer, a Congregational minister and an enthusiastic peace activist. By the time he died he had a collection of more than a thousand books. There could hardly have been a better example of the gospel of self-help in action.[32]

Smiles was not, of course, alone in his faith in individual self-improvement. In Victorian Britain, boasted Lord Palmerston, 'each individual of each class is constantly trying to raise himself in the social scale – not by injustice and wrong, not by violence and illegality – but by persevering good conduct, and by the steady and energetic exertion of the moral and intellectual faculties with which his Creator has

endowed him'. The essence of government, agreed his fellow Liberal William Gladstone decades later, 'is that the spirit of self-reliance, the spirit of true and genuine manly independence, should be preserved in the minds of the people'. But there was far more to this than party politics. Individualism was one of the great cultural forces of the age, fuelled not just by the ideas of Darwinism and Utilitarianism, but by literacy and libraries, novels and newspapers. Building on eighteenth-century foundations, the Victorian novel, the emblematic cultural form of the era, was inherently individualistic. Not only did it try to capture the unique experience of a singular, admirable central character, who often told the story in his own words – David Copperfield, say, or Jane Eyre – but the very experience of reading was necessarily highly personal.* Some of the most popular novelists of the day, such as Charles Dickens or Charlotte Brontë, could hardly have been better advertisements for individual self-help; indeed, Dickens was a regular speaker at libraries, societies and mechanics' institutes up and down the country.[33]

'Courage, Persevere,' Dickens told the Birmingham and Midland Institute in September 1869. 'This is the motto of a friend and worker . . . not because self-improvement is at all certain to lead to worldly success, but because it is good and right of itself.' And perhaps not surprisingly, given his own personal struggles, self-help plays a central part in Dickens's favourite novel, *David Copperfield* (1850), which first appeared at precisely the moment when Smiles was working on his own magnum opus. In the opening chapters, the downtrodden young narrator is plunged into the misery of life in the bottling factory; by the end, he has won fame, fortune and happiness as a successful writer. 'I never could have done what I have done, without the habits of punctuality, order, and diligence, without the determination to concentrate myself on one object at a time,' David tells the reader towards the end of the book. 'My meaning simply is, that whatever I have tried to do in life, I have tried with all my heart to do well; that whatever I have devoted myself to, I have devoted myself to completely; that, in great aims and

* It is true, of course, that many Victorians used to read novels aloud to their friends and family, so novel-reading was sometimes a more collective endeavour. But as adult literacy increased, this practice gradually died out.

in small, I have always been thoroughly in earnest.' Modern readers might find all this a bit excruciating, but the Victorians loved it.[34]

That said, though, the idea of Victorian Britain as a country ruled by selfish, individualistic materialism is the crudest of caricatures. Unlike, let us say, John Lennon and Simon Cowell, the Victorians took collective loyalty very seriously indeed. It would, in fact, be very easy to write a history of nineteenth-century Britain as a country ruled by the co-operative ethos: a country not just of mechanics' institutes and friendly societies, but of mass-membership political parties, rapidly growing trade unions and booming football clubs; a land of societies and institutions of every conceivable kind, guided by a spirit of team-work, mutuality and collective co-operation. Take, for example, the cricket match at the end of *Tom Brown's School Days*, already mentioned in Chapter 6. Cricket, says Tom's master, should be 'such an unselfish game', teaching 'discipline and reliance on one another . . . It merges the individual in the eleven; he doesn't play that he may win, but that his side may.' Yes, says Tom: that's why team games like cricket and football are so superior to games 'where the object is to come in first or to win for oneself'. For Tom and his fellows, the team is everything: as his house captain Old Brooke explains after an earlier rugby match, victory goes to those with 'more reliance on one another, more of a house feeling, more fellowship'. As a keen admirer of the co-operative movement, Samuel Smiles would surely have concurred with much of this. It is in 'helping and stimulating men to elevate and improve themselves by their own free and independent action as individuals', explains the first chapter of *Self-Help*, that 'the highest patriotism and philanthropy consist'. The goal of self-improvement, in other words, was not to enrich the individual, but to benefit the nation – not a sentiment with which many modern self-improvers would necessarily agree.[35]

Even Dickens, far from being an uncritical admirer of individual self-improvement, was very wary of the ambitious, self-made loner who leaves his family, his friends and his class far behind. In *Hard Times* (1854), he presents us with the mill owner Josiah Bounderby, the very picture of a self-made success story, who boasts that having been born in a ditch, 'I pulled through it, though nobody threw me out a rope'. But far from being the object of admiration, Bounderby is a dreadful man, selfish, grasping and 'perfectly devoid of sentiment'. Another of

Dickens's memorable self-improvers, *David Copperfield*'s villainous clerk Uriah Heep, cuts a similarly ghastly figure, his much-advertised 'umbleness' merely a mask for his greed, resentment and social ambition. As for Bradley Headstone, the villain in Dickens's last completed novel, *Our Mutual Friend* (1865), he seems like a vision of Smilesean self-improvement gone horribly wrong. A former 'pauper lad' who has raised himself up through hard work and education to become a schoolmaster, Mr Headstone initially strikes a figure of utter respectability. 'In his decent black coat and waistcoat, and decent white shirt, and decent formal black tie, and decent pantaloons of pepper and salt, with his decent silver watch in his pocket and its decent hair guard around his neck,' writes Dickens, Mr Headstone looks 'a thoroughly decent man of six-and-twenty'. Yet for all his intellectual efforts and 'mechanical' knowledge, the schoolmaster is a man of deeply repressed passion, his uppity social ambitions mirrored by his unrequited lust for the virtuous Lizzie Hexham and his hatred for her lover, Eugene Wrayburn, an annoying upper-class wastrel. As it happens, poor Mr Headstone always strikes me as being rather hard done by, despite his unfortunate homicidal tendencies. But he provides a useful reminder that even for a self-made man like Dickens, the cult of individualism had its limits.[36]

Above all, it was Dickens, the blacking-factory boy made good, who created one of the most effective portraits of individual self-absorption in all English fiction. For if *David Copperfield* preached the gospel of self-help, his other great coming-of-age novel, *Great Expectations*, approaches the issue of social mobility from a very different perspective. On the face of it, the narrator, Pip, is a classic success story, a poor orphan risen to wealth and status. But as the Dickens critic Jerome Meckier persuasively argues, his story is like a grotesque parody of Samuel Smiles's inspiring biographies. Far from Pip's fortune being the fruit of his hard work, it falls into his lap courtesy of the convict Magwitch. This is social success as the result of robbery and murder, rather than as the inevitable reward for talent and application. And far from being guided by a spirit of altruistic philanthropy, Pip becomes steadily more selfish and snobbish, scorning his background, his family and his old habits. Of course Dickens rescues him eventually: humbled by debt and shocked by the revelation of his true benefactor, Pip learns the error of his ways, reconciles with his old friends and starts again as a clerk.

But it is very easy to imagine an alternative scenario, in which Pip ends up a lonely, rich dilettante, holed up in the Victorian equivalent of the Dakota building, surrounded by piles of fine clothes and creditors' bills, and only occasionally issuing forth to lecture his fellow men on the iniquities of materialism. What fun Dickens would have had with John Lennon and Yoko Ono![37]

Previous pages: Kingsley Amis, 1956, cutting a typically self-effacing figure.

12

A Savage Story of Lust
and Ambition

I'M ALL RIGHT JACK

Already our didactic writers are getting back to Samuel Smiles;
it is only a matter of time before the evil old men of the day
flinch uneasily from the stare of some youthful Thomas Arnold.
<div align="right">The Times, 26 May 1956</div>

Samuel Smiles died in 1904, a man out of his time. A few years earlier, his publisher, John Murray, had turned down his proposed last book, *Conduct*, and after his death the manuscript was destroyed. This was the age of the New Liberalism, the heyday of socialism, Fabianism, public welfare and class solidarity. Even thrift, so dear to the heart of Smiles and his fellow Victorians, so deeply embedded in the Calvinist tradition, now seemed suspect: according to the New Liberal economist J. A. Hobson, excessive saving only encouraged under-consumption, so the government ought to redistribute income through the tax system. Smiles himself had once been a Liberal; he would have been horrified, though, by David Lloyd George's promise that a new welfare state would exorcise the 'four spectres' of Old Age, Accident, Sickness and Unemployment, and that government activism would 'banish the workhouse from the horizon of every workman in the land'.[1]

But in Edwardian Britain, fashionable opinion regarded Smiles's homilies as something of a joke. Predictably enough, the Bloomsbury intellectuals could barely contain their contempt for ordinary people who tried to rise out of their social station through education and self-improvement. For all his earnest ambitions, the clerk Leonard Bast in E. M. Forster's novel *Howards End* (1910) cuts a ridiculous, even

'An open conspiracy against the individual': the inimitable Fred Kite (Peter Sellers) leads his men out on strike in *I'm All Right Jack* (1959).

pitiable figure, while the tutor Miss Kilman in Virginia Woolf's *Mrs Dalloway* (1925), who has hauled herself up from poverty through her ability and hard work, even acquiring a degree in history, is positively monstrous. Even H. G. Wells, himself a self-made man, a shopkeeper's son from suburban Bromley whose talent had won him extraordinary celebrity, took a very jaundiced view of individual self-improvement. Many of his finest novels – *Kipps* (1905), *Tono-Bungay* (1909), *The History of Mr Polly* (1910) – are the stories of obscure, lower-middle-class men, struggling to break free from the constraints of their birth and background. But Wells's books, rather like *Great Expectations*, are also morality tales, warning of the dangers of material ambition and social snobbery. 'One seems to start in life expecting something. And it doesn't happen. And it doesn't matter,' reflects Mr Polly. 'It isn't what we try to get that we get, it isn't the good we think we do is good. What makes us happy isn't our trying, what makes others happy isn't our trying.' It is a safe bet that Smiles would not have approved of Mr Polly. But then Wells did not approve of Samuel Smiles. In the short story 'The Purple Pileus' (1896), Wells creates a downtrodden shopkeeper, Mr Coombes, who miraculously changes into a model of masculine self-assertion after stuffing himself with lurid mushrooms. At the beginning, though, Mr Coombes is the starchiest, weediest milksop imaginable. He is, Wells says contemptuously, 'a harmless little man ... nourished mentally on *Self-Help*'.[2]

For much of the twentieth century, Samuel Smiles served merely as a glorified punch-bag, and his individualist principles as relics of some political dark age. In May 1914, for example, *The Times* published a long piece warning that Smiles's creed was actually a recipe for moral and physical degeneration, something of an obsession in the years before the First World War. 'The self-made man', explained one Dr Mott, pathologist to the London County Asylums, 'is often the first step in the process of degeneration; and the first evidence of degeneracy in a family is the selfishness and meanness, or the cunning, avarice, and moral guile, by which the self-made man succeeds in amassing a fortune for his still more degenerate children to spend in gratifying their selfish desires.' Worldly success, added Dr Mott, was often 'a sign of disease rather than of health, and soon the disease has not even success to conceal it'.[3]

In the decades after the war, Smiles fell even further from public approval. By 1928 a speaker at the Old Boys' Association of University

College, London, could confidently describe Smiles's philosophy as 'extinct . . . among the enlightened youth of the present generation'. And although in 1937 the council unveiled a commemorative tablet celebrating Smiles's time at Zion School in Leeds, where he had taught during the 1840s, the occasion had a desultory, even irrelevant atmosphere. 'Of all the men – and they were many – who lectured the Victorians, he has been the most completely forgotten,' remarked the *Manchester Guardian*. The paper thought this was a bit unfair, since Smiles was 'a good Radical who fought strongly for national education and free public libraries'. But in the new world of the late 1930s, 'there is the feeling that for one man to work for his own success is less excellent than for all men to join together in the making of a better world for strong and weak alike. The world has changed since life was played to the hard rules of the Manchester School, and Samuel Smiles is an outmoded prophet.'[4]

If there was one moment in Britain's modern history when Smiles's spirit seemed closest to being extinguished, then it came during the 1940s. Total war demanded a genuinely collective effort: as Churchill told the nation in his first radio address as Prime Minister, the government would take 'even the most drastic' steps to secure victory, to the point of ignoring 'the interests of property, the hours of labour'. And once victory was won, Attlee's Labour government harnessed the collective spirit of the People's War, promising, as their manifesto put it, 'the wise organization and use of the economic assets of the nation for the public good'. In this atmosphere, Smiles's emphasis on self-improvement and self-realization seemed not so much defunct as prehistoric. This was an age, declared the *Manchester Guardian*, of overt 'contempt for Samuel Smiles and Mutual Improvement Societies'. The days of 'trying for some easy money' are over, says a demobbed soldier in J. B. Priestley's novel *Three Men in New Suits* (1945). 'Instead of guessing and grabbing, we plan. Instead of competing, we co-operate.'[5]

It may be a bit of a cliché to describe the period from the early 1940s to the mid-1950s as the peak of Britain's collective 'the-people-as-hero' culture, but it is only a cliché because it is true. Films such as Michael Powell and Emeric Pressburger's masterpiece *A Canterbury Tale* (1944) or Humphrey Jennings's *Family Portrait* (1950) showed Britain as a united, organic society, an extended family standing on layer upon layer of history and tradition. And, in its way, this was not so different from the ethos of the Ealing comedies of the same era. The studio's boss, Sir

Michael Balcon, declared in 1945 that he wanted to show 'a complete picture of Britain': not merely Britain as a 'mighty military power', or even as a 'questing explorer, adventurer and trader', but as 'a leader in Social Reform in the defeat of social injustices and a champion of civil liberties'.

What the Ealing films celebrate, therefore, is a settled, tolerant, cohesive society, where people need little encouragement to pull together for the common good. In *Passport to Pimlico* (1949), this happy state is threatened when Pimlico declares independence as the Duchy of Burgundy and lifts the government's rations and restrictions – something bound to strike a chord with audiences already wearying of post-war austerity. Alas, in flows a tide of entrepreneurs, black marketeers and all-round spivs, like demons unleashed from Samuel Smiles's tomb. Whitehall tries to blockade the Burgundians into surrender, but, as in the Second World War, the besieged populace pull together, finding an unexpected unity in the face of their enemies. In the end Pimlico returns to the fold, and back come the ration books. There could hardly be a better cinematic tribute to the spirit of collective solidarity – or, indeed, a more entertaining warning of the dangers of unchecked self-interest.[6]

By contrast, ambitious individualists generally come out pretty badly from the Ealing comedies. The outstanding example is Dennis Price's Louis Mazzini, the protagonist of the deliciously sardonic *Kind Hearts and Coronets* (1949). Louis, needless to say, is a thoroughgoing villain, though a very charismatic and amusing one. The son of an aristocratic heiress who was disowned by her family for marrying beneath her, he begins his working life as a Clapham draper's assistant. (In good intellectual style, he is particularly outraged to have been condemned to a 'suburban' existence.) There is enormous fun to be had in watching Louis work his way through his D'Ascoyne relatives, all hilariously played by Alec Guinness, bumping them off in turn so that he can get his hands on the family seat. 'It is so difficult', Louis muses winningly, 'to make a neat job of killing people with whom one is not on friendly terms.' Released at a time when Attlee's reforms were provoking squeals of protest from the landed upper classes, the film has sometimes been seen as a disguised assault on the old order: Simon Heffer, for example, once called it 'the most subversive [film] ever made here', since it attacks 'the class system, the hereditary principle, the political establishment, family life, the institution of marriage, the Church and the very distinction between right and wrong'. All true enough, and it would be a rare viewer who failed to enjoy Louis's vendetta against his upper-class

relatives. But as cinematic individualists go, he is about as far from being a role model as it is possible to imagine.[7]

Although the Ealing comedies are often taken as the supreme expression of mid-century Britain's commitment to social democracy, the truth is a bit more complicated. Even in *Passport to Pimlico*, with its cast of resentful shopkeepers and interfering bureaucrats, there are strong hints that the public are tiring of social improvement. The later Ealing comedies, such as *The Titfield Thunderbolt* (1953) and *The Ladykillers* (1955), are often seen as more conservative than their predecessors: more sceptical, more nostalgic, more suspicious of change. In any case, not all British filmmakers were equally devoted to Ealing's J. B. Priestley-style values of social solidarity and collective co-operation. When John and Roy Boulting made *Private's Progress* (1956), a comedy about shirkers, malingerers and fraudsters in the British army, with some excellent work from Ian Carmichael and Terry-Thomas, it was pointedly dedicated 'to all those who got away with it'. The Boultings were keen Liberals, scornful of what they saw as philistine Conservative materialism, but also suspicious of socialist intervention and the power of the state. Their films, John Boulting later explained, were 'a plea for the rights of the individual as against the Establishment, authority, society and all the things that are totally impersonal'.[8]

The one Boulting brothers' film that most people remember is *I'm All Right Jack*, which topped the domestic box office in 1959, a rare British triumph in an era of Hollywood domination. This scathingly funny portrait of Britain's creaking industrial relations was so successful that not even the Queen could ignore it: when Harold Macmillan came up to Balmoral that September to ask for a dissolution of Parliament, her aides organized a special showing for them. The mood is established right at the beginning, with a pre-titles sequence set in a gentleman's club on VE Day. A servant goes to wake 'old Sir John', to tell him that the war is over at last. But as the narrator warns, change is coming. 'Look hard,' he says, 'for this is the last we shall see of Sir John . . . a solid block in the edifice of what seemed to be an ordered and stable society. There goes Sir John – on his way out.' For with victory, says the narrator, comes 'a new age, and with that new age a new spirit'. The film cuts to a soldier celebrating on top of a lamppost and holding up a 'V for victory' sign, who grins triumphantly into the camera – and promptly turns his gesture into one of gleeful contempt for the audience. The titles roll. 'I'm all right, Jack, I'm okay,' sings the pop star Al Saxon.

> That is the message for today.
> So, count up your lolly, feather your nest,
> Let someone else worry, boy, I couldn't care less.[9]

As this might suggest, *I'm All Right Jack* is a film delicately poised between two very different cultural moments. The opening scene looks back to the war, the heyday of collective endeavour and national solidarity, but the song – both in content and style – seems to look forward to a new era of aggressive hedonism and unashamed self-interest.

At the time, though, what attracted most attention was Peter Sellers's hilarious performance as the obstreperous trade unionist Fred Kite ('We do not and cannot accept the principle that incompetence justifies dismissal'), which delighted many cinemagoers and won him a BAFTA. Not surprisingly, it went down very badly with trade union leaders and left-wing reviewers, but the Boultings were unrepentant. In an article for the *Daily Express*, they explained their reasoning:

> As individuals we believe in Britain because Britain has always stood for the individual.
>
> Nowadays there seem to be two sacred cows – Big Business and Organised Labour. Both are deep in an open conspiracy against the individual – to force us to accept certain things for what in fact they are not. Both are busy feathering their nests most of the time. And to hell with the rest of us …
>
> After all, who is King in the Welfare State? That humourless, faceless monster – the official, the bureaucrat, the combine executive.
>
> Certainly a great deal has changed since we used to be Angry Men before the war … But at the end of this huge revolution we are not so sure that the losses have not been as great as the gains.
>
> For example, the tendency to think of people not as human beings but as part of a group, a bloc, a class.

The Boultings knew, of course, that this would annoy some people. But the great strength of the 'average Briton', they insisted, lay in 'laughing at his leaders and institutions. We believe our films reflect the popular attitude and mood. Their success seems to prove our point.'[10]

Since *I'm All Right Jack* is in black and white, it is easy to forget how bracingly modern it must have seemed, not just to the Queen and Harold Macmillan, but to the large audiences who flocked to see it in the autumn of 1959. It was released only ten years after *Passport to Pimlico*, but the

difference in mood and tone can hardly be exaggerated. It is not just a question of collectivism versus individualism, but the social context that those two ideas reflected. The Ealing film was made against a background of austerity; the Boultings' film is drenched in consumerism. In the early scenes of *Passport to Pimlico*, we find ourselves in a world of rationing and restrictions, bomb damage and dereliction. What kicks off the action, in fact, is the accidental detonation of an unexploded German bomb. But *I'm All Right Jack* is set in the late 1950s, a world awash with appliances and advertising, in which wartime austerity is merely a fading memory. The narrator tells us that at long last 'industry, spurred by the march of science in all directions, was working at high pressure to supply those vital needs for which the people had hungered for so long'. But when Ian Carmichael's blundering hero gets a job in industrial management, he soon finds out what these 'vital needs' are: Num-Yum chocolate bars and Detto washing powder, each with its own irritatingly catchy jingle.

And what this reflected, of course, was the reality of the so-called affluent society. In just ten years, the average weekly wage had almost doubled. Unemployment had virtually disappeared, high-street showrooms were bursting with new appliances, and the government had relaxed the old credit controls. Quite suddenly, the landscape of working-class Britain – a world that would probably have seemed relatively familiar even to Charles Dickens and Samuel Smiles – was being radically transformed. Only a year later, in 1960, the social researchers Mark Abrams and Richard Rose reported that eight out of every ten working-class voters now owned a television; three in ten owned a washing machine; and many were beginning to make down-payments on a fridge or a car. The title of their book – *Must Labour Lose?* – spoke volumes about what all this seemed to mean for the old values of collective solidarity.[11]

I'm All Right Jack was, of course, an awfully long way from embracing the strenuous values of Samuel Smiles. Its hero, Stanley Windrush, is a classic upper-class twit, who depends entirely on his uncle's patronage and ends the film fleeing to a nudist colony. But in its irreverent spirit, its scepticism towards institutions (both left- and right-wing) and its fascination with the impact of materialism, it clearly anticipated the mood of the individualistic era to come. Indeed, there is a good case that the era of the mid-to-late 1950s, for all its inward-looking conservatism, represented the hinge moment in Britain's post-war story. This was the point at which the great engine of economic growth really began to roar, and

mass consumerism really began to change the lives of millions. It was at this point, crucially, that National Service was gradually wound down, freeing thousands of young men to enter the world of work, to go to university, to experiment and enjoy themselves.

It was at this point, too, that record companies and fashion firms began to realize the potential of the vast teenage market – another phenomenon mapped by Mark Abrams, who estimated that Britain's 5 million teenagers commanded some 10 per cent of the nation's personal income. It was now that rock and roll first entered the British charts, and that pop music first began to delight teenagers and annoy their parents; it was now that television became a mass cultural phenomenon, with ownership booming from 4 million households to 10 million households between 1955 and 1960. And of course it was now that the generation represented by John Lennon and his Beatles colleagues came of age: doing their O-levels and A-levels, working in summer jobs, getting their first girlfriends and defining themselves for the first time as adults and as individuals. These were the years, says the young narrator in Colin MacInnes's terrible but weirdly interesting novel *Absolute Beginners* (1959), of the 'teenage ball ... when we found that no one couldn't sit on our faces any more because we'd loot to spend at last, and our world was to be our world, the one we'd wanted and not standing on the doorstep of somebody else's waiting for honey, perhaps'.[12]

In the public imagination, the idea of Britain in the 1950s as the cultural equivalent of a stuffy old aunt, her gaze fixed inwards and backwards, has become virtually unshakeable. For all the pleasure of the Ealing comedies and the Boulting brothers' films, there is a degree of truth in it: beside the novelty, glamour and excitement of American, French or Italian culture, Britain undoubtedly felt like a bit of a backwater. And yet, partly because it so clearly reflected the changing balance between collective solidarity and individual ambition, popular culture in the 1950s was often the subject of extraordinary controversy. To cultural conservatives, innovations such as children's comics or rock and roll records seemed like dire portents of political and spiritual decline. And by the mid-1950s, even the literary novel had become a battleground. With television and pop music only just beginning to make inroads into the national imagination, the state of the novel was, for one fleeting moment, the stuff of public debate – or, at least, the kind of thing that attracted the attention of the popular press, which would not have dreamed of running long articles on the subject ten or twenty years later.

So when the so-called Angry Young Men burst on to the scene between roughly 1953 and 1956, it was the *Evening Standard* and the *Daily Express* that gave them their name, invented the idea that they were a coherent movement, and told readers that they reflected the social and cultural trends reshaping British life. 'A bright, brash and astonishingly bitter new crop of Angry Young Men has pushed up into the London scene this year, writing plays and books bristling with fresh if feverish ideas and opinions,' announced the *Express* on 4 September 1956. In a splendidly bathetic touch, this was actually the introduction to a tirade by the '18-year-old playwright Michael Hastings' about, of all things, pay and conditions for tailors' apprentices.* Yet even here there was a hint of the impatience and ambition that would play such key parts in British culture in the next fifty years. 'People laugh when I tell them the starting minimum wage for a tailor's apprentice,' wrote an outraged Hastings. 'It comes to 28s a week. What boy of 16 can exist on that? And wear drainpipe suits and have his hair cut well, and look clean?'[13]

Today the idea of the Angry Young Men survives only as a kind of historical curiosity. The outspoken, media-friendly trio at the heart of this supposed movement, Kingsley Amis, John Osborne and Colin Wilson, actually had very little in common at all. Amis was an Oxford-educated university lecturer who became a mordantly funny social moralist, conservative columnist and professional drinker. Osborne was a former stage manager who specialized in writing attention-grabbing plays on a bizarre variety of themes, from lower-middle-class life to the career of Martin Luther – although to my mind, at least, the high point was his inexplicable appearance as 'Arborian Priest' in the film *Flash Gordon* (1980). And Colin Wilson . . . well, where do you start? Having rocketed to fame with his cobbled-together pseudo-existentialist treatise *The Outsider* (1956), Wilson briefly became the darling of the newspapers, who adored the fact that he had slept rough on Hampstead Heath while working in the British Museum's Reading Room. But he plummeted back to earth when his next book, *Religion and the Rebel* (1957), received some of the worst reviews it is possible to imagine. Having been, very briefly, the great white hope of British literature in the mid-1950s, Wilson disappeared into total

* Hastings himself was a tailor's apprentice. His subsequent literary career was not very spectacular; if he is remembered at all, it is for his play *Tom and Viv* (1984), about the life of T. S. Eliot, which was subsequently made into a film.

obscurity, surfacing only to issue proclamations of his own exceptional talent. In his way he cut an outstandingly entertaining figure, although not, perhaps, for the right reasons. 'It strikes me that in five hundred years' time they'll say "Wilson was a genius", because I'm a turning point in intellectual history,' he told Humphrey Carpenter many years later. This put him on a par with John Lennon, who, like Wilson, became convinced of his own genius at a remarkably early age. The difference, though, was that Lennon wrote or co-wrote some of the best-loved songs of the twentieth century, whereas Colin Wilson's vast output included works such as *Atlantis and the Kingdom of the Neanderthals*, *The Mammoth Book of True Crime* and *World Famous UFOs*, none of which seems very likely to make it as a Penguin Classic.[14]

One thing the supposedly Angry Young Men did have in common was that they had come of age during or just after the Second World War. Both Amis and his friend John Braine had been born in 1922, John Wain in 1925, Alan Sillitoe in 1928, John Osborne in 1929 and Colin Wilson in 1931. As young men in their late teens and twenties – at precisely the point when they might have expected to be spreading their wings and having fun – they had known the rigours and annoyances of austerity, rationing and restrictions. Amis, Braine, Sillitoe and Wilson had also served briefly in the armed forces. No wonder, then, that they were so intolerant of authority and impatient for success, or that their books often had such little time for national institutions and collective loyalties.

In his analysis of the changing literary fashions, already quoted earlier in this book, the *Spectator*'s J. D. Scott argued that the new generation were not just 'sceptical, robust, ironic', but 'prepared to be as comfortable as possible in a wicked, commercial, threatened world which doesn't look, anyway, as if it's going to be changed much by a couple of handfuls of young English writers'. Those last few words are very telling: not only was this a wartime generation, it was the first generation to venture into print with British power very obviously in decline. 'I suppose people of our generation aren't able to die for good causes any longer. We've had all that done for us, in the Thirties and the Forties, when we were still kids. There aren't any good, brave causes left,' says Jimmy Porter, the irritable anti-hero of Osborne's play *Look Back in Anger* (1956). As plenty of critics pointed out, this was a weird exaggeration: if Jimmy wanted a cause, how about decolonization, or the anti-apartheid campaign, or the anti-nuclear movement? But

perhaps it is hardly surprising that Jimmy – whom the *Manchester Guardian*'s reviewer aptly described as 'a self-pitying, self-dramatising intellectual rebel' – has no time to contemplate such trivial concerns. He has something much more important to worry about: himself.[15]

In fact, Jimmy Porter was only the most annoying example of a wider trend for self-absorbed, self-indulgent and vaguely disaffected heroes. So in John Wain's novel *Hurry on Down* (1953) – which was one of the first books to capture the new mood, was very widely reviewed at the time, and is now almost completely forgotten – we follow the nominally comic adventures of young Charles Lumley, an Oxford graduate who has decided to run away from the expectations of middle-class society. Like so many heroes ever since, Charles feels 'imprisoned' by his background, and is determined to remain 'independent of class'; unusually, however, he deliberately heads *down* the social scale, becoming a window-cleaner, thereby leaping 'clear of the tradition of his class and type'. For contemporary critics, though, the outstanding example of the new individualism was Jim Dixon, the amusingly anti-idealistic history lecturer in Kingsley Amis's novel *Lucky Jim* (1954). 'A new hero has risen among us,' declared the *New Statesman*, seeing Dixon as the voice of a generation: graceless, anxious and 'playing the racket'.[16]

To older reviewers Dixon's hatred of intellectuals, suspicion of all things foreign and horror of eccentricity – three attitudes he shared with his creator – seemed genuinely shocking. The brilliant short-story writer V. S. Pritchett (born in 1900) described Amis as 'brashly, vulgarly, aggressively insensitive' and a 'literary Teddy Boy', while Somerset Maugham (born in 1874) was so horrified by Dixon's behaviour that he was convinced Amis had created him as a blistering satirical portrait of the new 'white-collar proletariat'. Dixon, he suggested in a hilariously wrong-headed piece for the *Sunday Times*, was typical of the new breed who would one day rule the country, and Maugham was glad that he would no longer be alive to see it. 'They do not go to the university to acquire culture, but to get a job, and when they have got one, scamp it,' he explained. 'They have no manners, and are woefully unable to deal with any social predicament. Their idea of a celebration is to go to a public house and drink six beers. They are mean, malicious and envious ... They are scum.'[17]

Not everybody went as far as Somerset Maugham. But even more restrained critics agreed that, as the meritocratic product of a grammar school and a redbrick university, Dixon spoke for a generation. 'Lucky

Jim Dixon is the first hapless hero to climb from the crib of the Welfare State,' declared Philip Oakes in the *Evening Standard*. 'His bones are reinforced by Government dried milk. His view of the world is through National Health spectacles.' But since *Lucky Jim* is clearly set in the late 1940s or very early 1950s, and since Dixon is a university lecturer, not a child, there is no way he could be a literal product of the welfare state.

In fact, many of those first, extravagantly outraged reactions to *Lucky Jim* now look very odd. Contemporary critics often described Dixon as brash and boorish, a delinquent, hard-drinking lout, yet to twenty-first-century eyes he seems remarkably diffident and his escapades extremely tame. It is very hard to imagine modern readers being seriously shocked when he steals a bottle of port, accidentally destroys his bedclothes or even impersonates strangers on the telephone. Indeed, compared with the antics of the anti-heroes created by Amis's son Martin, such as Charles Highway in *The Rachel Papers* (1973), John Self in *Money* (1984) or Keith Talent in *London Fields* (1989), Dixon's misadventures are more like something from the Billy Bunter stories. It is telling that, when the Boulting brothers adapted *Lucky Jim* for the cinema in 1957, they needed to make very few changes in order to present Dixon as an amiable twit, effortlessly played by Ian Carmichael. Even the ITV television adaptation in 2003, which starred the Sunday night stalwart Stephen Tompkinson, had no trouble in presenting Dixon as an affable everyman, and the very antithesis of a barbaric Teddy Boy.[18]

And yet, in his way, Dixon absolutely embodied the emerging mood of the 1950s. In some ways his story appears a very Victorian one: a young man making his way in society, and managing, after a series of misadventures, to get the girl and make his fortune. The difference, as D. J. Taylor points out, is that while heroes like David Copperfield were admirably plucky and virtuous characters, Dixon could hardly be more ordinary. He is a hero for a more aggressively demotic age, unexceptional in every aspect, with all the petty flaws and failings of his readers. He is far from being a Smilesean hero: contrary to popular belief, he is not very ambitious, hoping only to cling on to his academic job while doing as little work as possible. But in his increasingly blatant disrespect for authority, which reaches its peak in his hilarious drunken lecture on Merrie England, he reflected the mood of thousands of readers, many of whom had served in the army or done National Service and come to resent anything that smacked of military discipline. And though

Dixon is very far from being an angry young man – grumpy and grumbling would be nearer the mark – it was, in fact, this very *lack* of anger that made him such a modern figure. It was not Dixon's rebelliousness that shocked his critics; it was the complete absence of idealism or political commitment, which seemed such a contrast with the high seriousness of the interwar years. Indeed, like so many fictional heroes of the 1950s, Dixon is really interested only in one thing: himself. 'Doing what you wanted to do', he reflects at one point, 'was the only training, and the only preliminary, needed for doing more of what you wanted to do.' Doing what you wanted to do: the perfect motto for the age of affluence.[19]

CHAMPAGNE IN BINGLEY

As I walked down the hill I experienced the conqueror's sensation
again. Warley was below in the valley waiting to be possessed.
John Braine, *Room at the Top* (1957)

Lucky Jim transformed Kingsley Amis from an obscure young English lecturer into a genuine literary superstar, regularly profiled in the Sunday papers, invited on to the radio and television, and presented as the voice of his generation. The journey to Swansea, where Amis taught during the 1950s, became a regular pilgrimage for journalists looking for a boozy welcome and some colourful anecdotes. One such visitor, who had been asked to interview Amis for a magazine, was a man of exactly the same age, whom the novelist had already met in London.

'Pale, bespectacled, chubby, with a perpetual look of being out of condition,' Amis recalled in his memoirs, 'he had an expression of habitual gloom, even something approaching hostility, but always ready to lighten into a genial smile.' That evening the two of them got stuck into a bottle of 100 degrees proof bourbon, which Amis had been given as payment by another publication. The visitor was meant to be going back to London on the last train; instead, Amis had to put him to bed in the attic. 'The next morning', Amis reported, 'he was found there with the electric fire on and near enough to the bed to have caused it to burst into flames had he not rendered the sheets non-inflammable. He retains the prize – a closely fought distinction – for producing the most thoroughly maltreated bedroom I have ever set eyes on.'[20]

The supreme embodiment of materialistic ambition: Joe Lampton (Laurence Harvey) checks his appearance in the film version of *Room at the Top* (1959).

The man in Amis's attic was John Braine, whose book *Room at the Top* is one of the most memorable accounts of individualistic ambition in modern British fiction. Braine himself could hardly have been a more fitting standard-bearer for the values he championed. He was born in Bradford in 1922, the son of a sewage-inspector. He grew up in indus-trial Shipley, won a scholarship to the local grammar school and then held a succession of jobs as a furniture shop assistant, a bookshop assis-tant, a laboratory assistant and eventually an assistant librarian. This was an awful lot of assisting by any standards; perhaps it is no wonder he became so obsessed with success. During the war he briefly served in the Royal Navy; then he got tuberculosis and spent almost three years in and out of a sanatorium, which must have been intensely frustrating for a bright young man. By 1954, when at last he was well again, he had already published a few poems and short stories. Two years earlier he had started work on a novel, provisionally entitled either *Born Favour-ite* or *Joe for King*. But although his short stories had attracted an agent – the future novelist Paul Scott, of *The Jewel in the Crown* fame – no fewer than four publishers turned the book down. And then, at last, Scott had some good news. Eyre & Spottiswoode had agreed to take it on – and John Braine was heading to the Top.[21]

Room at the Top was published in the spring of 1957, only a few months before the new Conservative Prime Minister, Harold Macmillan, made his famous boast that, with Britain enjoying 'a state of prosperity such as we have never had in my lifetime – nor indeed ever in the history of this country', most people had 'never had it so good'. In its unashamed materialism, its sexual frankness and its hero's unbridled social aspira-tion, Braine's book reads like an uncannily accurate preview of the values that would define so much of Britain's cultural life in the decades to come. So it is easy to forget that, like *Lucky Jim*, *Room at the Top* was really a product of austerity, not affluence. Not only had Braine begun working on it five years earlier, but he happily admitted that the action was meant to take place in the immediate aftermath of the Second World War.

The narrator, Joe Lampton, was born in 1921, a year earlier than Braine himself, went to grammar school in the Yorkshire industrial town of Dufton, and then into local government before joining the RAF in 1940. He spent the last years of the war in a Nazi prisoner-of-war camp; his parents, meanwhile, were killed in a German air raid. Not surprisingly, there is in Joe an underlying bitterness, even violence, that

must have struck a chord with many readers who had undergone similar experiences. In an earlier chapter I quoted the strangely unsettling moment when, locked in conversation with his girlfriend's rich father, Joe has a flashback to a raid over Cologne, when the bomb-aimer's face was ripped off by flak. For twenty-first-century readers expecting a kind of northern version of *Lucky Jim*, this probably seems an unexpectedly dark and disturbing image. But it is a useful reminder that for many men and women the ghosts of the Second World War were rattling around the imagination for decades afterwards.[22]

Room at the Top may not be one of the great novels of the age – in essence, it is an enjoyable but eminently predictable Victorian-style melodrama – but it is surely one of the most revealing. The film version, released in January 1959, broke new ground for British cinema, not just in its sexual frankness but in its fascination with class, ambition and the landscapes of the industrial working-class North. And Joe Lampton, haunted by his memories of the war, obsessed with his position in the class system and determined to have whatever he wants, is such an interesting and emblematic figure that it is worth dwelling on him for a little while.

The book opens with his arrival by train in Warley – a thinly veiled Bradford – 'on a wet September morning with the sky the grey of Guiseley sandstone'. Almost immediately we get a glimpse of his James Bond-style fastidiousness about his appearance and his neurotic obsession with price tags: he is dressed, he says, in his Sunday best, 'a light grey suit that had cost fourteen guineas', while 'the shoes were the most expensive I'd ever possessed, with a deep, rich, nearly black lustre'. In case there is any doubt where he is, Braine tells us that 'the air tasted fresh and clean with that special smell, like good bread-and-butter, which means that open country is near at hand', which is the kind of thing that triggered contemporary readers' Yorkshire-detectors. And as Joe's landlady drives him back to her lodging-house, he feels a thrill that he is heading for the part of Warley known as the Top:

> a world that even from my first brief glimpses filled me with excitement: big houses with drives and orchards and manicured hedges, a preparatory school to which the boys would soon return from adventures in Brittany and Brazil and India or at the very least an old castle in Cornwall, expensive cars – Bentleys, Lagondas, Daimlers, Jaguars . . . and, above all, the wind coming from the moors and the woods on the far horizon.

What fuels Joe's driving ambition is his acute sense of social insecurity. He is haunted not merely by the war, but by the trauma of the 1930s, when three-quarters of his home town's population were unemployed. At one point, he remembers 'the streets full of men with faces pasty from bread and margarine and sleeping till noon and their children who wore plimsolls in the depth of winter ... [the] atmosphere of poverty and insecurity, a horde of nasty snivelling fears left in the town like bastards in the wake of an invading army'. These might have seemed distant memories in 1957, but to many of Braine's readers they felt alarmingly real: even Harold Macmillan's 'never had it so good' speech had actually been a warning that unless Britain followed the right economic policies, 'we should be back in the old nightmare of unemployment'.

On top of that, Joe is desperate to throw off the constraints of his background in the small town of Dufton, which will sound immediately familiar to any Catherine Cookson reader: 'the back-to-back houses, the outside privies, the smoke which caught the throat and dirtied clean linen in a couple of hours, the sense of being always involved in a charade upon Hard Times'. In Warley, the big city, full of girls and opportunities, he dreams of 'acting out a fairy story'. Yet in an unusually vulnerable touch – for Joe is, all in all, a pretty unsympathetic figure – he never quite manages to banish his sense of social inferiority. When he starts going out with Susan Brown, daughter of a rich local businessman, he has a brief moment of panic, imagining how her mother must see him, 'uncouth and vulgar and working-class'. He always has the fear, he says, of 'doing the wrong thing ... saying the wrong thing to the waiter or picking up the wrong fork'. This, of course, was a common anxiety in the socially mobile but intensely class-conscious world of the 1950s and early 1960s: just think of young Ken Barlow, lecturing his parents on the right way to eat their tea.[23]

Joe's defining quality, though, is his extraordinary, almost demonic ambition. 'What has happened to me', he says, 'is exactly what I willed to happen. I am my own draughtsman. Destiny, force of events, fate, good or bad fortune – all that battered repertory company can be thrown right out of my story, left to starve without a moment's recognition.' This immediately sets him apart from the diffident Jim Dixon. But it also gives *Room at the Top* a very different feel from all those twentieth-century books that showed their characters at the mercy of class and circumstance. Older writers who had written about young men and women making their way in modern society, such as H. G. Wells,

Arnold Bennett and D. H. Lawrence, had shown their characters strug-
gling against the great social and economic forces of the age. But what
makes Joe unusual, if rather implausible, is that he almost literally *wills*
himself out of his class. He propels himself upwards, not through talent,
virtue or even hard work, but through sheer drive and desire. 'I always go
straight for what I want,' he tells his friend Eva – and he means it.

To that extent, therefore, his ethos is more Simon Cowell than Samuel
Smiles. For while Smiles had believed that self-help went hand in hand
with mutual assistance and Christian charity, Joe has not an altruistic
bone in his body. In one extraordinary passage, he goes back to Dufton
to look at the ruins of his parents' house, reflecting on the tragedy of
their deaths in the German air raid. For a moment you almost feel sorry
for him. But then a bitter wind blows, and he feels reassured by 'the thick
wool of my overcoat and the soft cashmere of my scarf'. The wind, he
explains, 'had no power over me now, it was a killer only of the poor and
the weak'. He cannot wait to get back to Warley, away from his kindly
relatives in their mean little house. 'My aunt and uncle were unselfish
and generous and gentle, they spoke only the language of giving,' he tells
us, 'but no virtue was substitute for the cool smoothness of linen, the
glittering cleanliness of a real bathroom, the view of Warley Moor at
dawn, and the saunter along St Clair Road past the expensive houses.'

The other innovative thing about Joe is his unrepentant materialism. In
one famous passage, he looks down on Warley from the moors above, and
sees it merely as an accumulation of shops and brand names: 'Wintrup the
jeweller with the beautiful gold and silver watches that made my own
seem cheap, Finlay the tailor with the Daks and the Vantella shirts and the
Jaeger dressing-gowns, Priestley the grocer with its smell of cheese and
roasting coffee, Robbins the chemist with the bottles of Lenthéric
after-shave lotion and the beaver shaving-brushes'. This all feels very Ian
Fleming: a gigantic exercise in wish-fulfilment, reflecting not the lurid con-
sumerism of the late 1950s, when *Room at the Top* was published, but the
pinched austerity of the earlier part of the decade, when it was actually
written. And perhaps even more than Bond, Joe treats women, too, as little
more than commodities. The nicest thing he says about Susan, his future
wife, is that with her good looks and fine clothes, she is the ultimate 'justi-
fication of the capitalist system' – and he means it as a compliment. When
he takes her out, there is no sense of romance or even really of lust. Instead,
he daydreams about owning a big house in Harrogate, taking his holidays

in Monte Carlo, buying a mink cape, a 'made-to-measure shirt in real silk' and a Triumph roadster. 'At that very moment,' he explains, 'she made me rich.' 'Joe, do you love me?' she asks girlishly. 'How much?' His reply says it all: 'A hundred thousand pounds' worth.'[24]

What is often forgotten about *Room at the Top* is that Braine actually presents Joe's story as a morality tale, a parable of the dangers of unchecked ambition. 'Joe, you're very inexperienced. You can't get everything you want all at once,' one of his friends warns early on. So even though Joe gets the girl and a good job, he ends up losing his soul, because the woman he really loves – well, the woman he really likes having sex with – gets drunk and kills herself in a car crash. But it is hard to banish the feeling that, in these final sermonizing pages, Braine was merely going through the motions. 'A Savage Story of Lust and Ambition' screamed the posters for the film adaptation two years later, and it was lust and ambition, not finger-wagging moralizing, that most critics associated with Braine's book. Revealingly, *The Times* saw the novel as that rare thing, a 'success story' by a contemporary British writer, and welcomed the arrival of an 'ambitious, pushing' hero to banish all the 'angry, feckless and inept young men' who populated most novels of the 1950s. The *Observer*, too, saw Joe as a 'callous, ambitious, sexy Lucky Jim . . . a ruthless rather than an angry young man'.[25]

But not surprisingly there were plenty of people who hated both Joe and the book. The Labour MP Richard Crossman thought it was merely a 'nauseating', 'vulgarized' version of *Lucky Jim*: 'It is lower middle-class, anti-working-class, describing the working classes as dirty, smelly people, eating fish and chips, and favouring the upper class as people who have tiled bathrooms and beautiful voices.' As the historian David Kynaston remarks, perhaps only a former head boy of Winchester could so completely fail to grasp the appeal of tiled bathrooms to ordinary readers. The best reaction to the book, though, came from Malcolm Bradbury, who produced a splendid parody for the *Guardian*. 'Laetitia, Marchioness of Salop, was expensive; I only had to glance at her to see that,' Joe says. 'She put her hand lightly on my wrist, then took it away again. "Do say progress once more, Joe," she murmured. "I love it."'[26]

For Braine, the success of *Room at the Top* was a glorious case of life imitating art. In March 1957 he was on the bus to work at the branch library in the mining village of Darton, near Barnsley, rattling past the pit-heads and slag-heaps, when he opened the *Yorkshire Post* and saw

the first review, which called him 'one of the year's finds'. His reaction was pure Joe Lampton: he felt, he said, 'as if I were riding on the Golden Arrow [a luxury boat train] past mimosa and violets and palm trees. The praise in the very long review was as nourishing as steak and Burgundy.' At the time, Braine was making just over £12 a week, the equivalent of about £13,000 a year today. But soon after 10 million people had seen him interviewed on *Panorama* on 8 April, hardback sales hit 12,000 copies, unheard of for a debut novel by a Yorkshire librarian. A few days later he was taken up by the *Express* papers, which hailed him as the 'new apostle of success'. 'Success Story!' read one headline on 13 April, announcing that the *Daily Express* would be serializing Braine's novel over the next ten days. In the context of mid-1950s Britain, the headline for the first extract sounded almost incredibly alluring: 'Ambition and women: Right to the end it was to be explosive stuff!'

And for the next few months the *Express* gloried in the triumphs of its latest hero. 'It's cash, cash all the time for the man at the top,' read one headline from February 1958. For by now Braine's life had changed completely. Other writers might have waxed lyrical about the satisfaction of seeing their artistic ambitions realized, the joy of seeing their prose in the hands of so many readers – but not John Braine. 'We have never been so wealthy before,' he told the *Express* on Christmas Eve 1957. A year earlier, he and his family had 'five shillings – and a chicken – between themselves and starvation'. And now? 'There's a goose in the oven. A tree, decorations. I shall be playing Santa Claus. We have a new home.'[27]

The gloriously ironic thing about John Braine's success is that, having tried to present Joe Lampton as an object lesson in the dangers of unchecked materialism, he wasted no time in following his hero's example. As his friend Kingsley Amis drily remarked, success merely proved that, deep down, John Braine had always wanted exactly what Joe Lampton wanted. A year after publication, having sold the film rights for £5,000, the equivalent of perhaps £300,000 today, Braine told a reporter that he wanted the film to be good 'because the more successful it is the more copies of my book will be sold'. He was in luck: when Jack Clayton's hugely popular adaptation, the film that 'put an X in Yorkshire', came out in 1959, Penguin rushed out a new paperback version, which sold a million copies within a year. At the film's West End premiere, Braine cut a sleekly triumphant figure. The *Express* ran two pictures side by side: one showed Braine in early 1957, the other 'an

enlarged Braine' two years later, sporting what the paper called 'the prosperous, well-groomed and well-fed look'. Back in Yorkshire, Braine's wife was nursing his 2-year-old son, who was under the weather. But in London the conqueror basked in the acclamation of his subjects. Indeed, perhaps never has any author so completely followed the example of his most famous character. 'I have been drinking champagne and eating steaks,' Braine told the *Express*. 'But then I eat steaks and drink champagne in Bingley. So it's not so different after all.' He paused to say hello to a passing figure in the crowd of dinner jackets and mink coats. 'I knew it would lead to a night like this,' he said. 'The Top.'[28]

Braine was not, of course, the first writer to make a lot of money. He was not even the first to glory in his winnings. In the first two decades of the twentieth century, Arnold Bennett had been so successful that he could afford to keep two yachts, had a special omelette created for him at the Savoy and generally lived like a multi-millionaire. 'The professional author', Bennett mischievously remarked, 'labours in the first place for food, shelter, tailors, a woman, European travel, horses, stalls at the opera, good cigars, ambrosial evenings in restaurants; and he gives glory the best chance he can.' This earned him the undying hatred of upper-class snobs like Virginia Woolf, who thought that such things should be inherited, not earned. But not even Bennett, who was, in fairness, a far better writer than John Braine, could match his successor's gleeful delight at raking in so much cash. Amid all the consumerism of the late 1950s and early 1960s, there seemed no greater success story, no more enthusiastic materialist, no more fervent champion of the capitalist system, than the former librarian from West Yorkshire. 'There was', Kingsley Amis thought, 'more than a joke in John's declaration that his dream of real success was of a triumphal procession through Bradford with himself at the head, flanked by a pair of naked beauties draped in jewels.'[29]

The curious thing about Braine was that although he is remembered as one of the emblematic writers of the 1950s, he actually only wrote one decent book. With the exception of *Room at the Top*, his output is now completely forgotten. What saved him from obscurity was partly the film but also his public persona, at once endearingly innocent and ruthlessly self-interested, which made him an irresistibly entertaining champion of the new materialism. Many upwardly mobile writers of the 1950s – Amis being the most famous example – moved sharply to the right as they got older, partly because they resented paying their large tax bills, but also

because they were shocked by the very different tastes and values of the generation who succeeded them. But Braine was really in a class of his own. His columns calling for the reintroduction of hanging and the ending of all foreign aid, for example, were not the half of it. Even the flagrantly reactionary Amis found him such an 'extreme right-winger' that it was embarrassing to be allied with him, and that was saying something.

At weekly 'Fascist Beast' lunches with like-minded writers such as Amis, Robert Conquest and Anthony Powell, Braine would regularly subject the others to long lectures on the iniquities of socialism, as though unaware that he was preaching not just to the converted, but to some of the most conservative writers in the land. He put specially made stickers on his cigarette packets: 'CIGARETTES ARE GOOD FOR YOU – SMOKE MORE, LIVE LONGER'. He was stunned when the left-wing clergyman Lord Soper questioned the merits of the American system on the grounds that its black citizens were treated unfairly. 'But you stupid bugger, I'm not black,' Braine said, with what Amis called 'a real grimness, almost belligerence' in his eyes.

Similarly, he professed astonishment at newspaper reports of a German woman who had been arrested for keeping two teenage girls as slaves in her cellar. 'Let's face it,' said Braine, banging his fist on the table, 'we've all got a servant problem and there's a woman who solved hers. Would you believe there was talk of sending her to gaol?' Amis was convinced that he was not joking. Nor was Braine joking when he invited Amis to give a public talk defending the white supremacist government in South Africa, or when he lectured his fellow Fascist Beasts for more than half an hour on how lucky they were to be freelance writers ('We sell our wares to the highest bidder. We receive no wage. We work as and when and where we will . . .'). But at the end of all this, Amis recorded, there came a note of plaintive insecurity, immediately reminiscent of Joe Lampton's hang-ups about his own background. Gradually tailing off as his listeners lost interest, Braine eventually said in a very different voice: 'I know I'm hated. The reason being I never went to a university.'[30]

But it was precisely because Braine had such an unglamorous backstory – what Joe Lampton calls 'the world of worry about rent and rates and groceries, of the smell of soda and blacklead and No Smoking and No Spitting and Please Have the Correct Change Ready' – that he seemed such a satisfyingly symbolic figure. *Room at the Top* was published at exactly the moment when all the talk was of 'meritocracy', and

as a Yorkshire grammar-school boy, Braine seemed the perfect embodiment of change. He was not, of course, alone: among the meritocrats making names for themselves in the worlds of the arts and letters at the end of the 1950s were Malcolm Bradbury, Keith Waterhouse, Brian Redhead, John Carey, Peter Blake, Harold Evans and Lionel Bart, while a younger generation – Joan Bakewell, Trevor Nunn, Glenda Jackson, Tom Courtenay, Alan Bates, Ian McKellen, David Hockney – were poised to follow suit a few years later.

Of course social mobility did not come without a cost. Interviewed by the BBC in 1958, a pale, intense Oxford student called Dennis Potter, who had gone to a grammar school in the Forest of Dean, admitted he struggled to get on with his working-class family. His father, still a coal miner, was now forced to communicate with him 'almost, as it were, with a kind of contempt'. Even listening to the radio was a battleground: clever young Dennis wanted one thing, his father something else. Here was another situation that Ken Barlow would immediately have recognized. Indeed, the tension between working-class father and aspirational son was a common theme in the culture of the late 1950s. Joe Lampton's father was a Labour stalwart, but the culmination of Joe's journey, his climactic assault on the social order, takes place in the polished rooms of Warley's Conservative club, which smells of 'cigars and whisky and sirloin'. 'My father'd turn in his grave if he could see me,' Joe tells his future father-in-law, the rich businessman Mr Brown. 'So would mine, lad,' says Mr Brown, and winks. 'But we're not bound by our fathers.'[31]

Critics have sometimes argued that *Room at the Top* does not really count as a working-class novel, since even though Joe's parents were working-class, his job as a local government clerk means that he starts the book as a member of the lower-middle classes. But Braine himself described Joe as 'a boy from the working classes'. 'Most ambitious working-class boys want to get the hell out of the working class,' he claimed many years later. 'That was a simple truth that had never been stated before.' And it would be silly to underrate *Room at the Top*'s importance as a novel that put the lives of ordinary working-class and lower-middle-class people in the industrial North centre stage. It is true that, say, Catherine Cookson was doing much the same thing, but the difference is that, at that point, nobody noticed. By contrast, other young working-class writers were delighted to see *Room at the Top* doing so well. 'If you look for the working classes in fiction, and especially English

fiction,' George Orwell had written in 1940, 'all you find is a hole.' But Braine had proved that writing about ordinary people in Bradford or Bingley was now no barrier to success. For the young Stan Barstow, a coal miner's son from Wakefield who hit the jackpot with *A Kind of Loving* (1960), Braine's book was an inspiration. 'It is hard now', Barstow wrote a quarter of a century later, 'to convey [its] importance . . . for a generation of writers from the North of England' – not because of the merits of Braine's prose, but because he proved that a northern writer could sell books and win over the critics by writing about what he knew. In the context of the 1950s, that felt like a genuine breakthrough.[32]

Room at the Top was the first of a flurry of high-profile books and films – social realist, working-class, New Wave, call them what you will – set in the urban landscape of the industrial North. Why did *Saturday Night and Sunday Morning*, *A Kind of Loving*, *This Sporting Life*, *The Day of the Sardine* and *The Loneliness of the Long-Distance Runner* come along when they did? The conventional answer is that they reflected the collapse of class barriers. A more plausible explanation is that, like *Coronation Street*, they tapped a growing nostalgia for a disappearing world of smoky skies, crowded pubs and terraced streets, a world of sharp-tongued matriarchs and horny-handed husbands. And with traditional working-class values apparently under threat from affluence, advertising and consumerism, images of the industrial North seemed a refuge from the dreaded 'shiny barbarism' of modernity. Perhaps surprisingly, though, the one element which is completely lacking in all these stories, with the exception of *Room at the Top*, is individual ambition. Almost none of their heroes – Vic Brown, Arthur Seaton, Arthur Machin, Arthur Haggerston (there are a lot of Arthurs, and even Vic Brown's middle name is Arthur) – shows any serious interest in bettering himself, improving his mind or moving up the social scale. Indeed, getting on is positively suspect, a kind of surrender to 'them', the forces of authority. As D. J. Taylor aptly remarks, 'one looks for the ghost of Samuel Smiles in these accounts of "ordinary life" lived out in the shadow of the factory gate . . . and finds instead a handful of vague daydreams, simple exercises in wish-fulfilment'. Alan Sillitoe's hero Arthur Seaton is typical. All he wants, he says, is 'a good life: plenty of work and plenty of booze and a piece of skirt every month until I'm ninety'.[33]

And yet books like *Saturday Night and Sunday Morning* do reflect a kind of inarticulate individualism. Their heroes are restless, hedonistic,

defiantly anti-authoritarian and anti-idealistic. By and large, they have absolutely no sense of class solidarity, no commitment to their fellow men and no interest in anything beyond themselves. As Albert Finney's Arthur Seaton famously puts it in the film version: 'What I'm out for is a good time. All the rest is propaganda.'

Smith, the hero of Sillitoe's short story 'The Loneliness of the Long-Distance Runner', which he later adapted for the cinema, is cut from the same cloth. In an odd misreading of Sillitoe's screenplay, the British Board of Film Censors were initially worried that it was little more than Communist propaganda. In fact, Smith's great act of rebellion, when he refuses to win the race that would bring glory on his borstal, is motivated not by socialist idealism or class solidarity but by a kind of mute anarchism. Indeed, for Arthur Seaton, standing up to others is practically his entire philosophy. Reflecting on his National Service, he recalls his reaction when the sergeant major told him to get his hair cut, because he was 'a soldier now, not a Teddy Boy'. 'I'm me and nobody else,' he thinks; 'and whatever people think I am or say I am, that's what I'm not, because they don't know a bloody thing about me.' And at the end of the book, undeterred by his violent misadventures, he rededicates himself to his anarchistic, hedonistic philosophy:

Trouble it'll be for me, fighting every day until I die ... Fighting with mothers and wives, landlords and gaffers, coppers, army, government ... There's bound to be trouble in store for me every day of my life, because trouble it's always been and always will be ... and nothing for it but money to drag you back there every Monday morning.[34]

What Arthur and his fellows dread most is the prospect of being trapped. Their great fear is that they will be caught and imprisoned, not just by their bosses or even by their class, but by their families, their parents, their girlfriends, their environment. This was a well-worn theme in British literature, explored to great effect in, say, Arnold Bennett's masterpiece *The Old Wives' Tale* (1908), in which the wilful, frustrated Sophia flees from her suffocating family to start a new life with the man she thinks she loves, as well as his later novel *Clayhanger* (1910), in which young Edwin Clayhanger is forced by his father to abandon his dreams of becoming an architect. It was also a familiar sensation to generations of ambitious working-class men and women, who chafed at the constraints of their often intensely narrow, insular communities. The BBC

newsreader Wilfred Pickles, one of the first northern voices heard regularly on the radio, had grown up in Edwardian Halifax, where he visited his local library to read Shaw, Galsworthy and the Romantic poets. But at home he found 'a depressing narrowness of outlook and resented my family's unquestioning judgement that everything they did was right and anything to the contrary was to be condemned'. Pickles's great ambition was. to 'escape from this world of mean streets', something he achieved as an actor and radio celebrity. And although Arthur Seaton lacks Pickles's sense of drive, what he shares is the unflagging belief in his own uniqueness, and the nagging dread that he will somehow be tamed, neutered, absorbed into the community, losing his grit and his singularity.[35]

In a world that was now more socially mobile than ever before, the horror of being imprisoned while others soared free seemed greater than ever. It was the desire to escape that had driven Catherine Cookson to move south and pick up her pen; it is the terror of being trapped in the same old narrow streets, like a sardine in a tin, that haunts Sillitoe's Arthur Seaton and Stan Barstow's Vic Brown. Vic thinks he has got away: the son of a coal miner, he becomes a draughtsman, echoing Barstow's own story. But then he gets his girlfriend pregnant, and is forced not just to marry her but to move in with his mother-in-law, perhaps the ultimate form of imprisonment. Even Joe Lampton, the poster-boy for ruthless ambition, knows the terror of incarceration: he spent much of the war, after all, in a German prison camp.

So perhaps it is not surprising that great escapes and prison camps played such prominent roles in post-war British popular culture, from war films like *The Wooden Horse* (1950) to the BBC's tremendously popular series *Colditz* (1972–4). The same themes of imprisonment, escape and self-realization recur again and again in the music of the period, too, from the Rolling Stones' 'I'm Free' and the Kinks' 'Set Me Free', both of which were released in 1965, to Queen's 'I Want to Break Free' and Wham!'s 'Freedom', both released in 1984. But the television series that best captured Britain's fascination with imprisonment and escape was a long way from the moody surliness of the Rolling Stones or the gritty realism of *Colditz*. Steeped in the Technicolor surrealism and anti-Establishment individualism of the late 1960s, it left many viewers completely baffled. But its hero's most famous words could hardly be a better summation of the spirit of the age: 'I am not a number! I am a free man!'[36]

Previous pages: Elton John poses for the camera in his delightful Surrey home, 1974.

13

My Life Is My Own

YOU ARE NUMBER SIX

Society highly values its normal man. It educates children to lose themselves and to become absurd, and thus to be normal.

Normal men have killed perhaps 100,000,000 of their fellow normal men in the last fifty years.

R. D. Laing, *The Politics of Experience* (1967)

Whatever people were expecting when they turned the television on after tea on Friday 29 September 1967, it is a safe bet that it was not what they got. Thunder crashes overhead. A man in a yellow-nosed roadster, his face set in a grim smile, roars into London, past the Palace of Westminster and down into an underground car park. He leaps from the car, throws open some double doors, and strides down a corridor, a picture of determination. More double doors. More thunder. In an office at the end of the corridor, he remonstrates with a man behind a desk, finally throwing down a white envelope and storming out. As his car streaks away, a mysterious black hearse glides off in pursuit; meanwhile, a typewriter chews its way through his picture, covering his face with a line of Xs, before a machine drops it into a filing cabinet bearing the single word 'RESIGNED'. The man pulls up outside a smart London townhouse, rushes in and starts packing; meanwhile, an undertaker steps out of the hearse and walks to his door. Suddenly smoke – gas? – pours into the man's apartment, and he drops to the ground. The picture fades out. A moment later, the man awakes. He opens his window blinds and stares out. And there, before his disbelieving eyes, is a kind of Italianate village: the stuff of fairytales, or perhaps of nightmares ...

'Where am I?' 'In the Village.' Patrick McGoohan contemplates his fate in the first episode of *The Prisoner* (1967).

The Prisoner, which ran for seventeen episodes in the autumn and winter of 1967–8, is pretty much impossible to explain to somebody who has never seen it. The hero has no name and virtually no backstory. We know only that he used to be a secret agent; that he handed in his resignation, ostensibly to go on holiday; and that he is being held prisoner in a mysterious seaside village, cut off from the rest of the world by impassable mountains. The story revolves around his attempts to escape, but so bald a description cannot possibly do justice to the sheer weirdness of what unfolds.

Life in the Village is reminiscent of a Butlin's holiday camp: the inhabitants wear childish, colourful clothes and take part in communal games and activities. None of them have names, only numbers: our hero is told that he is Number Six, while the Village is governed by a succession of Number Twos, who are replaced when they fail to break the hero's resistance. Although the villagers seem unnaturally cheerful, they are kept under constant surveillance; should any of them rebel or try to escape, they are hunted down and absorbed by a giant white balloon, which is often seen chasing them through the lush gardens. And the general atmosphere is a bizarre blend of childish whimsy (nursery rhymes, schoolchildren's games), James Bond-style sets (the futuristic, Op Art designs for Number Two's headquarters) and outright surrealism (for example, an episode set in an annexe of the Village that resembles a town in the Wild West). It is hard to think of any series that better captures the psychedelic vogue of the late 1960s. But perhaps only when you look at the television schedules during the show's first week – *Dixon of Dock Green*, *Z Cars*, *Dr Finlay's Casebook*, *The Horse of the Year Show* – do you begin to realize how strange it must have seemed.

The Prisoner was the brainchild of Patrick McGoohan and George Markstein, who had first worked together on the series *Danger Man*, an ITV fixture between 1960 and 1966. *Danger Man* was a typical James Bond-style spy thriller, made almost entirely in black and white by Lew Grade's Incorporated Television Company (ITC) and then sold to the American network CBS. McGoohan played the lead, John Drake, a suave secret agent in the Bond mould, but with two notable caveats: he never carried a gun, and he never seduced girls. Having been brought up a strict Catholic, the darkly handsome McGoohan insisted on these requirements being written into his contract. Born to Irish parents in New York in 1928, he had been brought up in Ireland until he was 7,

when his father, formerly a farmer, moved to Sheffield to find work. After a miserable period as a Rank Organisation contract star in the 1950s, McGoohan moved into television and found fame with *Danger Man*. It was there that he came across Markstein, who had been born in Berlin to a Jewish family in the 1920s but fled to England a decade later and eventually became a screenwriter.

Which of them first came up with the idea for *The Prisoner* is still hotly debated; after the two men fell out, each of them claimed that it was really his idea. Markstein claimed that he devised it while sitting on the 6.21 train from Shepperton to Waterloo one evening in 1966, based on stories he had heard as a journalist from British intelligence agents, who told him of a remote place in Scotland where spies were held if they 'knew too much'. McGoohan, however, insisted that he had been planning *The Prisoner* for years – since he was 7 years old, in fact. He had always wanted, he said, to write something pitting 'the individual against the establishment, the individual against bureaucracy, the individual against so many laws that were all confining. The church, for instance: it was almost impossible to do anything that was not some form of sin.' This seems plausible enough, though it does seem a little unlikely that he was seriously thinking about it at the age of 7. The most likely scenario is that, with *Danger Man* running out of steam, the two men discovered that they had been thinking along similar lines and decided to put their heads together. After all, the idea of a series celebrating the struggle of the individual against authority was hardly terribly outlandish, especially in the mid-1960s. And since Markstein and McGoohan were both outsiders – being, respectively, a Jewish refugee and an Irish immigrant – it is easy to see why they might have liked it.[1]

By comparison with other cult series of the mid-1960s, *The Prisoner* was extraordinarily expensive. When the BBC started making *Doctor Who* in 1963, the budget was about £2,000 per twenty-five-minute episode. Independent television budgets were bigger: during *The Avengers'* early years, each fifty-minute episode cost between £3,000 and £6,000, rocketing to almost £40,000 when the series was sold to the Americans. But *The Prisoner*'s budget was a whopping £75,000 for fifty minutes, the equivalent of perhaps £2 million per episode today. The reason it was so expensive was that McGoohan was planning extensive location filming – the Village, of course, being a central element of the

programme – as well as a vast array of specially designed props, costumes and vehicles. From Lew Grade's point of view, though, it seemed a reasonable gamble. *Danger Man* had been very popular abroad, and ITC were confident that McGoohan's name alone, as well as the spy thriller premise, would be enough to secure foreign sales. The really remarkable thing is not that they agreed to spend so much, but that they allowed their star to have so much creative control. Not only had McGoohan co-devised the series, he was going to produce it and play the lead. He chose the writers and directors; he vetted and revised the scripts; he even helped to design the villagers' strange costumes and the Village's penny-farthing logo. Few series have depended so much on one man.[2]

Location filming began on 5 September 1966 in the mock-Italian village of Portmeirion, north Wales, which McGoohan and Markstein had selected as the setting for their hero's ordeal. And, as might have been predicted, it did not go entirely smoothly. The workload was absurdly punishing, with the crew working from six in the morning until at least eight at night, weekends included. The crowd of almost a hundred extras, who were playing the villagers and had been recruited at the local Labour Exchange, turned out to be difficult to control. The pressure on McGoohan himself would have broken a lesser man: at one stage the schedule was so crowded that he used to spend one day filming the interiors in the MGM studios at Borehamwood, Hertfordshire, then drive overnight to north Wales for location shooting the next day, and then head straight back to Borehamwood. All this naturally took its toll. By the end of the year, McGoohan was not merely demanding extensive revisions to the latest scripts, he had started to rewrite them himself in the evenings. When an Italian director failed to impress, McGoohan sacked him after just one morning, which must have made for a fun trip home. All the time, the show's style was changing, becoming steadily more bizarre to match McGoohan's increasingly autocratic vision. Even more alarmingly from ITC's point of view, the costs had drastically escalated, with the first thirteen episodes coming in well over budget. On top of all that, McGoohan and Markstein had now had a dreadful falling-out, which heaped even more responsibility on to the star. By the summer of 1967 his colleagues thought he seemed burned out. 'It appeared that something new', one of them said later, 'had been gathering force inside Pat, simmering away, heading for an implosion.'[3]

The Prisoner's fate, like its origins, has become the stuff of a bewildering litany of claims and counter-claims, but what seems pretty clear is that by the middle of 1967, before a single episode had been transmitted, Lew Grade had already decided to pull the plug. This explains the show's peculiar structure: instead of making two thirteen-part seasons, McGoohan's team effectively made a thirteen-part season and a four-part coda, which were then bolted together into one. They were actually still filming when ITC arranged a press conference, nine days before the first episode was due to go out. Perhaps the pressure explains McGoohan's peculiar behaviour, which recalls John Lennon in his world-peace phase. He turned up in one of the outfits for the sport Kosho, a weird martial art he had invented especially for the series, and insisted on answering questions from inside a metal cage, accompanied by some of the actors from the series and a host of extras dressed as villagers. The press, who had just seen the first two episodes, had been expecting something akin to *Danger Man* and therefore found the whole thing completely baffling. But McGoohan took great delight in throwing their questions back at them. One reporter asked about the show's narrative logic. From inside his cage, McGoohan said: 'Let me ask you two questions. You're living in this world? You must answer "Yes" to that. Do you always find it logical? No? That's your answer to that.'[4]

Although *The Prisoner*'s fans have spent almost half a century arguing about what it all meant, the series' origins were so murky and its gestation so haphazard that it would surely be a mistake to treat it as a coherent, carefully planned whole. As if the basic scenario were not surreal enough, the episodes were broadcast in a different order from that in which they were made. The second episode was actually made fifth; the third episode was made eleventh; and the sixteenth episode, which leads directly into the finale, was actually made sixth. Amazingly, *The Prisoner*'s official appreciation society even recommends watching them in an entirely different order, which probably says it all about the narrative coherence of McGoohan's project. The truth is that he was making it up as he went along. At one stage he even left the set to work on the film version of Alistair MacLean's thriller *Ice Station Zebra*, leaving his production team to make an episode in which Number Six's mind is transported into another actor's body. As for the controversial final instalment, 'Fall Out' – probably one of the most debated television episodes in history – McGoohan later claimed that he had locked

himself in his dressing room to write it over the weekend, surfacing on Monday morning, exhausted but triumphant, to hand copies to the cast and crew. By most accounts he was so pressed for time that the chief guest star, Kenneth Griffiths, had to write his own dialogue. This probably explains why the final episode seems so completely deranged.[5]

In terms of its message, though, *The Prisoner* is nothing if not consistent. Viewers eager to discover its meaning ought to start with the exchange that opens most episodes, pitting Number Six against successive Number Twos, which ends with McGoohan's cry of defiance: 'I am not a number. I am a free man!' This is the show's central theme from first to last: the individual's desperate struggle to cling on to his identity and assert his singularity in a society that wants to make him conform. From this perspective, the setting – a nightmarish holiday camp, a place where every activity is carefully organized and every move closely monitored – makes perfect sense. 'The Village is symbolic,' McGoohan explained later. 'We are all prisoners of this or that, many things ... each in his own Village.' The point of the series, he went on, was that 'our hero was striving to be completely free, utterly himself'.[6]

But this means defying not just the authorities – the succession of Number Twos, with their cameras, their double agents and their terrifying white balloons – but his fellow villagers. In the fourth episode, 'Free for All', Number Six runs for election to become the new Number Two. When he addresses the crowd: 'I am not a number ... I am a person,' they roar with laughter, drowning out the rest of his words. But he never loses his courage or his composure. In another episode, 'Dance of the Dead', a girl begs him to conform:

GIRL: I have my duty.

NUMBER SIX: To whom?

GIRL: To everyone. It's the rules. Of the people, by the people, for the people.

NUMBER SIX: It takes on a new meaning.

GIRL: You're a wicked man.

NUMBER SIX: Wicked?

GIRL: You have no values.

NUMBER SIX: Different values ...

GIRL: You want to spoil things.

NUMBER SIX: I won't be a goldfish in a bowl.

This theme is even more explicit in the penultimate episode, 'Once Upon a Time', which is largely taken up by a truly bizarre primal therapy-style confrontation between Number Six and Leo McKern's Number Two. 'Society is a place where people exist together,' says Number Two. 'That is civilization. The lone wolf belongs in the wilderness. You must not grow up to be a lone wolf. You must conform.' But Number Six refuses to crack. In a very surreal ending, anticipating Ingmar Bergman's film *Persona*, which came out in Britain in September 1967, the two men effectively swap roles. The clock counts down, Number Two is left trapped in a cage, and when the time runs out, he drops down dead. A door slides open, and in comes the mysterious Supervisor. 'Congratulations,' he says: 'What do you desire?' 'Number One,' the Prisoner replies. 'I'll take you,' says the Supervisor – and there the episode ends. For viewers at the time, the next seven days must have seemed like an eternity.

After sixteen episodes, viewers tuning in to *The Prisoner*'s final instalment, 'Fall Out', which went out on 1 February 1968, were surely looking forward to some explanations. What they got was perhaps the strangest fifty minutes of television drama ever broadcast. In a cavernous underground chamber, a judge in scarlet robes stands at a tribune, while a row of soldiers in white helmets marches imperiously past. Behind the judge, massed ranks of delegates wearing white hooded robes and black-and-white masks, and identified by a series of badges – 'Reactionaries', 'Anarchists', 'Welfare', 'Pacifists' – burst into applause; meanwhile, the Beatles' song 'All You Need Is Love' echoes around the chamber. The judge brings proceedings to order:

> This session is called in a matter of democratic crisis. And we are here gathered to resolve the question of revolt. We desire that these proceedings be conducted in a civilized manner, but remind ourselves that humanity is not humanized without force, and that errant children must sometimes be brought to book with a smack on their backsides ... The community is at stake and we have the means to protect it ...
>
> We understand he survived the ultimate test. Then he must no longer be referred to as Number Six or a number of any kind. He has gloriously vindicated the right of the individual to be individual. And this assembly rises to you – sir.

The judge produces two other examples of rebellion: Number Forty-Eight, a hippyish young man in a flower-decorated top hat and frilly shirt, who represents 'youth, with its enthusiasms, which rebels against any accepted norm'; and Number Two, miraculously brought back from the dead, 'an established, successful, secure member of the Establishment, turning upon and biting the hand that feeds him'. But then the judge turns back to the Prisoner:

> At the other end of the scale we are honoured to have with us a revolutionary of a different calibre.
>
> He has revolted. Resisted. Fought. Held fast. Maintained. Destroyed resistance. Overcome coercion. The right to be Person, Someone, or Individual. We applaud his private war and concede that despite materialistic efforts he has survived intact and secure.
>
> All that remains is recognition of a man. A man of steel. A man magnificently equipped to lead us: that is, lead us or go . . .

But when the Prisoner finally takes the stand to address the delegates, we never get to hear his great oration. 'I,' he begins – and then the masked delegates take up the chant: 'I, I, I, I . . .'

All this, bizarre as it may sound, is merely the preamble to a denouement that almost defies description, as the former Number Six and his fellow rebels confront Number One, make their escape and drive to London, dancing to the song 'Dem Bones' in a cage on the back of a truck. And then we go right back to the beginning: thunder crashes overhead, the hero's trusty roadster screams towards the camera, and the credits roll. It is no wonder that diehard fans of *The Prisoner* have been arguing about it for almost fifty years.

Afterwards, McGoohan claimed that the public reaction in February 1968 was so hostile that he seriously feared for his safety. 'I was nearly lynched in England when the episode came out. Everyone wanted to know what it was all about,' he once said. On another occasion, he claimed that he went 'into bloody hiding for two weeks' before fleeing with his family to Switzerland. Almost all histories of the series agree that the final episode was greeted by a vast outpouring of public fury. Even McGoohan's obituaries repeated the story. 'Television station switchboards were flooded with angry and perplexed callers,' the *Independent* told its readers after his death in 2009, 'while the press besieged McGoohan's home in London.'[7]

But like so many stories associated with *The Prisoner*, this seems to be a complete myth. By the end of the show's run, its viewing figures were less than spectacular, and a search through the newspapers in February 1968, from *The Times* and the *Guardian* to the *Express* and the *Mirror*, shows that, far from besieging his house, most papers never mentioned the final episode at all. Had the telephone switchboards really been jammed, then at least one of the papers would surely have reported it; but they didn't.

In fact, the only substantial review appeared in *The Stage*'s 'Television Today' supplement, which thought the whole thing had been 'an expensive failure', desperately trying to cover up for its weakly written scripts 'with technical gimmickry plus the sole recurring thought that the hero was an individual'. (I like *The Prisoner* a lot, but there is a fair bit of truth in this.) 'Probably many viewers who followed the show from the beginning', said an editorial, 'were wondering this week what it was all about and perhaps feeling angry or cheated that the ending did not make everything clear ... They may well feel that it is a breach of faith with them or a shirking of the issue just to say "that's it, make what you like of it".' On the other hand, *The Stage* had only limited sympathy for the audience, 'because it was obvious after the first two episodes that *The Prisoner* was nothing more than a succession of elaborate sets ... Television, however, is the great non-stop source of public entertainment and the viewers will soon forget *The Prisoner*.' On this point, at least, *The Stage* was dead wrong.[8]

In reality, the origins of McGoohan's story about fleeing the country seem to have been rooted in, of all things, a long-running dispute with his neighbours about his fence. (It is oddly reassuring to be reminded that even celebrity actors obsessed with the plight of the individual in society are subject to the same everyday annoyances as the rest of us.) As the *Mirror* reported in June 1968, McGoohan had built a six-foot fence around his house in suburban Mill Hill, north London, in order to deter fans who reportedly 'gathered in groups on the parapet to peer in'. According to McGoohan's deposition to a Housing Ministry inquiry, the sightseers 'goggled at his wife Joan and three daughters – Catherine, 16, Anne, 7, and six-year-old Frances – in the swimming pool', and 'even photographed Joan washing dishes in the kitchen'. This was a familiar story, the same kind of thing that had driven Rudyard Kipling and Bill Wyman to buy their country houses. Alas, McGoohan's solution was not popular with his neighbours, who complained that the

fence 'blocked a fine view over the Totteridge valley'; or with Barnet Council, who claimed that he had not bothered to get the necessary planning permission and ordered him to pull the fence down. The *Mirror* had some fun with the parallels, though. '"The Prisoner" Fights To Stay All Fenced In' read its headline, noting that in the Village, too, McGoohan had been 'under constant supervision'. Tragically, though, they did not follow the story up, so the fate of the fence remains a mystery.[9]

The Prisoner is often described as one of the great eccentricities of the age: a strange, iconoclastic one-off, made by an inspired maverick swimming against the tide. Yet in some ways it could hardly have been more conventional. The design, for example, was absolutely typical of the period, while the basic theme – the individual against society – was exactly what young audiences in the 1960s had come to expect. Although the series was filmed and broadcast before the student riots in France or the Prague Spring, the idea of rebellion was in the air. For more than a decade, a keen dedication to the works of, say, Albert Camus and Jean-Paul Sartre had been a kind of entry ticket to the ranks of the student intelligentsia, while even as McGoohan was making the series the newspapers were full of the heroism of the civil rights marchers in the American South and their anti-war counterparts in New York and California. By now the passions over the Vietnam War had seeped into British student life, too, and no self-respecting 21-year-old intellectual could afford to go out unless fully armed with quotations about the importance of upholding your conscience and fighting the system.

By January 1967 the first serious sit-ins had begun at the London School of Economics, protesting against the appointment of a new director who had previously worked in Rhodesia, and by the time *The Prisoner* made it to the screen, student protests had become endemic at universities across the country. To audiences watching the final episode in February 1968, therefore, the appearance of Number Forty-Eight, the flower-toting representative of youth in revolt, probably seemed depressingly familiar. Number Six's long tirades about freedom and resistance, far from being refreshingly unconventional, were precisely the kind of thing that, say, Tariq Ali might be telling Joan Bakewell on some painfully earnest BBC2 discussion programme later that evening. And even the peculiar extravagances of the final episode, with its flamboyantly shouting judge and rows of singing men in hoods and masks, could

quite easily have been mistaken for an afternoon's avant-garde happening at the Arts Lab in Covent Garden.

It is, in fact, surprisingly hard to think of many lasting cultural products of the mid-1960s that did *not* pay homage to the cult of the individual. The film that really kick-started Hollywood's love affair with British comedies, *Tom Jones* (1963; four Oscars from ten nominations), is the story of an uproarious eighteenth-century womanizer, bent on the pursuit of sexual self-indulgence. Similar themes dominate the now almost intolerably misogynistic *Alfie* (1966; five Oscar nominations, incredibly), in which Michael Caine spends his time chasing 'birds' around contemporary London. Indeed, although the two most enduring popular screen heroes of the decade, the cinematic version of James Bond and the BBC's time-travelling Doctor, look like representatives of the Establishment, they are really unashamed individualists at heart. The Doctor ran away from his own people, the Time Lords, not because he was oppressed but because he was bored. Whenever he is offered serious responsibility – rebuilding a shattered alien society, say, or serving as President of the Time Lords – his instinct is to run away again.[10]

As for Bond, he had always been shown in Ian Fleming's books as an impeccably reliable servant of Queen and country, his dealings with M a model of respectful deference. But Sean Connery's screen Bond is subtly different: a joker, a maverick, who never seems to take his superiors or his mission quite as seriously as he should. From M's point of view, it must be immensely infuriating to work with an agent who is always disrupting his briefings with silly wisecracks, absconding from the front line for dalliances with hotel chambermaids, and handing in his resignation at the drop of a hat. George Lazenby's Bond resigns in *On Her Majesty's Secret Service* (1969) because he thinks he, not M, should choose his assignments ('Take a memo please, Moneypenny ... and kindly present it to that monument in there'), while Timothy Dalton's Bond resigns in *Licence to Kill* (1989) because M refuses to let him take a break from his work to pursue a private vendetta ('We're not a country club, 007'). As for Daniel Craig's Bond, he can barely wait to get away from MI6. In *Casino Royale* (2006) he has no sooner completed his mission than he is typing out his resignation letter, while in *Skyfall* (2012) he spends the first part of the film boozing in a dodgy seaside bar. The only wonder is that M has not yet sent Bond for a prolonged stay in the Village.

In their ostentatious disrespect for authority, James Bond and Number Six were hardly unusual. Indeed, at some level they were merely following in the footsteps of Jim Dixon and Arthur Seaton, both of whom had greatly enjoyed tweaking their superiors. But there was an obvious difference. Kingsley Amis had written *Lucky Jim* at a time when respect for authority was still remarkably high, no doubt in part because so many British institutions were still basking in the glow of victory in the Second World War. To pick two obvious examples of public trust in established authority, voter turnout in the 1950 general election was a record 84 per cent, while the social anthropologist Geoffrey Gorer's survey of English attitudes in the same year found that three out of four people expressed 'an enthusiastic appreciation for the English police' and saw the policeman as a model of courtesy and courage.

But even a decade later, attitudes had started to change. Ever since the retirement of Winston Churchill in 1955, Britain's politicians had been battered by a succession of embarrassing fiascos, their reputations badly tarnished by the debacle at Suez, the salacious revelations of the Profumo scandal and the failure of both parties to reverse the nation's competitive economic decline. By the time *The Prisoner* finished its run, respect for the government had reached an all-time low: by the spring of 1968, a pitiful 19 per cent of respondents told Gallup that they approved of the Labour government's record, while satisfaction with Harold Wilson had fallen from 69 per cent to just 27 per cent in barely two years. As for the police, a succession of dreadful scandals gradually chipped away at their public reputation, with worse to come in the 1970s and 1980s. On television, *Dixon of Dock Green* still upheld the reputation of the old-fashioned bobby, with Jack Warner not handing in his truncheon until 1976, but by then nobody really believed it. 'At one time people thought of the police force in terms of the strong arm of the law, the warm protecting father's arms,' wrote the dramatist Jeremy Sandford in 1971. But now, as the policeman rode by 'on his jabbering motor cycle', the phrase that sprang unbidden to his mind was 'the surly lip of the law'.[11]

Did popular culture fuel public disrespect for authority? Or was it merely reflecting it? As so often, the answer probably involves a bit of both. The men and women behind the so-called satire boom of the early 1960s, which directed its fire at Establishment targets such as the Conservative Party, the British army and the Church of England, tended to

be from highly educated but socially modest backgrounds. Alan Bennett was the son of a Yorkshire butcher; David Frost's father was a Methodist minister; Dudley Moore had been born to an electrician and a typist on a Dagenham council estate. All three were quintessential post-war meritocrats, bright and ambitious, keen to poke fun at the tweedy patricians who dominated British public life. Yet even before, say, *Beyond the Fringe* opened in London in the spring of 1961, the idea of the anachronistic, snobbish Establishment was already in wide circulation. The very word 'Establishment' in this sense was several years old, having been coined by the historian A. J. P. Taylor in 1953 and popularized by the journalist Henry Fairlie two years later in an article about the elite's failure to expose the Cambridge spy ring. In the aftermath of Suez, and with the headlines full of stories about poor economic performance and the falling flag, commentators were queuing up to lay into the ineptitude and backwardness of Britain's institutions. To some extent, then, the satirists were aiming at some pretty easy targets.

It surely speaks volumes that, after the first night of *Beyond the Fringe*, the *Daily Mail* called it a 'sensation', applauding the way 'they carve up a clutch of sacred British institutions – the National Anthem, the "Few", Civil Defence, Mr Macmillan and the Church of England'. They could hardly have been that sacred if the *Mail* – then, as now, not exactly a voice of bohemian radicalism – enjoyed seeing them teased. Indeed, what is striking about the so-called satire boom, which peaked with the first series of the BBC's *That Was the Week That Was* over the winter of 1962–3, was not how controversial it was, but how *uncontroversial*. Mary Whitehouse might have complained that the show was 'the epitome of what was wrong with the BBC – anti-authority, anti-religion, anti-patriotism, pro-dirt and poorly produced' – but letters to the corporation ran heavily in its favour. Even the programme's single most controversial sketch, its 'Consumer's Guide to Religion', provoked just 246 complaints, a mere handful by later standards.[12]

'Do you know what I'd do if I had the whip hand?' asks Tom Courtenay's disaffected young delinquent in the film *The Loneliness of the Long-Distance Runner*, released in 1962. 'I'd get all the coppers, governors, posh whores, army officers and Members of Parliament, and I'd stick 'em up against this wall and let them have it, 'cause that's what they'd like to do to blokes like us.' At the time, such a sentiment might have sounded shocking. But within just a few years, it had become a

commonplace. By the second half of the 1960s, distrust, even outright scorn, for public institutions and authority figures had become a very familiar theme, from the blistering cinematic portraits of the British army in *The Charge of the Light Brigade* (1968) and *Oh! What a Lovely War* (1969) to the surreal skewering of middle-class social conventions in *Monty Python's Flying Circus*, which began on BBC1 in the final year of the decade. Of course there were exceptions: one reason that so many people loved *Dad's Army*, apart from the gentle brilliance of the characterization, was that it evoked a lost golden age when people loved their country, knew their duty and stood together to defend their island. But while there is a good case that *Dad's Army* captured the underlying conservatism of popular attitudes, it was hardly representative of the mood among most young writers, artists and musicians.

What was much more typical was the spirit of Lindsay Anderson's film *If . . .*, which was released in December 1968, only a few months after *Dad's Army*'s first episode. For while the BBC's beloved sitcom celebrates the institutions that saved Britain from the Nazis, Anderson's film treats them with withering contempt. This is *Tom Brown's School Days* turned completely upside-down: the public school as a Darwinian nightmare, animated not by Christian charity but by savage cruelty, with the school's cadet corps coming in for particularly scathing treatment. Tellingly, the young rebels launch their bloody uprising on Founder's Day, when the retired General Denson is addressing the boys on the importance of 'honour, duty and national pride'. 'We still need loyalty, we still need tradition,' he says fervently. 'I know the world has changed a great deal in the past fifty years. But England, our England, doesn't change so easily. And back here in college today I feel, and it makes me jolly proud, that there is still a tradition here, which has not changed and by God it isn't going to change.' A few moments later the shooting starts.[13]

To some extent this new mood of overt disrespect for authority simply reflected the broader retreat from the collective loyalties that had governed people's lives for so long. Attendances at pubs, cinemas and football matches, church membership, even membership of political parties, were all in steep decline, as people turned inwards, spending their free time shopping, gardening and watching television. In an age of rising living standards and mass education, so-called Establishment institutions such as the army and the Church of England were not the only institutions under pressure: many working men's clubs, brass

bands and even bowls clubs were haemorrhaging members, too. But the institution that really worried social conservatives was the family. In 1965 there had been just under three divorces per thousand married adults in England and Wales. By 1975, thanks in part to the reform of the divorce laws, there were almost ten, and by 1980 there were twelve. By this point, Britain already had the highest divorce rate of any country in Europe. In the meantime, more children were being born out of wedlock than ever before. In 1964 just seven in every hundred children were born to unmarried parents; by 1981 the figure had almost doubled, and by the 1990s it was well on its way towards 40 per cent. Divorce, illegitimacy and single-parent families had by this stage become familiar if not unremarkable elements of ordinary British life. But even a few years earlier, in the age of Jim Dixon and Joe Lampton, such figures would have provoked widespread disbelief.[14]

To some observers in the late 1960s, the decline of the family was a cause for celebration, smashing the fetters that had held so many individuals enslaved, and releasing them to pursue self-fulfilment and self-realization. Indeed, to many self-styled progressives, the family was a prison that made the Village look positively benign. 'Far from being the basis of the good society,' explained the Cambridge anthropologist Edmund Leach in the 1967 Reith Lectures, 'the family, with its narrow privacy and tawdry secrets, is the source of all our discontents.' The tabloids howled with fury, yet fashionable opinion increasingly agreed with him. More often than not, argued the psychiatrist R. D. Laing, whose own grip on sanity was not entirely secure, people whom society deemed 'mad' were merely rebelling against the repression of the nuclear family, dominated by 'violence masquerading as love'. Individuals, argued Laing, should be set free from this wicked and repressive institution: his guiding principle, as his biographer puts it, was that 'it was up to each individual to take responsibility for himself'. Most doctors treated Laing's ideas with well-deserved contempt.* Yet in the late 1960s few thinkers in any discipline had a deeper influence on popular culture. Writers and artists found Laing irresistible, and his ideas – madness is sanity and sanity madness; the family is a prison; the only

* Perhaps the best verdict on Laing came from his son Adrian, in an interview with the *Sunday Times* on 12 April 2009. 'Being the son of R. D. Laing was neither amazing nor enlightening,' he remarked. 'For most of the time it was a crock of shit.'

worthwhile goals are freedom and self-realization – appeared every-where, from Ken Loach's film *Family Life* (1971) to Peter Shaffer's play *Equus* (1973). And all the time radical feminists cast the nuclear family as the vehicle of male oppression, urging women to break free from the shackles of their husbands and children. 'We need an ideological revolution,' wrote the sociologist Ann Oakley in 1974. 'We need to abolish gender roles themselves ... Abolish the housewife role, therefore abolish the family.'[15]

By this stage Patrick McGoohan was long gone. By the end of 1968 he had moved to Switzerland, leaving his disputatious neighbours far behind. In the end he settled in Los Angeles's prestigious Pacific Palisades neighbourhood, where he worked closely with his friend Peter Falk on *Columbo*. In some ways this serious, saturnine, hard-drinking figure was a classic self-made man. Having left school at 16, McGoohan had literally tramped the streets of Sheffield looking for work, and had broken into acting only after the Sheffield Repertory Company took him on as a 'backstage dogsbody', working his way up to become the company's star performer. Yet, in other respects, he made an oddly inappropriate standard-bearer for the ideals of the late 1960s. Had it not been for his deeply held religious principles, he would probably have been cast as the first James Bond; yet he was so hostile to screen sex and violence that his contracts contained a no-kissing and no-guns clause. He had met his wife, the actress Joan Drummond, as a young man in Sheffield, and they were happily married for almost sixty years. Theirs was the model of an old-fashioned nuclear family, in which McGoohan's wife gave up her career to raise their children and look after the home, while he went out to make a living. R. D. Laing would not have approved.[16]

But if McGoohan himself might have been out of step with the values of his age, his most famous character now looks like their supreme embodiment. As Number Six is always telling us, he is not a number, but a free man. Free of what, though? He seems untroubled by loyalty, regrets or nostalgia. He has no habits, no tastes, no quirks, no eccentricities. He has no debts and no obligations; he has no friends, no family, no parents, no children. He does not even have a name. The Prisoner is Laing's ideal hero, a free man with no connections, the personification of atomized individualism. 'I will not be pushed, filed, stamped, indexed, briefed, debriefed, or numbered!' he says, not long

after arriving in the Village. 'My life is my own!' It is hard to think of many sentences that better capture the temper of the age.

THE LIBERATION OF HERCULES

When I announced I was gay in 1976, it really hurt me a lot. In America, a lot of radio stations stopped playing my music. I even thought about committing suicide. If I hadn't had Watford, I might have become a very big casualty. But I had to learn to take defeat well. If you take your seat at a football ground and 20,000 people are singing 'Elton John's a homosexual', you learn fairly quickly.

Elton John, interviewed on *The Tube*,
28 March 1986

On a sweltering day in August 1976, a tubby, balding man walked shyly into the corner room of his New York hotel suite, shook hands with his visitor and began to unburden himself of a secret he had been carrying for the best part of a decade. The night before, Elton John had been entertaining a packed house at Madison Square Garden. But now, drinking Perrier water with a reporter from *Rolling Stone* magazine, he was in contemplative, even confessional form. He had been stuck in the hotel for two weeks, he said, and it was driving him mad. 'I never wanted to do this in the first place,' he sighed. 'I only wanted to be a songwriter.' Sensing vulnerability, the reporter, Cliff Jahr, moved in. 'What about Elton when he comes home at night?' Jahr asked. 'Does he have love and affection?' 'Not really,' the singer said sadly. 'I go home and fall in love with my vinyl . . . Let me be brutally honest about myself. I get depressed easily. Very bad moods. I don't think anyone knows the real me. I don't even think I do.'

And then the most successful British musician of the 1970s, the man who was now selling more records worldwide than any solo artist of his generation, the boy born in a council house who had already played privately for the Queen's mother and sister, really opened up. 'I don't know what I want to be exactly,' he said mournfully. 'I'm just going through a stage where *any* sign of affection would be welcome on a sexual level. I'd rather fall in love with a woman eventually because I think a woman

probably lasts much longer than a man. But I really don't know. I've never talked about this before.' Jahr, surely unable to believe his luck, asked the obvious question: 'You're bisexual?' Elton John nodded. 'There's nothing wrong with going to bed with somebody of your own sex,' he said. 'I think everybody's bisexual to a certain degree. I don't think it's just me. It's not a bad thing to be. I think you're bisexual. I think everybody is.' Jahr pointed out that he had never said anything like this before. 'Probably not,' the singer admitted with a chuckle. 'It's going to be terrible with my football club. It's so hetero, it's *unbelievable*. But I mean, who cares! I just think people should be very free with sex – they should draw the line at goats.'

A few weeks later, the magazine ran the interview as its cover story, advertised with the headline 'Elton's Frank Talk: The Lonely Love Life of a Superstar'. In the following issue, letters poured in from his American fans. Some were supportive. 'He has opened my mind completely,' wrote C. Deley of Lima, Ohio. 'I'm never going to judge anyone by what they are physically, but instead by what an individual is inside.' Others were openly hostile. 'My disgust is matched only by my disappointment, which are both overshadowed by pity,' wrote Lisa Crane of Provo, Utah. And back home in Britain? Nothing. The biggest papers in Elton John's native country, the *Daily Mirror*, the *Daily Express* and the *Daily Mail*, merely reported the news in short inside pieces, with no comment at all and no attempt to follow it up. The *Sun*, then heading into its rabble-rousing pomp, did not even mention it. Elton John's entourage braced themselves to see what the *News of the World* would make of it. But its headline read merely: 'Elton: My Love Life Isn't So Strange.' 'I don't see why people should be so surprised,' the singer told the paper's reporter, who had caught up with him in the unlikely surroundings of Rochdale, where he had come to watch his beloved football team, Watford. 'It's not important, nor is it a big thing in my life. I don't see why it should affect the fan worship I've got. It hasn't hurt David Bowie, and I don't see why it should hurt me.'[17]

The 1970s are often remembered as a decade of liberation: the decade when, for countless individuals, Number Six's defiant boast, 'My life is my own!' became a reality. They began with the first National Women's Conference, held at Ruskin College, Oxford, in February 1970; the feminist protests at the Miss World contest at the Royal Albert Hall that November; and the first International Women's Day rally the

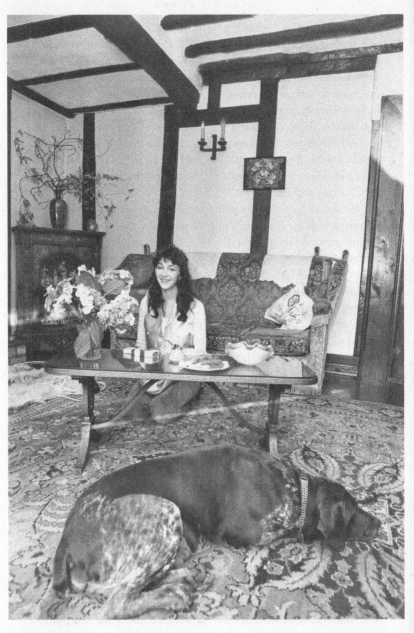

Kate Bush, then just 20, photographed at her parents' house in London, 1978. As the picture suggests, she came from a slightly bohemian but impeccably middle-class background.

following March, when more than a thousand women assembled in the pouring London rain to proclaim their support for equal pay, equal opportunities, twenty-four-hour nurseries, and free contraception and abortion on demand. They ended with the first woman Prime Minister, a working mother who had consistently defied the chauvinist prejudices of her own colleagues, turning her femininity into a political asset, a guarantee of fresh ideas and a new start. When the decade began, *Top of the Pops* regularly featured appearances by Pan's People, a nubile, scantily clad dance troupe who entertained the audience when groups could not perform their songs in person. But when it ended, the hottest new artist in the business was an elfin young woman from Bexleyheath, south-east London, who had already topped the charts with her very first single, becoming the first woman to reach number one with a song she had written herself. The press could not get enough of the apparent contrast between Kate Bush's childlike, innocent appearance and her steely intellectual integrity and business acumen. 'She skips out of the taxi, a skinny little creature in a red frock,' marvelled the *Mirror*, as though in disbelief that this apparently fragile, ethereal being could have become such a national phenomenon.[18]

Even at this early stage, Kate Bush seemed an entirely new kind of female artist: not just driven, self-possessed and intellectually adventurous, but determined to exercise complete control over her own career. Indeed, by the end of the 1970s, she had even set up her own publishing and management companies, to ensure that no record company could push her around. 'The freedom you feel when you're actually in control of your own music is fantastic,' she later explained. Her male predecessors might have agreed with the sentiment, but they would never have chosen her next metaphor. 'As soon as you get your hands on the production, it becomes your baby,' she went on. 'That's really exciting for me, because you do everything for your own child.' She was of course a one-off, an extraordinarily talented singer-songwriter from a professional middle-class family, whose father was a fine amateur pianist, whose mother was a traditional Irish dancer and whose brothers were both involved with the local folk music scene. But she was also a trailblazer, a role model, the product of a decade of 'women's liberation', who vetoed EMI's plans for her debut single, insisted on releasing 'Wuthering Heights' instead, and was triumphantly vindicated. In 1979, the writer Jeanette Winterson once remarked, 'every young woman I

knew at Oxford was listening to Kate Bush – even the chemistry students'.[19]

Kate Bush is often seen as one of two self-invented, self-determined individuals whose music effectively defined the decade, the other being David Bowie. The culture of the 1970s now seems almost unthinkable without Bowie, the boy from Bromley whose fascination with theatricality, image and constant self-reinvention, from the uproarious camp of Ziggy Stardust to the terrifying intensity of the Thin White Duke, turned him from an unsuccessful folk singer into one of the most influential figures of the age. 'If I've been at all responsible for people finding more characters in themselves than they originally thought they had,' Bowie told a BBC documentary team in 1974, 'then I'm pleased because that's something I feel very strongly about. That one isn't totally what one has been conditioned to think one is.' Many of Bowie's biographers see him as the defining figure not merely of the 1970s, but of the entire post-Beatles era. 'His influence', writes David Buckley, 'has been unique within popular culture – he has permeated and altered more lives than any comparable figure.' That may well be true; but there is, of course, no way of proving it. What is certainly true is that while Bowie's influence among, say, university-educated music enthusiasts is probably second to none, he was not even vaguely close to being the bestselling British artist of the 1970s. That title belonged to Elton John.[20]

Today Elton John's larger-than-life tabloid persona – his relationship with Princess Diana, his charitable activities, his lurid costumes and lavish parties – has largely eclipsed his monumental success as a musician. At his peak in the middle of the 1970s, he had no fewer than seven consecutive American number one albums, four of which simultaneously topped the British charts too. His appeal may have dipped thereafter, but in the all-time sales chart he is beaten only by the Beatles, Elvis Presley, Michael Jackson and Madonna, leaving groups such as Led Zeppelin, the Rolling Stones, Abba and Queen trailing well behind. His trophy cabinet – which includes countless Grammys, Brits, Tonys, Oscars and Golden Globes – would not disgrace a major European football club. Not for nothing does his biographer Philip Norman remark that Elton John's achievements still make 'eyes dilate and jaws sag'. He wrote the music for one of Disney's most successful films, The Lion King; he took his beloved football team, Watford, to Wembley for the FA Cup final; he played tennis with Billie Jean King, Martina Navratilova and Jimmy

Connors; he danced with the Queen at Windsor Castle; he had tea at the White House with Ronald Reagan; and, as we have seen, he played in Westminster Abbey at Diana's funeral. What makes this all the more extraordinary is that he did it without the two assets that are usually considered essential for worldwide fame: good looks and overpowering charisma. In 1972 one journalist wrote that 'for star quality in the accepted sense, I wouldn't pick him out of a crowd of two'. But if there is one person whose life bears witness to the stunning worldwide potential of British popular culture, then it is surely Elton John.[21]

What makes Elton John's story so richly fascinating is that, unlike so many cultural stars of the post-war era, he was never especially iconoclastic, idealistic or even particularly rebellious. No British star of comparable magnitude, in fact, has a better claim to be a genuine everyman. He was born Reginald Dwight in a council house in Pinner in 1947, the son of a flight lieutenant in the RAF. For the first two decades of his life there was nothing to suggest that he was anything other than an unassuming product of what had once been called Metro-land, the great expanse of unromantic suburban estates that spread from London's north-western fringes in the late nineteenth and early twentieth centuries. Accounts of his boyhood describe little Reggie Dwight as a chubby, cheerful little boy, 'careful, neat, methodical and polite', a talented pianist whose thank-you letters were always promptly and tidily written. Like so many of the stars of the 1960s and 1970s, he was a grammar-school boy. And like so many grammar schools of the day, Pinner County Grammar was almost more old-fashioned than its private equivalents, with its house system, its prefects, its sixth-form club and its paternalistic headmaster. Here, writes Philip Norman, 'the singular or eccentric pupil received equal interest and encouragement'.

But the singular thing about Reggie Dwight was that he was not, in fact, singular at all. He was 'a boy of such averageness and conventionality as to be almost invisible', a pleasant, round little chap who looked a bit like Billy Bunter. The only unusual thing about him was that he was very good at music. At home he spent hours in his bedroom, buried away with his growing record collection; but even that was hardly unusual in a teenager of the early 1960s. The only real hint of his hidden determination came in a letter to his father, who had broken up with his mother and left the family home some years before. 'I also know what I want to do when I leave school,' Reggie wrote. 'Actually I have known

for a long time but I have never said so before because I thought everyone would laugh at me. I want to entertain – that is to sing and play the piano . . .'[22]

Reggie's decision to leave school in early 1965, before he had even taken his A-levels, came as a shock both to his family and to his teachers. Had he stayed on, he would probably have done well enough to get into a decent university, and perhaps even the Royal Academy of Music. But he was set on a career as an entertainer, and off he went. For two years he drifted, working as an errand boy for a record company and playing in a band called Bluesology. But then he had an extraordinary stroke of luck. In June 1967 he spotted an advertisement in the *NME*, placed by Liberty Records, which invited applications from 'artistes, composers, singers [and] musicians'. Reggie went to see Liberty's man in London, Ray Williams, and recorded a demo. But he had a confession to make. He was 'no good at lyrics'. Luck was with him, though, because Ray Williams had also received a letter from a boy in Lincolnshire called Bernie Taupin, who could not write music but *could* write lyrics. It was Ray Williams's idea to put the two young lads together, and so one of pop music's great partnerships was born. Things could, however, have been very different, for among the other applications was a letter from a young man called Mike Batt. It is a bittersweet thought that, if only fate had smiled a little more kindly on Elton John, he might have played the piano on 'Remember You're a Womble'.*[23]

One of the enjoyable things about the former Reggie Dwight's career is how, despite all the silly outfits and oversized sunglasses, the private jets and the diamond earrings, he always remained at heart the dutiful mummy's boy from suburban Middlesex. Even his stage name – Elton Hercules John – was an oddly humdrum choice, harking back to the 1950s folk singer Elton Hayes, while not even the publicity photographer's best efforts could make him look like a teenage heartthrob. Even as his new label, Dick James Music, was bringing out his first records, he was still living with his mother, along with Bernie, who had temporarily moved in. Almost incredibly, the two of them were still there as

* I am aware, obviously, that there *is* no piano on 'Remember You're a Womble'. Usually, however, the piano seems to have been the domain of the brusque but essentially kindly Tobermory. It may be that in our alternative scenario Elton John would have donned Tobermory's costume himself. In personality, though, he was much more of an Orinoco.

late as the autumn of 1970, sharing bunk-beds in a cramped suburban flat, despite the fact that John had already completed a hugely successful American tour and was widely regarded as the music industry's next big thing. Indeed, while most self-styled artists love to talk themselves up, one of Elton John's most attractive characteristics was that he never took himself too seriously. 'Elton John – Shy Extrovert' read the headline on an interview in the *NME* in October 1970, which hailed John and Taupin as 'the next Lennon and McCartney'. 'I'm a shy person really,' the singer said:

> I get very embarrassed by all the publicity I receive. Over here people on Radio One treat me like some sort of god every time I have a record released, which is very flattering but can do as much harm as good because the kids who listen to music these days like to form their own opinions and not be hyped into liking something.

As the interviewer noted, it was remarkable how keen he was to share the credit with Bernie Taupin. 'If it weren't for Bernie', John said earnestly, 'there would be no songs.' Indeed, even in his first major BBC television appearance a few days later, John went out of his way to defer to his partner. 'He's more important than me,' he assured the cameras, 'because he writes the words.'[24]

Elton John was, of course, only human, and as the decade progressed his resistance to temptation – sex, drugs, more sex, a lot more drugs – faded to the point of nothingness. But at least at first his reaction to international success was marked by an impressive degree of generosity. Like the Beatles, he moved to an expensive new house in the Surrey stockbroker belt, which he filled with the fruits of his labour – Tiffany lamps and table-tennis tables, jukeboxes and fruit machines, Art Nouveau lamps and Pop Art prints – while outside, in the drive, stood two Rolls-Royces, a Ferrari and a Mini. Unlike, say, John Lennon's house, though, the John residence was a model of cleanliness and order, and his first parties were family occasions, with chauffeur-driven cars to fetch his relatives from Pinner and caterers to ply them with food and drink. His neighbours, the film director Bryan Forbes and the Fairy Liquid-promoting actress Nanette Newman, were struck by his boyish humility; on one occasion, Newman took him to Cartier, where he rushed around like a child in a toy shop, hoovering up presents for

friends and relatives, as well as a secret gift for Newman herself, which he delightedly handed over as they were driving back.

In December 1972, at the height of his newfound fame, he went back to his old grammar school to play at the sixth-form club's social night, a commitment that almost everybody had expected him to break. True, he pulled up in a Ferrari wearing a purple satin suit and red-tinted glasses, but the remarkable thing was he that he was there at all. It is hard to imagine John Lennon going back to his old school in 1965. It is even harder to imagine Lennon doing what Elton John did a few days later, which was to return unannounced carrying a large colour television for the sixth-form common room. In his biography, Philip Norman quotes a lovely end-of-term letter from the school headmaster, who told parents that they had all enjoyed 'the never-to-be-forgotten visit of ex-pupil Elton John who delighted the young membership with his songs and pleased the older members with the very real charm and common sense which lies behind the gimmickry of his profession'. As Norman remarks, at long last, after years of academic mediocrity, 'R. K. Dwight of Downfield House was going home with a good report'.[25]

The interesting thing about Elton John, though, is not that he seems to have been unusually generous for a pop star, or even that he sold an enormous quantity of records. It is that, all the time, he was hiding a secret that could easily have eaten away at his soul and destroyed his career. As a very young man in the late 1960s he had shown little overt interest in girls, but most people put it down to shyness. But, as early as 1971, he had effectively moved in with his manager, John Reid, and when he bought his house in Surrey, Reid came with him. The head of his record label, Dick James, who had previously worked with the impresarios Larry Parnes and Brian Epstein, greeted the news with consummate equanimity. 'Oh well,' he said, 'if he's living with his manager, at least he'll have someone to get him up in the morning.'

But Dick James knowing was one thing; the press and the public knowing was quite another. Indeed, when John went to see David Bowie's ground-breaking performance as Ziggy Stardust at the Rainbow Theatre on 19 August 1972, his reaction, at least in public, was stunned, horrified disbelief. As Bowie strutted on stage, a vision of lithe androgyny with his silver boxing boots, violently dyed blood-red hair and carefully rouged cheekbones, most of the audience were enthralled. 'Judy Garland hasn't left us!' wrote the critic from *Plays and Players*.

'David Bowie, his delicate face made up to look like hers, has the guts, the glitter, the charm of Garland and yes, even the legs.' For the supposedly heterosexual Elton John, though, it was all too much. 'That's it!' he muttered to a friend. 'He's gone too far. He's through!'[26]

There was a crucial difference, however, between David Bowie and Elton John. When Bowie told *Melody Maker* in January 1972, 'I'm gay, and always have been,' many readers probably thought this was just another of his eye-catching excursions into the world of fantasy. A year earlier, Bowie had posed in a dress on the cover of his album *The Man Who Sold the World*, and even when he was making his great confession, *Melody Maker*'s interviewer thought there was 'a sly jollity about the way he says it, a sly smile at the corner of his mouth'. Indeed, in 1973 Bowie told the journalist Ray Coleman that 'this decadence thing is just a bloody joke. I'm very normal.' In any case, Bowie's ambiguous sexuality was an essential part of his act, and his audience was unlikely to be very offended.

But Elton John's persona was very different: good-humoured, theatrical and self-mocking, yes, but less challenging, less adventurous, more . . . *ordinary*. His market was more mainstream, more middlebrow and, crucially, more American; what many people liked about records such as *Goodbye Yellow Brick Road* (1973) was the impression of old-fashioned, middle-of-the-road nostalgia. *Rolling Stone* enjoyed telling its readers about his sunburned, peeling face, his bruised knees, his everyday worries about his accountant and his solicitor. Since he was 'scarcely superstar material', agreed the *Sunday Mirror*, his great virtue was that 'his music is as honest as he is as a person'. David Bowie came from outer space. Elton John came from Pinner. Bowie was the man who fell to earth. Elton John was the boy next door. In the early 1970s, boys next door did not suddenly set up home with their managers.[27]

Ever since the Labouchere Amendment of 1885, which criminalized 'gross indecency' between consenting male adults, homosexual men had lived in terror of the law. Public censoriousness ebbed and flowed, but in the 1950s, when Elton John was growing up, there had been an intense panic about sexual decadence, with the newspapers effectively competing to publish the most aggressive anti-homosexual editorials. In the summer of 1952, for example, the *Sunday Pictorial* had run a three-part series, entitled 'Evil Men', promising 'an end to the conspiracy of silence' about homosexuality in Britain, 'a spreading fungus' that had infected 'generals, admirals, fighter pilots, engine drivers and

boxers'. Just over a year later, a Home Office crackdown on illicit behaviour on the streets of London claimed an extremely distinguished victim when the actor Sir John Gielgud, knighted only months before, was arrested for indecency in a public toilet. Gielgud, who was duly hauled up before the magistrate and issued with a fine and a reprimand, genuinely believed that his career was over. As it happened, his theatrical colleagues – and, perhaps more importantly, audiences – forgave him, and the episode was quietly forgotten. Unsurprisingly, though, it took a heavy toll on both his health and his self-confidence. Had Gielgud been exposed a second time, the chances of survival would have been slim at best. And if he needed any reminder of the dangers, the newspapers were always there to tell him. In November 1953, only weeks after his arrest, the *Mirror* was back on the case. Approvingly quoting the former Home Secretary Viscount Samuel's view that 'the vices of Sodom and Gomorrah appear to be rife', it argued that the government was far too slack in tackling 'the evils in society'. 'If they spread,' said the *Mirror*, 'they will poison the moral fibre of the country ... NOW WILL THE AUTHORITIES TAKE ACTION?' Such had been the climate when Reggie Dwight was a boy.[28]

Male homosexuality was not decriminalized until July 1967, only a few weeks after Elton John had spotted that life-changing Liberty Records advertisement in the *NME*. But although the law had changed, attitudes had not. In a survey by Geoffrey Gorer, published in 1971, the most common reaction to homosexuality, expressed by one in four men and women, was 'revulsion', while others muttered 'don't like it', 'not understandable, odd' or 'mentally ill, sick'. Even the more tolerant respondents tended to see it as some kind of mental disease. 'I am at a loss with this one; it is some form of illness and more to be pitied than anything else,' remarked a heating engineer. Younger people tended to be a bit more liberal: even so, about one in three people aged between 16 and 24, which was obviously Elton John's key audience, remained extremely hostile. A few years later, surveys still found considerable public antipathy: a poll of some 2,000 people in 1975, for example, found that fewer than half approved of gay couples (like Elton John and John Reid) living together openly, while half thought they should never be allowed to become teachers or doctors. And despite the change in the law, gay men still ran the risk of being attacked by 'queer-bashers', like the building workers who killed Peter Benyon, a 32-year old librarian, in

1977. In this respect, individual liberation had a long way to go. Little wonder, then, that other household names, from Alan Bates and John Curry to Peter Wyngarde and Larry Grayson, were so cautious about coming out.[29]

When Elton John gave that interview to *Rolling Stone* in August 1976, he was taking a tremendous gamble. Almost every major pop critic in the country already knew about his double life; but in an age of relative restraint, none had broken the story. Why did he do it? Because, exhausted after a long tour, he had simply let his guard down? Because he was in New York, where the gay rights movement was much more prominent than back home in London? Because he was tired of keeping it secret, weary of living a lie? Probably he did not even know himself. But the result was that, almost overnight, he became one of the most famous openly gay or bisexual entertainers on the planet, perhaps even *the* most famous. For an essentially shy man, it must have been agonizing, not least because whenever he went to watch his beloved Watford Football Club, which he bought in 1976 and turned into serious title contenders, thousands of opposition fans would chant as one: 'Elton John is a homosexual.'

It may well be no coincidence that the revelation roughly coincided with the beginning of a long period of turmoil in his personal life, including addictions to sex and drugs, eating disorders, a short-lived marriage to a German sound engineer and a succession of deeply implausible wigs. Yet it is worth noting that, after 1976, John never minded answering questions about his sexuality, and often spoke of his relief that the secret was out. 'I think I was a virgin until I was 22,' he admitted two years later:

> I did not accept the fact that I was gay and didn't come out of my shell until I was 24.* When I publicly admitted I was gay last year I did not think it was some startling revelation. A lot of people already knew. I felt that I would rather be honest about it than try to cover up.

He was aware, he told another interviewer, that 'it's not everyone's cup of tea, and I try not to dwell on it too much. But I had to get it off my chest. That's the way I am, and it's no good hiding it.'[30]

Elton John's story is, of course, very familiar. At the time, though, it

* In 1971, in other words, which is when he moved in with John Reid.

was almost unprecedented. No pop star of comparable stature had ever come out, and certainly none had done it with such frankness. Whatever his failings – and the singer himself freely admitted that with all the sulks, the tantrums, the cocaine binges and the shopping blowouts, he could sometimes be very hard work – it was to his great credit that instead of sinking into self-pity and self-indulgence he embraced his position as a role model to thousands of young men. A lot of homosexuals, he told an interviewer, were 'just very confused, frightened people . . . I've had a lot of letters from people who think they're gay, but live in small communities, where it would be very hard to say so. I rarely write back to anyone, but I wrote back to every one of those people and said, "If you ever get down in the dumps, write again."' Even his mother, Sheila, then in her fifties, was perfectly happy to talk about his sexuality to the *Daily Express*. 'I was upset at first,' she told an interviewer in, of all places, Moscow, where in 1979 her son became the first major British star to play in the heart of the Communist bloc.

> But I think it was a very brave thing for him to do. I would still like to think he can find some kind of happiness with a male or female – I don't care. A lot of people don't admire him for saying it. Some used to shout odd names after him. He was strong enough to come out of the closet when there's thousands more who won't.[31]

Even in the Soviet capital, the singer could not resist a dig at his hosts' repressive treatment of homosexuals. When a Russian journalist asked if he was opposed to apartheid, he replied pointedly: 'Yes, I object to apartheid, whether it's because of colour, class or sexual preference.' The British press were enormously impressed, hailing a champion of individual freedom whose music had 'delighted and excited the Russian teenagers', showing them 'a world beyond Shostakovich. A world to which they want to belong.' 'If ever the Iron Curtain finally rusts away,' declared the *Daily Mirror*, 'at least some of the credit should be awarded to Mr Reg Dwight, of Pinner.'

But just as Mr Dwight was in danger of getting an inflated opinion of himself, the tour ended on an entertainingly bathetic note. As the singer was leaving the country, wreathed in glory, the Soviet customs officials asked for a quiet word. He had, it turned out, rather overdone it in the art galleries. They promised to send on his haul after he had completed the right forms, but whether they ever did remains a mystery. Perhaps,

somewhere in a corner of a Russian airport, there is still a damp, mouldering box, stuffed with Elton John's forgotten purchases.[32]

The decade that followed was not kind to Elton John. While his personal life spiralled from one crisis to another, his musical career seemed stuck in a rut of bland, unadventurous, forgettable nothingness. What was worse, the sour public mood following the AIDS panic turned the focus once again on his sexuality, only now the tone was very different from the good-humoured sympathy with which the press had treated his confession ten years earlier. In February 1987 he was the victim of an extraordinarily brutal assault by the *Sun*, which, having swallowed a rent boy's invented story about John's private life, decided to escalate the allegations in an attempt to browbeat him into dropping his libel claim. Once again, however, Pinner County Grammar's answer to Billy Bunter showed that he possessed unexpected reserves of courage and resilience. As one front-page battering followed another, including a truly absurd story that he had removed the larynxes of his Rottweiler guard-dogs (which did not in fact exist) to turn them into 'silent assassins', he obstinately stuck to his guns. Other papers rallied to his cause. 'THE AGONY OF ELTON' roared the front page of the *Mirror*, his chief defender, which praised him as a man who had not only 'given pleasure to millions through his music', but who, 'by being honest ... felt he could save young homosexual people from being reduced to suicidal misery because they were unable to come to terms with their sexuality'. What was more revealing, though, was what the *Sun*'s marketing department anxiously told their top brass: that whenever they ran another anti-Elton exposé, the circulation figures fell by 200,000. On 12 December 1988, the day the case was due to open at the High Court, the *Sun* surrendered. Its headline that day contained just two words: 'SORRY ELTON!'[33]

In the long run, the anti-gay panic of the late 1980s was clearly an anomaly, a last spasm of aggression fuelled by public anxiety about AIDS and by the militant populism of the tabloid press. Over time, the advance of public tolerance was simply unstoppable; in an individualistic society in which most people believed, like David Bowie, that they had the right to be whoever and whatever they wanted, the thought of state repression of people's private lives now seemed weirdly prehistoric. Where Bowie and John had led, other pop stars followed, from Boy George and Frankie Goes to Hollywood to George Michael

and Will Young. Of course it would be silly to given John the credit. He did not create the trend. But he personified it. And what is surely crucial is that he did so not as one of rock's outlaws, but as one of Middle England's favourite pop stars, a safe, amusing, unthreatening figure, who was never happier than when playing before the Royal Family.

His extraordinarily lucrative, turbulent and eventful career, which would have been unthinkable only a few decades earlier, was a model of self-reinvention and self-determination. Often, it has to be said, it was also a model of ludicrousness and self-indulgence: the lurex suits and Tiffany lamps, the Cartier jewels and Mapplethorpe portraits, the Staffordshire porcelain, the replica of Tutankhamun's throne, the Victorian furniture, the watches, the pianos ... As John himself laughingly recalled, even Mick Jagger, hardly a monument to self-denying asceticism, could barely believe his eyes when he visited his house. 'You've got so much fucking porcelain!' he said in wonder. 'I've never seen so much fucking porcelain!'[34]

But what really distinguishes Elton John's career is not the drugs, the cars, the glasses or even the porcelain. It is, in fact, his commitment to popular culture as philanthropy. Today his various charitable activities have become almost a joke, but it is hard to think of many other self-made men in the entertainment world who have been so committed, for quite so long, to causes greater than themselves. To take an example that is probably better known in the United States than in Britain, in the mid-1980s, when his life was at a very low ebb indeed, John championed the cause of a haemophiliac American teenager called Ryan White, who had contracted AIDS from an infected blood transfusion. White was effectively forced out of his school in Indiana because his fellow pupils and their parents feared that he would give them AIDS – this is not, it has to be said, a story that presents Middle America in a very good light – and eventually his family were forced to move to another town. While they were scrabbling the money together for a $16,500 deposit on their new house, they had a message from Elton John. He would happily pay for it, he said. Some time later, White's mother contacted him to pay back what she had always regarded as a loan. The singer took the money and promptly set up a trust fund for her daughter's college fees. Two years after White died, he set up the Elton John AIDS Foundation in his memory.[35]

'How a man uses money – makes it, saves it, and spends it,' wrote Samuel Smiles in *Self-Help*, 'is perhaps one of the best tests of his practical wisdom.' As the great Victorian advocate of thrift and self-denial, Smiles would not have been terribly impressed by the £293,000 that Elton John spent on flowers in just twelve months in the mid-1990s, or, indeed, by the Jagger-dazzling hoard of porcelain. Contemplating the star's career, Smiles might well have felt vindicated in his belief that there is no greater 'temptation to ease and self-indulgence' than enormous wealth, especially if that wealth has been won by playing the piano and wearing enormous glasses. What would he have made of a star who kept a soap dispenser in the shape of a giant penis in his dressing room, or who once threatened to call off an entire tour because a fan had shouted 'Yoo-hoo!' at him while he was playing tennis? And yet, as a firm believer that the point of making money was to enrich society, and as a great admirer of the philanthropists of the age, perhaps even Smiles might have mellowed a little at the sight of the music industry's single most generous donor, an indefatigable activist for AIDS charities and gay rights groups, who, by even a conservative estimate, has given away tens of millions of pounds to improve the lives of sick and dying children.[36]

And although Elton John is far from being a saint, he does have the one quality that redeems almost everything else: a sense of humour. Anyone who tells the press that he would rather 'have my cock bitten off by an Alsatian than watch *The X Factor*' can be forgiven a multitude of sins. Long after he had banished what the papers loved to call his demons, the singer rather enjoyed recalling the time when, in the autumn of 1975, not long before he publicly revealed his sexuality, he had tried and failed to kill himself. He was in California at the time, staying at the legendary film producer David O. Selznick's old house in the Hollywood Hills, and his proud family had come to visit. They were all standing around the swimming pool, enjoying a drink, when the familiar figure of Reggie at last rolled into view, clutching a vial of sixty Valium tablets. To their stunned horror, he stuffed the pills into his mouth and, as he later recalled, 'jumped into the pool in front of my mother and seventy-five-year-old grandmother, screaming "I'm going to die!"' It was a dreadful scene. And as they pulled him out, he distinctly heard his grandmother saying wearily: 'I suppose we've all got to go home now.'[37]

SKATING IN A SARI

'Being here,' he continued, 'it isn't people's greed and selfishness
that surprises me. But how little people ask of life. What meagre
demands they make, and the trouble they go to, to curb their
hunger for experience.'

Hanif Kureishi, 'Girl', in *Midnight*
All Day (2000)

By the early twenty-first century Elton John and David Bowie had become part of Britain's cultural aristocracy. In the summer of 2012, many observers thought the two men had been the most glaring omissions from Danny Boyle's Olympic opening ceremony. Some reports suggested that, in characteristic fashion, John had fallen out with the Olympic organizers. But Bowie, at least, had always been at the top of Danny Boyle's shortlist. As the director later explained, he had flown to New York to beg Bowie to take part, but the 65-year-old musician stuck to his resolution that his days of singing live were over. Bowie's music, however, appeared in both the opening and closing ceremonies, reflecting its place at the centre of British rock's canon. Yet when Bowie himself was asked to name his favourite album, he chose not one of the acknowledged classics – say, *Hunky Dory*, *Station to Station*, *Low* or *Heroes* – but an album that had peaked at number eighty-seven and was never really heard of again.[38]

When Bowie's album *The Buddha of Suburbia* was released in November 1993, most people considered it merely a soundtrack to the BBC series of the same name. In fact, although Bowie *had* written the show's soundtrack, the album was something different, a collection of music inspired by, not written for, the television series. In the liner notes, Bowie wrote that he had drawn heavily on a 'stockpile of residue from the 1970s' – the period in which *The Buddha of Suburbia* is set – from Pink Floyd and Brian Eno to T.Rex and Kraftwerk. And although Bowie had worked closely with the Turkish musician Erdal Kızılçay, he was keen to play up the Britishness of his enterprise. The first few years of the 1990s were not a good time for British music: in both the charts and the music press, American acts such as REM, Nirvana and Pearl Jam were carrying all before them. 'As of writing,' Bowie complained, 'there

are but five British artists in the US Top Fifty, and a demoralizing TWO British albums in London's Virgin Megastore's "50 Essential Albums" rack.' This, he thought, was 'not as it should be'. Sounding rather like a latter-day J. Arthur Rank, he thought there was a real danger that British culture might be smothered beneath 'the Great American Cultural Blanket'. His own music, as he readily admitted, had not always been identifiably British: 'There has always been a hazy rootlessness to my writing. I put it down to an overwhelming sense of transience.' But in this album, looking back at the decade that he had made his own, Bowie clearly felt that he was coming home.[39]

There were good personal reasons for Bowie to have championed *The Buddha of Suburbia*. The series was based on an award-winning book by Hanif Kureishi, which had been published in 1990 and was set not just in Bowie's own stamping ground of Bromley, but at his old school. We find ourselves in the 1970s, and to our young narrator, Karim, and his friends at Bromley Technical High School, David Bowie is something of an idol, his escape from the suburbs a model of successful self-realization. As Karim explains:

> Bowie, then called David Jones, had attended our school several years before, and there, in a group photograph in the dining hall, was his face. Boys were often to be found on their knees before this icon, praying to be made into pop stars and for a release from a lifetime as a motor-mechanic, or a clerk in an insurance firm, or a junior architect.

But Bromley Tech was not merely Bowie's old school; it was also Hanif Kureishi's old school. Like Bowie's album, the book was partly autobiographical; but like Bowie's album, it is richer and more interesting than mere veiled autobiography.

The Buddha of Suburbia is a book not just about life in London in the 1970s, or even about the tensions and possibilities of life for the Asian families who had moved to Britain from its former colonies. It is a book about growing up, about escaping your origins and fulfilling your dreams, about finding yourself and reinventing yourself. 'One strong feeling dominated me: ambition,' says Karim:

> Until this moment I'd felt incapable of operating effectively in the world; I didn't know how to do it; events tossed me about. Now I was beginning to see that it didn't necessarily have to be that way. My happiness and

'I'm a Pakistani kid who likes Jimi Hendrix, takes drugs and wants sex.' Not that you would know it from the picture, though. Photographed here in 1994, Hanif Kureishi appears to be trying to look as serious as humanly possible.

progress and education could depend on my own activity – as long as it was the right activity at the right time.

Little wonder, then, that the book appealed to perhaps the best-known champion of individual self-reinvention in modern cultural history.[40]

During the 1950s and 1960s, well over 650,000 people had moved to Britain from the old imperial possessions of the Caribbean and South Asia. Some 128,000 of them came from Pakistan, and among them was a man called Rafiushan Kureishi, who had travelled across by boat in 1950 to study law. He came from a relatively privileged family: his own father had been a colonel in the Indian army, and as Hanif later put it, the Kureishis were used to the best of life: 'Big family. Servants. Tennis court. Cricket. Everything.' Alas, in post-war London, being used to everything in Pakistan counted for very little, and when Shanu Kureishi's money ran out he had to take a desk job at the Pakistani Embassy. He was still working there when, on a double date at Victoria Station, he met an English girl, Audrey. They got married, settled in suburban south London, and started a family. Hanif, their son, was born in December 1954. Like David Bowie, he went to Bromley Technical High School and was obsessed with music, but instead of winning fame as a pop star, he became a writer, producing plays for the Hampstead Theatre and the Royal Court. In 1985 Kureishi made a splash with the screenplay for Stephen Frears's film *My Beautiful Laundrette*; and when he published *The Buddha of Suburbia*, he found himself the darling of the literary intelligentsia. The one person who seemed a bit put out, sadly, was his father. 'He had wanted to be a writer and an artist', Kureishi said later, 'and he hadn't achieved that.'[41]

One of the things that *The Buddha of Suburbia* captures so well is an experience that thousands of immigrants and their children would immediately recognize: the sense of being both British and not-British, colonizer and colonized, like somebody trapped between two worlds. Kureishi was, in his own words, a 'child of empire', but he was also the child of a mixed marriage. Like so many immigrants' children in the 1950s and 1960s, he knew the relentless reality of everyday racism. People in Bromley, he recalled, cared nothing for his family's history as the loyal servants of Empire: they merely saw him as a 'Paki'. In an interview with the *Observer*'s Robert McCrum, he remembered the aftermath of Enoch Powell's controversial anti-immigration speech in

1968 as 'terrifying. We thought we were going to be sent back. We'd been brought over here to help run the NHS and the public services, but now we realised that we were just Pakis and niggers.' Kureishi's father even suggested that to escape the skinheads his son should change his name and try to blend in as a native-born Englishman. But to Hanif that seemed absurd, like denying who he was. But then who was he, really? At school, where he felt lonely and miserable, other boys threw mocking jibes at him: 'Who are you? Where do you belong? What are you doing here?' 'Those questions', he said, 'get inside you.' He loved writing, but could not quite find his voice. There were already established black and Asian writers: V. S. Naipaul, say, and later Salman Rushdie. But they, as Kureishi remarked in another interview, 'were born elsewhere. By the age of 14, I'm a Pakistani kid who likes Jimi Hendrix, takes drugs and wants sex. How do you make a book out of this?'[42]

By the time Kureishi published The Buddha of Suburbia, black and Asian writers had been exploring the modern experience of immigration for more than thirty years, kicking off with Samuel Selvon's book The Lonely Londoners, which was published as early as 1956. But Kureishi was inspired less by other immigrants' books than by rather more populist entertainments, from reggae music to Carry On films. 'I thought of myself as a British writer, an English writer even; English literature and British sitcoms had been a major influence on me,' he later told the Guardian. Indeed, he came to see himself less as a Pakistani or Asian or immigrant writer than as a 'comic writer, in the English comic tradition of Waugh and Amis and Angus Wilson'.

And in many ways this was the key to his success. It would be very easy to be insufferably po-faced and post-colonial about The Buddha of Suburbia, but the most important thing about it is that it is a very funny book. As the 17-year-old Karim makes his way through London in the 1970s, Kureishi has an enormous amount of fun teasing everybody from his hero's earnest Pakistani relatives to his left-wing friends. Indeed, right from the start of the novel, as his father, a civil service clerk, hurriedly practises his yoga positions before heading out to entertain some gullible neighbours, Karim proves a tremendously engaging narrator. When he discovers his father having al fresco sex with his mistress, the hippyish Eva, for example, his reaction is not horror or anger, but the kind of wry observation you might expect from the narrator of

a Kingsley Amis novel: 'My God, could Eva bounce! . . . But what of the crushing weight on Dad's arse? Surely the impress of the bench would remain for days seared into his poor buttocks, like grill marks on steak?'[43]

In many ways Karim is a very modern figure, a Pakistani immigrant's son who is attracted to both boys and girls and wrestles with the question of his own identity. The novel's first words capture both his uncertainty and his ambition: 'My name is Karim Amir, and I am an Englishman born and bred, almost. I am often considered to be a funny kind of Englishman, a new breed as it were, having emerged from two old histories. But I don't care – Englishman I am (though not proud of it), from the South London suburbs and going somewhere.' But as those last two words suggest, *The Buddha of Suburbia* is also a remarkably old-fashioned novel, chronicling a young hero's journey towards self-realization through a lovingly drawn panorama of London society. It is a story about not just immigrant ambition but *suburban* ambition. On the very first page, Karim himself wonders whether his restless drive is inspired by his 'odd mixture of continents and blood' or whether 'it was being brought up in the suburbs that did it'. Suburban ambition had been one of the great themes of British culture, especially pop music, for decades, but few fictional narrators have put it better than the teenaged Karim. 'In the suburbs', he says, 'people rarely dreamed of striking out for happiness. It was all familiarity and endurance: security and safety were the reward of dullness.' But like David Bowie before him, Karim is determined to make a break for it. 'It would be years', he thinks bitterly as a schoolboy, 'before I could get away to the city, London, where life was bottomless in its temptations.'

Kureishi could hardly have picked a better backdrop for his story of suburban lower-middle-class ambition, because, as we have seen, it was in Bromley that one of its greatest chroniclers, H. G. Wells, had been born in 1866. At one point Karim even parks his bicycle in Bromley High Street, next to a plaque that reads 'H. G. Wells was born here'. Like Wells's heroes Arthur Kipps and Mr Polly, Karim casts a wry, sceptical eye over the social and moral conventions that govern middle-class life; and like Wells's heroes, he is desperate to move on, to escape the crippling expectations of others. Kipps, who begins Wells's novel as an ordinary Kentish boy, dreams of a 'new and better life' where he can break free of all his 'low-class associations' and plunge into a world of 'money and opportunity, freedom and London, a great background of

seductively indistinct hopes'. Karim, too, fantasizes that as he moves into the city, so he will cast off his old anxieties and find a new identity, reconciling his Pakistani and English selves in a place where

> there were kids dressed in velvet cloaks who lived free lives; there were thousands of black people everywhere, so I wouldn't feel exposed; there were bookshops with racks of magazines printed without capital letters or the bourgeois disturbance of full stops; there were shops selling all the records you could desire; there were parties where boys and girls you didn't know took you upstairs and fucked you; there were all the drugs you could use.

The language is very different; the sense of drive, however, is remarkably similar. 'You see,' Karim adds drily, 'I didn't ask much of life; this was the extent of my longing. But at least my goals were clear and I knew what I wanted.'[44]

But whereas Kipps learns the limits of aspiration and eventually turns his back on his old fantasies, returning to his roots as a lower-middle-class Kentish shopkeeper, Karim remains true to his vision of self-realization through social ambition. Like Wells's book, *The Buddha of Suburbia* shows how the pursuit of self-improvement involves all kinds of compromises and hypocrisies. In Kureishi's novel, however, almost *all* of the characters are engaged in some kind of self-reinvention, from Karim's father, who becomes a fashionable guru, to Eva, a social climber whose 'assault on London' sees her become a high-society interior decorator. As for Karim, he finally lands a part in a television show that will make him a household name. 'I'm in a soap opera,' he triumphantly tells his disbelieving father. 'Top pay. Top job. Top person.' In the book's last scene, he takes his friends out for dinner at a swanky London restaurant, with 'duck-egg-blue walls, a piano and a blond boy in evening dress playing it'. The people, he says happily, 'were dazzling; they were rich; they were loud'. The date is 3 May 1979, Election Day. 'We had a small party,' he adds, 'and by the end of it everyone in the place seemed to have been told I was going to be on television, and who was going to be the next Prime Minister. It was the latter that made them especially ecstatic.'[45]

Although Karim is an actor rather than a writer, critics and interviewers were often quick to point out the parallels with his creator's own social odyssey from lonely Bromley schoolboy to Oscar-nominated screenwriter. And the reason that *The Buddha of Suburbia* struck such a

chord is surely that its central theme – the individual's journey towards self-knowledge and self-fulfilment – resonated not just with readers whose parents had braved prejudice and culture shock to settle in Britain, but with anybody who had ever wondered quite who he was, wished that his family was a little less suburban, or dreamed of a better life in the big city.

Yet as Kureishi discovered, drawing on your own experience inevitably comes at a price. A few years after *The Buddha of Suburbia*'s publication, his sister, Yasmin, wrote an astonishingly angry letter to the *Guardian*, insisting that far from being proud of his son's achievement, their late father had been mortified to find himself mocked in print, and that the portrait of Karim's father had 'robbed him of his dignity'. Hanif, she added, had been 'selling his family down the line' for personal gain. Even his mother weighed in, disputing his claims to have been working-class. 'Hanif has made us sound like the dregs of society because it suits his image and his career,' she said. 'I suppose it's trendy and fashionable nowadays for an author to pretend they had a working-class background, but Hanif had everything he wanted as a child.'[46]

It is, of course, impossible for an outsider to know the truth of all this, but one obvious observation is that, as Dennis Potter had discovered as a student in the 1950s, self-improvement never comes without a cost. On top of that, writing about the families of immigrants, with their cherished reminders of the old country, their complicated attitudes to their new neighbours – admiration, jealousy, suspicion, even contempt – and their carefully guarded religious customs and social conventions, is inevitably a delicate matter. *The Buddha of Suburbia* was, in fact, a lot less controversial than most, certainly when compared with, say, Monica Ali's book *Brick Lane*, which came out thirteen years later. Indeed, when work began on a film adaptation of Ali's novel in the summer of 2006, the protests on Brick Lane itself were so fierce that the producers were forced to abandon their plans and reshoot the exterior scenes elsewhere. It was a reminder of the sheer power of popular culture, not just to enlighten and entertain, but to arouse intense political and religious passions. 'A book has been written, that has greatly offended the hard-working, industrious Bangladeshi community,' one self-appointed spokesman told the BBC. 'There should be a limit to what you can write or say. You can write fiction, but you cannot use names that are reality. The reality is Brick Lane.'[47]

Unlike Hanif Kureishi, Monica Ali was born abroad. In the mid-1960s her father, Hatem, had come as a student from Bangladesh (then East

Pakistan) to the north of England, where he met her mother, Joyce, at a dance. 'He arranged to meet her again,' Monica later joked, 'but he was worried he wouldn't recognise her because all white women looked the same to him.' Joyce went back with Hatem to Dhaka, where he worked as an inspector of local technical colleges, and they got married and started a family. But in 1971 war broke out and they fled back to her home town of Bolton. It was there that Monica, who had been born in 1967, went to school. At first her parents ran a kind of knick-knack shop, selling, as she told the *Observer*, 'trinkets, jewellery, beads, porcelain figures. All the kind of things you see displayed in windows that have a net curtain raised in the middle.' But her father, like so many immigrants, was a great self-improver, studying for a history degree and eventually landing a job teaching at the Open University, while her mother worked as a counsellor. Between them they made enough money to send Monica to Bolton School, one of the largest private day schools in Britain. But like Kureishi, she was always aware that she did not quite fit in. 'Growing up with an English mother and a Bengali father', she once wrote, 'means never being an insider. Standing neither behind a closed door, nor in the thick of things, but rather in the shadow of the doorway, is a good place from which to observe. Good training, I feel, for life as a writer.'[48]

In stark contrast to *The Buddha of Suburbia*, however, *Brick Lane* is obviously not autobiographical, or at least not directly. Its central character, Nazneen, is a largely uneducated woman from rural Bangladesh, who moves when she is 18 to a bleak council flat in east London in order to marry a much older man, Chanu. The reader's expectation is that Chanu will turn out to be a dreadful monster, and indeed he does have some pretty unappealing habits, notably his expectation that his teenage bride will regularly cut his corns. But Chanu is not a bad man at all; in fact, he has something of V. S. Naipaul's Mr Biswas about him, being a comically earnest autodidact who, while constantly striving to better himself, is actually falling further and further adrift. A minicab driver in London's poorest neighbourhood, he is convinced that he is destined for much better things, and has a house full of marvellously tragi-comic 'certificates' to prove it: a qualification in 'transcendental philosophy', a maths A-level, a cycling proficiency certificate, an acceptance letter for an IT course, even the directions to get to some evening classes on nineteenth-century economic thought. 'It is lucky for you that

you married an educated man,' he says proudly. 'That was a stroke of luck.'

In one immensely entertaining and yet oddly moving scene, Chanu takes the family – Nazneen and their two girls – to Buckingham Palace, dressed in what he takes to be respectable tourist attire: a baseball cap, a money belt, shorts, even binoculars. Enthusiastically he reads from a guidebook, telling the girls about Queen Victoria's extensions to the building and the current Queen's garden parties. And yet all the time his dream of life in England – indeed, of becoming an Englishman – is slipping out of reach. At the beginning of the novel he is always talking airily of his impending 'promotion' and the new life it will bring. By the end, when his dreams of self-fulfilment have been exposed as a sad fantasy, it is Bangladesh that he means when he talks about 'home', not London.[49]

But if Chanu represents the failure of individual self-improvement, then his wife, Nazneen, represents its apotheosis. She arrives in London a shy, frightened, inarticulate girl; she ends the novel a self-aware, self-confident woman, running her own sari business with her friend Razia. The novel's central theme, in fact, is her growing realization that instead of merely being buffeted by events, she can take control over her own future, rather like the heroes of the great Victorian novels – or, indeed, like Joe Lampton, who told us in *Room at the Top* that he was his 'own draughtsman', and rejected the power of 'destiny, force of events, fate, good or bad fortune' over his story.

Nazneen comes from a community that believes absolutely in fate. When she is born, a sickly child in rural Bangladesh, the midwife persuades her mother not to take her to hospital, but to leave her survival to fate. 'We must not stand in the way of Fate,' her mother says. 'Whatever happens, I accept it. And my child must not waste any energy fighting against Fate. That way, she will be stronger.' As Nazneen grows up, she hears the tale again and again, 'this story of How You Were Left to Your Fate'. She never questions it: even as a young woman in London, she still believes that 'what could not be changed must be borne. And since nothing could be changed, everything had to be borne. This principle ruled her life. It was mantra, fettle and challenge.'* Only gradually, inspired partly by watching Torvill and Dean skating on television,

* This is an odd one: the text of *Brick Lane* says 'fettle', but Ali presumably meant 'fetter'. I take no credit for noticing this, though, since it was my editor who pointed it out.

a vision of grace, beauty, freedom and – crucially – self-expression, does Nazneen find her voice. 'For the first time', Ali writes, 'she could not wait for the future to be revealed but had to make it for herself.'[50]

The odd thing about *Brick Lane*, therefore, is that although the furore made it sound like a hard-hitting anthropological dissection of a very twenty-first-century phenomenon, an inner-city melting pot of British urban freedoms and Asian religious values, it is at heart an extremely old-fashioned kind of story. Like *The Buddha of Suburbia*, it is a book not just about the modern immigrant experience, but about the individual struggle for self-realization. From that perspective, the protesters who marched down Brick Lane denouncing Monica Ali and threatening to burn copies of her book (which, as it turned out, they never did), were not so different from the characters in the novel who threaten to stifle Nazneen's growing sense of self-determination. And as with *The Buddha of Suburbia*, or, for that matter, other self-consciously multicultural stories such as Zadie Smith's novel *White Teeth* (2000) or the film *Bend It Like Beckham* (2002), the book's fundamental appeal arguably has nothing to do with race or immigration at all.

The theme of the individual finding his (or indeed her) courage, taking control of his future and defining his life in his own terms, goes back not just to Victorian novels such as *David Copperfield* and *Jane Eyre*, but to earlier books such as Henry Fielding's *Tom Jones* (1749) and Daniel Defoe's *Robinson Crusoe* (1719) and *Moll Flanders* (1722), and perhaps even to John Bunyan's *The Pilgrim's Progress* (1678). And you certainly do not need to be an immigrant to appreciate the power of *Brick Lane*'s final scene – the perfect twenty-first-century encapsulation of individualism as personal liberation, not least since the characters are all women. At long last, thanks to the generosity of her daughters and her friend Razia, Nazneen gets the chance to emulate her ice-skating heroes. 'To get on the ice physically,' she thinks, 'it hardly seemed to matter. In her mind she was already there.' Yet still Nazneen hesitates. 'You can't skate in a sari,' she says. 'This is England,' says Razia. 'You can do whatever you like.'[51]

Overleaf: Mrs Thatcher's cultural hero: the much-loved figure of Andrew Lloyd Webber at home in Eaton Square, London, 1989.

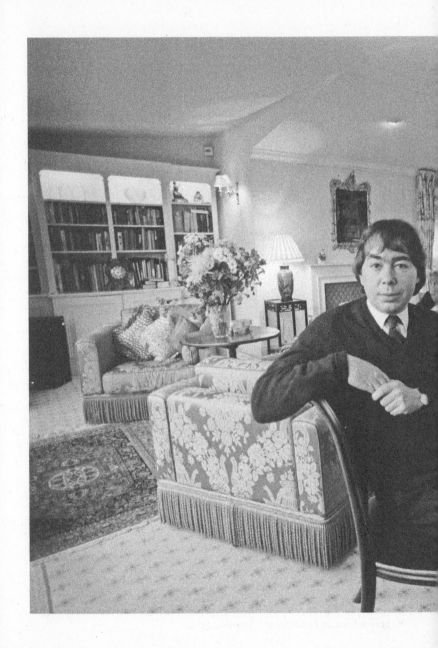

14

Aren't We All Extraordinary?

SMASH HITS

Q: How do you react to today's left wing pop acts – the Housemartins, the Style Council, Billy Bragg – who can't wait to get you out of Number 10?
A: Can't they? Ha ha ha!
Margaret Thatcher, interviewed in *Smash Hits*, 2 March 1987

In September 1980 London's West End was a drab and unwelcoming place. In the strike-torn final months of Jim Callaghan's Labour government, it had become notorious as a dumping ground for uncollected rubbish, the black bin bags piling up in Leicester Square and its surrounding alleys as passers-by gingerly navigated their way past scurrying rats and festering scraps. But even after the dustmen had gone back to work, the capital's entertainment heartland had a seedy, destitute feel. 'Heavy, greasy smells emanate from the hamburger bars and hot dog stands; raucous music competes with the cacophony of pinball machines. The people, mostly young, appear to be not so much relaxed as restless,' wrote the reporter John Young after visiting late one night. Abroad, he thought, Leicester Square might have been full of pavement cafés and bubbling fountains. But here, as a police van prowled past the square's locked gates, there was a palpable 'hint of menace in the atmosphere'. Young ducked down into Soho, but there it was little better. 'Wastebins are full to overflowing,' he wrote. 'Plastic bags and boxes of rubbish have been dumped on the pavements.' It felt like a grimly appropriate setting for a city apparently sliding into terminal decline, and a country on the brink of the deepest recession in its history.[1]

Culture as narcissism: George Michael during Wham!'s tour of Australia, 1985.

In the next few years, as unemployment soared and the inner cities burned, the West End might have been expected to decline further into squalid irrelevance. Yet four years on, the picture could hardly have been more different. By September 1984 tourist numbers had reached an all-time high, with some 30 million people visiting London from within the United Kingdom and a further 7½ million flying in from abroad, including some 2 million Americans. Indeed, with so many visitors descending on the capital, most hotels were booked solid, leaving some holidaymakers to sleep in dormitories. And while many of them came to see the Tower of London and Buckingham Palace, ticket sales at London's theatres suggested that some, at least, had come for the West End itself.

A year earlier, audiences had risen by a staggering 12 per cent, and by September 1984 theatre owners were confidently predicting that sales would reach a record-breaking 10 million by Christmas. Across the Atlantic, Broadway sales were down, while cinemas all over the Western world were struggling to compete with television, arcade machines and home computers. Yet the West End was booming, with theatres changing hands for record sums. When the Palace Theatre, which had been designed for Richard D'Oyly Carte in 1891, went on the market in the summer of 1983, it was snapped up for £1.3 million by the man whom many observers credited with reviving the West End's fortunes. For by now Andrew Lloyd Webber was more than merely a composer: he was a showman, an entrepreneur, a one-man industry. Nobody else in history had ever had three musicals performing in London and New York at once. 'He could turn the Reykjavik telephone directory', said the *Observer*, 'into a West End hit.'[2]

Having already made millions from *Joseph and the Amazing Technicolor Dreamcoat* (1968), *Jesus Christ Superstar* (1970), *Evita* (1976) and *Cats* (1981), Lloyd Webber had been planning a musical about trains for years. When he failed to secure the rights to the Reverend W. Awdry's much-loved Railway Stories, he decided to design his own. The result was a project with no parallel in West End history. *Starlight Express* was originally supposed to cost £2 million, more than any musical before it, but by the opening night it was already 35 per cent over budget. It would take at least forty weeks of full houses, insiders reported, for Lloyd Webber's backers to see a penny. To make matters worse, the designers had taken entire banks of seating out of the Apollo Victoria to make room for the gargantuan set, which was four times

bigger than the set for *Cats*, cutting capacity from 2,700 seats to just 1,400. With giant video screens, computer-controlled spotlights, whizzing skaters and a gigantic railway trestle, this would be a musical production like no other. 'It is the culmination of all the epic, spectacular ambitions which have been bubbling away in the British theatre,' wrote Bryan Appleyard in his preview for *The Times*. As he saw it, *Starlight Express* had the air of a 'grandiose folly, a vainglorious overstatement deriving its energy from the sheer cussedness with which it flies in the face of normal theatrical prudence'. And at such vast expense, he added, 'this show has to be a gigantic smash-hit or nothing'.[3]

Starlight Express was, of course, a triumph. 'As spectacle, overwhelming, as engineering, phenomenal. You have to see it – and then you won't believe it,' began John Barber's review in the *Telegraph*. Other critics were less effusive: in *The Times*, Irving Wardle called it a 'millionaire's folly, which happens to be open to the public', while the *Guardian*'s Michael Billington called it a 'computerised fairy story, a theatrical *Star Wars*, in which the human element is constantly struggling to get out'. Yet the audience loved it. By September 1986 Lloyd Webber was celebrating the 1,000th performance with drinks in Kensington's art deco Roof Gardens. And while the show's performance on Broadway was deemed relatively disappointing, especially given how well *Cats* had done with American audiences, the West End version ran for more than 7,000 performances, while there were also lucrative tours of Germany, Japan, Mexico, Scandinavia, New Zealand, South Africa, Hong Kong and Singapore. Indeed, nothing better reflected Lloyd Webber's extraordinary record than the fact that *Starlight Express* was actually thought to mark a slight *dip* in his popularity, even though the takings were more than many composers would make in their entire careers. 'Andrew Lloyd Webber', wrote Wardle, 'now ranks not only as the transatlantic king of popular music theatre but also as its reigning Medici' – and he still had *The Phantom of the Opera* to come.[4]

By many conventional standards, Andrew Lloyd Webber ranks as one of the outstanding cultural figures of the last half-century. Not only has he written some of the best-known songs in modern British history – songs which even his critics would immediately recognize, such as 'Any Dream Will Do', 'Don't Cry for Me, Argentina' and 'Memory' – but he is widely credited as the key figure in turning the West End around from

the doldrums of the 1970s. He is not merely a composer but an extremely successful businessman, his talent having secured him a knighthood, a peerage, a vast collection of Victorian paintings and a fortune in the hundreds of millions, like Arthur Sullivan and Richard D'Oyly Carte rolled into one. Yet few cultural figures inspire such visceral loathing. In 2012 I was part of a panel asked to choose sixty defining national figures from Elizabeth II's reign for a BBC Radio 4 series to mark her Diamond Jubilee. The public had already nominated a vast list of names, and predictably enough, some of them – Enoch Powell, say, or Gerry Adams – provoked a very lively discussion. But when I tentatively suggested that Lloyd Webber ought to make the final sixty, not merely as the author of some of contemporary Britain's most popular music, but as the face of the West End and the embodiment of the cultural entrepreneur, at least two of my fellow panellists looked at me as if I had just nominated Fred and Rose West. In that moment I knew the battle was lost. But I still think he should have been on the list.[5]

The case for Lloyd Webber hinges on the fact that, from 1968 to 1986, he created a string of musicals that enjoyed staggering popular success, not just in Britain but all over the world. Since its opening in 1986, *The Phantom of the Opera* alone has been seen by more than 130 million people worldwide, and has made more money than any film in history. To put it bluntly, it is hard to think of anybody else, in any branch of the entertainment industry, who was more adept at giving the public precisely what it wanted. The case against him, however, is not just that his music is superficial and second-hand, but that nobody better embodies the supposedly selfish materialism of the 1980s. In his history of the modern British theatre, the *Guardian*'s veteran critic Michael Billington draws up a powerful indictment. *Starlight Express*, he says, was typical: a 'mixture of monster spectacle and fake religiosity . . . a ghastly, over-produced show that turned a simple children's tale into a piece of showbiz kitsch'. Worse, the plot is a 'hymn to Thatcherite individualism': Rusty, the underdog train, discovers that the fabled 'Starlight Express' is not some external godlike figure, but was inside him all along, like some locomotive equivalent of the self-belief that the judges on *The X Factor* are always banging on about.

And for Billington this makes perfect sense. Lloyd Webber's musicals, he argues, were 'Thatcherism in action', providing 'escape from social reality and social uplift', while the composer himself was 'everything she

revered: entrepreneurial skill, a world-famous brand name, the priceless ability to make money'. What was even worse, Lloyd Webber did not even have the grace to be modest about it. It is hard to forget a horribly compelling clip of his appearance on the *Wogan* show at the end of the Thatcher years. Terry Wogan asks about the recent reports that the composer has insured himself for £10 million. 'Well, I was surprised to read that – a bit saddened really,' says Lloyd Webber, smirking, 'because the last time I picked up a paper I thought I was worth *three hundred* million!' On second thoughts, maybe we were right to leave him off that list.[6]

Margaret Thatcher had a great deal of time for Andrew Lloyd Webber. In August 1978, while she was still Leader of the Opposition, her speechwriter Ronnie Millar took her to see *Evita*. 'It was a strangely wondrous evening yesterday leaving so much to think about,' she wrote to Millar the next day. 'I still find myself rather disturbed by it. But if they [the Peronists] can do that *without* any ideals, then if we apply the same perfection and creativeness to *our* message, we should provide quite good historic material for an opera called *Margaret* in thirty years' time!' And by the time she was in her political pomp, the Prime Minister and the composer were delighted to acknowledge their mutual admiration. On one infamous occasion, the National Theatre boss, Peter Hall, who had voted Conservative in 1979, was horrified when Mrs Thatcher took him to task for complaining publicly about the state of British theatre. 'Look at Andrew Lloyd Webber!' she said firmly. Indeed, Mrs Thatcher was completely oblivious to the fact that many people found Lloyd Webber's personality distinctly off-putting. Interviewed before her trip to Vancouver for Expo '86, for example, she was keen to stress the cultural element in the British pavilion. This, she said earnestly, was 'something else at which Britain excels, whether it is music, whether it is art, whether it is musical shows. I do not know if Andrew Lloyd Webber is there, but of course, everyone knows his fantastic musical shows. We are marvellous at drama, and it is just something else at which Britain excels. There is a lot going for Britain.' She could have mentioned any number of people. But she just mentioned him.[7]

For his part, Lloyd Webber made no secret of his political enthusiasms. In 1987 he wrote the music for one of the Conservatives' election broadcasts, a stirring little tune to accompany a montage of Mrs Thatcher shaking hands with various international statesmen. ('I think it's a *marvellous* piece of music', she declared, 'and I think music lovers will want

to have it in their collection.') Five years later, he adapted a Purcell ron-deau as the theme for John Major's campaign appearances. In the meantime, he added greatly to the gaiety of the nation by issuing regular threats that unless the British people voted as he advised, then he might be forced to leave the country. As early as January 1988 – when Mrs Thatcher was still in power, taxes had been slashed and the next election was years away – Lloyd Webber warned that Nigel Lawson's 'high tax rates' were in danger of driving his 'skilled production people' across the Atlantic, and that he too might soon follow. In 1992 he declared himself 'desperate' with terror that Neil Kinnock, with his 'absurd obsession that high-earners are rich', would 'devastate show business'. And even five years later, when Tony Blair and Gordon Brown could hardly have done more to woo the City, Lloyd Webber warned the *Express* that, if elected, they might reveal their true colours as a 'lot of loonies'. It clearly never occurred to him that by issuing these threats he was making the Tories' task much more difficult. 'Alas, the reaction to his announcement casts him as another of his shows' heroes: the Phantom of the Opera,' remarked the *Independent*. 'His threat to leave the country was swiftly followed by seven Labour MPs tabling a Com-mons motion claiming that the possibility of his emigrating provided an extra incentive to vote Labour. Hence the Phantom-like Lloyd Webber, immensely powerful but unloved, craving affection but inspiring instead fear and loathing.'[8]

What makes Lloyd Webber such an interesting figure is that he was not just a composer. He was a cultural entrepreneur whose com-pany, the Really Useful Group, was floated on the stock market in 1986. That made him exactly Mrs Thatcher's sort of person: a self-made man, albeit one who had been to Westminster School and Oxford, who con-spicuously enjoyed making money. Cultural entrepreneurship was nothing new, of course: Richard D'Oyly Carte began his career in the late 1860s running a small operatic agency, and ended it as the owner of Claridge's, the Berkeley and the Savoy. The difference was that Lloyd Webber wrote his own music, which set him apart from, say, Brian Epstein and Chris Blackwell, and meant that he was closer, if anything, to the Beatles, whose attempt to set up Apple Corps had been a disas-trous failure.

But this kind of entrepreneurship looked very different in the 1980s, when it had the seal of approval of a Prime Minister who had literally

grown up above the shop, than it did in the vaguely countercultural 1960s. Ever since becoming Conservative leader, Mrs Thatcher had relentlessly lectured her audiences about the importance of entrepreneurship. It was 'free enterprise', she insisted a few months after toppling Edward Heath in 1975, that 'has enabled the arts to flourish. And to become, not just the preserve of the rich, but to be enjoyed by men and women from every walk of life.' And in office she wasted no opportunity to advertise her credentials as the friend of the investor, the risk-taker, the canny businessman. Indeed, her Enterprise Allowance Scheme, introduced nationwide in 1983 to encourage unemployed people to set up their own businesses, had unlikely cultural consequences. Among the recipients were Alan McGee, who used the money to set up Creation Records – the home of the Jesus and Mary Chain, Primal Scream and Oasis – and Chris Donald, who ploughed it into his fledgling *Viz* magazine. These were not, perhaps, the kind of results she had been expecting.[9]

Mrs Thatcher did not invent entrepreneurship. But as a cultural figure, the entrepreneur – the individual cutting his way through society armed only with his talent for making money – seemed far more resonant in the 1980s than at any time since the days of Dickens and Trollope. This was a decade that saw a stunning increase not merely in unemployment but in *self*-employment, up from 1.9 million people in 1979 to 3.4 million in 1990. In the newspapers, the economic heroes of the day were men such as Next's founder, George Davies, who had been born in Crosby, Lancashire, in 1941 and went to a Liverpool grammar school. Like many self-made men, Davies was driven by a sense of social inferiority: on the very first page of his bestselling autobiography, published in the last year of the decade, he recalled the humiliation of being blackballed by an amateur football club, the Liverpool Ramblers, because he had not been to a private school. 'When you are surrounded by the sort of person who cares about that thing,' he once said, 'you want to show them you can succeed.'

This sort of talk would have gone down very well with the would-be entrepreneurs whose adventures entertained tens of millions of television viewers, from *Only Fools and Horses*'s Derek Trotter, whose brother Rodney remarks that he could 'smell a fiver in a force nine gale', to *Minder*'s Arthur Daley, who advises his friend Terry that 'your modern entrepreneur is constantly gazing into the crystal ball of opportunity'. The irony is that *Minder*'s creator, Leon Griffiths, had formerly been a

committed Communist and even worked as a young man for the *Daily Worker*. Arthur Daley, he once said, represented 'the unacceptable face of private enterprise', and in fact the series began life in 1979 as a vehicle for Dennis Waterman, who played Terry. The fact that Arthur Daley then took it over – thanks not least to George Cole's splendid performance – speaks volumes about the mood of the decade.[10]

The cultural fascination with the self-made man was already growing even before Mrs Thatcher came to power. In David Edgar's play *Destiny* (1976), the Conservative Party is already being infiltrated by 'sharp young men with coloured shirts and cockney accents', while the mid-Seventies BBC drama series *The Brothers* introduced viewers to the ruthless Paul Merroney, a go-getting City whizz kid with an eye for the main chance, played with lip-smacking relish by the young Colin Baker. These were very far from the sort of self-made men that Samuel Smiles had celebrated in *Self-Help*, but they caught the imagination of a society in which the old bonds of class and community were fraying almost to nothingness. Even in the early 1970s, writers like the left-wing journalist Jeremy Seabrook had been warning that the old working-class culture celebrated by shows like *Coronation Street*, based on 'predictability and discipline' as well as the 'immutable realities of mill, school, and chapel', was close to extinction, a victim not just of affluence, consumerism and individualism, but of industrial decline and rising unemployment.[11]

By the following decade, even as millions of pounds were pouring into George Davies's shops and Andrew Lloyd Webber's coffers, many observers were reading the last rites for Britain's collective working-class culture. Retracing George Orwell's journey in *The Road to Wigan Pier* (1937), the writer and activist Beatrix Campbell was struck, half a century later, by the deep sense of 'unnamed, unacknowledged loss' in communities shattered by de-industrialization. Orwell, she thought, would no longer recognize working-class Britain. No such place existed; it had been broken into fragments, leaving 'no essential culture expressing its interests and ambitions'. And when the journalist Godfrey Hodgson revisited Manchester for *The Times* in 1982, he was struck by the total disappearance of the industrial landscape that he had known twenty years earlier. Then it had been a world of 'smoke-blackened cotton warehouses', 'seedy factories and workshops' and 'neat but insanitary rows of crimson brick terraced houses': a 'dirty, shabby

world, but crowded and busy'. Now it was gone; and as yet there was nothing to replace it.[12]

But while the world that Tony Warren, Catherine Cookson and John Braine had known so well was dying, individualism was all the rage – even on the *Guardian*'s women's page. 'The norm, if it ever existed, is out. The individual, with all his or her peculiarities, is in,' wrote the paper's feminist-in-chief, Jill Tweedie, in October 1983. The new fashion ethos, she thought, was this: 'You pays your money and you takes your choice . . . Cor, look at him. *God, look at her.* Aren't we all *extraordinary?*' Indeed, even the way that Mrs Thatcher's voters entertained themselves had become more individual, more small-scale, typified by their enthusiasm for the video recorder and the Sony Walkman. The trauma of the industrial holocaust had accelerated the privatization of culture and the domestication of leisure: as the *Guardian*'s economics editor, Victor Keegan, remarked, 'the average Briton's response to the first microchip recession is to retreat into his home and make that the centre of his entertainment and an escape from the outside world'. One statistic told the story: by the end of 1982, Britain had more video recorders per head than any other country in the world, even Japan. 'We are becoming a more private society, abandoning the cinema for the home video, the football terrace for *Match of the Day*, constituency meetings for the jousting of party leaders on *Panorama*,' wrote the young Michael Ignatieff, then a brilliant Cambridge historian and later a sensationally unpopular Canadian politician, in an essay for the *Guardian*. 'The result is a society with a strange new kind of unhappiness: better fed, clothed and housed than ever before, yet progressively impoverished in its capacity to provide collective belonging – a sense of community.'[13]

Of course it was precisely that sense of collective belonging that the rebels of the 1960s, intent on self-fulfilment and self-gratification, had been trying to throw off. And their New Romantic successors, emerging from the murky economic misery of the early Thatcher years, with their swashbuckling, piratical costumes, extravagant eye make-up and ostentatious disdain for political idealism, were similarly obsessed with their own singularity. At the Blitz club on London's Great Queen Street, a young man called Steve Strange ran an 'Electro-Diskow' night, inspired by David Bowie's song 'Heroes'. What he wanted, he said, was a club for 'people who created unique identities'. To get in, visitors had to have

the right look, the right style; while extravagant make-up, elaborate hair and colourful clothes helped, it was also a question of individual self-confidence. The Blitz was a club not for identikit punks, but for people confident in their own individuality, like the Saint Martin's fashion students who made up much of the clientele in the club's early days. Here, reported the *Evening Standard*'s pop columnist, were 'lads in breeches and frilly shirts, white stockings and ballet pumps, girls as Left Bank whores or stiletto-heeled vamps dressed for cocktails in a Berlin cabaret, wicked witches, kohl-eyed ghouls, futuristic man machines'. As with the Mods two decades earlier, self-expression was all; the point was not to lose yourself in the group, but to stand apart from the crowd. 'We're saying, "Make the best of yourself,"' explained Spandau Ballet's Gary Kemp. '"Even if you can't write or play you can look good, and that's a form of expression."'[14]

Since Spandau Ballet are often pilloried as the ultimate Thatcherite band, there is a nice irony in the fact that in February 1981, when they had only just released their first single, Kemp earnestly insisted: 'However much money I get, I could never vote Conservative.' Perhaps, even at this stage, he felt a little self-conscious about Spandau Ballet's emphasis on looking good, such a contrast with the studied drabness of more politicized groups. Right from the beginning, many older rock critics hated them: as early as December 1980, Richard Williams declared that the New Romantic movement was merely 'the ultimate and most depressingly sterile rerun of avant-garde pop's overextended infatuation with the life-is-a-cabaret ethic. Fun for some, certainly, and cash for others, but it has no heart.'

Yet fun and cash were hardly unusual or even ignoble ambitions for a working-class pop group. They were, in fact, precisely the ambitions that had lured the Beatles into pop music more than two decades earlier, and you do not have to be a great Spandau Ballet fan to think that much of the criticism is a bit harsh. Far from being card-carrying Conservatives, stamping on the upturned faces of unemployed miners as they hurried to their next gig, all but the lead singer, Tony Hadley, were Labour voters. Kemp's background was typical: born in 1959, he had grown up in a typical working-class north London household, in a terraced council house with no bathroom and a brick toilet in the back yard. Like millions of other young Britons, he dreamed of a better life, a life of style and comfort and material security. Success did not come

without a cost: like so many bright young men before him, he felt a tug of anxiety, even guilt, that he had loosened the ties of class and belonging. When he bought his first house, gazing at his 'church candles and interior magazines on the black enamelled coffee table . . . with a glass of claret in my hand and something light and choral on the stereo', he felt a 'strong sense of denying everything my family was'. Even so, feeling guilty about being successful was better than not being successful at all.[15]

The image of Britain in the 1980s as a society drenched in selfish consumerism, obsessed with style and image, in thrall to stockbrokers, entrepreneurs and advertising men, is, needless to say, a caricature. But like the caricature of the swinging, carefree Sixties that has become similarly ingrained in our national imagination, it was one created at the time, almost before the very things it was mocking had reached their peak. In fiction, for example, the defining image of Mrs Thatcher's Britain is probably the grotesque yet irresistibly compelling anti-hero John Self in Martin Amis's novel *Money* (1984). An advertising director who made his name with semi-pornographic fast-food commercials – could there be a more savagely emblematic figure? – Self has flown to New York to make his first film. He is, we discover, the quintessential self-made man, hence the name, having risen from a humble background as the son of a London pub landlord. He is also a truly monstrous figure, wallowing in fast food and cheap booze, drowning in pills and pornography.

In fact, it is hard to think of a fictional character more enslaved by the cult of consumerism. When Self meets Martin Amis, who in a post-modern twist appears as a character in his own novel, he is shocked to discover that the writer does not own a video recorder. 'It's immoral,' he exclaims. 'Push out some cash. Buy stuff. Consume, for Christ's sake.' He is also a supreme individualist, untroubled by social conscience and uninterested in meaningful social interaction. 'I realise, when I can bear to think about it, that all my hobbies are pornographic in tendency,' he muses. 'The element of lone gratification is bluntly stressed. Fast food, sex shows, space games, slot machines, video nasties, nude mags, drink, pubs, fighting, television, handjobs.' As this might suggest, he is also conveniently and rather implausibly self-aware, which is what makes him not merely tolerable but often very funny.[16]

Although John Self is a marvellous character, it is debatable whether he really embodies British society in the mid-1980s any more than, say, Uriah Heep captures the essence of British life in the late 1840s. As a

guide to our national experience, Amis's record is at best very patchy and at worst truly terrible: it is a chilling thought that one day, when society has been rebuilt after a nuclear holocaust, future historians may be forced to piece together a picture of twenty-first-century Britain from the charred fragments of *Yellow Dog* or *Lionel Asbo*. In fairness, Amis never meant to write *Money* as a portrait of an age: as he later explained to the writer Sathnam Sanghera, all he wanted to do was to 'create a comic monster', drawing on his own experiences in the 1970s as an unhappily displaced screenwriter in New York.

And really the idea that the culture of the 1980s was defined entirely by greed, pornography and selfish materialism is just silly. In many ways, in fact, it was strikingly idealistic: just think of Billy Bragg and Red Wedge, or Bob Geldof and Band Aid, or even the anti-Thatcher songs by Elvis Costello, Morrissey, UB40, the Specials and the Beat. When the Greater London Council organized five miners' benefit nights at the Royal Festival Hall in September 1984, even Wham! made an appearance. Alas, their generosity was not entirely appreciated by those listeners whose tastes ran more to Alexei Sayle and the Style Council, who had featured earlier that evening. As George Michael and Andrew Ridgeley took to the stage, it rapidly become obvious that they were miming. Aware of the murmurs of discontent from his audience, Michael made a valiant attempt to defend himself, insisting that 'if anyone thinks it matters they aren't here for the right reasons'. It was no good. 'Dressed in white and posturing farcically,' wrote the man from *Melody Maker*, 'Wham! greatly pleased the three rows of young girls at the back of the hall and left everybody else stone-faced and baffled. I must admit, I'd never realised quite how dreadful they really are.'[17]

At the time, Wham! were comfortably the hottest chart outfit in the country, having secured three number ones in less than a year. Yet their story suggests that there was at least a grain of truth in the stereotype of the unashamedly materialistic 1980s. Although groups like the Beatles and the Rolling Stones had revelled in their newfound riches, gleefully splashing out on cars and country houses, they had been careful to do so in private. Conspicuous consumption was never popular with the fans: even John Lennon, after all, kept Yoko's fur coats under lock and key while publicly dreaming about a world with no possessions. But by the time George Michael and Andrew Ridgeley hit the headlines, there seemed no need to apologize for making and spending money. Their

early singles, such as 'Wham Rap!', had at least nodded to the anti-Thatcher sentiments so popular in the music industry. But once they had tasted success, all of that largely disappeared. 'The rebelliousness could never come from us', insisted George Michael, 'because we come from middle-class backgrounds.'

Now their videos wallowed in a world of yachts and penthouses, luxury jets and swimming pools. 'Being rich is part of their image,' said *The Times*, which thought they looked like 'tanned, articulate young professionals who happen to have chosen popular music as their way of life'. Their manager Simon Napier-Bell justified their 'utter shamelessness' by explaining that they were 'first-generation immigrants, and the children of immigrants always see success in commercial terms'. The singers themselves disagreed. 'I credit myself with a bit more intelligence than that,' said George Michael. All the same, he made no effort to hide his delight at making so much money. 'It would be pointless', he said, 'to pretend that you didn't care about being healthy and wealthy and pretended to be living off the dole. We don't feel at all ashamed about our success.'[18]

It is tempting to say that in this, as in so much else, the tone had been set by the Prime Minister. It would be easy to write about, say, the pop music of the 1960s without mentioning Harold Macmillan or Harold Wilson, but to discuss the popular culture of the 1980s without mentioning Margaret Thatcher would be simply bizarre. Yet the idea that groups like Spandau Ballet, Duran Duran or Wham! were effectively following the Prime Minister's lead, their songs and their values merely a pale reflection of the materialist mood music coming out of Number 10, is surely very dubious. When the 21-year-old, Labour-voting Gary Kemp donned his finery for a night at the Blitz club, it is hard to imagine that the political ideals of a fifty-something woman in Downing Street were bouncing around his imagination. There is, of course, a popular argument that Mrs Thatcher established such a powerful cultural hegemony that even people uninterested in politics found themselves parroting her favourite mantras about individualism, free enterprise and the importance of making money. But this has never struck me as very persuasive, not least because groups such as Spandau Ballet and Duran Duran came to the fore during her first term, when she broke the all-time record for prime ministerial unpopularity and seemed certain to go down as a short-lived aberration.

Indeed, far from slavishly following her every whim, most of Britain's best-known writers, artists, actors and musicians regarded Mrs Thatcher with visceral hostility. Her motley crew of celebrity supporters – the snooker champion Steve Davis, the comedians Kenny Everett and Jimmy Tarbuck, the wrestler Mick McManus and the inevitable Andrew Lloyd Webber – have gone down in political folk-lore, but even Labour's disastrous general election campaign in June 1983 had a strong celebrity component, organized by the actor Bill Owen, who, perhaps unfortunately, was best known for playing the hapless Compo in *Last of the Summer Wine*. Two weeks before poll-ing day, the *Guardian* ran a long and magnificently self-regarding essay by Salman Rushdie, spluttering with disbelief at the 'class-ridden know-your-place . . . thin-lipped, jingoist' values of the British people. 'Dark goddesses rule,' he wrote portentously; 'brightness falls from the air.' If he thought this sort of thing was likely to sway floating voters, he was sadly mistaken.[19]

Far from being locked in a close embrace, therefore, Thatcherism and popular culture were often in direct opposition. And far from following the Prime Minister's lead, groups like Wham! and Spandau Ballet were surely reflecting much deeper trends that had nothing to do with her at all. Consciously or unconsciously, their models were not Margaret Thatcher and Sir Keith Joseph, but Joe Lampton, John Lennon, David Bowie and Elton John, a succession of self-defining, self-realizing indi-vidualists who had gradually been chipping away at the sanctity of institutions, the idea of authority and the old emphasis on collective loyalty. It was not Mrs Thatcher who made it possible for groups like Wham! to become rich and famous. If anything, the reverse was true. It was groups like Wham! – or more accurately their forerunners in the 1960s and 1970s, with all their talk of fighting the system, standing up to the Establishment, being who you wanted to be and living your life on your own terms – who opened the door for Mrs Thatcher. By under-mining the institutions that had dominated British life for decades, by emphasizing the importance of self-gratification and by celebrating the value of the individual, Lennon and his contemporaries made it much easier for younger voters, in particular, to embrace her free-market mes-sage. It was no wonder, then, that the move to embrace Mrs Thatcher in 1979 was greater among voters under 24 – a swing of some 8½ per cent – than any other age group. 'She and her radicalised, post-consensus

Conservative voters', the critic Ian MacDonald once argued, 'are the true heirs of the Sixties.' Perhaps that is overstating things slightly, but there is surely a fair bit of truth to it.[20]

Mrs Thatcher's ideas about free enterprise, individual responsibility and the virtuous pursuit of material self-interest had been formed in the late 1930s. It has become a commonplace to argue that she got them from thinkers such as Friedrich von Hayek, but this is not really true. Hayek did not convert her to the virtues of individualism; he merely confirmed the principles that she had picked up from her father, an old-fashioned Methodist liberal. These were the famous 'Victorian values' with which her government has become synonymous. But where did the phrase come from? Well, according to the historian David Cannadine, he coined it himself in a *New Society* essay about – of all things! – the Flashman books:

> A few weeks afterwards, I received a letter from Matthew Parris [then a Conservative MP], who told me that Margaret Thatcher had greatly enjoyed reading my essay. Six months later, in January 1983, she began talking publicly and admiringly about Victorian values, and about what she meant by them, and she continued to do so until the general election that was held in May of that year,* which, of course, she triumphantly won ...
>
> So there you have it: the pedigree of the phrase 'Victorian values' goes from Harry Flashman, via David Cannadine, to Margaret Thatcher. It's a very small footnote to history. Or am I, like George MacDonald Fraser, just making it up?

Actually, he *was* making it up. And since Victorian values play such a large part in this book, perhaps it is worth digging a bit deeper for a moment or two.[21]

Contrary to what many people seem to think, the phrase 'Victorian values' was not unknown before January 1983. Even a cursory search shows that it had appeared dozens of times in newspapers and periodicals since the 1880s. In an influential essay, the socialist historian Raphael Samuel wrote later that Mrs Thatcher appeared to have stumbled upon it 'as a rallying cry by accident, conjuring the phrase out of

* It was actually held in June, but as attentive readers of this book have probably noticed, nobody's perfect.

nowhere and launching it on its public career in the course of an interview with *Weekend World*'. But this is just not true, because it was not Mrs Thatcher who first used it. Indeed, the transcript of the famous *Weekend World* television interview, shown live on 16 January 1983, makes very interesting reading. The interviewer, the former Labour MP Brian Walden, asks her if she wants 'a more self-reliant Britain, a thriftier Britain, a Britain where people are freer to act, where they get less assistance from the State, where they're less burdened by the State'. Yes, she says. Then Walden goes on:

BRIAN WALDEN: All right, now you know, when you say you agree with those values, those values don't so much have a future resonance, there's nothing terribly new about them. They have a resonance of our past. Now obviously Britain is a very different country from the one it was in Victorian times when there was great poverty, great wealth, etc., but you've really outlined an approval of what I would call Victorian values. The sort of values, if you like, that helped to build the country throughout the nineteenth century. Now is that right?

MRS THATCHER: Oh exactly. Very much so. Those were the values when our country became great, but not only did our country become great internationally, also so much advance was made in this country. Colossal advance, as people prospered themselves so they gave great voluntary things to the State. So many of the schools we replace now were voluntary schools, so many of the hospitals we replace were hospitals given by this great benefaction feeling that we have in Britain, even some of the prisons, the Town Halls. As our people prospered, so they used their independence and initiative to prosper others, not compulsion by the State. Yes, I want to see one nation, as you go back to Victorian times, but I want everyone to have their own personal property stake. Property, every single one in this country, that's why we go so hard for owner-occupation, this is where we're going to get one nation. I want them to have their own savings which retain their value, so they can pass things onto their children, so you get again a people, everyone strong and independent of Government, as well as a fundamental safety net below which no-one can fall. Winston put it best. You want a ladder, upwards, anyone, no matter what their background, can climb, but a fundamental safety net below which no-one can fall. That's the British character.

It is a fascinating exchange, but not for the reasons you might expect. It is Walden, not Thatcher, who starts talking about the nineteenth century; and it is *Walden*, not Thatcher, who uses the phrase 'Victorian values'. She never uses it at all. Far from producing a phrase she had seen in an essay about Harry Flashman – a laughably implausible scenario, when you think about it – she is merely following his lead. And her interpretation of Victorian values is actually quite different from the selfish materialism with which she is usually attributed. She does, admittedly, talk about property and thrift, but she spends most of her time talking about voluntary philanthropy ('this great benefaction feeling which we have in Britain'). Indeed, at the end of the exchange she even starts talking about the welfare state ('a fundamental safety net'). Had any selfish materialists been watching from their luxury yachts, Duran Duran's latest playing in the background, a bottle of Krug chilling on ice, they might have been a bit disappointed.[22]

In the months that followed, Victorian values became something of a political football. According to Neil Kinnock, for example, 'Victorian Britain was a place where a few got rich and most got hell'. The real Victorian values, he said, were 'cruelty, misery, drudgery, squalor and ignorance'. Meanwhile, Mrs Thatcher was being pressed to expand on her view of nineteenth-century Britain. On 15 April she was interviewed by the radio journalist Peter Allen, who asked 'what you meant recently when you talked about Victorian values'. As so often when she was asked this question, her answer emphasized not just individual self-improvement but voluntarism, charity and community spirit.

> I was brought up by a Victorian grandmother. You were taught to work jolly hard, you were taught to improve yourself, you were taught self-reliance, you were taught to live within your income, you were taught that cleanliness was next to godliness. You were taught self-respect, you were taught always to give a hand to your neighbour, you were taught tremendous pride in your country, you were taught to be a good member of your community.

And when, a few weeks later, a Labour MP wrote asking (yet again) for her to expand on her definition, she, or her secretary, came up with a similar list: 'respect for the individual, thrift, initiative, a sense of personal responsibility, respect for others and their property, and all the other values that characterised the best of the Victorian era'. It is hard

to see this as a manifesto for John Self-style hedonism. If anything, Mrs Thatcher's definition of Victorian values sounds more like the sort of thing an earnest headmistress might tell her pupils at morning assembly.[23]

Today it is often thought that one of Mrs Thatcher's chief inspirations was none other than Samuel Smiles. Raphael Samuel thinks that she rehabilitated him from being a 'joke figure', while in his admirable history of the Victorians, Matthew Sweet writes that in 1983 she 'famously declared her allegiance to the works of Samuel Smiles'. In fact, the database of her speeches compiled by the Margaret Thatcher Foundation shows that she never mentioned Smiles at all. Perhaps more surprisingly, she never publicly used the phrase 'self-help'. Yet the parallel with the man who wrote *Self-Help* is actually very revealing. The grocer's daughter and the Scottish writer are often pilloried as the apostles of a harsh, uncaring individualism, fixated entirely on the self and completely indifferent to the suffering of others. Yet both of them – and I realize, of course, that dyed-in-the-wool anti-Thatcherites may now throw this book across the room – talked almost as much about social responsibility and voluntary philanthropy as they did about individual self-improvement. There is even a remarkable parallel between a passage in Smiles's book *Thrift* (1875) and Mrs Thatcher's notorious 1987 interview with *Woman's Own*, in which she said that there was 'no such thing' as society. In *Thrift*, Smiles denounced the idea that 'Nobody' was to blame for disease, poverty, crime and suffering: 'That terrible Nobody! How much he has to answer for. More mischief is done by Nobody than by all the world besides.' And as a close reading of her *Woman's Own* interview shows, Mrs Thatcher was *not* arguing that people were atomized, selfish individuals, as is often thought. In fact, she was arguing that instead of leaving suffering and injustice to 'Society', 'individual men and women' should step in themselves. 'The quality of our lives', she explained, 'will depend upon how much each of us is prepared to take responsibility for ourselves and each of us prepared to turn round and help by our own efforts those who are unfortunate.'[24]

Her critics might, of course, insist that she never really meant it, but she said it so often and so fervently that this seems unduly cynical. Indeed, her ardent belief in philanthropy surely explains why, having initially been suspicious of Bob Geldof's Band Aid single at the end of

1984, she could hardly have been more enthusiastic about Live Aid six months later. 'I thought it was marvellous,' she told *Smash Hits*. 'I watched some of it on the Wembley thing and it was absolutely terrific. It was the first time that we'd been able to get a great body of young people not merely interested in something but actually doing something for it and loving doing it, and I thought it was absolutely terrific.' It was a reminder, she added, that you should not judge people by their appearance: 'Some of the kindest people have the most strange appearance. You can't tell their politics by what they look like. You might be able to tell by what they've got printed on their T-shirt but not by what they look like.' And she was keen to advertise her support to older audiences, too. Addressing the American Bar Association in the Royal Albert Hall two days after the concert, she went out of her way to praise:

> those marvellous young people of Live Aid in both Wembley and Phila-
> delphia on Saturday who flashed their message of help and hope across
> the world. That was humanity in action. That was the young people of
> Britain and America moved by the plight of others thousands of miles
> away, using the magic of technology to restate in the language of pop the
> age-old brotherhood of man.

She could hardly have picked a more Victorian-sounding phrase. The idea of the 'brotherhood of man', wrote Gladstone in 1868, was 'part of our common inheritance, common as the sunlight that warms us, and the air that we breathe'. Victorian values indeed![25]

Yet as far as Mrs Thatcher's cultural image is concerned, all this is probably beside the point. Since her period in office coincided with the worst job losses in British history, the collapse of our manufacturing heartlands, the death-throes of the steel, motor and mining industries, and an unprecedented rise in homelessness and drug addiction – none of which, in fairness, was entirely her fault – it is hardly surprising that many people had little time for her Sunday school lectures about the dangers of state intervention and the importance of voluntary philanthropy. And just as Samuel Smiles's reputation degenerated into a caricature, so, to the writers, singers and artists who loathed her, Mrs Thatcher became the embodiment of everything that was wrong with Britain in the 1980s, the personification of hard-hearted selfishness and shameless materialism. Indeed, for all the success of Meryl Streep's

performance in *The Iron Lady* (2011), it is the *Spitting Image* view of Mrs Thatcher, a harpy in a power-suit, that endures.

Nothing captures that fact better than one of twenty-first-century Britain's most celebrated cultural exports. The second half of *Billy Elliot: The Musical* even opens with a song, 'Merry Christmas, Maggie Thatcher', in which the cast exult that every day brings them 'one day closer' to celebrating the Prime Minister's death. On the evening of 8 April 2013, hours after she had died at the age of 87, the cast of the London production asked the audience to vote on whether they wanted to hear it. They voted yes.[26]

COSMIC DANCER

Have you any idea what we're going through? . . . and you come round spouting shite. And you . . . fuckin' ballet. What are you trying to do, make him a fuckin' scab for the rest of his life? Look at him. He's only eleven, for fuck's sake.

Tony Elliot, in *Billy Elliot* (2000)

One sunny day on the French Riviera, Elton John went to see a film. Developed by BBC Films, *Dancer* was the first picture by the Royal Court's artistic director, Stephen Daldry, and to the producers' delight it had been chosen as the closing film of the Directors' Fortnight at the Cannes Film Festival in 2000. To Elton John, however, the film was a 'complete mystery'. But since he had been specially invited and knew of Daldry's glittering theatrical reputation, he decided to go anyway. Even at home the film was still an unknown quantity: in its Cannes preview, the BBC's website described *Dancer* as a vehicle for the much-loved comic actress Julie Walters. 'Set in northern England in 1974,' the site explained, 'it tells of a young boy who copes with the death of his mother and his brother's bullying to follow his dream of becoming a ballet dancer.' At least they got the bit about the ballet right.

But as the doors shut and the cinema darkened, the singer – like everybody else in the audience – found himself entranced. 'The story of young Billy, a gifted working class boy with artistic ambitions seemingly beyond his reach, had so many parallels to my own childhood,' he wrote later.

'Do you think being a ballet dancer will be better than a miner?' Jamie Bell in *Billy Elliot* (2000).

Like Billy, the opportunity to express myself artistically was a passport to a better, more fulfilling life. As a child, I dreamt of a career in music, escaping into my treasured record collection for inspiration and hope. It was the unfailing support of my mother and grandmother that helped me achieve my ambitions. With their encouragement and a scholarship to the Royal Academy of Music, I started building a foundation that has allowed me to rejoice in a musical career that has exceeded my wildest dreams. To see Billy literally dance his way out of the bleak and cruel environment created by the British mining industry's demise was inspirational. To see Billy's family rally behind his artistic gift moved me to tears.

This was no exaggeration. As the lights went up in the cinema, the crowd were on their feet, cheering and clapping. But Elton John, who was admittedly something of a stranger to the stiff upper lip, was almost prostrate with emotion. 'As Jamie Bell took a glorious victory lap around the cinema,' he admitted, 'I had to be helped up the aisle, sobbing. The film had really got under my skin.'[27]

On his website, John described the first screening of *Billy Elliot* as a moment that changed his life.* As a boy, he had always felt that his father, Stanley, disapproved of his musical career. There may have been a bit of self-mythology in this, since John's biographer shows that actually Stanley Dwight was very proud of his son, but it is certainly true that back in early 1965 Stanley had been alarmed and upset when his son left school without taking his A-levels. In any case, John immediately saw himself in 11-year-old Billy, the boy who dances his way from the strike-torn coalfield of County Durham to the Royal Ballet School. And more than a year later, after *Billy Elliot* had been rewarded with three Oscar nominations and more than £72 million at the box office, its writer, Lee Hall, received a telephone call. As Hall remembered it, the singer had 'apparently recovered from his viewing of the movie' and had decided that it would make a brilliant musical. Hall himself thought this was the 'worst idea in the world'. But after he had flown to New York to meet Elton John in Harry's Bar, he changed his mind. On the first day of 2002, Hall sat down with a blank sheet of paper and began work on the lyrics for the first song. Before going to bed, he faxed a

* The film's title was changed after Cannes, partly to avoid confusion with Lars von Trier's film *Dancer in the Dark*, which won the Palme d'Or at that year's festival.

copy to New York. At one in the morning the phone rang. It was Elton John, full of enthusiasm. He had already finished the first number.[28]

When the plans for *Billy Elliot: The Musical* were unveiled to the press in the summer of 2004, Lee Hall still seemed in a slight state of disbelief. Growing up in Newcastle listening to Elton John's records, he said, he could never have imagined that one day they would collaborate on a blockbuster West End musical. 'I thought I had written a very personal and peculiar piece about growing up in the North-east and about wanting to create art against all the expectations of my background,' he said wryly. 'I had the good sense to substitute dancing for writing otherwise I probably wouldn't be here today.' It was just as well that he did, for in its various forms *Billy Elliot* was one of the outstanding cultural triumphs of the 2000s. Quite apart from the tremendous success of the film, the West End show won four Olivier awards, including the prize for the best new musical, as well as a vast array of Broadway baubles, including ten Tony awards. In fact, no musical in history, except for *The Producers*, has ever received more Tony nominations. To win such acclaim in the United States was beyond anything they had imagined; as Hall put it, they had set out to write 'a musical that was truly British, that would be rough, lyrical, funny, and moving in equal measure'. But wherever it played, from Holland and Denmark to Australia and South Korea, audiences and critics alike loved it. And when, at the end of September 2014, the musical was screened live in cinemas across the country, it took a record £1.9 million, sending it to the top of the box-office charts.[29]

The genesis of *Billy Elliot* lay in events a very long way from the glitter and glamour of Broadway. On the eastern edge of County Durham, whipped by the cold winds from the North Sea, Easington Colliery was a mining town. It had always been a mining town; at least, as long as anybody remembered: a town of narrow streets and narrow expectations, where, as the writer Robert Chesshyre put it, boys once left school on Friday afternoon and went down the pit on Monday morning. Like so many pit villages, it felt distant, remote, cut off from the rest of the country, alone with the sea and the wind. 'Who knows East Durham?' asked J. B. Priestley after visiting in the early 1930s. 'The answer is – nobody but the people who have to live and work there.' Even decades later, Chesshyre thought it felt like 'the end of the road'. But though few other people even knew it existed, Easington Colliery was proud of its

history. In a park next to the miners' welfare club stood a little grove of eighty-three oak trees, one for every man killed in the terrible pit disaster of May 1951. This was a town that mourned its dead and remembered its wounds, a town that took its past seriously. And then, some thirty-three years later, Easington found itself at the centre of one of the great confrontations in modern British history, an ideological drama that defined a decade and provides the background for Billy Elliot's personal triumph.[30]

The miners' strike that broke out in March 1984 was hard on Easington Colliery. The Durham miners were more solid than most, and there were fewer divisions and recriminations than in areas further south such as Derbyshire and Nottinghamshire. But only a few months into the strike, the town was clearly suffering. Inside the 'rows of coal board houses that look like the set for *Coronation Street*', as one visitor put it, countless personal miseries were playing out. The local women's support group was serving some 400 hot meals a day, and at the NUM headquarters, officials distributed relief parcels of bread, margarine, baked beans and washing up liquid. Many of the town's shops, starved of custom, had already gone under; those that remained all displayed their SEAM signs – 'Save Easington Area Mines' – with the exception of the ironmonger's, which had put up a metal grille after its windows were smashed in.

By the autumn, the atmosphere felt heavy with tension. When one miner, Paul Wilkinson, decided to break the strike and return to work, the stage was set for daily confrontations between pickets and the police. 'As dawn breaks,' wrote one reporter, 'convoys of police vans and convoys of coaches bearing the pickets rumble down Seaview Road, like two 18th century armies arriving for a pitched battle at a pre-arranged time.' Almost unnoticed amid the shouting and shoving, Wilkinson clocked on and off every day, a lone rebel against the town's collective solidarity. To many people the strike seemed both a way of life and a struggle for life itself. Unemployment in Easington was already almost 20 per cent, but, as everybody knew, it was as much as 40 per cent in pit villages that had lost their mines. For Easington to suffer the same fate was simply unthinkable. Even the local branch of the Trustee Savings Bank had rallied to the cause, refusing to repossess miners' houses, even though many were unable to meet their repayments.

And by the New Year – when defeat was already looming – the

psychological and physical costs were mounting. In the north-east, as elsewhere, reported *The Times*, 'marriages have been destroyed, careers cut short; entire communities are still bleeding'. In one surgery near Durham, Dr Stephen Drew reported that Easington women, 'girls aged from 20 to maybe 27, with two or three kids, were coming to me with panic attacks. They were having palpitations, crying, wanting to run away.' Many asked him for sedatives; what they really wanted, though, was 'reassurance that they weren't cracking up'. In the pressure of the strike, he thought, the old collective loyalties had frayed and snapped. 'Now it's all about who went back to work and who didn't. People will remember this for years. I don't think it will ever be the same again.'[31]

Lee Hall was 17 when the miners' strike broke out, a clever working-class boy from nearby Newcastle. He had grown up in the city's East End, once its great shipbuilding heartland, across the river from Catherine Cookson's Jarrow. His father was a self-employed painter and carpet cleaner, and although the strike never touched them directly, everybody in Newcastle followed it with intense interest. 'Quite often in that strike year,' Hall later remembered, 'if Dad had a job in, say, Yorkshire, he would be turned back because they'd hear the Geordie accent and think he was a flying picket.'

Meanwhile, his son was spreading his wings. Already involved with local theatre groups, Hall won a place at Cambridge to read English, but, like so many working-class entrants before and since, he found it an alienating and frustrating experience. Indeed, much of the culture of the 1980s, fascinated as it was with money, glamour and status, seems to have left him cold. His own enthusiasms were more down-to-earth, from Ealing comedies and the *Carry On* films to writers such as J. B. Priestley, Arnold Wesker and Alan Bennett, who, he said, 'wrote about class and, very often, aspiration'. And as he began to find his voice as a playwright, Hall was determined to break down what he saw as the pernicious and artificial divide between 'high' and 'popular' art. 'I was working on an idea about a ballet dancer in a pit village, which seemed to allow for all kinds of artiness,' he wrote later. 'But if it was about the kid reaching for high art, why couldn't I strive to find a popular ("low") form for the story? If you can be "full on" in the ballet or the opera or in soaps or in a pop song, why can't you deal with emotion in a film?'[32]

From the very beginning, Hall saw *Billy Elliot* as an intensely political piece. 'Growing up in the north east under Thatcher', he wrote in

the *Guardian*, 'left the injustices that were perpetrated on hundreds of thousands of people indelibly stamped on my consciousness, and so the film is about growing up in that environment.' Driving with his father through the pit villages south of Newcastle, he was shocked by how quickly and completely the mines had disappeared. In Easington's case, the colliery had closed in 1993, throwing more than 2,000 men out of work. 'The slag heaps were grassed over,' Hall remembered; 'the winding gears were nowhere to be seen.' His story, he thought, would be 'an act of remembering'. But there was more to it than that. Hall was an unashamed admirer of one of the most controversial characters in modern British history, the miners' leader Arthur Scargill. Later, talking about *Billy Elliot*, he often mentioned something Scargill had said on television, an oddly touching paean to the artistic potential of the British working classes.

> I know that we can produce a society where man will cease to simply go to work and have a little leisure, but will release his latent talent and ability and begin to produce in the cultural sense all the things I know he is capable of: music, poetry, writing, sculpture, whole works of art that, at the moment, lie dormant simply because we, as a society, are not able to tap it.

Hall remembered Scargill saying this late at night at the height of the strike, when he would have been exhausted. In fact, his memory was playing him false. Scargill had actually said it on a chat show in August 1979, almost five years before the strike had started.[33]

If *Billy Elliot* had merely been an exercise in political tub-thumping, then it probably would never have made it to the screen at all. Hall wrote the first draft in the mid-1990s, when he was already making his name as a dramatist on the radio and the stage. A few people looked at his script but, as he put it, they beat 'hasty retreats' when they realized it was about 'mining and ballet'. But when he showed it to his friend Stephen Daldry, the director loved it. 'He had seen the connections to melodrama and musicals,' Hall wrote, 'which in my earnestness I had overlooked.' This is not to say, however, that the politics disappeared. Indeed, while Daldry was filming in Easington, the echoes of the recent past were impossible to miss. The scenes of violent clashes between pickets and policemen were filmed in the same streets where, in the autumn of 1984, miners and riot police had fought out the longest

strike in British history. And although relics of the area's mining past were surprisingly hard to find, the wounds were still raw. While they were filming in the street where Billy was supposed to live, Hall remembered, unemployed youths, who would once have been working down the pit, loitered in the background, buying and selling drugs. And although Daldry had enlisted several hundred locals to appear in the crowd scenes, there soon proved to be a problem. None of them was prepared to play a policeman.[34]

There is more to *Billy Elliot*'s tremendous appeal than its heart-warming story of a brave young boy's triumph against the odds. What the film perfectly captures, and what clearly appealed to Elton John that day at Cannes, is the ethos of personal liberation that has been such an important element of British popular culture since the 1960s. Like so many working-class heroes before him, Billy is a prisoner of his family's expectations. He goes to boxing lessons, which he loathes, because his father expects it. 'Jesus, Billy Elliot, you're a disgrace to them gloves, your father and the traditions of this boxing hall,' says his trainer after a disastrous sparring exercise. His gloves, a family heirloom, are the supreme symbol of his imprisonment: as his father, Jackie, reminds him, 'they were me dad's gloves'. Indeed, one of the film's underlying themes is how the old idea of being a man is being eroded by cultural and economic change. For much of the film, Billy, who has grown up in a traditional working-class household, is caught between two worlds. His friend Debbie tells him that 'plenty of men' do ballet. 'Poofs,' Billy says contemptuously. A few moments later, after joining Mrs Wilkinson's dancing class, he says he feels 'like a right sissy'. In a nice twist, Billy's anxiety mirrors the experience of the actor who played him, Jamie Bell, who had started tap-dancing at the age of 6 after seeing a girl on television and telling his mother that he could do better. There was, he said, 'hassle from the lads at school who kept saying "you shouldn't be doing that Jamie, it's not for boys, it's more for girls". They said I should be doing football or rugby so I just didn't tell them where I was going after football practice and went on to my dance lessons.'[35]

But while Billy represents the future, his father takes a rather more old-fashioned view. 'Ballet!' he says in horror over the dinner table. 'It's perfectly normal,' Billy desperately insists. 'Aye, for your Nana. For girls. Not for lads, Billy. Lads do football or boxing or . . . wrestling.

Not friggin' ballet.' And yet the story of the film is as much about Billy's father, and his gradual recognition that his idea of masculinity is out of date, as it is about Billy himself. Jackie is a widower, struggling to bring up a family in the midst of a long and bitter strike. When he tries and fails to stop his elder son, Tony, taking a hammer to the picket line, his powerlessness is brutally exposed. 'You haven't got it in you, man, you're finished,' snarls Tony. 'Since Mam died you're nothing but a useless twat! What the fuck are you gonna do about it?'

Although fictional, the scene expresses an important truth. As plenty of reporters had observed during the Thatcher years, long-term unemployment left men feeling useless and emasculated, unable to play their accustomed role as provider and protector. 'Men's tragedy', wrote Beatrix Campbell in 1984, the year *Billy Elliot* is set, 'is that unemployment makes them feel unmanned.' And as the strike takes its toll, so Jackie decides to abandon the one thing he really believes in – the solidarity of the working-class miners – and return to work to help his son. 'It's for wee Billy,' he tells the horrified Tony at the gates of the colliery, in one of the film's most moving and effective scenes. 'I'm sorry, son. We're finished, son. What choice have we got, eh? Let's give the boy a fucking chance.'[36]

One of Hall's chief inspirations for *Billy Elliot* was A. J. Cronin's novel *The Stars Look Down* (1935), which is set in a north-eastern pit village and explores the tensions not just between the miners and their bosses, but among the miners themselves. Indeed, *Billy Elliot: The Musical*'s first song, a hymn to the miners' struggle, is actually called 'The Stars Look Down', in a nice nod to Cronin's book. But in many ways the most interesting parallel is that between *Billy Elliot* and another Billy – Keith Waterhouse's novel *Billy Liar*, published in 1959. Waterhouse was a classic post-war meritocrat: born in Leeds in 1929, he went to a local secondary modern, worked as a cobbler's assistant and an undertaker's clerk, and then moved into journalism. *Billy Liar* was his second book, and since it is set in the North, and revolves around an ambitious young anti-hero, it is often described in the same breath as books like *Room at the Top* and *Saturday Night and Sunday Morning*. But it is actually much lighter, to the point of outright comedy, not least since its narrator, Billy Fisher, spends much of his time in a private fantasy world. And the parallels with *Billy Elliot* go beyond the superficial similarity of the titles. Both are stories about talented youngsters

living in the north of England who feel stifled by their families. And in both cases the denouement centres on the chance of escape to London.[37]

In Waterhouse's book, Billy Fisher is a 19-year-old undertaker's clerk in the Yorkshire town of Stradhoughton, a thinly disguised version of Waterhouse's native Leeds. He lives with his parents and grandmother – the latter, as in *Billy Elliot*, a comically aged figure. Like so many heroes of the 1950s, he feels like a 'trapped animal': not only does he fantasize about a life writing scripts for Danny Boon, a London-based comedian, he even invents 'entirely new parents' for himself, 'of the modern, London kind'. The irony, although Billy cannot see it, is that his life in Stradhoughton is really not so bad. He has a steady job, after all, which is more than he might have done if he was living in the 1980s. And although he thinks of Stradhoughton as a prehistoric provincial backwater, it actually seems a cheerfully up-to-the-minute sort of place, with 'new glass-fronted shops' and a trendy new coffee bar, the Kit-Kat Club, complete with 'cackling espresso machine'.

But for Billy, London is everything. Like Jim Dixon in *Lucky Jim*, he fantasizes about the new life he will build there, free from the entanglements of family and community. He imagines himself 'coughing my way through the fog to the Odd Man Out Club, Chelsea, with its chess tables and friendly, intelligent girls'. He will live, he decides, 'in a studio high over the Embankment, sometimes with a girl called Ann, a Londoner herself and as vivacious as they come, but more often with Liz', his favourite Stradhoughton girlfriend. What he loves most is the idea of casting off his old self: 'a man', he says, 'can lose himself in London'. Yet at the same time he feels a chill of terror at the prospect of leaving his familiar setting for a new life in the capital. 'The idea of being in London next Saturday, put down on paper and staring me in the face,' he tells us, 'filled my bowels with quick-flushing terror.'[38]

The idea of reinventing yourself and finding self-fulfilment in the bustling anonymity of London has been a popular theme in British literature for decades. As the cultural historian Dave Russell points out, it was particularly popular with northern writers, to the point of becoming a cliché. 'There grows in the North Country', remarked Arnold Bennett, himself a Midlander, in his first novel, *A Man from the North* (1898), 'a certain kind of youth of whom it may be said that he is born to be a Londoner. The metropolis, and everything that appertains to it, that

comes down from it, that goes up into it, has for him an imperious satisfaction.' But the theme of a new life in the capital was certainly not limited to northern writers. The story of *Great Expectations* is at least in part the story of Pip's attempt to throw off his upbringing in the Kentish marshes and turn himself into a London gentleman, while Irvine Welsh's novel *Trainspotting* (1993) ends with its anti-hero Renton, having betrayed his friends and cut his ties with Edinburgh, loose in the streets of London with a bagful of cash. When Dixon makes his escape from provincial academia in *Lucky Jim*, he gleefully pronounces the names to himself: 'Bayswater, Knightsbridge, Notting Hill Gate, Pimlico, Belgrave Square, Wapping, Chelsea' – though he changes his mind about Chelsea because he associates it with bohemian intellectuals. And in *The Buddha of Suburbia*, too, Karim lies awake dreaming of his new life in the capital: the bohemian radicals in 'velvet cloaks'; the crowds of people of all races and religions; the bookshops, the record stores; the boys and girls; and above all, the sex.[39]

The twist in *Billy Liar* is that after all the build-up, after all the grand claims and lavish fantasies, Billy bottles it. 'You're like a child at the edge of a paddling pool,' his girlfriend Liz says kindly. 'You want very much to go in, but you think so much about whether the water's cold, and whether you'll drown, and what your mother will say if you get your feet wet.' So indeed it proves: in the final scene of the novel, Billy stands paralysed with indecision at the station ticket barrier, suitcase in hand, his thoughts already beginning to flee from the real escape offered by the train to the false, illusory escape of his imagination. Many years later, Waterhouse remarked that his most famous character was simply a coward. But perhaps this is being unduly harsh. After all, Billy's life in Stradhoughton is comfortable enough, and unlike Billy Elliot he has no pressing reason to leave. Indeed, if a real-life Billy Fisher had chosen to stay in Leeds in 1959, he would have spent his twenties and thirties in a relatively successful, prosperous, self-confident city, surrounded by friends and family. That might not sound terribly glamorous: but life in London, with no friends, no contacts and no job, might easily have proved rather more difficult than he had imagined.[40]

The denouement of *Billy Elliot* works out rather differently. Like Billy Fisher, the younger Billy has his doubts about moving south. He is shocked when his ballet teacher first mentions applying to the Royal Ballet School. 'I'd never be good enough,' he says. 'I hardly know owt.'

But the idea grows on him. In one of the key lines of the film, he asks his friend Michael: 'Do you think being a ballet dancer will be better than a miner?' The answer is obvious. Indeed, by the end of the film even his father has come round. On the bus south, Jackie looks, if anything, even more nervous than Billy. 'What's it like, like?' Billy asks him, curious about their destination. 'I don't know, son,' his father says, rather shame-facedly. 'I never made it past Durham.' Billy is shocked. 'Why would I want to go to London?' asks Jackie – not a question that would have occurred to Jim Dixon or Billy Fisher. 'Well, it's the capital city,' his son says. 'Well, there's no mines in London,' replies his father. 'Christ,' says Billy, giving him a withering look, 'is that all you think about?' And, in a sense, everything that follows is superfluous, for in Billy's mind he has already left.[41]

Perhaps only somebody with very little soul, or indeed no soul at all, could sit through *Billy Elliot* without enjoying it. Beautifully shot and perfectly played, the film is the ideal crowd-pleasing blend of light and shade, humour and pathos, politics and entertainment. The odd thing, though, is that for a film inspired by the thoughts of Arthur Scargill, one of modern Britain's best-known champions of collectivism, it looks remarkably like a classic tale of individual self-realization. 'It is about wanting something better and doing everything you can to achieve it,' explained Lee Hall in the film's production notes.

But when critics described his film as a quintessential rags-to-riches story, or even attacked him, as Charlotte Raven did in the *Guardian*, for celebrating Billy's individual triumph at the expense of the miners' collective struggle, Hall was furious. His film was not, he said, about escape but about aspiration, 'about how you can integrate art into your everyday life'. Billy's triumph, after all, is only possible because his father organizes a whip-round by the striking miners, who pay for his coach fare to London. 'In the end,' explained Gary Lewis, the actor playing Jackie Fisher, 'it's the solidarity of Billy's family and the miners around them who give the last of what they've got, that make things possible for Billy.' Hall himself went further. What the film was absolutely *not* about, he insisted, was the triumph of the individual: 'The lie we've been told is that our history is individual and you scrabble up the greasy pole pushing everybody down. But actually, value is created between people collectively.' The point about Billy, he explained to *Socialist Review*, is that he only succeeds 'because there is some type of solidarity and

community which has allowed him to flourish'. So although 'he starts off as an individual ... he takes everybody with him'.[42]

Powerful stuff, but not, I think, very convincing. It is true that Billy never climbs the greasy pole by pushing others down. But does he really take everybody with him? In the film's moving final scene, set in the present, Jackie and Tony take their seats to watch the grown-up Billy dance the lead in *Swan Lake*. But knowing as we do what happened to towns like Easington after the miners' defeat, it is hard not to wonder what became of them in the meantime. Did they find new jobs? Did Billy's example spur them to find hidden talents of their own? Or, more plausibly, did they join thousands of others on the scrapheap of unemployment, while their extravagantly talented relative was building a new life for himself in London? And although it is true that Billy only gets to London because his father's friends put their hands in their pockets, it is surely debatable how much *Billy Elliot* really celebrates the triumph of collective solidarity. After all, Billy gets the news of his acceptance at the Royal Ballet School on precisely the day that the miners vote to go back to work. When his father bursts into the social club to tell his friends Billy's good news, they are sitting grim-faced, contemplating the defeat of their cause. 'Jackie? Have you not heard, man? We're going back,' one says. But they are not, of course, going back for long, for as anybody watching the film in 2000 would have known, the mines were doomed. A Smilesean hero elevated not just by his friends' generosity but by his extraordinary native talent, Billy gets on and moves up. But they cannot all go with him to London. And by the time he graduates from the Royal Ballet School, you wonder how many of them can afford to see him dance.[43]

None of this, I think, diminishes *Billy Elliot*'s power as a superbly rousing story. Indeed, in some ways it makes it an even more richly suggestive symbol of the social and economic changes of the last half-century. For what happened to Easington was an accelerated, intensified version of what happened to so many parts of Britain as Empire and industry became things of the past. From the Liverpool of John Lennon and Paul McCartney to the Birmingham of Tony Iommi and Ozzy Osbourne, from Catherine Cookson's Jarrow to John Braine's Bingley, towns and cities that had once rung with the sound of hammers gradually fell silent. The only difference was that Easington's story was even worse, because it had relied so heavily on the colliery,

and because the aftermath of the strike had left such a lingering sense of bitterness.

Yet as Robert Chesshyre noted, people often had complicated views: while they hated Mrs Thatcher for her role in the strike, many were glad their children never had to go down the pit. 'It was no bad thing that the pit closed,' said one miner's widow, remembering the dirt, the danger, the accidents, the terrible hacking coughs. 'My father was a miner, and he never wanted me to go underground,' a local taxi driver told another reporter some years later. 'He couldn't walk up to the top of Seaside Lane without stopping on a bench to have a breather. I finished school, I never had to work down that mine. My son's studying, he's going to university.' Catherine Cookson would surely have agreed with his next remark. 'My mother always said people forgot that it wasn't exactly all roses when the pit was open,' he recalled. 'People struggled, life was hard.'[44]

But at least they had jobs. When the colliery closed in 1993, Easington lost the central fact of its existence. By then the town already held the national record for invalidity benefit claimants, amounting to almost one in four of the population, and by the early 2000s its jobs, health and education figures were some of the worst in the country. In May 2005, a few days before *Billy Elliot: The Musical* opened at London's Victoria Palace Theatre, the journalist Sholto Byrnes went north to see how Easington had changed since the film was made. What he found made for the starkest imaginable contrast with the glamour of the West End. Many of the shops were boarded up; so were the Easington Colliery junior and infants' schools. Outside, a local priest reported finding needles in the grass. 'The pit closed, and the older people were left here,' he said. 'They sold off the old Coal Board houses and moved problem families in. There's lots of crime and drugs. It's declining all the time.' When Byrnes asked whether a 'real Billy' might emerge from the town, the priest just laughed. At the nearby Easington Colliery Club, Byrnes found similar responses. Everybody knew about the film. 'He wanted to be someone else. He managed to break out of the little cage that all the bairns were born into round here,' said a 65-year-old woman, which was precisely the interpretation that Lee Hall had tried to discourage. But nobody thought that a real Billy Elliot was possible in Easington. 'It's football they want, not ballet,' said one ex-miner. 'They're too busy taking drugs,' said another. On the street, Byrnes asked two small boys what they thought of the film. 'I'm not a poof,' one of them said.[45]

The story of Easington Colliery is a reminder that although the life of nations may well be lived partly in the imagination, it is not lived *entirely* in the imagination. But it would surely be too depressing to end on such a downbeat note. For *Billy Elliot* is not just a lament for a disappearing world; it is also a hymn to the possibility of self-reinvention. 'The piece', Lee Hall once said, 'is about the loss of community, identity and a collective politics which inspired generations of people ... But in the bravery, sensitivity and pure glee and energy of the boys I think there is a poignant image that there is hope for our future, that we can achieve extraordinary things if we all put our minds to it.'

And while it is true that the story of a ballet dancer could not save Easington from decline, it is too glib to dismiss all this as mere sentimentalism. For some people, at least, the film was genuinely life-changing – not just in Britain, but all over the world. For years after the film's release, newspapers reported surging applications by boys to Britain's ballet schools. But in 2011 the BBC ran a story about rising numbers in a place that could hardly be further away from Easington. 'It takes a certain bravery', the story explained, to wear a dancer's leotard in Mexico, 'where machismo is still rife.' But with more boys applying to ballet schools, the head of Mexico's Royal Academy of Dance – a branch of the British original – knew exactly who was responsible. 'Billy Elliot!' Julieta Navarro said delightedly. 'Thanks to Billy Elliot many of the boys really dare to say, "Yes, I want to be a dancer, I want to dance, I want to try ballet."'[46]

Perhaps above all, then, *Billy Elliot* is the perfect advertisement for the extraordinary global appeal of the British imagination. On stage young Billy has danced his way out of poverty everywhere from Seoul to São Paulo, and on Broadway alone the musical played for some 1,300 performances before a total audience of almost 2 million people. The opening night in New York was one Hall would never forget. 'It was very strange', he remarked, 'going from Times Square through the stage door and seeing a set of the village hall in Easington that's an exact replica of a village hall in the 1980s. From Easington to Broadway was an odd dislocation.' But perhaps it was no odder than Hall's own story, which had taken him from a working-class house on the banks of the Tyne to Harry's Bar in the heart of Manhattan. And it was certainly no stranger than the story of the man who had written the music. Born in a suburban council house, Reggie Dwight changed his name, his look, his very identity, to became one of the most popular entertainers of all

time, adding countless awards to his CBE and his knighthood. When Elton John played at the funeral of Princess Diana, some observers had thought it extraordinary. But if the Palace had been hoping to find somebody who embodied the sheer power of British culture in an age when industry and Empire had been consigned to history, then perhaps they could not have made a more fitting choice.[47]

Acknowledgements

I had a lot of fun writing this book, but it turned out to be not at all what I had imagined. I wrote it while making a television series on the same subject, produced by Oxford Scientific Films for BBC Two. That makes it sound like a TV tie-in. But since TV tie-ins, quite rightly, have a dreadful reputation, it is not a label I am terribly keen to embrace. The truth is that, although I originally thought it would be a simple matter to turn the scripts into a book, it actually proved completely impossible. So I decided to more or less ignore the scripts and start again from scratch. In some ways this was a mad thing to do, because it meant I was making a lot of extra work for myself, but it seemed like a good idea at the time. People who have watched the series, therefore, may be surprised to find that, although this book covers much of the same ground, it often uses different examples, and even comes to slightly different conclusions.

The original idea for this project came out of long conversations with Steve Condie, the man responsible for inflicting me on millions of innocent television viewers. I have learned more by talking and listening to Steve than by reading countless books; in truth this is as much his project as it is mine, and I can't thank him enough. I owe a tremendous debt to our brilliant series producer, Alex Leith, who spent months of his life in a succession of slightly sub-par hotels listening to me talking about John Braine. I am also immensely grateful to the splendid producers, James Giles and Caroline Walsh; the assistant producers, India Bourke, James Allnutt, Amy Morgan and Alec Webb; and the backroom team of Matt Grimwood and Emma Love. The crew – the supremely unflustered Patrick Acum and Stuart Thompson, the all-conquering Wordfeud champion Louis Caulfield and the art-detecting Adam Scourfield – were

not just great professionals, they were great company. And I also want to thank Janice Hadlow and Mark Bell, who commissioned the series in the first place and were full of ideas, advice and encouragement from the very beginning.

Working with the team at Allen Lane has, as always, been an immense pleasure. My editor, Simon Winder, could hardly have been more enthusiastic, and I am eternally grateful for his unstinting support, his superhuman patience and his keen eye for a Billy Bunter picture. Among his colleagues, Pen Vogler was an irrepressible source of publicity wheezes, while Maria Bedford proved remarkably tolerant as we ploughed through what seemed like thousands of potential photographs. And I owe a particular debt to my copy-editor, Kit Shepherd, who put in a staggering amount of work to save me from countless humiliating mistakes. Any remaining errors – and despite his efforts, there are probably bound to be a few – are my responsibility, not his. Without his extraordinary eye for detail, though, there would undoubtedly have been many more.

I have been enormously fortunate not just in my publishers but in my agents: the indefatigable Sue Ayton at Knight Ayton Management, and the supremely unflappable James Pullen at the Wylie Agency, the very model of a literary agent. I would also like to thank Paul Dacre, Leaf Kalfayan, Andrew Yates and Andrew Morrod at the *Daily Mail*, Martin Ivens at the *Sunday Times*, and Rob Attar and Charlotte Hodgman at *BBC History Magazine*. And I am especially grateful to Andrew Holgate for his generosity, friendship and encouragement over the last few years.

My greatest debts, which I can never repay, are to Catherine, whose patience, kindness and support make everything possible; and to Arthur, to whom this book is dedicated, with love.

Notes

Place of publication is London, unless otherwise stated.

PREFACE: THE BRITISH ARE COMING!

1. *Daily Mirror*, 19 July 2012; *New York Post*, 18 July 2012; *Der Spiegel*, 17 July 2012.
2. 'PM's Speech at Olympics Press Conference', 26 July 2012, https://www.gov.uk/government/speeches/pms-speech-at-olympics-press-conference; 'Prime Minister's Speech on the London 2012 Olympics', 5 July 2012, https://www.gov.uk/government/news/prime-ministers-speech-on-the-london-2012-olympics.
3. Asa Briggs, *Victorian People: A Reassessment of Persons and Themes, 1851–67* (rev. edn: 1965), pp. 26–7; *The Times*, 30 April 1851; *New York Post*, 18 July 2012; *Daily Mail*, 21 April 2011.
4. *Observer*, 24 June 2007; *Guardian*, 23 May 2000; *Spectator*, 14 July 2012; *Independent*, 26 July 2012.
5. *New York Times*, 27 July 2012; *Observer*, 29 July 2012; 'London 2012 Opening Ceremony Wows World Media', 28 July 2012, http://www.bbc.co.uk/news/world-19026951; *Washington Post*, 27 July 2012.
6. Amy Raphael, *Danny Boyle, Creating Wonder: In Conversation with Amy Raphael* (rev. edn: 2013), pp. xxvii–xxviii, 410; *Guardian*, 3 July 2013.
7. Raphael, *Danny Boyle*, pp. 414–15, 421; the figures are quoted in Robert Skidelsky's review of Nicholas Comfort, *The Slow Death of British Industry: A Sixty-Year Suicide, 1952–2012* (2013), in the *New Statesman*, 24 January 2013.
8. Martin J. Wiener, *English Culture and the Decline of the Industrial Spirit, 1850–1980* (2nd edn: Cambridge, 2004), p. 28; Samuel Smiles, *Lives of the Engineers*, vol. 1: *Early Engineering* (1874), p. xxiv. Smiles published the first edition in 1861, but I am using the revised and expanded edition, published thirteen years later.

9. George Orwell, *The Road to Wigan Pier* (1937: 2001), p. 148; Mark Leonard, *Britain™: Renewing Our Identity* (1997), pp. 24, 6, 44, 52, 53, 47.

10. Ibid., pp. 4–5, 65; Chris Smith, 'Britain's Creative Industries Booming', 11 November 1998, http://news.bbc.co.uk/1/hi/uk_politics/209198.stm; *Daily Telegraph*, 30 June 2014; *Financial Times*, 28 January 2014; *Guardian*, 24 November 2013.

11. *Independent*, 7 July 2014; *New Statesman*, 26 June 2014; 'Top Gear in Iran: Why Do Iranians Love Jeremy Clarkson?', 5 April 2013, http://www.bbc.co.uk/news/magazine-22020822.

12. Alfred North Whitehead, *Science and the Modern World* (1926: 1932), p. 94; George Orwell, 'Boys' Weeklies', *Horizon*, March 1940, http://theorwellprize.co.uk/george-orwell/by-orwell/essays-and-other-works/boys-weeklies; Wiener, *English Culture and the Decline of the Industrial Spirit*, p. xiv; *Independent on Sunday*, 6 August 2000.

13. *Spectator*, 3 January 2015.

14. Thomas Arnold, 'Letters on the Social Condition of the Operative Classes' (1832), in *The Miscellaneous Works of Thomas Arnold: Collected and Republished* (1845), p. 179; Goldwin Smith, *Reminiscences* (New York, 1910), pp. 1, 4, 11; and see David Newsome, *The Victorian World Picture: Perceptions and Introspections in an Age of Change* (1997), pp. 1–9.

15. Simon Heffer, *High Minds: The Victorians and the Birth of Modern Britain* (2013), p. 415; Newsome, *Victorian World Picture*, p. 262; Matthew Sweet, *Inventing the Victorians* (2001), pp. x–xi, 232.

16. David Sheff, *All We Are Saying: The Last Major Interview with John Lennon and Yoko Ono* (2000: 2010), p. 197.

CHAPTER I. THE LAND WITHOUT MUSIC

1. Tony Iommi, *Iron Man: My Journey through Heaven and Hell with Black Sabbath* (2011), pp. xi–xii, 20.

2. Ibid., pp. 1–3, 7–8, 15–16; *Birmingham Mail*, 17 May 2013.

3. Iommi, *Iron Man*, pp. 21–3; Andrew Cope, *Black Sabbath and the Rise of Heavy Metal Music* (Farnham, 2010), pp. 30–32.

4. Iommi, *Iron Man*, pp. 43, 45, 55–7, 73, 97–9. On Black Sabbath's sales and chart success, see the band's biography at the Rock and Roll Hall of Fame website: http://rockhall.com/inductees/black-sabbath/bio/.

5. *Guardian*, 11 December 2012; *Birmingham Mail*, 17 May 2007, 22 June 2007, 7 November 2008; *Birmingham Post*, 4 June 2013.

6. Cope, *Black Sabbath and the Rise of Heavy Metal Music*, pp. 9, 29–30; Brian J. Bowe, *Judas Priest: Metal Gods* (Berkeley Heights, NJ, 2009), n.p.; the Osbourne quotation is from *Q Classic*, April 2005.

7. Arthur Young, *Annals of Agriculture and Other Useful Arts*, 16 (1791), p. 532, quoted in Eric Hopkins, 'The Trading and Service Sectors of the Birmingham Economy', in R. P. T. Davenport-Hines and Jonathan Liebenau (eds.), *Business in the Age of Reason* (1987), p. 78; William Willey, *Willey's History and Guide to Birmingham* (1868), quoted in *Guardian*, 29 January 2014; Charles Dickens, *Hard Times* (1854: 2003), p. 27; David Duff, *Victoria Travels: Journeys of Queen Victoria between 1830 and 1900, with Extracts from Her Journal* (1970), p. 26.

8. Walter White, *All Round the Wrekin* (1860), pp. 6–7, 202–3; Alexis de Tocqueville, *Journeys to England and Ireland* (1835: New Haven, CT, 1958), p. 94; Asa Briggs, 'Economic and Social History: Social History since 1815', in W. B. Stephens (ed.), *A History of the County of Warwick*, vol. 7: *The City of Birmingham* (Oxford, 1964), pp. 223–45; Charles Dickens, *The Old Curiosity Shop* (1841: Oxford, 1997), pp. 348–9.

9. Cope, *Black Sabbath and the Rise of Heavy Metal Music*, p. 28; the Halford and Tipton quotations are from the documentary *Heavy Metal Britannia* (BBC Four, 5 March 2010) as well as the *Guardian*, 27 February 2010 and 20 May 2010.

10. *The Times*, 4 July 1980; *Sunday Times*, 15 May 1983; and see David Smith, *North and South: Britain's Economic, Social and Political Divide* (1989), pp. 132–3; Kenneth Spencer, *Crisis in the Industrial Heartland: A Study of the West Midlands* (Oxford, 1986).

11. Richard Taruskin, *The Oxford History of Western Music*, vol. 3: *Music in the Nineteenth Century* (Oxford, 2005), pp. 801–4; Amy Raphael, *Danny Boyle, Creating Wonder: In Conversation with Amy Raphael* (rev. edn: 2013), pp. 421–2; *Guardian*, 6 June 2013.

12. Martin J. Wiener, *English Culture and the Decline of the Industrial Spirit, 1850–1980* (2nd edn: Cambridge, 2004), p. 11; Genevieve Abravanel, *Americanizing Britain: The Rise of Modernism in the Age of the Entertainment Empire* (Oxford, 2012), p. 4.

13. W. T. Stead, *The Americanisation of the World, or, The Trend of the Twentieth Century* (1902), p. 5; Wiener, *English Culture and the Decline of the Industrial Spirit*, p. 89; T. S. Eliot to Eleanor Hinkley, 27 November 1914, in Valerie Eliot and Hugh Haughton (eds.), *The Letters of T. S. Eliot*, vol. 1: *1898–1922* (rev. edn: 2009), p. 77; Abravanel, *Americanizing Britain*, p. 135.

14. Robert McCrum, *Wodehouse: A Life* (2005), pp. 154–5, 186; Juliet Gardiner, *The Thirties: An Intimate History* (2010), pp. 668–70; Aldous Huxley, *Brave New World* (1932: 2007), p. xxxv. On the cricket club, see 'Caught Niven, Bowled Flynn', July 2001, http://www.espncricinfo.com/cricketer/content/story/210840.html.

15. Geoffrey Macnab, *J. Arthur Rank and the British Film Industry* (1993), pp. 53–4; Frank Costigliola, *Awkward Dominion: American Political,*

Economic, and Cultural Relations with Europe, 1919–1933 (Ithaca, NY, 1984), pp. 176–7; Kerry Segrave, *American Films Abroad: Hollywood's Domination of the World's Movie Screens from the 1890s to the Present* (Jefferson, NC, 1997), p. 59.

16. Abravanel, *Americanizing Britain*, pp. 14–15; Mark Glancy, *Hollywood and the Americanization of Britain: From the 1920s to the Present* (2014), pp. 14, 78–108; Hansard, 22 March 1927.

17. Jeffrey Richards and Dorothy Sheridan (eds.), *Mass-Observation at the Movies* (1987), pp. 34, 39, 47, 83; Gardiner, *The Thirties*, pp. 666–8; Macnab, *J. Arthur Rank and the British Film Industry*, p. 40. For defences of the 'quota quickies', see Matthew Sweet, *Shepperton Babylon: The Lost Worlds of British Cinema* (2005), pp. 103–4; Steve Chibnall, *Quota Quickies: The Birth of the British 'B' Film* (2007).

18. Gardiner, *The Thirties*, pp. 659–60, 663, 671; Anthony Aldgate and Jeffrey Richards, *Best of British: Cinema and Society from 1930 to the Present* (rev. edn: 1999), p. 1; Abravanel, *Americanizing Britain*, pp. 88–93.

19. Susan Sydney-Smith, *Beyond 'Dixon of Dock Green': Early British Police Series* (2002), p. 27; Hansard, 4 February 1930; Abravanel, *Americanizing Britain*, pp. 18–19; George Orwell, 'Raffles and Miss Blandish', *Horizon*, October 1944, pp. 232–44.

20. Abravanel, *Americanizing Britain*, pp. 85–6, 94; Wyndham Lewis, *Men without Art* (1934), pp. 32–3; Hansard, 14 May 1925; Jeffrey Richards, *The Age of the Dream Palace: Cinema and Society in 1930s Britain* (1984), p. 56–7.

21. Michael Wakelin, *J. Arthur Rank: The Man behind the Gong* (Oxford, 1996), pp. 73, 118, 145, 150–53; Macnab, *J. Arthur Rank and the British Film Industry*, p. 4; Sweet, *Shepperton Babylon*, p. 218.

22. Macnab, *J. Arthur Rank and the British Film Industry*, pp. 6–8; Wakelin, *J. Arthur Rank*, pp. 10, 14–15, 17–18, 23–4.

23. Ibid., pp. 13–14, 20, 33–5, 40–41; the final quotation, cited in Wakelin's book, comes from Alan Wood, *Mr Rank: A Study of J. Arthur Rank and British Films* (1952).

24. Macnab, *J. Arthur Rank and the British Film Industry*, pp. 11–12; John Trumpbour, *Selling Hollywood to the World: US and European Struggles for Mastery of the Global Film Industry, 1920–1950* (Cambridge, 2002), pp. 172–3; R. G. Burnett and E. D. Martell, *The Devil's Camera: Menace of a Film-Ridden World* (1932), p. 11; Wakelin, *J. Arthur Rank*, pp. 42–7.

25. Macnab, *J. Arthur Rank and the British Film Industry*, pp. 14, 17–20, 22–5, 32; Wakelin, *J. Arthur Rank*, pp. 50, 64, 69–71; *Methodist Recorder*, 26 March 1942.

26. Wakelin, *J. Arthur Rank*, p. 105; Macnab, *J. Arthur Rank and the British Film Industry*, pp. 169, 193; Sweet, *Shepperton Babylon*, pp. 238–9; Wood, *Mr Rank*, p. 202.

27. Sweet, *Shepperton Babylon*, pp. 220–21; Macnab, *J. Arthur Rank and the British Film Industry*, pp. 82, 90; *Time*, 19 May 1947; Wakelin, *J. Arthur Rank*, pp. 109–10; Wood, *Mr Rank*, p. 281.

28. Macnab, *J. Arthur Rank and the British Film Industry*, pp. 1, 41.

29. Ibid., pp. 9, 49, 79–80; Wakelin, *J. Arthur Rank*, pp. 21, 78, 106.

30. Macnab, *J. Arthur Rank and the British Film Industry*, pp. 67, 70; Wood, *Mr Rank*, p. 117; *Close Up*, 2 January 1928, cited in Abravanel, *Americanizing Britain*, p. 100.

31. James Chapman, *Past and Present: National Identity and the British Historical Film* (2005), pp. 119–20; Anthony Davies, 'The Shakespeare Films of Laurence Olivier', in Russell Jackson (ed.), *The Cambridge Companion to Shakespeare on Film* (Cambridge, 2007), pp. 170–71; Wood, *Mr Rank*, pp. 128–44; Macnab, *J. Arthur Rank and the British Film Industry*, pp. 83–6.

32. Harry M. Geduld, *Filmguide to Henry V* (Bloomington, IN, 1973), p. 53; James N. Loehlin, *Shakespeare in Performance: Henry V* (Manchester, 1996), pp. 28, 41; Chapman, *Past and Present*, pp. 121–2, 133.

33. Ibid., pp. 123–5, 131–2; Davies, 'Shakespeare Films of Laurence Olivier', pp. 171–2; Macnab, *J. Arthur Rank and the British Film Industry*, pp. 88–9; Sweet, *Shepperton Babylon*, p. 221.

34. Chapman, *Past and Present*, p. 125; *The Times*, 23 November 1944; *Manchester Guardian*, 5 September 1945; *Sunday Graphic*, 26 November 1944; J. P. Mayer, *British Cinemas and Their Audiences: Sociological Studies* (1948), pp. 214, 228.

35. Chapman, *Past and Present*, pp. 128–9; Leslie Halliwell, *Halliwell's Hundred: A Nostalgic Selection of Films from the Golden Age* (1982), p. 127; Anthony Holden, *Olivier* (1988), pp. 179–80; Davies, 'Shakespeare Films of Laurence Olivier', p. 169.

36. Holden, *Olivier*, p. 180; Davies, 'Shakespeare Films of Laurence Olivier', pp. 169, 171; Macnab, *J. Arthur Rank and the British Film Industry*, p. 89; *The Nation*, 3 August 1946; Richard Olivier and Joan Plowright (eds.), *Olivier at Work: The National Years* (1989), p. 66.

37. Terry Coleman, *Olivier: The Authorised Biography* (2005), p. 169. On the enduring legacy of the 'prestige' formula, see Macnab, *J. Arthur Rank and the British Film Industry*, pp. 35, 63.

38. Wakelin, *J. Arthur Rank*, pp. 89–92, 107, 129; Macnab, *J. Arthur Rank and the British Film Industry*, pp. 97–101, 163–4, 173–4, 189, 223; *Picturegoer*, 24 May 1947 and 7 June 1947, cited in ibid., pp. 97–8.

39. Wakelin, *J. Arthur Rank*, pp. 124, 170, 173, 163.

CHAPTER 2. I'M HENRY THE EIGHTH, I AM

1. Eric Jacobs, *Kingsley Amis: A Biography* (1995), p. 165; *Times Literary Supplement*, 29 August 1952; Harry Ritchie, *Success Stories: Literature and the Media in England, 1950–1959* (1988), pp. 5–7; the Priestley quotation is from George Scott, *Time and Place: An Autobiography* (1956), p. 214.

2. Kingsley Amis, *Lucky Jim* (1954), pp. 33, 87, 63, 178, 44, 227.

3. *Spectator*, 30 September 1954; Richard Ingrams (ed.), *The Life and Times of Private Eye, 1961–1971* (1971), p. 41.

4. Anthony Sampson, *Anatomy of Britain* (1962), p. 633; Arthur Koestler (ed.), *Suicide of a Nation? An Enquiry into the State of Britain Today* (1963), pp. 13–14, 239; Malcolm Muggeridge quoted in ibid., p. 29.

5. Robert Skidelsky, *John Maynard Keynes*, vol. 3: *Fighting for Britain, 1937–1946* (2000), pp. 294–5; George Melly, *Revolt into Style: The Pop Arts in Britain* (1970), p. 61.

6. John Osborne, *Look Back in Anger* (1956), p. 11; *Everybody's Weekly*, 3 July 1957; Harry Hopkins, *The New Look: A Social History of the Forties and Fifties in Britain* (1963), p. 454.

7. *Daily Mirror*, 11 May 1954; Richard Hoggart, *The Uses of Literacy: Aspects of Working-Class Life, with Special Reference to Publications and Entertainments* (1957), pp. 189–90.

8. John F. Lyons, *America in the British Imagination: 1945 to the Present* (New York, 2013), p. 40; *Melody Maker*, 5 May 1956; *Daily Mail*, 4 September 1956, 5 September 1956; *Sunday Times*, 30 December 1956; Asa Briggs, *The History of Broadcasting in the United Kingdom*, vol. 5: *Competition* (Oxford, 1995), pp. 202–3.

9. Spencer Leigh, *Puttin' on the Style: The Lonnie Donegan Story* (2003); Charlie Gillett, *The Sound of the City: The Rise of Rock and Roll* (3rd edn: 1996), pp. 259–60; Colin MacInnes, *England, Half English* (1961), pp. 11–18.

10. Hansard, 13 May 1964; *New Statesman*, 28 February 1964.

11. Tim Blanning, *The Triumph of Music: Composers, Musicians and Their Audiences, 1700 to the Present* (2008), pp. 325–6.

12. Tim Blanning, *The Romantic Revolution* (2010), pp. 31–43; Ian MacDonald, *Revolution in the Head: The Beatles' Records and the Sixties* (2nd edn: 1997), pp. xi, xii, 94.

13. Philip Norman, *Shout! The True Story of the Beatles* (1993), p. 157; Mark Lewisohn, *The Beatles: All These Years*, vol. 1: *Tune In* (2013), pp. 568, 647, 649; MacDonald, *Revolution in the Head*, pp. 78–9; Hunter Davies, *The Beatles* (2009), p. 186.

14. Lewisohn, *Tune In*, pp. 574–6, 739; Norman, *Shout!*, p. 211; Keith Badman, *The Beatles: Off the Record* (2000), p. 79.

15. Norman, *Shout!*, pp. 194–5; *New York Times*, 1 December 1963.

16. Dave Harker, 'Still Crazy after All These Years: What *Was* Popular Music in the 1960s?', in Bart Moore-Gilbert and John Seed (eds.), *Cultural Revolution? The Challenge of the Arts in the 1960s* (1992), p. 238; Alan Clayson, *Beat Merchants: The Origins, History, Impact and Rock Legacy of the 1960s British Pop Groups* (1995), p. 186; Shawn Levy, *Ready, Steady, Go! Swinging London and the Invention of Cool* (2002), p. 140; *Daily Mirror*, 8 February 1964, 10 February 1964.

17. Michael Pinto-Duschinsky, 'Bread and Circuses? The Conservatives in Office, 1951–1964', in Vernon Bogdanor and Robert Skidelsky (eds.), *The Age of Affluence 1951–1964* (1970), p. 57; Alan S. Milward, *The European Rescue of the Nation-State* (1992), p. 128; David Childs, *Britain since 1945: A Political History* (1979), p. 100.

18. Edmund Dell, *The Chancellors: A History of the Chancellors of the Exchequer, 1945–90* (1996), pp. 300–302; *New Statesman*, 28 February 1964; Davies, *The Beatles*, p. 285; *The Times*, 17 February 1964.

19. *The Times*, 9 March 1964, 17 September 1964, 12 June 1965; *Daily Mirror*, 12 June 1965.

20. Norman, *Shout!*, pp. 238–9; *The Times*, 12 June 1965; see the interview transcripts in Badman, *Beatles*, ch. 7, and at http://www.beatlesinterviews. org/db1965.0612.beatles.html.

21. Tony Benn, *Out of the Wilderness: Diaries, 1963–67* (1987), pp. 272–3; Barbara Castle, *The Castle Diaries, 1964–70* (1984), pp. 37–9; *The Times*, 15 June 1965, 16 June 1965, 17 June 1965, 22 June 1965. Colonel Wagg is quoted, oddly enough, in the *Southern Illinoisan*, 21 June 1965, which you can find at Google Newspapers.

22. *The Times*, 16 June 1965, 17 June 1965, 18 June 1965, 19 June 1965; *New Musical Express*, 25 June 1965.

23. Peter Leslie, *Fab: The Anatomy of a Phenomenon* (1965), p. 179; *New Musical Express*, 31 July 1964; Gillett, *Sound of the City*, p. 283; Levy, *Ready, Steady, Go!*, p. 152; MacDonald, *Revolution in the Head*, p. 90.

24. Nick Hasted, 'Ready, Steady, Kinks', *Uncut*, September 2004, p. 48; Jon Savage, *The Kinks: The Official Biography* (1984), pp. 42–3; Clayson, *Beat Merchants*, pp. 187–8, 207.

25. Tony Palmer, *All You Need Is Love: The Story of Popular Music* (1976), p. 225; Barry Miles, *Paul McCartney: Many Years from Now* (1997), p. 23.

26. Nigel Whiteley, 'Shaping the Sixties', in Jennifer Harris, Sarah Hyde and Greg Smith (eds.), *1966 and All That: Design and the Consumer in Britain, 1960–1969* (1986), p. 24; Richard Weight, *Patriots: National Identity in Britain 1940–2000* (2002), p. 393.

27. Elliott Roosevelt, *As He Saw It* (New York, 1946), pp. 121–2.

28. Mary Quant, *Quant by Quant* (1967), pp. 79, 117–20; Ernestine Carter, *Mary Quant's London* (1973), p. 6; Levy, *Ready, Steady, Go!*, pp. 53–4, 213; Marnie Fogg, *Boutique: A '60s Cultural Phenomenon* (2003), p. 26.

29. *Life*, 5 December 1960; Jane Stern and Michael Stern, *Sixties People* (New York, 1990) pp. 123–4, 139–40.

30. *Time*, 11 June 1965; James Chapman, *Licence to Thrill: A Cultural History of the James Bond Films* (1999), p. 112; John Cork and Bruce Scivally, *James Bond: The Legacy* (2002), p. 87; *Weekend Telegraph*, 16 April 1965.

31. Ibid.; *Time*, 15 April 1966. Masochists can read more about these effusions in my book *White Heat: A History of Britain in the Swinging Sixties* (2006).

32. *New York Times Magazine*, 12 June 1966.

33. *Horizon*, April 1947, quoted in Robert Hewison, *In Anger: Culture in the Cold War, 1945–60* (1981), p. 14; and see Randall Stevenson, *The British Novel since the Thirties: An Introduction* (1986), p. 116.

34. James Chapman, *Saints and Avengers: British Adventure Series of the 1960s* (2002), pp. 59–63; Kathleen Tracy, *Diana Rigg: The Biography* (2004), pp. 53–4.

35. Briggs, *History of Broadcasting in the United Kingdom*, p. 143; Steve Neale, 'Transatlantic Ventures and *Robin Hood*', in Catherine Johnson and Rob Turnock (eds.), *ITV Cultures: Independent Television over Fifty Years* (Maidenhead, 2005), pp. 73–82; James Chapman, '*The Adventures of Robin Hood* and the Origins of the Television Swashbuckler', *Media History*, 17:3 (2011), pp. 273–87; *News Chronicle*, 5 September 1956.

36. Chapman, *Saints and Avengers*, pp. 7–11, 52; Jeffrey S. Miller, *Something Completely Different: British Television and American Culture* (Minneapolis, MN, 2000), pp. 54–6.

37. Ibid., p. 56; Chapman, *Saints and Avengers*, p. 52.

38. Ibid., pp. 52, 77; 'Facts about the Programme and Its Stars', *c.* 1965, reproduced online at http://globalroadtrips.com/entertainment/avengers.html; Alexandra Harris, *Romantic Moderns: English Writers, Artists and the Imagination from Virginia Woolf to John Piper* (2010), pp. 37–8, 214–21.

39. 'Facts about the Programme and Its Stars'; Chapman, *Saints and Avengers*, pp. 76–7.

40. *Daily Express*, 14 May 1968; Chapman, *Saints and Avengers*, p. 93; *Guardian*, 13 November 2003; *Observer*, 22 March 2009.

41. Ian Fleming, *Octopussy and The Living Daylights* (1966: 2012), p. 30.

42. Matthew Parker, *Goldeneye: Where Bond Was Born: Ian Fleming's Jamaica* (2014), pp. 5–6, 55–56; Simon Winder, *The Man Who Saved Britain: A Personal Journey into the Disturbing World of James Bond* (2006), pp. 142–7; Ben Macintyre, *For Your Eyes Only: Ian Fleming and James Bond* (2008), pp. 162–3.

43. Andrew Lycett, *Ian Fleming* (1995), pp. 278–81, 322, 325, 328, 398; Parker, *Goldeneye*, pp. 48–9, 204, 273; Mark Binelli, 'Chris Blackwell: The Barefoot Mogul', *Men's Journal*, January 2014, http://www.mensjournal.com/magazine/chris-blackwell-the-barefoot-mogul-20140319.

44. Parker, *Goldeneye*, pp. 206–7; *Billboard*, 29 September 2001; *Daily Telegraph*, 8 May 2012.

45. Lycett, *Ian Fleming*, p. 280; Parker, *Goldeneye*, p. 207; *Billboard*, 29 September 2001; *Independent*, 1 May 2009; Binelli, 'Barefoot Mogul'.

46. *Daily Telegraph*, 20 May 2009; *Billboard*, 29 September 2001; Terry Lacey, *Violence and Politics in Jamaica 1960–70: Internal Security in a Developing Country* (Manchester, 1977), p. 12; Binelli, 'Barefoot Mogul'.

47. *Daily Telegraph*, 8 May 2012; *Independent*, 1 May 2009; Binelli, 'Barefoot Mogul'; and see the documentary *Keep on Running: 50 Years of Island Records* (BBC Four, 5 June 2009).

48. Colin Holmes, *John Bull's Island: Immigration and British Society, 1871–1971* (1988), p. 221; Sheila Patterson, *Dark Strangers: A Sociological Study of the Absorption of a Recent West Indian Migrant Group in Brixton, South London* (1963), p. 3; *Independent*, 1 May 2009; *Billboard*, 29 September 2001.

49. *Jamaica Gleaner*, 13 November 2013; *Independent*, 1 May 2009; Binelli, 'Barefoot Mogul'.

50. *Jamaica Gleaner*, 15 October 2006; Binelli, 'Barefoot Mogul'; *Billboard*, 29 September 2001.

51. Binelli, 'Barefoot Mogul'; *Billboard*, 29 September 2001; *Music Week*, 29 July 2007; *Independent*, 1 May 2009.

52. *Music Week*, 29 July 2007; *Independent*, 1 May 2009; *Daily Telegraph*, 20 May 2009.

53. *Guardian*, 9 August 1973, 13 March 1975; *Daily Express*, 20 November 1976; *Independent*, 1 May 2009; *Music Week*, 29 July 2007; Linton Kwesi Johnson, 'Roots and Rock: The Marley Enigma', *Race Today*, 7:10 (1975), pp. 237–8.

54. Binelli, 'Barefoot Mogul'; *New Musical Express*, 17 November 1984; David Katz, *People Funny Boy: The Genius of Lee 'Scratch' Perry* (rev. edn: 2006), pp. 362–3.

55. *Rolling Stone*, 18 February 1999; Binelli, 'Barefoot Mogul'; *Daily Telegraph*, 8 May 2012.

56. *The Times*, 2 August 1989; Binelli, 'Barefoot Mogul'; *Daily Telegraph*, 8 May 2012. For Goldeneye, see https://www.theflemingvilla.com.

57. *Music Week*, 9 April 2009. On the sugar barons, see Matthew Parker, *The Sugar Barons: Family, Corruption, Empire and War* (2011).

CHAPTER 3. SENSATION

1. John Hegarty, *Hegarty on Advertising: Turning Intelligence into Magic* (2011), pp. 126–7.

2. Winston Fletcher, *Powers of Persuasion: The Inside Story of British Advertising, 1951–2000* (Oxford, 2008), pp. 24, 99; J. B. Priestley and Jacquetta Hawkes, *Journey down a Rainbow* (1955), pp. 51–2; Raymond Williams, 'Culture Is Ordinary' (1958), reprinted in Raymond Williams, *Resources of Hope: Culture, Democracy, Socialism* (1989), p. 12.

3. Robert Hewison, *Too Much: Art and Society in the Sixties, 1960–1975* (1986), pp. 10–11; *New Statesman*, 26 January 1957; Fletcher, *Powers of Persuasion*, p. 99; James McMillan and Bernard Harris, *The American Take-Over of Britain* (1968), p. 183; Ivan Fallon, *The Brothers: The Rise and Rise of Saatchi and Saatchi* (1988), pp. 93–4.

4. Martin J. Wiener, *English Culture and the Decline of the Industrial Spirit, 1850–1980* (2nd edn: Cambridge, 2004), passim; Matthew Sweet, *Inventing the Victorians* (2001), pp. 43–5, 48, 52; Gillian Dyer, *Advertising as Communication* (1982), p. 31; Fletcher, *Powers of Persuasion*, pp. 13–14, 18.

5. Joe Moran, *Armchair Nation: An Intimate History of Britain in Front of the TV* (2013), pp. 105–6; Fletcher, *Powers of Persuasion*, p. 35; Hegarty, *Hegarty on Advertising*, pp. 116–18.

6. Fletcher, *Powers of Persuasion*, pp. 127–8.

7. Hegarty, *Hegarty on Advertising*, pp. 15, 22; Sam Delaney, *Get Smashed: The Story of the Men Who Made the Adverts That Changed Our Lives* (2007), p. 111; the Puttnam quotation comes from the documentary *The Men from the Agency* (BBC Four, 6 January 2003).

8. *Independent*, 5 June 2004 (David Puttnam's obituary of Colin Millward); Delaney, *Get Smashed*, pp. 58–9; Fletcher, *Powers of Persuasion*, pp. 71–2; Fallon, *Brothers*, p. 51. The 'shop window' line comes from the documentary *The Men from the Agency*.

9. Fletcher, *Powers of Persuasion*, p. 33; Hegarty, *Hegarty on Advertising*, pp. 97, 99; Fallon, *Brothers*, pp. 89–90, 254.

10. *Sunday Telegraph*, 19 October 1969, and *Daily Mail*, 27 November 1969, both quoted in James Chapman, *Saints and Avengers: British Adventure Series of the 1960s* (2002), p. 14; 'The Jean Varon Avengers Collection', *c.* 1965, reproduced online at http://globalroadtrips.com/entertainment/avengers.html.

11. Delaney, *Get Smashed*, p. 121; Anthony Hayward, *Which Side Are You On? Ken Loach and His Films* (2004), p. 200; Alexander Walker, *Hollywood, England: The British Film Industry in the Sixties* (1974), pp. 221–42; *Observer*, 7 August 1966, quoted in George Melly, *Revolt into Style: The Pop Arts in Britain* (1970), pp. 190–91.

12. Delaney, *Get Smashed*, pp. 91–5, 97, 99; Laurence F. Knapp and Andrea Kulas (eds.), *Ridley Scott: Interviews* (Jackson, MS, 2005), pp. 4–5, 48, 172–8; Alexander Walker, *National Heroes: British Cinema in the Seventies and Eighties* (1985), p. 89.

13. *The Times*, 6 June 1985; *Observer*, 4 March 1984; Delaney, *Get Smashed*, pp. 123, 131–2, 137.

14. Walker, *National Heroes*, pp. 173–5; *Daily Mail*, 14 July 2012.

15. Walker, *National Heroes*, pp. 178–9; James Chapman, *Past and Present: National Identity and the British Historical Film* (2005), pp. 291–3. On Hudson's debt to advertising, see also *The Times*, 23 March 1982.

16. *The Times*, 31 March 1982, 27 January 1982.

17. *Sun*, 19 September 2008; *The Age* (Melbourne), 2 July 2006; *The Australian*, 14 April 2012; *Observer*, 20 April 2003.

18. *Independent*, 10 March 1992, 15 August 1998; Julian Stallabrass, *High Art Lite: The Rise and Fall of Young British Art* (rev. edn: 2006), pp. 19–20; Sarah Kent, *Shark Infested Waters: The Saatchi Collection of British Art in the 90s* (1994), p. 37.

19. *Observer*, 20 April 2003.

20. Fallon, *Brothers*, pp. 176, 179, 404, 407, 412; R. W. Walker, 'The Saatchi Factor', *Art News*, 86:1 (1987), pp. 117–21, quoted in Rita Hatton and John A. Walker, *Supercollector: A Critique of Charles Saatchi* (2000), p. 9.

21. *Guardian*, 6 October 2001, 7 December 1998; Hatton and Walker, *Supercollector*, pp. 18, 158; *The Times*, 13 September 1997; Stallabrass, *High Art Lite*, pp. 204–7; and see Richard Shone, 'From *Freeze* to *House*: 1988–94', in Norman Rosenthal et al., *Sensation: Young British Artists from the Saatchi Collection* (1997), pp. 12–25.

22. *London Review of Books*, 21 March 1985; Lisa Jardine, 'Modern Medicis: Art Patronage in the Twentieth Century in Britain', in Rosenthal et al., *Sensation*, p. 41; Richard Marks, *Burrell: A Portrait of a Collector: Sir William Burrell 1861–1958* (rev. edn: Glasgow, 1988), pp. 18–19.

23. Nick Clarke, *The Shadow of a Nation: The Changing Face of Britain* (2003), p. 111; Anthony Trollope, *The Way We Live Now* (1875: Ware, 2001), p. 27; Charles Dickens, *Little Dorrit* (1857: Oxford, 1953), p. 246; and see David Newsome, *The Victorian World Picture: Perceptions and Introspections in an Age of Change* (1997), p. 78.

24. Stallabrass, *High Art Lite*, pp. 209, 214, 217; Hatton and Walker, *Supercollector*, pp. 187–9, 192; *Daily Mail*, 20 September 1997.

25. Norman Rosenthal, 'The Blood Must Continue to Flow', in Rosenthal et al., *Sensation*, p. 8; Sweet, *Inventing the Victorians*, pp. 4, 7; Brooks Adams, 'Thinking of You: An American's Growing, Imperfect Awareness', in Rosenthal et al., *Sensation*, p. 38; *Independent*, 20 September 1997; Simon Heffer, *High Minds: The Victorians and the Birth of Modern Britain* (2013), pp. 341–2; *Independent*, 31 August 2007.

26. *Evening Standard*, 23 October 1998; Hatton and Walker, *Supercollector*, p. 171; John Carey, *What Good Are the Arts?* (2005), pp. 26–7; *New Statesman*, 21 January 2002.

27. Craig Brown, *The Tony Years* (2006), pp. 222, 228–9.

28. *Independent*, 13 July 1990; Stallabrass, *High Art Lite*, pp. 53–4, 191, 193; Shone, 'From *Freeze* to *House*', pp. 17–19; *London Review of Books*, 9 October 2008; Adrian Searle, 'Shut That Door', *Frieze*, no. 11 (1993), p. 49, quoted in Stallabrass, *High Art Lite*, p. 19.

29. Julian Stallabrass, *Contemporary Art: A Very Short Introduction* (Oxford, 2006), p. 93; Stallabrass, *High Art Lite*, p. 133; Clarke, *Shadow of a Nation*, p. 118; *Dazed and Confused*, September 1997, quoted in *London Review of Books*, 30 October 1997; Hatton and Walker, *Supercollector*, pp. 19, 56.

30. *Observer*, 11 March 2012; *Independent*, 20 September 1997, 15 August 1998; *London Review of Books*, 9 October 2008; Stallabrass, *High Art Lite*, pp. 28, 30.

31. *London Review of Books*, 9 October 2008; *Daily Telegraph*, 16 September 2008; Felix Salmon, 'When Plutocrats Collect Artists', 3 February 2011, http://blogs.reuters.com/felix-salmon/2011/02/03/when-plutocrats-collect-artists/; *Observer*, 11 March 2012; *Daily Mail*, 17 August 2014; Stallabrass, *High Art Lite*, p. 31.

32. Sweet, *Inventing the Victorians*, p. 39; Fletcher, *Powers of Persuasion*, p. 13; Marie Corelli, *The Sorrows of Satan* (1895), pp. 80–81; Julia Kuehn, 'John Everett Millais's *Bubbles* and the Commercialization of Art', http://www.victorianweb.org/authors/corelli/kuehn6.html; Malcolm Warner, 'Millais, Sir John Everett', *Oxford Dictionary of National Biography*, http://www.oxforddnb.com/view/article/18713.

33. *London Review of Books*, 21 March 1985 (Januszczak), 30 October 1997 (Wollen); Stallabrass, *High Art Lite*, pp. 57, 180; Clarke, *Shadow of a Nation*, pp. 113–14; Hatton and Walker, *Supercollector*, pp. 229, 235; *Sunday Telegraph*, 23 March 1997.

34. Stallabrass, *High Art Lite*, pp. 237–8.

35. *The Times*, 5 October 1995; John Harris, *The Last Party: Britpop, Blair and the Demise of English Rock* (2003), pp. 101, 303, 273.

36. *Guardian*, 2 May 2007; *London Review of Books*, 26 September 1997.

37. Stallabrass, *High Art Lite*, pp. 198–203; 'Cool Britannia Hits the Street', 3 April 1998, http://news.bbc.co.uk/1/hi/special_report/1998/04/98/powerhouse/72853.stm; Hansard, 5 May 1998; Chris Smith, *Creative Britain* (1998), pp. 54–5.

38. *Independent*, 29 August 1999; 'Art Award under Fire', 14 November 1999, http://news.bbc.co.uk/1/hi/entertainment/519426.stm; *Guardian*, 30 May 2001; Stallabrass, *High Art Lite*, p. 11.

39. *Guardian*, 29 July 2014; *Telegraph*, 20 October 1999; Craig Brown, *This Is Craig Brown* (2003), pp. 210–13.

40. Hansard, 20 May 1997.

41. David Kushner, *Jacked: The Unauthorised Behind-the-Scenes Story of 'Grand Theft Auto'* (2012), pp. 39–41; Magnus Anderson and Rebecca Levene, *Grand Thieves and Tomb Raiders: How British Video Games Conquered the World* (2012), pp. 273–4.

42. *Daily Mail*, 24 November 1997; *News of the World*, 23 November 1997; Hansard, 13 January 1998.

43. *Music Week*, 2 January 2014; *Guardian*, 17 March 2006; 'PM Boasts UK Games Industry Is "Leading the Way" in Europe', 23 February 2010, http://www.gamesindustry.biz/articles/gordon-brown-boasts-uk-games-industry-is-leading-the-way-in-europe; 'Fighting for Your Future', 1 May 2010, http://www2.labour.org.uk/gordon-brown---fighting-for-your-future,2010-05-01.

44. *Guardian*, 27 December 1980, 15 January 1981; *The Times*, 29 November 1980, 14 January 1981, 22 January 1982, 7 March 1983.

45. Hansard, 20 May 1981; *Guardian*, 21 May 1981.

46. *The Times*, 29 January 1973; Sir Keith Joseph, 'Micro-Electronics', 8 June 1979, PREM 19/269, The National Archives (TNA); John Biffen, 'Micro-Electronics', 2 July 1979, PREM 19/269, TNA; 'Speech to Conservative Central Council', 26 March 1983, Margaret Thatcher Foundation, http://www.margaretthatcher.org/document/105285; 'Speech Presenting Computers to Portuguese Schools', 18 April 1984, Margaret Thatcher Foundation, http://www.margaretthatcher.org/document/105663.

47. *The Times*, 11 February 1980, 7 September 1982.

48. Anderson and Levene, *Grand Thieves and Tomb Raiders*, pp. 46–9, 52–6; *The Times*, 7 September 1982; Francis Spufford, *Backroom Boys: The Secret Return of the British Boffin* (2003), p. 75; 'Gaikai and Sony: Ladies and Gentlemen, Mr David Perry', 20 July 2012, http://www.eurogamer.net/articles/2012-07-20-gaikai-and-sony-ladies-and-gentlemen-mr-david-perry.

49. Spufford, *Backroom Boys*, pp. 75–6, 79; Anderson and Levene, *Grand Thieves and Tomb Raiders*, pp. 60, 67, 71.

50. See Spufford, *Backroom Boys*, pp. 87–101; the quotations are from p. 97.

51. Ibid., pp. 95, 109, 115; Anderson and Levene, *Grand Thieves and Tomb Raiders*, pp. 110, 120–22; for sales figures, see http://wouter.bbcmicro.net/bbc/elite.html, which seems pretty definitive.

52. Anderson and Levene, *Grand Thieves and Tomb Raiders*, pp. 122, 136–7, 170–71, 182; *Guardian*, 4 June 2014; Dave Lee, 'How No Man's Sky Took on the Games Industry – and Won', 12 June 2014, http://www.bbc.co.uk/news/technology-27807167. For *Fable*'s sales figures, see http://www.vgchartz.com.

53. *Scotsman*, 19 January 2013; William Walker Knox and Alan McKinlay, 'The Union Makes Us Strong? Work and Trade Unionism in Timex, 1946–83', in Jim Tomlinson and Christopher A. Whatley (eds.), *Jute No More:*

Transforming Dundee (Dundee, 2011), pp. 266–90; *Herald* (Glasgow), 20 May 1995; *Courier* (Dundee), 19 August 2010; Anderson and Levene, *Grand Thieves and Tomb Raiders*, pp. 158–9.

54. *Herald* (Glasgow), 20 May 1995; Anderson and Levene, *Grand Thieves and Tomb Raiders*, pp. 159–60, 164–5, 170–71; Kushner, *Jacked*, pp. 23–5; *Scotsman*, 20 December 1996; and see Dave Jones's and Mike Dailly's memoirs of their early days at http://www.dmadesign.net/about and http://www.dmadesign.org, respectively.

55. *Scotsman*, 4 May 1994, 20 December 1996; *Herald* (Glasgow), 20 May 1995; Anderson and Levene, *Grand Thieves and Tomb Raiders*, pp. 270–71; interview with David Braben, 6 November 2012, at http://www.nowgamer.com/features/1667359/elite_dangerous_david_braben_interview.html.

56. Kushner, *Jacked*, pp. 54, 68, 72–3; Anderson and Levene, *Grand Thieves and Tomb Raiders*, pp. 280–82; *Guardian*, 18 November 2012; *The List*, 8 November 2012.

57. Kushner, *Jacked*, pp. 2, 260, 270; Anderson and Levene, *Grand Thieves and Tomb Raiders*, pp. 283, 285; interview with Dan Houser, 27 December 2012, at http://www.stuff.co.nz/technology/games/8122020/Meet-the-brains-behind-Grand-Theft-Auto; Dave Lee, 'Grand Theft Auto: One of Britain's Finest Cultural Exports?', 17 September 2013, http://www.bbc.co.uk/news/technology-24066068; *Guardian*, 7 September 2013; 'NaturalMotion: From Neural Research to *Grand Theft Auto*', http://www.zoo.ox.ac.uk/impact/naturalmotion/.

58. Dave Thier, '"Grand Theft Auto 5" Has Sold Nearly $2 Billion', 13 May 2014, http://www.forbes.com/sites/davidthier/2014/05/13/grand-theft-auto-5-has-sold-nearly-2-billion-at-retail/; Johnny Minkley, 'Cameron Opens Accessible Gaming Centre', 10 March 2011, http://www.eurogamer.net/articles/2011-03-10-cameron-opens-accessible-gaming-centre.

59. DC Research, 'Economic Contribution Study: An Approach to the Economic Assessment of the Arts & Creative Industries in Scotland', Final Report, June 2012, http://www.creativescotland.com/__data/assets/pdf_file/0010/21403/ECS-Final-Report-June-2012.pdf; 'Scotland's Games Industry Adds "No Value" Suggests Study', 7 September 2012, http://www.bbc.co.uk/news/uk-scotland-tayside-central-19517306.

60. *Guardian*, 17 March 2006; and see the full list at http://www.bbc.co.uk/pressoffice/pressreleases/stories/2006/03_march/16/design.shtml.

CHAPTER 4. ENCHANTED GARDENS

1. Keith Richards, *Life* (2010), pp. 208–9; Philip Norman, *The Stones* (1984), pp. 176–7; Bill Wyman, *Stone Alone: The Story of a Rock 'n' Roll Band*

(1990), pp. 484–5; *Daily Express*, 11 May 1967. For the police's version of events, see *Guardian*, 15 August 2000.

2. The polls are quoted in Peter Thompson, 'Labour's "Gannex Conscience"? Politics and Popular Attitudes in the "Permissive Society"', in Richard Coopey, Steven Fielding and Nick Tiratsoo (eds.), *The Wilson Governments, 1964–70* (1993), p. 143; Mark Paytress, *The Rolling Stones: Off the Record* (2003), p. 139. For more on this, see my book *White Heat: A History of Britain in the Swinging Sixties* (2006), ch. 26.

3. *Guardian*, 15 August 2000; Harriet Vyner, *Groovy Bob: The Life and Times of Robert Fraser* (1999), pp. 164–5.

4. *Daily Mirror*, 20 February 1967, 30 June 1967, 5 July 1967; Wyman, *Stone Alone*, p. 562. On Block and the trial, see Simon Wells, *Butterfly on a Wheel: The Great Rolling Stones Drugs Bust* (2011).

5. Richards, *Life*, pp. 187–8; Wyman, *Stone Alone*, p. 440.

6. Sue Mautner, 'Sue Mautner Takes You Round Keith's House', in Sean Egan (ed.), *Keith Richards on Keith Richards: Interviews and Encounters* (Chicago, IL, 2013), pp. 9–12.

7. Richards, *Life*, pp. 34, 37; Norman, *The Stones*, pp. 36–7; Wyman, *Stone Alone*, pp. 41–2, 52, 56, 58.

8. Wyman, *Stone Alone*, p. 385; Norman, *The Stones*, pp. 124, 157; Richards, *Life*, pp. 201–2; Shawn Levy, *Ready, Steady, Go! Swinging London and the Invention of Cool* (2002), pp. 68, 202. The *Express* quotation, which I have been unable to track down, comes from Norman, *The Stones*, p. 124.

9. Levy, *Ready, Steady, Go!*, pp. 23, 68; Wyman, *Stone Alone*, p. 572.

10. Ibid., pp. 506, 514, 592; Norman, *The Stones*, pp. 254–6, 158–9.

11. Wyman, *Stone Alone*, pp. 385–6, 590–91, 603; *Forbes*, 10 September 2011.

12. Barry Miles, *Paul McCartney: Many Years from Now* (1997), pp. 167–70; Philip Norman, *Shout! The True Story of the Beatles* (1993), pp. 235, 266, 326.

13. Miles, *Paul McCartney*, pp. 104–5, 106, 118, 254, 256–7; Norman, *Shout!*, pp. 266–7.

14. Barney Hoskyns, *Trampled under Foot: The Power and Excess of Led Zeppelin: An Oral Biography of the World's Mightiest Rock 'n' Roll Band* (2012), p. 237; Tony Iommi, *Iron Man: My Journey through Heaven and Hell with Black Sabbath* (2011), p. 122. On the model of the Matterhorn at Harrison's house, see *Observer*, 17 August 2008.

15. Iommi, *Iron Man*, pp. 120, 122; for the history of Kilworth, see http://www.kilworthhouse.co.uk/about/history.

16. David Frost and Antony Jay, *To England with Love* (1967), p. 85; Martin J. Wiener, *English Culture and the Decline of the Industrial Spirit, 1850–1980* (2nd edn: Cambridge, 2004), pp. 11–13; David Newsome, *The Victorian World Picture: Perceptions and Introspections in an Age of Change* (1997), pp. 241–2.

17. *Daily Telegraph*, 28 May 2013.

18. *How to Spend It (Financial Times)*, 24 May 2010; *Evening Standard*, 21 March 2013.

19. Claire Tomalin, *Charles Dickens: A Life* (2011), pp. 13, 258, 264, 280.

20. David Gilmour, *The Long Recessional: The Imperial Life of Rudyard Kipling* (2002), pp. 167–9.

21. Brooklyn Museum, *The American Renaissance, 1876–1917* (New York, 1979), p. 37; National Trust, 'National Trust: Annual Report 2012/13', p. 14, http://www.nationaltrust.org.uk/document-1355802006974/; Peter Mandler, *The Fall and Rise of the Stately Home* (New Haven, CT, 1997), p. 1. See also the excellent essay by Blake Morrison in the *Guardian*, 11 June 2011.

22. *Guardian*, 27 September 2010; *New York Times*, 3 January 2013.

23. *Sunday Times*, 25 September 2011; *Newsweek*, 16 January 2012; *Vanity Fair*, December 2012; *New York Review of Books*, 8 March 2012.

24. Lucy Lethbridge, *Servants: A Downstairs View of Twentieth-Century Britain* (2013), pp. 71, 72, 67, 117, 167.

25. *Vanity Fair*, December 2012; Julian Fellowes, *Past Imperfect* (2008), p. 12; *Daily Telegraph*, 13 December 2011.

26. *Daily Telegraph*, 20 September 2010.

27. *London Review of Books*, 21 June 2012; and see also the perceptive essay by Carina Chocano in the *New York Times Magazine*, 17 February 2012.

28. Robert McCrum, *Wodehouse: A Life* (2005), pp. 71, 93, 123, 116–17, 402; P. G. Wodehouse, *Something Fresh* (1915: 2008), pp. 44, 108.

29. Evelyn Waugh, *Brideshead Revisited* (1945: 1962), pp. 7, 77; Martin Stannard, *Evelyn Waugh: No Abiding City, 1939–1966* (1992), p. 148.

30. 'Fawlty Towers Tops TV Hits', 5 September 2000, http://news.bbc.co.uk/1/hi/entertainment/911085.stm; *Guardian*, 12 January 2010; *The Times*, 23 March 1966, 25 March 1966, 12 September 1968, 17 September 1968.

31. *The Times*, 19 February 1969, 1 March 1969, 6 March 1969, 7 March 1969.

32. *The Times*, 23 September 1981; and see Charles Sturridge, *The Making of Brideshead: A Note from the Director*, which accompanies the Acorn DVD release of *Brideshead Revisited* (2002).

33. *The Times*, 23 September 1981, 13 October 1981, 15 October 1981, 17 October 1981; *Guardian*, 13 October 1981, 25 November 1981, 24 December 1981; *Daily Express*, 22 December 1981.

34. *The Times*, 27 December 1979.

35. *Writers' Monthly*, March 1987, http://homepages.which.net/~roger.still/MarlburyEcho.htm.

36. Mandler, *Fall and Rise of the Stately Home*, pp. 312–15, 351, 383, 390, 411; *Daily Express*, 19 June 1953; National Trust, 'Fascinating Facts and Figures', http://www.nationaltrust.org.uk/what-we-do/who-we-are/fascinating-facts-and-figures/.

37. *Guardian*, 11 June 2011; Lev Grossman, 'The Tragedy of the English Country House', *Time*, 2 May 2012, http://entertainment.time.com/2012/05/02/the-tragedy-of-the-english-country-house/; Susannah Hunnewell, 'Kazuo Ishiguro: The Art of Fiction No. 196', *The Paris Review*, no. 184 (2004), http://www.theparisreview.org/interviews/5829/the-art-of-fiction-no-196-kazuo-ishiguro.

38. Grossman, 'Tragedy of the English Country House'; Waugh, *Brideshead Revisited*, pp. 36–7, 39, 331.

39. A. S. Byatt, *The Children's Book* (2009), pp. 17–20; Ian McEwan, *Atonement* (2001), pp. 19, 91–2; L. P. Hartley, *The Go-Between* (1953: 1958), pp. 32–3, 40–41.

40. *Guardian*, 12 August 2011; *Mail and Guardian* (Johannesburg), 21 September 2012; Alan Hollinghurst, *The Line of Beauty* (2004), pp. 4, 48, 51; Waugh, *Brideshead Revisited*, p. 78.

41. Ibid., pp. 46, 76; Hartley, *Go-Between*, pp. 49, 51; Hollinghurst, *Line of Beauty*, p. 5.

42. Alan Hollinghurst, *The Stranger's Child* (2011), p. 341; Waugh, *Brideshead Revisited*, p. 32.

43. Ibid., p. 127; Hartley, *Go-Between*, pp. 166–7; Hollinghurst, *Line of Beauty*, pp. 479, 480, 482.

44. Ibid., p. 490; Waugh, *Brideshead Revisited*, pp. 23, 285; Hartley, *Go-Between*, pp. 252, 256; McEwan, *Atonement*, pp. 64, 90, 182.

45. Ishiguro, *The Remains of the Day* (1989), pp. 7–8; Waugh, *Brideshead Revisited*, pp. 326–7, 330–31.

CHAPTER 5. GOD SAVE THE QUEEN

1. Christopher Hibbert, *Queen Victoria: A Personal History* (2000), pp. 457–8; *The Times*, 23 June 1897.

2. *Sun*, 8 May 2010.

3. *Manchester Evening News*, 5 June 2012; 'Stars Gather Backstage at Jubilee Concert', 4 June 2012, http://www.bbc.co.uk/news/entertainment-arts-18324078.

4. *Mail on Sunday*, 10 June 2012; *Guardian*, 8 June 2012, 24 May 2012; *Daily Telegraph*, 18 May 2012.

5. *Guardian*, 5 June 2012.

6. See Tim Blanning, *The Triumph of Music: Composers, Musicians and Their Audiences, 1700 to the Present* (2008), chs. 1 and 2.

7. Adam Faith, *Poor Me: A Candid Self-Portrait* (1961), pp. 45–6, 79–81; Philip Norman, *Shout! The True Story of the Beatles* (1993), p. 191; *New Musical Express*, 7 May 1977.

8. Jon Savage, *England's Dreaming: Sex Pistols and Punk Rock* (rev. edn: 2005), pp. 314–15, 348–9, 364–5. For chart data, see www.everyhit.com and www.officialcharts.com.

9. *Guardian*, 15 September 1997, 4 November 2012; *Billboard*, 31 January 1998; *New York Times*, 24 September 1997.

10. *Observer*, 7 September 1997; *Spectator*, 13 September 1997; *Guardian*, 5 September 1997, 6 September 1997.

11. *Spectator*, 13 September 1997; *New Statesman*, 12 September 1997.

12. Mark Duffett, 'A "Strange Blooding in the Ways of Popular Culture"? *Party at the Palace* as Hegemonic Project', *Popular Music and Society*, 27:4 (2004), p. 490; 'McCartney and John Top Jubilee Gig', 26 February 2002, http://news.bbc.co.uk/1/hi/entertainment/1841657.stm.

13. *Guardian*, 4 June 2002; *Daily Mirror*, 4 June 2002; *Sunday Express*, 2 June 2002; Duffett, 'A "Strange Blooding in the Ways of Popular Culture"?', pp. 497–8; Tony Iommi, *Iron Man: My Journey through Heaven and Hell with Black Sabbath* (2011), pp. 334–5.

14. Duffett, 'A "Strange Blooding in the Ways of Popular Culture"?', pp. 495, 500–501; *Guardian*, 4 June 2002; *Scotsman*, 6 June 2002; *Sun*, 18 November 2010.

15. Mark Easton, 'Why Does the UK Love the Monarchy?', 29 May 2012, http://www.bbc.co.uk/news/uk-18237280.

16. *The Economist*, 17 October 2012; *Independent*, 10 January 2014.

17. T. A. Shippey, *The Road to Middle-Earth* (1982), p. 155; T. A. Shippey, *J. R. R. Tolkien: Author of the Century* (2000), pp. 172–4.

18. J. R. R. Tolkien, *The Lord of the Rings* (1955: 2012), pp. 156, 170, 393, 433, 968.

19. See Judy Anne Ford and Robin Anne Reid, 'Councils and Kings: Aragorn's Journey towards Kingship in J. R. R. Tolkien's *The Lord of the Rings* and Peter Jackson's *The Lord of the Rings*', *Tolkien Studies*, 6 (2009), pp. 71–90.

20. E. L. Risden, 'Aragorn and the Twentieth Century Arthur', http://www.lotrplaza.com/showthread.php?22873-Aragorn-and-the-Twentieth-Century-Arthur-Risden; Richard J. Finn, 'Arthur and Aragorn: Arthurian Influences in *The Lord of the Rings*', *Mallorn*, 43 (2005), pp. 23–6.

21. Humphrey Carpenter (ed.), *The Letters of J. R. R. Tolkien* (1981), p. 144; J. R. R. Tolkien, *The Fall of Arthur* (2013), pp. 20, 24, 88; *New York Times*, 21 June 2013; *Times Literary Supplement*, 26 June 2013; Richard Overy, *The Morbid Age: Britain between the Wars* (2009).

22. Meredith Veldman, *Fantasy, the Bomb and the Greening of Britain: Romantic Protest, 1945–1980* (Cambridge, 1994), pp. 14, 17, 21; Alice Chandler, 'Sir Walter Scott and the Medieval Revival,' *Nineteenth-Century Fiction*, 19:4 (1965), pp. 315–32; Thomas Carlyle, *On Heroes, Hero-Worship and the*

Heroic in History (1841), p. 316; and see Beverly Taylor and Elisabeth Brewer, *The Return of King Arthur: British and American Arthurian Literature since 1800* (Cambridge, 1983), chs. 1–5.

23. Fiona MacCarthy, *The Last Pre-Raphaelite: Edward Burne-Jones and the Victorian Imagination* (2011), pp. 55–7, 473–5; Stephen Wildman and John Christian, *Edward Burne-Jones: Victorian Artist-Dreamer* (New York, 1998), p. 316; and see Fiona MacCarthy's excellent essay on *The Sleep of Arthur in Avalon* in the *Guardian*, 17 May 2008.

24. Elisabeth Brewer, *T. H. White's 'The Once and Future King'* (Cambridge, 1993), pp. 17–18; François Gallix (ed.), *Letters to a Friend: The Correspondence between T. H. White and L. J. Potts* (New York, 1982), pp. 93–4.

25. C. M. Adderley, 'The Best Thing for Being Sad: Education and Educators in T. H. White's *The Once and Future King*', *Quondam et Futurus*, 2:1 (1992), pp. 55–6; 'T. H. White in Alderney', *Monitor* (BBC TV, 13 September 1959), http://www.bbc.co.uk/programmes/p015g2rv; *New York Times*, 21 April 1968, 10 September 1982; and see Sylvia Townsend Warner, *T. H. White: A Biography* (1967).

26. T. H. White, *The Once and Future King* (1958: 1996), p. 222. One of the problems of writing about *The Once and Future King* is that there are numerous different editions, some of them sticking to White's original versions, others incorporating his later revisions. I am using the version most commonly available in Britain today, published by Voyager/HarperCollins.

27. White, *Once and Future King*, pp. 4, 27, 35, 38, 78, 179, 181, 206, 684–6, 696; Brewer, *T. H. White's 'The Once and Future King'*, p. 41.

28. White, *Once and Future King*, pp. 136–7, 284; 'T. H. White in Alderney'; Patrick Wright, *On Living in an Old Country: The National Past in Contemporary Britain* (rev. edn: Oxford, 2009), pp. 96, 274; T. H. White, *England Have My Bones* (1936: 1981), p. 194.

29. The final screenplay of *The King's Speech* is at http://www.pages.drexel.edu/~ina22/splaylib/Screenplay-Kings_Speech_The.pdf. The earlier draft, dated 17 September 2008, is at http://www.imsdb.com/scripts/King's-Speech,-The.html.

30. J. K. Rowling, *Harry Potter and the Philosopher's Stone* (1997: 2014), p. 9; *Guardian*, 22 July 2008. There are interesting online essays about the Potter–Arthur parallels by Phyllis D. Morris ('Elements of the Arthurian Tradition in *Harry Potter*') and Denise O'Donoghue ('Arthurian Influence in *The Lord of the Rings* and *Harry Potter*') at, respectively, http://www.harrypotterforseekers.com/articles/elementsofarthur.php and http://heroesinhypertext.wordpress.com/cultural-remediation-film/arthurian-influence-in-the-lord-of-the-rings-and-harry-potter/.

31. Sigmund Freud, 'Family Romances', in James Strachey et al. (ed. and trans.), *Complete Psychological Works of Sigmund Freud*, vol. 9: *1906–1908*:

Jensen's 'Gradiva' and Other Works (1959), pp. 235–44; White, *Once and Future King*, p. 8; Rowling, *Harry Potter and the Philosopher's Stone*, pp. 31, 14. On the Freudian principles behind the Potter stories, see Alison Lurie's essay in the *New York Review of Books*, 16 December 1999, as well as Wendy Doniger's piece in the *London Review of Books*, 17 February 2000.

32. *Observer*, 25 June 2000; *London Review of Books*, 17 February 2000. On Rowling's debts to Tolkien and Lewis, see John Granger, 'Tolkien and Rowling: A Case for "Text Only"', http://www.hogwartsprofessor.com/ tolkien-and-rowling-a-case-for-text-only/. Rowling's remarks about C. S. Lewis are from *The Australian*, 7 November 1998, reproduced at http:// www.accio-quote.org/articles/1998/1198-australian-blakeney.html.

33. 'T. H. White in Alderney'; *Book-of-the-Month-Club News*, c. 1939, reproduced at http://www2.netdoor.com/~moulder/thwhite/tsits_b.html.

CHAPTER 6. BILLY BUNTER ON BROOMSTICKS

1. Jeffrey Richards, *Happiest Days: The Public Schools in English Fiction* (Manchester, 1988), pp. 27–9; Charlotte Mitchell, 'Hughes, Thomas', *Oxford Dictionary of National Biography*, http://www.oxforddnb.com/ view/article/14091; and see Kathryn Hughes's excellent article in the *Guardian*, 20 September 2008.

2. Thomas Hughes, *Tom Brown's School Days* (1857: 2013), p. 19. For Hughes's defence of 'preaching', see the preface in the Tauchnitz edition (Leipzig, 1858), p. xii.

3. Hughes, *Tom Brown's School Days*, p. 310.

4. Richards, *Happiest Days*, p. 26; Hughes, *Tom Brown's School Days*, pp. 187–8.

5. *Guardian*, 20 September 2008; Hughes, *Tom Brown's School Days*, p. 137.

6. Richards, *Happiest Days*, pp. 23, 55, 61; Jonathan Rose, *The Intellectual Life of the British Working Classes* (2nd edn: New Haven, CT, 2010), p. 232; Edward C. Mack, *Public Schools and British Public Opinion since 1860* (New York, 1941), p. 202; *Manchester Evening News*, 19 February 2007.

7. George Orwell, 'Boys' Weeklies', *Horizon*, March 1940, http://theorwellprize. co.uk/george-orwell/by-orwell/essays-and-other-works/boys-weeklies/; Rose, *Intellectual Life of the British Working Classes*, pp. 322–3; Richards, *Happiest Days*, p. 105.

8. Martin J. Wiener, *English Culture and the Decline of the Industrial Spirit, 1850–1980* (2nd edn: Cambridge, 2004), pp. 17, 21; Richards, *Happiest Days*, pp. 8, 300.

9. Frederick Willis, *Peace and Dripping Toast* (1950), pp. 56–7; and see Rose, *Intellectual Life of the British Working Classes*, pp. 322–4.

10. Orwell, 'Boys' Weeklies'.

11. 'Frank Richards Replies to George Orwell', *Horizon*, May 1940, pp. 346–55; this is also reproduced online at http://www.friardale.co.uk/Ephemera/Newspapers/George%20Orwell_Horizon_Reply.pdf.

12. E. S. Turner, *Boys Will Be Boys: The Story of Sweeney Todd, Deadwood Dick, Sexton Blake, Billy Bunter, Dick Barton et al.* (3rd edn: 1976), pp. 218, 235; Richards, *Happiest Days*, pp. 267–9.

13. Frank Richards, 'The Making of Harry Wharton', *Magnet*, 15 February 1908. Like the other Greyfriars stories cited below, this first tale is reproduced online at the Friardale website, http://www.friardale.co.uk/Magnet/Magnet.htm, where I have wasted – sorry, spent – entire days enjoying the adventures of the Fat Owl. The Friardale website is a fantastic resource, and much of what follows is based on its archives.

14. Ibid.; Richards, *Happiest Days*, p. 272; Orwell, 'Boys' Weeklies'; Turner, *Boys Will Be Boys*, pp. 222–3. For Bunter's increasing prominence, see the *Magnet* covers and extracts at http://www.friardale.co.uk/Magnet/Magnet.htm.

15. Frank Richards, *Billy Bunter of Greyfriars School* (1947), chs. 37 and 38, online at http://www.friardale.co.uk/Cassell/Cassell.htm; Richards, *Happiest Days*, pp. 272–3.

16. Frank Richards, 'A Lad from Lancashire', *Magnet*, 19 December 1908.

17. Richards, *Happiest Days*, p. 288; Turner, *Boys Will Be Boys*, p. 225; Frank Richards, *Billy Bunter among the Cannibals* (1950), online at http://www.friardale.co.uk/Cassell/Cassell.htm; Frank Richards, *The Autobiography of Frank Richards* (1952: 1962), p. 38; Frank Richards, 'The Yankee Schoolboy', *Magnet*, 24 December 1910. The quotation from Hurree Jamset Ram Singh comes from *Billy Bunter's Banknote* (1948), online at http://www.friardale.co.uk/Cassell/Cassell.htm.

18. Richards, *Happiest Days*, pp. 272–3; Richards, *Billy Bunter of Greyfriars School*, ch. 7.

19. Orwell, 'Boys' Weeklies'; Richards, *Happiest Days*, pp. 270–71, 289, 291–3; Rose, *Intellectual Life of the British Working Classes*, p. 330; V. S. Pritchett, *A Cab at the Door* (1968), pp. 109–10, 113–14.

20. Rose, *Intellectual Life of the British Working Classes*, pp. 323–5, 328–9; Nicklaus Thomas-Symonds, *Nye: The Political Life of Aneurin Bevan* (2015), p. 19.

21. Richards, *Happiest Days*, p. 293; Robert Roberts, *The Classic Slum: Salford Life in the First Quarter of the Century* (1971: 1990), pp. 160–61; 'Rowling Lauded for "Moral" Books', 26 October 2003, http://news.bbc.co.uk/1/hi/entertainment/3215099.stm.

22. Frank Richards, 'The Shadow of the Sack', *Magnet*, 18 May 1940. The editor's note is on the inside cover of the same issue.

23. *Picture Post*, 11 May 1946 (there is a scan online at http://www.friardale.co.uk/Cassell/Cassell.htm); Richards, *Happiest Days*, pp. 270–71; Turner, *Boys Will Be Boys*, p. 235; *Daily Mirror*, 4 December 1951; W. O. G. Lofts and D. J. Adley, *The World of Frank Richards* (1975), pp. 149–50.

24. *Guardian*, 29 June 2004; *Independent*, 29 June 2004.

25. Anthony Buckeridge, *Jennings Goes to School* (1950: 2008), pp. ix, 1, 12.

26. Ibid., pp. 5, 16.

27. On Hogwarts and multiculturalism, see Andrew Blake, *The Irresistible Rise of Harry Potter: Kid-Lit in a Globalised World* (2002), pp. 15, 103, 107–8.

28. J. K. Rowling, *Harry Potter and the Philosopher's Stone* (1997: 2014), pp. 112–13, 165, 245, 106; Richard Jenkyns, 'Potter in the Past', *Prospect*, October 2000; Alexandra Mullen, 'Harry Potter's Schooldays', *Hudson Review*, 53:1 (2000), p. 133; Blake, *Irresistible Rise of Harry Potter*, p. 39.

29. Rowling, *Harry Potter and the Philosopher's Stone*, pp. 34, 55, 71, 83–4, 139, 281; Hughes, *Tom Brown's School Days*, p. 91.

30. Ibid., pp. 291–2; Rowling, *Harry Potter and the Philosopher's Stone*, pp. 304, 308.

31. *Wall Street Journal*, 11 July 2000; *New York Times*, 23 July 2000; *Observer*, 25 June 2000.

32. Hughes, *Tom Brown's School Days*, p. 310; Mullen, 'Harry Potter's Schooldays', p. 134.

33. *Observer*, 10 July 2005, 25 June 2000; 'Harry Potter Makes Boarding Fashionable', 13 December 1999, http://news.bbc.co.uk/1/hi/education/563232.stm; *Times Educational Supplement*, 17 December 1999; Toby Young, 'J. K. Rowling: Why Is Harry Potter Author Pro-Labour When She's Obviously a Closet Tory?', 15 April 2010, http://blogs.telegraph.co.uk/news/tobyyoung/100034545/jk-rowling-why-is-harry-potter-author-pro-labour-when-shes-obviously-a-closet-tory/.

CHAPTER 7. THE ADVENTURES OF PEREGRINE CARRUTHERS

1. Charlie Higson, *SilverFin* (2005), pp. 17–18, 19–20, 22, 27, 372.

2. Ian Fleming, *You Only Live Twice* (1964: 2012), pp. 269–70.

3. Andrew Lycett, *Ian Fleming* (1995), pp. 1–3, 12.

4. Simon Winder, *The Man Who Saved Britain: A Personal Journey into the Disturbing World of James Bond* (2006), pp. 12–13; and see Lycett, *Ian Fleming*, chs. 1–6.

5. *The Economist*, 3 November 2012; Ben Macintyre, *For Your Eyes Only: Ian Fleming and James Bond* (2008), p. 48; James Chapman, *Licence to Thrill: A Cultural History of the James Bond Films* (1999), p. 274; James Chapman,

'Bond and Britishness', in Edward P. Comentale, Stephen Watt and Skip Willman (eds.), *Ian Fleming and James Bond: The Cultural Politics of 007* (Bloomington, IN, 2005), pp. 133, 136.

6. Lycett, *Ian Fleming*, p. 5.

7. Ian Fleming, *Casino Royale* (1953: 2012), pp. 2–4, 24, 27, 67; Winder, *Man Who Saved Britain*, pp. 83–4.

8. *Manchester Guardian*, 5 April 1958; *New York Times*, 17 February 1989; David R. Contosta, *The Private Life of James Bond* (Lititz, PA, 1993), pp. 46–8.

9. David Cannadine, *In Churchill's Shadow: Confronting the Past in Modern Britain* (2002), p. 292; Ian Fleming, *Moonraker* (1955: 2012), p. 185; Ian Fleming, *Dr No* (1958: 2012), p. 317; *Spectator*, 9 October 1959; Ian Fleming, *Thunderball* (1961: 2012), p. 12.

10. Richard Usborne, *Clubland Heroes: A Nostalgic Study of Some Recurrent Characters in the Romantic Fiction of Dornford Yates, John Buchan and Sapper* (3rd edn: 1983), pp. 2, 4–5, 66, 113, 152, 162.

11. Fleming, *Moonraker*, pp. 33–6, 48, 269, 279.

12. Ibid., p. 9; Ian Fleming, *From Russia, with Love* (1957: 1988), pp. 80–81.

13. Raymond Benson, *The James Bond Bedside Companion* (1984), pp. 7–8; Michael Denning, *Cover Stories: Narrative and Ideology in the British Spy Thriller* (1987), p. 92; Lycett, *Ian Fleming*, pp. 250, 276.

14. Ibid., pp. 276, 387–9.

15. Alexander Walker, *Hollywood, England: The British Film Industry in the Sixties* (1974), p. 187; Lycett, *Ian Fleming*, p. 393; Sheridan Morley, 'Niven, (James) David Graham', *Oxford Dictionary of National Biography*, http://www.oxforddnb.com/view/article/31503.

16. Walker, *Hollywood, England*, pp. 186–7; Christopher Bray, *Sean Connery: The Measure of a Man* (2010), pp. 70–71, 72–3.

17. Ibid., p. 74; *The Times*, 8 September 1994; Nick Sullivan, 'Dressing the Part', in Jay McInerney et al. (eds.), *Dressed to Kill: James Bond: The Suited Hero* (Paris, 1996), pp. 169, 174; Macintyre, *For Your Eyes Only*, pp. 186–7.

18. *The Times*, 5 October 1962, 10 October 1963, 29 December 1965, 15 June 1967. For Lampton and Bond, see Chapman, *Licence to Thrill*, pp. 68–9.

19. Ibid., pp. 74, 77, 81; Raymond Durgnat, *A Mirror for England: British Movies from Austerity to Affluence* (1970), p. 151.

20. Alexander Walker, *National Heroes: British Cinema in the Seventies and Eighties* (1985), p. 58.

21. Jay McInerney, 'How Bond Saved America – and Me', in McInerney et al. (eds.), *Dressed to Kill*, pp. 32, 36.

22. Lycett, *Ian Fleming*, p. 330; *New Statesman*, 5 April 1958; John le Carré, *Call for the Dead* (1961: 1964), p. 7; John le Carré, *The Spy Who Came in from the Cold* (1963), pp. 231–2; *Intimations: John le Carré* (BBC2,

8 February 1966), http://www.bbc.co.uk/archive/writers/12208.shtml; Kingsley Amis to Philip Larkin, 9 June 1981, in Zachary Leader (ed.), *The Letters of Kingsley Amis* (2000), p. 924.

23. Len Deighton, *The Ipcress File* (1962), pp. 14–15, 17. For Deighton's biography, see http://www.deightondossier.net/Author/biography.html.

24. Christopher Hitchens, *Arguably* (2011), pp. 359–60; George MacDonald Fraser, *Flashman* (1969: 2005), p. 13.

25. Thomas Hughes, *Tom Brown's School Days* (1857: 2013), pp. 140, 146, 150, 158; and see Kathryn Hughes's perceptive article in the *Guardian*, 20 September 2008.

26. *Guardian*, 20 September 2008; Fraser, *Flashman*, pp. 13, 15–16.

27. Ibid., pp. 17, 23, 30.

28. Ibid., pp. 13, 15, 285, 250.

29. *Independent*, 4 January 2008; *Spectator*, 24 May 2014; Allan Ramsay, 'Flashman and the Victorian Social Conscience', *Contemporary Review* (June 2003), http://www.thefreelibrary.com/Flashman+and+the+Victorian+social+conscience.-a0104136701.

30. Fraser, *Flashman*, p. 217; George MacDonald Fraser, *Flashman in the Great Game* (1975: 2005), pp. 288–9; George MacDonald Fraser, *Royal Flash* (1970: 2006), p. 288.

31. Hughes, *Tom Brown's School Days*, p. 310; Fraser, *Flashman in the Great Game*, p. 140; Fraser, *Flashman*, p. 289; George MacDonald Fraser, *Flashman and the Mountain of Light* (1990: 2005), p. 24.

32. George MacDonald Fraser, *Flashman at the Charge* (1973: 2006), p. 216.

33. Fraser, *Flashman in the Great Game*, p. 257.

34. George MacDonald Fraser, *Flashman's Lady* (1977: 2005), pp. 16–20.

35. Fleming, *You Only Live Twice*, p. 272.

36. Fraser, *Flashman in the Great Game*, pp. 368–71.

CHAPTER 8. ALL BACK ALLEYS AND BOOZE

1. Robert Giddings, 'Dickens from Page to Screen', *Canadian Notes and Queries*, no. 54 (1998), pp. 13–19, also online at http://charlesdickenspage.com/dickens_from-page-to-screen_giddings.html; Jonathan Rose, *The Intellectual Life of the British Working Classes* (2nd edn: New Haven, CT, 2010), pp. 111–12, 194; George Orwell, 'Charles Dickens', in Peter Davison, Ian Angus and Sheila Davison (eds.), *The Complete Works of George Orwell*, vol. 12: *A Patriot after All, 1940–1941* (1998), pp. 55, 47.

2. Robert Giddings, 'Dickens and the Classic Serial', 15 November 1999, http://charlesdickenspage.com/dickens_serials-giddings.html; Robert Giddings, 'Soft-Soaping Dickens: Andrew Davies, BBC-1 and "Bleak House"', http://

charlesdickenspage.com/Soft_Soaping_Dickens.html; *Guardian*, 28 December 2011.

3. Orwell, 'Charles Dickens', p. 31; Michael Sherborne, *H. G. Wells: Another Kind of Life* (2010), pp. 33, 120; H. G. Wells, *The History of Mr Polly* (1910: 2005), p. 120.

4. George Orwell, 'Wells, Hitler and the World State', in Orwell, *A Patriot after All*, pp. 539–40; Rose, *Intellectual Life of the British Working Classes*, p. 139. On Wells's influence, see Patrick Parrinder, *Science Fiction: Its Criticism and Teaching* (1980), p. 10; Adam Roberts, *The History of Science Fiction* (Basingstoke, 2005), pp. 143–4.

5. Giddings, 'Soft-Soaping Dickens'; *Guardian*, 17 October 2005; *Daily Telegraph*, 28 October 2005.

6. *Guardian*, 7 November 2005; Giddings, 'Dickens from Page to Screen'; Giddings, 'Soft-Soaping Dickens'.

7. Giddings, 'Soft-Soaping Dickens'; Victor Bailey, review of David F. Mitch, *The Rise of Popular Literacy in Victorian England: The Influence of Private Choice and Public Policy* (Philadelphia, PA, 1992), in *History of Education Quarterly*, 34:1 (1994), p. 88; John Sutherland, *Inside Bleak House* (2005), pp. 23–4; Charles Dickens, *Bleak House* (1853: 2008), p. 649.

8. Harry Hopkins, *The New Look: A Social History of the Forties and Fifties in Britain* (1963), p. 403; Asa Briggs, *The History of Broadcasting in the United Kingdom*, vol. 5: *Competition* (Oxford, 1995), p. 147.

9. Dorothy Hobson, *Soap Opera* (2002), pp. 5, 200.

10. Sean Egan, *Fifty Years of 'Coronation Street': The (Very) Unofficial History* (2010), pp. 90, 224–5; 'Interview for *TV Times*', 22 October 1990, Margaret Thatcher Foundation, http://www.margaretthatcher.org/document/108226.

11. Harry Elton, 'The Programme Committee and *Coronation Street*', in John Finch, Michael Cox and Marjorie Giles (eds.), *Granada Television: The First Generation* (Manchester, 2003), p. 102; Egan, *Fifty Years of 'Coronation Street'*, pp. 9, 26–7; *Guardian*, 23 June 2004; *Manchester Evening News*, 16 September 2010.

12. Tony Warren, *I Was Ena Sharples' Father* (1969); Egan, *Fifty Years of 'Coronation Street'*, pp. 6, 12; Olive Shapley, *Broadcasting a Life: The Autobiography of Olive Shapley* (1996), p. 161.

13. Daran Little, *The 'Coronation Street' Story: Celebrating Thirty-Five Years of the Street* (1995), p. 8; Joe Moran, *Armchair Nation: An Intimate History of Britain in Front of the TV* (2013), p. 119; David Kynaston, *Modernity Britain: A Shake of the Dice, 1959–62* (2014), pp. 116–17.

14. Egan, *Fifty Years of 'Coronation Street'*, pp. 10–11, 35–6, 77.

15. Ibid., pp. 35, 14–15, 27; Raphael Samuel, *Theatres of Memory: Past and Present in Contemporary Culture* (rev. edn: 2012), p. 73.

16. Charles Dickens, *Great Expectations* (1861: 2012), p. 256; and see Dennis Potter, *The Nigel Barton Plays* (Harmondsworth, 1967).

17. Hobson, *Soap Opera*, pp. 8–9, 33, 86–8, 116; Egan, *Fifty Years of 'Coronation Street'*, p. 37; *Daily Mirror*, 27 April 1961.

18. Egan, *Fifty Years of 'Coronation Street'*, p. 37; *Daily Mirror*, 10 December 1960; *Guardian*, 10 December 1960; *Sunday Times*, 11 December 1960; Moran, *Armchair Nation*, p. 119. See also Kynaston, *Modernity Britain: A Shake of the Dice*, pp. 117, 190–91, 235, which is very good on early reactions from critics and viewers alike.

19. The definitive study of the viewing figures is at the Corriepedia website http://coronationstreet.wikia.com/wiki/Viewing_Figures, although the figure for Ida Barlow's funeral comes from Egan, *Fifty Years of 'Coronation Street'*, p. 63.

20. *Spectator*, 29 December 1961; Hobson, *Soap Opera*, p. 41; Kynaston, *Modernity Britain: A Shake of the Dice*, pp. 116–17, 243; *Observer*, 2 December 1962.

21. Matthew Arnold, *Culture and Anarchy* (1869: 2009), p. 44; *New Statesman*, 7 July 1961, 12 January 1962.

22. *New Statesman*, 26 January 1962.

23. Egan, *Fifty Years of 'Coronation Street'*, p. 66; Robert Colls, *Identity of England* (Oxford, 2002), pp. 344–6; Patrick Nuttgens, *The Home Front: Housing the People, 1840–1990* (1989), p. 67.

24. Ibid., pp. 39, 49, 55, 100; Kynaston, *Modernity Britain: A Shake of the Dice*, pp. 367–8; *Sun*, 21 June 1967, quoted in Dave Russell, *Looking North: Northern England and the National Imagination* (Manchester, 2004), p. 200.

25. Egan, *Fifty Years of 'Coronation Street'*, pp. 277, 40, 192.

26. Phil Redmond, *Phil Redmond's Brookside: The Official Companion* (1987), p. 5; Christine Geraghty, 'British Soaps in the 1980s', in Dominic Strinati and Stephen Wagg (eds.), *Come On Down? Popular Media Culture in Post-War Britain* (1992), pp. 133–49.

27. Elton, 'Programme Committee and *Coronation Street*', pp. 100–101; Russell, *Looking North*, pp. 199–200; *Sun*, 13 December 1974.

28. Russell, *Looking North*, pp. 28, 60, 90, 184; Colls, *Identity of England*, pp. 13, 187; Raphael Samuel, *Island Stories: Unravelling Britain* (1998), p. 165; David Cecil, *Early Victorian Novelists: Essays in Revaluation* (1934), p. 29.

29. Piers Dudgeon, *The Girl from Leam Lane: The Life and Writing of Catherine Cookson* (rev. edn: 2006), p. 261; Kathleen Jones, *Catherine Cookson: The Biography* (1999), p. 300.

30. Jones, *Catherine Cookson*, pp. 254, 294, 314, 320; *Daily Express*, 11 June 1979; *Sunday Times*, 21 August 1994; Dudgeon, *Girl from Leam Lane*,

pp. 240–41; Julie Anne Taddeo, 'The Victorian Landscape of Catherine Cookson Country', *Journal of Popular Culture*, 42:1 (2009), p. 162.

31. *Sunday Times*, 21 August 1994; *London Review of Books*, 27 June 1991.

32. J. B. Priestley, *English Journey* (1934), p. 314; Jones, *Catherine Cookson*, pp. 10–12.

33. Dudgeon, *Girl from Leam Lane*, pp. 2–3, 5, 7–8, 21–2, 31; Catherine Cookson, *Our Kate* (1969: 1974), p. 305; Jones, *Catherine Cookson*, p. 13.

34. Ibid., p. 31; Cookson, *Our Kate*, p. 42.

35. Ibid., pp. 58, 62–3, 28; Dudgeon, *Girl from Leam Lane*, pp. xi, 34, 39, 49, 52, 53; Jones, *Catherine Cookson*, pp. 55–6, 60–61, 177.

36. Cookson, *Our Kate*, pp. 212–13; Dudgeon, *Girl from Leam Lane*, pp. 97–8, 100, 109–10; Jones, *Catherine Cookson*, pp. 94–5; Rose, *Intellectual Life of the British Working Classes*, p. 40; Robert Colls, 'Cookson, Chaplin and Common: Three Northern Writers in 1951', in K. D. M. Snell (ed.), *The Regional Novel in Britain and Ireland, 1800–1990* (Cambridge, 1998), p. 181.

37. Jones, *Catherine Cookson*, pp. 172–3, 179, 197, 207; Dudgeon, *Girl from Leam Lane*, pp. 160, 170, 175, 217; Cookson, *Our Kate*, pp. 283–4.

38. Ibid., p. 283; Catherine Cookson, *Kate Hannigan* (1950: 2008), pp. 12, 24, 151–2.

39. Dudgeon, *Girl from Leam Lane*, pp. 212–13; Catherine Cookson, *The Fifteen Streets* (1952: 1990), pp. 76, 78–9; Jones, *Catherine Cookson*, pp. 41, 210.

40. Russell, *Looking North*, pp. 80, 91–2; Dudgeon, *Girl from Leam Lane*, p. 16; Jones, *Catherine Cookson*, pp. 260–61; Cookson, *Fifteen Streets*, p. 40.

41. Taddeo, 'Victorian Landscape of Catherine Cookson Country', pp. 169–70, 172–3; Dudgeon, *Girl from Leam Lane*, pp. 101, 161; Catherine Cookson, *Tilly Trotter* (1980: 2007), p. 8.

42. Jones, *Catherine Cookson*, p. 254; Colls, 'Cookson, Chaplin and Common', pp. 172, 186, 166–7, 199, 190.

43. Ibid., p. 185; Jones, *Catherine Cookson*, p. 254; Dudgeon, *Girl from Leam Lane*, pp. 208–9; Taddeo, 'Victorian Landscape of Catherine Cookson Country', p. 163; Cookson, *Fifteen Streets*, pp. 219, 221.

44. Taddeo, 'Victorian Landscape of Catherine Cookson Country', p. 176; Jones, *Catherine Cookson*, p. 9; Dudgeon, *Girl from Leam Lane*, pp. 63–4, 72.

45. Orwell, 'Charles Dickens', p. 31; Dudgeon, *Girl from Leam Lane*, p. 193; John Carey, *The Violent Effigy: A Study of Dickens' Imagination* (1973), p. 7; *Financial Times Magazine*, 24 May 2013; Morten Høi Jensen, 'Bookforum Interview with Martin Amis', 20 August 2012, http://www.bookforum.com/interview/9965.

46. *Sunday Times*, 21 August 1994; Dudgeon, *Girl from Leam Lane*, p. 107; Colls, 'Cookson, Chaplin and Common', p. 187; Taddeo, 'Victorian Landscape of Catherine Cookson Country', pp. 164–5.

47. Catherine Cookson, *The Rag Nymph* (1991: 1992), p. 45; Jones, *Catherine Cookson*, pp. 245, 256; Dudgeon, *Girl from Leam Lane*, pp. 199, 235, 264; Taddeo, 'Victorian Landscape of Catherine Cookson Country', pp. 163–4, 166.

48. 'Cookson Loses Library No. 1 Spot', 13 February 2004, http://news.bbc. co.uk/1/hi/entertainment/3484369.stm; *Guardian*, 11 February 2010; *Daily Mail*, 20 October 2012, 23 January 2012.

CHAPTER 9. THE MARK OF CAIN

1. *The Times*, 15 September 2008; Laura Thompson, *Agatha Christie: An English Mystery* (2007), pp. 356, 382; Robert Barnard, *A Talent to Deceive: An Appreciation of Agatha Christie* (rev. edn: 1990), pp. 2–3.

2. Thompson, *Agatha Christie*, pp. 382, 383–4; *New Yorker*, 14 October 1944; *The Times*, 15 March 1977; *Guardian*, 2 June 1986; *London Review of Books*, 22 December 1994. The Dibdin and Rendell quotations are from Thompson, cited above; James is quoted in Toynbee's *Guardian* piece.

3. Barnard, *Talent to Deceive*, pp. 13, 31, 54; Agatha Christie, *One, Two, Buckle My Shoe* (1940: 2011), p. 219; Alison Light, *Forever England: Femininity, Literature and Conservatism between the Wars* (1991), pp. 73, 77–8.

4. Ibid., pp. 62, 64, 76, 80, 85, 106; Thompson, *Agatha Christie*, p. 156.

5. Ibid., pp. 33–6, 94, 210; *London Review of Books*, 7 February 1985 (letter from J. V. Stevenson); Barnard, *Talent to Deceive*, pp. 63, 77.

6. *London Review of Books*, 22 December 1994; Light, *Forever England*, p. 92; Aagje Verbogen, 'Agatha Christie and Her Murderers: A Case Study of the Miss Marple Novels', unpublished Masters thesis, University of Ghent, 2008, pp. 12–14, 23–5.

7. Verbogen, 'Agatha Christie and Her Murderers', pp. 66–8; Light, *Forever England*, p. 94; Barnard, *Talent to Deceive*, p. 120.

8. Ibid., pp. 25–6; Thompson, *Agatha Christie*, pp. 278–9.

9. Agatha Christie, *A Murder Is Announced* (1950), pp. 114–15.

10. Agatha Christie, *The Murder of Roger Ackroyd* (1926: 2011), pp. 245, 179; Agatha Christie, *The Body in the Library* (1942: 1979), p. 125; and see Light, *Forever England*, pp. 87–93, which is brilliant on this point.

11. Christie, *A Murder Is Announced*, pp. 85, 89; Agatha Christie, *The Murder at the Vicarage* (1930: 2007), p. 244; Agatha Christie, *The Thirteen Problems* (1932: 2008), p. 109; and see the similar passage in Agatha Christie, *A Pocket Full of Rye* (1953: 2008), p. 142.

12. Agatha Christie, *The Moving Finger* (1942: 1980), pp. 9, 11, 28, 29, 56, 69, 120, 153.

13. Clare Clarke, *Late Victorian Crime Fiction in the Shadow of Sherlock* (Basingstoke, 2014), p. 23; Judith Flanders, *The Invention of Murder: How the*

Victorians Revelled in Death and Detection and Created Modern Crime
(2011), pp. 424, 296. The lines from *Punch*, which come from p. 190 of the
second volume (January–June 1842) of the collected edition, are very slightly
misquoted on Flanders's title page.

14. P. D. James, *Devices and Desires* (1989), p. 188; *Spectator*, 18 September
1970.

15. Thompson, *Agatha Christie*, pp. 19, 432–3; *Life*, 14 May 1956; *The Times*,
20 February 1962; Light, *Forever England*, p. 61.

16. John Carey, *The Violent Effigy: A Study of Dickens' Imagination* (1973),
p. 39; Dickens, *Bleak House* (1853: 2008), p. 712; and see Philip Collins,
Dickens and Crime (1994).

17. Carey, *Violent Effigy*, pp. 18–19, 21–2, 24, 80–81.

18. Agatha Christie, *4.50 from Paddington* (1957: 2007), p. 270; Agatha Chris-
tie, *An Autobiography* (1977: 2011), p. 438; Barnard, *Talent to Deceive*, p. 41.

19. Carey, *Violent Effigy*, p. 38; Lisa Rodensky, *The Crime in Mind: Criminal
Responsibility and the Victorian Novel* (Oxford, 2003), pp. 76–8.

20. Christie, *A Murder Is Announced*, p. 220; Thompson, *Agatha Christie*,
pp. 397–8.

21. Agatha Christie, *Crooked House* (1949: 1959), pp. 92, 183, 185.

22. *Observer*, 4 March 2001; Agatha Christie, *Appointment with Death* (1938:
2008), pp. 41, 90; Christie, *Body in the Library*, p. 152.

23. Thompson, *Agatha Christie*, pp. 92–3, 316, 319–20.

24. Agatha Christie, *Taken at the Flood* (1948: 1993), pp. 43, 149, 121, 208–9.

25. John Braine, *Room at the Top* (1957: 1989), pp. 103, 211.

26. Paul Kildea, *Benjamin Britten: A Life in the Twentieth Century* (2013),
pp. 204–6, 2.

27. Ibid., pp. 219, 254–5, 248; Richard Taruskin, *The Oxford History of
Western Music*, vol. 5: *Music in the Late Twentieth Century* (Oxford, 2005),
pp. 242–3.

28. John Watney, *Mervyn Peake* (1976), p. 127; Mervyn Peake, 'The Consumptive,
Belsen 1945', http://www.mervynpeake.org/poet.html; *Guardian*, 4 April
2010; Mervyn Peake, *Titus Groan* (1946: 2011), p. 15.

29. John Carey, *William Golding: The Man Who Wrote 'Lord of the Flies'*
(2009), pp. 82–3, 108–9.

30. Ibid., pp. 149, 151–2.

31. William Golding, *The Hot Gates* (1965), pp. 85–6.

32. Carey, *William Golding*, pp. 260–61, 517, 56–7, 201.

33. Simon Heffer, *High Minds: The Victorians and the Birth of Modern Britain*
(2013), p. 13; Robert Louis Stevenson, *The Strange Case of Dr Jekyll and
Mr Hyde* (1886: 2003), p. 19; *New Statesman*, 6 May 1966.

34. John Russell Taylor, *The Second Wave: British Drama for the Seventies*
(1971), p. 206; Harold Pinter, *The Caretaker* (1960: 1991), pp. 118–19. On

popular anthropology, see Patricia Waugh, *The Harvest of the Sixties: English Literature and Its Background, 1960–1990* (Oxford, 1995), p. 58.

35. J. R. R. Tolkien, *The Lord of the Rings* (1955: 2012), pp. 52–4, 714.

36. Ibid., p. 945; Humphrey Carpenter (ed.), *The Letters of J. R. R. Tolkien* (1981), p. 326.

37. *The Nation*, 14 April 1956; *New Statesman*, 18 December 1954; *London Review of Books*, 21 July 1982; Michael Moorcock, *Wizardry and Wild Romance: A Study of Epic Fantasy* (1987), ch. 5; *Intelligent Life*, December 2007; T. A. Shippey, *J. R. R. Tolkien: Author of the Century* (2000), p. xxii.

38. Ibid., pp. vii, xxi, 308–9.

39. Humphrey Carpenter, *J. R. R. Tolkien: A Biography* (1977), pp. 27–8, 33, 38, 40.

40. John Garth, *Tolkien and the Great War: The Threshold of Middle-Earth* (2003), pp. 13, 77–8; Jared Lobdell, *The World of the Rings: Language, Religion, and Adventure in Tolkien* (Chicago, IL, 2004), pp. 4–5.

41. Garth, *Tolkien and the Great War*, pp. 16, 26, 34, 35.

42. Ibid., pp. 37, 143, 148, 158, 200–201, 250; Tolkien, *Lord of the Rings*, p. xxiv.

43. *Letters of J. R. R. Tolkien*, p. 78; and see Garth, *Tolkien and the Great War*, pp. 39, 106; Meredith Veldman, *Fantasy, the Bomb and the Greening of Britain: Romantic Protest, 1945–1980* (Cambridge, 1994), pp. 46–7.

44. Garth, *Tolkien and the Great War*, pp. 214, 217, 220–21, 223.

45. Carpenter, *J. R. R. Tolkien*, pp. 189–93; Tolkien, *Lord of the Rings*, pp. xxiii–xxiv.

46. John Garth, 'Why World War I Is at the Heart of *Lord of the Rings*', 29 July 2014, http://www.thedailybeast.com/articles/2014/07/29/why-world-war-one-is-at-the-heart-of-lord-of-the-rings.html; Garth, *Tolkien and the Great War*, pp. 164, 171; Tolkien, *Lord of the Rings*, pp. 626, 627.

47. Veldman, *Fantasy, the Bomb and the Greening of Britain*, pp. 20–21; *Letters of J. R. R. Tolkien*, pp. 72, 78, 88, 111, 116.

48. Richard Overy, *The Morbid Age: Britain between the Wars* (2009), pp. 2, 3, 16, 176; Hansard, 10 November 1932; *Herald* (Glasgow), 10 November 1936.

49. Overy, *Morbid Age*, pp. 4, 373; Aldous Huxley, *Ape and Essence* (1948: 2005), p. 97.

50. Overy, *Morbid Age*, pp. 11, 18, 20, 47; H. G. Wells, *The Salvaging of Civilisation* (1921), p. 1; H. G. Wells, *The Shape of Things to Come* (1933: 2011), pp. 214–15; Michael Sherborne, *H. G. Wells: Another Kind of Life* (2010), p. 304; H. G. Wells, *Mind at the End of Its Tether* (1945), p. 15.

51. Tolkien, *Lord of the Rings*, pp. 998, 1018, 1020.

52. Ibid., p. xxiv.

53. Ibid., pp. 999, 1009, 1002; *Letters of J. R. R. Tolkien*, pp. 63–4.

54. Tolkien, *Lord of the Rings*, pp. 1006–7, 1011.

55. Ibid., p. 1029; and see Shippey, *Author of the Century*, pp. 148, 155, 165.

56. Tolkien, *Lord of the Rings*, pp. 1004, 1013, 1016–17.

57. *Letters of J. R. R. Tolkien*, pp. 230, 390; Carpenter, *J. R. R. Tolkien*, pp. 28–9, 129–30; Garth, *Tolkien and the Great War*, pp. 11–12; *Guardian*, 28 December 1991.

58. John Carey, *The Intellectuals and the Masses: Pride and Prejudice among the Literary Intelligentsia, 1880–1939* (1992), pp. 36, 47–50, 118; H. G. Wells, *The New Machiavelli* (1911: 2014), pp. 29–30; Tolkien, *Lord of the Rings*, p. xxv. On the invention of 'Deep England', see Alun Howkins, 'The Discovery of Rural England', in Robert Colls and Philip Dodd (eds.), *Englishness: Politics and Culture, 1880–1920* (2nd edn: 2014), pp. 85–112, and Peter Brooker and Peter Widdowson, 'A Literature for England', in ibid., pp. 141–88.

59. C. S. Lewis, *The Last Battle* (1956: 2009), p. 37.

CHAPTER 10. THE DOOR IN THE WALL

1. Amy Raphael, *Danny Boyle, Creating Wonder: In Conversation with Amy Raphael* (rev. edn: 2013), p. 172; John Wyndham, *The Day of the Triffids* (1951: 2014), pp. 167, 233.

2. *Tonight: John Wyndham* (BBC TV, 6 September 1960), http://www.bbc.co.uk/archive/writers/12206.shtml; Wyndham, *Day of the Triffids*, p. 47.

3. Brian Aldiss, 'Harris, John Wyndham Parkes Lucas Beynon', *Oxford Dictionary of National Biography*, http://www.oxforddnb.com/view/article/33728; Christopher Priest, 'John Wyndham and H. G. Wells', http://www.christopher-priest.co.uk/essays-reviews/contemporaries-portrayed/john-wyndham-h-g-wells/; David Ketterer, '"A Part of the … Family[?]": John Wyndham's *The Midwich Cuckoos* as Estranged Autobiography', in Patrick Parrinder (ed.), *Learning from Other Worlds: Estrangement, Cognition, and the Politics of Science Fiction and Utopia* (Durham, NC, 2001), pp. 153–5, 157–9; *The Times*, 16 March 1968.

4. Priest, 'John Wyndham and H. G. Wells'; *The Times*, 16 March 1968, 6 September 1951; *Observer*, 26 August 1951; Philip Reeve, 'John Wyndham', http://philipreeve.blogspot.co.uk/2014/02/john-wyndham.html.

5. *The Times*, 13 September 1958, 23 January 1960; *Tonight: John Wyndham*.

6. Brian Aldiss and David Wingrove, *Trillion Year Spree: The History of Science Fiction* (1986), pp. 253–4.

7. Wyndham, *Day of the Triffids*, pp. 42, 69, 126–7.

8. H. G. Wells, *The War of the Worlds* (1898: New York, 2013), pp. 122–3, 124; Wyndham, *Day of the Triffids*, p. 177.

9. David Newsome, *The Victorian World Picture: Perceptions and Introspections in an Age of Change* (1997), pp. 257, 87.

10. Richard Jefferies, *After London, or, Wild England* (1885: 1905), pp. 1, 265–7. Morris is quoted in John Fowles's introduction to the Oxford University Press edition (Oxford, 1980), pp. viii–ix.

11. I. F. Clarke, *Voices Prophesying War: Future Wars 1763–3749* (2nd edn: Oxford, 1992), pp. 41, 48, 83, as well as chs. 2–4 generally; John Carey, *The Intellectuals and the Masses: Pride and Prejudice among the Literary Intelligentsia, 1880–1939* (1992), pp. 132–3; Michael Sherborne, *H. G. Wells: Another Kind of Life* (2010), pp. 103–5; Peter Fitting, 'Estranged Invaders: *The War of the Worlds*', in Parrinder (ed.), *Learning from Other Worlds*, p. 129; H. G. Wells, *The Time Machine* (1895: 2005), p. 91.

12. Priest, 'John Wyndham and H. G. Wells'.

13. Adam Roberts, *The History of Science Fiction* (Basingstoke, 2005), p. 211; Ketterer, '"A Part of the ... Family[?]"', pp. 161–2; Ministry of Education, *The Youth Service in England and Wales: Report of the Committee Appointed by the Minister of Education in November, 1958* (1960), p. 15; *Daily Mirror*, 15 September 1958.

14. John Wyndham, *The Midwich Cuckoos* (1957: 2008), pp. 186–7; Sherborne, *H. G. Wells*, pp. 126, 129; Priest, 'John Wyndham and H. G. Wells'; Andy Sawyer, '"A Stiff Upper Lip and a Trembling One": John Wyndham on Screen', in I. Q. Hunter (ed.), *British Science Fiction Cinema* (1999), p. 86.

15. Wyndham, *Day of the Triffids*, p. 93; John Wyndham, *The Chrysalids* (1955: 2008), pp. 182, 196.

16. John Carey, *William Golding: The Man Who Wrote 'Lord of the Flies'* (2009), pp. 178–9.

17. Wyndham, *Midwich Cuckoos*, pp. 102, 112–13, 175, 220; Wells, *War of the Worlds*, p. 2; see also Roberts, *History of Science Fiction*, pp. 210–11, as well as Dan Rebellato's thoughtful essay in the *Guardian*, 20 December 2010.

18. Aldiss, 'Harris, John Wyndham Parkes Lucas Beynon'; Priest, 'John Wyndham and H. G. Wells'; Donald Bull and Alice Frick, 'Science Fiction', March 1962, http://www.bbc.co.uk/archive/doctorwho/6400.shtml.

19. 'Interview with Steven Moffat', 24 July 2008, at http://io9.com/5028464/exclusive-interview-with-doctor-whos-steven-moffat.

20. On the politics of *Doctor Who*, see Andrew Harrison, 'Is Doctor Who a Lefty?', 23 November 2013, http://www.newstatesman.com/2013/11/spin-doctor; Pete May, 'The Politics of Doctor Who', 10 September 2014, http://www.newstatesman.com/culture/2014/09/politics-doctor-who-satire-has-always-followed-doctor-through-time/.

21. Asa Briggs, *The History of Broadcasting in the United Kingdom*, vol. 5: *Competition* (Oxford, 1995), pp. 396, 520; Jeremy Bentham, *Doctor Who: The Early Years* (1986), pp. 38–40.

22. Bull and Frick, 'Science Fiction'.

23. John Braybon and Alice Frick, 'Science Fiction: Follow-up Report', 25 July 1962, http://www.bbc.co.uk/archive/doctorwho/6401.shtml. Frick's minute of the meeting in March 1963 is online at http://www.doctorwhonews. net/2013/03/unearthly-series-origins-tv-legend-8-260313040017.html.

24. C. E. Webber, 'Concept Notes for New SF Drama', 29 March 1963, http:// www.bbc.co.uk/archive/doctorwho/6402.shtml; C. E. Webber, 'Dr Who: General Notes on Background and Approach', c. May 1963, http://www. bbc.co.uk/archive/doctorwho/6403.shtml. Webber's third memo, dated 20 May 1963, is online at http://www.doctorwhonews.net/2013/05/unearthly-series-11-200513070017.html.

25. James Chapman, *Inside the TARDIS: The Worlds of 'Doctor Who': A Cultural History* (2006), pp. 22–3; Marcus K. Harmes, *Doctor Who and the Art of Adaptation: Fifty Years of Storytelling* (Lanham, MD, 2014), p. 90.

26. Audience Research Report on 'An Unearthly Child', 30 December 1963, http://www.bbc.co.uk/archive/doctorwho/6406.shtml; Harmes, *Doctor Who and the Art of Adaptation*, p. 89.

27. H. G. Wells, *The Chronic Argonauts* (1888: 2012), p. 19; Sherborne, *H. G. Wells*, pp. 69–70, 103; Roberts, *History of Science Fiction*, p. 145; H. G. Wells, 'The Door in the Wall' (1906), in H. G. Wells, *Complete Short Story Omnibus* (2011), pp. 624, 635.

28. Interview with Terry Nation in *Starburst*, January 1979, reproduced online at http://www.huffingtonpost.co.uk/john-fleming/doctor-who_b_1163011. html; Chapman, *Inside the TARDIS*, pp. 27–8.

29. Alwyn W. Turner, *The Man Who Invented the Daleks: The Strange Worlds of Terry Nation* (2011), pp. 83, 88.

30. Wells, *War of the Worlds*, p. 13; Carey, *Intellectuals and the Masses*, pp. 128–9, 131; Turner, *Man Who Invented the Daleks*, p. 81; and see Fitting, 'Estranged Invaders', pp. 134–6.

31. Wells, *War of the Worlds*, pp. 93–4, 2.

32. *Independent*, 21 May 1996.

33. Bram Stoker, *Dracula* (1897: 2014), p. 131.

34. On the origins of the Cybermen, see Chapman, *Inside the TARDIS*, pp. 62–3.

35. Harmes, *Doctor Who and the Art of Adaptation*, pp. 87–9.

CHAPTER 11. WORKING-CLASS HEROES

1. *Guardian*, 9 October 1999; 'Queen Rock on in Poll', 8 May 2002, http:// news.bbc.co.uk/1/hi/entertainment/1974538.stm; 'Lennon Beats Beatles in Song Poll', 31 December 2005, http://news.bbc.co.uk/1/hi/entertainment/ 4571080.stm; 'Rear-View Mirror: "Imagine" by Yoko Ono?', 11 December

2013, http://music.cbc.ca/#!/blogs/2013/12/Rear-View-Mirror-Imagine-by-Yoko-Ono; 'John Lennon: Imagine', http://www.rollingstone.com/music/lists/the-500-greatest-songs-of-all-time-20110407/john-lennon-imagine-20110516. For sales figures, see 'Get Lucky Becomes One of the UK's Biggest Selling Singles of All-Time!', 27 June 2013, http://www.officialcharts.com/chart-news/daft-punks-get-lucky-becomes-one-of-the-uks-biggest-selling-singles-of-all-time-2315/.

2. *New Statesman*, 29 September 2003; *Daily Telegraph*, 20 September 2003; for the song's appearance on *Desert Island Discs*, see the 'Castaway Archive' at http://www.bbc.co.uk/radio4/features/desert-island-discs/.

3. *The Times*, 15 December 1980, 22 December 1980; *Guardian*, 25 November 2002; *Daily Telegraph*, 3 July 2001; Mark Lewisohn, *The Beatles: All These Years*, vol. 1: *Tune In* (2013), p. 186.

4. Ibid., pp. 356, 211.

5. *Disc Weekly*, 26 March 1966; *Rolling Stone*, 21 January 1971; the latter is also online at http://www.jannswenner.com/archives/john_lennon_part1.aspx.

6. David Sheff, *All We Are Saying: The Last Major Interview with John Lennon and Yoko Ono* (2000: 2010), p. 84; and see Tim Blanning, *The Romantic Revolution* (2010), esp. pp. 31–6.

7. Sheff, *All We Are Saying*, pp. 196–7; Ian MacDonald, *Revolution in the Head: The Beatles' Records and the Sixties* (2nd edn: 1997), p. 303; Lewisohn, *Tune In*, pp. 142, 233.

8. *Rolling Stone*, 21 January 1971; Lewisohn, *Tune In*, pp. 9, 11, 38.

9. Sheff, *All We Are Saying*, pp. 154, 160.

10. Philip Norman, *Shout! The True Story of the Beatles* (1993), pp. 8, 10; Lewisohn, *Tune In*, pp. 50–51, 64, 81, 92, 1–2.

11. For Lennon's O-level results, see ibid., p. 142.

12. Norman, *Shout!*, p. 234; *Evening Standard*, 4 March 1966.

13. Lewisohn, *Tune In*, p. 8; *Daily Mirror*, 2 July 1968; Norman, *Shout!*, pp. 331–2

14. *Daily Mirror*, 26 March 1969, 27 March 1969; and see Norman, *Shout!*, pp. 364–5.

15. *Guardian*, 26 November 1969; Norman, *Shout!*, pp. 382, 387.

16. *New Scientist*, 4 February 1960; Ray Coleman, *John Ono Lennon*, vol. 2: *1967–1980* (1984), p. 49.

17. *Daily Mirror*, 31 March 1969; *Guardian*, 7 July 1970.

18. *Guardian*, 31 May 2012; *Liverpool Echo*, 19 November 2002.

19. *Daily Telegraph*, 20 September 2003; Philip Norman, *John Lennon: The Life* (2008), pp. 615–16.

20. Norman, *John Lennon*, pp. 765–6, 772, 776.

21. *Guardian*, 31 December 1968.

22. Lewisohn, *Tune In*, pp. 136–7, 142, 233, 340; Norman, *Shout!*, pp. 36–7.

23. Lewisohn, *Tune In*, pp. 143, 165; *Rolling Stone*, 19 August 1971.

24. MacDonald, *Revolution in the Head*, pp. xiii–xvii.

25. Derek Jarman, *Dancing Ledge* (1984: 1993), p. 164; *The Times*, 5 July 1977; and see, of course, Jon Savage, *England's Dreaming: Sex Pistols and Punk Rock* (rev. edn: 2005).

26. J. W. Hudson, *The History of Adult Education* (1851), p. 45; Henry Brougham, *Speeches of Henry Lord Brougham upon Questions Relating to Public Rights, Duties and Interests* (1838: Philadelphia, PA, 1841), vol. 2, pp. 152, 361; see also 'The History of Our Buildings', http://www.lipa.ac.uk/Content/AboutUs/HistoryHeritage/BuildingHistory.aspx (the website of the Liverpool Institute for Performing Arts, which now occupies the same buildings).

27. Raphael Samuel, *Island Stories: Unravelling Britain* (1998), p. 163; John Forster, *The Life of Charles Dickens*, vol. 1: *1812–1842* (Philadelphia, PA, 1872), p. 324.

28. Samuel Smiles, *The Autobiography of Samuel Smiles* (1905), p. 129; Asa Briggs, *Victorian People: A Reassessment of Persons and Themes, 1851–67* (rev. edn: 1965), pp. 125–6; H. C. G. Matthew, 'Smiles, Samuel', *Oxford Dictionary of National Biography*, http://www.oxforddnb.com/view/article/36125.

29. Hansard, 7 March 2001, 21 June 1985, 7 November 1997; Nigel Lawson, *The View from No. 11: Memoirs of a Tory Radical* (1992), p. 64; *Guardian*, 8 August 2014; Simon Cowell, *I Don't Mean to Be Rude, But . . . : The Truth about Fame, Fortune and My Life in Music* (rev. edn: 2004), p. 7.

30. Samuel Smiles, *Self-Help, with Illustrations of Character and Conduct* (1859), pp. iii–v; Smiles, *Autobiography of Samuel Smiles*, p. 131; Briggs, *Victorian People*, p. 128; Simon Heffer, *High Minds: The Victorians and the Birth of Modern Britain* (2013), pp. 205–6.

31. Smiles, *Self-Help*, pp. 1–4, 238, 328; Samuel Smiles, *Life and Labour, or, Characteristics of Men of Industry, Culture and Genius* (1887), pp. 238–9; and see the excellent essay in Briggs, *Victorian People*, pp. 124–47, to which I am greatly indebted.

32. Briggs, *Victorian People*, pp. 125–6; Matthew, 'Smiles, Samuel'; Jonathan Rose, *The Intellectual Life of the British Working Classes* (2nd edn: New Haven, CT, 2010), pp. 68–70.

33. Briggs, *Victorian People*, p. 106; *The Times*, 28 October 1889; Ian Watt, *The Rise of the Novel: Studies in Defoe, Richardson and Fielding* (1957: Harmondsworth, 1972), pp. 13–14.

34. E. J. Evans, 'Self-Help', in Paul Schlicke (ed.), *The Oxford Companion to Charles Dickens: Anniversary Edition* (Oxford, 2011), pp. 519–22; Charles Dickens, *David Copperfield* (1850: 1992), p. 513.

35. Thomas Hughes, *Tom Brown's School Days* (1857: 2013), pp. 291–2, 101; Smiles, *Self-Help*, p. 2.

36. Charles Dickens, *Hard Times* (1854), pp. 17, 18, 20; Charles Dickens, *Our Mutual Friend* (1865: 1997), p. 204; and see Martin J. Wiener, *English Culture and the Decline of the Industrial Spirit, 1850–1980* (2nd edn: Cambridge, 2004), p. 35, which argues that Dickens's preference for Wrayburn over Headstone is symptomatic of Victorian Britain's turn away from entrepreneurial capitalism.

37. Jerome Meckier, *Dickens's Great Expectations: Misnar's Pavilion versus Cinderella* (Lexington, KY, 2002), pp. 109–15.

CHAPTER 12. A SAVAGE STORY OF LUST AND AMBITION

1. Richard Lloyd George, *Lloyd George* (1960), p. 120.

2. John Carey, *The Intellectuals and the Masses: Pride and Prejudice among the Literary Intelligentsia, 1880–1939* (1992), pp. 18–19; H. G. Wells, *The History of Mr Polly* (1910: 2005), pp. 207–8; H. G. Wells, 'The Purple Pileus' (1896), in H. G. Wells, *Complete Short Story Omnibus* (2011), p. 226; and see D. J. Taylor's illuminating essay in the *Guardian*, 11 March 2011.

3. *The Times*, 7 May 1914.

4. *The Times*, 12 January 1928, 6 December 1937; *Manchester Guardian*, 27 May 1924, 6 December 1937.

5. Winston Churchill, 'Be Ye Men of Valour', 19 May 1940, http://www.winstonchurchill.org/resources/speeches/1940-the-finest-hour/be-ye-men-of-valour; 'Let Us Face the Future: A Declaration of Labour Policy for the Consideration of the Nation', in Iain Dale (ed.), *Labour Party General Election Manifestos, 1900–1997* (2000), p. 59; *Manchester Guardian*, 24 October 1946; J. B. Priestley, *Three Men in New Suits* (1945), pp. 168–9.

6. Jeffrey Richards, *Films and British National Identity: From Dickens to 'Dad's Army'* (Manchester, 1997), pp. 101–2, 130; Anthony Aldgate and Jeffrey Richards, *Best of British: Cinema and Society from 1930 to the Present* (rev. edn: 1999), pp. 128, 150, 156.

7. *Daily Telegraph*, 11 September 2010.

8. Aldgate and Richards, *Best of British*, pp. 136–7; Julian Petley, 'The Pilgrim's Regress: The Politics of the Boultings' Films', in Alan Burton, Tim O'Sullivan and Paul Wells (eds.), *The Family Way: The Boulting Brothers and Postwar British Film Culture* (Trowbridge, 2000), pp. 15–34; Marcia Landy, 'Nation and Imagi-nation in *Private's Progress*', in ibid., pp. 175–88; *The Times*, 26 July 1974.

9. Aldgate and Richards, *Best of British*, pp. 175, 180, 182; Petley, 'Pilgrim's Regress', p. 28.

10. *Daily Express*, 14 August 1959.

11. Mark Abrams and Richard Rose, *Must Labour Lose?* (1960), pp. 42–3.

12. Mark Abrams, *The Teenage Consumer* (1959), pp. 13–14; Mark Abrams, *Teenage Consumer Spending in 1959* (1961), pp. 4–5; Asa Briggs, *The History of Broadcasting in the United Kingdom*, vol. 5: *Competition* (Oxford, 1995), p. 1005; Colin MacInnes, *Absolute Beginners* (1959: 1980), p. 12.

13. *Daily Express*, 4 September 1956; and see Harry Ritchie, *Success Stories: Literature and the Media in England, 1950–1959* (1988), pp. 28–30.

14. Humphrey Carpenter, *The Angry Young Men: A Literary Comedy of the 1950s* (2002), p. 197.

15. *Spectator*, 1 October 1954; Carpenter, *Angry Young Men*, pp. 80–82; John Osborne, *Look Back in Anger* (1956: 1957), p. 89; Dan Rebellato, *1956 and All That: The Making of Modern British Drama* (1999), p. 13; *Manchester Guardian*, 10 May 1956.

16. John Wain, *Hurry on Down* (1953: 1960), p. 32; *New Statesman*, 30 January 1954; and see D. J. Taylor, *After the War: The Novel and England since 1945* (1993), pp. 78–80.

17. *New Statesman*, 20 August 1955; *Sunday Times*, 25 December 1955; Carpenter, *Angry Young Men*, pp. 74–5, 91; Ritchie, *Success Stories*, pp. 41–2, 68, 72, 79.

18. *Evening Standard*, 26 September 1957; Ritchie, *Success Stories*, p. 79.

19. Taylor, *After the War*, pp. 72–3, 76–7; Ritchie, *Success Stories*, pp. 87–8; Kingsley Amis, *Lucky Jim* (1954: 1961), p. 146.

20. Kingsley Amis, *Memoirs* (New York, 1991), p. 155.

21. Kingsley Amis, 'Braine, John Gerard', *Oxford Dictionary of National Biography*, http://www.oxforddnb.com/view/article/39825; *Yorkshire Post*, 27 October 2006; Carpenter, *Angry Young Men*, pp. 155–60.

22. *The Times*, 22 July 1957; Ritchie, *Success Stories*, pp. 4–5; Carpenter, *Angry Young Men*, pp. 160–61; John Braine, *Room at the Top* (1957: 1989), pp. 148, 211.

23. Braine, *Room at the Top*, pp. 7, 9–10, 34, 24, 70, 74; *The Times*, 22 July 1957.

24. Braine, *Room at the Top*, pp. 124, 42, 94, 96, 196, 128, 132, 140.

25. Ibid., p. 46; *The Times*, 14 March 1957; *Observer*, 17 March 1957; Carpenter, *Angry Young Men*, p. 153.

26. David Kynaston, *Modernity Britain: Opening the Box, 1957–59* (2013), p. 203; *Guardian*, 16 July 1962.

27. *Yorkshire Post*, 14 March 1957, 27 October 2006; Carpenter, *Angry Young Men*, p. 153; Ritchie, *Success Stories*, p. 37; *Sunday Express*, 9 February 1958; *Daily Express*, 13 April 1957, 22 April 1957, 24 December 1957.

28. Amis, *Memoirs*, p. 155; Ritchie, *Success Stories*, pp. 53, 62; *Evening Standard*, 21 June 1958; Carpenter, *Angry Young Men*, p. 188; *Daily Express*, 24 January 1959.

29. Arnold Bennett, *The Truth about an Author* (1903), p. 142; Carey, *Intellectuals and the Masses*, pp. 153–4; Amis, *Memoirs*, p. 160.

30. Ibid., pp. 155–60.

31. Braine, *Room at the Top*, pp. 126, 202, 206; Kynaston, *Modernity Britain: Opening the Box*, pp. 205–6, 208, 210.

32. Dave Russell, *Looking North: Northern England and the National Imagination* (Manchester, 2004), p. 93; Ritchie, *Success Stories*, pp. 40, 190, 204; Richards, *Films and British National Identity*, pp. 149–50; George Orwell, 'Charles Dickens', in Peter Davison, Ian Angus and Sheila Davison (eds.), *The Complete Works of George Orwell*, vol. 12: *A Patriot after All, 1940–1941* (1998), p. 21; Carpenter, *Angry Young Men*, pp. 164–5.

33. Ritchie, *Success Stories*, p. 191; Taylor, *After the War*, pp. 115–17; Alan Sillitoe, *Saturday Night and Sunday Morning* (1958: 2008), p. 183.

34. Aldgate and Richards, *Best of British*, pp. 195–6; Ritchie, *Success Stories*, pp. 194–6; Sillitoe, *Saturday Night and Sunday Morning*, pp. 142, 219.

35. Russell, *Looking North*, pp. 32–3; Rose, *Intellectual Life of the British Working Classes*, p. 344.

36. On the 'sardines' image, see Taylor, *After the War*, pp. 111–15.

CHAPTER 13. MY LIFE IS MY OWN

1. *Guardian*, 14 January 2009; Alain Carrazé and Hélène Oswald, *'The Prisoner': A Televisionary Masterpiece* (1990), pp. 209–10; Alan Stevens and Fiona Moore, *Fall Out: The Unofficial and Unauthorised Guide to 'The Prisoner'* (Prestatyn, 2007), pp. 18–20.

2. Carrazé and Oswald, *'The Prisoner'*, pp. 210–12. For the costs of *Doctor Who* and *The Avengers*, see the interview with Waris Hussein, 16 October 2013, at http://www.radiotimes.com/news/2013-10-16/doctor-whos-waris-hussein-on-william-hartnell-bette-davis--peter-cook-loathing-david-frost; James Chapman, *Saints and Avengers: British Adventure Series of the 1960s* (2002), pp. 8–9.

3. Carrazé and Oswald, *'The Prisoner'*, pp. 214–15, 220; Stevens and Moore, *Fall Out*, pp. 22–5.

4. Carrazé and Oswald, *'The Prisoner'*, p. 223; Stevens and Moore, *Fall Out*, p. 26; Steven Paul Davies, *'The Prisoner' Handbook* (rev. edn: 2007), pp. 47–8.

5. Carrazé and Oswald, *'The Prisoner'*, pp. 224–5.

6. Ibid., p. 6.

7. Stevens and Moore, *Fall Out*, pp. 26–7; *Independent*, 16 January 2009.

8. *The Stage and Television Today*, 8 February 1968.

9. *Daily Mirror*, 14 June 1968.

10. On *Tom Jones* and *Alfie*, see Alexander Walker, *Hollywood, England: The British Film Industry in the Sixties* (1974), pp. 140–45, 307; Anthony Aldgate and Jeffrey Richards, *Best of British: Cinema and Society from 1930 to the Present* (rev. edn: 1999), pp. 216–17.

11. Geoffrey Gorer, *Exploring English Character* (1955), p. 213; Anthony King and Robert J. Wybrow (eds.), *British Political Opinion, 1937–2000: The Gallup Polls* (2001), pp. 168–9, 188; Jeremy Sandford, *Down and Out in Britain* (1971), p. 146.

12. Humphrey Carpenter, *That Was Satire That Was: 'Beyond the Fringe', the Establishment Club, 'Private Eye' and 'That Was the Week That Was'* (2000), pp. 18–26, 60–87, 245–6; *New Statesman*, 29 August 1953; *Spectator*, 23 September 1955; *Daily Mail*, 11 May 1961; Michael Tracey and David Morrison, *Whitehouse* (1979), p. 46.

13. On *If . . .*, see Aldgate and Richards, *Best of British*, pp. 203–17.

14. Jane Lewis, 'Marriage', in Ina Zweiniger-Bargielowska (ed.), *Women in Twentieth-Century Britain* (Harlow, 2001), p. 73.

15. *The Times*, 2 January 1968; Gavin Miller, *R. D. Laing* (Edinburgh, 2005), pp. 7–64; R. D. Laing, *'The Politics of Experience' and 'The Bird of Paradise'* (Harmondsworth, 1967); John Clay, *R. D. Laing: A Divided Self: A Biography* (1996), p. 136; Ann Oakley, *Housewife* (1974), p. 238.

16. *Guardian*, 14 January 2009; *Independent*, 16 January 2009; Marcus Dunk, 'How Star of the Stage Patrick McGoohan Became a Prisoner of His Own Success', 15 January 2009, http://www.dailymail.co.uk/tvshowbiz/article-1116243/How-star-stage-Patrick-McGoohan-Prisoner-success-switching-screen.html.

17. *Rolling Stone*, 7 October 1976; Philip Norman, *Sir Elton: The Definitive Biography of Elton John* (2000), p. 334.

18. *Guardian*, 7 May 1971; *Daily Mirror*, 15 October 1979; and see, for instance, *Daily Express*, 7 August 1978, 19 February 1979.

19. *Guardian*, 11 September 1982, 21 August 2014, 22 August 2014; Graeme Thomson, *Under the Ivy: The Life and Music of Kate Bush* (2012), pp. 17–21, 92–3.

20. David Buckley, *Strange Fascination: David Bowie: The Definitive Story* (rev. edn: 2005), p. 529; the Bowie quotation is from the documentary 'Cracked Actor', *Omnibus* (BBC1, 26 January 1975).

21. Norman, *Sir Elton*, pp. 4, 209.

22. Ibid., pp. 13, 15, 17, 19, 22, 24–8, 31.

23. Ibid., pp. 43, 61, 63; *New Musical Express*, 17 June 1967.

24. Norman, *Sir Elton*, pp. 94, 101, 142, 145–6; *New Musical Express*, 24 October 1970.

25. Norman, *Sir Elton*, pp. 197–9, 203, 210–11, 220–22.

26. Ibid., pp. 90, 169–72; *New Musical Express*, 26 August 1972; *Melody Maker*, 26 August 1972; *Plays and Players*, November 1972; James Miller, *Flowers in the Dustbin: The Rise of Rock and Roll, 1947–1977* (New York, 1999), pp. 298–9.

27. *New Musical Express*, 3 April 1971, 27 January 1973; *Melody Maker*, 22 January 1972, 12 March 1973; Norman, *Sir Elton*, pp. 177–8, 205, 209.

28. *Sunday Pictorial*, 25 May 1952, 1 June 1952; *Daily Express*, 22 October 1953, 27 November 1953; *Daily Mirror*, 6 November 1953; and see Alan Sinfield, *Literature, Culture and Politics in Post-War Britain* (Oxford, 1989), pp. 77–8; Jeffrey Weeks, *Sex, Politics and Society: The Regulation of Sexuality since 1800* (2nd edn: 1989), p. 241.

29. Geoffrey Gorer, *Sex and Marriage in England Today: A Study of the Views and Experience of the Under-45s* (1971), pp. 190–95, 204; *Gay News*, 20 November 1975; Weeks, *Sex, Politics and Society*, p. 275; Robert J. Wybrow, *Britain Speaks Out, 1937–87: A Social History As Seen Through the Gallup Data* (Basingstoke, 1989), p. 116; *The Times*, 20 January 1970, 5 February 1970, 26 January 1978.

30. *Daily Mirror*, 26 October 1978; Norman, *Sir Elton*, p. 373.

31. Ibid., p. 373; *Daily Express*, 29 May 1979.

32. Norman, *Sir Elton*, p. 372; *Daily Express*, 26 May 1979; *Daily Mirror*, 30 May 1979.

33. *Sun*, 25 February 1987, 12 December 1988; *Daily Mirror*, 17 April 1987; Norman, *Sir Elton*, pp. 450, 453, 466, 480–81.

34. *Rolling Stone*, 8 November 2001.

35. *People*, 8 April 1991; Norman, *Sir Elton*, pp. 494–5.

36. Samuel Smiles, *Self-Help, with Illustrations of Character and Conduct* (1859), pp. 215, 16; *Daily Telegraph*, 16 November 2000; *Guardian*, 1 June 2012.

37. *Guardian*, 1 June 2012; Norman, *Sir Elton*, p. 499.

38. *Guardian*, 13 August 2012; *Toronto Star*, 10 April 2013.

39. 'Bowie Picks Obscure Favourite Album', 23 September 2003, http://hub.contactmusic.com/the-buddha-of-suburbia/news/bowie-picks-obscure-favourite-album; *Guardian*, 24 October 2007.

40. Hanif Kureishi, *The Buddha of Suburbia* (1990), pp. 118, 155.

41. Colin Holmes, *John Bull's Island: Immigration and British Society, 1871–1971* (1988), p. 226; *Observer*, 19 January 2014; *Independent*, 23 October 1999.

42. *Observer*, 17 February 2008, 19 January 2014.

43. *Guardian*, 26 January 2008; *Observer*, 19 January 2014; Kureishi, *Buddha of Suburbia*, p. 16.

44. Ibid., pp. 3, 8, 64, 121; H. G. Wells, *Kipps* (1905: 2010), pp. 255, 237, 165.

45. Kureishi, *Buddha of Suburbia*, pp. 150, 280, 282.

46. *Guardian*, 8 May 1998; *Observer*, 10 May 1998.

47. Mario Cacciottolo, 'Brick Lane Protesters Hurt over "Lies"', 31 July 2006, http://news.bbc.co.uk/1/hi/uk/5229872.stm.
48. *Observer*, 1 June 2003; *Guardian*, 17 June 2003.
49. Monica Ali, *Brick Lane* (2003), pp. 42, 45, 291–4.
50. John Braine, *Room at the Top* (1957: 1989), p. 124; Ali, *Brick Lane*, pp. 14–16.
51. Ibid., p. 492.

CHAPTER 14. AREN'T WE ALL EXTRAORDINARY?

1. *The Times*, 24 September 1980.
2. *Observer*, 2 September 1984, 18 March 1984; *The Times*, 23 January 1984, 11 July 1984, 24 August 1983; Michael Walsh, *Andrew Lloyd Webber: His Life and Works* (1989), p. 155.
3. *Observer*, 18 March 1984; *The Times*, 19 March 1984;
4. Walsh, *Andrew Lloyd Webber*, pp. 162, 164; *The Times*, 28 March 1984; *Guardian*, 28 March 1984.
5. The programme was *The New Elizabethans* (2012), and the full list is at http://www.bbc.co.uk/programmes/b01jxs2c.
6. '*Phantom of the Opera* Screening Earns over £500,000 in the UK This Weekend', 5 October 2011, http://www.broadwayworld.com/article/PHANTOM-OF-THE-OPERA-Screening-Earns-Over-500000-in-the-UK-This-Weekend-20111005; Michael Billington, *State of the Nation: British Theatre since 1945* (2007), pp. 289, 284–6.
7. Margaret Thatcher to Ronnie Millar, 25 August 1978, Margaret Thatcher Foundation, http://www.margaretthatcher.org/document/111738; Peter Hall, *Making an Exhibition of Myself* (1993), quoted in Billington, *State of the Nation*, p. 284; 'Interview for Central Office of Information', 7 July 1986, Margaret Thatcher Foundation, http://www.margaretthatcher.org/document/106443.
8. Amanda Eubanks Winkler, 'Politics and the Reception of Andrew Lloyd Webber's *The Phantom of the Opera*', *Cambridge Opera Journal*, 26:3 (2014), p. 273; 'Radio Interview for IRN', 24 May 1987, Margaret Thatcher Foundation, http://www.margaretthatcher.org/document/106833; *Daily Express*, 19 January 1988, 21 March 1992, 15 February 1997; *Independent*, 20 February 1997.
9. 'Speech Launching Free Enterprise Week', 1 July 1975, Margaret Thatcher Foundation, http://www.margaretthatcher.org/document/102728; Alwyn W. Turner, *Rejoice! Rejoice! Britain in the 1980s* (2010), pp. 67–8.
10. Christopher Johnson, *The Economy under Mrs Thatcher, 1979–1990* (1991), pp. 15, 247; George Davies, *What Next?* (1989: 1991), pp. 1–2; *The Times*, 10 August 1985; interview with Leon Griffiths, c. 1985, reprinted online at http://www.minder.org/teryyear.htm.

11. David Edgar, *Destiny* (1976: 1978), p. 19; Jeremy Seabrook, *City Close-Up* (1971: Harmondsworth, 1973), pp. 11–12.

12. Beatrix Campbell, *Wigan Pier Revisited: Poverty and Politics in the Eighties* (1984), pp. 6, 116; *The Times*, 17 February 1982.

13. *Guardian*, 18 October 1983, 3 October 1983; *The Times*, 30 November 1982.

14. *Evening Standard*, 24 January 1980; *Observer Music Monthly*, 4 October 2009; Gary Kemp, *I Know This Much* (rev. edn: 2010), pp. 93–4; Steve Strange, *Blitzed! The Autobiography of Steve Strange* (2002), pp. 39–40; *Guardian*, 2 February 1981; and see David Johnson's excellent website www.shapersofthe80s.com.

15. *Guardian*, 2 February 1981; *The Times*, 31 December 1980; Kemp, *I Know This Much*, pp. 15–16, 176–7.

16. Martin Amis, *Money* (1984: 2011), pp. 262, 67.

17. *The Times*, 29 April 2010; *Melody Maker*, 15 September 1984, *New Musical Express*, 22 September 1984.

18. *The Times*, 9 January 1985.

19. *Guardian*, 6 June 1983, 23 May 1983; *The Times*, 30 May 1983.

20. David Butler and Dennis Kavanagh, *The British General Election of 1979* (1980), p. 343; Ian MacDonald, *Revolution in the Head: The Beatles' Records and the Sixties* (2nd edn: 1997), p. 29.

21. David Cannadine, 'How I Inspired Thatcher', 9 December 2005, http://news.bbc.co.uk/1/hi/magazine/4514594.stm.

22. Raphael Samuel, *Island Stories: Unravelling Britain* (1998), pp. 332–3; 'TV Interview for LWT *Weekend World*', 16 January 1983, Margaret Thatcher Foundation, http://www.margaretthatcher.org/document/105087.

23. Samuel, *Island Stories*, p. 333; 'Radio Interview for IRN programme *The Decision Makers*', 15 April 1983, Margaret Thatcher Foundation, http://www.margaretthatcher.org/document/105291; Margaret Thatcher to John Evans, 5 May 1983, Margaret Thatcher Foundation, http://www.margaretthatcher.org/document/132330.

24. Samuel, *Island Stories*, p. 332; Matthew Sweet, *Inventing the Victorians* (2001), p. 227; Samuel Smiles, *Thrift* (1875: Chicago, IL, 1890), p. 359; 'Interview for *Woman's Own*', 23 September 1987, Margaret Thatcher Foundation, http://www.margaretthatcher.org/document/106689.

25. *Smash Hits*, 2 March 1987; 'Speech to American Bar Association', 15 July 1985, Margaret Thatcher Foundation, http://www.margaretthatcher.org/document/106096. For more tributes to Live Aid, see Hansard, 16 July 1985; 'Speech at Tyne Tees TV Lunch', 17 July 1985, Margaret Thatcher Foundation, http://www.margaretthatcher.org/document/106099. The Gladstone quotation is from William Ewart Gladstone, *A Chapter of Autobiography* (1868), pp. 61–2.

26. *Daily Mail*, 9 April 2013.

27. 'Walters is a Dancer in Cannes', 19 May 2000, http://news.bbc.co.uk/1/hi/entertainment/755223.stm; 'Elton's Account of the Day He First Encountered Billy Elliot', http://www.eltonjohn.com/music/billy-elliot-the-musical/.

28. Philip Norman, *Sir Elton: The Definitive Biography of Elton John* (2000), pp. 43, 234–5; *Independent*, 23 June 2004; *Guardian*, 4 May 2005.

29. *Independent*, 23 June 2004; *Guardian*, 4 May 2005; 'Elton's Account of the Day He First Encountered Billy Elliot'; 'Billy Elliot Live Screening Tops UK Cinema Box Office', 30 September 2014, http://m.bbc.co.uk/news/entertainment-arts-29429557.

30. *Independent*, 16 July 2010; *The Times*, 8 August 1984.

31. *The Times*, 8 August 1984, 28 January 1985; *Guardian*, 25 October 1984.

32. *Guardian*, 10 March 2014, 24 November 1999, 27 August 2000, 11 November 2000; *Independent*, 29 November 2009; and see the introduction to Lee Hall, *Billy Elliot* (2000), pp. viii–ix.

33. *Guardian*, 11 November 2000, 10 March 2014, 4 May 2005; Michael Crick, *Scargill and the Miners* (Harmondsworth: 1985), p. 154; for the film's publicity, see 'Billy Elliot: Production Notes', http://cinema.com/articles/160/billy-elliot-production-notes.phtml.

34. *Guardian*, 27 August 2000, 4 May 2005; Hall, *Billy Elliot*, p. ix; 'Billy Elliot: Production Notes'.

35. Hall, *Billy Elliot*, pp. 7, 20, 16, 19; 'Billy Elliot: Production Notes'.

36. Hall, *Billy Elliot*, pp. 35, 52, 78; Campbell, *Wigan Pier Revisited*, p. 190.

37. On Waterhouse, see *Daily Telegraph*, 4 September 2009.

38. Keith Waterhouse, *Billy Liar* (1959: 1962), pp. 79, 12, 15, 23–4, 44, 29.

39. Dave Russell, *Looking North: Northern England and the National Imagination* (Manchester, 2004), pp. 95, 98; Arnold Bennett, *A Man from the North* (1898: 1911), p. 1; Kingsley Amis, *Lucky Jim* (1954: 1961), p. 250; Hanif Kureishi, *The Buddha of Suburbia* (1990), p. 121.

40. Waterhouse, *Billy Liar*, pp. 145, 187; Russell, *Looking North*, p. 109 n. 62.

41. Hall, *Billy Elliot*, pp. 42, 46, 81.

42. 'Billy Elliot: Production Notes'; *Guardian*, 10 October 2000, 10 March 2014; *Independent*, 29 November 2009; *Socialist Review*, December 2000, http://pubs.socialistreviewindex.org.uk/sr247/mitchell.htm.

43. Hall, *Billy Elliot*, p. 91.

44. *Independent*, 16 July 2010; Jessica Elgot, 'Margaret Thatcher Funeral: Easington Holds a Party', 17 April 2013, http://www.huffingtonpost.co.uk/2013/04/17/margaret-thatcher-funeral-easington-colliery-club_n_3101089.html.

45. *Independent on Sunday*, 8 May 2005.

46. *Guardian*, 4 May 2005; Will Grant, 'Macho Mexico's Ballet Boys Grow by Leaps and Bounds', 15 August 2013, http://m.bbc.co.uk/news/world-latin-america-23680534.

47. '*Billy Elliot* to Close on Broadway', 3 October 2011, http://www.broad wayworld.com/article/BILLY-ELLIOT-to-Close-on-Broadway-January-8-2012-20111003; 'Past/Present/Future for Lee Hall', 26 January 2009, http://www. whatsonstage.com/west-end-theatre/news/01-2009/pastpresentfuture-for-lee-hall_18521.html.

Further Reading

Britain's cultural history is very well-trodden ground, and I had a lot of fun tracking the footsteps of those writers who have covered various bits of it already. In fact, this section is really a list of debts, organized in the order that the topics crop up in the book. But before kicking off, I want to tip my hat to two books in particular: John Carey's *The Intellectuals and the Masses: Pride and Prejudice among the Literary Intelligentsia, 1880–1939* (1992) and the same author's *What Good Are the Arts?* (2005). Both have more than their fair share of detractors, but there is more amusement, enlightenment and inspiration to be found in Carey's books that in entire libraries of academic monographs.

There is obviously a vast number of books about the Victorians, but I learned most from Asa Briggs's classic *Victorian People: A Reassessment of Persons and Themes, 1851–67* (rev. edn: 1965). Martin J. Wiener's controversial *English Culture and the Decline of the Industrial Spirit, 1850–1980* (2nd edn: Cambridge, 2004) is full of interesting and provocative ideas. David Newsome, *The Victorian World Picture: Perceptions and Introspections in an Age of Change* (1997), is excellent on the Victorians' sense of themselves and their world. Matthew Sweet, *Inventing the Victorians* (2001), is a hilariously entertaining read, while Simon Heffer, *High Minds: The Victorians and the Birth of Modern Britain* (2013), is a book of great moral and intellectual seriousness, worthy of the Victorians themselves.

For the section on Black Sabbath, I relied most heavily on Tony Iommi's autobiography *Iron Man: My Journey through Heaven and Hell with Black Sabbath* (2011) – a book that sometimes seems quite sensationally humdrum – as well as Andrew Cope's *Black Sabbath and the Rise of Heavy Metal Music* (Farnham, 2010). The early twentieth-century anxiety about Americanization is explored most fully in Genevieve Abravanel, *Americanizing Britain: The Rise of Modernism in the Age of the Entertainment Empire* (Oxford, 2012), and Mark Glancy, *Hollywood and the Americanization of Britain: From the 1920s to the Present* (2014). For the life and career of J. Arthur Rank, I followed Geoffrey Macnab, *J. Arthur Rank and the British Film Industry* (1993), which is very good on the films, and Michael Wakelin, *J. Arthur Rank: The Man behind the Gong* (Oxford, 1996), which concentrates more on the man. Matthew Sweet,

Shepperton Babylon: The Lost Worlds of British Cinema (2005), is wonderful on the early days of the British film industry. On the background to Olivier's *Henry V*, I learned most from James Chapman, *Past and Present: National Identity and the British Historical Film* (2005).

There are probably even more books on the Beatles than there are about the Victorians. Although Philip Norman's *Shout! The True Story of the Beatles* (1993) is quite old now, it remains a cracking read. The really essential books, though, are Ian MacDonald, *Revolution in the Head: The Beatles' Records and the Sixties* (2nd edn: 1997), and Mark Lewisohn, *The Beatles: All These Years*, vol. 1: *Tune In* (2013), the first volume of what promises to be the band's definitive history. On *The Avengers*, the best overview is James Chapman, *Saints and Avengers: British Adventure Series of the 1960s* (2002). For Ian Fleming and Chris Blackwell in Jamaica, I used Matthew Parker, *Goldeneye: Where Bond Was Born: Ian Fleming's Jamaica* (2014). On Blackwell generally, the most illuminating piece I read was Mark Binelli's essay 'Chris Blackwell: The Barefoot Mogul', which appeared in the January 2014 issue of *Men's Journal*.

My discussion of advertising is based on Sam Delaney's gossipy and enormously amusing *Get Smashed: The Story of the Men Who Made the Adverts That Changed Our Lives* (2007); Winston Fletcher, *Powers of Persuasion: The Inside Story of British Advertising, 1951–2000* (Oxford, 2008), an excellent historical overview; and Ivan Fallon's biography *The Brothers: The Rise and Rise of Saatchi and Saatchi* (1988). For a blistering attack on Saatchi's influence as a collector, see Rita Hatton and John A. Walker, *Supercollector: A Critique of Charles Saatchi* (2000), while Julian Stallabrass's book *High Art Lite: The Rise and Fall of Young British Art* (rev. edn: 2006) empties both barrels into the art itself. For the video-games industry, meanwhile, I relied on Magnus Anderson and Rebecca Levene, *Grand Thieves and Tomb Raiders: How British Video Games Conquered the World* (2012), as well as David Kushner, *Jacked: The Unauthorised Behind-the-Scenes Story of 'Grand Theft Auto'* (2012). Francis Spufford's book *Backroom Boys: The Secret Return of the British Boffin* (2003) has a brilliant chapter on *Elite*.

The best sources for the Rolling Stones and their country houses are Keith Richards, *Life* (2010), and Bill Wyman, *Stone Alone: The Story of a Rock 'n' Roll Band* (1990). On country houses more generally, the definitive history is Peter Mandler, *The Fall and Rise of the Stately Home* (New Haven, CT, 1997). For the Royal Family and pop music, I learned a lot from Mark Duffett's article 'A "Strange Blooding in the Ways of Popular Culture"? *Party at the Palace* as Hegemonic Project', *Popular Music and Society*, 27:4 (2004), pp. 489–506, despite its rather off-putting title. The definitive life of T. H. White is Sylvia Townsend Warner, *T. H. White: A Biography* (1967). There are obviously hundreds of essays about Harry Potter: I thought the most interesting were Alison Lurie's piece in the *New York Review of Books*, dated 16 December 1999, and Wendy Doniger's essay in the *London Review of Books*, dated 17 February 2000.

On school stories, I owe an enormous debt to Jeffrey Richards's definitive history *Happiest Days: The Public Schools in English Fiction* (Manchester, 1988). Their impact on ordinary readers is one of several subjects covered in Jonathan Rose's wonderful book *The Intellectual Life of the British Working Classes* (2nd edn: New Haven, CT, 2010). There is a nice chapter on the Greyfriars stories in E. S. Turner, *Boys Will Be Boys: The Story of Sweeney Todd, Deadwood Dick, Sexton Blake, Billy Bunter, Dick Barton et al.* (3rd edn: 1976). The standard life of Ian Fleming is Andrew Lycett, *Ian Fleming* (1995). On the Bond films, the best book is James Chapman, *Licence to Thrill: A Cultural History of the James Bond Films* (1999). And on Bond in general, Simon Winder's *The Man Who Saved Britain: A Personal Journey into the Disturbing World of James Bond* (2006) is both very insightful and immensely funny. (Simon commissioned and edited this book, but don't let that put you off.) For Bond's debts to earlier heroes, meanwhile, see Richard Usborne's enormously enjoyable *Clubland Heroes: A Nostalgic Study of Some Recurrent Characters in the Romantic Fiction of Dornford Yates, John Buchan and Sapper* (3rd edn: 1983).

There are thousands of books on Dickens: my favourites are John Carey, *The Violent Effigy: A Study of Dickens' Imagination* (1973), and Claire Tomalin, *Charles Dickens: A Life* (2011). On Dickens's relationship with the soap opera, I learned a lot from Robert Giddings's essay 'Dickens from Page to Screen', *Canadian Notes and Queries*, no. 54 (1998), pp. 13–19, as well as the same author's piece 'Soft-Soaping Dickens: Andrew Davies, BBC-1 and "Bleak House"', which is online at http://charlesdickenspage.com/Soft_Soaping_Dickens.html. There are also lots of books about *Coronation Street*, but I found Sean Egan, *Fifty Years of 'Coronation Street': The (Very) Unofficial History* (2010) to be the most informative, complemented by Dorothy Hobson's book *Soap Opera* (2002). Nobody interested in the show can afford to ignore the Corriepedia website, http://coronationstreet.wikia.com/wiki/Corriepedia. For Catherine Cookson, meanwhile, there are two excellent biographies: Kathleen Jones, *Catherine Cookson: The Biography* (1999), and Piers Dudgeon, *The Girl from Leam Lane: The Life and Writing of Catherine Cookson* (rev. edn: 2006). Cookson's own memoir, *Our Kate* (1969: 1974), is interesting as much for what it does *not* say as for what it does. My discussion of Cookson also owes a lot to Robert Colls's essay 'Cookson, Chaplin and Common: Three Northern Writers in 1951', in K. D. M. Snell (ed.), *The Regional Novel in Britain and Ireland, 1800–1990* (Cambridge, 1998), pp. 164–200, and Julie Anne Taddeo's article 'The Victorian Landscape of Catherine Cookson Country', *Journal of Popular Culture*, 42:1 (2009), pp. 162–79.

For Agatha Christie, the most interesting and provocative biography is Laura Thompson, *Agatha Christie: An English Mystery* (2007). Robert Barnard's excellent book *A Talent to Deceive: An Appreciation of Agatha Christie* (rev. edn: 1990) tries to unpick how her novels work, while Alison Light, *Forever England: Femininity, Literature and Conservatism between the Wars* (1991), analyses her

early books against the social and political background of the interwar period. For William Golding, I followed John Carey, *William Golding: The Man Who Wrote 'Lord of the Flies'* (2009). For Tolkien, there are a vast number of books, chief among them Humphrey Carpenter's definitive *J. R. R. Tolkien: A Biography* (1977) and Tom Shippey's splendidly spirited books *The Road to Middle-Earth* (1982) and *J. R. R. Tolkien: Author of the Century* (2000). My discussion of Tolkien and the First World War draws very heavily on John Garth, *Tolkien and the Great War: The Threshold of Middle-Earth* (2003), a tremendously learned and moving book. The idea of the 'morbid age' comes from Richard Overy, *The Morbid Age: Britain between the Wars* (2009). There is no biography, oddly, of John Wyndham. I learned most, I think, from Christopher Priest's essay 'John Wyndham and H. G. Wells', http://www.christopher-priest.co.uk/essays-reviews/contemporaries-portrayed/john-wyndham-h-g-wells/. For Wells himself, I relied on Michael Sherborne, *H. G. Wells: Another Kind of Life* (2010). The relevant BBC documents for the origins of *Doctor Who* have been put online at http://www.bbc.co.uk/archive/doctorwho/. There are endless books on the series by fans, but very few that try to make sense of it as a historical phenomenon without descending into pretension, lunacy or cultural-studies babble. The best is James Chapman, *Inside the TARDIS : The Worlds of 'Doctor Who': A Cultural History* (2006).

The life of John Lennon is pretty well covered in the Beatles books, but if you really need to read just about him, the best biography is Philip Norman, *John Lennon: The Life* (2008). The best thing I read on Samuel Smiles was the relevant chapter of Asa Briggs's *Victorian People*. For good overviews of the films of the 1950s, see Jeffrey Richards, *Films and British National Identity: From Dickens to 'Dad's Army'* (Manchester, 1997), and Anthony Aldgate and Jeffrey Richards, *Best of British: Cinema and Society from 1930 to the Present* (rev. edn: 1999). The novels of the same period, meanwhile, are brilliantly covered in Harry Ritchie, *Success Stories: Literature and the Media in England, 1950–1959* (1988), and Humphrey Carpenter, *The Angry Young Men: A Literary Comedy of the 1950s* (2002). D. J. Taylor's book *After the War: The Novel and England since 1945* (1993) makes some characteristically pointed and thoughtful observations about post-war novels generally.

Kingsley Amis's *Memoirs* (New York, 1991) are even funnier than his novels, while Dave Russell, *Looking North: Northern England and the National Imagination* (Manchester, 2004), is excellent on the fictional image of the North. *The Prisoner* suffers from the same malaise as James Bond, *The Avengers* and *Doctor Who*: there are lots of books about it, but many of them are a bit dodgy. I drew most heavily on Alain Carrazé and Hélène Oswald, *'The Prisoner': A Televisionary Masterpiece* (1990), and Alan Stevens and Fiona Moore, *Fall Out: The Unofficial and Unauthorised Guide to 'The Prisoner'* (Prestatyn, 2007). On Elton John, I relied entirely on Philip Norman, *Sir Elton: The Definitive Biography of*

Elton John (2000), which is, I think, the most accomplished of all Norman's rock biographies. For Andrew Lloyd Webber, meanwhile, I used Michael Walsh, *Andrew Lloyd Webber: His Life and Works* (1989), which is a bit dated, but very informative on the early works. Finally, for the documents on Mrs Thatcher's relationship with the arts, I used the extraordinary Margaret Thatcher Foundation website at http://www.margaretthatcher.org, a gift to the historian and a model of its kind.

Index

Page numbers in *italic* indicate illustrations.